T0227227

Process Tomography

Process Tomography

Process Tomography

Principles, techniques and applications

Edited by
R. A. Williams
M. S. Beck

Butterworth-Heinemann Ltd
Linacre House, Jordan Hill, Oxford OX2 8DP

A member of the Reed Elsevier group

OXFORD LONDON BOSTON
MUNICH NEW DELHI SINGAPORE SYDNEY
TOKYO TORONTO WELLINGTON

First published 1995

British Library Cataloguing in Publication Data

Process Tomography: Principles,
Techniques and Applications
 I. Williams, R. A. II. Beck, M. S.
 607.427028

ISBN 0 7506 0744 0

Library of Congress Cataloging-in-Publication Data

Process tomography:principles, techniques, and applications/edited
 by R. A. Williams, M. S. Beck.
 p. cm.
 Includes bibliographical references and index.
 ISBN 0 7506 0744 0
 1. Flow visualization – Industrial applications. 2. Tomography
 –Industrial applications. I. Williams, R. A. II. Beck, M. S.
 (Maurice, S.)
 TA357.P749 1995
 660'.281'028 – dc20 94–41070 CIP

Transferred to digital printing 2006

Contents

7. Electrodynamic Sensors for Process Tomography 101
A. R. Bidin, R. G. Green, M. E. Shackleton, A. L. Stott and R. W. Taylor

8. Ultrasonic Sensors 119
B. S. Hoyle and L. A. Xu

Preface

There is a widespread need for the direct analysis of the internal characteristics of process plants in order to improve the design and operation of equipment. The measuring instruments for such applications must use robust non-invasive sensors which, if required, can operate in aggressive and fast moving fluids and multiphase mixtures. Process tomography involves using tomographic imaging methods to manipulate data from remote sensors in order to obtain precise quantitative information from inaccessible locations. The need for tomography is analogous to the medical need for body scanners, which has been met by the development of computer-aided tomography.

Process tomography will improve the operation and design of processes handling multi-component mixtures by enabling boundaries between different components in a process to be imaged, often in real-time using non-intrusive sensors. Information on the flow regime, vector velocity, and concentration distribution in process vessels and pipelines will be determined from the images.

The basic idea is to install a number of sensors around the pipe or vessel to be imaged. The sensor output signals depend on the position of the component boundaries within their sensing zones. A computer is used to reconstruct a tomographic image of the cross-section being observed by the sensors. This will provide, for instance, identification of the distribution of mixing zones in stirred reactors, interface measurement in complex separation processes and measurements of two-phase flow boundaries in pipes with applications to multi-phase flow measurement. The image data can be analysed quantitatively for subsequent use to actuate process control strategies or to develop models to describe individual processes.

Process tomography essentially evolved during the mid-1980s. A number of applications of tomographic imaging of process equipment were described in the 1970s, but generally these involved using ionizing radiation from X-ray or isotope sources, and these were not satisfactory for the majority of on-line process applications on a routine basis because of the high cost involved and safety constraints. Most of the radiation-based methods used long exposure times which meant that dynamic measurements of the real-time behaviour of process systems were not feasible.

In the mid-1980s work started that led to the present generation of process tomography systems. At the University of Manchester Institute of Science and Technology (UMIST) in England there began a project on electrical capacitance tomography for imaging multi-component flows from oil wells and in pneumatic conveyors. At about the same time, a group at the Morgantown Energy Technology Center in the USA were designing a

capacitance tomography system for measuring the void distribution in gas fluidized beds. The capacitance transducers used for both the above systems were only suitable for use in an electrically non-conducting situation.

Also in the mid-1980s medical scientists started to realize the potential of electrical impedance tomography (measuring electrical resistance) as a safe, low-cost method for imaging the human body. There was rapid progress in several centres with Sheffield University Royal Hallamshire Hospital in the UK and Rennselaer Polytechnic Institute in the USA taking major roles. The success of this early work encouraged the setting up in 1988 of a European Union (EU) co-ordinated activity on electrical impedance tomography for medical applications.

In 1988 work started at UMIST on the development of electrical impedance tomography (EIT) for imaging vessels containing electrically conducting fluids. Previous work on medical EIT facilitated progress because some of the instrumentation problems were common for medical and process EIT. However, major differences are apparent. Principally, medical EIT aims to measure the location of objects in space, whereas process tomography needs to measure both the location and velocity of movement. In France a major EU initiative in development of microwave imaging technology was undertaken.

By 1990 it was felt that process tomography was maturing as a potentially useful technique for application to industrial process design and operation, although the effort was somewhat fragmented and dispersed. Therefore it was timely to establish a 4-year programme for a European Concerted Action on Process Tomography within a framework of the Brite Euram scheme. This resulted in the first workshop on the subject, held during March 1992 in Manchester, England. One outcome of the workshop was to reveal the existence of several other sensor systems such as acoustic, optical and radiation techniques, emission techniques and magnetic resonance imaging which were amenable for use in process systems.

Undoubtedly, development in the 1980s of low cost array processors did much to solve the previous problem of high cost and slowness in tomographic image reconstruction using Van Neuman computer architectures. This has led to process tomography becoming a cost-effective technique.

Developments in the availability of sophisticated computer aids have also changed the design capabilities in the chemical process industries. Design strategies are now firmly founded on a variety of modelling techniques and simulations which may incorporate thermodynamics, reaction kinetics and hydrodynamics. For instance, the explosion of computational fluid dynamics models for increasingly realistic process scenarios must be accompanied by independent validation of each model against experimental results. It is in this context that the various sensing methods of process tomography offer a convenient means of model verification in an industrial environment, rather than in a simplified 'model' reactor using conventional laser or optical tracer techniques. Conventional techniques require invasive sampling methods or that the process mixture is modified in some artificial manner (e.g. solid/liquid suspensions have to be diluted in order to gain optical access for measurements). Furthermore, measurement information is normally restricted to one small

zone within the process vessel, or requires a multiplicity of measurement zones, whereas tomographic techniques have an excellent spatial range and can be used for imaging in two and three dimensions. This philosophy is demonstrated by several application examples in this book.

Besides model validation, the ability to measure component concentration profiles and, in some cases, to identify phase sizes and boundaries within vessels and pipelines, will provide a battery of information for the process engineer, of relevance in the elucidation of fundamental reaction kinetics and for optimum geometric design of large-scale equipment. It is envisaged that as three-dimensional imaging techniques develop, process tomography will be used for the purposes of plant control, either for alarm functions, or in the form of a full mass-balancing and circuit-monitoring service.

This book is edited by the group at UMIST, where two new laboratories were set up in 1990: one, in the Electrical Engineering Department, concerned with research in instrumentation for process tomography; and the other in the Chemical Department concerned with industrial applications of the subject. The authorship is drawn from the international community developing the subject, prompted by meetings of eight UK based research groups who began to meet on a regular basis in 1989, aided by the commencement in 1991 of the EC co-ordinated activity in process tomography.

We consider it timely to draw together in one volume the scientific and engineering design features of process tomography instrumentation and to present this information in a practical industrial problem-solving approach. We must therefore address three potential audiences; the student who requires an introduction to the theoretical basis of the subject, the advanced research and development engineer who requires the theory and its practical implementation in considerable depth, and the industrial process engineer who is interested in the practical aspects of performance and the use of process tomography for process model verification, process design and operation. We realize that these people may come from electrical, chemical or mechanical engineering or physics backgrounds, so we endeavour not to assume any specialization in the basic discipline, and hence extensive theoretical derivations and scientific detail is sometimes omitted with a reference made to other publications where such detailed information can readily be found.

Instrumentation for process tomography involves an understanding of the basic principles of tomographic image reconstruction (Part I), the sensing techniques for measuring the process data (Part II), and the data-processing techniques for reconstructing the image information (Part III). However, the production of tomographic images of equipment is a new technique of service to the process industry; the method has passed the infant stage, so industrial applications are feasible. Therefore, other vital parts are those which describe the principles of tomography in a process system (Part I) and process applications (Part IV).

Part I introduces the subject and describes the industrial need for more information on the location and movement of materials in process vessels in order to secure cost effectiveness in design and operation of processes. The general principles of tomography are then described without theoretical

detail, leading on to a description of electrical methods which provide one means for measuring the dynamics of processes. Process tomography is an applied subject so this part also deals with the way in which tomographic image information can be used for process model verification, and hence for providing a new route for more precise process design. This is based on tomographically observed data about the internal behaviour of the process vessels, rather than the traditional methods of design, which are often based on theoretical approximations with some empirical support and considerable extrapolation. Processes designed in an optimum way and operating in a cost-effective way close to a tolerance limit will, undoubtedly, require precise methods of monitoring and control to ensure continuous efficient operation. For these purposes simplified tomographic systems may be feasible and their use in process control is also introduced in Part I.

The performance of instrumentation systems is critically dependent on the correct choice and design of sensors, and an understanding of their limitations. Part II on 'sensing techniques' first considers the selection of suitable sensing techniques for a range of process tomography applications. A description of a variety of currently available sensors is then presented, including details of electrodes, electronics and system performance wherever this information is currently available. Most of the systems currently developed have been used for imaging two-component processes, however in some cases three or more components need to be imaged separately, so Part II includes consideration of multi-modality sensor systems which could be used for multi-component imaging.

Secondary to using the most suitable sensing technique, the quality, usefulness and cost of process tomography depends on the design of the data-processing system. Part III examines the quantity of data that needs to be processed and then describes the way in which serial and parallel processing computers can be used to reconstruct the images. Image reconstruction involves repetitive operations at high speed, so reconfigurable 'hard systems' for image reconstruction are considered. Having set the scene concerning signal processing, the specific image-processing techniques needed in process tomography are then described with emphasis on the special needs for electrical impedance tomography systems, and mention of the need to measure the velocity of material movement. The geometry of the electrodes and the electrode field is critical in optimizing the resolution and discrimination of a process tomography system, so electrode design based on finite element methods is an important aspect of Part III; this takes the form of a computer-aided design procedure which can be extended to include an overall design method for the whole of a process tomography system. Part III concludes with a systematic approach to error estimation so that readers can obtain an understanding of the contribution of different components in a system to its overall accuracy.

Applications of process tomography have increased in number in recent years, although the full potential for process design and operation has still to be realized. Therefore Part IV, on applications, illustrates how tomography can be used in the modelling, design and operation of a wide range of

processes. The first four chapters consider dry powders and particulate processes that are stationary or moving slowly (in packed columns and hoppers), moving rapidly (in mixers), flowing (in pneumatic conveyors), or experiencing complex dynamic behaviour (in fluidized beds). The examples illustrate how the high-resolution sensing methods (positron emission tomography, γ photon transmission tomography) can be used to provide detailed microstructural information in a laboratory environment. Lower resolution methods (electrical capacitance tomography) have specific utility for on-line monitoring and real-time control applications. The following three chapters describe the use of optical, resistance and nuclear magnetic resonance sensors to characterize and model the flow and mixing behaviour of fluids and multi-phase mixtures. A wide range of process and environmental applications is considered, including on-line measurements on a centrifugal separator and biological systems. The final chapter describes an advanced development in which optical tomography is used to visualize temperature distributions in flames. This has important implications for combustion research and provides a good example of how parallel computation is used to implement image reconstruction and interpretation. Other applications, of process tomography, for example in the oil industry, are included with the case studies in Part III.

R. A. Williams
M. S. Beck

1995

Contributors

F. Abdullah
Department of Electrical Electronics & Information Engineering, City University, Northampton Square, London EC1V 0HB, UK

M. S. Beck
Department of Electrical Engineering & Electronics, UMIST, P.O. Box 88, Manchester M60 1QD, UK.

A. R. Bidin
School of Engineering, Sheffield Hallam University, Pond Street, Sheffield S1 1WB, UK.

J. Ch. Bolomey
Supelec, Plateau de Moulon, 91192 Gif sur Yvette, France.

J. Bridgwater
Department of Chemical Engineering, University of Cambridge, Pembroke Street, Cambridge CB2 3RA, UK.

H. Burkhardt
Technische Universitat Hamburg-Harburg, Arbeitsbereich Technische Informatik I, Harburger Schloßstr. 20, D-21071 Hamburg 90, Germany.

F. J. Dickin
Department of Electrical Engineering & Electronics, UMIST, P.O. Box 88, Manchester M60 1QD, UK.

P. Dugdale
School of Engineering, Bolton Institute, Deane Road, Bolton BL3 5AB, UK.

T. Dyakowski
Department of Chemical Engineering, UMIST, P.O. Box 88, Manchester M60 1QD, UK.

A. Fellhölter
Institut für Verfahrenstechnik University of Hannover, Callinstraße 36, 3000 Hannover 1, Germany.

R. G. Green
School of Engineering, Sheffield Hallam University, Pond Street, Sheffield S1 1WB, UK

J. S. Halow
Morgantown Energy Technology Center, US Department of Energy, Morgantown, WV, USA

A. J. Hartley
School of Engineering, Bolton Institute, Deane Road, Bolton BL3 5AB, UK.

D. G. Hayes
Department of Electrical Engineering & Electronics, UMIST, P.O. Box 88, Manchester M60 1QD, UK.

M. R. Hawkesworth
Positron Imaging Centre, School of Physics & Space Research, University of Birmingham, Birmingham B15 2TT, UK.

M. E. Hosseini-Ashrafi
Department of Chemical & Process Engineering, University of Surrey, Guildford, Surrey GU2 5XH, UK.

B. S. Hoyle
Department of Electronic & Electrical Engineering, University of Leeds, Leeds LS2 9JT, UK.

S. M. Huang
Schlumberger Cambridge Research Ltd, P.O. Box 153, Cambridge CB3 0HG, UK.

R. G. Jackson
School of Engineering, Bolton Institute, Deane Road, Bolton BL3 5AB, UK.

S. H. Khan
Department of Electrical Electronics & Information Engineering, City University, Northampton Square, London EC1V 0HB, UK.

J. Landauro
School of Engineering, Bolton Institute, Deane Road, Bolton BL3 5AB, UK.

N. MacCuaig
Surrey Medical Imaging Systems Ltd, Alan Turing Road, Surrey Research Park, Guildford GU2 5FY, UK.

S. L. McKee
Department of Chemical Engineering, UMIST, P.O. Box 88, Manchester M60 1QD, UK.

D. Mewes
Institut Für Verfahrenstechnik University of Hannover, Callinstraße 36, 3000 Hannover 1, Germany.

D. J. Parker
Positron Imaging Centre, School of Physics & Space Research, University of Birmingham, Birmingham B15 2TT, UK.

A. J. Peyton
Department of Electrical Engineering & Electronics, UMIST, P.O. Box 88, Manchester M60 1QD, UK.

M. E. Shackleton
School of Engineering, Sheffield Hallam University, Pond Street, Sheffield S1 1WB, UK.

E. Stoll
Arbeitsbereich Technische Informatik I, Technische Universitat Hamburg-Harburg, Harburger Schloßstr. 20, D-21071 Hamburg 90, Germany.

A. L. Stott
Department of Electrical Engineering & Electronics, UMIST, P.O. Box 88, Manchester M60 1QD, UK.

R. W. Taylor
College of Engineering, Western Michigan University, Kalamazoo, MI 49008, USA.

U. Tüzün
Department of Chemical & Process Engineering, University of Surrey, Guildford, Surrey GU2 5XH, UK.

M. Wang
Department of Electrical Engineering & Electronics, UMIST, P.O. Box 88, Manchester M60 1QD, UK.

R. A. Williams
Camborne School of Mines, University of Exeter, Pool, Redruth, Cornwall TR15 3SE, UK.

C. G. Xie
Department of Electrical Engineering & Electronics, UMIST, P.O. Box 88, Manchester M60 1QD, UK.

L. A. Xu
Department of Electrical Engineering & Automation, Tianjin University, Tianjin, People's Republic of China.

Part I

Principles

Section Editor: T. Dyakowski

Chapter 1

Introduction to process tomography

R. A. Williams and M. S. Beck

1.1 Basic systems and components

Tomographic technology involves the acquisition of measurement signals from sensors located on the periphery of an object, such as a process vessel or pipeline. This reveals information on the nature and distribution of components within the sensing zone. Most tomographic techniques are concerned with abstracting information to form a cross sectional image. This can, for example, utilize a parallel array of sensors (Figure 1.1) placed so that their sensing field interrogates a projection of a suitable radiation across the subject, which is assumed to be of circular cross section. In order to explore the entire cross section it is necessary to obtain other projections by rotating the subject in the direction normal to the direction of the sensor field or, preferably, to rotate the measurement sensors around the subject. It may not always be possible to adopt such a methodology since it may be impractical physically to rotate the subject, or the sensors, and the time required to rotate the assembly may take too long compared to changes occurring within the subject under investigation.

This measurement protocol is a typical technique that falls under the

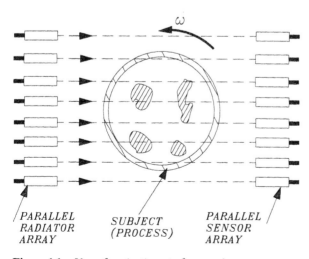

PARALLEL RADIATOR ARRAY *SUBJECT (PROCESS)* *PARALLEL SENSOR ARRAY*

Figure 1.1 *Use of projections to form an image*

definition of tomography. The root of the word tomography is derived from the Greek word $\tau o\mu o\zeta$) meaning 'to slice', and according to the *Oxford English Dictionary* may be defined as:

> Radiography in which an image of a predetermined plane in the body or other object is obtained by rotating the detector and the source of radiation in such a way that points outside the plane give a blurred image. Also in extended use, *any analogous technique using other forms of radiation.*

Implicit in this definition is an emphasis on the use of radioactive sensing methods, which were first used in developing tomographic imaging methods for visualizing internals within the human body and, more recently, for various types of medical computerized tomographic body scanners using other sensory technologies.

However, another type of imaging technique exists, which involves the use of tracer species that are added into the process under investigation. These tracers emit an appropriate and detectable signal via the sensor(s) placed at the periphery of the vessel. Such methods do not conform to the above definition since the sensors can only detect and track the movements of a few individual tracer species, rather than being able to reveal a complete image of the components in the entire cross section probed by sensors. An example of this method is positron emission tomography (PET).

Nevertheless, as will be demonstrated in subsequent chapters, such techniques can provide invaluable information for the process engineer. Taking this type of technique to an extreme case where many hundreds or millions of tracers are added to the process under interrogation, the system can be considered to meet the above definition (although this may not be a practical or popular course of action, particularly if the tracers disturb the process or introduce undesirable safety constraints). An example of such a limiting case, but with no deleterious side effects, is the use of nuclear magnetic resonance imaging (MRI), which exploits the electromagnetic properties of individual molecules in a liquid based mixture. Few other tomographic techniques are able to offer such chemical specificity.

The basic components of any process tomographic instrument are shown in Figure 1.2, embodied in hardware (sensors, signal/data control) and software (signal reconstruction, display and interpretation facilities, generation of output control signals to process hardware). The detailed functions of each component will be described in subsequent chapters, since it is evident that the design and selection of an appropriate tomographic system to allow interrogation of a given process demands detailed consideration of each component. It is, however, necessary to emphasize that obtaining a good quality computed 'image' represents only the first stage of information input to the process engineer. The ultimate goal is quantitative (numerical) interpretation of an image or, more likely, many hundreds of images corresponding to different spatial and temporal conditions. In most circumstances a visual diagnosis based on glancing at the images will be insufficient, except perhaps to diagnose gross malfunction of a process. This represents a major and fundamental difference between the general philosophy of medical tomography and that of

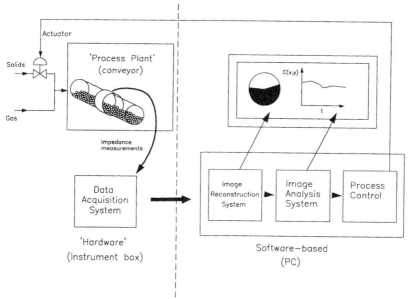

Figure 1.2 *Principal components in a process tomographic instrument, in this case controlling a pneumatic conveyor*

process tomography. A second important distinction is that the images should normally convey quantitative information rather than relative changes, for example absolute values for the void fraction distribution of a component in a given cross-sectional image.

From an engineering perspective one of the key requirements for a tomographic technique is that it should be non invasive (i.e. it should not necessitate rupture of the walls of the process vessel, for instance, by the introduction of the probes) and non-intrusive (i.e. it should not disturb the nature of the process being examined). It is not always possible to meet both requirements, although the latter can generally be satisfied. A number of related instrumental methods and techniques can be used to obtain information in a non-invasive and non-intrusive manner, but without recourse to tomography. Again, some of these techniques can help greatly in understanding complex processes, and will be included in Part II.

1.2 Process applications

The heart of any tomographic technique is the sensor system that is deployed. The basis of any measurement is to exploit differences or contrast in the properties of the process being examined. A variety of sensing methods can be employed based on measurements of transmission, diffraction or electrical phenomena using radiation, acoustic or electrical sensors. Table 1.1 shows a small selection of possible sensing methods and their principal attributes.

Table 1.1 *Sensors for process tomography*

Principle	Spatial resolution* (%)	Practical realization	Comments
Electromagnetic radiation	1	Optical	Fast. Optical access required
		X-ray and γ-ray	Slow. Radiation containment
		Positron emission	Labelled particle. Not on-line
		Magnetic resonance	Fast. Expensive for large vessels
Acoustic	3	Ultrasonic	Sonic speed limitation. Complex to use
Measurement of electrical properties	10	Capacitive; conductivity; inductive	Fast. Low cost. Suitable for small or large vessels

*Percentage of the diameter of the cross-section.

Whilst most devices employ a single type of sensor, there may be a number of opportunities for hybrid systems using two (or more) different sensing principles (see Section 3.2). The choice of sensing system will be determined largely by:

• The nature of components contained in the pipeline, vessel, reactor or material being examined (principally, whether they exist as a solid, liquid, gas or a multi-phase mixture, and, if so, in what proportions).
• The information sought from the process (steady state, dynamic, resolution and sensitivity required) and its intended purpose (laboratory investigations, optimization of equipment, process measurement or control).
• The process environment (ambient operation conditions, safety implications, ease of maintenance, etc.).
• The size of the process equipment and the length scale of the phenomena being investigated.

Some of these aspects will be discussed in detail below, but at this stage it is

sufficient to note that a multi-disciplinary and integrated approach to the selection of tomographic instrumentation is vital.

The concept of using tomographic techniques in process engineering is not, in itself, new, but its recent development has been facilitated through the improved design of measurement transducers, digital electronics and advanced computation methods. This can be seen in Figure 1.3 which charts the citations of various tomographic methods based on different sensing principles from 1970 until 1990. This figure is based on literature citations in the INSPEC and COMPENDEX databases. Any such exercise is unlikely to be comprehensive. However, it is interesting to note that the technology is dominated by medical applications which tend to use shorter wavelength radiation sensing principles (Table 1.1), yielding some 1300 publications annually, followed by optical methods. Since 1990 the clear upward trend in electrical impedance methods (which find applications in geophysics, medical, materials science and process engineering sectors) has continued. Process-industry related applications have increased, exceeding 180 in 1993. From an overall perspective the proportion of reported applications in manufacturing, chemical and process related industries remains relatively small (between 1 and 5% of the total tomographic literature) many of these lying within the domain of non-destructive component testing. The advances in sensor technology and associated computation is now beginning to have a profound effect by diversifying the range of sensor systems that can be exploited for tomographic purposes. A rapid growth in many sectors can be expected over the next decade, including the use of two or more types of sensor (Chapter 3) in order to enhance component discrimination in complex process mixtures (thus complicating the classification of tomographic methods presented in Figure 1.3).

The virtue of many tomographic methods is that they allow interrogation of systems which are not amenable to measurement using conventional

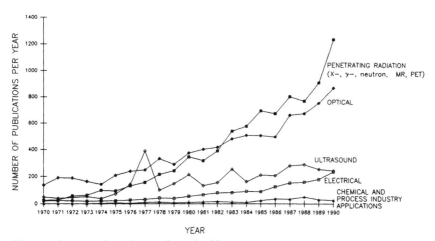

Figure 1.3 *Growth in the number of publications relating to tomographic technology (1970–1990), classified on the basis of sensor type and application. (Source: S. L. McKee, M.Sc. Thesis, UMIST, 1992)*

instrumentation. The latter is often based on optical methods involving light and laser technology, which presumes that optical access to a reactor can be gained and that the mixture within the process is not opaque. Medical tomographers overcame this problem using penetrating radiation, but sometimes with consequent hazards to those subjected to this treatment. Lower energy radiation could be used but this often requires a longer 'exposure time' – a luxury that is not afforded to many process operations which may not be operating at a steady state and for which high-speed imaging may be required. Some of the most exciting applications for process tomography lie in its potential ability to image the dynamic internal characteristics of processes, ultimately in three dimensions.

To date, most applications have involved imaging in a single cross-sectional plane. Table 1.2 presents a selection of examples taken from the literature, many of which will be illustrated in subsequent chapters. Applications for process tomography technology may be divided into five main categories as follows:

- Characterization of individual components or products and non-destructive testing.
- Modelling in a laboratory environment.
- Equipment design and optimization in a laboratory or industrial environment.
- Process monitoring and control in an industrial environment.
- Remote sensing in manufacturing, quality control, environmental protection, or pollution control on an industrial or waste containment/disposal site.

From the perspective of a process design engineer it is essential that any imaging device can produce information on a time-scale and spatial dimension that is congruent with the process itself, as discussed in Chapter 2. For example, to observe mixing phenomena that are occurring over short periods of time in a small zone within a mixing vessel. Inevitably, as discussed in later chapters, some trade-off exists between the quality of the images that can be obtained (spatial resolution, contrast sensitivity, non-linearities in the sensing capability within a given cross-section) and the measurement time required to collect and average signals. Whilst there are applications for tomography where the measurement (or 'snapshot') times could be quite long (a few seconds if the process was in a steady-state condition), this is not the case for observing mixing kinetics for which the measurement times must be small (down to 0.1–50 ms). The frequency at which these measurements have to be repeated will vary according to the nature of the mixing process, but a value of 1 Hz is likely to be the lowest frequency acceptable and 100 Hz would be highly desirable. This specification, therefore, sets a target for those engaged in instrument design.

It is useful to consider the relative time-scale required in order to acquire measurement information, previously referred to as the aperture or snapshot times (see Table 3.1), and the time required to reconstruct and interpret the image. These time-scales are determined by the physical nature of the sensing principle and the complexity of reconstructing an image. A general conclusion

Table 1.2 *Examples of tomographic techniques used in process industries*

*Process application**	*Sensing method*
Microstructural characterization of components, particles, pastes, foams, filters (1–10 000 μm)	Magnetic resonance imaging (MRI).† Neutron tomography. X-ray microtomography. Optical tomography
Liquid mixing and multi-phase flow (0.01–0.5 m)	Optical tomography.† Resistive tomography.† Capacitance tomography.† Acoustic tomography
Powder mixing, transport and conveying (0.01–0.5 m)	Positron-emission tomography (PET).† Capacitance tomography.† γ-Photon transmission.† Electrodynamic tomography†
Fluidization and trickle bed reactor studies (0.01–3.0 m)	γ-Tomography. X-ray tomography. Positron-emission tomography (PET).† Capacitance tomography†
Thermal mapping of reactors, objects and atmospheres (0.01 m to 5 km)	Infra-red emission imaging. Resistance tomography. Microwave tomography†
Groundwater monitoring and soil remediation (1 m to 2 km)	Impedance tomography†
Atmospheric pollution monitoring (50 m to 10 km)	Laser absorption imaging
Ore deposit and oilfield reservoir exploration (50 m to 50 km)	Acoustic velocity imaging. Acoustic diffraction tomography

*Typical operating length scales are given in parentheses.
†These specific applications are considered in later chapters.

is that X-ray methods tend to be slow but the computed images are more readily reconstructed than, for example, impedance methods. Electrical sensing impedance methods can be fast, but real-time imaging may only be feasible by using advanced computational hardware (Chapter 13).

The application categories listed above may be further divided into those which will use the tomographic information to:

• Feed back information to the process itself for the purposes of process control, alarm or malfunction detection.

- To provide measurement information for the purposes of process visualization or process modelling, but without any dedicated control output.

Those applications requiring feedback may benefit from, or require the tomographic measurement to be available in real-time, whereas for visualization or process modelling it may suffice to have a delay of minutes or longer between data collection and interpretation of the computed image. For example, environmental monitoring of groundwater moving through a porous medium (see Chapter 23) does not demand fast acquisition of measurement signals or fast rendering of the computed image information. In such cases the measurements can be averaged over long periods of time.

1.3 Performing measurements in an industrial environment

A number of related factors contribute to the selection of an appropriate tomographic tool to measure the distribution and motion of components within a process. Here an overview of some of these factors will be presented which will provide a framework for more detailed descriptions covered in later chapters. Figure 1.4 summarizes a possible scheme for identifying the relevant 'process', 'sensor', and computational 'hardware' constraints in the context of the specific measurement that is to be sought.

The starting point is to define the *purpose* of the measurement information (Section 1.2) and the measurement that needs to be obtained. A computed image of a given cross-section will consist of a number of picture elements ('pixels') the dimensions of which usually represent the best spatial resolution that can be resolved (Table 1.1). On occasions, the computer image may be composed of pixels with dimensions smaller than can be justified on the basis of the sensor sensitivity – such 'enhanced' images are obtained by interpolation and, evidently, must be interpreted with care. The pixels are often symmetrical (squares), but do not necessarily correspond to the geometry of the sensing fields described by the raw measurement data, since the spatial sensitivity of the sensing method may be non-uniform over the cross-section. Values are assigned to these pixels according to the material composition within that zone and displayed as a grey level on a computed image or stored as a number within the processor. If distinct phases (e.g. solid particles) are larger in size than the pixel dimensions, then the boundaries of the phases can be delineated. Otherwise, the pixel value corresponds to the average composition of the mixture or material present in that sensing zone. Different sensing methods have different spatial resolutions and different abilities to resolve changes in contrast (i.e. component concentrations). However, in some instances contrast sensitivity and spatial resolution are related to the means of image acquisition and the method of image reconstruction (Chapters 15 and 16).

Assuming that a detectable difference or contrast between components in a process can be sensed and that it is possible to relate this value in a quantitative manner to the phase concentration (or analogous property), the following

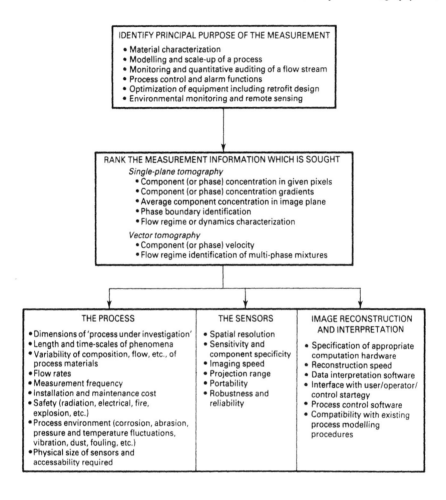

IDENTIFY PRINCIPAL PURPOSE OF THE MEASUREMENT

- Material characterization
- Modelling and scale-up of a process
- Monitoring and quantitative auditing of a flow stream
- Process control and alarm functions
- Optimization of equipment including retrofit design
- Environmental monitoring and remote sensing

RANK THE MEASUREMENT INFORMATION WHICH IS SOUGHT

Single-plane tomography
- Component (or phase) concentration in given pixels
- Component (or phase) concentration gradients
- Average component concentration in image plane
- Phase boundary identification
- Flow regime or dynamics characterization

Vector tomography
- Component (or phase) velocity
- Flow regime identification of multi-phase mixtures

THE PROCESS
- Dimensions of 'process under investigation'
- Length and time-scales of phenomena
- Variability of composition, flow, etc., of process materials
- Flow rates
- Measurement frequency
- Installation and maintenance cost
- Safety (radiation, electrical, fire, explosion, etc.)
- Process environment (corrosion, abrasion, pressure and temperature fluctuations, vibration, dust, fouling, etc.)
- Physical size of sensors and accessability required

THE SENSORS
- Spatial resolution
- Sensitivity and component specificity
- Imaging speed
- Projection range
- Portability
- Robustness and reliability

IMAGE RECONSTRUCTION AND INTERPRETATION
- Specification of appropriate computation hardware
- Reconstruction speed
- Data interpretation software
- Interface with user/operator/control startegy
- Process control software
- Compatibility with existing process modelling procedures

Figure 1.4 *Criteria for sensor selection*

primary measurement information can be deduced from a single cross-sectional image (Figure 1.2):

- Composition (concentration) in each pixel, $C(x,y)$.
- Concentration profile.
- Average concentration in entire cross-section:

$$\bar{C} = \frac{\sum\limits_{x=1}^{j} \sum\limits_{y=1}^{k} C(x,y)}{j \cdot k}$$

- Phase boundaries, if present.

By comparing images obtained at different times, transient information can be

derived for each of the above measurements. For example, in the case of fluids flowing in a pipe this might enable the prevailing flow regime to be identified (Chapters 2, 17 and 20).

The provision of an additional image of a second cross-section close to the original slice may allow the following measurements:

- Velocity of one or more constituent phases (Section 13.3).
- In a pipeline, the mass flow rate of the constituent phases could be deduced.

Full three-dimensional imaging using many slices also allows vectorial information to be abstracted, which is of value in detailed process modelling and control.

Chapter 2

Tomography in a process system

T. Dyakowski

This chapter considers problems concerned with both qualitative and quantitative aspects of *modelling of a multi-fluid flow*. Numerical techniques applied to solve a set of equations for calculations of the pressure, momentum, and void fraction distributions of the various phases are presented. An application of neutron and photon tomography to verify, in both a qualitative and quantitative way, gas–liquid flow patterns in channels is described. Finally the use of computed images or parts of the image information for *process control* is considered.

2.1 Process modelling and verification

2.1.1 Formation of process models for multi-phase systems

Process tomography can be used to obtain both qualitative and quantitative data needed in modelling a multi-fluid flow system. For instance, different flow patterns are characterized, in a qualitative way, by using both time and space scales. Next, a process model verification of a qualitative model is based on comparison of calculated fields of void fractions or velocities with measurement results. Here, process tomography provides, in a non-invasive way, cross-sectional profiles of the distribution of materials or velocities (vector tomography) in a process vessel or pipeline. These various applications are summarized in Figure 2.1. This diagram indicates some possible measurement applications for the purpose of process design and process control by employing simple (two-dimensional) and advanced (three-dimensional) tomographic methods. The significance of the features indicated on this figure will become apparent during the discussion which follows.

Examples of different multi-phase flows existing in industrial equipment are presented in Figure 2.2, indicating the various types of flow patterns that could occur within them. Multi-phase flows may be classified according to the following criteria:

- Technological function of flows.
- Type of phases (gas, liquid, solid particles).
- Forces inducing flow.
- Flow patterns.

SINGLE-PLANE
IMAGES

SINGLE- AND
MULTIPLE-PLANE
IMAGES

MULTIPLE PLANE
IMAGES

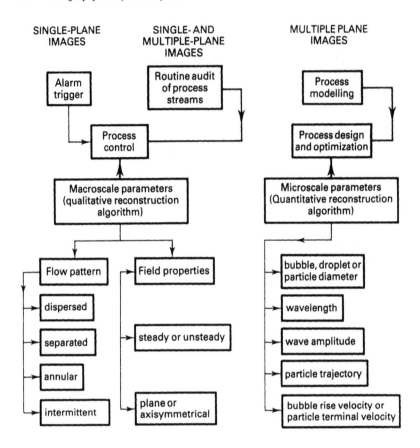

Figure 2.1 *Schematic diagram showing the applications of tomography to process modelling and control*

It should be emphasized that the quantification of a multi-phase pattern is of great importance both to define the intensity of heat or mass in processes such as boiling, condensation, absorption, distillation or fluidization, and to design fluid-based conveying processes (hydraulic or pneumatic transport). It is interesting to note that geophysical flows involving sediments and clouds were among the first multi-phase flows observed from a scientific point of view. Important milestones in the development of the theory of multi-phase systems were the foundation of the porous-medium theory, models for dusty gases, chemical processing in fluidized beds, and nuclear engineering. A short description of how the theory of multi-fluid systems evolved is given in an excellent paper by Drew (1983).

To describe these flow patterns, in a quantitative way, either the so-called 'multi-phase continuum' or the 'cell' model can be employed. The choice is a function of both time and space domains which, in turn, are determined by the prevailing flow patterns. The flow field may be classified into several

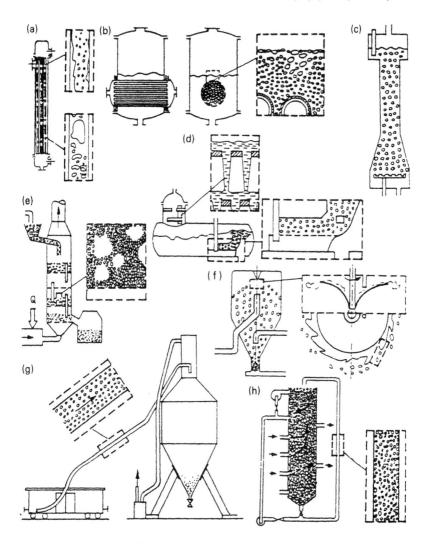

Figure 2.2 *Examples of different two-phase flows. (a) Co-current flow of vapour–liquid mixture in an evaporator. (b) Ascending vapour bubbles in a boiler. (c) Counter-current dispersed droplet flow of two non-miscible liquids. (d) Liquid jets and vapour bubbles in a degasifier. (e) Particle and gas bubble flow in a fluidized-solid drying plant. (f) Liquid droplets in a centrifugal atomizer. (g) Pneumatic conveying. (h) Hydraulic transport of ions in an ion-exchange column*

domains, based on the nature of the flow, (Figure 2.3). For instance, this can be convenient when the flow pattern is known and the phases are fairly well separated (annular, stratified, or slug flows). For example, in an annular flow the movement of the liquid layer flowing down along the wall can be described

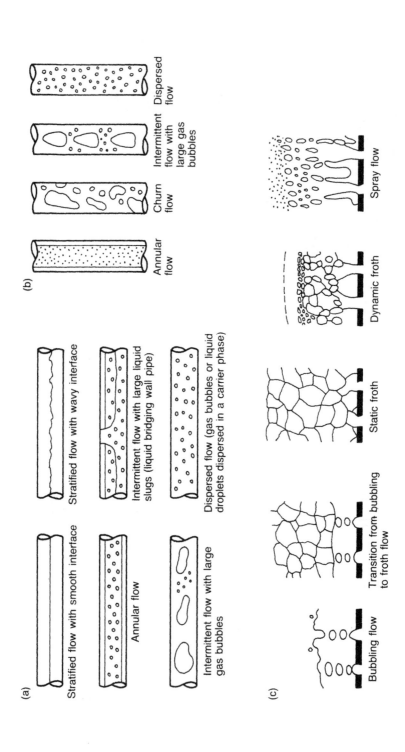

(a)

Stratified flow with smooth interface

Annular flow

Intermittent flow with large gas bubbles

Stratified flow with wavy interface

Intermittent flow with large liquid slugs (liquid bridging wall pipe)

Dispersed flow (gas bubbles or liquid droplets dispersed in a carrier phase)

(b)

Annular flow

Churn flow

Intermittent flow with large gas bubbles

Dispersed flow

(c)

Bubbling flow

Transition from bubbling to froth flow

Static froth

Dynamic froth

Spray flow

(d)

Dispersed homogeneous flow

Small dunes on the top of the settling layer

Dispersed non-homogeneous flow

Intermittent flow with large particle slugs

(e)

Homogeneous fluidization

Bubble fluidization

Large non-uniform distributed bubbles

Channeling flow

Spouted bed

Figure 2.3 *Different flow structures. (a) Gas–liquid flow in a horizontal channel. (b) Gas–liquid flow in a vertical channel. (c) Gas–liquid flow on a sieve tray. (d) Gas particles flow in a horizontal channel. (e) Flow structures in fluidization*

by a cell model and the gas–liquid dispersed flow in the centre of a pipe by a multi-phase continuum model.

General remarks on mathematical modelling

It is appropriate to review the principles involved in deriving a process model for a single-phase flow. Figure 2.4 summarizes the main steps that are required. As can be seen from this figure, the motion of a single-phase flow is described by a mathematical model which consists of mathematical concepts, general axioms and constitutive axioms. In continuum mechanics these correspond to variables, conservation and constitutive equations, whereas at the singular surface the mathematical model supplies the interfacial conditions. For a single-phase flow a set of basic equations which describes the conservation of mass, momentum and energy is given rigorously in the form of conservation equations valid in infinitesimal volume ($\mathrm{d}v$) and infinitesimal time duration ($\mathrm{d}t$). These equations can be applied to all the volume and time domains under consideration. In this way the model which describes the single-phase flow is based on the local instant field equations. Hence, it is evident from Figure 2.4 that the method embodies three essential parts, i.e. the derivations of local conservation field equations, constitutive equations, and interfacial conditions.

To describe a fluid motion in a continuum, space and time co-ordinates are generally used; these co-ordinates are the most natural choice (theoretically other independent co-ordinates such as velocity, momentum, or entropy could be used). We can then say that a vector ξ representing a physical property of a given motion is a function of the position vector s_i and the time t. First let the vector s_i represent the position that an infinitesimal fluid element occupies at a time $t = t_0$. If, for instance, ξ instead of velocity or forces, happens to be the position vector \mathbf{r} then, at the time origin $t = t_0$, $\mathbf{r} = \xi$ identifies the element in question (Figure 2.5). As the time increases, ξ varies and the properties of the element also vary, while the initial position remains a constant. This is known as

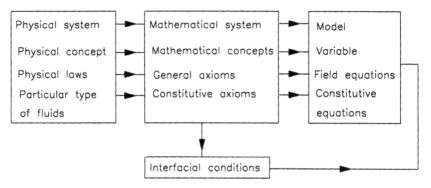

Figure 2.4 *The basic procedure used to obtain a mathematical model from a physical system*

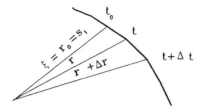

Figure 2.5 *A Lagrangian description of fluid movement*

a *Lagrangian* description and is widely used to study particle mechanics by tracing the individual locations and trajectories of particles.

When studying the motion of a continuum, this method of expressing the motion of an infinite set of particles becomes extremely cumbersome. Often the observer is not interested in what happens at a given time t to various location points **r**. The position dependence is no longer a dependent parameter

Table 2.1 *Main characteristics of a two-phase cellular model*

Flow pattern	Characteristic	Industrial application	Phases
Separated flow	Dense phase flows along the bottom of the channel and the lighter phase above it	Heating pipes, boilers or evaporators	Gas–liquid; gas–solid; liquid–liquid
Annular flow	Liquid flows on the wall of the tube as a film and the gas is in the centre	Conventional or nuclear power plant condenser; absorbers; evaporators	Gas–liquid
Intermittent flow	A complex flow which can be divided into three categories	Oil transport system; fluidization; fermentation processes; pneumatic or hydraulic system; heat and mass transfer exchangers with phase change	Gas–liquid; gas–solid; liquid–solid; liquid–liquid
Plug flow	Bullet shaped bubble		
Churn flow	Transition from plug to annular flow		
Slug flow	Lump of liquid or large particle cloud		

(as in Lagrangian method) but truly an independent variable as is t. This description is referred to as a *Eulerian* method.

Multi-phase flows can be described by using both cell or multi-continuum models. The cell model is mainly used to describe separated (annular) and intermittent flows. The main characteristics of these flows are listed in Table 2.1. To describe dispersed flows by applying a multi-continuum model has been a main task of the theoretical efforts in the last few decades.

Multi-fluid continuum model

Multi-phase continuum models are based on the premise that it is sufficient to describe each phase as a continuum, occupying the same region in space. The new 'fluid' consists of many different phases and sometimes its motion can also be described as a mixture. The fact that all phases remain physically separate implies that the motion of each phase has to be constrained by the presence of other phases. The change of each phase in a control macroscopic volume is measured by the void or volume fraction (the volume of each phase per unit volume of mixture). Therefore, the principal task of the theoretical description or model is to specify how the different phases interact between themselves. The concept of interpenetrating continua is natural in mixtures where the dispersion occurs on the molecular level. However, it is the theory of mixtures where many constituents remain unmixed on this level that forms the basis of multi-phase continuum model. For this model the conservation equations are given in averaged forms in a certain volume or over a certain time period. For most purposes of equipment or process design, averaged, or macroscopic flow information is sufficient. Fluctuations, or details in the flow must be resolved only to the extent that they effect the mean flow (as, for example, Reynolds stresses).

Averaging process

Averaged equations can be postulated without reference to any microscopic equations and the necessary terms in the macroscopic equations can be deduced without using an averaging equation. This approach has been proposed by Soo (1967), Kenyon (1976), Nunziato (1982), and Truesdel (1984), among others.

Applying an averaging procedure allows different terms in macroscopic equations to be described from appropriate local instant equations. Moreover, it gives an insight into the constitutive equations and is also a straightforward way of relating macroscopic variables to microscopic ones.

Many researchers have derived equations of motion of multi-phase flows by applying an averaging process to the microscopic equations of motion. Hinze (1959) suggested the equations of motion by applying an averaging approach to turbulence. Time and space averages were first proposed by Frankl (1953), and Teletov (1958). This philosophy in formulating multi-phase flows has been continued by Anderson and Jackson (1967), Vernier and Delhaye (1968), Wallis (1969), Kocamustafaogullari (1971), Drew (1971, 1982), Boure (1973), Whitaker (1973), Ishii (1975), Nigmatulin (1979), Banerjee (1980), Banerjee and Chan (1980), and Gough (1983). The application of statistical averages to

the equations of motion has been demonstrated by Batchelor (1974), Buyevich and Shchelchkova (1978), Herczynski and Pienkowska (1980), among others.

In an averaging process each phase is treated separately as a different fluid and the interface is regarded as a moving boundary. This is the reason why this model is sometimes referred to as the 'multi-fluid model'. In each phase, the local instant conservation equation in a single-phase flow can be written down. In addition, at the interface, local instant balances of mass, momentum and energy are formulated as boundary conditions. The above equations are then averaged over time and space domains. Using several integral theorems (Leibniz's rule, Gauss's theorem, etc.) the averaged field equations of mass, momentum and energy conservation are derived for each phase. This formulation accurately reflects the physical aspects of multi-phase flow. However, the field equations obtained are given in averaged form for a certain volume or over a certain time period. In this sense these equations do not have a local instant character. It should be noted that the local instant formulations used in the multi-fluid model described above are valid only in each phase or at the interface; they are not valid for all the space and time domains.

More recently, the local instant formulation of mass, momentum and energy conservations of multi-phase flow has been developed by Katoaka (1986), who introduced the distribution as an extended notation of functions. His concept of a distribution overcomes difficulties associated with differentiation of the discontinuous function and the representation of the source terms at the interface which appear in the local instant formulation. On this basis, and using a characteristic function for each phase, the physical parameters of 'a multi-phase mixture' can be defined as field quantities and the local conservation equations may be derived. This model, which is largely theoretical in nature, generalizes the conservation equations which are obtained by an averaging process.

Mixture model

The mixture model is the earliest and simplest version of the multi-fluid model. The model is widely used to describe finely dispersed co-current flows both in unbounded conditions and through channels. The model introduces the concept of a baricentric velocity (which is the velocity at the centre of gravity). A main assumption which lies behind this model is that the relative velocity of each phase through the plane moving at baricentric velocity is at least one order of magnitude smaller than the baricentric velocity of the mixture. Moreover, it is postulated that there is a random component to the particle motion, leading to diffusive motion. On this basis a mixture momentum equation is used to replace the equations for the momentum of each phase. As a consequence, the motion of each phase is described as a function of its relative velocity. Sometimes, the model may be simplified by an assumption that all phases move with the same velocity. The relative mass flux through a plane moving at baricentric velocity is described by applying a constitutive rule which is analogous to Fick's diffusion law. As a result, a multi-phase 'fluid' may be considered as a single, fictitious fluid.

To compare the mixture model (Table 2.2) with the model for a single-phase

Table 2.2 *Governing set of equations*

Equation	One-phase flow	Multi-phase flow
Mass conservation	$\dfrac{\partial \rho}{\partial t} + \nabla \rho \mathbf{v} = 0$	$\dfrac{\partial \rho}{\partial t} + \nabla \rho \mathbf{v v} = \mathbf{F} + \nabla \mathbf{T}$
Momentum conservation	$\dfrac{\partial}{\partial t}\alpha_i \rho_i + \nabla \alpha_i \rho_i \mathbf{v}_i = m_i$	$\alpha_i \rho_i \dfrac{\partial \mathbf{v}_i}{\partial t} + \nabla \alpha_i \rho_i \mathbf{v v}_i = $ $\alpha_i \rho_i \mathbf{F}_i + \nabla \alpha_i \mathbf{T}_i + \mathbf{M}_i$
Volume conservation	—	$\displaystyle\sum_{i=1}^{N} \alpha_i = 1$

m_i, Interface mass transfer rate; \mathbf{M}_i, momentum transfer between phases; N, number of phases.

flow, a minor difference in notation is required to accommodate the new unknowns, i.e. the volume fractions of each phase. In calculating these values the crucial problem is to determine both the physical properties of the fictitious fluid and constitutive equations for describing the interaction between phases. Note that the mixture is incompressible only if all the constituents of the mixture are incompressible *and* the dispersed phase is neutrally buoyant. In situations where this is not the case, the compressibility of the mixture can have a significant effect on its rheological properties.

One–dimensional model

A multi-phase model based on the cross-sectionally averaged equations for gas-liquid flow through channels was developed by Wallis (1969). This model can be used to calculate the void fraction in both co- and counter-current flows if the volumetric flows of both phases are known. Here, the void fraction is defined as the fraction of the channel cross-sectional area that is occupied by the gas phase. The main assumptions of this model are that the shear stress at the channel wall may be ignored, and consequently there is no variation in void fraction or velocity across the channel. A constitutive equation which describes the relative motion between both phases is based on the drift flux approach which, in turn, is based on an idea of a drift velocity for each phase through the plane moving at a total superficial velocity. This velocity is defined as a quotient of a total volume flow rate divided by the channel area. In this case a total volume flow rate is taken to be the sum of gas and liquid volume flow rates. This model is widely used to predict both the conditions under which co- or counter-current flow may be realized and to identify the onset of flooding phenomena in a counter-current flow through the channel.

Flow maps

At the beginning of this chapter the cell model was cited as being the most commonly used method in modelling multi-phase flow. In particular, this model is widely used to characterize the main parameters of such flow patterns as intermittent, annular and separated flows. The conditions under which each of these flow regimes can exist are illustrated in the form of two-dimensional flow maps. Superficial velocities, mass fluxes, pressure drops, and flow quality are frequently used as co-ordinate variables in these maps; some examples are presented in Figure 2.6.

2.1.2 Computational techniques

Linear equations

The computational techniques applied in tomography to solve both the forward and the inverse problem (see Chapter 15) resulting in the production of an image, are analogous with those used in modelling multi-fluid flows. Before describing the various numerical methods it should be emphasized that these methods are based on difference calculus. Application of this calculus transforms a function to a vector of finite dimensions, a differential operator is transformed to a matrix operator, and partial or ordinary

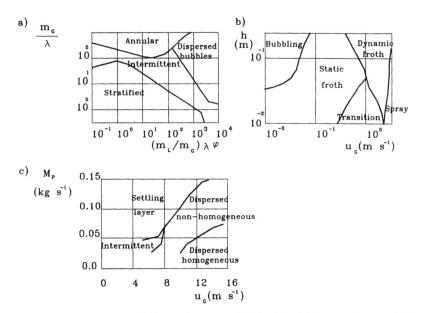

Figure 2.6 *Examples of different flow maps. (a) Gas–liquid flow in a horizontal channel. (b) Gas–liquid flow on a sieve tray. (c) Gas–particle flow in a horizontal channel*

differential equations are transformed into finite matrix equations.

The solution of a system of simultaneous linear equations, usually with as many equations as unknowns, is a frequently encountered problem in scientific computation. The methods of solving linear-equations problems include the approximation of ordinary, partial or integral equations by finite, discrete algebraic systems, the local linearization of systems of simultaneous non-linear equations, and the fitting of polynomials and other curves to data.

In general, a set of linear equations can be written in the form:

$$\mathbf{A}\mathbf{u} = \mathbf{w} \tag{2.1}$$

where \mathbf{A} is a quadratic matrix of dimension n which may vary from 100 up to 100 000.

Application of Cramer's rule to solve this equation requires that the determinant of the matrix \mathbf{A} be calculated. For example, the calculation of this determinant for an $n \times n$ matrix involves $n!$ multiplications. Clearly the direct application of Cramer's rule to these problems is out of the question. This is the reason why numerical techniques are commonly used to find the solution of the equation.

The application of computational techniques to solve the eqn (2.1) is based on a numerical linear algebra theory. These techniques are effective because they make use of the particular properties of special and commonly recurring matrices. It is important to distinguish between two types of matrix:

- A *stored* matrix is one for which all n^2 matrix elements a_{ij} are stored in the computer memory.
- A *sparse* matrix is characterized by a pattern of zero and non-zero elements, and special matrix methods have been developed to take these patterns into consideration. The non-zero elements can be either stored in some special data structure or regenerated as needed. (This type of matrix often results from finite-difference and finite-element methods for partial differential equations.) The order n is frequently as large as several tens of thousands, and occasionally even larger. The property of being sparse is common to matrices which result from problems formulated in any number of space dimensions. In one dimension, however, the resultant matrices frequently have the additional property of being tridiagonal, where only elements along the three leading diagonals are non-zero.

Two general numerical procedures used to solve systems of this nature are *direct* and *iterative* methods.

Direct methods are those that in the absence of round-off errors yield the exact solution in a finite number of arithmetic operations. An example of a direct method is Gaussian elimination which involves two stages: the forward elimination and back substitution.

There is a substantial class of linear-equation systems for which the elements of the matrix \mathbf{A} are known by some simple formula and so can be generated as needed (for example, in modelling Poisson's equation). Methods which do not alter the matrix \mathbf{A} and never require the storage of more than a few vectors of length n are called *iterative methods*. These methods start with an initial guess

of the solution and then, by applying a suitably chosen algorithm, lead to better approximations. In general, iterative methods require less storage and fewer arithmetic operations for large sparse systems than do direct methods. It is worth noting that the use of the iterative method for the *tridiagonal matrix* is extremely simple and efficient, since for $n \times n$ *tridiagonal matrix* equations operating on a vector of dimension n, only $9n$ arithmetic operations are required to solve the system. While *tridiagonal matrix* equations are particularly simple to resolve in one-dimensional problems, in analogous multi-dimensional problems matrix coupling is considerably more complex (except for the simplest example of Poisson's equation). Nevertheless, we may usefully employ the properties of tridiagonal matrices in such multi-dimensional problems.

The simplest iterative method is the *Gauss–Seidel method* (or the *method of successive displacement*). Here the basic iterative step is to solve the ith equation for the ith component u_i of the new vector **u** using for each other component of **u** its most recently computed value. It can be proved to converge for various types of matrix, including any symmetric positive-defined matrix **A**. With many iterative processes in numerical analysis convergence is so slow that the most important problem is to find a way of accelerating the convergence, e.g. of $u^{(k)}$ to the solution. In the application of the iterative method, we must question, first, whether convergence will be achieved for any solution guess and, second, how rapidly the solution vectors will converge. Indeed, algorithms for accelerating the convergence of sequences form an important part of numerical analysis. The method of *successive over-relaxation* (SOR) is one type of acceleration of the Gauss–Seidel process. It can speed up the convergence so well that the SOR method is quite widely used in solving finite-difference equations that model the elliptic boundary value problem in two dimensions. There is a family of iterative methods known as the *methods of conjugate gradients*, or conjugate directions. These methods seem to be relatively successful for symmetric positive-defined matrices and involve no assumptions of the structure of the matrix **A**.

Ordinary and partial differential equations
In modelling multi-fluid flow, a certain class of numerical problems is so typical that they may be solved by use of computer libraries. Most computer facilities have at least one of the following mathematical libraries: IMSL, NAG, or Harwell. The following numerical problems can be solved by using these libraries:

- Initial-value problem for ordinary differential equations.

- Boundary-value problem for ordinary differential equations by using either discrete variable methods or finite element methods.

- Partial differential equations in two space variables.

To solve an initial-value problem for an ordinary differential equation, both explicit and implicit methods are used. The method is explicit since the function is evaluated with known information, i.e. on the left-hand side of the

subinterval. It should be mentioned that commonly used explicit methods include the Euler, the second-order Runge–Kutta, and the Runga–Kutta–Gill methods, among others. The explicit methods suffer from their stability limitations. To improve stability criteria, implicit methods are used. The method is implicit because the function is evaluated on the right-hand side of the subinterval. The best-known implicit methods are the Euler method and the trapezoidal rule. Generally, implicit methods 'out-perform' explicit methods on 'stiff' problems because of their less demanding stability criteria. Explicit methods are best suited for 'non-stiff' equations.

Another class of method that may be applied to solve an initial value problem are the multistep methods which make use of information about the solution and its derivative at more than one point in order to extrapolate to the next step. For example, the Adams–Bashorth, Adam–Moulton, Runge–Kutta–Fehlberg, Caillaud–Pdmananabhan and Michelsen algorithms may be used to solve a set of stiff equations.

The boundary-value problem may be solved by applying methods which convert it into an initial-value problem. Examples include the multiple shooting, superposition and global methods. The superposition method may be easily implemented to solve non-linear problems, but they must first be 'linearized'. A drawback of the multiple shooting method is the necessity both to carefully choose the mesh dimension and to guess the components of the starting vector. Another class of methods applicable to solving the boundary-value problem are the so-called 'global methods'. These methods, in contrast to the two previous methods, produce a solution over the entire interval, simultaneously.

There is a second group of numerical methods which, for special conditions, can be used to solve the boundary-value problem. These methods produce approximate solutions that, in contrast to those produced by finite-difference methods, are continuous over the interval. The approximate solutions are piece-wise polynomials, thus qualifying the techniques to be classified as finite-element methods. Two types of this technique are commonly used: Galerkin and collocation. Cubic splines form the basis of a collocation technique. These techniques enable the solution of problems such as, for example, non-linear equations, other than homogeneous Dirichlet boundary conditions, or generally 'difficult' boundary value problems arising in modelling multi-fluid flows. However, it should be pointed out that these methods are not very popular because of the large computational effort required compared with other methods.

First, numerical schemes for solving conservation equations (in partial differential form) may be applied in both *Eulerian* or *Lagrangian* form. *Lagrangian* methods are more descriptive for transport processes in fluid flows. The field methods and computational techniques based on the *Lagrangian* viewpoint are not so well developed or advanced as are *Eulerian* methods. The major difficulty in a pure *Lagrangian* computation is that the computational grids vary with the movement of fluid flows. The computational grids can be so distorted that the numerical errors stemming from the discrete approximation of the governing equations erode the validity of the numerical

solution. As modelling techniques based on *Eulerian* methods have been well tested, the results from *Eulerian* modelling can be used as the basis for performing additional *Lagrangian* computations. It may be suggested that the combined *Eulerian–Lagrangian* method is very effective in revealing accurately the *Lagrangian* properties of fluid flows which are truly of *Lagrangian* nature. It may be advantageous to use this technique to investigate other aspects of transport processes in fluids.

Second, numerical schemes may be classified according to whether they solve directly for the 'primitive variables' v and p, or solve for the vorticity and stream function. The vorticity/stream function approach is particularly appealing because vorticity is generated locally near boundaries in high Reynold's number flows, and subsequently diffused and convected away. The pressure is governed by the elliptic equation (for incompressible flows) so that it is affected instantaneously at all points in space. Thus, with limited spatial resolution and extent, it should be easier to determine time-dependent flows accurately using the vorticity and stream function method.

The principal obstacle in the development of multi-dimensional software to solve both elliptic or particle partial differential equations is the solution of large, sparse matrices. *Explicit schemes*, because of their poor stability are rarely used to solved multi-dimensional problems. *Implicit schemes*, with their superior stability properties, are commonly applied to solve these equations; the resulting matrix problems are easily solved. Both the finite-element method (FEM) and finite-difference method (FDM) are used. The literature on the use of the FEM is extensive and expanding. The reason for this growth is related to the ease with which the method accommodates complicated geometries.

Numerical errors

When making mathematical calculations on a computer, errors are introduced into the solutions. These errors are brought into a calculation in three ways:

- The error is present at the outset in the original data (*inherent error*).
- The error results from replacing an infinite process by a finite one (*discretization or truncation error*), e.g. representing a function by the first few terms of a Taylor series expansion.
- The error arises as a result of the finite precision of the numbers that can be represented in a computer (*round-off error*).

The effect of *inherent errors* will be discussed in Chapter 17, which is concerned with the accuracy of a backward problem solution. The *truncation errors* are the result of replacing differential operators by difference operators.

Round-off errors are caused by the fact that in computer memory each number is stored in a set **F** which consists of a sign (\pm) plus a fixed number of digits. Because **F** is a finite set, there is no possibility of representing the continuum of real numbers in any detail. Indeed, real numbers that are larger in absolute value than the maximum member of **F** cannot be said to be represented at all. For many purposes, the same is true of non-zero real numbers that are smaller in magnitude than the smallest positive number in **F**.

To define a result of the arithmetic operations of addition and multiplication (likewise, subtraction and division) the computer selects a nearby element of the set **F**. This can be done in two ways: rounding and chopping. Both methods are commonly used in present-day computers. These methods are a source of some round-off error introduced by the process. This error is smaller than the smallest positive machine number. For example, in a modern PC this number is 10^{-99} for single precision, and in an IBM 3032 computer this number is 9.54×10^{-7} and 2.2×10^{-16} for single and extended precision, respectively.

2.1.3 Model matching with tomographic data

Mathematical and physical modelling

In general, constructing a cross-sectional view of a flow pattern by analysing tomographic data involves solving the inverse problem. This problem has its origins in physics, in trying to fit experimental results to a theoretical model. The determination of the range of errors in the unique parameters is a principal function of 'error calculus'; it was considered as necessary but routine work for the experimental physicist. A new aspect of an inverse problem appeared in 1826 with Abel's famous integral equations.

The inverse problem is typical of a broad class of ill-posed problems arising in physics and technology. Depending on the number of measurements and pixels used, an undetermined or overdetermined system of equations may exist. The former contains an infinite number of solutions and the latter is an inconsistent and inherently ill-posed problem.

To obtain a solution of the inverse problem, first the mapping of a set **Z** of 'theoretical' parameters onto a set **U** of 'results' (i.e. direct or forward problem) has to be defined (Chadan and Sabatier, 1977). The relationship between the 'results' (e.g. a measured vector **u** (**u**∈**U**)) and the 'theoretical' parameters (represented by a vector **z**(**z**∈**Z**)) is given in the form:

$$\mathbf{Az} = \mathbf{u} \tag{2.2}$$

where **A** is a $(M \times N)$ matrix representing the direct mapping of the problem. M is the number of measurements and N the number of unknown 'theoretical parameters'. Here we consider $M > N$, i.e. an overdetermined problem.

To obtain the solution of the inverse problem, first the matrix **A** has to be constructed. To construct this matrix a model or family of physical models must be applied to connect the 'theoretical' parameters with the 'results'. The applicability of these models has to be tested, preferably, by inspection. This will be illustrated below.

Due to the assumed random nature of the data errors, a test for the acceptability of a given model will ultimately be based on a probabilistic model for the errors (see Chapter 17). Here, it should be pointed out that the method used to construct the solution of the inverse problem depends on the character of the measurements.

When 'error-free' measurements are assumed to be available, the inverse mapping is the inverse matrix \mathbf{A}^{-1}. However, in order to construct the matrix **A**, one frequently has to know the value of the vector **z**. In other words, to solve

the inverse problem in order to find z, one has to know in advance the value of z so that the required inverse mapping can be constructed. To overcome this problem, the successive approximation process can be applied. In this process, an approximation of the value of z is provided and used to construct an 'approximate' direct mapping A which is then inverted to obtain A^{-1}. The successive approximation process is represented by:

$$z_{k+1} = A^{-1}(z_k)u \qquad k = 0, 1, 2, \ldots \tag{2.3}$$

where k is the order of approximation and $A^{-1}(z_k)$ indicates that the matrix A is constructed using the vector z. The mathematical conditions required to obtain the convergence and uniqueness show that the so-called 'contraction mapping' is essential for convergence (Hussein *et al*, 1987).

When statistical measurement errors are involved, the set U must be extended to contain both the computed and the measured results. For any element belonging to the set U, the existence (or not) of a non-void subset of the set Z that maps onto $u(u \in U)$ has to be demonstrated (this is referred to as the 'criterion'). Next, the mapping of the set U onto the set Z has to to be defined (this is a construction problem). The final step is to check the continuity of these mappings.

Here, the element u is usually obtained from 'non-error-free' measurements, and hence we know that it is only approximate. Let \tilde{u} denote the approximate value. In such cases, we can speak only of finding an approximate solution of the equation (that is, close to z):

$$Az = \tilde{u} \tag{2.4}$$

Frequently, matrix A in eqn (2.4) is such that the inverse operator A^{-1} is not continuous. Under these conditions we cannot take for the approximate solution the exact solution of an equation containing an approximate right-hand member. First, such a solution may not exist. Second, even if such a solution does exist, it will not possess the property of stability since the inverse operator A^{-1} is not continuous. The stability of a solution of the problem usually arises as a consequence of its physical determinancy, and hence an approximate solution must possess this property. Finally, the mathematical results must be given a physical interpretation. Allowance must be made for inadequacies in the original mathematical formulation of the problem. The solutions must be tested against any physical constraints which are not included explicitly in the mathematics. The residuals must be examined for consistency with the assumptions of randomness. If a family of possible solutions has been identified, these should be examined for features which are common to all solutions.

To fulfill the condition of the closest approximate solution \tilde{u} to the exact solution, one can choose a solution by minimizing, for example, the residual of the problem, as expressed by the cost function defined by:

$$D = \sum_{i=1}^{M} w_i^2 \left(u_i - \sum_{j=1}^{N} A_{ij} z_j \right)^2 \tag{2.5}$$

where A_{ij} are the elements of matrix A, and w_i are the reciprocals of the

measurement variances. The 'quasi-solution' z that minimizes the above function is a 'least squares' solution and is given by:

$$\tilde{z} = (AWA)^{-1}A^TW\tilde{u} \tag{2.6}$$

where A^T is the transpose of A, and W is a diagonal matrix containing the elements w_i.

The physical constraint that the vector z must be contained in a given closed interval is not necessarily met by the 'least-squares' inverse mappings.

In order to construct mappings that result in physically acceptable solutions one can rely on 'regularization' methods to construct 'constraint' mappings. The quasi-solution is then constructed as:

$$\tilde{z} = (AWA)^{-1} + [(\tau^2/N)Q^{-2}]^{-1}A^TW\tilde{u} \tag{2.7}$$

where Q is a diagonal matrix whose elements are the elements of the weak upper-bound vector q, the elements of which are defined by:

$$q_i = \min_j \frac{u_j + \sigma_j}{A_{ij}}; \ A_{ij} \neq 0 \tag{2.8}$$

where σ_j is the standard deviation of the measurement u_j, and A_{ij} are the elements of matrix A that defines the direct mapping.

The parameter τ^2 is called the 'regularization parameter'. By choosing the appropriate value of this parameter the solution can be contained within the required interval. In the examples presented below, τ^2 is equal to the number of unknowns N. Here, matrix A is constructed by applying the successive approximation process.

Examples of reconstructing image

The general method for solving the inversion problem presented above is illustrated here by applying it to scattering techniques of penetrating radiation. These techniques have been used to measure non-intrusively the local density of two-phase flows for more than 20 years, and they are popular in the nuclear engineering industry. The use of neutrons and photons as a radiation source in an air–water system is presented. Scattering techniques depend on the fact that, in such a system, only the liquid phase scatters radiation at a rate proportional to the phase content.

Reconstructing a neutron scattering image

The magnitude of neutron scattering in a gas–liquid flow system depends on the density and composition of the liquid phase. The density of the mixture is proportional to the local gas fraction (specific volume of the liquid is at least an order of magnitude smaller than that of the vapour). There is a unique relationship between the energy and angle of a single elastic scattering by the hydrogen in the flow stream. The energy of the detected neutrons provides information on the amount of water in each cell. Therefore, it is possible, in principle, to reconstruct the void distribution ('theoretical parameters') from the measured detector response.

Two different approaches were applied to construct the matrix **A**. In the first, the matrix was obtained by solving a neutron transport equation by applying the Monte Carlo technique. In the second, a single elastic scattering model was applied to calculate the elements of matrix **A**.

From a mathematical point of view, the neutron scattering technique is characterized by an overdetermined ill-posed system of equations. A number of 'possible' experimental results (i.e. the sets of points in **U** that are consistent with the error bars) do not correspond to any point in **Z**. It follows that both the definition of errors and the choice of solution necessitate a special formulation which is consistent with physical intuition and the 'regularization' technique, discussed above.

- *Quantitative results* Based on the experimental work reported by Hussein *et al.* (1986), a test section of a two-phase flow was exposed to a beam of a neutron source. This section was covered by a fictitious mesh and it was assumed that both phases were uniformly distributed inside the cells of this mesh. A 100-mm diameter test section with 4×4 rectangular mesh was considered, and 20 detector responses (measurements) were used. The experimental results contained the contribution of multiple scattering and statistical errors, and also errors introduced by the detection system, mainly unfolding errors. The effect of these different errors on the reconstruction process is examined below.

- *Results from simulated detector responses* To calculate the coefficients of matrix **A**, two different physical models can be applied. First, a single scattering model was used. Second, the coefficients of this matrix were calculated by solving a neutron transport equation. Figure 2.7(a) shows the original assumed water fraction to be reconstructed, while Figure 2.7(b)

Figure 2.7 *Simulation of (a) annular flow and (b) separated flow with reconstructed neutron images using two different physical models (scattering and transport equation methods). After Hussein* et al. *(1986)*

show the reconstructed phase distribution. The results obtained from the
neutron transport equation show a deviation from the original void
fraction. This is caused by the assumption that both phases are homogeneous
in each cell. For a stratified flow, the distribution reconstructed from the
neutron transport equation underestimates the void distribution in the
stratified section, i.e giving some values (0.75, 0.83, 0.95) other than 1.0.
This could be caused by the effect of re-scattering.

- *Experimental results* The result of reconstructing the aluminium test
 section completely filled with water (46.8 mm internal diameter, 50.9 mm
 outside diameter) is presented in Figure 2.8. In this case the matrix **A** was
 constructed only by applying the single scattering model. The deviation of
 the measurement from the value assumed in the single scattering model was
 the reason for the observed errors. The asymmetry shown in this figure was
 caused by taking measurements at only one side of the test section; as a
 consequence, the cells closer to the detector were more influenced by
 measurement errors.

Reconstruction a photon scattering image

The results of applying photon scattering to investigate air–water flow
patterns in a vertical eccentric annulus are reported by Lahey and Okhawa
(1989). Figure 2.9 shows a cross-section of an eccentric annulus test section
and the measurement points. The results concerning the mixture density
distribution are presented in Figure 2.10. From this figure it can be seen that
the mixture density is lower in the wide gap than in the narrow gap. This
means that substantial lateral phase separation occurs. Such a conclusion is of
great importance in modelling this two-phase flow. When a mean void
fraction increases, the two-phase flow starts to be homogenized (as shown in
Figure 2.11).

The use of non-intrusive techniques to investigate, both quantitatively and

Figure 2.8 *Reconstruction of the liquid void fraction from experimental results. (a) The
original distribution. (b) Reconstructed distribution obtained using a single scattering
model. After Hussein et al. (1986)*

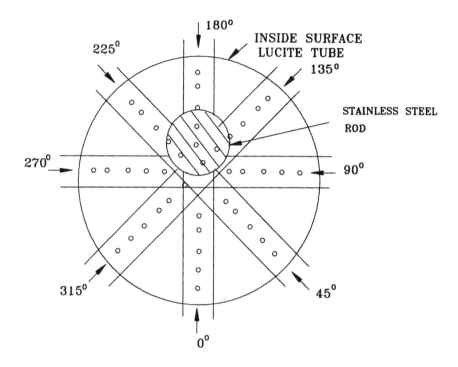

Figure 2.9 *Cross-section of an eccentric annulus test section and the measurement points for imaging air–water flows using photon scattering. After Lahey and Okhawa (1989)*

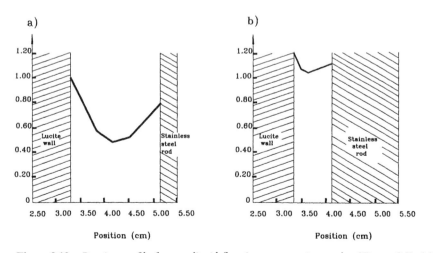

Figure 2.10 *Density profile for gas–liquid flow in an eccentric annulus (Figure 2.9). (a) For a wide gap. (b) For a narrow gap. After Lahey and Okhawa (1989)*

Figure 2.11 *Cross-sectional voidage distribution for gas–liquid flow in an eccentric annulus. (a) 50% global void fraction. (b) 80% global void fraction. After Lahey and Okhawa (1989)*

qualitatively, multi-phase flow systems were introduced more than 20 years ago. These techniques are popular in nuclear engineering where they find use in many laboratories as a routine experimental device. In other industries, as for example the chemical and food industries, the use of these techniques could be restricted for safety reasons. Hence we need to develop alternative techniques to those based on scattering-radiation principles for routine use in process engineering plant.

2.2 Implications for process control

The problem of process control plays an essential role in engineering practice. With the aid of a control system it is possible to investigate and to recognize regularities that are present in an object, a phenomenon or a process of interest. For control to be effective, it is often sufficient to describe the characteristic parameters in a qualitative way. Therefore, a non-intrusive tomographic technique offers a means of controlling both the routine auditing of process and its macroscale parameters (Figure 2.1), altough this has not yet been widely implemented in industrial practice.

Some processes are critically dependent for their efficiency on close control of the operating conditions, others are not. For those requiring close control, the highest yield and product quality can only be ensured by using automatic control. This is a necessity in any plant which gives erratic yields or an appreciable percentage of reject product. For example, 'coking up' the preheater tubes of an oil-cracking plant is accelerated by 'peaks' of temperature. This results in a lower heat-transfer rate and an increased pressure drop through the tubes, and so decreases the efficiency of the unit. Another example is the accelerated ageing of catalyst, due again to variations in peak temperature or perhaps to an increase in concentration of an impurity in the reacting gases. The losses of process materials or products due to such fluctuations in operating conditions are costly, from both the production and maintenance cost points of view.

Evidently, an adequate description of a process is needed to solve problems of control and prediction. In most cases a mathematical description which establishes a relationship between input and output variables is necessary. On the basis of this relationship, control of a process can be worked out such that the achievement of manufacturing or production goals is guaranteed. Mathematical models that describe different two-phase flow structures which may exist in chemical equipment have been discussed in Section 2.1, where it also was shown that tomographic methods could be applied in modelling various heat or mass processes. In general, these processes are non-stationary and, therefore, are rather complicated to investigate using conventional instrumental methods.

However, in some cases non-stationarity can be approximated well enough by a linear model based on separate segments within the operation. In this connection the problem arises of estimating quantitatively the degree of non-stationarity. To do this a tomographic system can be used to investigate the following problems:

- Qualititative estimation of a degree of spatial distribution of physical properties of the mixture or fluid.
- Quantification of an appropriate identifier describing the process.
- Choice of a proper model for different output variables in order to simplify the control problem.

In many control systems, use of on-line or recursive identification is desirable in order to make optimum adaptation to the system goal possible in the face of environmental uncertainty and changing environmental conditions. Tomography can be used in both 'classical' (Sage and Melsa) and computational techniques of system identification.

Identification of the system can be achieved by inserting different kinds of disturbance input to the system and cross-correlating the system output. Thus, obtaining probability characteristics, on which identification methods are based, is very specific, i.e. the methods and solutions depend on the exact nature of the problem. Spatial or temporal probabilistic characteristics of random processes can be measured using tomography, and on this basis both auto- and cross-correlation functions can be calculated. According to the tomographic instrument used, the output signal can be measured in analogue, analogue–digital or digital form.

Tomographic techniques also provide a tool for the computational identification of the dynamic characteristics of a given object. The possibilty of storing in a computer memory a large set of results, and analysing them in accordance with the process and needs, is the principal advantage of this technique. It should be emphasized that by applying tomographic techniques (especially an electrical tomography) the identification time of a given object is very short. An advantage of receiving, in non-intrusive way, the images of a given process can also be used in developing 'learning models', which are based on adaptive systems.

Neural networks are a vast and developing technique which may be used in process control. At present, this technique is mainly applied in the engineering

industry. For instance, neutral networks are used in robotics technology, which has stimulated interest in the research on autonomous learning system. In general, a control system based on theories of neural information processing allows real-time control of the task.

Therefore, it seems that the application of process tomography will also be of use in the chemical industry. Process tomography would provide (for a control system based on a neural network) information needed concerning flow patterns. A significant advantage would be the possibility of getting images in digital or analogue form of slices of the process control.

References

Anderson, T. B. and Jackson, R. (1967) A fluid mechanical description of fluidized beds. *Ind. Eng. Chem. Fundam.*, **6**, 527–539

Banerjee, S. (1980) Separated flow models. II. Higher order dispersion effects in the averaged formulation. *Int. J. Multiphase Flow*, **6**, 241–248

Banerjee, S. and Chan, A. M. C. (1980) Separated flow models. I. Analysis of the averaged and local instantaneous formulation. *Int. J. Multiphase Flow*, **6**, 1–24

Batchelor, G. K. (1974) Transport properties of two-phase materials with random structure. *Ann. Rev. Fluid Mech.*, **6**, 227–255

Boure, J. (1973) Dynamite des emoluments diphasiques: propagation des petite perturbation. *Cern Report TEA-R-4456*, Grenoble

Buyevich, X. A. and Shchelchkova, I. N. (1978) Flow of dense suspension. *Prig. Afros. Sci.*, **18**, 121–150

Chadan, K. and Sabatier, P. C. (1977) *Inverse Problems in Quantuum Theory*, Springer-Verlag, New York

Drew, D. A. (1971) Average field equations for two-phase media. *Stud. Appl. Math.*, **50**, 133–166

Drew, D. A. (1983) Mathematical modelling of two-phase flow. *Ann. Rev. Fluid Mech.*, **15**, 261–191

Frankl, F. I. (1953) On the theory of motion of suspended sediments. *Dokl. Akad. Nauk SSSR*, **92**, 92–247

Gough, P. S. (1980) On the closure and character of the balance equation for heterogenous two-phase flow. In *Dynamics and Modelling of Reactive Systems*, Academic Press, New York, 151–159

Herczynski, R. and Pienkowska, I. (1980) Toward a statistical theory of suspension. *Ann. Rev. Fluid Mech.*, **12**, 237–269

Hinze, J. O. (1959) *Turbulence*, McGraw-Hill, New York

Hussein, E. M., Meneley, D. A. and Banerjee, S. (1986) Single-exposure neutron tomography of two-phase flow. *Int. J. Multiphase Flow*, **12**, 1–34

Ishii, M. (1975) *Thermo-fluid Dynamic Theory of Two-Phase Flow*, Eyroless, Paris

Kenyon, D. E. (1976) The theory of an incompressible solid-fluid mixture. *Arch. Ration. Mech. Anal.*, **62**, 131–147

Kocamustafaogullari, G. (1971) Thermo-fluid dynamic theory of separated two-phase flow. Ph.D. Thesis, Georgia Institute of Technology, Atlanta, GA

Kotoaka, I. (1986) Local instant formulation of two-phase flow. *Int. J. Multiphase Flow*, **12** 745–758

Lahey, R. T. and Ohkawa, K. (1989) An experimental investigation of phase distribution in an eccentric annulus. *Int. J. Multiphase Flow*, **15**, 447–457

Nigmatulin, R. I. (1979) Spatial averaging in the mechanics of heterogeneous and dispersed systems. *Int. J. Multiphase Flow*, **5**, 353–385

Nunziato J. W. (1982) A multiphase mixture theory for fluid-particle flow. *Ann. Rev. Fluid Mech.*, **14**, 127–173

Sage, A. P. and Melsa, J. L. (1971) *System identification*, Academic Press, New York

Soo, S. L. (1967) *Fluid Dynamics of Multiphase Systems*, Ashgate Publishing Waltham, MA

Teletov, S. G. (1958) Problems of hydrodynamics of two-phase mixtures. *I. Vestn. Mosk. Gos. Univ., Ser. Mat. Mekh. Astron. Fiz. Khim.*, **15**, 15–27

Truesdel, C. (1984) *Rational Thermodynamics*, 2nd edn, Springer-Verlag, New York

Vernier, P. and Delhaye, J. M. (1968) General two-phase flow equations applied to the thermodynamics of boiling water nuclear reactors. *Energ. Primaire*, **4**, 5–46

Wallis, G. B. (1969) *One dimensional Two-phase Flow*, McGraw-Hill, New York

Whitaker, S. (1973) The transport equations for multiphase systems. *Chem. Eng. Sci.*, **28**, 139–147

Part II

Sensing techniques

Section Editor: S. M. Huang

Chapter 3

Selection of sensing techniques

M. S. Beck

In Chapter 1 we introduced various sensing methods for process tomography based on transmission, diffraction and electrical measurement. In this chapter we discuss the features of various sensors in relation to specific applications. Tomographic systems for distinguishing between two phases of components in the object space involve using only one type of sensor (Section 3.1). However, tomographic systems for imaging three or more phases of components require the use of sensor systems having specific sensitivity to the individual phases or components (Section 3.2), such systems are referred to as 'dual-modality' (for three phases or components) or multi-modality (for more than three phases or components).

For brevity, in the following sections the term 'two component' is used to describe systems having two separate components (such as oil and water) and also to describe systems more strictly referred to as two-phase systems (e.g. gas–liquid mixtures).

3.1 Sensors for tomographic imaging

The range of on-line sensing methods is summarized in Table 3.1 with reference to their operating principle, practical realization and typical applications. Further information on each sensing method can be found in the chapters referred to in the table.

3.2 Multi-modality tomographic imaging systems

A multi-modality tomographic system can be defined as one in which two or more different sensing entities (e.g. two selected from Table 3.1) are used to locate or measure different constituents in the object space. 'Multi-modality' type measurements are common in normal instrumentation, for example optical spectroscopy can be used to measure several chemical species which are present along the path of a light beam, by selecting the different absorption spectra which are appropriate to the specific species.

The reported examples of multi-modality systems used for tomographic imaging have been confined to using only two different measuring entities, therefore the argument in this section will frequently be restricted to 'dual-modality systems', although the reader should understand that the techniques can be extended to cover 'multi-modality systems'.

One example of using dual-modality systems occurs in medical tomography

Table 3.1 Features of on-line sensing techniques for process tomography

Principle (chapter reference)	Practical realization	Typical applications	General remarks	Remarks on signal processing and reconstructions algorithms	Typical no. frames per second
Modulation of beam of electromagnetic radiation by the dispersed components in the fluid (Chapters 10 and 11)	Optical techniques	Multi-component systems where the carrier phase is transparent to the radiation used Location of fugitive environmental emissions using long-path optical systems	Conceptually simple, high definition possible, fibre optic light guides can simplify optical arrangements. Images of central region poor if second phase concentration is high, due to absorption near walls Can be specific to desired component by using spectroscopic sensors	Similar algorithms well established for medical CAT Sensor field is essentially 'hard' so iterative reconstruction is not normally required. However, some field distortion may occur if diffraction is caused by density gradients	1000
	Ionizing radiation: X-ray and γ-ray	Processes where there is a substantial density difference between the components	Heavy shielding may be required to collimate beams and for safety. Photon statistical noise limits response time (although recent	Beam hardening may alter sensitivity along the projection path. Not significant for narrow energy band γ-rays. May be significant for X-rays,	0.1–10

Diffraction, reflection, attenuation or transit time change of external radiation (*Chapter 8*)	Ultrasonic systems Sensors which project perpendicular to flow used for material distribution imaging. Projections inclined to flow direction used for velocity profile imaging	Systems where refraction or reflection occur at boundaries, e.g. liquid–gas processes	advances in detector sensitivity may avoid these problems) Ultrasound, say, 1 MHz pass through metal–liquid interface so a 'clip-on' system may be feasible. 'Ringing' of transmitter may cause difficulty in imaging discontinuities close to the pipe walls	because the lower energy radiation may be largely attenuated near the point of incidence	1–10, depending on process dimensions
(*Chapter 9*)	Microwave systems	Processes providing suitable impedance contrast at microwave frequency. Systems in which diffraction effect at boundaries can enhance impedance contrast	Non-contacting. Published results are few – mainly imaging knots in timber and body imaging	Similar to some NDT and medical applications where operator intervention is used to reduce errors caused by multiple reflections, etc. For process applications great care may be needed with sensor signal processing, reconstruction and image interpretation to avoid errors	100

Table 3.1 (continued)

Principle (chapter reference)	Practical realization	Typical applications	General remarks	Remarks on signal processing and reconstructions algorithms	Typical no. frames per second
Measurement of electrical properties. Generally referred to as 'electrical impedance tomography' (EIT). Measures resistance, capacitance, eddy current, permeability, etc. (Chapters 4–6)	Resistivity sensing electrodes which are invasive but non-intrusive	Electrically conducting systems – liquid/solid/gas/liquid	Very small electrodes can be used. Similar to system used for medical imaging	Electrical fields are 'soft' so that complex (e.g. iterative) reconstruction algorithms may be needed to reduce image distortion if component distribution is very non-uniform. Compensation may be needed for reduced sensitivity (and poorer resolution) near the centre of the image	100
	Capacitance sensing electrodes which are non-invasive if separated from the process fluid by a (say) 10 mm thick plastic liner	Electrically insulating systems – gas or liquid/solid/gas/liquid	Electrodes may need to be of (say) 10 cm$^2$ area to give sufficient capacitance change		

	Inductive (magnetic) sensors which are non-invasive	Detection of components in a process which affect the field due to generation of eddy currents	Excitation frequency chosen to suit eddy current domain dimensions		
		Detection of components which affect the field due to their magnetic permeability			
Emission of photons from material in the process (*Chapter 12*)	Ionizing radiation emission from radioisotope labelled components, e.g. positron emission tomography	Experimental investigation of mixing and separation processes	High resolution, but low response. Requires skilled personnel and is not suitable for continuous monitoring. Enables imaging of specific components in a multi-component system	Provides trajectory of labelled particles	Discontinuous technique (see *Chapter 12*)

Table 3.1 *(continued)*

Principle (chapter reference)	*Practical realization*	*Typical applications*	*General remarks*	*Remarks on signal processing and reconstructions algorithms*	*Typical no. frames per second*
Emission of electrostatic charge from material in the process *(Chapter 7)*	Simple electrodes and a.c. amplifiers measure electrostatic charge caused by frictional and other charge separation processes	Electrically insulating systems where material interfaces allow charge separation to occur	Highly sensitive to material close to electrodes. Induced current is proportional to rate of change of charge, hence the detected signal is a function of velocity	Need further development to compensate for local sensitivity and velocity effects	100

where body imaging using X-ray computed tomography (CT) (Chapter 18) clearly images the bone structure, but is not sufficiently sensitive to differentiate between healthy and diseased soft tissue. On the other hand, magnetic resonance imaging (MRI) (Chapter 24) can locate diseased tissue within other soft tissue, but is not sensitive to bony structure. In cases where the surgeon wishes to know the exact position of diseased tissue relative to bone structure, both X-ray CT and MRI images are used together. Here one of the major problems in dual-modality imaging occurs, i.e. both images are geometrically distorted due to the imprecise knowledge of the sensing field geometry, limitations in the construction of sensors, beam bending, etc. Hence the two tomographic images do not register exactly and the relative location of the bony structure and diseased tissue cannot be relied on. In this case image registration can be improved by the skill of the observer who looks for anatomical features which are detected by both of the imaging modalities. The observer can then use this information to make appropriate adjustments in registration. Alternatively, computer-aided image registration should be a feasible method of improving image registration.

The problems of image registration become greater when electrical sensors are used for tomographic imaging, because electric field equipotentials may be severely distorted by variations in the electrical properties of the object space, with a consequent distortion of the image and difficulties in image registration.

Image registration is generally less important for process tomography, because precise location of objects is not required. A more normal requirement is for information on the general distribution of materials, the flow regime, or even to use the tomographic data to provide the time-averaged value of some process variable.

An example of dual-modality process tomography occurs in the oil industry, where there is a need to measure the quantity of water and gas in a cross-section of the pipe from an oil well, and at the same time to have information on the flow regime (the physical distribution of the gas and water in the cross-section). From these data the productivity of the well (quantity of oil, gas and water produced) and information useful to an understanding of the multi-phase transport and separation process is obtained.

The solution is to use electrical capacitance tomography (Chapter 4) for imaging and measuring the water distribution (water has a permittivity approximately 40 times that of oil). The gas distribution is then determined by a system which is responsive to the large density difference between the gas and the liquid. Two alternative tomographic systems can be used to detect the density difference, the alternatives being γ-tomography (Chapter 18) or ultrasonic tomography (Chapter 8).

3.3 Inherently multi-modality systems

An inherently multi-modality system uses a single imaging method which can differentiate between different species in the object space. Thus all the

measured information is available using the same measurement field and image registration.

Optical tomography is inherently multi-modality, because by using the spectral analysis available from optical systems (Section 3.2) with the optical tomographic systems described in Chapter 10, differentiation between appropriate species in the optical paths can be attained.

Electrical tomography systems are, in certain cases, the most attractive for real-time imaging of industrial processes because of their inherent simplicity, rugged construction and high-speed capability. During recent years work has started on exploring the potential of impedance spectroscopy and dielectric spectroscopy to increase the component specificity of electrical tomography systems. A paper by Riu *et al.* (1993) describes a multi-frequency electrical impedance tomography system. Their work involved taking image readings at two different frequencies, in order to image a slowly varying or static phenomenon, when using an instrument which was not calibrated for the initial state of the object space. Although not actually involving species identification, the potential of the method could be extended to this area. An investigation of the use of impedance spectroscopy for differentiating between different materials has been carried out by Etuke *et al.* (1993, 1994 a,b). This technique appears likely to lead to a system which could be incorporated within an electrical impedance tomography system to enable component specificity to be obtained.

Electromagnetic (inductive) tomography systems (Chapter 6) are capable of distinguishing between ferrous materials and electrically conducting materials in the object space. This distinction occurs because electrically conducting materials involve energy absorption by eddy-current loss, which is electrically in-phase to the applied magnetic field and can be detected by a phase-sensitive demodulator measuring the field strength. On the other hand, ferrous components in the object space affect the applied field in vectorially orthogonal to the eddy-current effect, and can be separately identified by a phase-sensitive demodulator using an orthogonal reference signal.

References

Etuke, E. O., Hall, D. A., Waterfall, R. C., Beck, M. S., Williams, R. A. and Dyakowski, T. (1993) *Principles of Tomographic Characterization of a Two Particle Type Dispersion. Sensor VI Technology, Systems and Applications*, IOP Publishing, Bristol, 353–358

Etuke, E. O., Waterfall, R. C., Dickin, F. J. and Beck, M. S. (1994a) DSP-based spectroscopic impedance analyzer. In *IMEKO XIII Congress*, Italy, September 1994, Institute of Measurement and Control, London

Etuke, E. O., Hall, D. A., Waterfall, R. C., Beck, M. S., Williams, R. A. and Dyakowski, T. (1994b) Monitoring the sedimentation of a two-particle-type dispersion by impedance spectroscopy. In *IMEKO XIII Congress*, Italy, September 1994, Institute of Measurement and Control, London

Riu, P., Rosell, J. and Pallas-Areny, R. (1993) Multifrequency electrical impedance tomography as an alternative to absolute imaging. In *Tomographic Techniques for Process Design & Operation*, Computational Mechanics Publications, Southampton, 53–62

Chapter 4

Impedance sensors – dielectric systems

S. M. Huang

4.1 Introduction

Electrical capacitance sensors are appropriate for imaging dielectric components in process vessels or pipelines. Capacitance sensors have been used to measure the component fraction of multi-component flow processes (Hammer, 1983; Huang, 1986). In these applications, the sensors usually consist of two electrode plates and the capacitance measured is determined by:

$$C_x = K\varepsilon_m \tag{4.1}$$

where K is a factor determined by the geometric configuration of the sensor electrodes, and ε_m is the global average of the fluid dielectric property over the entire sensing volume of the sensor. In order to improve the signal-to-noise ratio (SNR) of the measurement, the size of the electrodes can be increased, limited only by installation restrictions and cost consideration. The standing capacitance values (for $\varepsilon_m = 1$) in these applications range from a few to a few tens of picofarad. The measurement requirement for this range of values can be met with capacitance transducers with a medium SNR and stability, such as a charge-transfer device (Huang et al., 1988a).

The requirements for tomographic imaging sensors are different. The sensors should facilitate multiple and localized measurement throughout the region of investigation. This implies that multiple electrodes should be arranged around the boundary of the region (see Figure 4.1) and the capacitances between all the combination pairs of the electrodes should be measured in order to perform a 'body-scan' of the imaging volume. For the configuration shown in Figure 4.1, the capacitance between electrodes 1–2, 1–3, 1–4 until 1–8, then 2–3, 2–4, until 7–8, can be measured sequentially with appropriate sensor electronics, providing a total number of 28 measurements. Each of these measurements has a unique sensitivity weighting over the cross-section of the imaging volume, and hence is independent of the others. Generally, for an N-electrode sensor, the number of independent measurements obtainable is determined by the combination formula:

$$N = n(n - 1)/2 \tag{4.2}$$

As shown in Figure 4.1, the N measurements are obtained via appropriate sensor electronics and sent to the image-reconstruction computer. The computer controls the data-acquisition process and generates a tomographic

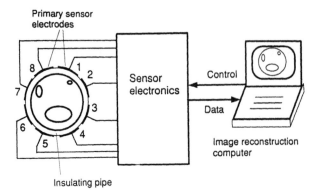

Figure 4.1 *Capacitance tomographic imaging system*

image of the dielectric distribution from the measurements and their corresponding sensitivity distribution maps (for more details see Chapters 15 and 16).

The spatial resolution of a tomographic imaging system depends on the number of independent measurements and the fineness of sensitivity focus for each measurement (Chapter 15). Therefore, more electrodes with smaller size would result in better imaging reconstruction. However, the measurement sensitivity of a capacitance sensor is proportional to the electrode area. As the electrode size reduces, the SNR of the system decreases. Thus the minimum size is limited by the noise level of the data-acquisition system. Given the dimensions of the imaging volume, the electrode size has to be reduced as the total number of electrodes increases. Therefore the maximum number of the electrodes that can be used in such an imaging system is restricted by the SNR requirement. For the same reason, an adequate electrode length along the axial direction of the imaging volume (the third dimension) is required. Thus the tomographic images produced by capacitance methods result from the cross-sectional dielectric distribution averaged along the length of the electrode. The selection of electrode dimensions is a matter of balancing between the spatial imaging resolution and the SNR.

In practice, the number of electrodes used is between 8 and 16 (Huang *et al.*, 1989, 1992; Fasching and Smith, 1991), with the minimum standing capacitance (between the pair of electrodes separated by diameter, e.g. 1–5 in Figure 4.1, and when the pipe is empty) ranging from a few hundred to a few femtofarad (with axial electrode length at about 100 mm). For applications where the dielectric contrast between the different materials is not very large, e.g. oil and gas, a measurement resolution of a few per cent of the standing value is often required. This minimum standing capacitance value depends mainly on the number of electrodes and the electrode–guard–insulator configuration, and it cannot be significantly increased by increasing the diameter of the insulating pipe liner. This is because the increase in the angular size of the electrodes is compensated for by the increase in the distance between the diagonally

separated electrodes. For a 16-electrode system with real-time imaging requirement (a data sampling rate of above 10 000 words per second may be required), achieving a sufficient SNR in measuring capacitances of the order of subfemtofarads, becomes a real challenge.

The above discussion highlights the need for good primary sensor and sensor electronics design in order to provide low noise level, high stability and well-focused measurement sensitivity distributions in the imaging volume. In the following sections, the design of primary sensor, sensor electronics and data-acquisition system for a working capacitance tomography system is described to demonstrate the general principle. The system was developed under the SERC/DTI's LINK scheme by the joint work of University of Manchester Institute of Science and Technology (UMIST), Leeds University, Schlumberger Cambridge Research and Schlumberger Industries, and its main application is aimed at imaging multi-phase flow in oil field pipelines. Section 4.2 describes the sensor electrode design and the basic principle of the sensor electronics, Section 4.3 describes the data-acquisition electronics between the sensor and the image-reconstruction computer, and Section 4.4 discusses the test results and the possibility for further improvement of the design.

4.2 Primary sensor and sensor electronics

4.2.1 Electrode design

The electrode configuration of the primary sensor is shown in Figure 4.2. Twelve electrode plates are mounted on the periphery of an insulating pipe liner section, which conveys the multi-phase flow to be investigated. The electrode length along the flow direction is 100 mm. The projected guards (earthed) between the neighbouring electrodes are used to eliminate the capacitances between the back surfaces of adjacent electrodes, thus reducing the standing capacitance which is insensitive to the dielectric distribution inside the pipe liner. The overall screen (earthed) is used to protect the sensor from the interferences of external electromagnetic fields. The space between the screen and the electrodes is filled with potting compound to ensure mechanical rigidity.

In the structure shown in Figure 4.2, a number of parameters should be carefully selected to optimize the sensor performance. The most important parameter is the wall thickness of the insulating pipe liner, which can significantly influence the sensitivity distributions inside the pipe bore. If the wall is too thick, then the capacitance between adjacent electrodes will not respond monotonically to the permittivity increase inside the pipe bore, making image reconstruction difficult. The situation is illustrated in Figure 4.3, where for a wall thickness of about 15 mm the measured capacitance between electrodes 1 and 2 starts to fall as the permittivity of the flow increases above 3, and the situation improves as the pipe wall thickness reduces. However, reduction in the wall thickness is limited by the requirement for the mechanical strength and it also results in more uneven measurement

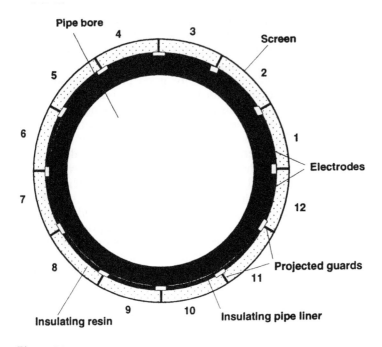

Figure 4.2 *Cross-sectional structure of the imaging sensor*

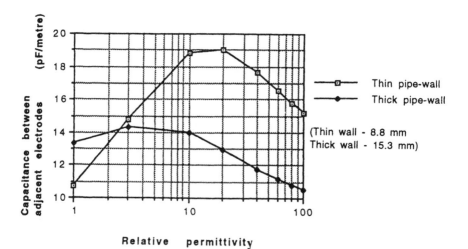

Figure 4.3 *The capacitance between adjacent electrodes versus the relative permittivity inside the pipe bore for different pipe-wall thicknesses*

sensitivity distribution inside the pipe (the sensitivity rises sharply near the electrode edge, as described in Chapters 16 and 17), causing a relative decrease in system sensitivity towards the centre of the pipe. Other parameters to be optimized include the gap between the overall screen and the electrodes, the gap between the projected guard and the electrode, the penetration depth of the projected guard into the pipe liner and the permittivity of the insulating pipe liner, etc. The criteria used in the optimization can be the quality of the reconstructed images for a number of given phase distributions. The optimization results are application dependent. For instance, for imaging water/oil mixtures, the optimum insulating pipe thickness is different from that used for imaging oil/gas mixtures.

Computer-aided design of the electrode structure has been carried out at City University, London, and at UMIST (see Chapters 16 and 17). In this the finite-element method was used to solve the electrical field equations for the given sensor structure, producing the optimized design parameters.

4.2.2 Capacitance measurement

An essential requirement of the imaging system is that for each capacitance measurement, the measurement sensitivity should be focused into a narrow area between the two selected electrodes. In selecting a capacitance measuring method, the stray-immune measurement circuit must be selected to satisfy this requirement. A stray-immune circuit measures only the capacitance between the selected pair of electrodes, and is insensitive to the stray capacitances between the selected and the redundant electrodes and those between the selected electrodes and earth. This also results in better baseline stability and much lower standing capacitance, compared with non-stray-immune circuits. Typical examples of stray-immune circuits are a.c. ratio-arm bridges with current detection and the switched capacitor charge-transfer circuit (Huang *et al.*, 1988a). The a.c. bridges operate usually with excitation frequencies below a few hundred kilohertz, and they are superior to the charge-transfer circuit in terms of low baseline drift and high SNR. How-ever, with a switching frequency of up to 2 MHz, the charge-transfer circuit can offer a faster data-capture rate, and because of its simple circuitry, parallel measurement channels can be used to increase the speed further without a substantial increase in cost or complexity of the circuitry. For more complex circuits such as the a.c. bridges, the use of parallel measurement channels means that each channel will have its own demodulator, and this results in a substantial increase in complexity and cost. Therefore selection of the basic capacitance measuring circuit is a balance between the requirement for high SNR and that for low cost and complexity. In our application, the SNR of the charge-transfer circuit is considered to be adequate and hence it is selected.

The principle of the circuit can be explained with reference to Figure 4.4. One electrode of unknown capacitance (C_x) is connected with a pair of CMOS switches (S1 and S2) and is called the 'source electrode'. Another electrode

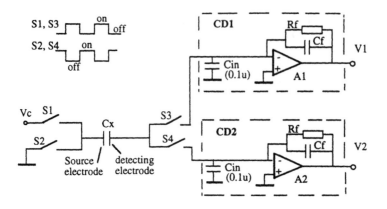

Figure 4.4 *The basic capacitance measurement circuit*

(detecting electrode) is connected with switches S3 and S4. In a typical operating cycle, switches S1 and S3 are first closed (S2 and S4 open) to charge C_x to a constant voltage V_c, and the charging current flows into the input (at virtual earth potential) of the current detector CD1 where it is converted in to a negative voltage output. In the second half of the cycle, switches S2 and S4 close (S1 and S3 open) to discharge C_x to earth potential. The discharging current flows out of the current detector CD2, producing a positive voltage output. This typical charge–discharge cycle repeats at a frequency (f) and the successive charging and discharging current pulses are averaged in the two current detectors, producing two d.c. output voltages:

$$V_1 = -fV_c R_f C_x + e_1 \tag{4.3}$$

$$V_2 = fV_c R_f C_x + e_2 \tag{4.4}$$

where R_f is the value of the feedback resistors of the current detectors, and e_1 and e_2 are the output offset voltages of CD1 and CD2, which are caused mainly by the charge injection effect of the CMOS switches (discussed later in this subsection). The capacitors, C_{in} (0.1 μF) ensure that the virtual earth potentials at the inputs of CD1 and CD2 remain stable during the high-speed charge and discharge operation. Since, during operation, the source electrode is always connected with low impedance supplies (V_c and earth), and the detecting electrode always at virtual earth potential, stray capacitances have virtually no effect on the measurement (Huang *et al.*, 1988a).

The dynamic characteristics of the current detectors are similar to that of a first-order low-pass filter with its time constant determined by $R_f C_f$. The time constant is so chosen that the required data-capture speed is satisfied.

The differential output voltage $V_2 - V_1$ is taken as the output of the capacitance transducer. From eqns (4.3) and (4.4):

$$V_2 - V_1 = 2fV_cR_fC_x + e_2 - e_1 \tag{4.5}$$

Compared with eqn (4.1) or (4.2), eqn (4.3) shows that the differential arrangement has two advantages. First, the sensitivity of the measurement is doubled to $2fV_cR_f$, and so is the ratio of signal to the noise picked up by the detecting electrode (noise generated by electrostatic charges in the flow, for instance) (Huang *et al.*, 1988b). Second, the offset voltages e_1 and e_2 tend to cancel each other out, provided that S3 and S4 have similar charge-injection effects and the two operational amplifiers have matched off-set voltages (from a dual amplifier package, for instance).

The major contribution to the offset and temperature drift of the transducer baseline comes from the charge-injection effect of the semiconductor switches. Charge injection is caused by feedthrough of gate control signals of semiconductor switches via the gate–channel capacitances. In the circuit shown in Figure 4.4, the gate control signals for switches S3 and S4 inject unwanted charge into the current detectors, resulting in offset voltages at their outputs. The offset voltage e_1 (as well as e_2) can be expressed using the following formula (ignoring the relatively much smaller offset voltage of the operational amplifier):

$$e_1 = fV_hR_fC_1 \tag{4.6}$$

where V_h is the voltage of logic 'high' of the gate control signal and C_1 represents the charge-injection capacity of switch S3 and is related to the value of the gate–channel capacitance. The value of C_1 depends on the type and make of the switches. It also depends on the voltage level of the signal channel with respect to the supply voltages of the switch. For CMOS switches 4066 used in this application, C_1 is lowest when the channel input/output is at the V_{ss} (ground in this case) potential. The design shown in Figure 4.4 ensures that the input/output potentials of S3 and S4 always remain virtual earth. Therefore, a low C_1 value of around 0.1 pF is achieved. With the differential arrangement (eqn (4.5)), the charge-injection effect is further reduced (to about 0.03 pF for the particular circuit that we tested). However, considering the smallest standing capacitance in a 12-electrode system is still significantly smaller than this value, and the charge-injection effect is temperature dependent, the offset and its temperature drift must be compensated by the arrangement described below.

The idea is to check the baseline regularly and correct the drift by subtracting the baseline from the values measured afterwards. To implement this, a calibration mode is incorporated in the circuit operation. In this mode the source electrode is earthed while switches S3 and S4 remain operational, and the output offset due to the charge injection is measured and stored. Then the measurement is resumed by enabling the charge/discharge control signals connected to S1 and S2, and the offset obtained during the calibration is subtracted from each subsequent measurement value. In this way, the baseline drift is compensated.

4.3 A data-acquisition system system for capacitance tomography

4.3.1 Operating principle

The principle of the data-acquisition system is shown in Figure 4.5. The system is designed to accommodate up to 12 electrode channels. To increase the overall data-capture speed, parallel measurement channels are used. Each channel consists of four CMOS switches and a pair of current detectors. The

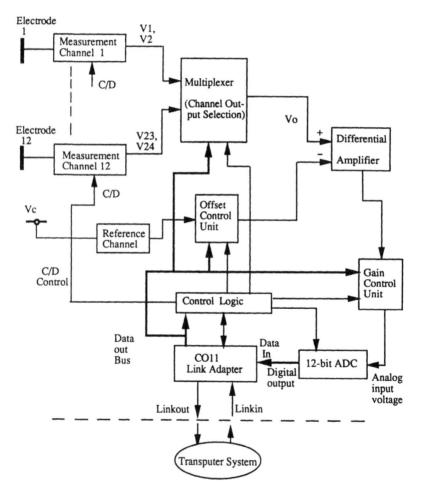

Figure 4.5 *Block diagram of the sensor electronics circuit*

control logic unit controls the status of the electrodes so that each electrode can be selected as either the source or detecting electrodes. A complete data-capture cycle starts with electrode 1 is selected as the source and all the others as detecting electrodes. The capacitances between electrode pairs 1–2, 1–3, to 1–12 are measured simultaneously. (The source and each of the detecting electrodes and the current detectors in the corresponding measurement channel form the capacitance measuring circuit shown in Figure 4.4.) The 11 parallel channel outputs are then selected one by one by a multiplexer for further amplification and analogue-to-digital conversion. The amplification and conversion time is short compared with the settling time of the current detectors in the basic measurement circuits, whereas the effect of the latter on the overall data-acquisition speed is reduced by the parallel-measurement approach. In the next step, electrode 2 is selected as the source (electrode 1 is set to idle (earthed)) and electrodes 3–12 as the detecting ones. Capacitances between 2–3, 2–4, to 2–12 are measured simultaneously. This process continues until electrode 11 is the source and 12 the detecting electrode. In this way, 66 independent capacitance measurements are obtained in a scan cycle.

4.3.2 Automatic off-set and gain balance

A problem associated with capacitance measurement in the system shown by Figure 4.2 is that the standing capacitance and sensitivity values of different electrode pairs can be very different. For instance, for a 12-electrode system, the standing capacitance value between electrode 1 and 2 can be 100 times larger than that between 1 and 7. Even for pairs with similar configuration, e.g. 1–2 and 1–12, the measured standing values may be more or less different owing to manufacturing errors in the electrode system and different charge-injection levels of these channels (see Section 4.2.2). This causes difficulties for the capacitance measuring circuit which has a limited dynamic range.

The solution to this problem is to use a programmable reference voltage to balance the standing offsets of the measurements (zeros) and a programmable gain amplifier to satisfy the different sensitivity requirements. A calibration procedure has been designed to learn the 66 zeros and required gains (Figure 4.6) and it should be performed before the measurement and imaging process. During the calibration, the sensor pipe is first filled with the component of lower permittivity (e.g. air for a gas/liquid two-component flow) and the 66 capacitance values are measured and stored as the zeros. Then the pipe is filled with the component of higher permittivity and the gain of the circuit is adjusted so that each measurement output reaches its full-scale value. The 66 gain values thus obtained are then stored in the transputer system which is used as a sensor control and image reconstruction unit. During the measurement and imaging process (Figure 4.7), each time after a measurement channel has been selected by the multiplexer, the stored offset and gain values for this particular configuration of electrode pair are sent from the transputer to the offset and gain control units to preset the appropriate zero balance and

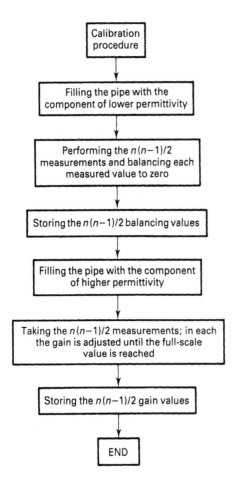

Figure 4.6 *The calibration procedure*

gain. This approach significantly increases the dynamic range of the data-acquisition system.

4.3.3 Interface to image reconstruction computer

As shown in Figure 4.5, a CO11 transputer link adaptor (from INMOS) is used to provide an interface between the sensor electronics and the transputer system. The link adapter is built into the sensor electronics, and is connected with the transputer system via two serial communication links (one input and one output). Control codes from the transputer system are converted by the CO11 into parallel format output which controls the data-acquisition process,

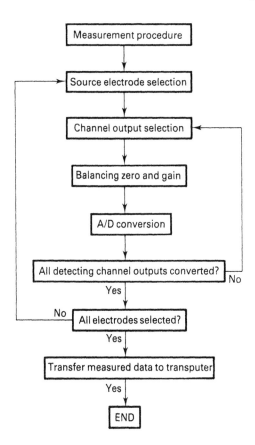

Figure 4.7 *The measurement procedure*

whereas the parallel output from the analogue-to-digital converter is converted into a serial output and sent to the transputer system. The functions of the control codes include:

- Selection of operating mode, data acquisition or baseline checking.
- Selection of electrode status (source, detecting or idle).
- Selection of measurement channel outputs for analogue-to-digital conversion.
- Zero balance.
- Gain control.
- Analogue-to-digital conversion control.
- Charge/discharge frequency selection (625 kHz for lower measurement sensitivity and 1.25 MHz for higher sensitivity).

The sensor electronics support both electrical and optical fibre links between the transputer system and the CO11. For the standard 10 Mbit/s data communication rate, electrical link cables can be used with a maximum length

of 13 m, whereas optical fibre links can be used over a much longer distance (up to 250 m). This enables the image-reconstruction computer to be placed in a less-hostile environment, far away from the sensor electronics which are mounted on the pipeline.

4.4 Test results and discussion

4.4.1 Test results

The performance of the data-acquisition system shown in Figure 4.5 has been tested in the laboratory. The results are described below.

Noise level

The noise generated in the sensor electronics is primarily random and it is mainly generated by the first stage current detectors. When low noise operational amplifiers (OP270 from PMI) were used, the typical r.m.s. value of the noise voltage measured at the input of the analogue-to-digital converter was equivalent to an input capacitance of 0.08 fF for a data-capture rate of 100 frames/s (6600 measurements/s). It can be observed from the probability density function of the noise (Figure 4.8) that the peak level of the noise voltage does not exceed 19.3 mV (equivalent to 0.26 fF input capacitance). For oil/gas systems and with our present version of primary sensor (Figure 4.2), the measurement resolution required is typically about 0.3 fF, which corresponds to a 2% oil fraction change at the centre of the pipe. Therefore the ratio of the minimum signal level to the r.m.s. value of the noise (SNR) is 3.8.

Figure 4.8 *The probability density function (PDF) of noise before analogue-to-digital conversion*

In a test of an imaging system incorporating the data-acquisition system described above, although some background noise was observed on the reconstructed images, a plastic rod at the pipe centre occupying 2% of the pipe cross-section could be identified, showing that the SNR is acceptable.

Baseline drift
The stability of the system incorporating the baseline correction arrangement (Section 4.2.2) can be represented by its baseline drift with time and temperature. When the system was placed in a room with constant temperature ($\pm 1\,°C$ change maximum), no apparent baseline drift was observed over a period of 5 h. However, further investigation on the temperature drift of the primary sensor and sensor electronics should be carried out in the future.

Speed
The data-acquisition time for obtaining the 66 independent measurements was 10 ms when a T801 (25 MHz) transputer was used as the sensor controller. This provided an acquisition rate of 100 frames of image data per second.

Dynamic range
The smallest capacitance change detectable by the system is 0.3 fF. The maximum input capacitance acceptable is 2 pF. Thus the dynamic range of the system is $D = 20 \log(2/0.0003) = 76$ dB.

Real-time test
A tomographic imaging system incorporating the primary capacitance sensor and the sensor electronics described in this chapter was tested in real time on a multi-phase flow loop at Schlumberger Cambridge Research Laboratories. The system produced cross-sectional flow images for a range of different oil/gas and oil/water flow patterns, which agreed qualitatively with the visual observation of these flows.

4.4.2 Discussion

Potential applications of the capacitance tomographic imaging system in industrial environments require a robust and stable primary sensor and sensor electronics. Appropriate design methods, manufacturing technologies and materials for producing the industrial version of the primary sensor need to be investigated, in order to minimize drifts in sensor characteristics. The temperature response of the electronics also needs to be investigated, and additional compensation methods should be used if necessary.

The measurement resolution of the sensor electronics is mainly limited by the level of noise voltage generated in the circuit. Some possible ways for further improving the SNR are:

- Using operational amplifiers with lower noise, if they become available.
- Further increasing the charge/discharge frequency, f. The SNR is proportional

to f because the signal level (eqn (4.5)) is proportional to f. However, the maximum frequency that can be used is limited by the equation:

$$f_{max} = 0.05/(R_{on}C_s) \tag{4.7}$$

where R_{on} is the 'on' resistance of the CMOS switches, and C_s the stray capacitance between an electrode (including its lead to the measuring circuit) and the ground. In this design, C_s is typically 150 pF and R_{on} is typically 100 Ω. Therefore the maximum frequency is limited to about 3.3 MHz, to ensure the settling time needed to fully charge and discharge the electrode to V_c (with better than 0.01% accuracy).

• Limiting the bandwidth of the electronics to what is just necessary to satisfy the required data-acquisition speed.

If a further increase in the number of the electrodes (say, to 16) is required, or the length of the electrode is to be shortened to reduce the averaging effect along the flow direction, then the present capacitance measuring circuit based on the charge-transfer principle may not satisfy the increased SNR requirement, and circuits based on a.c. bridge techniques may be appropriate. With these techniques, the input capacitance signal will be modulated by a sinusoidal wave, and this will allow the signal and noise to be separated easily. Bandpass filters and phase-sensitive demodulators may be implemented on modern digital signal processors, which could form part of the image-reconstruction unit, thus reducing the complexity of the sensor electronics.

References

Fasching, G. E. and Smith, Jr., N. S. (1991), A capacitive system for three-dimensional imaging of fluidized beds. *Rev. Sci. Instrum.*, **62**, 2243–2251

Hammer, E. A. (1983) Three-component flow measurement in oil/gas/water mixtures using capacitance transducers. Ph.D. Thesis, University of Manchester

Huang, S. M. (1986) Capacitance transducers for component concentration measurement in multi-component flow processes. Ph.D. Thesis, University of Manchester

Huang, S. M., Stott, A. L., Green, R. G. and Beck, M. S. (1988a) Electronic transducers for industrial measurement of low value capacitances. *J. Phys. E*, **21** 241–250

Huang, S. M., Xie, C. G., Stott, A. L., Green, R. G. and Beck, M. S. (1988b) A capacitance-based solids concentration transducer with high immunity to interference from the electrostatic charge generated in solids/air two-component flows. *Trans. Inst. Meas. Control*, **10**, 98–102

Huang, S. M., Plaskowski, A. B., Xie, C. G. and Beck, M. S. (1989) Tomographic imaging of two-component flow using capacitance sensors. *J. Phys. E*, **22**, 173–177

Huang, S. M., Xie, C. G., Thorn, R., Snowden, D. and Beck, M. S. (1992) Design of sensor electronics for electrical capacitance tomography. *IEE Proc. G*, **139**, 83–88

Chapter 5

Impedance sensors – conducting systems

F. J. Dickin and M. Wang

5.1 Introduction

Unlike the capacitance tomography system described in the previous chapter, the most sophisticated impedance sensing systems for use on electrically conducting materials (referred to as electrical impedance tomography (EIT) systems) were originally developed for clinical applications. Consequently, a number of EIT sensor systems have been built by biomedical research groups in the USA and Europe for use in clinical observations. Notably, the largest group, at Rennselaer Polytechnic Institute (RPI), Troy, New York, have assembled arguably the most accurate and, therefore, the most expensive system. The group at Sheffield University, with their 'real-time' applied potential tomography (APT) system, also opted for a high-speed data-and signal-processing approach which utilized a number of transputers to perform qualitative image reconstruction (at rates in excess of 20 frames/s) and several Texas Instruments 320C25 digital signal processors (DSPs) to manipulate the measured voltage data. Due to the constraints imposed by the strict safety requirements of clinical instrumentation, the majority of biomedical EIT data-collection systems are restricted to a band of amplitude and frequency measurements. The wide dynamic range of measurement conditions occurring in the process industry cannot therefore be easily encompassed by the majority of such restricted biomedical EIT systems. The specification of the UMIST electrical impedance tomography data-acquisition system is given in Section 5.3. This chapter is concerned with the primary sensors (the electrodes, see Section 5.2) and the associated sensor electronics (the data acquisition system, see Section 5.3) of a typical EIT system such as the one shown in Figure 5.1.

5.2 Electrode geometry and construction

The electrodes depicted on the periphery of the process vessel in Figure 5.1 are point electrodes. They are positioned equidistantly around the boundary of the vessel at fixed locations in such a way that they make electrical contact with the fluid inside the vessel but do not affect the normal mass transfer within the process. The electrodes are connected to the data-acquisition system by short lengths of co-axial cable to reduce the effect of extraneous environmental noise and interference. The outer sheath of the co-axial cable is coupled to the

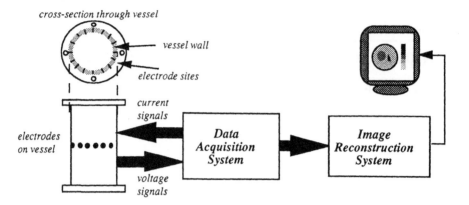

Figure 5.1 *Schematic diagram of an EIT instrument*

feedback path of a voltage buffer to provide further noise immunity and the inner core is capacitively coupled to the input of the voltage buffer (Section 5.3.1).

The material used for the electrodes depends largely on the process application. The material *must* be more conductive than the fluids being imaged, otherwise problems will occur due to contact impedance. Typically, the electrode material is brass, stainless steel or silver palladium alloy which is commercially available in bolt or screw form and can often be threaded into the vessel wall (Figure 5.2). Alternatively, the electrode can be coated at its tip with a durable ceramic conductor, assuming any contact impedance within the electrode is small or is known and constant. The portion of the electrode in contact with the fluid can be of any desired size, providing the electrodes do not touch each other.

The appropriate electrode construction will depend on: the corrosive or abrasive nature of the mixture under investigation; abrasion/erosion effects; the process operation environment (i.e. temperature, pressure, electrical fire hazards, vessel wall thickness and material); and accessibility in terms of spatial and geometric constraints on the vessel and adjacent plant, including the ease of maintaining or, if necessary, replacing electrodes.

Ideally, electrodes should be positioned at equal intervals around the periphery of the vessel in order to abstract the maximum amount of information from the inside of the vessel. In many cases this can be readily achieved. However, variants of this procedure are necessary if images have to be obtained of cross-sections that contain what might be called 'process clutter', such as stirrers, intrusive sensing probes, etc. or where the geometry of the inner wall is complicated by the presence of baffles.

For certain applications it may be possible to exploit the clutter, for example by installing electrodes inside the vessel on, say, impellers (which, in principle, could increase image resolution). Since the EIT method requires prior knowledge of the distribution of the electric fields in a given cross-section, the above factors must be considered in tandem with the image-reconstruction

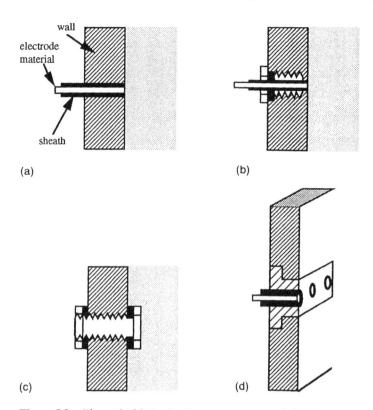

Figure 5.2 *Electrode fabrication into a process vessel. (a) Low-pressure vessel, permanently sealed. (b) High-pressure vessel, removable electrode. (c) High-pressure vessel, replaceable electrode (bolt). (d) Demountable electrode ring integrated into the vessel construction*

requirements (Chapter 15). Ultimately, this must be addressed via a rigorous protocol, based on an integrated computer-aided-design procedure (Chapter 17).

In choosing the number of electrodes (n) it must be noted that the time taken to acquire the data and reconstruct the image is a function of n, whereas the spatial resolution is proportional to \sqrt{N}, where N is the number of unique measurements. From the lead theorem, when using n electrodes in a classical four-electrode measurement configuration (i.e. two electrodes for current in and another two for voltage out), the number of independent measurements is $n(n-3)/2$. Therefore, for $n = 16$ electrodes, the number of unique measurements $N = 104$; for twice the number of electrodes ($n = 32$), N increases by a factor of more than 4 to 464

The work described in this chapter will address only two-dimensional EIT, although clearly opportunities for three-dimensional imaging exist. It is

possible to acquire sequenced images using multiple two-dimensional image planes by inserting several sets of electrodes around the vessel perimeter at positions of interest and switching the EIT system to acquire data from an alternative cross-section in a programmed sequence (i.e. a multiplexing arrangement). The EIT system described has been designed for use with 16 or 32 electrodes, which can be attached to the data-acquisition system according to the requirements of the process under investigation.

5.3 Data acquisition system for electrical impedance tomography

With regard to the wide dynamic range of measurement conditions occurring in the process industry, the primary aim in designing an EIT system to measure the distribution of electrically conductive components inside process equipment was to make the system as 'flexible' as possible for use on a number of different process applications. Thus the following outline specification was drawn up to maintain optimal flexibility and accuracy, whilst accommodating the majority of process applications:

(a) *Injected a.c. current frequency bandwidth*: 75 Hz to 153.6 kHz.
(b) *Injected a.c. current amplitude*: 0–30 mA (peak-to-peak).
(c) *Methods of current injection*: adjacent, opposite, multi-reference, and multi-sink.
(d) *Analogue-to-digital converter (ADC) resolution*: 12 bits minimum (about 0.025%).
(e) *Mode of measurement*: either serial or parallel.
(f) *Maximum number of electrode modules*: 32.

The first two requirements (a) and (b) are the most restricted ones in biomedical systems; they are usually limited to currents of less than 5 mA amplitude and over 20 kHz frequency to avoid patient discomfort. To overcome the problems associated with process vessel size it is useful to have the facility to either increase or decrease the amplitude of injected currents in order to optimize the signal-to-noise ratio (SNR) of the measured voltage signal. Also, for slowly changing processes, more accurate measurements are facilitated at lower frequencies of injected current. Hence, the motivation for the ranges given in (a) and (b) above.

The requirement in (c) for several different methods or 'protocols' of injecting a.c. current (described by Brown and Seagar (1985)) is readily achievable by using more than one current source/sink pair. The adjacent and opposite protocols only require one current source and sink pair, thereby minimizing the cost the associated circuitry. Conversely, the multi-reference method requires that all but one of the electrodes has an identical fixed amplitude current source attached to it. The corresponding voltage measurement is taken across a grounded load connected to the free electrode. The multi-sink method is a compromise between the adjacent/opposite methods and the

multi-reference method in that only a limited number of fixed amplitude current source/sink pairs are necessary to acquire voltage measurements. A further current injection method employed by the RPI group is called the 'adaptive' method, since each electrode has a different current amplitude source/sink on it. The method is so called because a set of electrode current amplitudes is iteratively generated for internal objects to optimize the SNR of the measured voltages. Thus, the applied currents are said to be 'adapted' to the object(s) inside the vessel. The adaptive method, although attractive from an image reconstruction standpoint, because it optimizes the accuracy of the measured voltage data, is both expensive to implement and time consuming. The RPI group have implemented an independent programmable current source on each electrode of their 32-electrode ACT3 system. Every electrode also has an associated DSP device (AD2101) which demodulates and filters the measured voltage signal. The combined cost of the hardware for *each* electrode is reputed to be around £2800. The specification outlined in part (d) will enable up to 64 fixed-amplitude current sources to be attached to the process vessel. By making the current source constant amplitude and performing the voltage measurement demodulation and filtering sequentially using analogue circuitry, the combined hardware cost per electrode is reduced to approximately £35. Furthermore, the option of making voltage measurements in parallel, encompassed by specification (e), similar to the RPI ACT3 and Sheffield real-time systems, is realizable by employing additional voltage demodulation and filtering subsystems.

The overall accuracy of the voltage measurements is governed by the resolution of the ADC. A 12-bit ADC has a resolution of 1/4096, or approximately 0.025% of the input signal. A 16-bit ADC has a resolution of 1/65536, corresponding to 0.0015% of the input signal. Once again, cost is the limiting factor: a typical 12-bit successive approximation, sample and hold, ADC with a conversion time of 3 ms costs around £40. A 16-bit ADC with similar conversion time specifications presently costs approximately £700. To conduct preliminary investigations, it was felt that a 16-bit ADC was unnecessary and that a 12-bit device would suffice. It must be noted, however, that both the RPI and Sheffield systems employ 16-bit converters since their DSP devices can handle 16 bits of data as quickly as 12 bits, thereby yielding higher accuracy.

The following sections are arranged in such a way as to describe the key components of the data-acquisition system (DAS) shown in Figure 5.3. Starting at the bottom left-hand corner of Figure 5.3 and moving in a clockwise direction: Section 5.3.1 describes the operation of the voltage generator; Section 5.3.2 explains the structure of the electrode module attached to each electrode on the process vessel; Section 5.3.3 describes the voltage measurement demodulation and filtering functions; and Section 5.3.4 discusses the performance-related aspects of the circuitry covered in the previous three sections and outlines the approaches adopted by the authors in maintaining the flexibility versus accuracy trade-off.

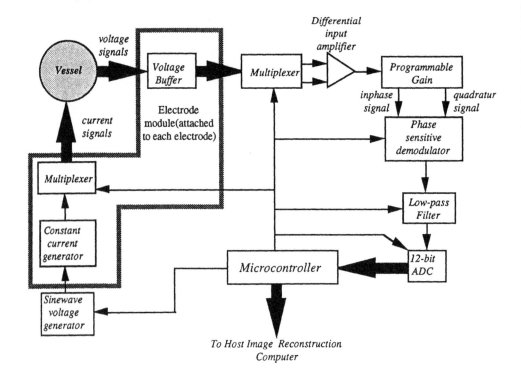

Figure 5.3 *Components of a typical data-acquisition system. Boxed components correspond to those contained in a small module attached to each individual sensing electrode*

5.3.1 Voltage generator

The voltage generator, shown in the bottom left-hand corner of Figure 5.3, is an important integral part of all EIT DASs. To minimize the number of harmonic components in the 'probe' signal, the voltage generator is required to produce a sinewave-shaped output. However, with the emergence of fast and accurate signal-processing devices, both digital and analogue, researchers are now beginning to examine the use of multi-frequency EIT (Record *et al.*, 1992) in which the material is interrogated simultaneously by a range of different frequencies. The resultant measurements are then processed by frequency-selective circuitry to yield more detailed analyses of the material.

Two important attributes of the voltage generator for use in EIT are:

- Good amplitude stability. For example, in a sequential measurement 16-electrode system where the applied a.c. current is at 50 kHz, the amplitude must remain stable (to $\pm 0.1\%$) for at least 320 ms.
- Low harmonic distortion. The phase-sensitive demodulator (see Section

5.4) uses the oscillator output to synchronously rectify the measured voltage signal. The noise contribution from the harmonic coefficients (see later analysis) is also rectified by the demodulator causing an error. This error can be reduced by employing a switching demodulator (in which only odd-numbered harmonics cause errors) or a digital demodulator in combination with a digital function generator.

The Wien-bridge oscillator is a traditional sinewave generator which exhibits low output signal distortion. Van der Walt (1981) used three FET operational amplifiers (op-amps) to construct a Wien-bridge circuit which had a distortion of 0.01% at 5 kHz. Some monolithic function generators such as the Exar XR-2206 (0.5% distortion), and the Datel ROJ-1K can also produce a good-quality sinewave. The main problem in using the above circuits is that it is difficult to get both a variable frequency sinewave signal *and* a synchronous (square wave) signal used for demodulation, as well as being able to adjust the phase shift (see Section 5.3.2) at different frequencies. The solution, also adopted by other groups, is to use an EPROM-based staircase function generator. The EPROM is programmed with a digitized sinewave signal. This signal can be stored as a variable number of samples (usually 16 or 32), depending on the required accuracy of the reconstituted signal. A counter is used to repetitively clock the stored 'staircase' waveform out of the EPROM which is then converted into a voltage by a zero-order hold digital-to-analogue converter (DAC) and subsequently filtered by an op-amp stage to remove the unwanted harmonic components. This digital approach generates both a sinewave voltage output as well as two synchronous square waves. One of the square waves is supplied to the analogue phase-sensitive demodulator as a synchronous demodulation signal and the other is used to produce an analogue-to-digital conversion pulse if synchronous digital demodulation is desired.

Evans and Towers (1980) produced detailed mathematical descriptions of sinewave generators from staircase waveforms. Brown and Seagar (1985) also produced a 51-kHz sinewave with 16 values per cycle from a 820-kHz clock based on a staircase function generator for their first clinical APT system. A final-year B.Sc. degree student at UMIST designed and built a programmable generator with adjustable frequencies from 500 Hz to 62.5 kHz (selectable over nine steps) with 32 values per cycle from a 2-MHz clock. The generator had a 53-dB attenuation of the second harmonic when the fundamental frequency was 30 kHz. For ideal conditions, the harmonics components C_m of the staircase waveform are given by:

$$|C_m| = \frac{1}{2}\left|\mathrm{sinc}\left\{\frac{m\pi}{N}\right\}\right| \tag{5.1}$$

where $m = kN \pm 1$ (N = number of samples per cycle, and $k = 0, 1, 2, \ldots, \infty$).
From eqn (5.1), a simple formula describing coefficients can be derived:

$$|C_m| = \frac{\frac{1}{2}\left|\mathrm{sinc}\left\{\frac{\pi}{N}\right\}\right|}{m} = \frac{|c_1|}{m} \tag{5.2}$$

The total harmonic distortion (THD) is defined as:

$$\text{THD} = \sqrt{1 - (\text{sinc}(\pi/N))^2} \times 100\% \qquad (5.3)$$

In the case of 32 samples per cycle (i.e. $N = 32$), the coefficients are shown in Table 5.1. The total harmonic distortion (THD) for three different values of N are shown in Table 5.2.

The harmonic components are easily removed by a low-pass filter for $N \gg 1$. The UMIST system uses an active second-order Butterworth low-pass filter, the amplitude function of which is given by (Harry, 1979):

$$B_p(\omega) = \frac{1}{(1 + \omega^{2p})} \approx \frac{1}{\omega^{2p}} \qquad (\text{if } \omega \gg 1) \qquad (5.4)$$

where ω is the normalized angular signal frequency, and p is the number of filter poles (2 in this case).

The attenuation (A) of the power function between the corner frequency (F_c) and the filtered frequency (F_b) is given by:

$$A = 10 \log_{10} \left[\frac{B_p(\omega_b)}{B_p(\omega_c)} \right] = 20p \log \left(\frac{F_c}{F_b} \right) \qquad (5.5)$$

For $N = 32$ and $p = 2$, the attenuation of the lower harmonic (31st) is -59.65 dB at the output of the filter. Considering the original coefficients of the first

Table 5.1 *Coefficient values for N = 32 using eqn (5.2)*

Harmonic	Coefficient	Value
Fundamental	C1	0.4992
31	C31	0.0161
33	C33	0.0151
63	C63	0.0079
65	C65	0.0077
67	C67	0.0074

Table 5.2 *Total harmonic distortion values for different values of N using eqn (5.3)*

N	THD (%)
6	13.071
32	5.6645
64	2.8336

harmonic and the fundamental frequency, the total attenuation of the lower harmonic (31st) is −89.48 dB. In practice, the main distortion does not arise from the staircase waveform but from the switching of the DAC and the harmonic distortion from the op-amps. The resultant distortion contains a number of low-order harmonics. It is thus imperative to use a high-speed DAC and low harmonic distortion op-amps when constructing the voltage generator. When using an AD7545 digital-to-analogue converter coupled to a two-pole active low-pass Butterworth filter, the attenuation of the second harmonic was found to be lower than 65 dB at 38.4 kHz, 57.2 dB at 76.8 kHz and 45.5 dB at 153.6 kHz. All of the high-order harmonics from the staircase waveform were lower than 70 dB (see Section 5.3.2).

Because the voltage to current converter (VCCS) (see Section 5.3.3) and filter stages produce a combined phase delay (5.6 ° at 38.4 kHz by the VCCS, and approximately 45° by the filter), it is necessary to maintain a synchronous reference with the measured signal at the input of the demodulator. In order to obtain a synchronous signal for input to the demodulator reference, the signal from the sinewave voltage generator is passed through a phase shift circuit, which will delay the phase of the reference signal by the same amount as that of the injected sinewave signal caused by hardware. Since a wide band of frequencies and a wide range of current amplitudes are inherent in the system, different phase delays at the output of the VCCS will be generated, particularly at high frequencies. It is difficult to adjust the phase delay using the above approach for all situations. Thus the EPROM-based staircase wave generator was altered to generate square waves in phase with the original sinewave which can be used for either analogue or digital demodulation. The phase of square waves are shifted relative to the sinewave by microcontrolled switches from 0.7° to 180° and more precise adjustment can be achieved by using adjustable 5–500 ns delay lines. For the enhanced sinewave generator shown in Figure 5.4, the lower 5 bits of the EPROMs address line are connected to the output of a CMOS counter which clocks out 32 samples of the staircase wave. The highest 8 bits of the EPROM are controlled by a microcontroller, which selects one of 256 staircase waves with different precalculated phase shifts also

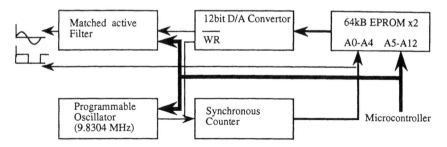

Figure 5.4 *Enhanced digital sinewave voltage generator with a programmable synchronous square-wave output*

being stored in the EPROM. The most significant bit and bit 2 of the counter output also form the synchronous signals and are used elsewhere.

5.3.2 Electrode module

A distinct problem in clinical EIT systems is the distance of the a.c. current injection source to the electrodes. Many clinical instruments suffer from the effects of stray capacitance arising from lengths of co-axial cable (typically 100 pF m$^{-1}$ for UR95-type cable) connecting the current source to the injecting electrodes. Rigaud *et al.* (1990) suggested that a module containing the necessary current injection and voltage measurement circuitry be constructed on the electrode, thereby removing the problems associated with stray capacitance. Thus the authors constructed a small batch of such modules, called 'electrode modules' (Figure 5.5). Each module is mounted directly onto the vessel via male and female subminiature gold-plated SMB connectors to the electrode. Switches K0 and K1 are employed to route the output voltage to one input of the differential op-amp. Switches K2 and K3 select one of the input sinewave voltages (one is in-phase, the other inverted) so that the VCCS can be configured as either a current source or a current sink to enable various data-collection protocols (Brown and Seagar 1987) to be used.

Voltage controlled current source (VCCS)

The VCCS is probably one of the most critical aspects of a current injection EIT data-collection system. The simplest form of a VCCS is an inverting amplifier (Figure 5.6(a)). The output current error produced by such a circuit is less than 0.0003% for a typical open-loop gain of 600 at $-90°$ (Webster, 1990). However, it cannot be used for systems requiring more than one current source, or on systems with a grounded load (which are prevalent in the process industry). An extension of the above circuit is accomplished by using a transformer to isolate the output of the op-amp from Z_L (Figure 5.6(b)). Due

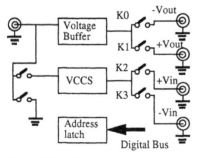

Figure 5.5 *Electrode module showing the connection of routine switches to the injection point, voltage buffer and voltage controlled current source (VCCS)*

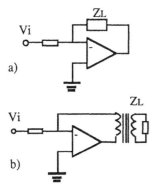

Figure 5.6 *Fundamental negative feedback VCCS designs. (a) Simplest circuit. (b) Extension of (a) using a transformer coupled load*

to the limitation of inductance associated with the transformer, it still cannot be used in a system requiring high accuracy due to its inherent low output impedance.

Positive feedback VCCSs are a popular alternative. Nowicki and Webster (1989) used a single op-amp with positive feedback and obtained a respectable performance at 50 kHz for a 5 mA current amplitude output (see Figure 5.7). Having tested the same circuit, the authors found it to be unstable when the voltage dropped across load was higher than 10 V.

Lidgey *et al.* (1990) introduced a VCCS employing an op-amp supply current technique to obtain high performance (see Figure 5.8). The circuit does not use positive feedback and thus operates in a unity gain condition. Hence, it is inherently stable and has a wide bandwidth. Its performance is limited by the inherent inaccuracies in the current-mirror portions of the design. For example, it is difficult to maintain the mismatch of the required transistor pair lower than 0.1%. In fact, the best commercially available

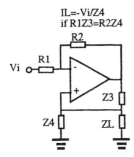

Figure 5.7 *A single op-amp VCCS with positive feedback, used by Nowicki and Webster (1989)*

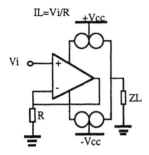

Figure 5.8 *A VCCS for sensing the op-amp supply current*

matched transistor pair costing £13 is only $\pm 0.2\%$ at 10 μA. Hilland (1991) built a VCCS using a similar circuit: the current mirrors were based on a CA3096E transistor array; and the second harmonic produced by the VCCS was reported to be 8 dB at a fundamental frequency of 30 kHz.

Lidgey and Zhu (1992) presented a new front-end architecture (Figure 5.9). In essence, the circuit is a voltage driver, but its current can be measured easily by a differential op-amp. In operation, a voltage V_i is input and the corresponding output voltage V_{out} is measured. The input voltage V_i is altered until sufficient accuracy in I_j calculated by V_{out}/R_j was obtained. The circuit has a relatively straightforward structure and manages to produce a high accuracy injection current at a frequency of 10 kHz. However, this circuit is difficult to modify to accommodate the high-speed and high-frequency specifications given in Section 5.3.

The VCCS finally adopted by the authors is based on a positive feedback architecture, the schematic circuit for which is shown in Figure 5.10. The transconductance term of the circuit is

$$G_T = -\frac{Z_2}{Z_1 R} \tag{5.6}$$

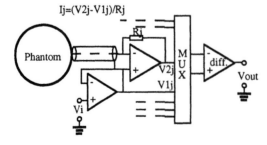

Figure 5.9 *Dynamically adjustable VCCS by Lidgey and Zhu (1992)*

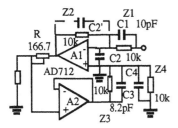

Figure 5.10 *The two op-amp VCCS with positive feedback, used in the UMIST system*

and its output admittance is

$$G_{\text{out}} = \frac{1 - [1 + (Z_2/Z_1)]/1 + (Z_3/Z_4)]}{R} \tag{5.7}$$

$$I_1 = \frac{V_i Z_2}{Z_1 R} \tag{5.8}$$

If the ratio Z_2/Z_1 is equal to the ratio of Z_3/Z_4, G_{out} should tend to zero, but due to the input capacitances C_2 and C_4 of the differential op-amp A1, two capacitances C_1 and C_2 are present between both inputs to A$_1$ (see Figure 5.10) and ground. Among them, the equivalent capacitance C_2' is used to represent C_2 from Miller's theorem. It is necessary to complement Z_1 and Z_2 with C_1 and C_2 in order to attain a higher VCCS output impedance. Furthermore, the value of R should be chosen to be as large as possible according to eqn (5.6). Unfortunately, due to the finite limit of the op-amp power rails, the voltage dropped across R can lower the saturation voltage V_s of the VCCS:

$$V_s = V_{\text{pp}} - I_L R - 5v \tag{5.9}$$

The VCCS produces significant phase shift at high frequency (over 20 kHz). This produces errors in phase-sensitive demodulated data if there is no phase compensation. As described in Section 5.3.1, the authors system employs an accurate programmable phase shift function which can adjust the matched phase error to less than $0.7\,°$.

Although the technique of direct connection between the vessel and electrode modules is used, the driven shield technique is necessary to cancel any stray capacitance associated with the SMB (sub-miniature type B) connectors. The choice of op-amp for the voltage buffer is also critical. In order to obtain a high input impedance for the voltage buffer, FET or CMOS input op-amps are used. Due to stray capacitance of the output transducer cable (about $100 \, \text{pF m}^{-1}$), instability of the VCCS will be produced with some types of CMOS op-amp, such as the AD711 and the TL081c. The LF411 JFET input op-amp was found to have a good performance for either input impedance or driving capacitance load.

Through the use of compensation techniques, the bandwidth and the

amplitude of current from the VCCS extends linearly from 75 Hz up to 153.6 kHz and the current from 0 to 30 mA, respectively. Also, the output impedance of the electrode module is increased to 1.74 MΩ at 153.6 kHz, and 2.5 MΩ at 76.8 kHz.

5.3.3 Voltage measurement, demodulation and filtering

The voltage measurement circuitry (Figure 5.11) extends from the voltage buffers in the electrode module to the digital data output from the ADC. One of the most problematic measurement errors arises from common mode voltage (CMV) because of the limitations of the op-amps. To establish the bounds of such voltage measurements, a four-electrode simulation circuit based on a measurement model suggested by Brown and Seagar (1985) was constructed (Figure 5.12). The current source and sink both have an output impedance R_s to ground. The current passes through a multiplexer with an 'on' resistance R_m, and an equivalent capacitance C_m to represent the multiplexer's 'in' and 'COMMOM' terminal leakage capacitances. The equivalent contact resistance R_{e1} and R_{e2} is larger than R_m, since they are connected serially in the injection circuit and cause the major part of the

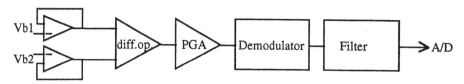

Figure 5.11 *The voltage measurement, demodulation and filtering components of the UMIST EIT data-acquisition system*

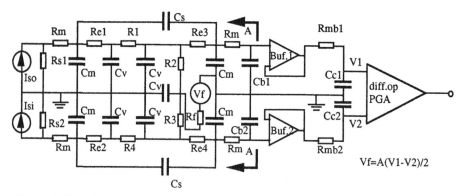

Figure 5.12 *The four-electrode measurement model*

common mode voltage. Stray capacitance (C_s) appears directly between the wires at the driving electrodes and those at the measuring electrodes. At each interface between the electrode and conducting region there is a stray capacitance (C_v) to ground. The conductive region is simplified to R_1, R_2, R_3 and R_4 $(R_4 > R_3 > R_2 > R_1)$. The input impedance of the voltage buffer is mainly determined by the input capacitance C_{b1} and C_{b2} at high frequency. R_{mb1} and R_{mb2} are the sum of the output impedances of the op-amp and multiplexer. C_{c1} and C_{c2} are the sum of the stray capacitances of the transfer cable, between the output of the multiplexer and the differential op-amp.

The common mode voltage is generated due to a leakage current and is determined from a combination of the injecting current value, the electrode contact resistance, and the conductivity of the conductive region. The error caused by the common mode voltage is formed from the difference between the output impedance, looked at from the A–A direction, and the mismatched input impedance of the op-amp, and the coupling components.

At the differential programmable gain amplifier (PGA) (PGA202): if the output impedance of the common voltage are identical to the two inputs of the PGA, the CMRR (common-mode rejection ratio) only depends on the mismatch error of integrated circuit. The CMRR will be increased, i.e. the error will be reduced, if the gain of the PGA is increased. The PGA202 has CMRR of 32 dB at gain 1, 53 dB at gain 10, and 73 dB at gain 100 and gain 1000, all at 100 kHz according to its specification. After the compensation values of 24.8 dB at gain 1, 69.7 dB at gain 10, 74.1 dB at gain 100, and 71.9 dB at gain 1000 were obtained from the authors' system when the frequency was 153.6 kHz. For an imbalance of output impedance of the common mode voltage, the maximum realizable CMRR is (Garrett, 1981):

$$CMRR_{max} = \frac{1}{4\pi f \Delta R_s \Delta C_s} \tag{5.10}$$

According to Figure 5.12, if $\Delta R_s = R_{mb1} - R_{mb2} = 50\ \Omega$ which is contributed to mainly by the mismatched multiplexer 'on' resistance, $\Delta C_s = C_{c1} - C_{c2} = 20$ pF is contributed to mainly by multiplexer's output capacitance and the stray capacitance of cable, the CMRR at 76.8 kHz will be 60.3 dB. In order to increase the CMRR at this stage, a transformer can also be used, for which a higher CMRR will be attained. It is worth noting the balance of output impedance of the transformer: a differential op-amp is still necessary because a common voltage is still maintained on the output of the transformer (see Figure 5.6(b)) caused by mutual inductance and stray capacitance between the primary and secondary coils. In particular, the error caused by the common mode voltage at the voltage buffer will become a sum of differential signal and a common voltage. According to Murphy and Rolfe (1988), the differential signal from the common voltage at the output of the two op-amps is:

$$V_o = (4\pi f \Delta R \Delta C)^2 V_{cm} + j(4\pi f \Delta R \Delta C) V_{cm} \tag{5.11}$$

Among them: ΔR is the difference in the output impedances looked at from the A–A direction, which is mainly from contact resistance of electrodes and the

impedance of the conductive region; and ΔC is the difference in the output capacitance, which is mainly from the connecting cables and multiplexers. Because $\Delta R \gg \Delta R_s$, the error caused at the voltage buffer is larger than that at the differential op-amp. Besides reducing the mismatched impedance (as discussed above) such as ΔR_s, ΔC_s, ΔR, ΔC, the best method is to reduce the common voltage. One method used by Brown and Seagar (1985), is the technique of common-mode voltage feedback (CMFB). In clinical applications, electrical isolation of the current generator enables common-mode feedback to be applied to a common reference electrode and so improve the common-mode rejection ratio. Figure 5.13 is a simplified circuit for the adjacent injection model. If $Z_{c1} = Z_{c2} = Z_{c3}$, $Z_1 = 0.1\,Z_2$, $|Z_2| \ll |Z_{cn}|$, then V_1 is $4IZ_1$, $V2$ is $3IZ_1$, and $V3$ is $-7IZ_1$. There a feedback current is induced. If $I_f = -9IZ_1/Z_c$ to ground, it merely cancels the current through Z_{c2}, and so the common voltage V_2 will be zero. However, the CMFB is not without limitation. Because of the phase delay of the feedback circuit, it will cause a phase error in the demodulation and possible feedback oscillation (Murphy and Rolfe, 1988) at high frequency. Thus, due to there being no voltage being dropped across Z_{c2} in an ideal CMFB, (Figure 5.13), point 2 can be connected to ground directly (Figure 5.14) since electrical isolation is no longer necessary in industrial applications. The current change in the floating model is similar to the CMFB in Figure 5.13. The feedback path of the CMFB and the ground floating measurement (GFM) methods is generally through any unused electrode in contact with the conductive region. This is necessary to remove the influence of contact impedance between the electrode and the low frequency a.c. signal caused by the feedback.

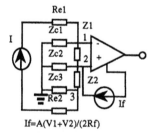

If=A(V1+V2)/(2Rf)

Figure 5.13 *Common-mode feedback (CMFB) in the adjacent model*

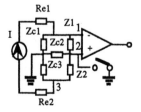

Figure 5.14 *Grounded floating measurement (GFM) in the adjacent model*

The other method for reducing the error caused by the common-mode voltage (CMV) is to use a low CMV injection method and some coefficients of the phantom. The CMV in subsequent tests (see Section 5.3.5) is more than 6.6 V(p-p) for the adjacent method, larger than 5.5 V(p-p) in the multi-reference method, more than 4.4 V(p-p) in opposite method and lower than 0.63 V(p-p) in the multi-sink method. The multi-sink injection method was devised specifically for use on metal-walled phantoms which has the advantage of a lower CMV. Increasing the surface area of the electrode in contact with the process material, increasing the conductivity of process material, and decreasing the amplitude of injection current can all act to reduce the CMV of the conductive region.

Demodulation and filtering

Demodulation, in the UMIST system, is achieved either by switched demodulation or digital demodulation. It is well known that the phase shift of the signal must be less than $1.266°$ for 12-bit accuracy in switched demodulation. Demodulation for the quadrature wave is much more sensitive than for the in-phase wave. For example, a quadrature signal deviated by only $0.015°$ can be located with a 12-bit ADC. The DAS is initially calibrated at the quadrature position for the injection current phase and then the correction phase is subtracted by $90°$ to represent the reference phase at the demodulator for in-phase demodulation. The minimum adjustable phase shift is $0.7°$ by microcontroller and 5-ns delay by manual delay line adjustment.

At the output of a switching demodulator an in-phase signal Y can be expressed using a Fourier series:

$$Y(\omega t, \theta) = \frac{2}{\pi} V_{m} \cos\theta + \frac{4}{\pi} \sum_{n=1}^{\infty} \frac{1}{4n^2 - 1} (2n \sin 2n\omega t \sin\theta - \cos 2n\omega t \cos\theta) \quad (5.12)$$

where θ is the phase shift of the signal and $(-\pi/2 < \theta \leqslant 0)$.

Using a two-pole active low-pass filter, the d.c. component of Y is obtained. The corner frequency F_c of such a filter is calculated from:

$$F_c = 2F_0{}^p \sqrt{\delta} \quad (5.1)$$

where F_0 is the fundamental frequency of the signal, p is the number of filter poles, and δ is the accuracy which is $1/4096$ for a 12-bit ADC.

The filter settling time is given by Webster (1990), and can be determined from:

$$\frac{V_o}{V_i} = 1 - e^{-\omega_c t} \left\{ 1 + \omega_c t + \frac{\omega_c{}^2 t^2}{t!} + \ldots + \frac{(\omega_c t)^{n-1}}{(n-1)!} \right\} \quad (5.14)$$

The settling times with different poles at 76.8 kHz are shown in Table 5.3 and at different frequencies with two fixed poles in Table 5.4.

The matched filter can be constructed using op-amps or from a monolithic switched capacitor Butterworth low-pass filter such as the MF4. The latter is

Table 5.3 *Low-pass filter settling times (F$_0$ = 76.8 kHz) for different numbers of poles* p

Pole	$\omega_c t$	F_c(Hz)	T (mS)
1	8.3247	37.5	35.3
2	10.799	2400	0.716
3	14.923	19200	0.123

Table 5.4 *Low-pass filter settling times (p = 2) for different fundamental frequencies (F$_0$)*

F_0 (kHz)	2.4	9.6	38.4	76.8	153.6
T (mS)	22.9	5.7	1.43	0.716	0.358

easier to implement and has a better performance. Using digital demodulation and simplified demodulation algorithms, a SNR much closer to the theoretical value can be attained, since the synchronous sampling signals can all be obtained from the EIT DAS.

The data-collection speed of an EIT system is mainly limited by the filter and its associated couplings. Because there are several coupling circuits from the current generator to the ADC input, the transition effects will occur as the electrode is switched to connect to the measurement circuit with the multiplexer. In a flexible data-collection system, it is difficult to satisfy both the high speed and wide bandwidth. In the UMIST system several parts of the coupling circuit and some function circuits are placed in a small module which can be exchanged easily in order to satisfy the different requirements. The fastest speed of collection for one frame of 104 measurements is 40 ms at 38.4kHz using the digital demodulation method.

5.4 Performance of data-collection system

5.4.1 Output impedance of current source

For the electrode module described in Section 5.3.2, the current source is accompanied by a voltage buffer and a multiplexer. Hence, the measured output impedance is influenced by both the buffer and multiplexer. A purely resistive load was attached to the output of the module. The voltage dropped across different resistive loads for the same current and frequency was measured and inserted in

$$Z_s = \frac{\Delta V}{\Delta I} = \frac{V_2 - V_1}{(V_2/R_2) - (V_1/R_1)} \tag{5.15}$$

to determine the impedance Z_s listed in Table 5.5. (Note: $R_1 = 1000.7\ \Omega$, $R_2 = 51.2\ \Omega$. The sample electrode was number 15 and was measured with a Fluke 8842A meter.) The phase shift caused by the electrode module when measuring the phase shift with the quadrature measurement technique was found to be 185.6° at 38.4 kHz.

5.4.2 VCCS harmonics

The harmonics were measured on a HP4195 spectrum analyser. At the output of the sinewave voltage generator, the attenuation of second harmonic is lower than 65 dB at 38.4 kHz, 57.2 dB at 76.8 kHz and 45.5 dB at 153.6 kHz. All of the high-order harmonics from the 31st order upwards were lower than 70 dB, which were due to the staircase waveform. The attenuation caused by the electrode module is 6 dB at 38.4 kHz and 76.8 kHz.

5.4.3 Common mode rejection ratio (CMRR)

The CMRR was measured at the output of the PGA with a Fluke 8842A voltmeter. The results for different values of the PGA gain are given in Figure 5.15. The input common-mode voltage at the differential inputs of the differential input amplifier are 12 V(p-p) sinewave from a Farnell LF1 generator. The CMRR at 153.6 kHz were as follows: 24.8 dB at gain 1, 69.76 dB at gain 10, 74.31 dB at gain 100, and 71.87 dB at gain 1000.

5.4.4 Input offset voltage of the signal-measurement stages

The digital output of the ADC in the UMIST system in response to zero at its

Table 5.5 *Current source (module) output impedance*

F (kHz)	V_{r1} (mV)	V_{r2} (mV)	I_1 (mA)	ΔI (mA)	Impedance (MΩ)
153.6	2458.0	125.830	2.456	0.0013	1.7449
76.8	3284.2	167.970	3.282	0.0012	2.5159
38.4	3276.2	167.669	3.274	0.00088	3.5449
19.2	3294.6	168.584	3.292	0.00036	8.6628
9.6	3295.5	168.633	3.293	0.00042	7.4713
4.8	3294.5	168.489	3.292	0.0014	2.2414
2.4	3289.3	168.250	3.287	0.00087	3.6028

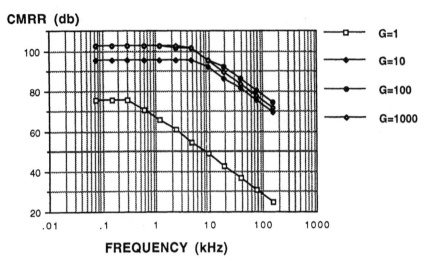

Figure 5.15 *CMRR of the UMIST system for different values of PGA gain*

input is ±1LSB when the gain of the programmable gain amplifier was changed from 1 to 1000.

5.4.5 Gain error of the signal-measurement stages

The errors were +0.19% at gain 1, +0.12% at gain 10, +0.38% at gain 100, and +1.4% at gain 1000, all measured at a frequency of 9.6 kHz, which were acquired from the digital output of the ADC, and the input voltages were measured with the Fluke 8842A voltmeter (the accuracy of the Fluke 8842A is ±0.08% + 100 digital).

5.4.6 Accuracy of the signal-measurement stages

A voltage was placed at the input of the DAS which was also measured with the Fluke 8842A voltmeter. The digital data from the output of the ADC showed a deviation of less than +0.5% from 0.6–76.8 kHz (the accuracy of the Fluke 8842A voltmeter is ±0.07% + 150 digital at 0.6–9.6 kHz, ±0.19% + 150 digital at 38.4 kHz, and ±0.5% + 300 digital at 76.8 kHz).

5.4.7 Load range

The load range can be determined using the approximate equation:

$$V_s = V_{pp} - I_L R - 5v \tag{5.16}$$

where V_s is the saturation voltage, V_{pp} is the amplitude of the supply voltage (30 V in this case), I_L is the current through the load, and R is the value of the feedback resistor in electrode module (66.7 Ω).

5.4.8 Accuracy of the adjacent-electrode method

A resistor network was used to determine the DAS error for this form of measurement method. The majority of errors were lower than $\pm 1\%$; the maximum error was 5%, corresponding to two readings taken when the measurement electrode pair was diametrically opposite the current injection pair.

5.5 Conclusion

The specifications of a flexible data-collection system built to enable investigation of process equipment using electrical impedance measurements have been given. The structure and function of the key circuits constituting the system have also been described, and a comparison given of equivalent circuits employed by other workers. A trade-off between system flexibility, measurement accuracy, cost, and speed of data acquisition was achieved. The result was a data-collection system with seven programmable frequencies and 256 selectable levels of a.c. current injection frequency and amplitude, as well as a number of voltage signal measurement, demodulation and filtering options. The performance criteria relevant to such a data-collection system have been highlighted, and measured figures given for the system.

References

Brown, B. H. and Seagar, A. D. (1985) Applied potential tomography: data collection problems. *IEE International Conference on Electric and Magnetic Fields in Medicine and Biology*, London, 4–5 December.

Brown, B. H. and Seager, A. D. (1987) The Sheffield data collection system. *Clin. Phys. Physiol. Meas.*, **8A**, 91–98

Evans, W. A. and Towers, M. S. (1980) Hybrid techniques in waveform generation and synthesis. *IEE Proc.*, **127**, 3

Garrett, P. H. (1981) *Analogue I/O: Acquisition, Conversion, Recovery*, Reston, Virginia

Harry, Y. F. (1979) *Analog and Digital Filters: Design and Realization*, Prentice-Hall, Englewood Cliffs, NJ

Hilland, J. (1991) Optimization of data acquisition and signal processing for use in process tomography. Final-year project report, Department of Electrical Engineering and Electronics, UMIST, Manchester

Lidgey, F. J. and Zhu, Q. S. (1992) 'Electrode current determination from programmable voltage sources'. *Clin. Phys. Physicol. Meas.*, 13, (Suppl. A), 51–56

Lidgey, J., Vere-Hunt, M. and Toumazou, C. (1990) Development in current driver circuitry. *Proceedings of the CAIT Conference*, Copenhagen, 183–190, University of Sheffield

Murphy, D. and Rolfe, P. (1988) Aspects of instrumentation design for impedance imaging. *Clin. Phys. Physiol. Meas.*, **9A**, 5–14

Nowicki, D. J. and Webster, J. G. (1989) A one-amp current source for electrical impedance tomography. *Proc. Ann. Int. Conf. IEEE Eng. Med. Biol. Soc.*, **11**, 457–458

Record, P. M., Gadd, R. and Vinther, F. (1992) 'Multifrequency electical impedance tomography', *Clin. Phys. Physiol. Meas*, **13**, (Suppl. A), 67–72

Rigaud, B., Anah, J., Givelin, P., Graziotin, P. and Morucci, J. P. (1990) Multifuction electrode module for electrical impedance tomography. *Proceedings of the CAIT Conference*, Copenhagen, 217–225, University of Sheffield

Van der Walt, E. G. (1981) A Wien-bridge oscillator with high-amplitude stability. *IEEE Trans. Instr. Meas.*, **IM-30**, 292–294

Webster, J. G. (ed.) (1990) *Electrical Impedance Tomography*, Adam Hilger, Bristol

Chapter 6

Mutual inductance tomography

A. J. Peyton

6.1 Introduction

A wide range of sensing techniques has been employed for process tomography, including nucleonic, infra-red, optical, microwave, ultrasonic and electrical methods, with each offering different benefits in terms of imaging rate, resolution, cost and operating considerations (Beck *et al.*, 1992; Beck, 1993; Xie, 1993). Electrical techniques in particular have received attention because of their potentially high imaging speeds and relatively low cost. Within the category of electrical methods, electrical impedance tomography (EIT), which is based on the measurement of resistance/reactance patterns to produce conductivity (σ) and, more recently, permittivity (ε) images, and electrical capacitance tomography (ECT) which is based on the measurement of capacitance patterns to produce ε images have been widely used (Dickin *et al.*, 1992; Huang *et al.*, 1992; Xie *et al.*, 1992; Griffiths *et al.*, 1992; Purvis *et al.*, 1993; Scaife *et al.*, 1994). In comparison with the other electrical methods, electromagnetic tomography (EMT), based on the measurement of complex mutual inductance, is relatively new and is so far unexploited for process tomography applications. This form of EMT could more accurately be termed 'mutual inductance tomography' and can extract data on permeability (μ) and conductivity (σ) distributions. Consequently, EIT, ECT and EMT can be considered as a complementary set of techniques, each measuring one of the three passive electrical quantities (i.e. impedance (resistance), capacitance, and inductance, respectively) in order to create images related to σ, ε and μ.

The aim of this chapter is to give a brief review of the present state of this type of EMT. Section 6.2 gives a summary of the principal of operation, followed in Section 6.3 by a general overview of an EMT system covering some of the main generic design considerations. In Section 6.4, three practical systems are described, namely, an experimental high frequency biomedical system (Al-Zeibak and Saunders, 1993), a medium frequency parallel field system, and a low-frequency system. These systems illustrate the variety possible for inductive EMT systems. The final section contains a discussion and addresses likely future developments and the potential for process tomography applications.

6.2 Principle of operation

The underlying principle of this type of EMT system may be summarized as follows. The object space is energized by an a.c. sinusoidal magnetic field created by one or more excitation coils. Material within the space causes the spatial distribution of the magnetic field $B(x,y)$ to be distorted, with the spatial distortion being dependent mainly on the electrical conductivity $\sigma(x,y)$, magnetic permeability $\mu(x,y)$, size, shape and position of the object material and upon the angular frequency, (ω), of the applied magnetic field. In complex phasor notation (Hayt, 1981) the field distribution within the object space is given by Maxwell's equations:

$$\nabla \times \{(\sigma(x,y) + j\omega\varepsilon_0\varepsilon_r)^{-1}[\nabla \times [\mu(x,y)^{-1}B(x,y)]]\} = -j\omega B(x,y) \qquad (6.1)$$

and

$$\nabla \cdot B(x,y) = 0 \qquad (6.2)$$

These expressions take the two-dimensional case, assume materials with linear properties (i.e. $\sigma(x,y)$ and $\mu(x,y)$ are independent of $B(x,y)$), neglect free charges, and take the permittivity ε_r to be constant over the object space. In general, for this type of mutual inductance imaging, the frequency is sufficiently low such that wavelengths are considerably larger than the dimensions of the object space, usually by several orders of magnitude, so that the entire sensor can be considered to operate within the electromagnetic near zone, i.e.

$$\omega \ll \frac{2\pi c}{l} \qquad (6.3)$$

where l is the maximum width of the object space.

In addition, induced displacement currents within insulating regions of the object space are small enough to ignore at these frequencies, especially when compared to the magnitude of induced eddy currents, and consequently the $j\omega\varepsilon_0\varepsilon_r$ term in eqn (6.1) can be neglected resulting in:

$$\nabla \times \{\sigma(x,y)^{-1}[\nabla \times [\mu x,y)^{-1}B(x,y)]]\} = -j\omega B(x,y) \qquad (6.4)$$

In effect, conducting material is detected by virtue of its induced eddy currents created in response by the applied field. The eddy current themselves give rise to an eddy current field which can be detected by the coils. The flow of eddy currents is always to limit the penetration of the applied field into the conducting material, where the depth of penetration is often known as skin depth (δ), which is a very important parameter in describing conductor behaviour in electromagnetic fields. Skin depth is given by the simple formula:

$$\delta = \sqrt{\frac{2}{\omega\mu\sigma}} \qquad (6.5)$$

Skin depth can be used to give an indication of the minimum values of conductivity which can be detected. In particluar, the skin depth of the

material at the value of excitation frequency must be at least comparable to the sensor dimensions, otherwise the material will not cause a significant attenuation or change in the applied excitation field pattern, and consequently will not be detected. For example, with metals, at frequencies typically used for electrical tomography (i.e. 10 kHz and above) the skin depth for many metals is usually much less than 1 mm. Consequently, at these frequencies metals virtually exclude all flux, which causes a significant variation in the applied field patterns and so, with appropriate sensor design, metals can be readily detected. As a further example, salty water with a conductivity of, say, 5 S m$^{-1}$ would require a higher excitation frequency in excess of 5 MHz to give a skin depth less than 10 cm. This implies that excitation frequencies in the low megaherz range are required to tomographically image ionized water by entirely inductive methods; in fact present-day experimental systems designed to image ionized water do operate at these frequencies.

In the case where the conductivity is zero for all the object space then eqn (6.1) further simplifies to the steady-state form:

$$\nabla \times [\mu(x,y)^{-1} \cdot B(x,y)] = 0 \qquad (6.6)$$

The tomographic problem is to excite the object space with a number of field strength patterns and then measure the field components for each pattern around the outside of the space. A sufficient number of excitation patterns and field measurements must be used to enable an image of adequate quality to be reconstructed and accurate image reconstruction would require a non-linear or iterative reconstruction algorithm to take into account the double curl nature of the actual field distributions. In addition, to gain the maximum amount of information from the object space, the real and imaginary parts of both the radial and tangential vector field components should be measured. For simplicity, however, most practical systems ignore the tangential components, and only recently has phase information been considered.

6.3 Overview of an EMT system

A typical EMT system is shown in Figure 6.1. It consists of three main subsystems: the sensor array, interface and conditioning electronics, and the host computer. The important features of each of these subsystems are described below.

6.3.1 Sensor array

The sensor array consists of at least four main elements: the object space, the excitation coil(s), the detection coil(s), and the screen. The excitation coils are able to provide several excitation profiles to excite the object space with field projections from a number of different directions. The geometry of the excitation coils can be designed for a wide variety of empty space field

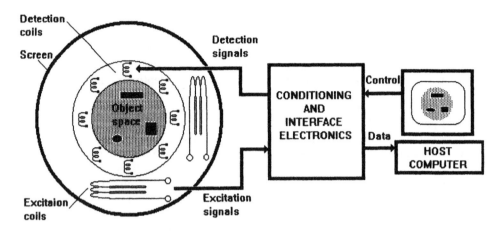

Figure 6.1 *Block diagram of a typical EMT system*

excitation patterns, for example either parallel or fan-like magnetic flux lines. For each excitation pattern, the detection coils act as simple search coil magnetometers and measure the peripheral flux densities. Naturally, future systems may adopt more complicated types of magnetometer. Present systems have usually been designed around circular object spaces, with sensor access restricted to the outer circumference. The diagram shows, in abstract form, a system with multiple excitation and detection coils but, of course, if there is only one excitation coil or one detection coil then the object space must be physically moved with respect to the two coils in order to obtain the required multiple projections.

The shield provides three main functions, first to confine the magnetic flux inside the sensor in order to avoid shadow effects from external objects, second to avoid external interference (i.e. to increase electromagnetic compatibility), and third to concentrate flux within the object space in order to increase sensitivity. As an example, Figure 6.2 shows lines of magnetic flux obtained by simulation for a sensor which employs a parallel magnetic field (see Section 6.4.2) and which has an empty object space. Figure 6.2(a) shows the situation with no high permeability magnetic shield (i.e. $\mu_r = 1$ for the sheild), whereas Figure 6.2(b) shows the field distribution with $\mu_r = 2000$, typical of a 3C85 grade ferrite. The screen offers two important features. First, external flux is reduced and consequently rejection of external objects is improved, as can be seen from the diagram. Second, the flux density inside the object space is increased and hence the sensitivity is also increased by approximately 100%. In laboratory conditions, it is possible to operate without a shield as the environment around the sensor may be sufficiently stable and free from sources of interference; however, in practical industrial applications shielding is essential.

(a)

(b)

Figure 6.2 *Effects of a magnetic shield. (a) Screen relative permeability of 1. (b) Screen relative permeability of 2000*

6.3.2 Conditioning and interface electronics

The conditioning and interface electronics performs the following functions:

- Sinusoidal waveform generation.
- Control of the excitation coils.
- Conditioning the outputs of the detection coils.
- Data acquisition.

With multiple coil sensors, the excitation coils should be fed from a high impedance current source and, similarly, the detector coils must be connected to high input impedance buffers. In general, it is important to ensure that the impedances of the circuitry connected directly to the sensor array are sufficiently high, otherwise the distribution of magnetic flux resulting from the flow of induced eddy currents (in σ object material) and polarization (of μ object material) will be affected by the measurement coils, which in turn will affect the sensitivity. In addition, it can be important to minimize interconnection parasitics, in particular cable capacitances, because a significant problem can arise at high excitation frequencies (i.e. above a few hundred kiloherz) in which the cable capacitances interact with the coil inductances to form resonant circuits, producing unwanted phase shifts and measurement errors. This problem can be further exacerbated by intercoil capacitances and mutual inductances causing compound resonant effects. Consequently, the front-end current drivers and buffer amplifiers may need to be positioned as close as possible to the sensor coils themselves.

Any distortion on the excitation current waveforms tends to be exaggerated by the differential action of the detector coils, and this effect consequently increases the rejection requirements of the conditioning electronics.

The conditioning electronics generally consist of programmable gain amplifiers to accommodate the large signal variations between excitation and detection coils which are adjacent to each other and those which are opposite. With circular arrays, a gain switching range in excess of 40 dB is often required. The conditioning electronics must also contain some form of demodulation, usually in the form of a phase-sensitive detector (PSD) to convert the a.c. coil outputs into d.c. for subsequent digitization. Often both the in-phase and quadrature signal components (with respect to the excitation waveform) are acquired.

6.3.3 Host computer

The host computer controls the measurement procedure and implements the image reconstruction algorithm. At present, most experimental EMT systems use existing algorithms, such as simple linear correlation or filtered back-projection.

6.4 Examples of experimental EMT systems

Three different examples of EMT systems are described in this section. These examples reflect the variety of possible configurations for the sensor array. The three systems also employ different operating frequencies for detecting different types of object material.

6.4.1 An experimental biomedical system

Figure 6.3 shows a simplified diagram of a two coil experimental biomedical system (Al-Zeibak and Saunders, 1993). The object to be imaged is situated on a turntable which can be drawn in a horizontal plane along the line of symmetry between the two coils. Coil C1 is used for excitation purposes and is a 160-turn solenoid. Coil C2 is also a solenoid but with 80 turns. Both coils are covered with a grounded electrostatic screen to ensure that the coupling mechanism between the coils is inductive as opposed to capacitive. The excitation coil is driven from a sinusoidal supply at 2 MHz and the detection coil forms a resonant circuit with the capacitance of the connecting cables and detection circuitry which is tuned to the excitation frequency. The object is scanned mechanically between the coils, typically at a few centimeters per second, to produce each projection and the turntable can be rotated to obtain as many projections as required. The recorded data are fed into an image reconstruction computer and images reconstructed using both back-projection and filtered back-projection algorithms.

The system has been used to image a variety of phantom objects such as a

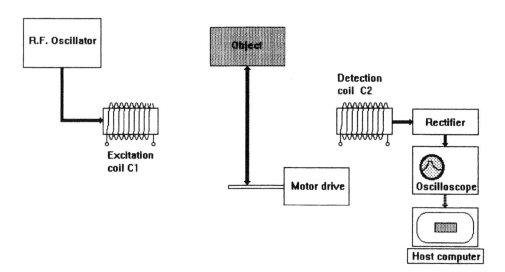

Figure 6.3 *Schematic diagram of the experimental biomedical system*

circular (diameter 10.2 cm) beaker and a square (side 22.5 cm) and a rectangular (sides 14 cm by 10.5 cm) plastic tank, each filled with saline (concentration $0.1 \, mol \, l^{-1}$). In addition, aluminium cylinders were also placed inside the tanks in some applications in order to assess the potential of the technique for determining the shape of internal features. In general, a relatively small number of projections (typically 12) was used for reconstruction.

An image produced by the system (Figure 6.4), is clearly representative of the actual objects. This figure shows the image of a square plastic tank filled with saline with two aluminium cylinders placed inside the tank. The image clearly shows the outline of the saline in the tank and in addition, the shapes of the two conducting cylinders are also present. This image was obtained using a filtered back-projection algorithm with 12 projections.

The system clearly demonstrates the potential of the inductive approach for imaging conducting aqueous solutions with electromagnetic properties typical of those found in biomedical applications.

6.4.2 Parallel excitation field system

Figure 6.5 shows an overview of an inductive EMT system which employs a parallel excitation field when the object space is empty (Yu *et al.*, 1993a, b, 1994). The primary sensor in this system has an internal diameter of 75 mm and is composed of four assemblies: excitation coils, detection coils, a magnetic confinement screen, and an external conducting screen. The

Figure 6.4 *Typical image obtained from the experimental biomedical system. (Reproduced courtesy of S. Al-Zeibak and N. H. Saunders)*

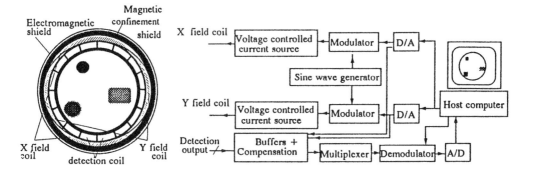

Figure 6.5 *Block diagram of an inductive EMT system employing a parallel field*

excitation coil consists of two pairs of orthogonal (X and Y) windings. Each winding surrounds the object space and has an appropriate turns density to ensure that a parallel magnetic field is created within the object space when it is empty (Yu *et al.*, 1992). The applied field has a frequency of 500 kHz and the direction of the field can be controlled over 360° by the relative magnitudes of the excitation currents in the X and Y windings. The currents are controlled by the image reconstruction computer and a large number of field projections are possible. There are 21 individual detection coils, which are equally positioned round the circumference, enabling 21 concurrent measurements of the peripheral field to be acquired for each particular field projection. The ferrite magnetic confinement shield both concentrates the field inside the space to increase sensitivity, and prevents interference from external objects, as described earlier. The conducting shield further confines the flux and improves electromagnetic compatibility.

The image-reconstruction algorithm used with this system is a simple linear correlation type and was derived in two stages. First, the forward problem was solved by an experimental method. The image area was divided into 144 small squares (12 × 12) which corresponded to the pixels in a later reconstructed image. The outputs of the 21 detection coils were measured for each of the five field projections while every pixel in the image was occupied in turn by a copper sample bar. A large amount of data (12 × 12 × 21 × 5 = 15 120 values) was obtained from the system, which described the system response to each individual pixel. The data were defined and normalized according to:

$$S(p,c,x,y) = \frac{M(p,c,x,y) - M_E(p,c)}{M_F(p,c) - M_E(p,c)} \tag{6.7}$$

where $M(p,c,x,y)$ is the flux, measured by the channel c in the projection p, when the (x,y) element was occupied by the copper sample bar. $M_E(p,c)$ and $M_F(p,c)$ are the fluxes measured by channel c in projection p, when the

measured area was empty and was completely filled with copper, respectively.

Second, for image reconstruction the data were organized as a transform matrix, which transformed 105 measurements into an image. The grey level of each pixel was obtained by using the back-projection algorithm:

$$G(x,y) = k \cdot \exp \frac{\sum\limits_{p=1}^{5} \sum\limits_{c=1}^{21} M(p,c) \times S(p,c,x,y)}{\sum\limits_{p=1}^{5} \sum\limits_{c=1}^{21} S(p,c,x,y)} \tag{6.8}$$

where $M(p,c)$ are the normalized signals, measured from 21 detectors in five projections. The exponential function helped to enhance the grey-level contrast and a suitable scale factor (k) was needed to show the image on the screen.

Figures 6.6 and 6.7 contain images for a number of conductivity distributions. Figure 6.6 shows the image of a single 15-mm diameter copper tube (left) together with a three-dimensional graphical representation (right) of the same image. This image was obtained using five equally spaced field projections ($0°$, $72°$, $144°$, $216°$ and $288°$). Figure 6.7 shows images of other conductivity distributions, also obtained using five field projections. Clearly, the images show the correct characteristics of the actual contents of the object space. Similar images were obtained from this system when ferrite rods were inserted in the object space. Conductive material tends to exclude flux and produces positive pixel values, whereas ferrite material tends to concentrate flux and produce negative pixel values. Of course the images from this system are poor since they are based on a small number of projections, and consequently only $5 \times 21 = 105$ measurements are available for reconstruction. In addition, no

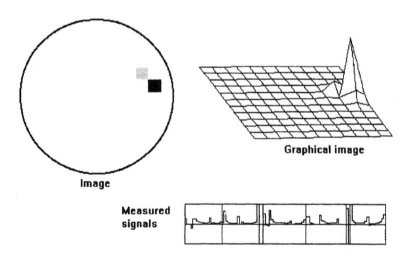

Graphical image

Image

Measured signals

Figure 6.6 *Reconstructed image of a single copper tube (15 mm diameter)*

Figure 6.7 *Reconstructed images of different conductive objects. (a) Two conductive bars. (b) One conductive bar in the centre. (c) Half-filled object space*

attempt has been made to increase artificially the apparent resolution by adding a greater number of pixels than data. Naturally, the image quality would be expected to improve significantly if more projections were used. Another factor limiting image quality is the use of a simple real linear reconstruction algorithm which does not take into account the considerable variations in the magnetic flux patterns caused by the presence of conducting or ferromagnetic material. Consequently, image fidelity is poor, especially in the central region (see Figure 6.7(b)).

6.4.3 Multiple pole system

A final example of an inductive EMT system is shown in Figure 6.8 (Mardiyanto *et al.*, 1994). Here, the sensor is based on a soft iron magnetic shield and so can only operate at low excitation frequencies (below 5 kHz),

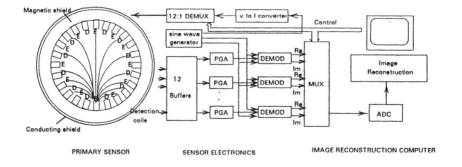

Figure 6.8 *Block diagram of a multiple pole inductive EMT system*

which ultimately limits frame capture rates to a few per second. This sensor has a similar structure to some capacitance tomography systems, but with the electrode plates being exchanged for magnetic poles fitted with either excitation or detection coils. The object space has a diameter of 115 mm and the shield is composed of 24 poles with alternate poles assigned to excitation or detection purposes (12 of each). The shield itself is built from a stack of 0.63-mm-thick soft iron laminations and has a total axial length of 50 mm. Each of the excitation coils is individually energized in turn to give a total of 12 projections. For each projection, both the in-phase and the quadrature signal components (with respect to the excitation waveform) from the 12 detector coils are measured. Therefore, $12 \times 12 \times 2 = 288$ measurements are available per frame.

Some initial results from this system are shown in Figures 6.9 and 6.10, which show the 144 real and imaginary measured signal values with different test objects present. These graphs are compensated for by the empty space values and are normalized to these base values. Figure 6.9 shows the effect of a ferrite test rod inserted near detection coil 10 and excitation coil 11. There are significant variations for the real values, but the imaginary values are all close to zero. Figure 6.10 shows the outputs with a copper tube inserted in the same position. Here the situation is the opposite, the real values are close to zero, but now the imaginary ones are affected. In both cases, the graphs clearly show the expected characteristics such as, for example, maximum outputs for the channels closest to the test objects.

6.5 Discussion and conclusions

As can be seen from the previous section, there can be considerable variety in the design of these types of sensor. However, they all have the same main components in common, particularly screening and coils for excitation and detection. The use of magnetic coupling allows the excitation and detection elements in the sensor to be separated, a feature which can be difficult to

Figure 6.9 *Sensor output with a ferrite test object*

Figure 6.10 *Sensor output with a conducting test object*

engineer in some other electrical tomographic sensors. The separate excitation coils enable a degree of flexibility in the design of the sensor array. For example, the sensor can be designed for specific flux patterns (such as the parallel field described earlier) or to preferentially excite a particular section within the object space for higher regional sensitivity or to improve axial resolution. In addition, resonant techniques can be used with the detection coils.

The images obtained from the systems are, on the whole, representative of the real object distributions; however, their quality is restricted. A significant software limitation is the use of only a few projections, together with reconstruction algorithms such as linear or filtered back-projection methods which do not accurately take into account the considerable variations in the actual distributions of the magnetic flux caused by the presence of objects (the soft-field effect). Furthermore, these algorithms do not account for the field interactions which result from the proximity of multiple objects, where for instance the eddy current/polarization field created by one object mutually affects the eddy current/polarization field produced by another. It is expected that more complex reconstruction algorithms will become an important part of future EMT systems, and perhaps the duality with other forms of electrical tomography may be exploited to assist in their development.

With regard to system hardware, advances may be expected in some of the following areas:

- Phase sensitive acquisition schemes which take into account the real and imaginary components of $B(x,y)$. This may be beneficial for moderately conducting object material (i.e. where the skin depth is greater than several pixels in size) because the circulating eddy currents in these materials will have a significant quadrature component.
- Resonant detectors for low conductivity applications.
- Compensation schemes which subtract empty space signal levels to extend the dynamic range of the data acquisition section.

Finally, an important consideration must be the potential of this technique for future applications, particularly because process tomography is a practical subject. EMT may be applied in situations where the material distribution of interest can be characterized by significant electrical conductivity or permeability properties. Examples include: tracking or concentration measurements of ferrite labelled particles in transport and separation processes, foreign-body detection and location for inspection equipment such as used in the food processing, textile and pharmaceutical industries, crack or fault detection, and possibly imaging water concentrations (such as three-phase oil/gas/water flow) where the water phase is significantly ionized to ensure a high conductivity. The encouraging biomedical results (Al-Zeibak and Saunders, 1993) support this possibility. Naturally, these suggestions are at present speculative and need to be proved by research.

In summary, this chapter has presented a general overview of inductive EMT systems, concentrating in particular on three examples. The important features of these types of system with respect to other electrical tomographic techniques are:

- Non-contacting.
- Provides information on the distribution of conductive and/or ferromagnetic material.
- Ability to operate at high excitation frequencies (i.e. of the order of megaherz) to provide fast image capture rates.
- Separate excitation and detection coil assemblies which provide flexibility in the design of the sensor array.

At present, these systems are all laboratory based and were developed primarily for feasibility purposes. Consequently, this form of tomography is at a very early stage of development. The initial results from these systems, however, are promising and it is expected that more practical prototype systems will emerge shortly, which will subsequently be applied to real process applications.

References

Al-Zeibak, S. and Saunders, N. H. (1993) Feasibility study in *in vivo* electromagnetic imaging. *Phys. Med. Biol.*, **38**, 151–160

Beck, M. S., Campogrande, E., Morris, M., Waterfall, R. C. and Williams, R. A. (1992) In *Proceedings of the 'European Concerted Action on Process Tomography'*, Manchester, UK, 26–29 March 1992, CEC BRITE EURAM

Beck, M. S., Campogrande, E., Morris, M., Waterfall, R. C. and Williams, R. A. (1993) Process tomography – a strategy for industrial exploitation – 1993. In *Proceedings of the European Concerted Action on Process Tomography*, Karlsruhe, Germany, 25–27 March 1993, CEC BRITE EURAM

Dickin, F. J., Hoyle, B. S., Hunt, A., Ilyas, O., Lenn, C., Waterfall, R. C., Williams, R. A., Xie, C. G. and Beck, M. S. (1992) Tomographic imaging of industrial process equipment – techniques and applications. *IEE Proc. G*, **139**, 72–82

Griffiths, H., Leung, H. T. L. and Williams, R. J. (1992) Imaging the complex impedance of the thorax. *Clin. Phys. Phisiol. Meas.*, **13** (Suppl A), 77–81

Hayt, W. H. (1981) *Engineering Electromagnetics*, 4th edn, McGraw-Hill, New York

Huang, S. M., Xie, C. G., Thorn, R., Snowden, D. and Beck, M. S. (1992) Design of sensor electronics for electrical capacitance tomography. *IEE Proc. G*, **139**, 83–88

Mardiyanto, Yu, Z. Z., Peyton, A. J. and Beck, M. S. (1994) Electromagnetic tomography (EMT). Part II: Dual modality (μ, σ) imaging, *Proceeding of the European Concerted Action in Process Tomography*, Oporto, Portugal, 24–26 March, 1994

Purvis, W. R., Tozer, R. C., Anderson, D. K. and Freeston, I. L. (1993) Induced current impedance tomography. *IEE Proc. A*, **140**, 135–141

Scaife, J. M., Tozer, R. C. and Freeston, I. L. (1994) Conductivity and permittivity images from an induced current electrical impedance tomography system. *IEE Proc. A*, **141** (5), 356–62, Sept. 1994

Xie, C. G. (1993) Review of process tomography image reconstruction methods. In *Sensors VI – Technology Systems and Applications*, IOP Conference Proceedings, 341–346

Xie, C. G., Huang, S. M., Hoyle, B. S., Thorn, R., Lenn, C., Snowden, D. and Beck, M. S. (1992) Electrical capacitance tomography for flow imaging: system model for development of image reconstruction algorithms and design of primary sensors. *IEE Proc. G*, **139**, 89–98

Yu, Z. Z., Conway, W. F., Dickin, F. J., Xie, C. G., Beck, M. S. and Xu, L. A. (1992) Field design for electromagnetic tomography systems. *Proceedings of the 1992 International Conference on Electronic Measurement & Instruments*, Tianjin, China, 20–22 October

Yu, Z. Z., Peyton, A. J., Conway, W. F., Xu, L. A. and Beck, M. S. (1993a) Imaging system based on electromagnetic tomography (EMT). *Electron. Lett.*, **29**, 625–626

Yu, Z. Z., Peyton, A. J., Beck, M. S. and Xu, L. A. (1993b) Electromagnetic tomography (EMT): a new process imaging system. In *Sensors VI, Institute of Physics Conference*, Manchester, 12–15 September, Institute of Physic Publishing, Bristol and Philadelphia

Yu, Z. Z., Peyton, A. J. and Beck, M. S. (1994) Electromagnetic tomography (EMT). Part I: Design of a sensor and a system with a parallel excitation field. *Proceeding of the European Concerted Action in Process Tomography*, Oporto, Portugal, 24–26 *March*, 1994

Chapter 7

Electrodynamic sensors for process tomography

**A. R. Bidin, R. G. Green, M. E. Shackleton, A. L. Stott
and R. W. Taylor**

7.1 Introduction

The work presented in this chapter investigates the application of electrodynamic sensors to the imaging of solids being conveyed either pneumatically or by gravity. These images are required for two reasons: (i) as a method of investigating how the solids are behaving within the conveyor, and (ii) as a method which can determine the solids mass flow rate. Many materials become electrostatically charged during transport, primarily by virtue of friction of fine particles amongst themselves and abrasion on the walls of the conveyor (Cross, 1987). Sensors mounted in the wall of the conveyor can detect the presence of this charge. After appropriate signal conditioning it is possible to reconstruct the image of the transported material within the conveyor.

Pneumatic conveyors are used to move a wide range of solid materials. Important factors relating to the measurement include particle size and shape, moisture content, particle velocity and the ratio of air to solids either by volume or mass. Electrodynamic techniques are intended to be used with light to medium phase concentrations. For the higher medium to dense phase ratios, capacitance methods appear satisfactory. A further advantage of electrodynamics for imaging is that it has a much narrower 'slice width' than conventional long electrode capacitance techniques.

This chapter is organized in three sections. In the first, models are developed to predict: (a) the effect of a single falling charge on a small sensor placed off the axis of the falling charge, and (b) the response of the transducers to a continuous flow of particles. The second section presents the sensor electronics and results obtained using them compared with the predictions of the models. Finally, flow regime identification and an initial approach to image reconstruction are described.

7.2 Process tomography in pneumatic transport of powders

7.2.1 The tasks of a process tomography system

Increasingly, computational models based on transport phenomenon studied on a molecular level assist in visualizing what actually happens within a

bounded flow. However, the limitation on these models is that they are based on ideal conditions. Flow measurement can provide information to determine parameters such as mass flow rate and volumetric flow velocity. However, process tomography can be used as a tool to check the validity of simulations and as an aid to improving them.

7.2.2 The use of process tomography in the powder processing industry

Imaging techniques can help the process industry in actually observing the efficiency of distribution of materials in flow profiles, reactors and mixing tanks. These distribution images can help diagnosis of problems that would have otherwise been difficult. The application of such images to process design could be a considerable advancement over the present methods which are based on input–output measurements, with only a very limited amount of information about the detailed internal characteristics of the process.

In the food industry there is a great potential for applying process tomography, especially electrodynamic imaging techniques, which can use the electrical charge developed by flowing powders such as milk and flour. Not only can process design be improved in terms of better qualitative and quantitative knowledge of the process parameters, but safety hazards in terms of charge accumulation and hot spots can be forewarned by this technique.

7.3 Theoretical models of boundary voltage profiles in the flow conveyor: the forward problem

7.3.1 The physical model for a single particle

A vertical downward flow of particles in a pipeline is considered for the model. On a macroscopic level, these particles flow in a turbulent manner causing changes in particle concentration. However, by the use of superposition, it is reasonable to assume that the net effect due to the negative and positive charges from the various particles in the particulate cloud will result in a volume of charge travelling in the axial direction of the pipeline, not necessarily through the central axis of the pipeline. Analogously, on a microscopic level, it may be assumed initially that only one particle is being detected by the sensors at any instant. For a low flow loading this assumption is reasonable (Beck *et al.*, 1990).

The models investigate the vertically downwards movement of a single, point charge (q) moving at a constant velocity (v). The two models considered are the field effect and the induced effect models. The assumptions made in these models are:

- The point charge is travelling in an axial direction parallel to the axis of the pipe.

- The particle has a constant, finite amount of charge which is not dissipated during the time it travels through the sensing volume.
- The surface area of the pin electrode is small compared to the radius of the pipe.
- The charge is a regular shaped sphere with a uniform surface density.
- The pipe is constructed of non-conducting material.

7.3.2 The induction model

For a single charged particle, assumed to be a point charge of value q, the field is uniformly radial, thus:

$$E = \frac{q}{4\pi r^2 \varepsilon_0} \tag{7.1}$$

This point charge induces a potential onto the surface of a pin electrode used to sense the change in potential at a point on the wall of a non-conducting or dielectric pipe. It is assumed that there are no other interacting fields on the electrode since there is no surface charge on the pipe wall.

For a given sensor, the surface area is πr_e^2 which is considered normal to the flux (Figure 7.1). So the proportion of flux for each sensor is

$$\frac{\pi r_e^2}{4\pi r_i^2} \tag{7.2}$$

The charge induced in the ith sensor will be proportional to q. Hence,

$$Q_{\text{induced}} = \frac{k r_e^2 q}{4 r_i^2} = \frac{k_1 q}{r_i^2} \tag{7.3}$$

But $Q_{\text{induced}} = C V_{\text{induced}}$ and C is constant for all sensors, therefore

$$Q_{\text{induced}} = k_2 V_{\text{induced}}$$

Figure 7.1 *Positonal relationship between particle and sensor*

Hence,

$$V_{induced} = k_3 \frac{q}{r_i^2} \tag{7.4}$$

From Figure 7.2, the distance from the charge to the sensor is given by the geometrical relationship

$$D = \sqrt{r^2 + R^2 - 2Rr\cos(\theta - \alpha)} \tag{7.5}$$

The angle θ is the radial position of the charge, while α is the angle for the sensor location from a reference diametrical axis. Note that the notation r_i is used to describe the distance between the sensor and the charge.

Because q and k are unknowns in the above equation, the voltages are normalized over the maximum voltage to cancel out any constant terms in the model due to sensor or pipe geometry and size of charge. Hence,

$$v_{normalized} = \frac{v_i}{v_{max}} = \frac{r_{max}^2}{r_i^2} \tag{7.6}$$

From this model, an estimation of the profile of the boundary voltages is produced. It is possible to simulate different positions of the charge by changing the values of r and θ. However, changing θ will only give an angular offset to the profiles, as shown by the results. Hence in the end, only results from one diametrical axis is shown.

7.3.3 The induction model

For a point charge (q) the field E at a radius r is uniformly radial over a 4π solid angle:

$$E = \frac{q}{4\pi r^2 \varepsilon_0} \tag{7.7}$$

Figure 7.2 *Geometrical relationship between particle and sensor*

This point charge induces a potential onto the surface of the small, flat electrode used to sense the change in potential at a point on the wall of a non-conducting pipe. For a given sensor, the surface area is πr_e^2 which is considered normal to the flux. So the proportion of flux passing through the sensor due to the charged particle at a distance i from it is

$$\frac{\pi r_e^2}{4\pi r^2}$$

The charge induced in the sensor, Q_e, is proportional to q. Hence,

$$Q_e = \frac{kqr_e^2}{r^2}$$

This charge is stored on capacitor value C and provides a voltage V_e given by

$$Q_e = CV_e$$

Hence,

$$V_e = \frac{kqr_e^2}{r^2} \tag{7.8}$$

It is assumed that there is no interaction with the surroundings and that V_e can be measured without distorting the field.

7.3.4 The response to a moving particle

Assume an electrode at the origin, and a particle (charge q) moving at constant velocity v along the line $x = D$, $z = 0$ (Figure 7.3). Assuming that the inverse-square-law relationship holds, then the induced charge Q is given by:

$$Q = -kq\frac{1}{D^2 + y^2}$$

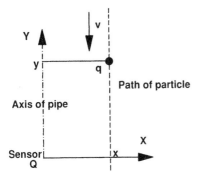

Figure 7.3 *Moving particle co-ordinate system*

where $y = vt$ and $t = 0$ when the particle is directly opposite the electrode. The equation then becomes

$$Q = -kq\frac{1}{D^2 + v^2t^2}$$

This charge Q is varying with time and results in a current dQ/dt which results in the sensor signal.

The current i is given by

$$\frac{dQ}{dt} = 2kq\frac{v^2t}{(D^2 + v^2t^2)^2}$$

Results for this case have been evaluated for $v = 5\ \text{m s}^{-1}$ and for $D = 10$. The results are shown graphically in Figure 7.4.

7.3.5 The multi-particle model

A more generalized model for predicting the voltage output u due to induction from the moving particle flow V is considered by looking at the inductive effects due to the mass charge of the particles. From first principles, the

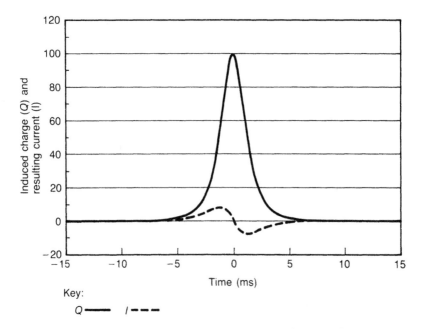

Figure 7.4 *Plots showing modelled induced charge and current flow*

potential induced at a point due to the charge on a volumetric mass flow is given by

$$u_i = k \iiint \frac{\rho_v}{r_i} \, dV \tag{7.9}$$

where $k = 1/4\pi\varepsilon_0$, $V = V(r,\theta,x)$, ρ_v is amount of charge per volume of material (Q/vol), and r_i is the charge to sensor distance. This only applies if the charge is unbounded. However, in the practical case the pipe is surrounded by an earthed metal screen at earth potential, so the results will only be approximate.

Assuming no variation in concentration and mass of particles in the x direction for a given flow, then only the surface charge density (ρ_s) needs to be considered. Then

$$\rho_v = \rho_s/x = Q/A_f x$$

where A_f is the cross-sectional area of the flow, and A is the pipe cross-sectional area. Hence,

$$\rho_s = Q/A_f$$

but

$$\frac{A_f}{A} = \sigma \qquad (\textit{spatial distribution ratio})$$

therefore

$$\rho_s = \frac{Q}{\sigma A}$$

and eqn (7.9) becomes

$$U_i(t) = kQ/r_i = k\sigma A \rho_s/r_i$$

where

$$r_i = f(\alpha)$$

and, therefore,

$$u_i(t) = \frac{k'}{r_i} \tag{7.10}$$

where r_i is the distance of the effective 'charge centroid' to the sensor.

By plotting the potential readings U_i against the sensor location θ, the effective charge source is located. In order to check this proposition, some specific cases are considered below.

Uniform, annular and core flows

In these cases the charge will be symmetrical about the central axis and, by superposition, effectively at the centre. That is $(r,\theta) = \text{origin}$. Hence, $r = 0$ and $\theta = 0$. Substituting in

$$r_i^* = \sqrt{[r^2 + R^2 - 2rR\cos(\theta - \alpha)]}$$

gives $r_i = R$; therefore $U_i = \text{constant} \times V_i$.

Stratified flow (semi-circular profile; Figure 7.5)

$$r_i = \sqrt{\left[\frac{1}{4}R^2 + R^2 - 2\cdot\frac{1}{2}\cdot R^2\cdot\cos(\theta - \alpha)\right]}$$

$$= \sqrt{R^2\frac{5}{4} - \cos(\theta - \alpha)}$$

and $\theta = 0$ by choice of the maximum amplitude. Hence from eqn (7.10)

$$U_i = \frac{k'}{R}\left(\frac{5}{4} + \cos\alpha\right)^{-0.5}$$

$$U_{\text{normalized}} = \frac{U_i}{U_{\text{max}}}$$

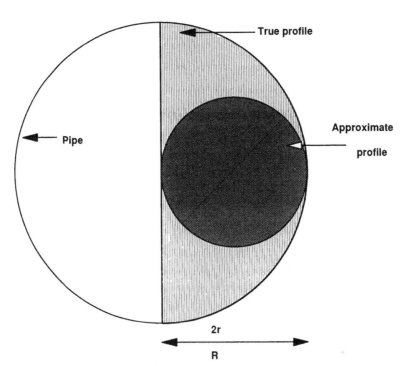

Figure 7.5 *Model for half flow*

therefore

$$U_{\text{normalized}} = \left(\frac{5}{4} - 1\right)\left(\frac{5}{4} + \cos\alpha_i\right)^{-0.5} = 0.25(1.25 - \cos\alpha_i)^{-0.5}$$

7.3.6 Simulations and results

The results from the simulations of the models described above give rise to some interesting observations:

- The use of eight electrodes in the sensor system gives more information than is possible by either the ring or the single electrode systems used in earlier work.
- These sensors individually act as points along a ring electrode and collectively form a profile of the potential around the boundary of the pipe. This provides a practical form of locating the position of the originating source of a single point charge.
- The rate of change of the potential with respect to distance from the sensor is higher in the induction model. The range of maximum and minimum potential around the boundary changes faster in the field model with respect to the location of charge from the sensors.

In the simulation, a charged particle is first considered at the centre and then moved radially outwards towards the wall of the pipe. The voltage profiles produced at various radial positions along a chosen zero diametrical axis are plotted on one graph.

It is found that at the centre the voltage profile produced is uniform, as expected. However, as the charge is moved outwards towards the pipe wall along the reference radial axis, the increase in voltage intensity is proportional to the square of the radius for the induction model and proportional to the radius for the field model. Because normalized voltages are used, the unknown quantities (quantity of charge, area of the electrode surfaces and other geometrical correction factors) are cancelled out.

The reconstruction of the radial position is obtained by plotting the range of sensor readings obtained against the test positions and, therefore, interpolating the measured range to find the unknown radial position.

7.4 An electrodynamic measurement system

7.4.1 The electrical charging phenomenon in the pneumatic transport of powders

The generation of electrical charge in the pneumatic transport of materials has been a problem in many industries. The magnitude of the charge is dependent on various factors such as the type of material (whether conducting or non-conducting), the quantity involved, moisture level, air flow rate and physical dimensions of the conveyor.

The mechanism by which electrical charge is generated during flow can be classified in many ways (Kelly and Spottiswood, 1989). In general, they can be described as follows:

- *Tribo-electrification.* This occurs when two dry solid surfaces come into contact and separate due to movement of flow. This can happen between different types of surface such as two conductors (metals), two non-conductors, or between a conductor and a non-conductor. The mechanism involves transfer of ions between the two surfaces as a result of surface forces. Harper (1967) classified contact and frictional electrification as two separate entities, but essentially they both happen in the same manner on a macroscopic level.
- *Homogeneous or symmetrical charge separation.* When a particle breaks up, two smaller particles are created which carry either zero or equal and opposite charges with no net accumulation of one charge.

In the context of powder processing, both of the above mechanisms may happen. Irrespective of how they happen, the charged particles induce a certain amount of charge on the surface of a sensor placed on a conveyor wall as it passes by it. This mechanism has been studied by Shackleton (1981).

7.4.2 The sensing and measurement of electrical charge during transport

The term 'electrodynamics' is used to describe the measurement of a moving charge. One of the earliest works using electrical charge measurements or electrodynamics to detect flowing materials is that by King (1973). King developed a method of relating the electrodynamic noise level, solids mass flow rate and particle–electrode collision rate to theoretical ideas of intensity of turbulence within a horizontal two-phase pipe flow. Essentially, the method allows the monitoring of the rate at which electrical charge is conveyed through a pipe.

In an industrial application, Featherstone *et al.* (1982) measured yarn velocity in the textile process. The yarn, which generates an electric charge as it rubs on machine spindles, is passed through two metal guides which act as sensors. This induces charge on each metal loop which is then amplified by an a.c. coupled charge-to-voltage converter. The output voltages are cross-correlated by an inexpensive cross-correlator, designed for on-line velocity measurement. The transit time for the charge to travel between the two points is determined, and hence velocity is calculated.

Shot velocity measurements using electrodynamic measurements was studied by Gregory (1987). Electrostatic variations within a high-speed flow are detected by two axially spaced electrodynamic sensors. These sensors measure the random changes in induced charge arising from the turbulent nature of pneumatic conveying. As in the above examples, the cross-correlation technique was used to obtain the velocity.

The electrodynamic process tomography system consists of three main

components: the sensors, the transducer array and data-acquisition system, and the image-reconstruction and display system (Figure 7.6).

7.4.3 The eight-channel electrodynamic transducer

The transducer system consists of two basic components: the pin electrode as sensing device and the signal-processing electronics. Capacitance and impedance sensors make use of an injected current into the system to produce a field. However, in electrodynamic tomography, the field is due to the conveying material, and the electrodes are therefore passive.

Ring electrodes are not suitable for measuring induced potential on the sensors around the walls, because they do not provide information about spatial distribution. Pin electrodes, apart from being cheap and simple to construct, give point data along the circumference. Eight electrodes are used, which means the sampling has to be very fast and, if possible, instantaneous, to synchronize the sensors picking up charge simultaneously at any one time during the flight of the particle through the sensing volume. By having these sensors around the walls of the pipe, variations of the strength of the measured output voltage gives a relationship with the position of the inducting charge.

The range of particle sizes in this work is 300–600 μm. The maximum amount of charge that particles of this size range accumulate induced voltages in the range of 10^{-5} to 10^{-2} V (Shackleton, 1981). The transducer was therefore designed to have a gain of 500 to give an output of up to 5 V.

In order to meet the requirements of the design gain, a two-stage amplifier is used. The input to each channel of the transducer is from a guarded buffer

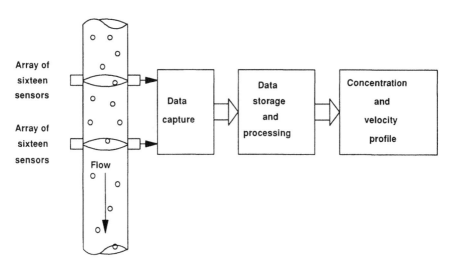

Figure 7.6 *Electrodynamic process tomography system*

receiving outputs from the sensor. In this way the effects due to capacitance from the wires in the active field are minimized and the sensitivity of the output measurement is ensured. By introducing an input impedance of about 3 MΩ, the effect of the potential due to field is minimized and the measured potential is primarily due to induction.

7.5 The flow imaging system

7.5.1 Experiments for model verification

An experimental rig was designed to verify which model best explained the pick-up potential on the pin electrodes. A bead made from Perspex, polystyrene or similar plastic material is rubbed with wool and immediately dropped through a narrow, 10 mm external diameter, non-conducting tube to specify its path through a PVC pipe of 100 mm diameter. The pipe wall is mounted with eight pin electrodes, located at equally spaced positions around the pipe wall. Figure 7.7 shows a schematic diagram of the experimental set-up.

The guide tube is gripped in a vertical position just above the sensing volume of the pipe by slipping it through a tightly fitting hole on the Perspex lid over the pipe. Holes are at specified locations, so the co-ordinate of the charge passing through them is known. These holes are at 15, 22.5, 30 and 37.5 mm from the centre. The output from each sensor is buffered and uses driven-guard techniques to obtain maximum sensitivity. These sensors are

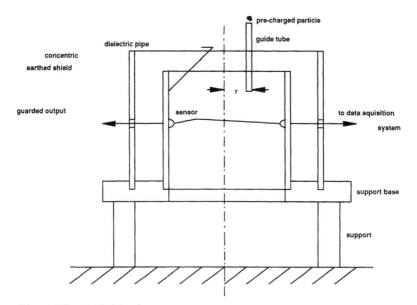

Figure 7.7 *Guided bead test system*

connected to two four-channel 20-MHz storage oscilloscopes to capture the measurements which are then transferred onto printed graphs.

The experimental procedure is:

1. Rub the bead against the wool about 10–15 times, making sure all the surface of the bead is charged.
2. Drop the bead through the guide tube held at the specified distance from the central axis of the pipe.
3. Observe the response on the display and freeze the screen when the peak voltage on the trace appears near the middle of the screen.
4. Take measurements for each channel.
5. Repeat the above procedure for other tube positions.
6. Repeat the procedure three times at each position to check repeatability.

The response from each sensor in the time domain is shown in Figure 7.8. Each channel response is displayed and captured from the oscilloscope and the peak voltage is then measured. The peak voltage is proportional to the strength of the induced charge on each sensor. The strength of the induced charge depends on the initial charge on the bead as well as on the sensor–bead distance.

As the charge gets weaker, either due to small bead charge or being relatively far from the charged bead, the amplitude of the output sensor potential gets less. Hence, the signal-to-noise ratio increases under these conditions. This difficulty is more pronounced as the bead is dropped near the pipe walls. After verifying that the results appear sensible, the data logging is transferred to a computer-based system. The data are processed statistically and the mean and standard deviation values used to plot the voltage profile of the pipe boundary. Normalized values are used, as before.

The results are plotted on special graphs where the theoretical profiles have already been plotted. The results are plotted in such a way that the sensor with

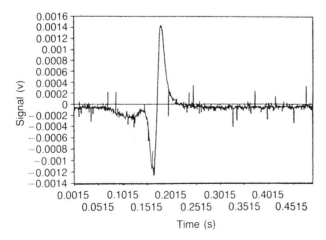

Figure 7.8 *Signal from bead flow*

maximum value is fixed as the reference sensor at $\theta = 0°$ and the readings from the other sensors plotted on the graph in a cyclic manner. Typical results are shown in the Figure 7.9.

7.5.2 The interpolation model for image reconstruction

From the voltage profile around the boundary of the pipe wall obtained by the technique described in Section 7.4, the position where the maximum voltage is measured suggests which sensor is closest to the charge inside the pipe. In a single-charge situation, the position of a minimum voltage will confirm that the diametrically opposite position is the nearest point where the charge is located.

In order to determine the radial position of the charge, a graph is used. A few readings of the maximum and minimum range values are calculated for several

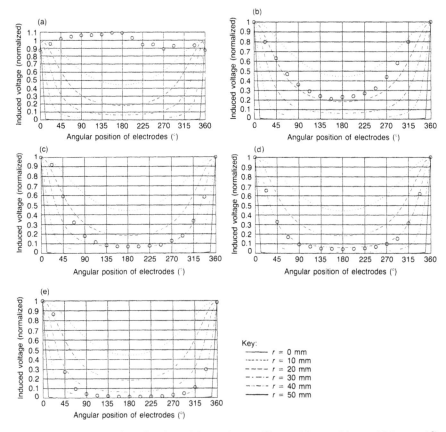

Figure 7.9 *Results for a bead at: (a)* r $= 0$ *mm; (b)* r $= 15$ *mm; (c)* r $= 22.5$ *mm; (d)* r $= 30$ *mm; (e)* r $= 37.5$ *mm*

radial charge positions. These are then plotted to correlate the range and radial position, as demonstrated in Figure 7.10. Hence, knowing the range value from the voltage profile obtained by the method described in Section 7.4, the radial position of the charge can be determined. In reconstructing the image, the task of determining the values of r and θ is, therefore, achieved.

The algorithm for image reconstruction is:

1. Construct a theoretical profile for a given geometry of sensor array based on the model described in section 7.3.3 and verified by experiment. Repeat this procedure for a few charge positions.
2. Construct a few graphs from the above profile on a plot of normalized voltage versus sensor angular position as well as a correlogram of range versus charge radial location.
3. Obtain measurements from sensors, in the time domain.
4. Estimate the angular position of charge from the record of the sensor which has the highest measured voltage.
5. Find the range of maximum–minimum readings and correlate from the correlogram obtained in step (2) to estimate radial position of the charge.

A direct analytical solution to the problem of the single charge in a circular boundary exists as can be shown. For each sensor, $v_i = -qk/D_i^2$ is as derived in eqn (7.3). Hence,

$$v_1 D_1^2 = -qk$$

$$v_2 D_2^2 = -qk$$

$$\vdots$$

$$v_n D_n^2 = -qk$$

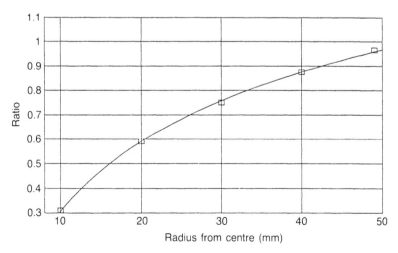

Figure 7.10 *Ratio of maximum to minimum sensor outputs versus bead drop position*

Where

$$D_i^2 = r^2 + R^2 - 2rR\cos(\theta - \alpha_i)$$

Since R and α are known from equipment geometry and v from the measurements at each sensor, solving simultaneous equations would give r and θ. For each charge, there are three unknowns (q, r and θ). The analytical solution is complicated by the non-linear relationship of the variables. This becomes even more cumbersome as the number of charges used is increased. However, a more elegant and faster solution to reconstruct the image using the voltage profiles and graph produced from the models is demonstrated above. Hence, the solution presented in this work appears more attractive for a single particle.

7.5.3 Results and discussion

The results from the experiment show close agreement with the induction model. The results are close to the estimated profiles for all charge locations except the centre. With the charge positioned at the centre, it is extremely difficult to obtain results close to the theoretical ones because the charge dropped has a certain amount of free play through the guiding tube and, therefore, can come out of the tube mouth at a slight angle and fall off-centre. The diameter of guide tube is 13 mm, that is an error of 6.5/50 or 13% off-centre.

For charges located at 15, 22.5, 30 and 37.5 mm the results were extremely close to the theoretical ones. This verifies that the induction model used to describe the voltage profile is correct for the set-up of the instrumentation in the experiment. It has been reported (Gajewski, 1989) that the output potential is due to the combined effect of the field of the charged particle and induced charge into the sensor. Using a low impedance input would cancel out the former effects and, therefore, simplify the model for reconstruction purposes.

There were three important observations through trial and error that were found to be critical to obtain good results:

1. The earth shield should be concentric with the pipe. This was not obvious in the first instance because earlier work was based on metal conveyors. However, scrutiny of the results from tests made early in the project using a box shield suggest a certain amount of potential due to field distribution influenced the readings.
2. To make the measurements more sensitive, the correction of the field effects was minimized by controlling the input impedance of the transducer as well as the buffer.
3. The buffer was included to ensure a steady potential on the input to the transducers and to isolate the sensors from effects external to the pipe.

What is interesting is that, in the hardware situation, it is easy to reconstruct the image of the charge through such a profile by looking at which sensor the maximum voltage is recorded. If the charge is axially between two neighbouring

sensors, then simple interpolation will give the angular position of the charge. Hence, the resolution is increased by increasing the number of electrodes.

References

Beck, M. S., Green, R. G., Plaskowski, A. B. and Stott, A. L. (1990) Capacitance measurement applied to a pneumatic conveyor with very low solids loading. *Meas. Sci. Technol.*, 1, 561–564

Cross, J. (1987) *Electrostatics: Principles, Problems and Applications*, Adam Hilger, Bristol

Featherstone, A. M., Green, R. G. and Shackleton, M. E. (1983) Yarn velocity measurement. *J. Phys. E*, 16, 462–464

Gajewski, J. B. (1989) Continuous non-contact measurement of electric charges of solid particles in pipes of pneumatic transport. Parts I & II. *Conference Record of the 1989 IEEE/IAS Annual Meeting*, San Diego, 1–5 October

Gregory, I. (1987) Shot velocity measurement using electrodynamic transducers. Ph.D. Thesis, UMIST, Manchester

Harper, W. R. (1967) *Contact and Frictional Electrification*, Oxford University Press, Oxford

Kelly, E. G. and Spottiswood, D. J. (1989) The theory of electrostatic separations: a review. Part 3: Particle charging. *Minerals Eng.* 2, 193–207

King, P. W. (1973) Mass flow measurement of conveyed solids by monitoring of intrinsic electrostatic noise levels, *Second International Conference on the Pneumatic Transport of Solids in Pipes*, Cranfield, D2-9, D2-20, BHRA Fluid Engineering, Bedford

Shackleton, M. E. (1981) Electrodynamic sensors for process measurement. M.Phil. Thesis, University of Bradford

Chapter 8

Ultrasonic sensors

B. S. Hoyle and L. A. Xu

8.1 Introduction

This chapter reviews the application of ultrasonic sensors in process tomography including the basic principles of data reconstruction. A more detailed general treatment of the reconstruction methods and, in particular, of appropriate computational techniques can be found in Chapter 15.

Ultrasonic sensors have been successfully applied in process measurement (in particular for flow measurement) (Asher, 1983; Lynnworth, 1989; Plaskowski et al., 1992), in non-destructive testing (McMaster, 1963; Silk, 1984), and widely in medical imaging (Havlice and Taenzer, 1979). The object or field will interact with the ultrasonic beam through some form of acoustic scattering; and the interaction must then be sensed to yield information about the object or field. Ultrasonic sensor systems are based upon interactions between the incident ultrasonic waves and the object to be imaged. For example, the incident waves may be reflected from boundaries; the reflections may be sensed and their data combined to indicate the location of the boundary.

Clearly, the use of ultrasonic sensors is applicable only to processes where a significant interaction occurs, and perhaps where such interactions provide a greater level of measurable signal than that available using other methods of transduction. The above interactions are related closely to density, and thus the object or field of interest must contain significant variations in density, e.g. a liquid containing gas bubbles.

Process tomography systems are concerned with the derivation of information relating to two or three dimensions. Such derivations require information, or *projections*, from a number of different viewpoints, preferably symmetrically surrounding the object or field of interest.

The further dimension of time may not be critical in applications where the process of interest is in a steady-state condition, or where only time-averaged information for a stationary process is required. An example of such a system could be the investigation of the mixing of an injected material in a chemical reactor. Here the measurement time would not be a critical constraint and the requisite number of projections could be obtained sequentially.

In other processes the dimension of time may be critical. For example, the on-line measurement of a two or three component flowing mixture would probably need requisite projections to be obtained in a time interval such that the flow evolution was relatively insignificant. Measurement epochs in ultrasonic sensed systems are limited intrinsically by the velocity of sound,

which is very low compared with electromagnetic waves. A typical sonic velocity in water is 0.0015 m μs^{-1} (or 1.5 mm μs^{-1}), compared with 300 m μs^{-1} for electromagnetic waves, a ratio of 200 000. In effect, this would place an upper limit on the component flow velocity for which the process tomography system would be usable.

The following sections deal with the various theoretical and practical aspects of the use of ultrasonic transduction for process tomography, in two and three dimensions, and feature a number of examples of current research and development work from the literature. The end-point of this discussion is assumed to be a pseudo-image, whether realized for display or not. Other chapters of this book deal with the possible interpretation of the image in terms of the process under examination, and also with the details of how necessary computation may be performed, although some reference is made to this aspect here where the context is close.

8.2 Principles of ultrasonic transduction

In most non-destructive testing or medical applications, an object or field of interest is irradiated (or *insonified*) from a single viewpoint, usually with a narrow beam of ultrasonic acoustic energy. Some proposed methods for ultrasonic process tomography utilize a wide angle beam, typically fan-shaped, particularly when time is critical; this permits a large region of insonification in a short time.

8.2.1 Ultrasonic waves in materials

Whether an ultrasonic beam is narrow or wide angle, it advances as a longitudinal wavefront, in common with all sound waves. If the wavefront moves forward far from the influence of boundaries, it acts as if it were moving in an unbounded medium as a *bulk wave*. This results in a relatively straightforward model for liquids and gases (the situation is more complex for solids) in which the speed of the longitudinal wave, (c), is related to the bulk properties of the material:

$$c = \sqrt{\frac{K}{\rho}} \tag{8.1}$$

where K is the stress modulus, and ρ is the density.

Clearly, the density of a material is also related to its volume and hence its temperature. For simplicity, we assume here that processes do not exhibit variations of temperature. Where significant variations do exist these must be taken into account; some systems may even use this property to provide a tomographic temperature distribution measurement system (one such system is reviewed in Section 8.5).

The wavelength of the ultrasound wave is related to its velocity and frequency by the standard relationship:

$$\lambda = c/f \tag{8.2}$$

As implied by eqn (8.1) the speed is constant for a particular material under the same ambient conditions. The frequency of the vibration will be determined by the transducer which emits the ultrasonic beam. Thus the wavelength may be considered to arise from this frequency and the material through which the beam passes.

It is evident, in principle, that the wavelength is directly linked to the resolving power of the process tomography system; in a given material increasing the frequency may be expected to increase the resolution of the system. Thus the longitudinal wavelength is linked to the corresponding *axial* resolution. The *lateral* resolution will also be of interest and demands consideration of a two-dimensional field model which encompasses the profile of the beam.

Objects smaller than the wavelength of the ultrasonic beam will not block or reflect the acoustic pressure wave, but will diffract them. A later discussion deals with Rayleigh scattering and specular reflection.

Most process tomography systems depend upon blocking and reflective interactions, since these are the easiest to detect and interpret. A lower limit on the band of frequencies which are likely to be useful will generally be simple to determine. Fortunately, the process fluids to be measured are usually liquids, which have sonic velocities of approximately 1 mm μs$^{-1}$. Thus an ultrasonic beam having a frequency greater than 1 MHz could resolve objects less than 1 mm in diameter.

Due to other limitations, most systems will only depict objects much larger than this; hence, in practice, frequency will seldom limit the system resolution. Although reasonable in principle, this link between resolution and wavelength is affected by other parameters concerned with the detailed design of the transducer, which may also be shaped to focus the beam (Havlice and Taenzer, 1979; Crecraft, 1983). For a process tomography system which results in an image, whether displayed or used in computer-assisted interpretation, the image resolution will be limited intrinsically by the ultrasound wavelength, but this limit is likely to be an horizon which is difficult to reach in practical systems.

Although it is apparent that a reduced wavelength may be advantageous to a point, and can be achieved by increasing the frequency of the transducer, this also will incur fundamental costs in terms of attenuation of the ultrasonic beam with distance. This attenuation is due to losses which arise in the material through which the ultrasound energy travels. To a crude approximation this attenuation increases linearly with frequency for a given material under the same ambient conditions. Table 8.1 illustrates the variation in pressure-wave attenuation with distance for a range of materials of general interest in process tomography (McMaster, 1963).

The table shows that attenuation in liquids is low, for example in water for ultrasonic energy having a frequency of 10 MHz this is only 5 dB over a 0.2 m

Table 8.1 *Pressure-wave-attenuation coefficient* ($dB\ m^{-1}$) *for different materials and frequencies*

	Frequency (MHz)		
Material	*1*	*5*	*10*
Dry air	170	4000	17 000
Perspex	150	700	—
Polystyrene	80	350	—
Paraffin oil	1.0	25	100
Aluminium	<1	7.0	26
Distilled water	0.2	6.3	25
Quartz (fused)	—	1.0	2

path. In constructional materials, the attenuation per metre is higher, but path lengths are usually very short, typically a few millimetres. Air presents a high attenuation, especially at high frequencies. This, added to the large loss at the interface with liquids (see Section 8.2.2), explains why gas bubbles effectively block ultrasound energy.

8.2.2 Ultrasonic waves at interfaces

The essence of process tomography is in the identification of interfaces between different materials, which in the case of ultrasonic sensing will rely upon detectable interactions at these interfaces. Several interactions are possible:

- Attenuation of the amplitude of the incident acoustic waves due to the absorption and scattering effects caused by the object or field of interest.
- Variation of the speed of sound in an inhomogeneous medium.
- Variation of both the amplitude and phase of the scattered field caused by a physical inhomogeneous field.

Ultrasonic tomography for imaging of the human body is a well-known example. These systems are designed to deal primarily with weakly inhomogeneous object fields. In contrast, most process applications are likely to present strongly inhomogeneous object fields.

A useful descriptor of the interaction of ultrasound with a material is its *acoustic impedance*, which is analogous to electrical impedance (here the complex ratio of sound pressure to particle velocity), and equal to the product of density and speed of sound:

$$Z = \rho c \tag{8.3}$$

Lynnworth (1965) gives useful data (in CGS units) on impedance and

interaction processes for a wide range of materials of interest in the development of process tomography systems.

When considering the behaviour of a normal ultrasonic wavefront at an interface the power reflection and transmission coefficients (P_r and P_t) are given (Wells, 1969) in terms of the incident (p_i), reflected (p_r) and transmitted (p_t) sound pressures:

$$P_r = \left(\frac{p_r}{p_i}\right)^2 = \left[\frac{(Z_2 - Z_1)}{(Z_2 + Z_1)}\right]^2 \tag{8.4}$$

$$P_t = \left(\frac{p_t}{p_i}\right)^2 = \left[\frac{2Z_2}{(Z_2 + Z_1)}\right]^2 \tag{8.5}$$

It is clear that the greater the difference in impedance at the interface, the greater will be the amount of energy reflected. Conversely, if the impedances are similar, most of the energy is transmitted. It may be deduced that reflections may provide a basis for process tomography where the materials of interest have distinctly different acoustic impedance values; water and air, for example, fulfil this requirement. The complete interaction behaviour is complex and does not depend simply on the differences in acoustic impedance, but on the physical size and shape of the interface. Interfaces due to objects (such as particles) which are much smaller than the acoustic wavelength interact according to Rayleigh scattering; basically, related to the fourth power of frequency.

Conversely, where the wavelength of the ultrasonic energy is small compared with the size of the smallest object particles of interest (specular reflectors), the analysis may be simplified considerably by assuming a straight-line *ray* behaviour. This leads to straight lines of interaction between an incident acoustic wavefront and an object or interface. Hence rays may be assumed to continue in a straight line when transmitted through an attenuating medium and interfaces may be assumed to cause reflections which also travel along straight lines.

In most instances ultrasonic beams employed in process tomography systems may be expected to be incident at interfaces in a non-normal fashion. Such waves will split into reflected and transmitted components. As in the analogous optical case, for the reflected wave, the angle of reflection (θ_r) will equal the angle of incidence, (θ_i). The transmitted wave will obey Snell's law which relates the angle of incidence (θ_i) and the angle of refraction (θ_a) to the speed of sound in the two materials (c_1 and c_2):

$$\frac{\sin(\theta_i)}{c_1} = \frac{\sin(\theta_a)}{c_2} \tag{8.6}$$

As the incident angle (θ_i) becomes more acute, the proportion of the energy reflected increases until at a critical value all energy is reflected and no transmission takes place. As for the analogous case for light waves, the value of the critical angle is related to the two materials of the interface.

The straight-line ray behaviour mentioned is clearly violated when the ray

transits through part of the object field which exhibits strong inhomogeneity, e.g. a gas bubble in a liquid. However, as noted in Section 8.2.1, if the ultrasonic process tomography system primarily makes use of reflection and of blocking in transmission interactions, such refractions may not be important.

The majority of ultrasonic process tomography systems which have been investigated utilize an impulse, or a sequence of discrete impulses, transmitted into the medium, as distinct from a continuous wave (Krautkramer and Krautkramer, 1983). The resulting interactions with the medium to be imaged are sensed to provide raw data for tomography.

As noted above in Section 8.1, tomography systems are concerned with the derivation of information relating to two or three dimensions. However, some basic transduction principles may be appreciated from a simple one-dimensional case. Here interaction would be sensed either: (i) from the same viewpoint by the partial reflection of the ultrasonic acoustic energy; or (ii) from an opposing viewpoint by transmission, where the energy is partly attenuated.

For either viewpoint the time of flight to an object may be estimated from both reflection and transmission sensor data. Figure 8.1 illustrates these general concepts. U represents a composite transmit/receive (T/R) ultrasound transducer; V represents a receive (R) ultrasound transducer. As noted above, for simplicity we are concerned here only with the one-dimensional axis between the transducers. The interposing area between the transducers consists of a homogeneous fluid containing closed regions of lower density. In two dimensions this could be exemplified as a liquid containing gas bubbles. The function $f(x,y)$ describes the attenuation of the object field to the ultrasonic energy; a complementary function $g(x,y)$ describes its reflection properties.

Figure 8.1 illustrates three interactions: the top ray passes directly to the receiver; the middle ray passes in transit through a single area of low density; and, at the interface a reflection will arise, but some energy will pass on to the receiver. The bottom ray will also give rise to a reflection and some energy will continue to meet the second low density region, etc.

A common ultrasonic excitation signal for tomographic applications is an impulse. If such an impulse of ultrasonic acoustic energy is transmitted from transducer U then a simple way to view the various interactions is from a time/amplitude graph, called an *A scan*. The graphs sketched in Figure 8.1 are A scans which show idealized signals observed by each of the two transducers (U and V) resulting from a typical set of interactions. In the left-hand A scan, T represents the observed narrow beam impulse of transmitted ultrasonic energy, and Rr represents reflected energy as observed by U. In the right-hand A scan, Rt represents the attenuated transmitted energy as observed by the transducer V.

As shown in Figure 8.1 information relating to the amplitude of both transmitted and reflected signals may also be measured and this may also be used for tomography.

The attenuation process may be modelled by Lambert's exponential law of absorption, where the ultrasonic energy intensity of transmitter and receiver are related:

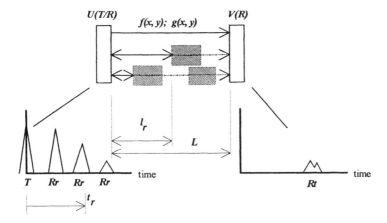

Figure 8.1 *One-dimensional ultrasonic reflection and transmission*

$$I_R = I_T \exp\left[\int_L f(x,y)\mathrm{d}l\right] \tag{8.7}$$

where L represents the total path length.

As illustrated in Table 8.1, the attenuation will be critically dependent upon the material through which the ultrasound travels. For systems whose path is less than 1 m, in which the medium is a liquid of density between that of water and oil, the attenuation is likely to be tolerable with respect to the capabilities of typical ultrasound transducers.

If the transmitted signal is an impulse and its time of instigation is known then, as illustrated in Figure 8.1, the *time of flight* of the transmitted signal can be estimated from the observation at viewpoint V. This may then be used to estimate the mean speed of sound in the interposing medium along the path L. The speed of sound characterizes the medium along the path for this simple one-dimensional single projection. Clearly, if similar other (two-dimensional) projection information were available this could be used jointly to estimate $f(x,y)$, through an appropriate reconstruction algorithm.

A further simple one-dimensional insight may be gained by considering reflections which arise along the path of the transmitted impulse. Such reflections arise at the interface of the liquid and gas components illustrated in Figure 8.1. A simple assumption may be made that the reflections travel back to $U(T/R)$ only through the higher density component (possibly a liquid). Even if some reflections are attenuated by a return transit through a lower density region (possibly gas), as illustrated, along their return path, these will be attenuated relative to those which do not. Under this simplification the speed of sound is that for the liquid (c_1). Thus the time of the observations Rr may then be assumed to be proportional to their distance of travel. Hence for the echo received at time t_r the distance l_r from interface to the transducer U is simply:

$$2l_r = c_1t_r \tag{8.8}$$

The above one-dimensional case illustrates basic interactions, but is clearly a gross simplification. A more thorough review must explore interactions not only from simple transducers which radiate a wavefront of parallel rays, as illustrated above, but more practically must include transducers which radiate on a circular front. Such an arrangement, introduced above as a fan-shaped beam transducer, allows the simultaneous insonification of a large area, and ameliorates the serious real-time limitations outlined in Section 8.1. This necessitates a two-dimensional study. Figure 8.2 depicts a configuration which illustrates the most relevant interactions. Three fan-shaped beam transducers $(U(T/R)$, $V(R)$ and $W(R))$ are depicted in a circular housing. For illustration we assume that this is a pipe section containing a liquid in which objects A and B represent gas bubbles. We then consider the various interactions which result from a pulse of omni-directional ultrasonic energy radiated from U.

Energy transmitted directly from U to W is illustrated as ray (1). This is subject to attenuation as defined in eqn (8.7), but is likely to be detectable if it travels in a liquid. Its measured time of flight could lead to the estimation of the velocity of sound in the liquid. The presence of a received pulse, at the amplitude expected for transmission directly through the liquid at the expected time, may be used to infer the absence of bubbles in the path between U and W.

Energy transmitted from U is reflected by the curved surface of bubble A, back to U, now acting as a receiving transducer, illustrated as ray (2). By measuring the time delay of the received pulse, a locus for the position of A may be estimated. The major component of the reflected energy received at U will be that incident normally at A. Other minor components may result from

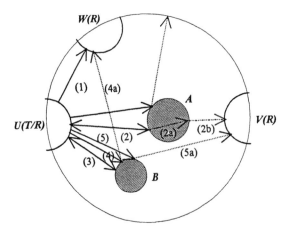

Figure 8.2 *Two-dimensional ultrasonic reflection and transmission*

non-normal incident rays whose reflections still lie within the *capture window* of *U*.

A fraction of the pulsed energy emanating from *U*, related to the ratio of the acoustic impedance of the liquid and the gas bubbles, will be transmitted into the bubble, as ray (2a), and a further fraction will re-emerge into the liquid and travel on, as illustrated as ray (2b). Once again, depending on the capture window of *V*, part of this energy will be received. It is unlikely that the energy level received at *V* for this form of interaction will be significant for materials whose acoustic impendance difference is significant, e.g. water/air. However, the lack of significant transmitted energy from *U* to *V* may be used to infer the presence of a bubble in the interposing path. This effect of *shadowing* by bubbles calls attention to a limitation of ultrasound in tomographic applications. Large bubbles, particularly when they are near the transmitting transducers, are likely to block the penetration of energy into other parts of the field of interest.

Turning now to interactions involving bubble *B* it will be clear that this gives rise to reflections similar to those from *A*. A ray from *U*, incident normally at the surface of *B*, is illustrated as ray (3). Since the distance from *U* to *B* differs from that of *U* to *A* reflections will be received at *U* at different times with respect to those from *A*. Hence the inferred locus of the reflecting object will be at a different distance, enabling a reconstruction process to discriminate between the two reflections. This illustration deals solely with a projection from the viewpoint of transducer *U*. It is obvious that the reconstruction process must be supplied with other projection data in order to estimate the periphery of the bubbles.

A ray, (4), emanating from *U* which incident non-normally at *B*, will be reflected such that the angles of incidence and reflection are equal. In the case of illustrative ray (4) this is reflected as ray (4a) at an angle which causes it to be received by *W*. The total transit time of the ray will be proportional to the total path length. A further ray (5) from *U* is incident at *B* at a more acute angle. Its reflection will cause the ray (5a) to continue to transducer *V*. These examples illustrate that pulses received at *V* and *W* may be ambiguous in that they could arise from a variety of bubble arrangements.

The above discussion relates to a two-dimensional view. Circular objects (which may be cross-sections of cylindrical objects) will increase the scattering of the ultrasonic energy, generally reducing both the transmitted and reflected energy in any given direction. Three-dimensional circular (spherical) objects may be expected to increase the scattering further, resulting in lower energy incident at the transducers. The intensity of reflection interactions in liquid/gas mixtures can thus be expected to be related to the bubble size. For an incident parallel ray the reflected intensity is greatest when the reflecting surface is flat. The intensity may then be expected to decrease as the radius of curvature of the bubble is increased. Hence smaller bubbles may be expected to be poor reflectors and more difficult to detect.

The interaction of gas bubbles with ultrasonic energy can also be shown to depend upon their size and their resulting natural frequency of vibration (which may occur in several modes), and these effects may be expected to introduce errors. The process is further complicated at the micro-scale by the

swarm behaviour of bubbles (Nakagawa, 1989). Such resonant effects may offer the opportunity to detect specific sizes and agglomerations of bubbles with ultrasonic transducers of selected frequency. A more thorough examination of the interaction of ultrasonic energy with multi-component objects is beyond the scope of this book.

8.2.3 Transducer geometry

The realization of ultrasonic process tomography is critically dependent upon the design of transducers. There is a wealth of design experience due to the widespread use of transducers for non-destructive testing, flow measurement and for medical applications (Crecraft, 1983). Current products suited to these mature application areas may not be suited to use in process tomography. The assumptions, often not expressed, which underlie the design of such transducers must be examined for relevance to the process tomography system, before their application to the new system. Gai (1991) has investigated the design of ultrasonic transducers specifically for process tomography, and deals with important aspects of invasion and intrusion into the process.

An ultrasonic tomography system must insonify the interfaces within the process of interest from several viewpoints, to obtain a number of independent projections, in essence to provide information relating to two dimensions. As outlined in the introductory remarks, the dimension of time is likely to be critical in dynamic process applications. This arises from the low velocity of sound and the need to acquire interaction data in an appropriate real-time window. These intrinsic limitations have critical implications for transducer design relating to the need for multiple projections for tomography. This latter topic is resumed in the following section; here we concentrate on aspects which impinge on the design of an individual transducer.

For processes which are pseudo-static, multiple projection insonification may be achieved by physically moving a single narrow-beam transducer in steps around the field of interest. At each step the reflection and attenuation interactions could be monitored as required. In most applications a movable transducer will be difficult to couple acoustically to the process. In many applications moving parts will not be acceptable. To achieve the same effect, a set of fixed identical transducers can be arranged at intervals around the field of interest and excited in sequence. This system will allow coupling to be arranged, and clearly avoids moving parts. Such a system could, for example, monitor reflection interactions as well as the movable transducer.

Simple calculations can determine the general parameter envelope for a sequentially excited, multiple transducer system. For a system designed to sense reflection interactions the maximum transit distance with reference to Figure 8.1 is $2L$. If there are N transducer positions, or transducers, then the time taken per complete scan (T) is:

$$T = \frac{2LN}{c} \tag{8.9}$$

This value indicates in essence the minimum time required for one complete cross-sectional tomographic view of the process; and the corresponding minimum time during which process features must remain pseudo-statically detectable in the view window.

If the process is dynamic and the features under observation by the sensor system are evolving, then it is clear that the time T will impose an upper limit upon the speed of the evolution. Simple calculations again can indicate these general limits if information relating to the evolution is known. If, for example, the cross-sectional features are in motion at right angles to the imaging plane and, the depth of the observation view is d, the maximum linear speed of evolution (v) is simply:

$$v = \frac{d}{T} \tag{8.10}$$

The beam width and geometry of the transducer are critical design parameters. Considerable work is documented in the literature regarding the analysis of ultrasonic transducers, with the aim of enhancing resolution (Penttinnen and Lukkala, 1976; Sung, 1989). The geometry of the ultrasonic beam can be shaped through the use of acoustic lenses to achieve a narrow beam (Tarnoczy, 1965; Dines and Goss, 1987). A common method for focusing the beam in medical applications is the *phased array* (Von Ramm and Thurstone, 1976; Havelice and Taenzer, 1979). This system uses a linear array of transducers which are excited by phased signals to and from the elements using variable delay circuits; such systems provide both beam focusing and steering (Von Ramm and Smith, 1983). Many of these developments, however, are likely to be difficult to apply in dynamic process tomography applications. As previously discussed, due to the limiting low speed of sound, the real time available to sweep a narrow beam to obtain each of several projections will provide a major limitation to the application of narrow focused beams, although the underlying principles may be useful in the design of wide-angle beams.

In many systems an ultrasonic transducer will be required to emit an impulse. In practice this will be only a crude approximation to the mathematical ideal, and this will contribute to the blurring of the image resulting from a reconstruction. Other contributions may well dominate such blurring effects in practice, e.g. noise, multiple reflections and refractions, quantization errors and image pixel size.

For a system using multiple transducers, the number is likely to be governed by practical as well as theoretical considerations: there will be a practical limit in terms of space and cost, and the field of view of each transducer must be designed accordingly. The transducer geometry is therefore likely to be determined by the needs of an application; some may permit a narrow-focused beam, others may require a wide-angle beam. The use of a narrow beam offers relatively precise directional information, but implies a large number of transducers, or transducer positions.

A wide-angle beam offers poor directional information but a wide area of

simultaneous insonification. The use of multiple omni-directional transducers has been investigated by Norton and Linzer (1979) who illustrated how their composite multiple projection data could be reconstructed (discussed in more detail later).

A transducer employing a fan-shaped beam has been investigated by Moshfeghi (1985, 1986). Wiegand and Hoyle (1989b) have investigated a large variety of possible transducer arrangements through simulations, including systems employing fan-shaped transducers. It is apparent from this work that such transducers are probably near optimal for dynamic process tomography applications where the scan time is critical, such as flow imaging (Plaskowski *et al.*, 1992).

The fan-shaped beam clearly offers the dynamic advantage of wide-angle insonification. However, the reconstruction algorithm must reassemble the corresponding multiple projection data, in order to estimate intersections which correspond to objects in the view field. These data will contain little intrinsic directional information, since the transducer is omni-directional over its circular arc of view in its receive mode, as well as in its transmit mode. The lack of direct directional data will limit the fidelity of the image obtainable from a reconstruction algorithm.

A further refinement of the fan-shaped transducer is one employing *multiple segments* which can be simultaneously triggered in transmit mode, but separately interrogated in receive mode, thus providing enhanced directional information. This enhancement, suggested by Flemons (1988), has been examined both through simulation studies (Wiegand and Hoyle, 1989b), and through simple laboratory tests (Wiegand, 1990). This work has indicated that the highest fidelity images are obtained when using several multiple-segment transducers with a combination of reflection and transmission interaction data. Li and Hoyle (1993) have simulated a range of possibilities.

8.2.4 Transducer fabrication, mounting and driving electronics

Although the more theoretical aspects of ultrasonic process tomography discussed above must obviously be soundly based when considering a particular application, its success in the end will be dependent equally upon the practical constraints of making suitable transducers, introducing them to the process, and acquiring process data from them. Gai (1990) has carried out a detailed survey of these aspects applied to flow imaging; however, his work will probably be equally applicable in other application areas. His work provides a useful compendium reference for many of the topics outlined below, in addition to those specifically cited.

Ultrasonic transducers are fabricated using piezo-electric ceramics (Jaffe *et al.*, 1971), or polymers (Ohigashi *et al.*, 1984: Lovinger, 1985; Ohigashi, 1985). Ceramic transducers in general provide higher acoustic power in transmit mode, but polymer transducers provide higher sensitivity in receive mode. Gai (1990) has examined the possibility of composite transducers in which a ceramic material is used for transmission and a polymer material for reception.

A key aspect is the acoustic design of the transducer to ensure good matching to the process fluid to be insonified. Equation (8.4) illustrates that for optimum transmission of the acoustic energy into the process, the acoustic impedance of the transducer and the entry material must be matched. Lynnworth's (1965) contribution, mentioned above, details a wide range of investigations covering a large variety of materials and has provided a useful set of design data, in particular for the acoustic matching of a transducer to its intended environment.

Matching can be achieved by use of a front face layer to enhance the acoustic power transfer (Jayet *et al.*, 1983). The application of this technique may be limited in tomography applications. Such layers depend upon reflected energy and wave trains composed of multiple cycles, and hence are not ideal for reflection time measurements, where a single pulse is the ideal signal. Such a signal thus may not be enhanced by a matching layer.

The aperture of the transducer must be of a reasonable size in order to inject sufficient power for subsequent detection. This may be expected to give rise to a theoretical error due to the different path lengths to reflectors (Linssen and Hoeks, 1992); however, this is unlikely to be significant with respect to the resolution of the overall system. For example, transducers are likely to have dimensions of the order of millimetres and have ultimate resolutions of several millimetres or a centimetre.

The mounting of an ultrasonic transducer onto a process vessel is an important aspect of the overall system design. The process may have restrictions on the intrusion, or invasion of the transducer; for example, process tomography on some mixtures may present serious problems of erosion and corrosion to an ultrasonic sensor. A variety of designs have been proposed for flow imaging applications which may extend to similar processes which exhibit a circular cross-section (Gai *et al.*, 1989a; Gai, 1990).

Transducers must be driven by specialized electronic systems which provide the large electric impulse needed to induce the piezo-electric material to emit the corresponding ultrasonic impulse. It is expected that the transmitted impulse will be very large compared with any received signal, since coupling and dispersion losses are usually large in common materials. This will usually necessitate the inclusion of special gating or clipping in the receiver, so that it is not damaged when the composite device is used in its transmit mode. Hence the design of driving electronic systems demands special attention (Certo *et al.*, 1984; Schafer and Lewin, 1984; Schueler *et al.*, 1984; Büchler *et al.*, 1987).

8.3 Process tomography using ultrasonic transduction

It is clear from the above discussion that the use of ultrasonic transducers for tomography will rest upon the careful design of the transducers to meet the requirements of their intended operating environment. The number and form of the transducers, their mode of use, their excitation and the capture of the resulting data are critical *architectural* aspects of the design of an ultrasonic process tomography system.

8.3.1 Multiple tomographic projections

With reference to the example given in Figure 8.1, it is apparent that the illustrated narrow ultrasonic beam can only observe part of the object. Even when fan-shaped beams are employed, as in the example given in Figure 8.2, only one facet of the object will be insonified.

The use of multiple beams, applied in sequence, will allow the whole object to be insonified with ultrasound energy from the general viewpoint U. The collection of multiple observations from such a view is called a *B scan*. Figure 8.3 illustrates such an arrangement in which a linear array of transducer beams or positions is used. A sector shaped array is also possible, allowing a single transducer to be moved simply about an axis to generate a B scan. Such an arrangement is commonly used in clinical ultrasonic imaging where the transducer is rotated about an arc by a small motor, or the motion is synthesized by means of a small array of transducers which are phased to produce a steerable focused beam.

The need for information relating to several viewpoints, or multiple projections, is the central requirement of any form of tomography. Figure 8.3 illustrates the acquisition of data for a single projection; Figure 8.4 illustrates a second projection of observations.

8.3.2 Reconstruction from ultrasonic sensor data

Either reflection or transmission data may be used in isolation as a basis for a projection. Radon (1917) provided a basis for the description of scalar (two-dimensional) tomographic projections (Deans, 1983).

With reference to Figure 8.5, for the attenuation function $f(x,y)$ the projection $p(l,\theta)$ is the sum of line integrals of the normal straight-line paths

Figure 8.3 *Multiple beams/positions*

Figure 8.4 *Multiple projections*

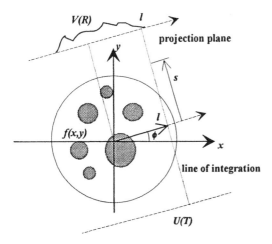

Figure 8.5 *Attenuation function projection*

(s). Thus, the projection for the object function $f(x,y)$ for one projection angle ϕ is:

$$p(l,\phi) = \int_s f(x,y)\cdot ds \qquad (8.11)$$

This can be re-stated in circular co-ordinates as:

$$p(l,\phi) = \int_s f(l\cos\phi - s\sin\phi, l\sin\phi + s\cos\phi)\cdot ds \qquad (8.12)$$

where the transposition to the circular co-ordinates system is given by:

$$\begin{bmatrix} x \\ y \end{bmatrix} = \begin{pmatrix} \cos\phi & -\sin\phi \\ \sin\phi & \cos\phi \end{pmatrix} \begin{bmatrix} l \\ s \end{bmatrix} \tag{8.13}$$

The mapping defined by the projection along all possible lines of integration S, is the (two-dimensional) *Radon transform* (R). A limited collection of projections, as illustrated by multiple discrete applications of eqn (8.11), is known as a *sample* of the Radon transform.

Radon showed that an inverse transform exists such that:

$$f = R^{-1}\{R\{f\}\} \tag{8.14}$$

In this case this is:

$$f(l,\phi) = \frac{1}{2\pi}\int_0^\pi \int_{-\infty}^{+\infty} \frac{1}{x\cos\phi + y\sin\phi - l}\frac{\partial p(l,\phi)}{\partial l}\cdot dld\phi \tag{8.15}$$

The result of equation (8.15) may provide the basis for the estimation of $f(l,\theta)$.

A further useful result may be derived by the one-dimensional Fourier Transform of equation (8.12):

$$\psi(m,\phi) = F\{p(l,\phi)\} = \int_{-\infty}^{+\infty} \int_S f(l\cos\phi$$

$$- s\sin\phi, l\sin\phi + s\cos\phi)ds\cdot\exp(-jml)\cdot dl \tag{8.16}$$

Substituting back into rectilinear co-ordinates from eqn (8.13):

$$\psi(m,\phi) = \int_{-\infty}^{+\infty} \int_{-\infty}^{+\infty} f(x,y)\exp[-j(m\cos\theta\cdot x + m\sin\theta\cdot y)]\cdot dx\cdot dy \tag{8.17}$$

Equation (8.17) is called the *projection slice theorem* and relates the Fourier components of the projection to Fourier components of the attenuation function.

A similar general analysis to the above can be carried out for the reflection function $g(x,y)$, in which a reflectivity projection is derived for a co-located ultrasonic transmitter and receiver (Figure 8.6). The similarity between Figures 8.5 and 8.6 can be clearly seen; the line integration path is now a circular arc rather than a straight line:

$$p(q,\phi) = \int_C g(x,y)\cdot ds \tag{8.18}$$

where the radius of the *projection arc* is:

$$q = \sqrt{r^2 + l^2 - 2rl\cos(\theta - \phi)} \tag{8.19}$$

The value q may be estimated from eqn (8.8):

$$q = \frac{ct}{2} \tag{8.20}$$

As in the attenuation case, eqn (8.18) could also be expressed in polar co-ordinate form.

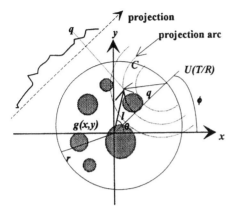

Figure 8.6 *Reflection function projection*

If the transducers have multiple segments, as described in Section 8.2.3, then the analysis is almost identical, the measured projection data will now be separate for each distinct segment. The geometry of the sensor will be known and thus the circular arc is then projected in separate parts corresponding to each segment. If this processing can be done in parallel it may considerably speed up the real-time performance of the system through the availability of increased directional data.

To provide a range of projections (over angle ϕ) a number of transducers will be arrayed around the process of interest, each in effect taking the role of $U(T/R)$ in Figure 8.6. In order to increase the volume of data available, in a limited real-time window, it is possible to utilize these other transducers as receivers, in effect as a multiple set $(V(R))$. In this case it has been shown (Norton and Linzer, 1979) that the projection arc for these cases is elliptical rather than circular.

As noted in Section 8.2.3, a transducer will not deliver an idealized impulse. Thus the measured projection at any point may be considered in relation to the actual time domain function of the pulse. A simple convolution relation exists:

$$p_{\mathrm{meas}}(q,\phi) = p(q,\phi) \otimes p_{\mathrm{trans}}(q,\phi) \qquad (8.21)$$

In practice, a further distortion will arise. The actual impulse will be distorted throughout its propagation. The distortion may be considered in terms of the differing attenuations corresponding to the frequency components of the Fourier transform of the impulse. Hence eqn (8.21) is only an approximate description of the process.

In both the attenuation case (summarized by eqn (8.11)) and the reflection case (summarized by eqn (8.18)), an *inverse algorithm* must be applied, which operates upon the multiple projection data, to yield an estimate of the tomographic cross-section of the object. A variety of techniques such as *Fourier inversion* or *Filtered back-projection* (Herman, 1980; Natterer, 1986)

exist based upon the measurement of the projection data and the above relationships. Chapter 15 deals in detail with such reconstruction techniques.

8.3.3 Ultrasonic sensing modes

In Section 8.2.2 we discussed the various interactions that may be used to gain information relating to the internal nature of a process. These possibilities yield a variety of sensor configurations which may provide raw data for processing to yield both one- and two-dimensional scalar and three-dimensional vector tomographic results. It is convenient to review these techniques as three distinct modes (although practical systems may combine them):

- Transmission mode.
- Reflection mode.
- Diffraction mode.

Theoretically, all three modes can be treated as individual solutions (based on different assumptions) of the same inverse problem of a scattered field produced by an object, or group of objects (Xu, 1990). Norton and Linzer (1981) provide a theoretical basis for ultrasonic tomography.

If the data acquired in a system are due to the measurement of the forward scattering, and the reconstruction algorithm used is based on the inverse solution of wave equation, it may then be called *transmission mode diffraction tomography*.

In the case of forward scattering, if the data acquired only concern the amplitude and/or time of flight, and a reconstruction algorithm based on the assumption of straight-line propagation is used, it may be referred to as *transmission mode tomography*.

For the case of the measurement of back-scattering, if both the amplitude and the phase of the signals are acquired, and a reconstruction algorithm based on the inverse solution of wave equations is used, it is then called *reflection mode diffraction tomography*.

Similarly, if in the case of back-scattering only the amplitude and the time of flight of signals are measured, and the reconstruction algorithm is based on the assumption of straight-line propagation, it is then referred to as *reflection mode tomography*.

The relationship between these modes is illustrated in Figure 8.7.

The groundwork for ultrasonic process tomography has been laid by research in medical ultrasonic imaging. It is appropriate to briefly review this work here, chiefly to allow key differences in the applicability of sensing modes to be highlighted.

Much of the medical imaging work, whether using transmission, reflection or diffraction mode, assumes that the object field is only weakly inhomogeneous; e.g. human organs comply with this assumption, except for bone (Norton and Linzer, 1979; Müeller *et al.*, 1979, 1980; Greenleaf, 1983).

For example, the straight-line ray approximation, which ignores refraction effects through different objects, can be supported in medical imaging where

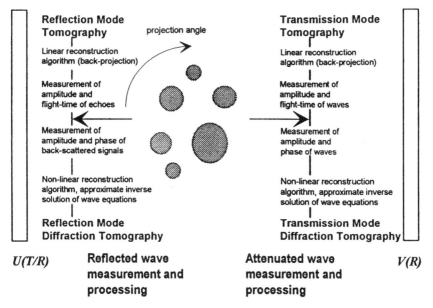

Figure 8.7 *Relationship between ultrasonic tomography modes*

these effects are small. In contrast process applications will in general feature object fields that exhibit strong inhomogeneity and the underlying mathematical descriptions must account for these properties (Barton *et al.*, 1979). This key difference limits the degree to which current techniques, which are successful in the medical field, can be employed in process tomography. Thus for process tomography involving transmission through components which have large differences in acoustic impedance the straight-line assumption would be false.

Many current medical image reconstruction algorithms are based on the approximate solution of the acoustic propagation equation in weakly inhomogeneous media. For example, the transmission reconstruction employs the geometrical scheme (geometrical optics-based method or geometric acoustic equation) (Greenleaf, 1983). Diffraction reconstruction employs the Born approximation and the Rytov approximation (Müeller *et al.*, 1979). Such image-reconstruction algorithms cannot be adapted for image reconstruction in strongly inhomogeneous object fields.

As noted above, there are circumstances in medical ultrasonic tomography when the object fields exhibit strong inhomogeneity, e.g. in body structures which include bone and air-filled cavities. Thus, for example, transmission ultrasonic tomography will be subject to blocking (due to internal reflection), known in the medical field as *signal loss*. Iterative techniques, which make use of *a priori* knowledge of body physiology, have been employed to reconstruct images from data sets which have been subject to such signal loss (Choi *et al.*, 1982; Luo, 1985). Some researchers have investigated moderately inhomogeneous media, using the refractive-index difference to describe

ultrasound propagation, diffraction and attenuation, and have proposed corresponding image-reconstruction algorithms (Slaney *et al.*, 1984; Lu, 1986). Such techniques are not applicable to process applications where *a priori* knowledge is unlikely to be available, for example the distribution of bubbles in a pipe or vessel will be unknown and also will evolve with time.

In summary, the application of ultrasonic tomography in process applications presents different challenges to those of the medical field and, although there are common basic tenets, each case must be examined in terms of the likely inhomogeneous object field.

8.3.4 Transmission sensing mode

Early work in acoustic tomography was based on the algorithms that were developed for X-ray and optical transmission mode tomography. Figures 8.1–8.3 illustrate the general geometry; the basic premise being that the transmitted wave travels in a straight line to the receiver. Thus the sensed wave at each point on the receiver can be related to some characteristic of the medium only along this straight line, as summarized by eqn (8.11).

The straight-line assumption is clearly an approximation, even though reasonably good results have been obtained using this technique. If significant transmission passes through strongly inhomogeneous parts of the object field then large errors may result. Attempts have been made to include corrections to the straight-path approximation using geometrical optical and ray-tracing methods. These are generally time consuming and may not be suitable for real-time application; furthermore, such methods neglect diffraction effects (Greenleaf, 1983).

Although analogous, the performance of ultrasonic transmission mode systems as compared to X-ray systems is relatively poor, due to the much longer wavelength and corresponding lower resolving power. Further degradations occur when there is inhomogeneity of refractive index along the transmission path. For example, Greenleaf and Bahn (1981) have noted that there are cases in medical transmission tomography where cancerous regions do not show an acoustic velocity or attenuation contrast with respect to surrounding tissues. The spatial resolving capability of the transmission approach is also limited by the lateral resolution of the transmitting and receiving transducer. In order to correct for image distortions caused by such inhomogeneties, ray-tracing techniques have been developed and applied with some success (Müeller *et al.*, 1979).

8.3.5 Reflection sensing mode

Reflection tomography in effect images ultrasonic reflectivity, and can be considered as an extension of transmission tomography. In this case the wave sensed at the receiver can be related to the characteristics of the interface which

produces a reflection along the straight line outward and return paths, as summarized above by eqn (8.18).

The first detailed theoretical analysis of reflection sensing mode was made by Norton and Linzer (1979). Their analysis was based upon a single pulse-echo transducer used as a transmitting and receiving element. The transducer is moved around the object on a circular path in the cross-sectional plane viewing the object field radially. Their results demonstrate the result noted above that the back-scattered echoes from a transmitting transducer to a coincident receiver arise from a circular arc at the radius of each object interaction. They also demonstrate the further result noted above that for a transmitter and receiver separated by a constant angle the same perceived echo lies upon an elliptical arc. They note the possible use of multiple transmitters and receivers based on these results.

The B-scan method of medical tomography in essence provides multiple projections from a single viewpoint. This method thus cannot yield sufficient data to reconstruct the reflectivity function mathematically. However, in certain circumstances, for processes with some degree of symmetry, it may provide useful results.

8.3.6 Diffraction sensing mode

When the object inhomogeneties become comparable in size to the wavelength of the ultrasound it is not appropriate to treat propagation along lines or rays. It is helpful to consider the example of water for which the wavelength of sound at a frequency of 1 MHz is approximately 1.5 mm. Energy transmission must be discussed in terms of wavefronts and scattering arising from the inhomogeneties. In such cases the interaction of the incident ultrasound with the imaged object can be modelled by wave equations. The image reconstruction is then accomplished by solving an inverse scattering problem referred to as the *diffraction mode* (Müeller *et al.*, 1980).

The target to be imaged is insonified by a plane wave and both the amplitude and the phase of the forward scattered acoustic pressure are measured in the surrounding medium. Multiple projections can be obtained by relative rotation of the object (as illustrated in Figure 8.4). Convenient Fourier processing to and from the spatial frequency domain then allows the construction of a map of a complex-valued function that is related to the acoustic parameters (the speed of sound and the attenuation) in a cross-section of the target. The typical speed of sound in water of 1.5 mm μs^{-1} is useful to visualize this process.

In diffraction mode, small perturbation approximations (e.g. the Born approximation and the Rytov approximation) are usually employed to solve the wave equation for weakly inhomogeneous objects, where the scattered field within the scatterer can be neglected. This solution of the wave equation allows the scattered field of the object to be presented as an explicit closed-form function of a characteristic function of the object. An inverse procedure can then be implemented to reconstruct a map of this characteristic

function from a set of measurements of the scattered field (Devaney, 1982; Kaveh *et al.*, 1982). Chapter 17 provides further discussion of such solutions and their stability in terms of the prime assumptions.

A classical diffraction reconstruction technique is based on the far-field Born approximation solution. However, the far-field requirement imposes an impractical large distance requirement between the object and the receiver. Exact inverse procedures for the wave equation for a weakly inhomogeneous object, which does not rely on the far-field assumptions, have been derived by several researchers (Nahamoo *et al.*, 1984).

As noted above, most process tomography applications will present a strongly inhomogeneous object field. Lu (1986) and other researchers have presented several new reconstruction algorithms which allow the diffraction mode to be employed in the case of a moderately or strongly scattering medium.

8.4 Performance limitations of ultrasonic process tomography

Important aspects of the construction of transducers and their driving electronics have been discussed in Sections 8.2.3 and 8.2.4. These aspects are examined below in terms of the constraints which they impose on a composite ultrasonic process tomography system.

8.4.1 Real-time constraints

The speed of propagation of ultrasound in a medium is relatively very slow in comparison with electromagnetic or optical waves. For example, for water at $20\,°C$, the speed of sound is only about 1500 m s$^{-1}$.

In Section 8.2.3 eqn (8.9) was derived, which gives the data-acquisition time needed for one complete *frame* of multiple projections. For example, for a reflection mode process tomography system aimed at the imaging of a two-component flow, with 30 transducers mounted on the circumference of a pipe with diameter of 0.2 m, eqn (8.9) indicates that the minimum time per scan is simply:

$$T = \frac{2 \times 30 \times 0.2}{1500} = 0.008 \text{ s}$$

A simple system may transmit a pulse from each transducer in sequence. A delay to allow reverberations to decay must be included, otherwise interference with later pulses will result. Experience for a particular system will indicate how long this delay should be. If it is made equal to the time taken for a an echo from the far wall of the vessel, the total frame time will be doubled; in the above case to 0.016 s. Equation (8.10) then indicates the real-time constraints in simple terms.

This real-time constraint problem has two aspects: the relatively trivial

engineering problem of ensuring that the real-time data can be captured in the available sampling window; and the fundamental systematic limitation on the *maximum speed of evolution* of the process under examination relative to the spatial sampling window.

The use of modern digital electronics and computer systems will provide a solution to the data-collection problem. This will probably be relatively straightforward for systems which employ the simplest sequential excitation and sensing regime. More complex systems employing multiple simultaneous sensing will demand more sophisticated engineering solutions, perhaps employing parallel computer systems for real-time data collection and processing.

The maximum speed constraint imposes a fundamental limit on the application of ultrasonic process tomography. In the case cited above, aimed at imaging two-component flows, this limit will be the maximum speed of evolution, or velocity of the discontinuous component, for which the sensor will detect flow features. This is described concisely by eqn (8.10): if the depth of the acoustic beam along the axis of the flow is 15 mm, the maximum velocity is simply:

$$v = \frac{0.015}{0.016} = 0.94 \text{ m s}^{-1}$$

In order to allow objects in the field to be captured in the image frame a value of half the maximum may be taken as a practical limit.

8.4.2 Soft-field effects

The *soft-field* nature of scattered ultrasound waves may also cause a serious problem when implementing a real-time ultrasonic tomography system. Many practical process tomography systems will exhibit strong inhomogeneity, although as noted above it is possible to rely upon reflection and blocking for simplicity. Otherwise, as the propagation of ultrasound waves in an inhomogeneous medium is always characterized by diffraction and multi-path effects, it is theoretically necessary to use a non-linear reconstruction algorithm in order to reconstruct a cross-section image with reasonable resolution. Such algorithms are explored in Chapter 15, however, this kind of algorithm will be time consuming whether it is based on the transform method or series-expansion method.

8.4.3 Transducer design and installation limitations

Transducer design and installation will be critical in a composite system. One of the major potential advantages of an ultrasonic system is that it can be non-invasive and possibly non-intrusive, but these desirable features are not simple to achieve in practice.

A key decision is the choice of transducer geometry (as reviewed in Section

8.2.3): focused narrow-beam acoustic field, or fan-beam shape acoustic field. In the first case, after a large number of views of the object from different angles have been obtained, a cross-sectional image of this object can be reconstructed, similar to X-ray computer-assisted tomography. In the second case, a small number of fan-beam transducers will cover the area. In many applications focused narrow beams will be excluded since it will not be practicable to mount a large number of transducers. With few transducers, the resulting restricted number of projections will limit the resolution of the image which can be obtained; the limitation will be exhibited as blurring of the image.

In order to realize a non-invasive system, it is desirable to mount the ultrasound transducers on the outside surface of the process vessel. Several factors, some of which were explored at the theoretical and component level in Section 8.2, must be taken into account. These include: the coupling efficiency between the pipe wall and transducer; introduction of the fan-shape beam or narrow beam into the process via the vessel wall; maximizing the number of views of the imaged object; the number of transducers; the scanning regime; signal-to-noise ratio; and signal preprocessing. Clearly a number of careful engineering compromises must be made.

8.4.4 Temperature effects

As the temperature of the measured medium in which ultrasound waves propagate varies the speed of sound changes. This relationship is non-linear and it may be necessary for a system to compensate for such temperature variations, unless the measurement of temperature distribution is the primary aim of the system.

8.5 Examples and applications of ultrasonic process tomography

A survey of the literature on the application of ultrasonic process tomography reveals a small collection of work across a wide spectrum of techniques and applications. A brief overview of contrasting techniques is provided here. Some applications below in the medical arena are included where it is apparent that they could be applied in industrial process tomography.

8.5.1 Tomography of temperature distribution

Based on the relationship between the sound speed and the temperature, Peyrin et al., (1989) applied ultrasonic tomography to the measurement of internal temperature of a solid object. Their results show that the refraction phenomenon has to be taken into account in the reconstruction algorithm.

Norton et al. (1984) have reported the measurement of internal temperature distributions in a metal body in which a laser beam was used as a scanning energy source. The induced ultrasound waves were then detected and the

resulting data used for reconstruction of the temperature distribution. In addition to standard time-of-flight tomography they introduce a new technique which they call *dimensional resonance profiling*. They note that the former is well suited for measuring temperature in a cylindrical geometry, but that a combination of the two techniques is superior for measuring temperature profiles in the more practically important rectangular slab geometry.

Sato *et al.* (1987) have reported a new method for the measurement of the change of temperature distribution, based on the temperature dependency of the non-linear interaction between ultrasonic waves and a medium. The image is obtained by using an ultrasonic non-linear parameter tomography system. They claim that a real-time non-invasive observation of change of temperature distribution was obtained. The paper does not include a technical specification of the system employed.

8.5.2 Tomography of the discontinuous phase in two-component flow

Fincke *et al.* (1980) carried out early work investigating density distributions in two-component flows using reconstructive tomography.

Wolf (1988a, b) has described an experimental system which determined the spatial distribution of the gas bubbles in the cross-section of a gas/liquid flow. The system in essence used transmission mode sensing. The back-projection algorithm was used to reconstruct images based on the assumptions: (i) that the ultrasound was attenuated in straight-line paths; (ii) that the gas bubbles can be modelled as opaque, sound-absorbing plates; and (iii) that the diameter of bubbles was larger than the incident wavelength (hence that the diffraction effects can be neglected).

A model relating the attenuation of an ultrasonic ray with the flow parameter *specific interfacial area* was used during the image-reconstruction process. The transducer subsystem designed by Wolf is complex and its cost is, therefore, presumed to be very high: more than 100 transducers were used. Experimental reconstructions obtained by Wolf indicate that his system is satisfactory only when the gas flow rate is low and there are relatively few bubbles in the liquid.

Gai with others (Gai *et al.*, 1989a, b; Gai, 1990) carried out experimental investigations on ultrasound transducers suitable for two-phase flow imaging. He presented two novel designs aimed at non-invasive measurement, one using ceramic PZT material and one using polymer PVDF material. His designs feature a fan-shaped beam consisting of a single segment, or multiple segments as first suggested by Flemons (1988). The latter is investigated in order to reduce data-acquisition time and improve the signal-to-noise ratio.

In order to implement a real-time system, Gai also proposed *time-resolved transmission mode tomography*. This derivative mode incorporates a timed sampling of transmission pulse data arrival rather than attenuation. Gai claims that this mode can substantially reduce the data-acquisition time compared with the use of the traditional reflection mode.

Xu *et al.* (1990, 1993) have investigated the use of transmission tomography for two-component bubbly gas/liquid flow. They propose a fast two-value filtering algorithm which makes use of the blocking signal loss caused by reflection. They have demonstrated the feasibility of the system with static experiments.

Wiegand and Hoyle (1989a,b) have developed a real-time ultrasonic process tomography system. The system makes use of fan-shaped transducers with both single and multiple (three) segments, and employs both reflection and transmission-mode data. To provide maximum use of sparse data, the system utilizes all transducers as simultaneous receivers, as transmission pulses sequentially insonify the view field from a number of angular positions. Transducers with a close angular displacement to the transmitter operate in receive reflection mode, those distant operate in receive transmission mode.

They employ a filtered back-projection algorithm in which both circular and elliptical projections are computed, as detailed in Section 8.3.2. The algorithm utilizes the transmission mode data not in the conventional manner for attenuation estimation, but to reject blurring artefacts from the limited data back-projection. Their system yields real-time image reconstruction performance viable for flow imaging through the use of an array of parallel processing devices (Wiegand and Hoyle, 1991).

In section 8.3.5 it is noted that B-scan tomography, as employed in medical ultrasonic scanners, cannot be used for process tomography in the sense discussed here. Blackledge (1992) has demonstrated that a B-scan system, based on a conventional medical ultrasonic scanner, can produce reasonable data from a single viewpoint. His preliminary work captures the B scan as a raster and utilizes standard frame-capture techniques together with conventional medical image-processing algorithms to enhance the result.

8.5.3 Tomography of vector fields

The above discussion has been limited to two-dimensional or cross-sectional process tomography. Some work has been carried out on the use of process tomography for three-dimensional or vector field imaging.

A number of researchers have carried out theoretical studies of the general problem: Johnson *et al.* (1975, 1977) on the reconstruction of three-dimensional velocity vector field from transmission-mode measurements; and Kramer (1979) on reconstructing vector fields.

Hauk (1989), with Braun (1990), investigated the application of ultrasonic transmission mode tomography to the imaging of vector fields. They described an experiment carried out on a pseudo-static flow velocity field produced by injecting water at two jets to produce a rotational vortex in a water bath. Twin linear arrays of 36 transducers are used (immersed in the water bath for good coupling); one set acts as the transmitter, the other receives transmission-mode data. Each corresponding pair of transducers is used in isolation to build up a superimposed data set for one x,y plane projection angle ϕ. Continuous-wave, rather than pulsed, ultrasonic excitation is used together with a variable

frequency phase-locked-loop for each sensor pair to provide one measure of speed of sound across the ray path. This is repeated for each of the 36 sensors. The whole procedure was repeated for nine view positions (spacing $= 40°$). The experiment was then wholly repeated with the sensor array inclined in the z plane by $20°$; thus providing two z projections ($\gamma = 70°$ and $90°$). The resulting superimposed data were reconstructed using a three-dimensional inverse Radon transform.

Results were verified using a laser anemometer and show a good correspondence between the two different measurements. Hauk also notes that similar experiments with a 2% by volume air bubble vortex also gave good results. This technique appears to hold some promise for industrial and laboratory investigations on similar pseudo-static processes, however, the system appears impractical using current technology for dynamic systems.

Jhang and Sato (1989, 1991) report a programme of work which explores a related concept, but one that is realized through a completely different technique. Instead of an array they employ a set of transducers which use acrylic lenses to synthesize a parallel plane of ultrasound (50 mm (width) × 100 mm (length)) through a vector field of interest. Six such plane detectors were used in the site of the flow field at different positions (z) and angles (ϕ and γ) with respect to a reference plane detector. The three-dimensional positions of the planes are chosen for their mutual partial orthogonality. The resulting data may then be processed through the six-order correlation function to reveal the resulting velocity flow field resulting from the motion of the fluid.

They used several test regimes: a thick pipe containing a laminar flow and two thin tubes containing flows in opposite directions. They found it necessary to collect data over intervals of a few seconds for flow of the order of $0.5 \, \text{m s}^{-1}$. They used a small computer for reconstruction processing, for which the authors simply note that the processing time was long. As discussed in Section 8.4.1, the critical problem is not the real-time processing, but the collection of sufficient data in the available real-time window. Hence with suitable enhancements, perhaps from an increased number of plane detectors, to increase the correlation data, this system could provide a dynamic method of three-dimensional ultrasonic process tomography.

8.6 Summary

This chapter has reviewed the component aspects of ultrasonic tomography systems, the underlying theoretical aspects of process tomography, and a range of applications. Major points are:

- Any application of ultrasonic process tomography should be considered in the light of the properties and limitations of ultrasound.
- The design of the ultrasonic transducer will be a critical aspect in the composite tomography system. A viable tomography system will demand a number of projections, which for most applications will call for a number of transducers arrayed about the process of interest. Such transducers will

probably require careful integration to ensure good coupling to the process. The choice of frequency and geometry will depend on the process; the highest frequency will provide the highest resolution, but with higher attenuation.
- A range of modes is available for the acquisition of projection data from which reconstruction can be carried out.
- In order to enhance real-time performance, multiple simultaneous receiving transducers should be employed.
- The filtered back-projection algorithm has been found the most efficient for real-time applications.
- Both scalar and vector methods have been tried with some success.

Acknowledgement

The authors of this chapter are grateful to Ralph Flemons for his study of the draft and his many constructive suggestions which have clarified the concepts presented.

References

Asher, R. C. (1983) Ultrasonic sensors in the chemical and process industries. *J. Phys. E*, **16**, 959–963

Barton, J. P., Barton, C. F. and Barley, K. (1979) Computerized tomography for industrial applications. *Technical Report IRT-4617-011*, Instrument Research Technology Corporation, San Diego, CA

Blackledge, J. (1992) Analysis of two-phase flows using ultrasonic scanning. *Proc. Ind. J.*, **May**, 27–29

Braun, H. and Hauk, A. (1991) Tomographic reconstruction of vector fields. *IEEE Trans. Acoust., Speech Signal Proc.*, **ASSP-39**, 464–471

Büchler, J., Platte, M. and Schmidt, H. (1987) Electronic circuit for high frequency and broad-band ultrasonic pulse-echo operation. *Ultrasonics*, **25**, 112–114

Certo, M., Dotti, D. and Vidali, P. (1984) A programmable pulse generator for piezo-electric multi-element transducers. *Ultrasonics*, **22**, 163–166

Choi, J. S., Ogawa, K., Nakajima, M. and Yuta, S. (1982) A reconstruction algorithm of body sections with opaque obstructions. *IEEE Trans. Son. Ultrason.*, **SU-29**, 143–150

Crecraft, D. I. (1983) Ultrasonic instrumentation: principles, methods and applications. *J. Phys. E*, **16**, 181–189

Deans, S. R. (1983) *The Radon Transform and Some of its Applications*, Wiley-Interscience, New York

Devaney, A. J. (1982) A filtered backprojection algorithm for diffraction tomography – ultrasonic imaging. *Ultrasonic Imaging*, **4**, 336–350

Dines, K. A. and Goss, S. A. (1987) Computed ultrasonic reflection tomography. *IEEE Trans. Ultrason. Ferroelec. Freq. Control*, **UFFC-34**, 309–317

Fincke, J. R. (1980) The application of reconstructive tomography to the measurement of density distribution in two phase flow. *Proceedings of 26th International Instrumentation Symposium*, Research Triangle Park, NC, 235–243

Flemons, R. (1988) Ultrasonic transducer and ultrasonic flow imaging method. *UK Patent Application 8815000*

Gai, H. (1990) Ultrasonic techniques for flow imaging: front- end transducers, image reconstruction algorithms and system design. Ph.D. Thesis, University of Manchester

Gai, H., Beck, M. S. and Flemons, R. (1989a) An integral transducer/pipe structure for flow imaging. *Proceedings of the IEEE 3rd International Ultrasonic Symposium*, Montreal

Gai, H., Li, Y. C., Plaskowski, A. and Beck, M. S. (1989 b) Flow imaging using ultrasonic time-resolved transmission mode tomography. *IEE 3rd International Conference on Image Processing and its Applications*, Warwick

Greenleaf, J. F. (1983) Computerized tomography with ultrasound. *Proc. IEEE*, **71**, 330–337

Greenleaf, J. F. and Bahn, R. C. (1981) Clinical imaging with transmissive ultrasonic computerized tomography. *IEEE Trans. Biomed. Eng.*, **BE-28**, 177–186

Hauk, A. (1989) Ultrasonic time of flight tomography for the non-instrusive measurement of flow velocity fields. *Proceedings of the 18th International Symposium on Acoustical Imaging*, Santa Barbara, CA

Havelice, J. F. and Taenzer, J. C. (1979) Medical ultrasonic imaging: an overview of principles and instrumentation. *Proc. IEEE*, **67**, 620–641

Hermon, G. T. (1980) *Image Reconstruction from Projections – The Fundamentals of Computerised Tomography*, Academic Press, London

Jaffe, B., Cook, W. R. and Jaffe, H. (1971) *Piezo-electric Ceramics*, Academic Press, New York

Jayet, Y., Lakestan, F. and Perdrix, M. (1983) Simulation and experimental study of the influence of a front face layer on the response of ultrasound transducer. *Ultrasonics*, **21**, 177–183

Jhang, K. Y. and Sato, T. (1989) Flow velocity field tomography using multiple ultrasonic beam detectors and high-order correlation analysis. *J. Acoust. Soc. Am.*, **86**, 1047–1052

Jhang, K. Y. and Sato, T. (1991) 3-D velocity field measurement using multiple plane detections and high-order correlation analysis. *IEEE Trans. Ultrason. Ferroelec. Freq. Control*, **UFFC-38**, 93–99

Johnson, S. A., Greenleaf, J. F., Samoya, W. A., Duck, F. A. and Sjostrand, J. (1975) Reconstruction of three-dimensional velocity fields and other parameters by acoustic ray tracing. *Proceedings of the IEEE Symposium on Ultrasonics*, 46–51

Johnson, S. A. (1977) Reconstructing three dimensional fluid velocity fields from acoustic transmission measurements. *Trans Instrum. Soc. Am.*, **16**, 3–15

Kaveh, M., Soumekh, M. and Müeller, R. K. (1982) A comparison of Born and Rytov approximations in acoustic tomography. In *Acoustical Imaging* (ed. J. Powers), Vol. 11, Plenum, New York

Krautkramer, J. and Krautkramer, H. (1983) *Ultrasonic testing of materials*, Springer-Verlag, Berlin

Kramer, D. (1979) On the problem of reconstructing images of non-scalar parameters from projections: application to vector fields. *IEEE Trans. Nuc. Sci.*, **NS-26**, 2674–2677

Li, W. and Hoyle, B. S. (1993) Sensor optimisation for ultrasonic process tomography. *Proceedings of the 2nd ECAPT Conference*, Karlsruhe, UMIST, Manchester, 121–123

Linssen, F. and Hoeks, A. (1992) Computation of the signal distortion of reflections from specular reflectors by impulse ray modeling. *J. Acoust. Soc. Am.*, **91**, 1270–1277

Lovinger, A. L. (1985) Recent developments in the structure, properties and applications of ferroelectric polymers. *Jap. J. Appl. Phys.*, **24-2**, 8–22

Lu, Z. Q. (1986) JKM perturbation theory, relaxation perturbation theory, and their applications to inverse scattering: theory and reconstruction algorithms, *IEEE Trans. Ultrason. Ferroelec. Freq. Control*, **UFFC-33**, 722–730

Luo, S. B. (1985) *The Technique of Computed Tomography*, Jiangsu Science & Technology Publications (in Chinese)

Lynnworth, L. C. (1965) Ultrasonic impedance matching from solids to gases, *IEEE Trans. Sonics Ultrasonics*, **SU-12**, 37–48

Lynnworth, L. C. (1989) *Ultrasonic Measurements for Process Control*, Academic Press, New York

McMaster, R. C. (ed.) (1963) *Nondestructive Testing Handbook*, Ronald Press, New York

Moshfeghi, M. (1985) Ultrasonic reflection mode tomography using cylindrically diverging beams. PhD Thesis, University of Bristol

Moshfeghi, M. (1986) Ultrasonic reflection mode tomography using fan-shaped beam insonification. *IEEE Trans. Ultrason. Ferroelec. Freq. Control*, **UFFC-33**, 299–314

Müeller, R. K., Kaveh, M. and Wade, G. (1979) Reconstructive tomography and applications to ultrasonics. *Proc. IEEE*, **67**, 576–587

Müeller, R. K., Kaveh, M. and Iverson, R. D. (1980) A new approach to acoustic tomography using diffraction techniques. *Acoust. Imaging*, **8**, 615–628

Nahamoo, D., Pan, S. X. and Kak, A. C. (1984) Synthetic aperture diffraction tomography and its interpolation-free computer implementation. *IEEE Trans. Sound Ultrason.*, **SU-31**, 218–229

Nakagawa, J. (1989) Measurement of the diameter of bubbles in a bubble swarm in water by the response to a sound pulse method. *Int. Chem. Eng.*, **29**, 729–733

Natterer, F. (1986) *The Mathematics of Computerised Tomography*, Wiley, New York

Norton, S. J. *et al.* (1984) Reconstruction of internal temperature distribution from ultrasonic time of flight tomography and reconstruction measurement. *J. Res. Nat. Bureau Std.*, **89**, 65–74

Norton, S. J. and Linzer, M. (1979) Ultrasonic reflectivity tomography: reconstruction with circular transducer arrays. *Ultrasonic Imaging*, **1**, 154–184

Norton, S. J. and Linzer, M. (1981) Ultrasonic reflectivity imaging in three dimensions: exact inverse scattering solutions for plane, cylindrical, and spherical aperture. *IEEE Trans. Biomed. Eng.*, **BME-28**, 202–220

Ohigashi, H. (1985) Piezoelectric polymers – materials and manufacture. *Jap. J. Appl. Phys.*, **24-2**, 23–27

Ohigashi, H., Koga, K., Suzuki, M., Nakanishi, T., Kimura, K. and Hashimoto, N. (1984) Piezoelectric and ferroelectric properties of P(VDF-TrFE) copolymers and their applications to ultrasound transducers. *Ferroelectrics*, **60**, 263–276

Penttinnen, A. and Lukkala, M. (1976) The impulse response and pressure near-field of a curved ultrasonic radiator. *J. Phys. D*, **9**, 1547–1557

Peyrin, F. (1989) Mapping of internal material temperature with ultrasonic computed tomography. *Proceedings of the International Conference on Ultrasonics*, **83**, 31–36

Plaskowski, A., Beck, M. S. and Thorn, R. (1992) *Flow-imaging*, Adam Hilger, New York

Sato, T. (1987) Real-time non-invasive observation of change of temperature distribution using ultrasonic non-linear parameter tomography. *Automedica*, **8**, 283–293

Schafer, M. E. and Lewin, P. A. (1984) The influence of front-end hardware on digital ultrasonic imaging. *IEEE Trans. Son. Ultrason.* **SU-31**, 259–306

Schueler, C. F., Lee, H. and Wade, G. (1984) Fundamentals of digital ultrasonic imaging. *IEEE Trans. Son. Ultrason.*, **SU-31**, 195–217

Silk, M. G. (1984) *Ultrasonic Transducers for Non-destructive Testing*, Adam-Hilger, New York

Slaney, M., Kak, A. C. and Larson, L. E. (1984) Limitations of imaging with first-order diffraction tomography. *IEEE Trans. Microwave Theory Technol.*, **MTT-32**, 860–874

Sung, S. H. (1989) Acoustic wave-field analysis of ultrasonic transducers. *J. Acoust. Soc. Am.*, **86**, 1595–1601

Tarnoczy, T. (1965) Sound focusing lenses and waveguides. *Ultrasonics*, **3**, 115–127

Radon, J. (1917) Über die bestimmung die funktionen durch irhe integralwerte längs gewisser mannigfaltigkeiten. *Ber. Säch Akad. Wissenschaft.*, **29**, 262–279

Von Ramm, O. T. and Smith, S. W. (1983) Beam steering with linear arrays. *IEEE Trans. Biomed. Eng.*, **BME-30**, 438–452

Von Ramm, O. T. and Thurstone, F. L. (1976) Cardiac imaging using a phased array ultrasound system. *Circulation*, **53**, 258–262

Wells, P. N. T. (1969) *Physical Principles of Ultrasonic Diagnosis*, Academic Press, New York

Wiegand, F. (1990) VLSI parallel processing in flow image based measurement. Ph.D. Thesis, University of Leeds

Wiegand, F. and Hoyle, B. S. (1989a) Real-time parallel processing in industrial flow imaging

using transputer arrays. *CONPAR-88, Parallel Processing and Applications* (ed. C. Jesshope), Cambridge University Press, Cambridge, 482–491

Wiegand, F. and Hoyle, B. S. (1989) Simulations for parallel processing of ultrasound reflection-mode tomography with applications to two-phase flow measurement. *IEEE Trans. Ultrason. Ferroelec. Freq. Control*, **UFFC-36**, 652–660

Wiegand, F. and Hoyle, B. S. (1991) Development and implementation of real-time ultrasound process tomography using a transputer network. *Parallel Comput.*, **17**, 791–807

Wolf, J. (1988a) Investigation of bubbly flow by ultrasonic tomography. *Part. Part. Charact.*, **5**, 170–173

Wolf, J. (1988b) Ultrasonic tomography in the field of flow measurement. *Proceedings of the Acoustical Society of America Congress*, Seattle, WA, 1–10

Xu, L. (1990) Ultrasonic computerized tomography and its applications to process monitoring. Internal report, UMIST, Manchester

Xu, L., Xu, L. and Chen, Z. (1993) Investigation of transmission-mode UCT system for bubbly gas/liquid distribution monitoring. *Proceedings of the 2nd ECAPT Conference*, Karlsruhe, 209–212, UMIST, Manchester

Xu, L. and Chen, Z. (1990) The study of ultrasonic computerized tomography technique for gas/liquid two-phase flow measurement. *Proceedings of the Third National Multiple Flow Measurement Technique Conference*, Shanghai, 100–111 (in Chinese)

Microwave sensors

J. Ch. Bolomey

9.1 Introduction

The microwave imaging techniques which are analysed in this chapter concern near-field or short-range modalities. Remote sensing techniques, such as those considered in satellite observations, are thus excluded. Short-range microwave imaging techniques have been developed quite recently, compared with other techniques based on ultrasound, X-rays, etc., and even electrical impedance tomography. The major reason for this is that the mechanisms of interaction between microwaves and materials are rather complicated. Indeed, they are relevant to diffraction phenomena. The most recognized drawbacks of diffraction effects are: (1) the impossibility of producing well-collimated and narrow beams with diameters less than the wavelength; (2) the limitation of the spatial resolution to one-half of a wavelength resulting from imperfect focusing; and (3) multi-path interactions (edge effects, multiple scattering, creeping waves, etc.). As compared to what can be achieved with other testing modalities, such drawbacks explain, to a large extent, why microwaves have not been widely used for material inspection and process imaging. The objective of this contribution is to show that the situation has changed significantly. Some of the tools required for an efficient use of microwaves are already available. Furthermore, it is reasonable to expect that further advances will undoubtedly contribute to making microwaves very competitive with respect to other industrial non-destructive testing/evaluation modalities and to lead to new applications in process engineering and manufacturing.

This chapter is organized as follows. In the first part, the specificities of microwave inspection and the basic equations used to describe diffraction mechanisms are briefly reviewed. A test case is then analysed. Microwave biomedical imaging and, more specifically, microwave non-invasive thermometry cannot yet be considered as recognized imaging modalities. However, even though the problem is not fully solved, non-invasive thermometry has been selected as a test case, for two reasons. First, microwave medical imaging is quite representative of the difficulties which are encountered when competing with other existing and well-established imaging techniques. Second, microwave medical imaging has stimulated research which has resulted in technologies and algorithms that can be extended to other industrial problems. After the test case presentation, other promising industrial applications are considered. Finally, some general remarks concerning the development of fully operational sensors are given to guide the development of microwave imaging techniques.

9.2 Microwave-material interactions

As is well known, interactions between microwave beams and materials are described by diffraction mechanisms. What is considered a second-order effect in classical optics instrumentation is the predominant interaction scheme with microwaves. Indeed, roughly speaking, the dimensions of the structures to be analysed are of the order of magnitude of the wavelength. An accurate description of diffraction effects requires a rather heavy formulation derived from Maxwell's equations.

With respect to microwaves, materials are characterized by means of their complex dielectric permittivity (ε) and magnetic permeability (μ). The following will be devoted to non-magnetic materials for which the permeability μ is equal to the permeability of vacuum (μ_0). If a material object is introduced in the known interrogation incident field ($\mathbf{E}_i, \mathbf{H}_i$) the field distribution is perturbed, the perturbation consisting of the diffracted field ($\mathbf{E}_d, \mathbf{H}_d$) (Figure 9.1). Equivalence principles allow the consideration that the diffracted field results from the radiation of equivalent currents \mathbf{J} induced in the object by the incident field.

As a result, the total electromagnetic field ($\mathbf{E}_t, \mathbf{H}_t$) can be written as:

$$\mathbf{E}_t(\mathbf{r}) = \mathbf{E}_i(\mathbf{r}) + j/(\omega\varepsilon)[k^2 + \text{grad div}] \iiint \mathbf{J}(\mathbf{r}')G(\mathbf{r},\mathbf{r}')d\mathbf{r}' \qquad (9.1)$$

$$\mathbf{H}_t(\mathbf{r}) = \mathbf{H}_i(\mathbf{r}) - \text{rot} \iiint \mathbf{J}(\mathbf{r}')G(\mathbf{r},\mathbf{r}')d\mathbf{r}' \qquad (9.2)$$

where ω is the angular frequency, and k is the propagation constant in the host medium:

$$k = \omega(\varepsilon\mu_0)^{1/2} = 2\pi/\lambda \qquad (9.3)$$

λ being the wavelength in this medium; G is the so-called 'free-space' Green's function such that:

$$G(\mathbf{r},\mathbf{r}') = - \exp\{ - jk|\mathbf{r} - \mathbf{r}'|\}/\{4\pi|\mathbf{r} - \mathbf{r}'|\} \qquad (9.4)$$

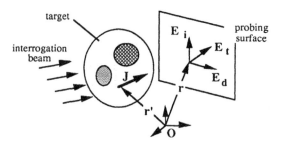

Figure 9.1 *Diffraction of a microwave interrogating beam by a target*

The equivalent current density **J** is related to the local permittivity contrast $C(\mathbf{r}) = \varepsilon_r(\mathbf{r}) - 1$ and to the total field inside the object:

$$\mathbf{J}(\mathbf{r}) = j\omega\varepsilon_0 C(\mathbf{r})\mathbf{E}_t(\mathbf{r}) \tag{9.5}$$

where the relative permittivity (ε_r) is defined with respect to the permittivity ε of the host medium.

Equations (9.1) and (9.2) provide the basic formulation of microwave imaging problems consisting in retrieving either the equivalent current (**J**) or the contrast (*C*) from the knowledge of the measured diffracted field in certain conditions. The retrieval of **J** is a linear source problem. It does not provide specific information on the object (namely its contrast *C*) because of the corruption effect by the total field, except in some very particular cases where the total field can be considered as constant or known. Such an imaging process is called 'qualitative'. Conversely, the determination of the object contrast (*C*) requires a non-linear inverse scattering problem to be solved. The non-linearity results clearly from the fact that the total field, itself, depends on the contrast. Such a reconstruction of the intrinsic properties of the object is called 'quantitative' imaging, because the images can be calibrated in terms of permittivity.

Some years ago, the utility of qualitative imaging was considered questionable. However, the fact that the equivalent currents are representative of some changes *in* the object (outside the object, they are equal to zero) means that qualitative imaging may provide some access to these internal modifications. Qualitative images have a comparative value. In the case of small changes, they can even be calibrated. Of course, quantitative imaging provides more objective information, but at the cost of requiring more effort. The knowledge of the complex permittivity makes it possible to access the different quantities that it is dependent upon. Composition, water content, blood flow rate, temperature, etc., are some examples of physiological or physico-chemical factors which influence the value of the complex permittivity. The translation of some permittivity change into a specific factor change is usually a very complicated task which requires extensive dielectric characterization under different conditions. However, the permittivity constitutes a valuable intermediate quantity.

9.3 A case study: non-invasive thermometry

9.3.1 Historical context

As has been the case for some other tomographic sensing modalities, medical applications have provided the pretext for initiating research in the microwave frequency range. The test case described here illustrates the evolution of microwave tomographic techniques over the last 10 years. Even if some additional effort is still required before total acceptance and recognition from the medical community is obtained, microwave imaging is fairly well representative of typical difficulties encountered in developing microwave

imaging equipment and in dealing with competing solutions based on more popular approaches. At the beginning of the 1980s, Larsen and Jacobi (Walter Reed Army Institute) (Jacobi *et al.*, 1979; Jacobi and Larsen, 1980) produced microwave images of organs, (e.g. dog's kidneys) demonstrating the potential use of microwave tomography in medicine. The principle of the experimental set-up is shown in Figure 9.2. Both transmitting and receiving antennas were aligned and translated simultaneously, resulting in the measurement of some kind of transmission coefficient through the biological target. The measurements were conducted in a frequency band extending roughly between 3.1 and 3.8 GHz. In order to select the most direct path and to discriminate against parasitic paths, time-domain spectroscopy techniques were used. Such discrimination was expected to make possible the use of reconstruction algorithms developed for X-ray scanners. A key point in the experiment was to use of the so-called 'immersion' technique, consisting of placing the organ under investigation in water (Larsen and Jacobi, 1982). The advantages of such a water immersion are:

- Reduction of reflection losses at the surface of the organ due to a better wave impedance matching;
- Reduction of the effect of parasitic creeping waves propagating around the organ due to water losses;
- Reduction of the wavelength arising from the high relative dielectric constant of water (about 80).

Indeed, due to the wavelength contraction, the spatial resolution obtained in water is approximately 9 times better than in air. On the images produced by Larsen and Jacobi (1982) anatomical details were clearly visible and the specific dependence of the dielectric constant to factors such as blood flow rate (Burdette *et al.*, 1980) or temperature (Miyakawa, 1988) was expected to offer

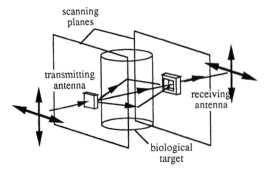

Figure 9.2 *Experimental set-up for projection imaging of a biological target in the 3–4 GHz frequency band. Transmitting and receiving antennas are translated simultaneously and remain aligned. The biological target is immersed in water* (*Jacobi* et al., *1979*)

significant advantages and hence further catalysing the development of this new imaging modality for diagnostic purposes (Jacobi and Larsen, 1980). However, at that time, the probing duration of the transmitted field through the organ was around 3 h for a dog kidney. As a consequence, the opportunity of considering such a new imaging modality was questioned, considering that much more efficient and sophisticated techniques were already available. But, the difficulties encountered in developing deep hyperthermia treatments continued to provide the principal stimulus for the development of microwave imaging techniques.

9.3.2 Hyperthermia treatment

Undoubtly, hyperthermia has constituted a very important stimulus in initiating research into microwave tomography. The problem was, and still is, that the demonstration of hyperthermia efficiency requires careful control of the temperature of the heated tissues. This is particularly necessary for deep-seated tumours. A uniform temperature of around 45 °C must be obtained and maintained during the treatment in tumoural volumes, while healthy tissues must remain at acceptable temperature levels in order to avoid burns. Actually, thermometry is achieved by using invasive devices such as thermocouples or fibre optics. Although these techniques provide accurate measurements, the measurements can be conducted at only a finite number of points, for evident reasons. This explains why only superficial, interstitial or endocavitory hyperthermia treatments which do not require traumatic invasive thermometry can be conveniently controlled.

Non-invasive thermometry remains a dream for any medical personnel involved in the treatment of hyperthermia. Several modalities have been considered (e.g. Cetas, 1984; Bolomey and Hawley, 1990). Microwave radiometry appears a natural means of passively measuring subcutaneous temperature gradients. Unfortunately, its investigation depth is limited (for sensitivity reasons) to a few centimetres. This is the reason why other imaging modalities have been considered, e.g. X-ray, ultrasound, magnetic resonance imaging, and electrical impedance tomography. Among these candidates (which are briefly reviewed in Section 9.3.4) microwaves exhibited some *a priori* advantages in terms of temperature sensitivity, ease of handling, and cost. Accordingly, some research effort has been devoted to this approach, mainly in France, Spain, the UK and Japan.

The resolution requirements for deep-hyperthermia treatments have been debated intensively. It is clear that the ultimate goal of 0.1 °C temperature resolution, 1 mm space resolution and 25 images/s would satisfy the most exigent clinician. However, taking into account the actual lack of non-invasive control and the practical difficulties in dealing with deep heating equipment, the final Workshop of the COMAC-BME Hyperthermia European Program recommended that the following specifications could bring significant improvement with respect to the present practice: 1 °C temperature, 1 cm space, and 30 s time. To date, no technique has reached this level of

performance, and even qualitative thermal monitoring would be considered as highly desirable for clinical practice.

9.3.3 Different microwave imaging approaches

Two main options have been selected. The first consists of compensating diffraction effects at a fixed frequency by means of suitable wavefront processing. The second is to try to discriminate between multi-path contributions by means of swept frequency measurements and spectral time-domain analysis.

Single-frequency techniques
Two experimental configurations are indicated in Figure 9.3. The first one, developed at Supélec (France), consists of a planar probing of the diffracted field by means of an array of 32 × 32 sensors, at 2.45 GHz (Peronnet *et al.*, 1983). This arrangement provides two-dimensional measurement capabilities over a 22 cm × 22 cm area (Figure 9.3(a)). Multi-viewing is possible by rotating targets such as perfused organs (Guerquin-Kern *et al.*, 1985) or phantoms (Bolomey *et al.*, 1983; Pichot *et al.*, 1985). The second set-up has been developed by the Polytechnic University of Barcelona (Spain) (Rius *et al.*, 1987). It consists of a circular array of 64 antennas at 2.33 GHz (Figure 9.3(b)). The radius of the array is 25 cm. When one antenna is transmitting, the diffracted field is measured on 32 receiving antennas located in front of the transmitting one. This arrangement is particularly suitable for multi-viewing, because the target may remain fixed during the data-acquisition process. In both planar and circular geometries, the acquisition time has been reduced to about 1 s by using the modulated scattering technique (MST) and the modulated multiplexing technique (MMT) (Bolomey, 1982). Time averaging can be used to increase the signal-to-noise ratio, which is typically in the range 30–40 dB.

During the first years of the assessment of these pieces of equipment, a spectral approach has been used, based on Born's approximation (Pichot *et*

a) b)

Figure 9.3 *Single-frequency measurement configurations for biomedical imaging.*
(a) 2.45 GHz planar microwave camera; 32 × 32 'MST' sensors over 22 cm × 22 cm.
(b) 2.33 GHz circular scanner; 64 'MMT' antennas circular array; radius 22 cm

al., 1985). Such reconstructions are now performed on microcomputers in times of the order of a second. Extensive measurements have been conducted, more particularly within the framework of the French TEP (transfer and evaluation of prototypes) procedure (Gautherie, 1987). This procedure has been developed to assess the capabilities of new equipment for medical applications. According to this procedure, a given piece of equipment is installed and evaluated independently by different selected clinical units. For the microwave cameras, the evaluation has been only done on phantoms and volunteers. A critical and comparative study of both planar and circular geometries has been performed (Bolomey *et al.*, 1991a; Rius *et al.*, 1992).

The results can be summarized as follows. Spectral tomographic approaches (diffraction tomography (Pichot *et al.*, 1985)) provide satisfactory results for, as expected, low-contrast objects (e.g. water tubes at varying temperature) or for differential imaging and, less expected, for high-contrast structures with simple shapes (e.g. the human hand). In the latter case, the results are surprisingly good, even though the effective spatial resolution is 7 mm in water. The temperature resolution, which was found to be of the order of 1 °C in the case of quasi-homogeneous media, is decreased by a factor of 5 to 10 when dealing with inhomogeneous and high-contrast objects (e.g. bone/muscle contrast). Several experimental trials have been conducted within the framework of the COMAC-BME Hyperthermia European Programme, with clinical groups in France (Institut Curie, Paris) and the Netherlands (Akademiek Ziekenhuis in Amsterdam, Rotterdam and Utrecht). These trials have demonstrated the difficulties that arise when moving from laboratory experiments to the clinical situation (Joisel *et al.*, 1992). Both mechanical and electromagnetic compatibility (interference with heating equipment) may cause serious difficulties. Furthermore, the water bollus needed between the camera and the patient has been found to create some microwave leakage around the patient, resulting in severe parasitic artefacts in the image-reconstruction process.

More recently, new algorithms have been developed for quantitative reconstruction of the complex permittivity. For instance, a Newton–Kantorovitch iterative scheme has been used to solve the non-linear inverse scattering problem (Figure 9.4). Both planar and circular geometries have been considered (Chew and Wang, 1990; Joachimowicz *et al.*, 1991a, b). Since such a non-linear reconstruction involves the inversion of an ill-posed operator, it is very important to evaluate the noise dependence. Some experimental data provided by the Barcelona group have been used to verify that the reconstruction is effective for biological structures such as human forearms (Joachimowicz and Pichot, 1992). Further experiments conducted on cylindrical calibrated phantoms, made with well-known materials, have shown that the reconstruction of permittivity is fairly accurate (Joachimowicz *et al.*, 1993).

There are some disadvantages in using these spatial iterative techniques. First, they are based on the comparison between the data estimated from a numerical model and those measured with the experimental set-up. As a consequence, some 'model' error is introduced if the model does not duplicate

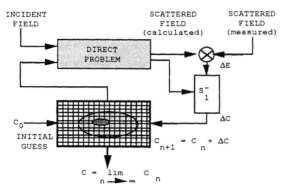

Figure 9.4 *Principle of the quantitative reconstruction of the dielectric contrast by means of an iterative spatial technique*

exactly the experimental configuration, as discussed in Chapter 2. Especially critical are the possible interactions between the target under investigation and the sensor arrangement. Second, the computation time is very long (minutes or hours), as compared with spectral approaches (seconds). However, it is clear that a convenient architecture of the numerical processor could provide a drastic decrease in the reconstruction time. Furthermore, in the medical area, it can be considered that deferred-time delivery of images may be acceptable. For instance, in addition to 'on-line' temperature control, dielectric imaging of the patient can be very useful in order to determine the effective dielectric constant distribution in the patient. Such measurements could be used for treatment planning. Instead of using values of the different organ permittivities taken from the litterature, the prediction of the specific absorption rate (SAR), which is simply the power dissipated in tissues per unit volume, could be based on true measured values. Such dielectric measurements could be performed 'off-line' before treatment and, consequently, enough time could be available to perform the required quantitative reconstructions.

Despite their drawbacks, spatial iterative techniques exhibit the huge advantage of breaking the usual rules concerning the selection of the operating frequency to optimize the penetration/spatial resolution trade-off. Indeed, previous assessments show that the spatial resolution is not definitely limited by the wavelength, but depends on the signal-to-noise ratio. Accordingly, it is possible to move towards lower frequencies for which materials are less absorbing and for which higher signal-to-noise ratios can be expected.

To take advantage of past experience, work was initiated and is now in progress with the hyperthermia unit of the Akademiek Ziekenhuis in Utrecht. This project is characterized by the use of a sensor geometry which fits perfectly the heating equipment in circular geometry. Furthermore, spatial iterative algorithms will be used. The hyperthermia equipment geometry is shown in Figure 9.5. The applicator used to deliver r.f. power at about 100 MHz, consists of a TEM slotted co-axial structure (Lagendijk and de Leeuw, 1986). The patient is naturally immersed in water, in such a way that a water

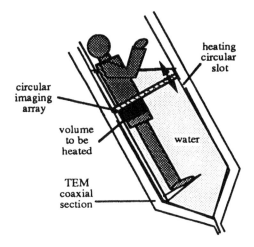

Figure 9.5 *The TEM slotted co-axial applicator of the Utrecht hyperthermia unit (Lagendijk and de Leeuw, 1986) and the projected microwave imaging array for non-invasive thermal control*

bolus is no longer necessary. The circular cross-section of the applicator is convenient for introducing a circular array of transmitting/receiving antennas.

Swept-frequency techniques

The direct use of microwave transmission data in X-ray tomographic reconstruction algorithms has been shown to operate conveniently for simple-shape and low-contrast objects (Yamavra, 1985). More recently, new chirp radar equipment has been developed to process these data more efficiently (Miyakawa, 1991). The selection of the most direct path in transmission measurements is achieved by time-domain spectroscopy. The results obtained on phantoms are significantly better. The chirp radar concept now needs to be validated from a practical point of view, particularly with regard to eliminating any mechanical movement of the transmitting and receiving antennas.

9.3.4 Other non-microwave based approaches

During the last 10 years several imaging modalities have been considered as possible candidates for non-invasive thermometry. The only one to be integrated into heating equipment is microwave radiometry. Rather than providing a true temperature map inside heated tissues, microwave radiometry is used as a means of controlling heating treatments up to only a few centimetres. The difficulty in operating at different frequencies and/or with several probes is probably the main obstacle to the development of clinically

efficient imaging control equipment (Chivé, 1990; Mizushina *et al.*, 1992; Bardti *et al.*, 1993). Besides microwave radiometry, the techniques which have been investigated are X-ray tomography, magnetic resonance imaging, ultrasound (linear and non-linear approaches), electrical impedance tomography and microwave tomography. For each imaging technique, the objective is to monitor temperature changes inside the body by using the temperature dependence of the quantity which is displayed. Consequently, and in contrast to microwave radiometry, these imaging techniques only provide an indirect approach to temperature gradients and in all cases the images have to be calibrated in terms of temperature. The difficulty results from the need to have available the temperature coefficient of the quantity delivered by the imaging equipment. A complete database is required, organ by organ, and for the whole temperature range of interest. While *in vitro* measurements can be systematically performed on excised tissues, *in vivo* measurements, which are required to take into account both direct and indirect temperature effects, including complex thermoregulatory processes, are much more complicated to obtain.

A thorough comparison between all these imaging techniques can be found in previous papers (e.g. Cetas, 1984; Bolomey and Hawley, 1990). To summarize, X-ray tomography has been abandoned despite encouraging results on phantoms (Bentzen *et al.*, 1984; Saito *et al.*, 1988). Linear ultrasound imaging offers different modalities (echotomography, diffraction tomography) but none of them has provided encouraging results, except on very simple laboratory test cases. More promising is the non-linear approach which has allowed the development in Japan (Ueno *et al.*, 1990) of a prototype which has been engaged in assessments on animal and volunteers. Even in this case, the lack of a convenient database and the difficulty in assessing the true performance has resulted in this path being abandoned, at least temporarily. At present magnetic resonance imaging is probably the most advanced technique (Le Bihan *et al.*, 1989; Delannoy *et al.*, 1990) as discussed elsewhere in this volume. Recent progress in reducing the time resolution to well below 1 s by using echo planar techniques, has released this technique from its basic drawback associated with its modest sensitivity, resulting in long measurement times. The financial cost, the electromagnetic compatibility between imaging and heating equipment, as well as the need for clinical validation, constitute the last points which will have to be addressed before the technique can be applied for operational use in deep-hyperthermia treatments. Electrical impedance tomography suffers from its poor imaging performance when dealing with strongly inhomogeneous media, but exhibits advantages in terms of speed and cost. The loss in spatial resolution in central regions, together with some equipment-related difficulties, such as the drift observed during monitoring, demonstrate the need for further improvements (Conway *et al.*, 1992). Combining imported data from other imaging modalities and local thermocouple measurements has been suggested as a possible way of compensating for these remaining drawbacks (Henriksson, 1993).

9.4 Developing industrial applications

9.4.1 Introductory comments

The potential uses of microwave radiation have not been exploited in the area of internal testing and evaluation of materials until recently, despite the fact that the techniques exhibit some interesting specificities (IEEE-MTT, 1993). Indeed the main motivation for investigating these uses is that the existing testing/evaluation techniques do not provide an adequate answer for new materials (e.g. composites) and for fabrication processes. However, it is worth mentioning that, for a long time, microwave sensors have been considered for use in industrial testing (Nyfors and Vainikainen, 1989). But these sensors, often using horns as antennas, did not provide adequate spatial resolution and were only able to provide averaged measurements over an ill-defined area. Furthermore, the need to move such sensors was incompatible with real-time operations. Some possible industrial applications are considered below.

9.4.2 Conveyed products

Conveyed products, especially when they are not too thick, offer a convenient configuration for microwave inspection (Bolomey, 1989b; Bolomey *et al.*, 1991 a, 1991b; Bolomey and Pichot, 1991; Bolomey and Berthaud, 1992; Lhiaubet *et al.*, 1992; Portala and Bolomey, 1993). The conveyance of the product naturally provides a means of one-dimensional scanning to allow image formation. Such conveying processes apply both to high- and low-volume throughput. In the first case, the products are often primary products to be used for further transformation, e.g. paper or wood. The justification of the control is then to reduce material losses by means of an efficient reaction for the industrial process. In such a case, speed is of prime importance, for instance to get real-time transverse profiles of some characteristic of the product. For low-volume production, on-line control can be also justified in the case of high-added-value products, such as conducting textiles, etc. The need of the control no longer results from quantities but from high fabrication costs. If the material is not too thick, monitoring the local reflection or transmission coefficient with a linear sensor allows information on the internal structure or composition of the product under investigation to be obtained. With respect to other existing inspection modalities, microwaves offer non-contacting capabilities, no thermal or ionizing effects, relative immunity against environmental constraints as well as significant contrasts with respect to factors such as humidity, temperature, etc. Amplitude phase measurements at a given frequency have been shown to give access to humidity and density, after a convenient calibration procedure. The difficulty in separating different factors can be overcome using multi-sensor approaches. Particularly interesting is the case of microwave materials which need to be characterized from their electromagnetic properties in the microwave frequency

range. Accordingly, they do not need any such calibration of the sensor data because measured amplitude and phase data can be related directly to the material performance, such as absorption for anti-radar coatings (Bolomey and Berthand, 1992).

9.4.3 Bulk materials and buried objects

While thin conveyed products only involve projection (reflection or transmission) imaging, the control of thick materials can be approached with microwaves using a tomographic measurement method. The two main probing configurations are linear and circular. The linear configuration is adequate for inspecting 'semi-infinite' or at least very thick products or media. Inspecting a concrete beam, a bridge, a wall, etc., or detecting buried objects in the ground are some examples of practical interest and represent a substantial market. The existing equipment can be distributed in two main categories according to the probing process. The first one consists of a single sensor probing associated with mechanical scanning. Such synthetic aperture procedures are used for underground radars (Barker and Wallace, 1993; D'Errico *et al.*, 1993). The image reconstruction cannot be started before moving the sensor over the surface of interest. Single-sensor probing is usually performed either in time (pulse waveform) or frequency (synthetic pulse) domains. The second class of equipment is more directly related to an imaging modality. It involves multi-point sensors (Chommeloux *et al.*, 1986; Pichot and Trouillet, 1991), and the reconstruction can be obtained without any movement of the sensor, resulting in increased rapidity and flexibility.

The circular geometry is, *a priori*, particularly interesting for pipes involved in industrial processes. Practically, the problems result from the mounting of the sensors into the process which requires some apertures to be made in the pipe, either for the sensing area or for the wiring. It is of course desirable to perturb the flow of the product as little as possible. At present, it is not really clear how microwave tomographic approaches are able to fit time requirements for high-rate product flows. Spectral techniques are the most rapid, but they do not allow one to deal with highly contrasted products. On the contrary, spatial iterative techniques which are able to provide convenient reconstructions with high contrasts, are not yet rapid enough to be used for real-time purposes.

9.5 Concluding remarks

The available reconstruction algorithms and microwave technology already constitute a solid base for futher specific developments. The existing tools and the experience which has been gained with them indicate the most promising trends in terms of 'technical' solutions. For instance, it is now clear that an efficient compensation of the diffraction effects for internal sensing purposes requires sophisticated non-linear reconstruction schemes at 'low' microwave frequencies rather than increasing the frequency up to millimetre waves, in

Table 9.1 *Classification of different microwave imaging techniques for industrial and medical applications*

Material configuration	Thin 'slab' material 'Wide'	'Narrow'	Thick 'bulk' material 'Simple' shape slowly varying, or high local contrast	'Arbitrary' shape and contrast
Sensors	Linear, one frequency		Linear, N-frequency circular	Any arrangement
Processing technique	Simple projection Back-projection Synthetic aperture	Model neural network	Diffraction tomography (qualitative)	Inverse scattering (quantitative)
Spatial resolution	Sampling rate	Spatial averaging	$\lambda/2$ Diffraction limitation	$\ll \lambda/2$ S/N ratio limitation
Time resolution	Real-time (from 1000 to 100 000 points/s)		Seconds (from 10 to 0.1 image/s)	From a few minutes to hours
Noise sensitivity	Moderate to low		Low	Significant
Possible applications	Non-contacting/on-line control of conveyed products: wood, paper, textiles, etc.		NDE/NDT contacting or non-contacting diagnostic: civil engineering, buried objects, process tomography, etc.	Same as DT: medical diagnostic, free space, metrology, etc.
Status	Operational products	In progress	Available prototypes *in situ* assessments	In progress

order to retrieve quasi-optical situations. Furthermore, rapidity is often a factor of prime importance in many applications and, consequently, intense investigations will be required in order to determine efficient parallel processor architectures and/or neural network devices. Table 9.1 gives a classification of the possible approaches to industrial and medical applications. For some typical shapes and configurations of the products under test, different processing schemes and measuring equipment are suggested, while expected limitations in performance are outlined. Evidently, microwave-based sensing techniques have a very broad field of unexplored application. They are just starting to emerge and will undoubtly be developed much more extensively during the next decade.

However, one must not forget that a successful sensor development is not only a matter of reconstruction algorithms and microwave technology. For example, significant efforts will be necessary to obtain an accurate calibration of microwave sensors and a convenient compatibility (mechanical, thermal, electromagnetic) with their operational environments, as discussed in Chapter 1. Cost considerations are also determinant. The development of a sensor has to be strictly justified by economical reasons, such as improving efficiency of processes (energy saving, material loss reduction, etc.) or quality of products. The 'pay-back' period of the sensor development must not be too long. As is well known, the cost of developing a sensor, or a pre-series of sensors, is much higher than recurrent costs which can be practised for larger scale sensor production when research and development (R&D) has been completed. Accordingly, true needs will have to be identified carefully. The acceptance of a new sensing modality evidently depends on the capabilities of the existing techniques in the field of application under consideration, but it is well known that it does not obey completely objective considerations. Finally, the cultural gap existing between R&D laboratories and operational units must not be underestimated, even within the same company. Consequently, any assessment in operating manufacturing plants must be carefully prepared.

References

Bardati, F., Brown V. I. and Tognolatti. (1993), 'Temperature reconstructions in a dielectric cylinder with multifrequency microwave radiometry' *J. Electromagnetic Waves Appl.* 7, 1549–1571

Barker A. B. and Wallace J. W., (1993), 'Nondestructive testing of bridge decks using dual frequency rada' *Int Conf NDT Concrete in Infrastructure Proc*, 114:132

Bentzen, S. M., Overgaard, J and Jorgensen J., (1984) 'Isotherm maping in hyperthermia using subtraction X-ray computed tomography', *Radiother. Oncol*, **2**, 225–260

Bolomey, J. Ch., (1982), 'La méthode de diffusion modulée: une approche au relevé des cartes de champs microondes in temps réel', *Onde Electrique*, **62**, 5:73–78

Bolomey J. Ch, Jofre, L., Peronnet, G. (1983), 'On the possible use of active microwave imaging for remote thermal sensing, *IEEE Trans.*, **MTT-31**, 777–781

Bolomey, J. Ch., (1989). ' Recent European developments in microwave imaging techniques for ISM applications', *IEEE Trans.* **MTT-37**, 12:2109–2117

Bolomey J. Ch. and Hawley M. S., (1990), 'Noninvasive control of hyperthermia', *Methods of Hyperthermia Control*, Section 2, 35–111, ed., M. Gautherie, Springer-Verlag, Berlin

Bolomey, J. Ch., Pichot, C. and Gaboriaud, G., (1991), 'Planar microwave imaging camera for biomedical applications: critical and prospective analysis', *Radio Science*, **26**, 2:541–549

Bolomey, J. Ch., Picard, D., Cottard, G. and Simon, J. Y., (1991 a), 'Rapid IPD measurements by means of microwave imaging techniques', *Proc 6th European Electromagnetic Structures Conference*, Friedrichshaffen, 313–320

Bolomey, J. Ch., Cottard, G. and Cown, B. J., (1991 b), 'On-line non-destructive control of material by means of microwave imaging techniques', *Mat. Res. Soc. Symp. Proc.*, **189**, 49–43

Bolomey, J. Cch. and Pichot, C., (1991), 'Microwave tomography: from theory to practical imaging systems', *Int. J. Imaging Systems and Technology*, **2**, 144–156

Bolomey, J. Ch. and Berthaud, P., (1992), 'Microwave imaging approach to non destructuve testing of absorbing composite materials' *J. Wave-Material Interaction*, **7**, 1:71–88

Bolomey, J. Ch., Joachimowicz, N. and Pichot, C., (1993), 'A nonlinear reconstruction algorithm for quantitative microwave tomography', *PIERS '93*, Pasadena, 70–72, Jet propulsion Laboratory

Bolomey, J. Ch., (1994), 'New concepts for microwave sensing', *Advanced Microwave and Millimeter-Wave Detectors, Proceedings SPIE Meeting*, San Diego, SPIE Proceedings Series, **2275**, 2–10

Burdette E. C., Cain F. L. and Seals J., (1980), 'In-vivo probe measurement technique for determining dielectric properties at VHF through microwave frequencies', *IEEE Trans.* **MTT-28**, 414—427

Cetas T., (1984), 'Will thermometric tomography become practical for hyperthermia treatment monitoring', *Cancer Res (Suppl)*, **44**, 4805s–4808s

Chew, W. C. and Wang, Y. M., (1990), 'Reconstruction of two-dimensional permittivity distribution using the distorted Born iterative method', *IEEE Trans. Mid. Imaging*, **9**, 218:225

Chivé, M., (1990), 'Use of microwave radiometry for hyperthermia monitoring and as a basis for thermal dosimetry', *Methods of Hyperthermia Control*, Section 2, 113–128, ed. M. Gautherie, Springer-Verlag, Berlin

Chommeloux, L., Pichot, C. and Bolomey, J. Ch., (1986), 'Electromagnetic modeling for microwave imaging of cylindrical buried inhomogeneities', *IEEE Trans.* **MTT-34**, 10:1064–1076

Conway, J., Hawley, M., Mangnall, Y. F., Amasha, H. and van Rhoon, G. C., (1992), 'Experimental assessment of electrical impedance imaging for hyperthermia monitoring', *Clin Phys Physiol Meas*, 13(Sup A):185–189

Delannoy, J., Le Bihan, D., Hoult, D. and Levin, R., (1990), 'Hyperthermia system combined with a MRI unit' *Unit Med Physics*, 17:855–860

d'Errico, M. S., Douglas, B. L. and Lee, H., *PIERS' 93 Proc*, (1993), 'Synthetic aperture microwave imaging and its applications to nondestructive evaluation of civil structures', 76, Jet Propulsion laboratory, Pasadena

Gautherie, M., (1987), 'Rapport d'expérimentation', *TEP Procedure Hyperthermia, Contract GBM n°84012, Final Report*, Laboratoire de Thermologie Biomédicale, Université Louis Pasteur, Strasbourg

Guerquin-Kern, J. L., Gautherie, M., Peronnet, G., Jofre, L., Bolomey, J. Ch., (1985), 'Active tomographic imaging of isolated, perfused animal organs; influence of temperature', *Bioelectromagnetics*, **6**:145—156

Henriksson, H., (1993), Private communication

Jacobi, J., H., Larsen, L., E. and Hast, C. T., (1979), 'Water immersed microwave antennas and their applications to microwave interrogation of biological targets', *IEEE Trans.*, **MTT-27**, 1:70–78

Jacobi, J. H. and Larsen L. E., (1980), 'Microwave time delay spectroscopic imagery of isolated canine kidney', *Med. Phys.*, **7**, 1:1–7

Joachimowicz, N., Pichot, C. and Hugonin, J. P., (1991), 'Inverse scattering: an iterative numerical method for electromagnetic imaging', *IEEE Trans.* **AP-39**, 1742–1752

Joachimowicz, N., Bolomey, J. Ch., Pichot, C., Franchois, A. Hugonin, J. P., Garnero, L., Gaboriaud, G., (1991), 'Quantitative microwave tomography for noninvasive control of

hyperthermia: preliminary results', *J. Photographic Sci.*, **39**, 149–153

Joachimowicz, N., Bolomey, J. Ch. and Pichot, C., (1992), ' A non-linear reconstruction algorithm for quantitative microwave tomography' *Process Tomography*, 164–166 (eds M. S. Beck, E. Campogrande, M. Morris, R. A. Williams, R. C. Waterfall), UMIST, Manchester

Joachimowicz, N., Franchois, A., Joisel, A., Bolomey, J. Ch. and Pichot, C., (1993), 'Quantitative imaging for the 2D scalar and 3D vectorial cases: reconstructions from simulated and experimental data', *PIERS* 93 *Proc*, 80, Jet Propulsion Laboratory, Pasadena

Joisel, A., Bolomey, J. Ch., Gaboriaud, G., Lagendijk, J. and van Dijk, J., (1992), 'The impact of active microwave imaging on the control of deep hyperthermia treatmens', *6th Int. Conf. Hyperth. Onc. Proc*, 206, (ed. E. W. Gerner), Arizona Board of Regents

Lagenkijk, J. and de Leeuw, A., (1986), 'The development of applicators for deep-body hyperthermia', *Recent Results in Cancer Research*, **101**, 18–35, (eds G. Bruggmoser, W. Hinkelbein, R. Engelhardt, M. Wannenmacher), Springer-Verlag, Berlin

Larsen L. E. and Jacobi J. H., (1982), 'Microwaves offer promise as imaging modality', *Diagn. Imag. Clin. Med*, **11**:44–47

Le Bihan, D., Delannoy, J. and Levin, R., (1989), 'Temperature mapping with MR imaging of molecular diffusion: application to hyperthermia', *Radiology*, 171:853–857

Lhiaubet, C., Cottard, G., Ciccotelli, I., Portala, J. F., Bolomey, J. Ch., (1992), 'On-line control in wood and paper industries by means of a rapid microwave linear sensor', *Proc 22nd European Microwave Conference*, Espoo, **2**, 1037–1040, Microwaves Exhibition and Publishers, Kent

Miyakawa, M. (1988), 'A study of the permittivity of biological tissues', *Jap. J. Hyperthermic Oncology*, 4:306–315

Miyakawa, M., (1991), 'Tomographic imaging of temperature change in a phantom of human body using a chirp radar-type microwave tomograph', *Med. Biol. Eng. Comput*, **29**, 2:745–752

Mizushina, S., Shimuzu, T. and Sugiura T., (1992), 'Noninvasive thermometry with multifrequency microwave radiometry', *Front Med. Biol. Eng.*, **4**, 2:129–133

Nyfors, E. and Vainikainen, P., (1989), *Industrial Microwave Sensors*, Artech House, Norwood

Peronnet, G. Pichot C., Bolomey J. Ch., Jofre L., Izadnegadhar, A., Szélès, C. Michel, Y., (1983), 'A microwave diffraction tomography system for biomedical applications', *13th European Microwave Conference Proc.*, 529–533, Microwaves Exhibition and Publishers, Kent

Pichot, C., Jofre, L., Peronnet, G., Bolomey, J. Ch., (1985), 'Active microwave imaging of inhomogeneous bodies', *IEEE Trans.*, **AP-33**, 4:416–425

Pichot, C. and Trouillet, P., (1991), 'Diagnosis of reinforced structures: an active microwave imaging system', NATO workshop on Bridges-ASCE Structures, Baltimore, April 90, Evaluation, ed. A. S Nowak, Kluwer, Academic Publishers, Dordrecht

Portala, J. F. and Bolomey, J. Ch., *PIERS*' 93 *Proc*, (1993), 'Comparison between inverse scattering and neural network approaches: application to microwave inspection of wooden materials', 75, Jet Propulsion Laboratory

Rius, J. M., Ferrando, M., Jofre, L., de los Reyes, E. and Broquetas, A., (1987), 'Microwave tomography: an algorithm for cylindrical geometries', *Electron Lett*, **23**, 11:564–565

Rius, J. M., Pichot, C. Jofre, L. Bolomey, J. Ch., Joachimowicz, N., Broquetas, A., Ferrando, M., (1992), Planar and cylindrical active temperature imaging', *IEEE Trans. Med. Imaging*, **11**, 4:457–469

Saito, M. Sano, T. and Itoh, T., (1988), 'Possibility of temperature monitoring by X-ray CT,, Symp Equipt Cancer Therapy, AIST/MITI/JETRO, Tokyo

Ueno, S., Fukukita, H., Yano, T., Miyakawa, M., Kanai, H., Egawa, S., (1990), 'Noninvasive thermometry system using ultrasound nonlinear phenomena', *Jap. J. Hyperth. Onc.*, **6**, 4:402–411

Yamaura, I., (1987), 'Non-invasive thermometry using microwave transmission CT', *Automedica*, **8**, 4, 233–246

Chapter 10

The development of optical systems for process imaging

R. G. Jackson

10.1 Introduction

The use of optical techniques for gathering information on the production process has a long history. From early times visual inspection of the fermentation process, for example, in terms of its colour, clarity and gas hold-up, has been one of the main techniques for determining the state of the process and of its quality. In recent times several of the ways in which matter interacts linearly with light have been used to examine process parameters or flow fields. Examples of applications of these phenomena are described briefly below. Some of these applications use tomographic techniques.

The *absorption* of light is a simple but cost-effective technique used in instrumentation systems. The advent of infra-red laser diodes providing narrow beams and a power of order of 0.1 W has enabled appropriate detectors to produce a signal of a reasonable size even after passing through tens of centimetres of an absorbing medium. The wavelengths available permit matching to an absorption/transmission window in, for example, aqueous solutions, crude oil and some solvents. Koop *et al.* (1979) have described the measurement of interfacial waves in an immiscible mixture of water in kerosene using near-infra-red radiation (910–975 nm). Santoro *et al.* (1981) have used the absorption of He–Ne laser light at 339 nm for the measurement of air methane concentrations in a free turbulent jet. The purpose of this flow field study was to provide a preliminary assessment of the utility of multiangular absorption techniques for combustion diagnostics. A convolution-type tomographic reconstruction was used on 12 projections recorded at 15° intervals. Various heights within the jet were examined. The number of sampling points per projection varied between 81 distant from the burner to 101 close to the burner exit. Graphs were produced for cross-sections of the jet at the different heights.

The *diffraction* of light by particles the size of which is comparable to the wavelength of the light is a well-known technique for particle sizing. Recently, the non-computational technique of optical filtering has been applied to aid discrimination. Chittenden (1986) has used an optical Fourier transform technique for the pre-processing of the diffracted light from water droplets in a vapour.

Reflection/refraction are the common modes by which illuminated objects affect the incident light to become visually apparent. These phenomena also enjoy widespread use in process instrumentation. The optical so-called

'dip-stick' combines reflection and refraction effects, the proportion being set by the depth of liquid surrounding the partially immersed transparent rod.

Measurement of the size of a falling droplet has been reported by Hayashi and Karakama (1990) using a He–Ne laser and a CCD (charge coupled devices) camera. Ray tracing analysis was used to relate the bright spots produced from the two sides of the droplet, when illuminated orthogonally, to the actual droplet diameter.

Hanzevack *et al.* (1987) have used the 'light sheet' technique to study two-phase flow. A sheet of light from a pulsed dye laser oriented orthogonal to flowing kerosene illuminates tiny droplets of water as they pass before a camera mounted mutually orthogonal to pipe and laser. The light sheet can be steered to different horizontal planes in the flow, and image-processing software is used to determine droplet-size distributions.

Infra-red *emission* has been used by Uchiyama *et al.* (1985) to flame temperature distribution. They measured infra-red intensities in the 1–2 μm wavelength band (from a methane/air laminar flame) using a photoconductive sensor. A tomographic convolution-type reconstruction technique was used with 30 projections over 180°, having 96 samples per projection. Temperature profiles measured using a thermocouple were in fairly good agreement with the tomographic results. Limitations were stated as due to flame flicker, infra-red absorption by the flame, and imperfect collimation which affects the quality of the line integrals.

Hertz (1985) has used *interference* to study flame temperature distribution. The physical phenomenon used was the variation in refractive index with temperature. A Mach–Zehnder interferometer produced fringe patterns due to the interference of light beams from a He–Ne laser. The laser light was split into two: one portion going through the flame mounted on a turntable, and the other was a reference. The detector was an array of 1024 photodiodes and eight projections were taken. The temperature distribution was reconstructed tomographically using an ART-type algorithm. The limitations in this investigation were said to be due to flame flicker, smoothing between projections, and the lens effect of the flame.

Snyder and Hesselink (1985) have used holographic optical elements to produce an interferogram of a test object having a refractive index with slight graduation. The test object (a Pyrex rod in a liquid of similar refractive index) is a preliminary for high-speed flow field diagnostic studies such as used in aerodynamics or combustion. Ten interferograms were produced by rotating the object through 360°, which effectively provided five different projections. A one-dimensional Fourier transform was performed on the interferogram after it had been digitized to a width of 360 pixels. The phase information was extracted from the Fourier transform and plotted against width. Linear interpolation was then used to produce 100 projections over 180° from the five original projections. The convolution back-projection technique was used to provide a tomographic reconstruction. Although fairly good results were obtained here and by Hertz (1985), the use of interference tomography is limited to object fields where optical path lengths do not vary by more than a few wavelengths.

Holography, first proposed by Gabor in 1949, is a technique for recording and reconstructing light waves. To record a wave its amplitude and phase must be stored, which is not possible on film or sensors as these only record intensity. However, by using a reference beam with the object beam to produce an interference pattern at the detector, phase and amplitude information can be stored. If the detector is a photographic plate, the recorded interference pattern can be used as a diffraction 'grating' so that when illuminated by the reference beam the original object beam, with its particular phase and intensity distribution is reproduced. For a treatise on holography, see Vest (1979).

Lee and Kim (1986) have reviewed the use of holography in multi-phase flow visualization. The two significant features of holograms that exceed the capabilities of conventional photographs are that:

- The three-dimensional image is effectively providing extra projections.
- The resolving power is increased from $r^2/2\lambda$ to rW/λ, where r is the radius of a particle, W is the diameter of the hologram, and λ the wavelength of the incident beam.

The advantages of holograms over diffraction techniques are that particle sizing by diffraction cannot differentiate between particle types or cope well with non-spherical disorientated shapes. At present, holography is the only technique by which high-resolution images of particles in a dynamic field can be produced.

10.2 Optical tomography rationale

10.2.1 The use of optical techniques

In Section 10.1 optical phenomena and some applications to process and flow measurement were described. The advantages of using light are:

- The technique is non-intrusive.
- Response times are negligible.
- Small wavelengths can potentially provide high resolution.
- The propagation of light through media can be functionally described.
- Emitters and detectors for various absorption/transmission windows are readily available.
- Measurements are immune to electrical noise/interference.
- At low light energies it is intrinsically safe.

The disadvantages of using light are:

- Many materials forming the object field are opaque either due to absorption or multiple scattering.
- When considering applications in the process industries many reactors and pipes cannot be made of transparent materials or be permitted to have a window or lead-throughs for safety reasons. However, theoretical modelling

for reactors, fermenters or multi-component flows could be validated empirically in the laboratory using transparent vessels.
- With inhomogenous fields multiple reflection/refraction may make a functional interpretation of the received projection very difficult.

10.2.2 The use of tomographic reconstructions obtained with optical techniques

Given that optical sensing is an appropriate technique for a particular investigation, the question remains as to whether the subsequent data should be processed tomographically.

Uchiyama *et al.* (1985) point out that the use of thermography is an inappropriate technique for measuring the temperature distribution in flames as the emitted infra-red radiation received by the sensor is the line integral of the emitted radiation along the optical path. This is of course the case generally when a ray of light is transmitted through any object field the receiver produces a signal dependent on the line integral of interactions occurring along the line. However, this is the required feature for tomographic reconstructions based on the two-dimensional transform put forward by the German mathematician Johann Radon in 1917 (Chapter 15). For a treatise on the Radon transform, see Deans (1983).

The conditions that need to be satisfied to enable this type of tomographic reconstruction to be employed are that:

- The sensor is receiving light from a line integral through the object field of a path which is determinable.
- Many such line integrals can be measured for a given projection through the object field.
- A number of projections around the object field each containing many line integrals are possible.

Optical sensing modalities that can fit these criteria include:

- Scattering/absorption of light by the object field.
- Reflection of light into or out of the line integral by tiny bubbles or particles.
- Emission of light from points within the object field.
- Slight variation in the optical path length through the object field due to pressure or temperature effects.

Some examples of such techniques have been illustrated in Section 10.1 (see also Chapter 11).

It is also possible to use tomographic techniques on diffracted beams. Diffraction will occur when fine structural detail within the object field has dimensions similar to that of the wavelength of the light. However, such conditions are unlikely to be met in process applications.

10.2.3 Optical tomography, light sheets and holography

The potential effectiveness of optical tomography needs to be compared to other techniques which can provide similar information.

The light-sheet technique uses reflected light and has enjoyed widespread use in combustion studies for illuminating smoke particles. A camera is mounted obliquely to the light sheet to record the illuminated plane of the object field. However, the technique is not so effective if dense clouds obscure the camera; multiple reflections within the cloud diffuse the light. In multi-component flow the highly curved highly reflecting surface of a bubble can send relatively intense beams of light sweeping into other parts of the flow field and the camera as it passes through the light sheet. Strong refractions can also occur and although both phenomena can be functionally described by geometrical optics the randomness of their size, speed and occurrence make the task of image processing very difficult. The potential advantage of tomography is due to the use of multiple projections which are providing sets of data from different views and, therefore, it is more likely that the problems of multiple reflections and refraction will be overcome. In addition, since the sensing path is orthogonal to the flow, it is effectively shorter, and with good collimation many spurious rays can be prevented from reaching the receivers. Effectively the three-dimensional geometry is restricted to two dimensions.

Holography is also a technique in widespread use for combustion studies and bubble dynamics in two-phase flow (see the review article by Lee and Kim (1986)). However, the same problems can arise, as discussed for the light sheet– obscured views and confused light paths due to multiple reflections and refractions producing a degraded image. This has led Trolinger and Field (1980) to suggest that light-sheet holography may help to extend the useful range over that of the normal hologram. Deason (1982) has concluded that, in bubbly flow when a maximum void fraction of 0.2 is attained, holographic image quality is too poor to be useful apart from imaging bubbles near the pipe wall. It should be possible to improve on these limitations again because optical tomography uses multiple projections. A further benefit is that in optical tomography there is no requirement for highly specialized optical components, as with holography, to improve depth of field. In addition, the requirement in holography that optical path lengths remain stable to $\lambda/8$ has, in practice, meant the use of expensive Q-switched lasers, providing 20–50 ns pulse lengths, to overcome the problem of vibration in the optical component mountings. These pulses need to be repeated within a very short time period if high-speed sequences are to be recorded by cinematography for flow studies. In optical tomography more conventional light sources and optics together with algorithms maximized for parallel computer architectures should be able to produce low-resolution images within several tens of milliseconds. A further advantage optical tomography has is in the recording and subsequent processing of the data. Holography requires a photographic technique for the recording of the optical data. Any subsequent processing of the reconstructed image, such as examining particle distributions, is usually done manually. With optical tomography the reconstructed image is already in RAM or some

binary file and any appropriate image processing can be carried out on this directly.

10.3 Reconstruction algorithms

Other than the simple 'layergram' where the projections are back-projected and stacked on top of each other in the image plane, there are two general approaches to choose between when designing an algorithm to reconstruct an image from projections. Factors which will influence the choice include:

- Whether parallel (or fan) beams are to be used in sets of projections, and their number.
- The computational power available in terms of memory size and speed of retrieval and processing, especially if near-real-time images are desired.

Kak and Slaney (1988) have produced a well-written book describing the different approaches, and their applications and limitations.

10.3.1 Algebraic reconstruction techniques

The cross-section through the object field is considered as a matrix of n unknowns or cells (Figure 10.1). The line integral is the sum of the effects of each cell traversed. So the intensity I_1 of the light beam reaching detector d_1 is

$$I_1 = w_{11}f_1 + w_{12}f_2 + w_{13}f_3 \ldots w_{1n}f_n$$

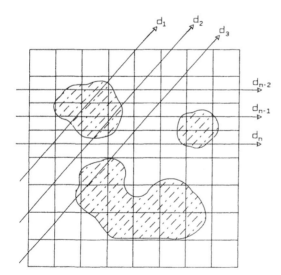

Figure 10.1 *A section through the object field*

$$= \sum_i^n w_{1i} f_i$$

where f_i is the local value of the object field $f(x,y)$ at the ith cell, and w_{1i} is the weighting factor which relates the proportion of the ith cell being interrogated by the beam, the beam having a finite width. Most cells will of course not be interrogated by a particular beam and so have a zero weighting factor.

Considering all M beam paths

$$I_j = \sum_i^n w_{ji} f_i$$

where $j = 1, 2, \ldots, M$. When designing the configuration of the optical components these M beams may be subgrouped into sets of projections, but this is not a requirement for the calculations. However, some iterative algorithms work through projection by projection.

For the special case of attenuation of a beam by a medium an exponential law is followed

$$I_1 = I_0 \theta^{-\mu x}$$

where I_0 is the intensity of the emitter, x is the path length, and μ is some attenuation coefficient. The value of μ will vary and can be used as the equivalent of $f(x,y)$, $\mu(x,y)$ the attenuation per cell. The exponent can therefore be written

$$-\sum_i^n w_{1i} \mu_i$$

Taking natural logarithms gives

$$\ln(I_1/I_0) = -\sum_i^n w_{1i} \mu_i$$

showing that the same algebraic equations can be produced, provided the data are preprocessed logarithmically.

The solving of these sets of equations to determine the f_i values at first appears as a straightforward matrix-inversion problem. However, three problems present themselves:

1. The number of beams needed will be the same as the number of cells ($M = n$). Consequently, the number of w_{ji} values will be n^2 which could be large even for a moderately resolved image. For example, if the cross-section through object space is considered as a grid of 64 × 64 giving 4096 cells, 16 777 216 w_{ji} values need to be determined and stored.
2. For situations where there are more unknowns than equations ($n > M$), conventional matrix inversion is not possible.
3. If the data recovered suffer from the usual empirical limitations due to random fluctuations and noise, an exact solution will not be possible.

The latter two problems can be overcome by using a 'least-squares' iterative

approach, but only if n is not too large. It may be that in a particular process tomography application high resolution is not needed, in which case the three problems listed may be overcome.

This has not been the situation in medical computed tomography (CT) where high resolution is paramount. Progress has been made in recent decades by reconsidering the problem as a set of intersecting hyper-planes in n-dimensional space. Kak and Slaney (1988) illustrate the details, with references. Again an iterative technique is employed which adjusts the f_i values by comparing the computed beam intensity with the actual intensity measured. The simplest algebraic reconstruction technique (ART) algorithm updates each f_i value of the cells intersected by a beam from a particular projection set. This leads to 'salt-and-pepper noise' in the image being exacerbated because previously upgraded f_i values could be re-adjusted again when the next beam from the same projection set is considered. The slower simultaneous iterative reconstructive technique (SIRT) algorithm reduces this problem by only updating the f_i values after all the calculations for all the beams are complete, then beginning the next iteration. 'Salt-and-pepper noise' occurs due to the approximations used in determining the weighting coefficients. As mentioned above, to store such values is a colossal task, so these are often calculated in real time. One simple approach is to use 1s or 0s for weighting, depending on whether the cell has been intersected by the beam or not.

The simultaneous algebraic reconstruction technique (SART) algorithm, in a similar way to SIRT, only updates the f_i values after the corrections for a complete projection have been determined. The additional features in SART include the use of a Hamming filter on the corrections and the use of a bilinear (pyramidal) weighting function on groups of pixels in the image. In the excellent review article by Brooks and Di Chiro (1976), a comparison is made of the number of multiplications required for the different algorithms:

Algorithm type	No. of multiplications
Matrix inversion	Mn
Iterative least-squares technique	$4Mm$ per iteration
ART	$4Mm$ per iteration
SIRT	$4Mn$ per iteration

where m is the number of beams per projection. Typically, 5–10 iterations are used.

For a comparison with the SART algorithm, see Andersen and Kak (1984).

10.3.2 Frequency space techniques

The original EMI medical CT scanner patented in 1972 used the ART algorithm because of its speed compared to the other algebraic techniques, (see Hounsfield (1972)). However, as data-gathering speeds increased, the need to produce faster algorithms has meant that later developments in the

field have been based on frequency space techniques, notably the 'filtered back-projection' method. The restriction imposed on an optical system in order to use frequency space techniques is that the rays are straight and equally spaced; the rays are usually parallel, although fan beams can be used.

The frequency space techniques are based on $F(k_x,k_y)$, the two-dimensional Fourier transform of $f(x,y)$:

$$F(k_x,k_y) = \int_{-\infty}^{\infty} \int_{-\infty}^{\infty} f(x,y)\exp[-2\pi j(k_x x + k_y y)]dxdy$$

and, conversely,

$$f(x,y) = \int_{-\infty}^{\infty} \int_{-\infty}^{\infty} F(k_x,k_y)\exp[2\pi j(k_x x + k_y y)]dk_x dk_y$$

where k_x and k_y are the wavenumbers.

In order to make the derivation below easier to follow, we will consider the special case of the Fourier transform along the line in k space corresponding to $k_y = 0$ (the k_x axis):

$$F(k_x, k_y = 0) = \int_{-\infty}^{\infty} \int_{-\infty}^{\infty} f(x,y)\exp[-2\pi j(k_x x)]dxdy$$

$$= \int_{-\infty}^{\infty} \left\{ \int_{-\infty}^{\infty} f(x,y)dy \right\}\exp[-2\pi jk_x x]dx$$

The term in brackets is the line integral of $f(x,y)$ along a line of constant x. Adding up all such line integrals throughout the range of x gives the 'projection' $p_\theta(x)$ at the given angle $\theta = 0°$, θ being the angle of the projection to the x-axis (Figure 10.2):

$$p_{\theta=0}(x) = \int_{-\infty}^{\infty} f(x,y)dy$$

$$F(k_x,k_y) = \int_{-\infty}^{\infty} p_{\theta=0}(x)\exp[-2\pi jk_x x]dx$$

Clearly this result cannot depend on the orientation of the object field to the co-ordinate system, so a more general result can be expressed as:

$$F(k_x,k_y) = \int_{-\infty}^{\infty} p_\theta(r)\exp[-2\pi jkr]dr$$

The term k is the frequency space line corresponding to the real-space line r having an orientation θ. Thus:

$$F(k_x,k_y) = P_\theta(k)$$

where $P_\theta(k)$ is the Fourier transform of $p_\theta(r)$.

This is an important result known as the *Fourier slice theorem*. Referring to Figure 10.2, the theorem states that the Fourier transform of a projection $p_\theta(r)$ through the slice a–a in real space is a line A–A in the two-dimensional

Figure 10.2 *A projection of a slice through the object field transformed into* k *space*

frequency space at the same orientation θ. (Note that a rotation of the co-ordinate system in real space produces an identical rotation in frequency space.)

The reader may be interested to observe that the family of projections $p_\theta(r)$ is the two-dimensional Radon transform mentioned in Section 10.2.2.

To implement these frequency space concepts, data will be provided from the detectors at discrete points across a projection $p_\theta(r)$. The transform integrals effectively become discrete summations. The most efficient algorithm developed in recent years for Fourier transformations is the fast Fourier transform (FFT). A consequence of using a FFT is that the detectors must be equally spaced across $p_\theta(r)$.

The FFT will produce a set of discrete frequencies up to some maximum k_{max}. Now, from the Shannon–Nyquist sampling theorem, we know that a time-domain signal must be sampled at least twice the frequency being measured. The corollory applies with spatial frequencies. Thus if the detectors

across $p_\theta(r)$ are spaced s apart we have a sampling frequency $1/s$. This spatial sampling frequency must, therefore, be at least twice k_{max}:

$$1/s \geqslant 2k_{max}$$

Undersampling results in aliasing which appears as streaks and Moiré patterns. Undersampling can occur in two ways, as can be seen by referring to Figure 10.3. Too few detectors results in undersampling along the radii. Too few projections results in angular undersampling, which is most significant along the circumference. To keep the artefacts from the two effects to the same order, the number of sampling points per projection should be similar to the number of projections. Kak and Slaney (1988: p. 178) have a set of reconstructions illustrating the effects of different sampling régimes.

Another type of artefact can appear because a limited Fourier series is being used from which to reconstruct the final image. The effects here are due to the Gibbs phenomenon. These appear as graded streaks near discontinuities.

The use of beams of finite widths tends to lessen the severity of these artefacts in practice. 'Wide' beams reduce the sharpness of discontinuities, acting effectively as a high-frequency filter.

There are two main methods by which frequency space techniques can be implemented:

1. *Two-dimensional Fourier reconstruction* One-dimensional Fourier transforms are taken of projections $p_\theta(r)$ and a matrix of values built up in two-dimensional frequency space. As can be seen in Figure 10.3, the

Figure 10.3 *Values in* k *space are produced on a polar grid. Interpolation is needed to produce values on a Cartesian grid*

one-dimensional FFT values produce a polar grid of points. Unfortunately, to perform the inverse two-dimensional FFT on all these values a Cartesian grid is required. An interpolation algorithm is therefore needed.

2. *Filtered back-projection* The concept here is an extension of the simple 'layergram'. In the layergram the projections are back-projected onto the image plane and overlayed. This crude method produces star artefacts in the image. Kak and Slaney (1988) show that the problem arises because a polar co-ordinate system is being used to produce data, which has the effect of underweighting the higher frequency components. The Fourier coefficients need to be multiplied by $|k|$. This correction can be simply done as a multiplication in frequency space or as a convolution in real space. As in the previous method, interpolation is needed in the image plane, but this is now done after taking one-dimensional inverse FFTs of each projection (or after calculating the convolutions of each projection). The interpolation is one dimensional.

Brooks and Di Chiro (1976) have produced estimates for the number of multiplications required for these two techniques.

Algorithm type	*No. of multiplications*
Two-dimensional Fourier reconstruction	$1.3(\log_2 m)^2 n$
Filtered back-projection	$\simeq n \times$ No. of projections

The filtered back-projection technique is seen to be computationally the fastest, especially since the one-dimensional FFTs and their inverses can be done sequentially or shared between processors. The interpolation algorithm is usually the limiting feature.

10.3.3 Comparison of reconstruction techniques

The factors that affect the choice of reconstruction technique were indicated at the beginning of Section 10.3. To conclude, we can summarize the advantages of using an algebraic technique:

- The line integrals need not be taken along uniformly spaced straight lines, which enables refraction or other object field distortions to be taken into account, provided of course the paths are known and fixed.
- The spacings between detectors need not be uniform.
- The grouping of beams together into sets of projections is not required in the SIRT algorithm.
- The cells forming the matrix in the object field need not be uniform in size or distribution.

The disadvantage of an algebraic reconstruction technique is that for large n (high resolution) the calculations become cumbersome. A crude comparison can be made of the relative speeds by using the estimates quoted above of the numbers of multiplications for the two approaches:

$$\frac{ART}{Filtered\ back\text{-}projection} = \frac{4Mm\ \text{per iteration}}{n \times \text{No. of projections}}$$

If we assume the object field is divided up as a square matrix of side m, then $m^2 = n$. Also, $M = m \times$ No. of projections, giving:

$$\frac{ART}{Filtered\ back\text{-}projection} = 4\ \text{per iteration}$$

Thus the ART algorithm, the fastest of the algebraic techniques, could be 20–40 times slower than the fastest frequency space technique, depending on the number of iterations used. Clearly then, if near-real-time images are desired the filtered back-projection technique is the best choice, provided the more restrictive criteria for its implementation can be met. However, if only a crudely resolved image is required of a simple object field, then a small number of projections may suffice with an iterative algebraic technique, whereas with the same few projections any frequency space technique would require extensive interpolation/image processing to reduce artefacts.

References

Andersen, A. H. and Kak, A. C. (1984) Simultaneous algebraic reconstruction technique (SART); a superior implementation of the ART algorithm. *Ultrason. Imaging*, **6**, 81–94

Brooks, R. A. and Di Chiro, G. (1976) Principles of computer assisted tomography (CAT) in radiographic and radioisotopic imaging. *Phys. Med. Biol.*, **21**, 689–732

Chittenden, A. M. I. (1986) A real-time laser scattering device for particle sizing and particulate mass concentration. *Test and Transducer Conference*, Trident International Exhibitions Ltd, Wembley, London

Deans, S. R. (1983) The Radon Transform and some of its Applications. Wiley, Chichester

Deason, V. A. (1982) Applications of Holography and Holographic Interferometry at the INEL. *EGG-ID-5693*, EG&G Idaho, Inc., Idaho

Hanzevack, E. L., Bowers, Jr., C. B. and Chi-Hong, Ju (1987) Study of two phase flow by laser image processing. *AIChe*. **33**, 2003–2007

Hayashi, K. and Karakama, T. (1990) Droplet size measurement with linear charge coupled device camera. *J. Nucl. Sci. Technol.*, **27**, 295–306

Hertz, H. M. (1985) Experimental determination of 2D-flame temperature fields by interferometric tomography. *Opt. Comm.*, **54**, 131–136

Hounsfield, G. N. (1972) A method of and apparatus for examination of a body by radiation such as X-ray or gamma radiation. *Patent Specification* 1283915, The Patent Office, London

Kak, A. C. and Slaney, M (1988) *Principles of Computerised Tomographic Imaging* IEEE Press, New York

Koop, C. G., Rungaldier, H. and Sherman, J. D. (1979) Infra-red optical sensor for measuring internal interfacial wave motions. *Rev. Sci. Inst.*, **50**, 20–23

Lee, Y. J. and Kim, J. H. (1986) A review of holography applications in multiphase flow visualisation study. *J. Fluid. Eng.*, **108**, 279–288

Santoro, R. J., Semerjian, H. G., Emmerman, P. J. and Goulard, R. (1981) Optical tomography for flow field diagnostics. *Int. J. Heat Mass Transfer*, **24**, 1139–1150

Snyder, R. and Hesselink, L. (1985) High speed optical tomography for flow visualisation. *Appl. Opt.*, **24**, 4046–4051

Trolinger, J. and Field, R. (1980) Particle field diagnostics by holography. *AIAA Paper No. 80-0018* AIAA 18th Aerospace Sciences Meetings, Pasadena, CA

Uchiyama, H., Nakajma, M. and Yuta, S. (1985) Measurement of flame temperature distribution by IR emission computed tomography. *Appl. Opt.*, **24**, 4111–4116

Vest, C. M. (1979) *Holographic Interferometry* Wiley, New York

Chapter 11

Design of an optical tomography system

A. J. Hartley, P. Dugdale, R. G. Green, R. G. Jackson and
J. Landauro

11.1 Introduction

The system developed at Bolton Institute (Dugdale *et al.*, 1990, 1991) has, as
its basic element, an optical transducer pair consisting of a GaAs infra-red
light-emitting diode (Siemens SFH401 lll) and a sensing photodiode (silicon
PIN Siemens BP104). Pulses of infra-red light are generated from the emitter
and optically configured to form a collimated beam incident on the vessel
containing the process of interest. The photodiode is aligned opposite the
emitter and senses the beam after transmission through the process vessel
(Figure 11.1). The peak voltage generated by the sensor is related to the degree
of attenuation and thus to the relative proportion of the two different
components in the process traversed by the beam.

A number of transducer pairs can be arranged in different configurations
around a cross-section of flow pipe. For development purposes a dry section of
pipe is used in which phantom models can be investigated. This is identical to a
pipe on a flow rig which is capable of generating two-phase flow regimes from
a combination of liquid and pressurized gas. After signal conditioning the
analogue output voltages from the sensors are converted into digital form and
passed into a transputer system (Chapter 14). These output signals contain
information on the relative proportions of the process components along
different lines through the flow-pipe cross-section. This information is then

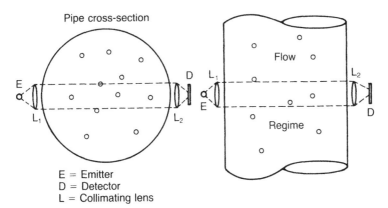

Figure 11.1 *Cross-section of a pipe, showing optical coupling*

interpreted by suitable software algorithms in the transputer system to obtain the positions of the component boundaries.

This optical approach to process tomography has the advantages of being conceptually straightforward and relatively inexpensive. Good spatial resolution of down to 1 mm is possible using the approach adopted in Bolton, which is an improvement of an order of magnitude on methods using electric fields. This is achieved using recent developments in small lenses and semiconductor-based emitters and detectors. Temporal resolution is also good. In the present system electronic driving circuitry has been developed which energizes the emitters with a pulse of approximately 25 μs duration. This short pulse allows a high current of 1 A to be applied, producing sufficient intensity of radiation to penetrate flow regimes in the laboratory flow rig. The peak value of the detected signal, from the corresponding sensor, is stored. The hardware system is constructed to take 64 of these detected values from successive transducer pairs around a cross-section into the transputer system in 200 μs. Modern developments in digital signal processing, such as the transputer, enable these data to be analysed rapidly. These features of optical tomography make it especially suited to real-time calibration of the various electrical methods.

A requirement for effective use of the system is a degree of optical clarity, and this constitutes the principal limiting factor on its usefulness. Reflections from high numbers of small bubbles or particles lead to significant information loss, and work is underway in Bolton to quantify this effect. In general, the technique is suitable for fast-moving flows and processes with low numbers of bubbles.

Each emitter–detector pair is termed a 'view' and the views are arranged into parallel arrays known as 'projections' (Figure 11.2). The prototype system had two orthogonal projections with eight views in each, whilst the

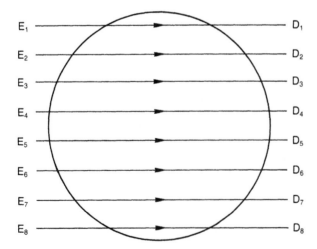

Figure 11.2 *An array of eight transducer pairs*

current system has 16 views in each projection. In theory, if there are n views in a projection, n projections in different directions through the cross-section are needed to obtain a uniquely defined image, since each view gives one piece of information and there are n^2 pixels. This is probably unrealistic in practice and considerations of cost, space and processing speed may preclude there being sufficient transducer pairs to obtain a unique solution to the reconstruction problem. However, it is anticipated that a full tomographic reconstruction will not be necessary in some applications. It will, for example, be sufficient to obtain bubble-size distributions rather than the position of each individual bubble. The relevant question then becomes: How many projections will give enough information to be useful? The answer is likely to be different for each application.

11.2 Optical transducer pairs

The optical approach to tomography requires an intense collimated beam. Selection of an appropriate emitter–detector pair and their optical coupling with appropriate lens arrangements is of crucial importance. Initial work was undertaken with the application of flow regime identification in the oil industry in mind. The system now in use was first developed to exploit the property of crude oil being semi-transparent at certain windows in the infra-red spectrum. This led to a choice of 950 nm as the peak spectral emission and detection of the transducers. For experimental work on the transducers, a single emitter–detector pair was constructed and the emitter pulsed for 6 μs with a current of 1 A for maximum radiation intensity. The sensor is operated in photoconductive mode in which it produces a voltage proportional to the intensity of light incident on it. Figure 11.3 shows the effect at the detector of pulsing the emitter for a time T with a positive voltage. The intensity of emitted radiation is proportional to the voltage applied. The

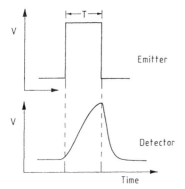

Figure 11.3 *Response of the detector to a pulse at the emitter*

corresponding detector produces an analogue voltage, as shown. The peak value of this detected pulse is recorded as it is inversely proportional to the amount of attenuation of the emitted radiation as it traverses the process vessel.

11.2.1 Emitter–detector pair

Selection of a transducer pair is made by taking into account the fact that the system is expected to have to operate under industrially demanding conditions. Durability, ruggedness, cost and size are the relevant considerations in this context. The tomographic requirements on the emitter are high radiant intensity and switching speed, since it is to be pulsed and real-time operation is required.

The most powerful and coherent light source is the laser, but this was considered inappropriate for prototype construction since the optical system required would be expensive and difficult to control. Laser diodes have the advantage of operating as small discrete components. However, they were rejected for a prototype system on grounds of cost, although they are now being investigated as their cost has fallen significantly. The current system has been based instead on the light-emitting diode (LED). Although this has lower intensity than the laser diode it has a number of useful features. It is easy to modulate the emitted light flux with the amplitude and frequency of the controlling signal. They are small, light, long lived, economical and run cool. They are designed to emit either from their surfaces (SLED) or their edges (ELED). Gallium arsenide (GaAs) is the main semi-conductor used for LEDs and the usual construction is of a homojunction (i.e. GaAs layers doped with silicon). Heterojunction LEDs (i.e. GaAIAs with two epitaxial layers doped with zinc and tellurium) are also available which have faster response and higher light output; however, for a forward current of > 20 mA and a pulse duration of > 3 μs they are not a significant improvement on the conventional homojunction devices.

The Siemens SFH 401 lll GaAs infra-red LED was selected for use in the system. This is of high efficiency, reliability, long life and emits a sufficient intensity of radiation in the near-infra-red region. In addition, it can be activated by d.c. or pulse operation in the forward voltage direction. It is housed in a T018 hermetically sealed package with glass lens. The spectral emission across the near-infra-red region is shown in Figure 11.4 (a) which shows the peak at 950 nm. Figure 11.4 (b) shows the high radiant intensity due to a narrow beam which forms a good basis for collimation.

Factors to consider when selecting the sensor are responsivity (output current for specified radiant power) at the required wavelength, noise limit (smallest signal that can be handled), speed of response, and leakage current. Semi-conductor detectors have faster response times and smaller leakage currents with small surface area. A further advantage is in ensuring high resolution in the tomographic image. Clearly the trade-off here is with the large sensitive area needed to give large output voltage. Photodiodes have been preferred to phototransistors. This is because, despite high responsivity,

Figure 11.4 *Characteristics of the LED. (a) Relative spectral emission versus wavelength. (b) Radiation characteristic – relative spectral emission versus half-angle*

phototransistors are relatively slow, have poor linearity and are temperature sensitive. The photodiode consists of a reverse biased p-n junction which, when exposed to photons of the appropriate energy, results in a photocurrent proportional to illumination. An improvement on this is the p-i-n photodiode with a sandwich structure including an intrinsic layer. This increases the speed of the device, improves its linearity and reduces its leakage current and noise. An amplifying device can be obtained by reverse biasing the p-i-n photodiode until it has a sufficiently strong electric field in its depletion layer to obtain avalanching. However, a reverse bias of several hundred volts is required, stable to within 0.1 V, thus making the sensor temperature dependent. Not surprisingly, this was rejected on the grounds of complication and expense.

In view of the above, a p-i-n photodiode sensor was employed; to match the SFH 401 lll emitter, the Siemens BP104 silicon photodiode was chosen. This is contained in a lead frame, black epoxy resin package with daylight filter. It has high reliability, low noise and high spectral sensitivity in the near-infra-red region. It also has low capacitance and hence a short switching time. Figure 11.5(a) shows the spectral sensitivity as a function of wavelength. Peak detection occurs at 950 nm corresponding to the peak emission from the emitter. Figure 11.5(b) shows spectral sensitivity versus sensor half-angle.

11.2.2 Emitter–detector electronics

The emitter is operated in pulse mode because it can handle a larger current and hence can generate a greater intensity of radiation. The maximum forward current of the emitter is determined by the duty cycle D which is the fraction of time for which the emitter is on. The prototype system was designed to have

Figure 11.5 *Characteristics of the detector. (a) Relative spectral sensitivity versus wavelength. (b) Directional characteristic – relative spectral intensity versus half-angle*

eight transducer pairs per projection and it is advantageous to pulse these sequentially to ensure detection of radiation from the corresponding emitter. This results in a duty cycle of 0.125. The pulse length must be sufficient to allow the detector to respond and generate a sufficient voltage. It must also be sufficient to allow time for the previous pulse to have been detected, passed through the signal conditioning circuitry into the analogue-to-digital converter (ADC), which has a maximum conversion time of 2 μs, and into the transputer network. On the other hand, it must not be so long that the cross-section of the process being measured will change while the transducers are being scanned. The prototype system used a pulse length of 6 μs, resulting in a time of 48 μs for pulsing the complete projection of eight views. The maximum flow rate of 10 ms$^{-1}$ results in a maximum movement of 0.06 mm during the pulsing of each transducer and 0.48 mm during the scanning of a single projection. For pulse lengths as short as this, the major determinant of maximum permitted forward current in the emitter is the duty cycle D. For $D = 0.125$ we have maximum current of approximately 2 A.

A Darlington configuration was used to provide sufficient current to the emitter (Figure 11.6). The controlling timing pulse is fed into the BC107. The RFP2N15L is an enhancement MOSFET which is able to cope with large currents at high frequency. The charge storage effects of the transistor have to be compensated for at the high frequencies used. The necessary resistive paths to ground are connected as shown in Figure 11.6. The 1 Ω resistor is for current

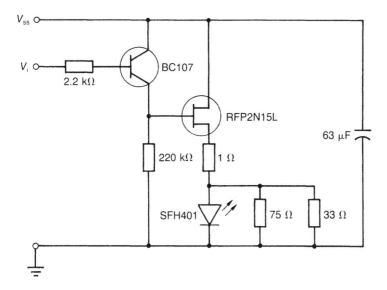

Figure 11.6 *The driving circuit for the emitter*

monitoring during development. The appropriate timing pulse voltage V_i to provide the emitter with a current within its maximum capability was determined by experimentally monitoring the various voltages in the circuit for different values of V_i.

The diode is used in reverse-biased photoconductive mode. A reverse voltage of 15 V increases the sensitivity of the diode producing a higher peak voltage during the pulse time. However, the voltage does not fall to the required ambient light level within 42 μs due to the capacitive nature of the diode. This can be rectified as follows. The photocurrent is made to produce a voltage across a biasing resistor R_b (Figure 11.7), which effectively forms a low-pass filter with the diode capacitance C for which cut-off frequency (f_c) is given by:

$$2\pi f_c = \frac{1}{R_b C}$$

A frequency of 1 MHz for f_c would be appropriate for a pulse length of 6 μs; for a reverse voltage of 15 V, diode capacitance is 7.5 pF at this frequency, so $R_b = 22$ kΩ. This allows the sensor output voltage to fall to the background level between emitter pulses.

A high value of R_b also produces a larger voltage and reduces the effects of thermal noise. The peak voltage generated is in the region of 10 mV from a sensor 15 cm from the emitter without optical coupling. Preamplification is

therefore necessary so that the signal detected is not degraded by subsequent noise. The preamplifier, which has a gain of approximately 20, is shown in Figure 11.7.

Initially an ultra-high-speed operational amplifier 5539 (slew rate 600 V μs^{-1}, 1.2 GHz BW, saturating at 2 V output, 15 V supply) was used to amplify the signal to detect all its features. In the final system this was substituted by a cheaper and less environmentally sensitive high-speed operational amplifier 6364 (slew rate 300 V μs^{-1}, 175 MHz BW, saturating at 13 V output, 15 V supply).

It is necessary to capture the peak voltage and hold it for approximately 2 μs for analogue-to-digital conversion. Variations in timing of a conventional sample-and-hold circuit would result in peak values being missed. To avoid this, a peak follower with reset was used (Figure 11.8). Amplifier A_1 drives capacitor C_1 to the highest point reached by the input waveform since the last

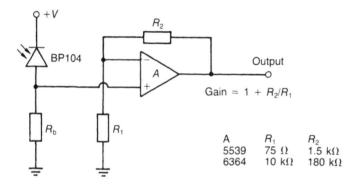

Figure 11.7 *The preamplifier circuit for the detector*

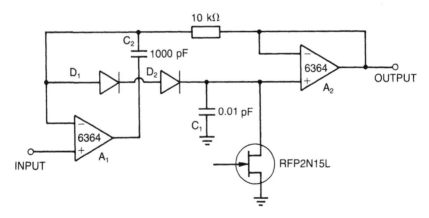

Figure 11.8 *The peak-follower circuit*

reset pulse applied to the gate of the MOSFET. The value of C_1 is a compromise between keeping it large enough to minimize loss of charge through the transistor and small enough for high-speed signals to be followed. The ultra-fast settling diodes D_1 and D_2 help ensure that amplifier A_1 does not saturate when the capacitor is holding the peak value of the input signal. Capacitor C_2 is for the feedback-loop stability.

11.2.3 Optical coupling

The radiation generated by the emitters is collimated into highly directional beams. This increases the intensity of radiation in the direction of the beam, it ensures that a particular sensor only detects light from its corresponding emitter, and it enables the use of reconstruction algorithms developed for medical X-ray tomography. Collimation also ensures that the detected optical intensity is dependent on the length of attenuating component traversed by the beam, and is relatively independent of the distance of the attenuating component from the source.

The half-angle of radiation emitted from the emitter is 15°, so that at a distance of 15 cm the radiation will be spread over an area of radius 4 cm. However, the radiant sensitive area of the sensor is approximately 4 mm². This divergence of the beam results in a loss of intensity at the sensor and a variation in intensity along the path through the process. Collimation is clearly necessary. This can be achieved by use of a plano-convex lens or a Fresnel lens. Fresnel lenses can be lighter and cheaper; however, they are only commonly available in diameters > 30 mm, which is too large for a beam diameter. Instead plano-convex lenses were used as they are available with small diameters, short focal lengths, and at relatively low cost. The lens chosen was 5 mm in diameter and of 10 mm focal length (Ealing Electro-optics 42000). This was large enough to encompass all the divergent radiation from the emitter with a short enough focal length not to distance the emitter too far from the walls of the process vessel. Unfortunately, the infra-red light from the LED has an oval wavefront. Anomorphic prisms are available which can convert this to a circular wavefront, but these are expensive. An alternative approach was adopted – the LED is placed behind a pin hole and this acts as a point source for the plano-convex lens. This results in some loss of intensity, but a satisfactory collimated beam of 5 mm diameter is produced. A second lens in front of the sensor could be used to focus radiation onto its sensitive area. However, adequate results have been obtained without the use of this second lens. With optical coupling the peak detected voltage is approximately 500 mV with the sensor and emitter installed 15 cm apart across a 12 cm diameter pipe filled with air and the emitter pulsed for 6 µs. Insertion of water between the sensor and emitter attenuates the beam by approximately a factor of 2 for each 3 cm of water. The absorption is Lambertian so the intensity is reduced by a factor of 16 for a pipe full of water.

Care must be taken with the arrangement of transducer pairs in parallel arrays on a pipe. Ideally, we require the beams in an array to be equidistant

within the pipe. However, for non-diametrically opposed transducer pairs, the curved glass surface refracts the beam towards the centre of the pipe. The effect is increased the further one moves from the diameter. The transducers are offset accordingly outside the pipe; the separation of the outer transducers in an array being greater than that of the inner members.

11.3 Data-acquisition electronics

In order to minimize the system complexity and cost, the outputs of several sensors are multiplexed (Dugdale *et al.*, 1992). This allows the use of a single signal-conditioning and transputer interface circuit (Figure 11.9). The emitter of one pair is pulsed for time T (6 μs initially) and the corresponding sensor read. This is then repeated for the adjacent transducer pair, and so on, until the whole array has been operated. The detected signal from each detector is passed into a preamplifier which is close to the sensor to minimize noise, and then passed into a corresponding channel of the multiplexer. The output from the multiplexer consists of a series of analogue peaks representing the pulses from each detector. These are then passed to a peak detector circuit which is designed to hold the maximum analogue value of each pulse long enough for analogue-to-digital conversion.

A half-flash ADC is used which produces an 8-bit parallel digital word. A handshaking control loop allows this to be converted into a serial signal via a C011 parallel to serial interface chip for a transputer network. The C011 is run from an independent 5 MHz clock.

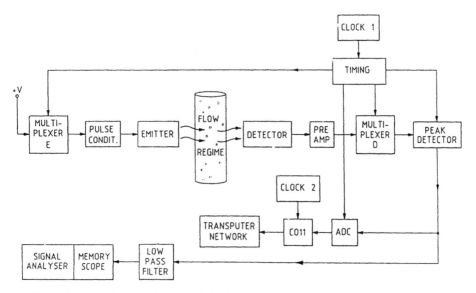

Figure 11.9 *Schematic diagram of the data-acquisition system*

The timing of the electronics for an array of eight transducer pairs is shown in Figure 11.10. The figure shows how the emitters are each pulsed in turn for a certain time (6 μs). Although the emitters are pulsed, the sensors are continuously reverse biased to 15 V, and hence they are receptive to incident infra-red radiation at any time. Nevertheless, their output signals are multiplexed to coincide with the multiplexing of the corresponding emitters. Available ADCs can convert in about 1.5 μs, so the peak detector must hold the maximum value from a sensor for at least this long before resetting and following the signal from the adjacent sensor. The timing and control circuit is constructed of TTL 74 series integrated circuits and analogue multiplexers. For development purposes the system was worked from a variable-frequency clock, allowing the timing to be changed easily. The clock was set to a period of 1 μs. A schematic diagram of the circuit is shown in Figure 11.11.

Counter 1 counts up from 0 to 5 on each clock pulse. On completion it generates a pulse and resets, thus giving a pulse every 6 μs. This pulse is fed into the clock of counter 2 which counts down from 7 to 0 on lines A_0, A_1 and A_2. It selects the desired emitter by outputting to the emitter multiplexer as shown. The same pulse from counter 1 is fed into a shift register which delays it by 2.5 μs before it is passed onto counter 3 which uses the detector multiplexer to select the corresponding sensor. The shift register delays the pulse a further 4 μs before passing it to monostable 1 which produces an initiation pulse for the ADC. Monostable 2 also uses the completion of this pulse to produce a reset signal for the peak detector.

The ADC used in the system is the AD7820 with a maximum conversion time of 1.36 μs, which produces an 8-bit parallel word. The C011 link adaptor chip is then required to convert this to an 8-bit serial word and interface to a

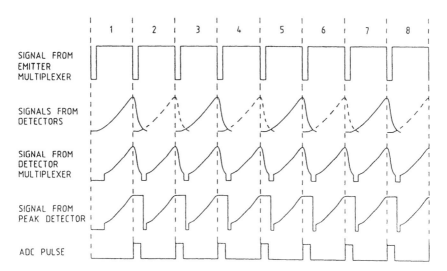

Figure 11.10 *Timing for the electronics*

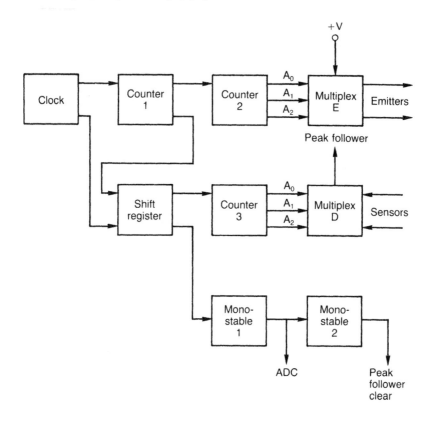

Figure 11.11 *The timing and control circuit*

transputer communication link. The circuit diagram of the transputer interface is shown in Figure 11.12. The transputer network runs at 10 Mbit s$^{-1}$ and so takes in an 8-bit word in approximately 0.8 μs. However, the acknowledge signal from the transputer system takes at least 2.5 μs, depending on the program handling the data.

The data-capture circuitry has been developed to handle the information from up to 64 pairs of optical transducers, arranged initially in arrays of eight. Each transducer could be pulsed in turn, followed by immediate reading of the data by the transputer system. In this case one sweep of the cross-section with 64 transducer pairs would take approximately 600 μs (pulse width 6 μs, transmission to transputer approximately 3 μs). This would lead to a movement of 6.4 mm in a flow moving at the maximum design velocity of 10 m s$^{-1}$, which is unacceptably high. To reduce this we need to capture data from more than one transducer pair at the same time and we need to interleave this with transmission of blocks of data to the transputer.

The method used is to lengthen the pulse width to 25 μs; to capture data from corresponding transducers in each array at the same time and to read this

Figure 11.12 *The transputer interface circuit*

into the RAM. Instead of reading data at the end of data capture, the data are read from the RAM into the transputer whilst the data-capture system is operating. The whole process now takes 200 μs, so the distance moved by the flow at 10 m s$^{-1}$ is 2 mm. Data capture and control circuitry for one array of eight transducer pairs is shown in Figure 11.13.

The constituent member pairs of each array are numbered 1 to 8. Starting with the first pair, the analogue signals from the corresponding transducers in each array are multiplexed simultaneously, converted into digital form and stored in a RAM. As one transducer pair is enabled for 25 μs, the total data capture time for an array of eight, and hence for the whole 64, is 200 μs. Writing one 8-bit byte to the RAM takes 2 μs, leaving 23 μs between writes. In this time the total data from one array (i.e. 8 byte) is read by the C011 interface and passed to the transputer network via link lines. Since there are another seven transducer pairs in an array the system has time to read the RAMs of another seven arrays. By transferring data in this way the data-capture time of the transputer network remains at 200 μs.

To perform the simpler task of flow recognition rather than reconstruction, an extra circuit has been constructed. This gives a continuous voltage from a single sensor, which varies with attenuation of light reaching the sensor from a pulse emitter. To obtain this, the detected signal is passed through a low-pass

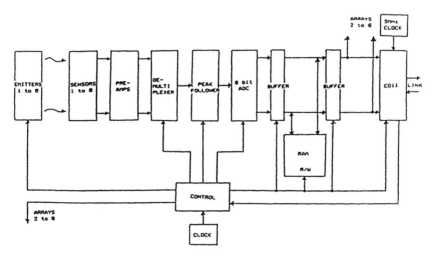

Figure 11.13 *Schematic diagram of the data-capture and control circuitry for one array of eight transducers*

filter consisting of a simple inverting op-amp circuit. The result should still contain information on the flow regime which is normally limited to an upper frequency of 500 Hz, while removing the effect of noise. This circuit is used to study signals for different flow regimes using a storage scope and a frequency analyser.

11.4 System performance

The design of the system was started with the aim of investigating flow regimes in pipes. A laboratory flow rig has been constructed on which to test and evaluate the system. The first objective in the development work was to identify the particular flow regime by examining the signal from a single transducer pair. Identification of flow regimes provides *a priori* information to assist in reconstruction algorithm selection. The flow rig was designed to produce bubble flow, churn flow and plug flow in air/water mixtures. The signal from a transducer pair mounted on the flow rig is low-pass filtered and then the time signals and frequency spectra are examined to find a method of flow regime recognition.

The flow rig uses mixtures of water and compressed air in vertical pipes of 12 and 6 cm diameter. By controlling the pressure of air released into the pipes the different flow regimes can be generated. As the pressure is increased the flow produced varies from bubble through to churn. Plug flow is generated by short releases of high-pressure air. The transducers are placed around the top half of the pipe to allow a stable flow regime to develop well above the air and water inlets at the bottom of the pipe. The pipe is screened to counter the effects of fluctuations in the infra-red background. An SI 1220 spectrum analyser was

used to analyse the detector signals. Figure 11.14 shows the display from the analyser.

The four graphs in Figure 11.14 are the analogue voltages from one transducer pair, aligned across the diameter of the pipe for static, bubble, churn and plug flow. The time-span along the x axis is one second. As the circuit used to filter the transducer signal incorporates an inverting op-amp, the signal displayed is also inverted. Thus the voltage scale on the y axis is negative.

For static water in the pipe (top graph) the detected signal is a continuous voltage of -0.3 V. As bubbles of air pass through the beam of radiation this signal is attenuated at the same rate. By the onset of churn flow only a very limited amount of radiation penetrates the regime. Finally, as the domed top of a plug crosses the beam its surface scatters all radiation (bottom graph). The body of the plug then removes more and more of the water from the pipe cross-section. This causes the level of attenuation to be reduced and the value of the (inverted) transducer signal falls accordingly, below -0.3 V to -0.7 V. Once the main body of the plug has moved on there is a sudden return to chaotic churn flow, as shown by the associated signal.

An investigation into the frequency spectra of these signals was also made to determine whether they gave a clear indication of flow regime type. Both the instantaneous frequency spectra of particular time signals and the average

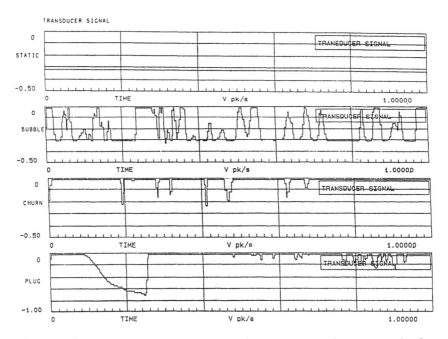

Figure 11.14 *Analogue voltages from an optical sensor corresponding to particular flow regimes*

frequency spectra taken over many time signals were examined. In addition, the probability densities of the frequency spectra were examined. The following conclusions can be made from the data obtained. The magnitude of the d.c. component gradually falls as the rate of the bubble flow increases, reaching a minimum at the onset of churn flow and increasing again as the churn flow becomes more chaotic. The spread of frequencies increases as the regime passes from bubble through to churn up to the most chaotic flow. Plug flow is a special case and contains frequency bands near the d.c. component which are larger than the rest of the signal. Clearly frequency spectra such as these can be used as a method of flow-regime recognition. A simpler approach to differentiating between spectra is to express them in terms of probability density. Such functions quickly reveal the different flow regimes.

Tomographic reconstruction of cross-sectional images has been developed using phantom flow regimes, i.e. static models constructed in a dry section of pipe. These enable the results of image-reconstruction algorithms to be compared with the original object. Development of a useful algorithm to obtain an image from four projections has also been undertaken (Landauro *et al.*, 1992). Different arrangements of arrays around the pipe have been tried from the basic orthogonal 8 × 8 arrays to more complicated arrangements. Initially, one array of eight transducers was used per projection, i.e. placed across one side of a 12 cm pipe. Thus the distance between the centres of the 5 mm beams was 15 mm. However, the sensor photodiode has a sensitive area of 4 mm$^2$. This makes the active width of the beam 2 mm. As a result, there is a 13 mm gap between beams. Objects smaller than this may be missed by a simple orthogonal 8 × 8 arrangement. The present system has 16 transducer pairs per projection, so the gap between beams is now approximately 5 mm. This can be improved on by the addition of more projections. The 16 × 16 system reconstructs phantom models accurately and is being used to determine off-line how many projections will be needed to reduce image ambiguity to an acceptable level.

The replacement of the LEDs with laser diodes (Philips CQL 63C/D) is being undertaken. Each emit 200 times more radiant energy then conventional LESs and contain sensing diodes which monitor their output. These can be incorporated in feedback loops to ensure that an array of laser diodes will all produce the same level of radiation. This greater intensity of laser diodes will enable better optical management, allowing the use of optical stops and baffles which restrict the angle of admittance of radiation to a sensor. Thus the system will be more selective in the volume of the flow from which information is obtained. Currently we have adequate light penetration through a 30 cm thickness of 10% fermentation broth. Work is continuing on this promising low-cost optical tomography system.

References

Dugdale, P., Green, R. G., Hartley, A. J., Jackson, R. G. and Landauro, J. (1990) Process tomography of two component fluid flows using a transputer based system. In *Proceedings of Conference on Computer Image Processing and Plant Control* IEE, London

Dugdale P., Greeen, R. G., Hartley, A. J., Jackson, R. G. and Landauro, J. (1991) Tomographic imaging in industrial process equipment using optical sensor arrays. In *Sensors: Technology, Systems and Applications* (ed. K. Grattan) Adam Hilger, New York, 227–232

Dugdale P., Green, R. G., Hartley, A. J., Jackson, R. G. and Landauro, J. (1992) Optical sensors for process tomography. In *Tomographic Techniques for Process Design and Operation* (ed. M. S. Beck *et al.*) Lomivtational Mechanics Publications, Southampton, 45–52

Landauro, J., Dugdale, P., Green, R. G., Hartley, A. J. and Jackson, R. G. (1992) Algorithm for optical process tomography. In *Tomographic Techniques for Process Design and Operation* (ed. M. S. Beck *et al.*) Lomivtational Mechanics Publications, Southampton, 193–204

Emission tomography
M. R. Hawkesworth and D. J. Parker

After a brief review of other emission techniques in process tomography, this chapter concentrates on the use of positron-emitting radiolabels, since these appear to have a unique potential for non-invasive flow studies in real process equipment. The physics of the positron annihilation process, and the availability of appropriate positron-emitting radionuclides are summarized, followed by a description of the industrial 'positron camera' developed at the University of Birmingham and the methods of using such cameras for flow imaging both by conventional tomographic reconstruction and by tracking a single tracer particle.

12.1 Introduction

Non-invasive imaging techniques have been developed primarily in medicine. X-ray radiography was the earliest, and is still the most widespread. The more recent tomographic version (computed tomography (CT)) provides high-resolution three-dimensional images of body *structure* based on the local attenuation of the transmitted X-ray beam. For studying *function*, on the other hand, radioactive-tracer techniques have been developed for observing the uptake of labelled substances within individual organs based on the detected γ-ray emissions ('nuclear medicine'); here again tomographic methods enable three-dimensional images to be produced. Both transmission and emission techniques have also found application outside medicine, and, although not within the scope of this chapter, it should be noted that transmission tomography using X-rays, γ-rays or neutrons is now important in a number of industrial areas (MacCuaig *et al.*, 1985; Barton *et al.*, 1987; Wellington and Vinegar, 1987).

The major attraction of using radiation emitted by the working fluid itself to produce three-dimensional non-invasive images of the functioning of equipment is directness and hence possible specificity – the component of the flow of interest is observed directly rather than having to be inferred via a secondary process (such as the change in radiation attenuation or electrical impedance it produces), which may be significantly influenced by external factors.

The simplest three-dimensional imaging techniques of all depend on the emission or reflection of light, but these are only practical for transparent fluids or particulate flows on or near-transparent surfaces (Merzkirck, 1987); in general, therefore, they cannot be applied to observing flow within real

(usually metallic) equipment. The newest and fastest growing medical tomographic imaging modality, magnetic resonance imaging (MRI), formerly known as nuclear magnetic resonance (NMR) imaging, is an emission technique based on stimulating radiofrequency signals from nuclei by causing them to precess in phase in a strong magnetic field (Foster and Hutchinson, 1987). Usually, signals are excited in a selected two-dimensional slice through the subject, and positional information within this slice is obtained by superimposing a magnetic field gradient so that nuclei in different regions precess at different frequencies; a three-dimensional image comprises a stack of two-dimensional slices acquired sequentially. In principle, by suitable choice of magnetic field and excitation frequency, a MRI signal may be obtained from any nucleus having a non-zero nuclear magnetic moment (basically any one with uneven atomic number or mass number). In practice, medical MRI has concentrated almost exclusively on imaging hydrogen atoms, which give a particularly strong signal. By suitable choice of repetitive excitation sequences, information can also be obtained on the environment of the hydrogen atoms, since this affects the rate at which the stimulated signal decays; in this way different types of tissue having similar hydrogen content can be differentiated. Information on the average flow velocity in each region can also be obtained by using a time-varying field gradient during the period between excitation and read-out (Caprihan and Fukushima, 1990).

MRI is being increasingly used in engineering studies (Rothwell and Vinegar, 1985), but suffers here from the limitations that conducting materials are opaque, and that it cannot be used in the presence of ferromagnetic or paramagnetic materials since the volume under study must be wholly confined in a precisely controlled magnetic field. Furthermore, the high-intensity magnets that are available generally have a rather small internal bore, limiting the size of industrial equipment which may be studied (at present to about 100mm in diameter). Within this volume, MRI can provide a precise quantitative image of the distribution and average velocity of hydrogenous material, with a positional resolution of typically 1% of the total field of view. On small systems this resolution can be as good as 20 μm (Aguayo *et al.*, 1986). In medicine, where concern over potential hazard to the patient is important, MRI is likely to develop at the expense of the γ-ray-based tomographic techniques, but its ultimate role in process tomography is as yet less certain.

Other emission techniques rely on introducing flow tracers, either in the form of a macroscopic neutrally buoyant particle whose location with time is tracked, or as suspended/dissolved labelled material the distribution of which at any time can be determined from its emissions by tomographic reconstruction techniques.

A miniature (1 cm diameter), neutrally buoyant radiofrequency transponder has been used to determine circulation times in operating process equipment by measuring the time between successive transits past the detector (Fields *et al.*, 1984), but the possibility of extending this technique to provide three-dimensional flow data appears uncertain, and, in any case, the use of radio signals is restricted to non-metallic equipment.

The use of γ-ray-emitting radioactive tracers, on the other hand, can

provide non-invasive imaging through metallic casings, since γ-rays travel in straight lines between interactions. On passing through matter, some γ-rays are absorbed and others are scattered with a reduction in energy, but the remainder emerge undeviated. The effect of absorption and scattering is that the fraction emerging is attenuated by a factor $\exp(-\mu x)$, where x is the thickness of material traversed, and μ is the linear attenuation coefficient, which depends both on the nature of the material (being highest for high atomic number, high density material) and the energy of the γ-rays (high-energy γ-rays being attenuated less than low-energy ones).

The use of radioactive tracers to measure average transit times of flows in pipework, and more recently in large chemical plant, is almost as old as the commercial availability of short-lived radionuclides (Charlton, 1986). Occasional attempts have been made to extend such one-dimensional pulsed methods to the two-dimensional and three-dimensional visualization of flow patterns by tracking small γ-ray-emitting particles (Lin *et al.*, 1985), using the relative strengths of signals seen by an array of scintillator–photomultiplier detectors placed around the equipment to locate the tracer. However, the need for adequate counting statistics means that only slow-moving or averaged flow patterns can be observed, and differential attenuation in the equipment and working fluid distorts the observed location. The great advantage of γ-ray-based imaging remains, nevertheless, in the ability to observe fluid flows in real process equipment.

In medicine, the principal instrument used for forming images of γ-ray-emitting tracers is the Anger Gamma Camera (Ott *et al.*, 1988), which consists of a large-area scintillator viewed by an array of photomultiplier tubes which locate the position of each γ-ray interaction, and a collimator to produce a two-dimensional image on the crystal of the activity distribution within the subject (projected along the collimated line of sight). The three-dimensional distribution of γ-radioactivity can be tomographically reconstructed from a set of projections obtained by rotating such a camera about the subject; this is known as 'single photon emission computed tomography' (SPECT) (Ott *et al.*, 1988). The collimator used is generally a block of lead containing a large number of parallel holes, to permit transmission only of γ-rays incident almost normal to the collimator; focused and pin-hole collimators are more rarely used. The commonest radiolabel employed in medical imaging is $^{99m}$Tc, which has a half-life of 6 h and emits γ-rays of 140 keV, an energy high enough to give reasonable penetration through the body, but low enough to be effectively collimated by a reasonable thickness of lead. Similar technology has found only occasional application in process engineering research (Davies *et al.*, 1986; Huang and Gryte, 1988; Jonkers *et al.*, 1990), however, even though second-hand Anger cameras have been widely available for some time. This is presumably because collimators are largely ineffective with the higher energy γ-rays needed to penetrate industrial equipment.

Radionuclides which decay by positron emission offer a more promising method of γ-ray-based imaging in industrial process equipment, since each positron formed rapidly annihilates with an electron, giving rise to a pair of 511 keV γ-rays which are emitted almost exactly back-to-back. These γ-rays

are sufficiently penetrating that they can emerge through considerable thicknesses of metal, and coincident location of both of the pair defines a line in space passing close to the original positron emission, without the need to introduce collimation. The intensity of pairs of coincident annihilation γ-rays detected along each line of sight provides the basic projection data from which tomographic reconstruction of the three-dimensional distribution of positron-emitting radiolabel can be performed.

In carrying out this reconstruction it is necessary to correct for the differing attenuation of the signal along different lines of sight, but a further advantage of using back-to-back γ-rays is that the total attenuation for the pair (probability of both emerging unscattered) depends only on the total amount of material along the line of sight, and is independent of the position along this line at which emission occurred. Thus an exact correction for attenuation can be made if the total attenuation along each line is known, or can be measured independently. The intensity of 511 keV γ-rays is in fact reduced to 10% in traversing approximately 10 cm aluminium or 3.6 cm iron, implying the possibility of imaging through, for example, a 2 cm steel casing.

Positron-emission tomography (PET) is now well established as a medical imaging technique for observing the uptake by organs within the body of labelled metabolic substances (Tilyov, 1991). Medical PET scanners generally employ one or more rings of scintillator detectors, constructing their three-dimensional image as a stack of independent two-dimensional image slices, acquired either simultaneously or sequentially. An advantage of this approach is that heavy metal crude collimators, or 'septa', can be introduced between the detector rings, helping to block scattered γ-rays which would otherwise contribute background to the image. The need for increased sensitivity in order to get fast dynamic images has, however, led to interest in fully three-dimensional imaging systems, without septa, and the problem of removing the resulting scattered background during image processing remains a major challenge. Some scanners can partly discriminate against scattered γ-rays on the basis of the detected energy, but the achievable energy resolution is quite poor, since it has to be traded off against spatial resolution. Such scanners are not ideal for engineering research, because of their inflexible ring geometry, limited instantaneous field of view, and sheer cost (over £1 million at 1993 prices).

The use of positron-emitting radiolabels for flow imaging in engineering studies has been pioneered at the University of Birmingham (Hawkesworth *et al.*, 1991), using a purpose-built area-detector 'positron camera' (Hawkesworth *et al.*, 1986), which was installed in 1984, originally for the purpose of studying lubrication in engines and gearboxes. After a brief introduction to the physics of positron annihilation, and an overview of the available positron-emitting radionuclides, the remainder of this chapter describes the ways in which the Birmingham positron camera has been used. It remains the only PET facility devoted to non-medical imaging and, in conjunction with the two cyclotrons belonging to the University of Birmingham, has now been applied to a wide range of engineering studies, some of which are mentioned below to illustrate the capability of the technique.

Such an area-detector positron camera can be used in two distinct modes: conventional tomographic imaging, and single-particle tracking. These are described separately in Sections 12.5 and 12.6. Conventional tomography requires the collection of large volumes of data, so that acquisition of an image takes typically several minutes. On the other hand, if it is known that only a single positron-emitting particle is present within the field of view, its position can be determined accurately from a small number of detected events. Such a particle can thus be located many times per second, and introduced as a flow tracer into real process equipment can provide a direct measure of the velocity field within. Before describing the reconstruction methods associated with these two modes of operation, it is appropriate to review the principles of the positron-annihilation process, and the range of positron-emitting labels which is available.

12.2 Positron annihilation physics

Nuclei consist of protons and neutrons. For any given mass of nucleus, there is an optimum ratio of neutrons to protons which makes the nucleus stable, generally with slightly more neutrons than protons. Nuclei with too many protons can become more stable by converting a proton into a neutron, and one of the processes by which this occurs is β^+ decay, in which a proton 'decays' into a neutron, a positron and a neutrino. The Q value of this reaction is -1.3 MeV so that it can only take place within the nucleus, and the increase in nuclear stability must provide at least 1.3 MeV, with any additional release in energy appearing as the kinetic energy of the products. In fact, the change in nuclear binding energy resulting from this conversion may be several million electron-volts, but a large energy release corresponds to a highly unstable nucleus with a very short half-life, so that the radiolabels in common use generally correspond to kinetic-energy releases of up to about 1 MeV. This energy is shared mainly between the positron and the neutrino, so that the positron may be emitted with any energy between zero and the maximum available; as a rough guide the most probable positron energy from a given β^+ decay is about one-third of the maximum.

The positron is the anti-particle of the electron and on encountering one another they can annihilate, the rest mass energy of both appearing as electromagnetic radiation, usually in the form of two γ-rays (in about 1% of annihilations three γ-rays are emitted, but these events are not of interest for imaging). Fortunately, from the viewpoint of imaging using positrons, the probability of annihilation is negligible at high energy, and the principal interaction is inelastic scattering from electrons until the positron has energy close to thermal (0.025 eV). Thus the momentum of the positron/electron pair at annihilation is small compared to the momentum carried by the γ-rays, and conservation of momentum in the reaction therefore requires that the two γ-rays are emitted almost exactly back-to-back and that each has an energy close to the 511 keV rest mass energy of the electron or positron.

An emitted positron may travel a significant distance in matter before its energy is sufficiently reduced by inelastic collisions with electrons that annihilation is likely to occur. The slowing down process is random; for a 1 MeV positron, the range can be anything up to a maximum of approximately 0.5 mm in iron, 3 mm in water, or 2.6 m in air at standard temperature and pressure (STP); the average ranges for positrons from a β^+ decay giving a maximum positron energy of 1 MeV will obviously be significantly less in each case. These values indicate that localized imaging is possible in liquids and solids but not in gases (except in narrow channels).

The two γ-rays emitted are collinear to within, typically, 2mrad (0.1 °); using two detectors 500 mm apart to locate them, this would correspond to a positional error of, at most, only 0.5 mm.

The time taken for the emitted positron to thermalize within a material is typically about 20 ps. In some materials annihilation follows almost immediately, but in metals there is a significant probability that a quasi-stable positronium 'atom' may form (electron and positron orbiting around each other in an imitation of a hydrogen atom), in which case annihilation may be delayed for up to 200 ps. In either case the times involved are too small to have any significance for imaging, but it is worth noting in passing that, since the positron life-time depends on the electronic structure of its environment, measurements of life-time can provide information on, for example, the fatigue state of metallic components (Coleman, 1977).

12.3 Positron-emitting labels for engineering research

A radiolabel for flow studies needs a chemical form which is compatible with all the other fluids and materials with which it might come into contact, sufficient activity to provide useful images in an acceptable time, and a long enough life to cover the duration of the study. It is usually advantageous, however, if its life is not significantly longer than necessary, so as to avoid any problem from persistent residual activity in the test equipment after the end of the study. Table 12.1 lists the nuclides that have found use in positron-based imaging in medicine and engineering so far, together with some other promising candidates. Of these, only $^{68}$Ga, $^{18}$F and $^{22}$Na have been routinely used in process engineering research at Birmingham to date.

$^{68}$Ga (half-life 68 min) is eluted from a 'generator' carrying its 'parent' nuclide ($^{68}$Ge, half-life 271 days) adsorbed on tin oxide. The generator principle for making available a relatively short-lived radionuclide from the decay of a long-lived parent is well known in nuclear medicine (Waters *et al.*, 1983), and it provides in $^{68}$Ga a convenient and readily transportable source of positron-emitting label for engineering studies based on a mobile positron camera. The much shorter-lived label $^{82}$Rb (half-life 1.3 min) is also available from a generator holding its parent $^{82}$Sr (half-life 25 days).

If the 68 min half-life of $^{68}$Ga is too short for a particular application, $^{18}$F (half-life 110 min) may be useful, but a reasonably powerful particle accelerator (in practice usually a cyclotron) is needed for its production. A

Table 12.1 Nuclides used to date in positron-based imaging in medicine and engineering

Nuclide*	Half-life	Fraction of decays giving β^+	Max. positron energy (MeV)	No. of γ-rays associated with β^+ emission (energies)		Production route and comments†
$^{82}$Rb	78 s	0.96	3.3	0.1 (0.8)	\subsetM	From $^{82}$Sr generator (25 days) (see below)
$^{15}$O	122 s	1	1.7	None	M	$^{14}$N(d,n)$^{15}$O
$^{13}$N	10 min	1	1.2	None	M	$^{12}$C(d,n)$^{13}$N
$^{11}$C	20.3 min	1	1.0	None	M	$^{14}$N(p,α)$^{11}$C
$^{68}$Ga	68 min	0.9	1.9	0.01 (1.1)	\subset	From $^{68}$Ge generator (271 days) (see below)
$^{18}$F	110 min	0.97	0.6	None	M	$^{18}$O (p,n)$^{18}$F, or $^{16}$O($^3$He,p)$^{18}$F and ($^3$He,n)$^{18}$Ne\rightarrow^{18}F
$^{45}$Ti	3.1 h	0.86	1.0	None		$^{45}$Sc(p,n)$^{45}$Ti
$^{62}$Zn/$^{62}$Cu	9.2 h	0.98	2.9	None		$^{63}$Cu(p,2n)$^{62}$Zn
$^{64}$Cu	12.7 h	0.19	0.6	None	\subset	$^{64}$Ni(d,2n)$^{64}$Cu
$^{140}$Nd/$^{140}$Pr	3.4 days	0.49	2.4	None		$^{141}$Pr(p,2n)$^{140}$Nd
$^{124}$I	4.2 days	0.25	2.1	~0.6 (0.6–0.7)	\subsetM	$^{124}$Te(d,2n)$^{124}$I
$^{82}$Sr/$^{82}$Rb	25 days	0.96	3.3	0.1 (0.8)	\subset	Abundant fission product
$^{68}$Ge/$^{68}$Ga	271 days	0.9	1.9	0.01 (1.1)	\subset	$^{66}$Zn(α,2n)$^{68}$Ge
$^{22}$Na	2.6 years	0.9	0.5	1 (1.3)	\subset	$^{24}$Mg(d,α)$^{22}$Na

*Where two nuclides are listed together, the second is the positron-emitting daughter of the first and has a relatively short half-life; the half-life quoted is for the parent, while the decay information is for the daughter.
†M indicates that the label has been used in medical PET studies. \subset indicates that the nuclide is commercially available.

variety of nuclear reactions may be used; in Birmingham the route usually chosen is to irradiate a target containing oxygen with 33 MeV $^3$He ions, whereby $^{18}$F is produced by the reactions $^{16}O(^3He,p)^{18}F$ and $^{16}O(^3He,n)^{18}Ne \rightarrow ^{18}F$, the target material being either water (to produce $^{18}F^-$ ions in dilute solution) or a silica bead (to produce a solid labelled particle). Copious quantities can readily be produced in water; 100 mCi $(3.7 \times 10^9$ Bq) $^{18}$F has been delivered to the Rolls-Royce test bed at Staverton, 50 miles from Birmingham, to permit a study of the lubrication of an operating aero-engine lasting up to 12 h (Stewart *et al.*, 1988). In such studies, solvent extraction may be used to transfer the label from aqueous into organic solution so that it is miscible with the lubricant.

Measurements over time-scales longer than 12 h currently rely on the nuclide $^{22}$Na (2.6 years) which is also cyclotron produced. Its long life makes it useful for calibration purposes and also (in the form of the chloride) for sealing into beads and pellets for particle-tracking studies (Section 12.6) in which the labelled bead can be reliably retrieved. However, the quality of data obtained using $^{22}$Na is poorer than with the other positron emitters discussed above, as the emitted positron is accompanied by an additional γ-ray which cannot be distinguished by the positron camera from an annihilation γ-ray, and thus results in a background of spurious coincidence events.

Development of positron-emitting radiolabels with half-lives of days or weeks, intermediate between $^{18}$F and $^{22}$Na, would be of considerable benefit to process engineering studies. Measurements have been made using $^{124}$I (4.15 days), but the quality of the images was seriously degraded by the large number of additional γ-rays accompanying the positron. More promising candidates include $^{64}$Cu (12.7 h) and $^{140}$Nd (3.4 days).

12.4 The Birmingham positron camera

Unlike the ring scanners generally used for medical PET, the Birmingham positron camera, which was designed and custom-built for engineering work by the Rutherford Appleton Laboratory, is based on two *large area* position-sensitive detectors which are placed on either side of the field of view. The advantages of this design are: it has flexibility for accommodating equipment of varied dimensions, a large three-dimensional volume is viewed continuously (essential for the particle-tracking studies described in Section 12.6), and it is less expensive and more robust than the medical designs. A brief description is provided here to draw attention to features of particular value in the context of process engineering research.

The design and operating principles of the camera are summarized in Figure 12.1. The two simultaneous γ-rays arising from a positron–electron annihilation event are detected in the pair of detectors, each of which is a gas-filled multi-wire chamber containing a stack of 20 anode–cathode planes, with a sensitive area of 600 mm × 300 mm (Hawkesworth *et al.*, 1986). An incident γ-ray is most likely to interact with an electron within one of the cathode 'wires' which are, in fact, strips of 50 μm thick lead plated onto strips of copper

Figure 12.1 *Schematic illustration of the operating principles of the Birmingham positron camera, showing the delay-line co-ordinate read-out*

(2.2 mm wide 0.8 mm apart) on standard 1.6 mm thick glass-fibre-stiffened printed-circuit board (Figure 12.2). As a result of this interaction, an electron may be released into the surrounding gas (isobutane plus 1% Freon-113 at atmospheric pressure), where it causes ionization which is amplified in the vicinity of the nearest anode by the 3.5 kV potential difference between anode and cathode. This ionization induces a voltage pulse in the anode wire and also in the neighbouring cathode wires. Fast voltage pulses used for recognizing simultaneous, or 'coincident', γ-ray detection in both detectors are provided by the anodes, while the positions of the detected γ-rays are given by the associated cathode strips; the lead strips of the cathodes either side of each anode are orthogonal so as to provide both x and y co-ordinates, which are read in the form of a proportionate time delay using the delay-line principle. The anode wires are made of tungsten (20 μm diameter). They must be held under considerable tension in order to hold their position under the electrostatic forces present in the detectors and are, therefore, plated with gold in order that a strong solder joint may be made at each end.

Figure 12.2 *Schematic view of part of an anode plane and two neighbouring cathode planes. Each of the two detectors contains a stack of 20 such assemblies*

The lead strips have to be kept thin so that electrons released through photoelectric absorption or Compton scattering have a reasonable chance of escaping into the gas. As a result, the probability of a 511 keV γ-ray interacting in a single cathode is small, which is why a stack of 20 detector planes is used. Even so, each 20-stack chamber has a detection efficiency of only about 7% for incident 511 keV γ-rays, so the efficiency for detecting an annihilation pair is about 0.5%. To arrive at the overall efficiency this figure must be further reduced by a geometrical factor depending on the detector separation, which is adjusted (typically between 300 and 600 mm) to accommodate the subject under investigation, and by the effect of γ-ray attenuation in the subject. In practice, between 10^{-4} and 10^{-5} of the positron annihilation events in that portion of the subject which is actually between the detectors are recorded. A major aim of the research into improved detectors for positron-based imaging is to improve these figures (Wells *et al.*, 1991), but, as will be seen, they are already high enough to enable valuable research in process engineering.

Only when γ-rays are detected in both detectors within the resolving time of the system (2τ, approximately 20 ns) are they accepted as 'coincident', and their data recorded event-by-event on disk using, at present, a VAX4000/200 computer. Unfortunately, for every valid coincidence event, many more γ-rays are detected without their coincident partner, and these load the electronics, as well as giving rise to spurious 'random' coincidences (at a rate $2\tau C_1 C_2$, where C_1 and C_2 are the total count rates in the two detectors), so that at present the maximum useful data rate is around 3000 coincidence events per second. For each event, the co-ordinates of detection of both γ-rays are recorded, together

with the times of detection provided by two different clocks, one measuring 'real' time and the other 'live' time; there is generally a significant difference between these times due to a short 'dead-time' following the detection of every γ-ray during which the electronics is unable to process further incoming events.

The geometrical efficiency of area-detector cameras not only varies with the detector separation, but also varies across the field of view, being highest at the centre. When a small system is being studied, a separation of 300 mm is usually adopted, giving a field of view 600 mm × 300 mm × 300 mm, as shown in Figure 12.3. For points close to the centre of this volume the stationary pair of detectors covers a sufficiently wide range of angular views that three-dimensional tomographic reconstruction is possible, although the resolution of the resulting images is notably poorer in the z direction (the axis linking the two detectors) than in the other two directions. This geometry has also provided the basis for most of the particle-tracking studies to date. With the larger detector separations required to accommodate some equipment, full three-dimensional tomographic reconstruction can only be achieved by rotating the pair of detectors about a central axis. Using the rotating gantry shown in

Figure 12.3 *Schematic view of the detector geometry and co-ordinate system, showing an* N × N × N *cubical voxel space*

Figure 12.4, which executes a 180 ° rotation in 60 s, detector separations up to 600 mm are available. Still larger separations are feasible using a fixed geometry (Stewart *et al*., 1988), but then the resulting images are essentially only two dimensional.

12.5 Image reconstruction in positron-emission tomography

The process of generating a tomographic image basically involves measuring the intensity of positron annihilation γ-ray pairs along all possible lines of

Figure 12.4 *View of the Birmingham positron camera showing the rotating gantry*

sight, back-projecting each measured intensity uniformly along its path (with appropriate correction for attenuation by material on the path, if any) into an object space comprising a three-dimensional array of cubical voxels (Figure 12.3), and finally deconvolving from the resulting back-projected image the image of a point source, the 'point spread function' (PSF), measured under the same conditions. This deconvolution removes blurring due to the tails introduced by the back-projection process, in which each detected event is assigned not only to its correct voxel, but also equally to all other voxels on the line of sight.

Implicit in this approach is the assumption that the PSF is invariant over the field of view. This is not the case *ab initio*, since a much wider range of emitted γ-ray directions can be detected for a point at the centre of the field than for one near the edge. However, by arbitrarily restricting the γ-ray paths used to those subtending less than some limiting angle with the normal linking the two detectors, uniform response can be achieved over an adequately large central portion of the field, albeit by discarding a significant fraction of the recorded data. The tighter this 'angle limit', the larger the volume over which uniform response is achieved, at the expense of accepting less and less of the data for processing and reducing the stereoscopic view of the detectors, so that the resulting images have good resolution in the x and y directions but much poorer resolution in the z direction (unless the camera is rotated about the subject). For example, with a detector separation of 300 mm, by restricting the accepted γ-rays to those subtending an angle of less than 25° to the normal, it is possible to achieve uniform response over approximately one-quarter of the volume of the full field of view, the PSF then having a full-width-at-half-maximum (FWHM) resolution of approximately 8 mm in the x and y directions and 25 mm in the z direction.

To achieve three-dimensional reconstruction with better resolution in the z direction, it is necessary (as explained earlier) to rotate the detectors about the volume of interest. In this case the requirement to impose angle limits can be removed in the radial direction since, for each point within the central region, all radial angles of emission are sampled equally as the detectors are rotated at constant speed through 180°, and a simple radial normalization can be applied to compensate for the residual radial variation in detection efficiency (Clack *et al.*, 1984). It is still essential, however, to apply an angle limit in the axial direction. A typical imaging situation uses a detector separation of 600 mm, rotation about the central x axis, and an axial angle limit of 15°; the resulting PSF is invariant over a volume consisting of a cylinder, 280 mm in diameter and 350 mm long (plus an additional conical region at each end) and has a FWHM resolution of 8 mm in the axial direction and 12 mm radially.

As mentioned above, the annihilation γ-rays may be significantly attenuated on emerging from the equipment under study. Differing attenuation along different lines of sight would obviously result in distortion of the back-projected image; accordingly each back-projected event is weighted by a factor $1/a$, where

$$a = \exp\left(-\int \mu \, dx\right)$$

is the attenuation integrated along this line. In an engineering context it is usually possible to calculate *a* from the known configuration of the equipment; alternatively the attenuation of 511 keV γ-rays along each line of sight can be measured separately using a line source (usually $^{22}$Na) attached to the front of one detector. For quantitative images, further normalizations are applied to correct for dead-time in the electronics and for the gradual decay of the tracer activity. Coincidence events are recorded in list mode and subsequently back-projected event-by-event, applying the appropriate weighting for each.

Two effects give rise to background in the images: detection of random coincidences, and of scattered γ-rays. Random coincidences can be measured explicitly by temporarily introducing a delay in the time coincidence circuit, so that the true coincidences are no longer accepted and only the randoms remain. This is done at frequent intervals during each measurement, and the resulting 'random' data are used to reconstruct an image in exactly the same way as the 'real' one; the final image is then obtained by subtracting the 'random' image (normalized to the same live time of acquisition) from the 'real' image. Unfortunately, no such explicit subtraction is possible in the case of scattered γ-rays, which are detected in proper coincidence but in a corrupted position. Lead-strip detector technology offers no capability for measuring γ-ray energy and an area-detector camera without collimation suffers considerably from detected scatter. In an attempt to remedy this, the usual approach is to use as the PSF the image of a point measured under similar scattering conditions, so as to deconvolve from the image the tails due to scattering which appear also in the PSF. This would only truly be a valid approach if scattering were independent of position within the field of view, which is rarely the case. Nevertheless, in practice such processing generally gives usefully quantitative results.

As an indication of the three-dimensional imaging power of the PET technique, Figures 12.5 and 12.6 show results obtained from measurements made in the rotating operating mode on a system consisting of line sources of $^{22}$Na (NaCl powder in 1 mm internal diameter steel tubes): two lines 100 mm long oriented in a vertical plane and forming the letter 'V', and five lines 50 mm long arranged to form a horizontal 'H'. Figure 12.5 shows four views of the image obtained after recording 10^7 events, back-projected into an array of $128 \times 128 \times 128$ voxels, each $2.5 \times 2.5 \times 2.5$ mm, after deconvolution of the measured PSF. Figure 12.6 shows just the single horizontal tomograph (2.5 mm wide) containing the letter 'H'. Profiles in the axial and radial directions are shown for the full image constructed from 10^7 events; the FWHM resolution is seen to be approximately 8 mm in each co-ordinate. The corresponding radial profile is also shown for two other images, obtained using just 10^6 and 2×10^5 events, respectively. It is apparent that as fewer data are used the images become more noisy, making it necessary to impose additional smoothing in order to see genuine features. It can be seen that, even for a relatively simple system such as this one, it is necessary to detect some 10^5 events in order to obtain acceptable three-dimensional tomographic images.

As an example of a real application in process tomography, Figure 12.7 shows a sequence of vertical tomographs through the centre of a mould into

SIDE END

PLAN

Figure 12.5 *Four views of the three-dimensional PET image of seven line sources (10^7 events reconstructed in $128 \times 128 \times 128$, 2.5 mm \times 2.5 mm \times 2.5 mm voxels): The side, plan and end views are projected views showing (grey scale) the maximum voxel contents in each column of 128 voxels. The other view is a three-dimensional view of those voxels having contents higher than 50% of the maximum*

which radiolabelled dough was hydraulically extruded. Each image corresponds to 60 s recorded data (up to 10^5 events). The formation of a blockage halfway down the mould is apparent, after the initial rod of dough hit the bottom and became kinked, seriously hindering subsequent filling of the lower part of the mould.

12.6 Positron emission particle tracking

An alternative method of using positron-emitting flow tracers has been developed at Birmingham, which can provide information even for processes which develop on time-scales much shorter than 1 min, which is too short a time to acquire sufficient data for reconstruction of a three-dimensional tomographic image using the existing Birmingham positron camera. The method, which has been named 'positron emission particle tracking' (PEPT) involves introducing a single labelled tracer particle, and uses the *a priori* knowledge that all the positron-emitting activity in the field of view is concentrated at a point to help determine its location. This requires very little data, since in principle all the measured γ-ray paths should meet at this point. In the absence of undesirable experimental effects, detection of just two coincidence events would be sufficient to locate a positron-emitting particle by

Figure 12.6 (a) *Single horizontal tomograph (2.5 mm thick) from the image shown in Figure 12.5. (b) Axial profile across this tomograph between A–A. (c) Radial profile between B–B. (d) As (c), but constructed using only 10^6 events. (e) As (c), but constructed using only 2×10^5 events*

Figure 12.7 *Centre-plane vertical tomographs selected from a sequence showing extrusion of* 68*Ga-labelled dough into a mould; each image comprises 60 s of data*

'triangulation'. In practice, of course, a significant fraction of the detected events are 'corrupt' (involving scattered γ-rays or random coincidences) and must, if possible, be discarded. But, whereas the paths of the good events meet (to a good approximation) at a point, the paths of these corrupt events are broadcast randomly, so that if a sufficient number is examined it is possible to discriminate with reasonable success against the corrupt ones. Typically, a sample of 80 detected events is sufficient to locate the particle to within a few millimetres in three dimensions, which means that its position can be determined many times per second. Provided, therefore, that it is possible to introduce a labelled particle whose motion faithfully follows that of its surrounding fluid, the PEPT technique can be used to study high-speed fluid motion. For PEPT, the Birmingham camera has been used with the two detectors stationary and as close together as possible (generally 300 mm apart).

The PEPT algorithm proceeds roughly as follows. Given an initial sample of N detected coincidence events, an analytical expression exists for the point in three-dimensional space closest to which all these N γ-ray paths pass. This point is found, then those paths which pass furthest from it are rejected as corrupt, and the process is repeated for the remaining paths. The algorithm iterates until only a fixed fraction f of the original N paths remain, these are

assumed to be good and the point closest to which they all pass is taken as the instantaneous position of the particle. From tests using data measured for stationary particles (Parker *et al.*, 1993), it has been found that the value of f giving optimum location is essentially independent of the sample size N, and depends (as expected) on the detector geometry, the position within the field of view, the extent of scattering in the surrounding material, and the number of associated γ-rays emitted by the chosen radionuclide. The highest retained fraction was obtained for a bare ^{18}F source centred between the two detectors 300 mm apart, for which an optimum value of 0.33 was found, corresponding to discarding 67% of the detected events. This compares with an expected fraction of roughly 26% corrupt events in this geometry (due to scattering, etc.), indicating that the present algorithm is not perfect at discriminating corrupt events, but inevitably discards some good ones along with the bad.

For a stationary particle, the precision of location (standard deviation of repeated locations) is then given approximately by $\sigma_{PSF}/\sqrt{N_F}$, where σ_{PSF} is the standard deviation of the PSF in this geometry, and $N_F = fN$ is the number of γ-ray paths used in the final calculation after corrupt events have been discarded. With $N = 80$ and $f = 0.33$ a central tracer is located to within about 2 mm in three dimensions, i.e. with an uncertainty of about 0.9 mm in both the x and y co-ordinates and 1.6 mm in the z co-ordinate linking the detectors. At a logging rate of 2500 events/s, a location can be determined using 80 approximately 30 times per second (and even more frequently if overlapping sets of 80 are used).

A stationary tracer can obviously be located arbitrarily well by using a sufficiently large value of N. However, for a moving particle there is an optimum sample size, large enough to provide adequate statistics but not so large that the particle moves too far during the sampling process. This optimum has been determined from data recorded for a labelled particle moving on a turntable at various speeds (Parker *et al.*, 1993). As an example Figure 12.8 shows the results obtained with a ^{18}F particle at a radius of 95 mm on a turntable rotating at 1.4 rev/s (particle speed 0.84 m s$^{-1}$) analysed using $N = 80$ and $f = 0.3$; the uncertainty in location (Δ) is given by the root-mean-square (r.m.s.) deviation of the locations from the fitted sinusoidal curves. Perhaps surprisingly, the optimum location (lowest r.m.s. deviation) was found to correspond always to a sample size such that the particle moved approximately 20 mm during its acquisition. In the latest PEPT algorithm the sample size is automatically adjusted to be 'optimal' by examining the degree of scatter of the final set of γ-ray paths about the estimated position, so as to reliably track an erratically moving particle. Figure 12.9 shows how the resulting sample size and precision of location vary with speed. To a good approximation the precision of location depends only on N_F, the number of events retained in the final calculation, and on the distance moved during the corresponding time, so that the curves shown in Figure 12.9, in which the tracer speed is expressed in units of distance moved per retained event, can be used for any situation if the appropriate value of f is known. The upper scale shows the corresponding speed for a ^{18}F tracer ($f = 0.3$) giving a data rate of 2500 events/s in a low attenuation environment. Such a particle moving at 1 ms$^{-1}$

Figure 12.8 *Example of PEPT location data from a tracer particle on a turntable rotating in the x,z plane at 1.4 rev/s (from Parker* et al., *(1993))*

can be located to within 5 mm in three dimensions up to 50 times per second. Location is somewhat less precise near the edges of the field of view, or when a large amount of scattering is present, or when $^{22}$Na is used as the label, since in these cases the optimum value of f (specified as an input parameter for the algorithm) is reduced, and the distance moved per retained event is correspondingly higher. Nevertheless, the technique always provides unbiased estimates of position.

Locations are not evenly spaced in time, but each is associated with a precise time, given by the average of the times of detection of the events finally used in its determination. Thus each location in fact comprises four values (x,y,z,t). From a pair of successive locations, the tracer velocity can be obtained simply as the distance moved divided by the difference in time. The uncertainty in the resulting value has been shown to be about 15%, almost independent of speed.

As mentioned in Section 12.3, positron-emitting particles may be made either by encapsulating $^{22}$Na (within, for example, a drilled glass bead) or by directly irradiating a bead of silica to produce $^{18}$F *in situ*. The latter is generally the preferred approach, since detection of the associated γ-ray emitted by $^{22}$Na means that more of the recorded data must be discarded as corrupt, giving

Figure 12.9 *Root-mean-square location error (A) and average number (N$_F$) of retained events per sample (B) given by the PEPT algorithm as a function of particle speed, expressed in units of millimetres moved per useful retained event; the upper scale shows the corresponding speed for an unshielded [18]F tracer giving 2500 detected events per second*

poorer location at speed. Labelled silica particles as small as 1 mm diameter can now be routinely produced, and, if it is important that the tracer has a density lower than the 2.3 g cm$^{-3}$ of silica, it can be encapsulated in resin.

As an illustration of the power of the PEPT technique, Figures 12.10–12.13 show the results obtained using a 2 mm silica tracer in a horizontal axis ploughshare mixer, partially filled with rice. Results have been reported for a number of fill levels (Beynon *et al.*, 1993) and blade speeds (Bridgwater *et al.*, 1993). Each measurement lasted about 30 min, during which time data were continuously recorded, and were subsequently analysed with the PEPT algorithm to give over 10$^4$ successive tracer locations (x_i, y_i, z_i, t_i). Figure 12.10 shows as a grey scale the fraction of the total run time spent by the tracer in each 5 mm × 5 mm pixel in the y,z plane, perpendicular to the mixer axis. For this purpose (x_i, y_i, z_i) is considered to represent the location over the period from $(t_{i-1} + t_i)/2$ to $(t_i + t_{i+1})/2$. Provided that the tracer faithfully followed

Figure 12.10 *Examples of PEPT data obtained in a horizontal-axis ploughshare mixer at four levels of fill (shaft frequency 4 Hz): the grey scale denotes the fraction of time spent by the tracer in each pixel in the y,z plane (from Beynon et al., 1993))*

Figure 12.11 *As Figure 12.10 (10% fill), but a single 30 mm wide slice surrounding the first blade, and gated on the mixer shaft angle (60° intervals, measured from top-dead-centre)*

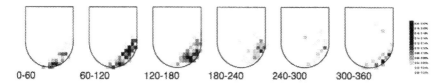

Figure 12.12 *Average PEPT tracer velocity (magnitude and direction) versus position in the y,z plane at the same four fill levels shown in Figure 12.10*

the behaviour of the surrounding rice, this representation is equivalent to measuring the density of rice in each pixel and is fully tomographic; the results given in Figure 12.10 have been integrated along the axial length of the mixer, but they could equally well be broken down into axial slices. Thus Figure 12.11 shows the data from just a 30 mm wide slice covering the first ploughshare blade, which has been further broken down into a sequence of six images corresponding to different sections of the 360° blade rotation cycle (for each PEPT location the simultaneous blade angle was also recorded); the displacement of material by the blade is clearly seen, although a longer measurement than 30 min is clearly needed to provide satisfactory statistics for such images.

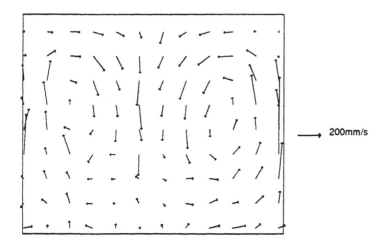

Figure 12.13 *Average tracer velocity in the* x,y *plane* (*side view of mixer*) *at 70% fill* (*shaft frequency 6 Hz*) *showing circulation in two cells* (*from Bridgwater* et al. (*1993*))

Thus, in a closed system in which a representative tracer particle moves continuously, the set of particle locations measured over an extended period can be used to provide a tomographic image of the fluid distribution. The data are automatically compensated for variations in detection efficiency; when the tracer enters a region of lower efficiency the located points may be spaced further apart in time, but each will carry correspondingly greater weight when the entire set is averaged. It is interesting to note that in such a situation PEPT may actually offer a more powerful way of observing the bulk distribution in three dimensions than conventional PET, since in the latter technique the spurious events distort the image in a way which can only partially be corrected after back-projection, whereas in PEPT spurious events are almost entirely discarded by the tracking algorithm. It can also be extremely instructive to watch the path of the tracer particle on a computer graphics monitor, which often enables an initial characterization of the behaviour.

Perhaps the greatest strength of PEPT results, however, is in the information they contain on velocities and dynamic behaviour. Since an estimate of the instantaneous vector velocity is provided by the difference between each two successive locations, the average three-dimensional velocity field at each point can be built up. Figure 12.12 shows the average velocities in the y,z plane, integrated in the same way as in Figure 12.10 and Figure 12.13 shows the corresponding view in the x,y plane, in which the presence of two circulation cells within the mixer is apparent. The full velocity distribution within each region can also readily be presented. Finally, in a mixing context it is valuable to use PEPT results to predict the dispersion with time of an initially compact volume of material, by examining the future motion of the tracer, starting each time it passes through the selected volume.

12.7 Summary and outlook

The two major *emission* techniques for process tomography are MRI and PET/PEPT. Of these, the restrictions associated with MRI preclude its use on most actual process equipment, though the excellent spatial resolution which it offers will no doubt be invaluable in some process engineering research.

The use of positron-emitting radioactive tracers provides a non-invasive way of observing flows within real equipment, irrespective of the presence of metallic casings, by detection of the pairs of collinear coincident 511 keV γ-rays emitted following positron/electron annihilation. This chapter has inevitably concentrated on the capabilities of the Birmingham positron camera, since to date it is the only PET facility designed for studies in process engineering. Conventional three-dimensional tomographic imaging with a FWHM resolution of around 8 mm is possible over a cylindrical field of view approximately 350 mm long by 300 mm in diameter, but generally several minutes are required to record sufficient data to form an adequate image. Tracking a single positron-emitting tracer particle enables much shorter timescales to be addressed, it being possible to locate such a particle several times per second, to an accuracy of 2 mm (in three dimensions) at low speeds, rising to around 8 mm at 1 m s$^{-1}$, and to determine its instantaneous velocity each time to an accuracy of 15%. In a closed system in which the tracer particle moves continuously around the field of view, and provided its motion is representative of that of the surrounding fluid, the set of particle locations measured over an extended period can also be used to provide excellent tomographic images of the fluid distribution.

Perhaps the main limitation of the present Birmingham positron camera is its restricted data recording rate. A new design of area detector has recently been developed at the Rutherford Appleton Laboratory, based on BaF$_2$ scintillator crystals, but retaining multi-wire positional read-out similar to the present Birmingham system. A camera based on these new detectors would have much higher detection efficiency and better time resolution; it would thus be able to operate at a logging rate at least 10 times that of the present system (which is essentially limited by the rate of random coincidences), significantly extending the ability to study the dynamics of real engineering processes. Systems with more than two area detectors may also be considered, since each is also expected to be significantly less expensive than the present technology.

Although a major strength of positron-based imaging is that studies can be carried out on actual plant, provided sufficient access is possible for the detection equipment, to date its use has been restricted to that of a research tool, rather than for process monitoring, largely because of the capital cost of current positron cameras. It is possible, however, to conceive the development of much simpler on-line systems, for example a ring of a few scintillator–photomultiplier detectors continuously imaging flow within a pipe, one phase of which had been labelled using a short-lived positron emitter such as $^{82}$Rb obtained from a portable radioisotope generator. No attempt to develop such a system is known, possibly simply because the potential of PET is only now beginning to be appreciated.

References

Aguayo, J. B., Blackband, S. J., Shoeniger, J., Mattingly, M. A. and Hintermann, M. (1986) Nuclear magnetic resonance imaging of a single cell. *Nature*, **322**, 190–191

Barton, J. P., Farny, G., Pearson, J. L. and Rottger, H. (eds) (1987) Computed tomography. In *Neutron Radiography. Proceedings of the Second World Conference., Paris, France, 1986*, D. Reidel, Dordrecht, 695–782

Beynon, T. D., Hawkesworth, M. R., McNeil, P. A., Parker, D. J., Bridgwater, J., Broadbent, C. J. and Fowles, P. (1993) Positron-based studies of powder mixing. In *Powders and Grains 93* (ed. C. Thornton), Balkema, Rotterdam, 377–382

Bridgwater, J., Broadbent, C. J. and Parker, D. J. (1993) Study of the influence of blade speed on the performance of a powder mixer using positron emission particle tracking. *Trans. I. Chem. E.*, 71A, 675–681

Caprihan, A. and Fukushima, E. (1990) Flow measurements by NMR. *Phys. Rep.*, **198**, 195–235

Charlton, J. S. (ed.) (1986) *Radioisotope Techniques for Problem-solving in Industrial Process Plants*, Leonard Hill, Glasgow

Clack, R., Townsend, D. and Jeavons, A. (1984) Increased sensitivity and field of view for a rotating positron camera. *Phys. Med. Biol.*, **29**, 1421–1431

Coleman, C. F. (1977) Positron annihilation – a potential new NDT technique. *NDT Int.*, **10**, 277–239

Davies, G., Spyrou, N. M., Hutchinson, I. G. and Huddleston, J. (1986) Application of emission tomography in the nuclear industry. *Nucl. Instrum. Meth.*, **A242**, 615–619

Fields, P. R., Mitchell, F. R. G. and Slater, K. H. (1984) Studies of mixing in a concentric tube air-lift reactor containing xanthan gum by means of an improved flow follower. *Chem. Eng. Commun.*, **25**, 93–104

Foster, M. A. and Hutchison, J. M. S. (eds) (1987) *Practical NMR Imaging*, IRL Press, Oxford

Hawkesworth, M. R., O'Dwyer, M. A., Walker, J., Fowles, P., Heritage, J., Stewart, P. A. E., Witcomb, R. C., Bateman, J. E., Connolly, J. F. and Stephenson, R. (1986) A positron camera for industrial application. *Nucl. Instrum. Meth.*, **A253**, 145–157

Hawkesworth, M. R., Parker, D. J., Fowles, P., Crilly, J. F., Jefferies, N. L. and Jonkers, G. (1991) Non-medical applications of a positron camera. *Nucl. Instrum. Meth.*, **A310**, 423–434

Huang, Yi-Bin and Gryte, C. G. (1988) Gamma-camera imaging of oil displacement in thin slabs of porous media. *J. Petrol. Technol.*, **October**, 1355–1360

Jonkers, G., Van Den Bergen, E. A. and Vermont, P. A. (1990) Industrial applications of a gamma-ray camera system. 1. Qualitative studies, *Appl. Radiat. Isot.*, **41**, 1023–1031

Lin, J. S., Chen, M. M., Chao, B. T. (1985) A novel radiation tracking facility for measurement of solids motion in gas-fluidised beds. *J. Am. Inst. Chem. Eng.*, **31**, 465–473

MacCuaig, N., Seville, J. P. K., Gilboy, W. B. and Clift, R. (1985) Application of gamma-ray tomography to gas-fluidised beds. *Appl. Opt.*, **24**, 4083–4085

Merzkirck, W. (1987) *Flow Visualisation*, 2nd edn, Academic Press, London

Ott, R. J., Flower, M. A., Babich, J. W. and Marsden, P. K. (1988) The physics of radioisotope imaging. In *The Physics of Medical Imaging* (ed. S. Webb), Adam Hilger, Bristol, 142–318

Parker, D. J., Broadbent, C. J., Fowles, P., Hawkesworth, M. R. and McNeil, P. A. (1993) Positron emission particle tracking – a technique for studying flow in engineering equipment. *Nucl. Instrum. Meth.*, **A326**, 592–607

Rothwell, W. P. and Vinegar, H. J. (1985) Petrophysical applications of NMR imaging. *Appl. Opt.*, **24**, 3969–3972

Stewart, P. A. E., Rogers, J. D., Skelton, R. T., Salter, P., Allen, M. J., Parker, R., Davies, P., Fowles, P., Hawkesworth, M. R., O'Dwyer, M. A., Walker, J. and Stephenson, R. (1988) Positron emission tomography: a new technique for observing fluid behaviour in engineering systems. In *Non-destructive Testing: Proceedings of the 4th European Conference on Non-destructive Testing, London, 1987* (eds. J. M. Farley and R. W. Nichols), Pergamon Press, Oxford

Tilyou, S. M. (1991) The evolution of positron emission tomography. *J. Nucl. Med.*, **32**, 15N–26N (subsequent papers to p. 56N also relevant)

Waters. S. L., Horlock, P. L. and Kensett, M. J. (1983) The application of hydrous tin (IV) oxide in radiochemical separations and, in particular, for the $^{68}Ge/^{68}Ga$ and $^{82}Sr/^{82}Rb$ generator systems. *Int. J. Appl. Rad. Isot.*, **34**, 1023

Wellington, S. L. and Vinegar, H. J. (1987) X-ray computerized tomography. *J. Petrol. Technol.*, **August**, 885–898

Wells, K., Ott, R. J., Suckling, J., Bateman, J. E., Stephenson, R. and Connolly, J. F. (1991) The status of the ICR/RAL BaF_2-TMAE positron camera. *IEEE Trans. Nucl. Sci.*, **38**, 1668–1672

Data processing techniques

Section Editor: C. G. Xie

Data processing techniques

Chapter 13

Computational needs for process tomography

R. W. Taylor

13.1 Introduction

Computers are an essential part of any process tomography system. The data-acquisition system is often under computer control, providing flexible and fast data capturing. The captured data are processed within the computer by using suitable image-reconstruction algorithms to generate cross-sectional images of the process media being studied. The realization of real-time image reconstruction is usually dependent on the architecture and performance of the computer and on the complexity of the reconstruction algorithm. The modelling of process tomography sensors and systems is also made possible by using high-performance computers running simulation software that is often based on the finite-element method. Some iterative image-reconstruction algorithms depend on the finite element solver to provide calculated measurement data for the up-dated distributions of process media; this demands that the computer system be extremely efficient and powerful in solving matrix equations of large dimensions.

The development of efficient algorithms is also important and is often related to the computer architecture on which the algorithms are implemented. For example, algorithms running on serial computers often need to be rewritten or parallelized, in order for them to be implemented efficiently on parallel computers.

This chapter starts by introducing the processor families that are in use. A brief description of parallel processing then follows and, finally, the performance issue is addressed.

13.2 An introduction to processor technology

13.2.1 Processor architectures

In essence, a processor is a finite state machine, combining instructions and stimuli (data and/or events) and generating results (as data and/or other events). The simplest formalization of this processor, the *Turing machine*, is capable of performing the same logical operations as any of its more modern rivals – it differs only in its speed and convenience of use. The purpose of this section is to describe the essential features of the modern processor, discuss

variants on the theme and then introduce several specialized forms with applications in process tomography: the reduced instruction set computer, the digital signal processor, the parallel processor, the custom computer, and the systolic array.

Most computer systems essentially consist of memory, a processor capable of reading and writing the memory, some form of internal communications channel (the bus) and some form of input/output subsystem.

In order to understand the differences between different processor families, it is necessary to be aware of the evolution of the modern computer. In the beginning came the valve – processors were bulky, expensive and simple. As time went on, the development of the transistor, the integrated circuit and, more recently, very-large-scale integration (VLSI), meant that more and more facilities could be integrated onto a single piece of silicon. At first, this was beneficial. Useful facilities were added to each processor's instruction set and most designs were still simple enough to be understood by their programmers and designers. VLSI changed all this – processors became too complex for any one designer to understand, although for a while at least these problems were masked by improvements in speed gained through improved fabrication techniques.

Most of these processors made use of microcode – a smaller, simpler instruction set embedded within the machine (Figure 13.1). Rather than being executed directly in hardware, each instruction was first converted internally to a set of 'microinstructions' before being executed.

The instruction sets that these machines understood were rich and complex. This was seen as being important to the designer, since it reduced the workload for the compiler writer, making commonly used sequences of instructions more efficient and hence keeping memory usage down. The generic name

Figure 13.1 *The microcode computer*

given to the families of these processors is *complex instruction set computers* (CISC).

13.2.2 CISC processor families

The CISC processor is the most common general-purpose processor type on the market today, encompassing the bulk of the Intel range of processors (from the 8086 through to the 80586) and the Motorola family (the 6800 through the 68040). The arguments for retaining the CISC architecture are many, but can be summarized as:

- Microcoded instructions operate very much faster than external instructions (which must be fetched from external memory), and so complex sequences of micro-instructions are more efficient than similar sequences of macro-instructions.
- The use of microcode does not make rich instruction sets very much more expensive to generate than simple (or reduced) instruction sets.
- In order to maintain backward compatibility, processors must resolve the conflict between older, less efficient instruction sets and newer, more compute efficient sets – this is easier done in microcode than through hardwired design.
- Compiler design is simplified through microcode.

Of these, the compatibility issue is probably one of the most important. Both Intel and Motorola have developed a range of processors backwardly compatible with their ancestors. Both companies have been successful, but Intel dominate with the 8086 family. Code written for the original IBM PC 15 years or more ago may still be run on computers thousands of times faster and five generations removed. Indeed, since it is the case that the money tied up in software facilities far outweighs that of the hardware that it runs on, making processors that are compatible with their ancestors all the more valuable.

13.2.3 RISC processor families

The reduced instruction set computer (RISC) was the result of a combination of factors; observations on the shortcomings of CISC machines, better understanding of the nature of uniprocessor parallelism and a reduction in the cost of memory. Essentially, the justification for making use of a smaller, more carefully controlled instruction set is that:

- The basic hardware is simpler, making it possible to 'hardwire' instructions into the machine, allowing individual instructions to execute faster than their microcoded cousins.
- The development of effective instruction caches has meant that the bandwidth lost through having to execute more instructions for a given line of source code is dramatically reduced.

- A better match occurs between the compilers and the machine – in this case the machines are simple enough for the compiler writers to make effective use of all of the carefully tuned facilities.
- Design effort is lower for RISC than for CISC.
- It is easier to introduce parallelism (both temporal and spatial) into a RISC unit than a CISC unit, primarily because of the ease of analysis.

RISC design has emerged from careful statistical analysis of exactly how software uses the resources of a processor. Dynamic measurement of system kernels and object code generated by compilers show that the simplest instructions are the most frequently executed. Complex instructions are less likely to be used since either the compiler writer is not aware of their many forms, or they do not exist in a form that is suitable for the algorithm in hand.

It is interesting to note that all the major manufactures are either developing or marketing sophisticated RISC designs – Motorola with the 88000 family, Intel the i860, MIPS and R3000 and Sun the SPARC.

There is no question that RISC processors are here to stay. In their short development life, they have shown themselves to be more cost effective than CISC units, and further improvements in memory and cache design are likely to improve the situation. For the bulk of process tomography applications, it is more important that *source code* rather than *object code* be transportable between different architectures. In this case, the underlying processor architecture is of less interest than the performance per unit cost.

13.2.4 Processors designed for parallel processing

When a parallel computer system is developed from conventional, sequential processing units, many of the advantages of the parallelism get lost in the overheads of supporting message passing and/or shared memory. This has led manufacturers to develop specialized facilities on board their processors specifically designed to support parallel operation. Other than the 'supercomputers' from companies such as NCUBE and Thinking Machines, two designs have dominated the market, the Inmos transputer and, more recently, the Texas Instruments C40. Both designs borrow from RISC and CISC philosophies.

Inmos took an early lead, developing a high speed processor (e.g. the T8xx family) capable of being connected to other processors through 4 fast (20 Mbit s^{-1}) serial links. Combined with a style of programming that made the development of multi-processor code relatively painless, the transputer family has become very popular for many multi-processor applications.

During the early 1990s, the transputer fell behind its rivals in raw processing power. Changes in the company structure delayed the introduction of the new T9000 transputer (Inmos 1991) and allowed Texas Instruments to introduce a more competitive processor, the C40. The C40 shares some of the characteristics of the transputer – six fast, byte-wide communication links (capable of 20 Mbyte s^{-1} each) and a processor designed to be integrated with others in a parallel array.

The use of multiple T4xx and/or T8xx transputers with electrical capacitance and ultrasonic tomography systems for flow imaging applications is described, in Chapter 14.

13.2.5 Digital signal processors

Many signal-processing applications make use of a restricted set of operations. This has led manufacturers such a Texas Instruments to introduce processors optimized for executing sequences of these operations. Typically, most digital signal processing (DSP) units are treated as *array* processors. Array processors use parallel hardware and a computational pipeline in which numerical operations, data input and output, program fetching and address updating are all done in parallel. The array processor is normally a peripheral device to some controller, provided with its own private, high-speed memory that allows it to work efficiently on the data at hand.

The primary difference between the array processor and a conventional processor is the explicit use of arrays. Rather than operating on single data items, whole arrays are manipulated (added, multiplied, divided, etc.). A typical example of a successful and relatively low-cost array processor is the Motorola DSP56001. This processor can execute up to 12.5 million instructions per second (MIPS), and with a single instruction perform a 24 × 24 bit multiply, a 48 plus 56 bit addition, two 16-bit address updates and three parallel memory moves.

Provided that the problem can be formulated in a way which allows contiguous arrays of data to be manipulated, the DSP processor (or multiple DSP processors) provide a cost-effective solution to image reconstruction. The use of DSPs/transputers for performing image reconstruction and cross-correlation between two image planes for flow velocity imaging is described in Chapter 14.

13.2.6 Field programmable gate arrays

There are many tasks that could be handled very effectively through the use of digital application specific integrated circuits (ASICs). To date, the cost and complexity of developing these circuits has precluded their use in relatively specialized applications such as process tomography. The introduction of the field programmable gate array (FPGA) may change this.

Evolution
Programmable logic devices have been developed from the integration of a number of technologies, including fuse programmed memory (PROM/EPROM), static RAM and conventional, functional logic. These families of devices rely on a 'sea' of uncommitted logic devices and a pool of interconnection resources. By modifying the function of each logic block and its connections with neighbours, a range of different composite functions may be produced.

Early generations of programmable logic arrays (PLAs) were 'write-once' devices. By applying higher than normal voltages, 'fuses' could be blown, setting both the function and the connectivity within the unit.

Although early devices were simply AND–OR Inverter arrays, these were rapidly refined to include registered outputs, programmable output inversion and input/output (I/O) with internal feedback of outputs back to the logic array. These devices have become widely used as 'mop-up' logic, replacing conventional TTL for 'gluing together' more complex integrated circuits.

With the development of fabrication techniques capable of integrating many more gates per unit area, the simple AND–OR-Macrocell architecture became unsuitable; the bulk of fuses remained unused and the large numbers of input became redundant.

In order to achieve higher utilization, companies began to place many PLAs on a single chip, connecting them via one or more central buses. Combined with the addition of electrically erasable memory (EEROM) instead of fuses, these devices were introduced as the erasable and programmable logic devices (EPLDs) of Altera.

The higher functionality of these devices was matched by the development of design tools that included standard macro libraries containing amongst others, 74 series logic – soft macros defined in terms of logic equations. Efficient utilization was achieved through the use of logic reduction systems. The Altera device was not simply a sophisticated glue, it could in fact form the basis of system components. The major limitation on the use of the device is its memory capacity.

FPGAs were introduced to compete with true gate arrays. Unlike the older programmable logic, the fuses were replaced by static memory cells, in which the state of the memory determined whether a connection was to be made or not. This allowed the rapid programming and reprogramming of the devices.

FPGAs typically consist of a checkerboard array of logic cells with some routing resource (global, local, or a mixture of the two). Connections and cell function are determined by the contents of the array's memory. The configuration memory effectively 'sits above' the gate-array circuitry, defining the operation of the gate array as a top mask determines the functionality of a conventional gate array.

The term 'FPGA' is used to describe any two-dimensional array of programmable logic cells, and these do not need to be SRAM based. This discussion will, however, concentrate on SRAM units. FPGA applications can be divided into three distinct areas:

- Gate-array replacement.
- Circuit prototyping.
- FPGA computing.

For the purposes of this discussion, only the first and third issues will be addressed.

Gate array replacement
FPGAs are rapidly replacing mask programmed gate arrays for a range of applications. This is primarily due to the savings in 'non-recurring engineering'

expenses, the time and money invested in the development of masks. FPGA solutions can be designed and implemented in days rather than weeks or months. There are other advantages:

- Typically more than half of all ASIC designs require a second design iteration, increasing masking costs. Second sourcing requires yet more masking, further increasing costs.
- FPGAs are standard 'off-the-shelf' components, produced in high volume and hence at low cost.
- A standard device. There is less need for 'design for testability' since many fault coverage procedures have already been developed.
- It is less critical to get the design right first time, allowing the designer to spend less time on simulation.

The importance of the rapid turnaround can not be overemphasized. Products that are late to the market lose sales very rapidly, ASIC development is likely to only be contemplated for very large and/or expensive products.

FPGA computing

There are two approaches to solving algorithms in digital logic:

- *Software*: the implementation of the solution through the programming of a general-purpose processor, capable of a wide range of computations. The general-purpose nature of the underlying hardware means that this solution is not necessarily the fastest, the most efficient of the most easily scalable solution. It does, however, have the advantage of rapid design turnaround.
- *Hardware*: the implementation of the solution through custom hardware. This has the advantage of speed and size, but the major disadvantages of a longer design and implementation time.

To summarize, software is flexible and hardware is fast. FPGAs bridge the gap–flexible hardware that still retains many of the speed advantages of its custom sister. FPGA computing takes advantage of the fast reconfigurability of FPGAs. Instead of compiling to an intermediate machine code, compilation to an FPGA configuration occurs. The FPGA can then 'run' the application. There are some limitations:

- A FPGA can only implement about 20% of the logic of a fully custom device and at about 30% of the speed.
- If not handled properly (possibly through the use of macros), the compile time may be measured in days rather than seconds.

The limitations of the FPGA tend to favour applications with a number of characteristics:

- *Non-numeric*: arithmetic operations (beyond the regular fixed point add and multiply) are very expensive and are better dealt with by dedicated units.
- *Repetitive*: problem complexity is limited by the amount of hardware available. Control logic (such as IF *a* THEN *b* ELSE *c*) is wasteful of cells since only small parts of the system are computing at any one time. Repetitive loops are preferred since the download compute ratio is high.

- *Easily segmentable*: problems that can be broken up to fit inside single FPGAs are preferable, since the variation on the interface between FPGAs makes design more complex.

Applications that are suitable for FPGA solutions include:

- Digital signal processing.
- Graphical calculations and rendering.
- Fine grain systolic structures (cellular automata, fuzzy logic, artificial neural networks).

A number of FPGA machines have been, or are being developed, including Splash (Gokhale *et al.*, 1991), a machine for implementing one-dimensional systolic arrays; DecPeRL (Bertin *et al.*, 1989, 1992), a general-purpose machine for Digital Equipment; CHS2x4 (Gray and Kean, 1989), a machine development platform; TRAM standard FPGAs (Page and Luk, 1991); and cellular array machines (Cockshott *et al.*, 1992).

Zelig

Zelig (Howard *et al.*, 1992) is a machine that uses FPGA computing for applications most suited to this method, i.e. cellular automata and other fine-grain systolic arrays. Zelig is a parallel machine, on two counts:

- All automata rules or 'instructions' are executed in parallel, being implemented in hardware. The equivalent of around 10 to 100 microprocessor instructions are seen by the processor as a single 'macro-instruction'.
- It contains many FPGAs. Many copies of the automata rule may be placed on them – the exact number depending on the complexity of the rule. Zelig is a vector processor. The execution of a single macro-instruction updates a large (and variable) number of automata cells. This trade-off between complexity and performance, normally associated with software, is a general feature of the machine.

A further type a parallelism may be introduced by pipelining the macro-instruction.

Zelig is most similar to the Splash machine, but is far more flexible with regard to the systolic array structure and cell interconnection, being intended for two- and three-dimensional models. It consists of a ring of 32 Xilinx XC3090s, each with its own 64K × 8 bit static RAMs, in which cell state data (node data) are stored. Each FPGA in the ring can 'see' the node data of the two FPGAs directly above and below. Also, there is an 8-bit wide direct connection between directly neighbouring FPGAs which could be used for global signalling or video purposes. The data transfer between the FPGAs and the node data is controlled by the master processor, a T800 transputer, which executes dummy read and write operations to control the data transfer. Thus, the cell neighbourhood is partly defined by the sequence of read and write instructions executed by the master. The speed of generating these addresses by software is the limiting factor in the speed of the overall machine. Provision has been made for some extra hardware, an address generation accelerator, to be placed between the master and the node data to speed up the machine by a

factor of around 10. Experience needs to be gained in the use of the machine before a specification can be defined for this hardware. The master and/or accelerator also controls the transfer of data from the node data to the video board. This video board is capable of displaying a screen with resolution of up to 512 × 512 with 256 colours. The support software, written in OCCAM and running on the master processor and the host computer, provides commands to configure all FPGAs, transfer data between disk and node data and to control the processing and video frame updating of the machine.

13.3 An introduction to parallel processing

13.3.1 Why go parallel?

Parallel computers offer a number of significant advantages over their serial counterparts, including:

- The ability to break away from the *von Neumann bottleneck*, with its physical limitations.
- Cheaper systems.
- Faster computing inherent in multiplicity of processing nodes.
- The ability to handle bigger problems; made possible by problem fragmentation.
- The choice of more system functionality; made possible by an ability to distribute different tasks and functions across the system.
- Fault tolerance.

Note that these advantages must be paid for somehow, and this payment is normally exacted in terms of increasing the complexity of solution and a reduction in program productivity.

A major determining factor in new technologies is economics, and mass produced VLSI components favour parallel computing built from many cheap processors as opposed to expensive mainframe and vector supercomputers. A corollary to this is that more parallel computing personal workstations with hundreds of nodes will become more widely available as we approach the next century.

The main disadvantage of parallel computing is its relative complexity with respect to serial computing. The possibility that all the software investment of the last 30 or so years might be lost is not a prospect that delights most potential users.

13.3.2 What is parallelism?

At the abstract level, there are three types of parallelism:

- *Problem parallelism*: here the parallelism is seen within the problem's structure and can be extracted. This can either be *obvious* as occurs in problems involving large, regular data sets with problem parallelism exceeding the number of available processors, or *inherent* as in some real

world problems involving interacting subsystems; an example is a chemical plant control system with sensors and controllers.

- *Discovered parallelism*: the problems here have no obvious parallelism, and more hard work is required to develop parallel algorithms. Problems in this class include sorting algorithms, linear algebra, the classical travelling-salesman problem, graph problems and many others.
- *Implicit parallelism*: in this class, the user completely ignores parallelism. An automatic parallelizer handles all aspects of parallelism. If possible, this would be the ideal situation since it places no burden on the user and means enormous economic savings on all that Fortran. Cobol and other codes developed over so many years. However, the time and development costs combined with relatively low efficiencies for general-purpose parallelizers are unacceptable.

Once parallelism has been abstracted, there are a number of solution paradigms, the following four being widely used (Hey, 1989):

- *Farm parallelism*: this is suited to problems where the data space can be partitioned into many pieces with a high degree of independence. One node in the network is designated the master and distributes tasks to other nodes (workers) which return results to master on completion. There are no worker communications. There is automatic load balancing since workers are kept busy all the time. Examples include ray tracing in image construction; database and payroll transaction processing.
- *Geometric parallelism*: in this case, the problem has a geometric structure which yields a data space such as volumes in fluid dynamics. Computations for each data space typically runs on one node. Examples include weather prediction and finite-element modelling.
- *Algorithmic parallelism*: this corresponds to problems with no regular structure and the whole problem's code needs to be partitioned. Examples include systolic arrays and dataflow machines.
- *Dynamic parallelism*: the above three solution techniques are static in that they are bound to processor-maps at compile time. Some problems require dynamic parallelism with processes created and mapped at run-time. This technique is not widely used due to its inherent difficulties. Examples include dynamic load balancing, and the 'divide-and-conquer' algorithm where the problem is divided into two or more smaller problems to be solved independently and solutions combined in an iterative manner.

13.3.3 Classification

It is useful to have a classification of computational models for the purposes of characterization and reference. The most familiar classification is that given by Flynn (1972) based on the concepts of data stream and instruction stream. Three of the machines characterized by Flynn are widely used today:

- Single instruction single datastream (SISD) machines, (the simple sequential processor).

- Single instruction multiple datastream (SIMD) machines.
- Multiple instruction multiple datastream (MIMD) machines.

The von Neumann model, as well as most serial computers of today, fall in the SISD class (Figure 13.2). Instructions are executed sequentially but may be overlapped (that is pipelined). In the SIMD class (Figure 13.3), there are many processing elements under supervision of one control unit. All processing elements receive the same instruction from the control unit but operate on

Instructions Data

Processor

Figure 13.2 *The single instruction, single datastream (SISD) architecture*

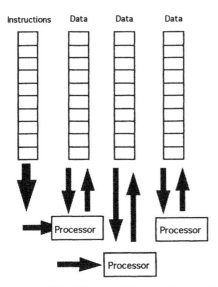

Instructions Data Data Data

Processor

Processor

Processor

Figure 13.3 *The single instruction, multiple datastream (SIMD) architecture*

different streams. Most multi-processor systems belong to the MIMD category (Figure 13.4). In this class, each processor is capable of executing its own process independently of other processors, with the option to perform interprocessor communication for tasks that require cooperation.

13.3.4 Processor interconnection mechanisms and organization

The ideal communication topology is one where every *node* (the term *node* is used here and subsequently in this chapter to mean a processing element which may include attached memory) is connected to all nodes in a one-to-one correspondence; this is too expensive for the number of nodes required to truly exploit parallelism. Interconnection networks are approximations to this ideal case. There are two processor interconnection configurations: *static* and *dynamic* topologies. Static topologies remain fixed throughout the life-time of the machine and are suited to problems that can be divided to yield local interactions only. Dynamic topologies are more general purpose and more expensive but allow direct connection between requesting nodes by switching. The bulk of process tomography systems are likely to remain static in the near future, the overheads in switching messages being too expensive for such low-cost, dedicated systems.

Mesh architectures
The one-dimensional mesh (linear array) is the simplest interconnection. Connecting the boundary nodes of the linear array gives a ring of degree 2. (The degree of a node is the number of other nodes it is connected to; the central node of an N-node star network has degree $N - 1$ which means it has a

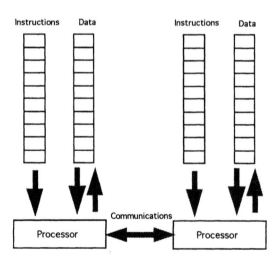

Figure 13.4 *The multiple instruction, multiple datastream (MIMD) architecture*

poor fault tolerance.) The star topology is not practical because of the large degree of the central node. In the tree topology, the root node and leaves is of degree 1 and interior nodes are of degree 2. In a tree with N nodes, the worst time for a node to communicate to any other node is $2\ln(N)$ steps (from a leaf to root and backtracking). Tree topologies are suited to VLSI designs, search algorithms and rule-based production systems. The completely connected topology is optimum in performance, but with all nodes having degree $(N - 1)$, it is not cost-effective.

The two-dimensional mesh is a special case of k-dimensional meshes, of degree $2k$. For the two-dimensional mesh, variations exist on connections of the boundary nodes, with wrap-around being more common. Efficient algorithms for sorting, matrix manipulation and solution of second-order differential equations have been developed for meshes (Quinn, 1987). Routing in k-dimensional meshes is performed one dimension at a time; to route data in a three-dimensional mesh from node (x_i,y_i,z_i) to node (x_j,y_j,z_j), move along the first dimension to node (x_j,y_i,z_i), then along the second to (x_j,y_j,z_i) and along the third to (x_j,y_j,z_j). The main disadvantage of mesh networks is that the network *diameter* (the number of steps required to communicate data from one node to another) grows with the number of nodes.

Hypercubes
The number of nodes N in a k-dimensional *hypercube* is 2^k, each of degree k. A zero-dimensional hypercube is a single node, a one-dimensional hypercube is a two-node linear array, and a four-dimensional hypercube has 16 nodes. Nodes are labelled $i = \{0,1, . . .,N - 1\}$ and any two nodes are connected if they differ by 2^i (if they differ by one bit position only). Hypercubes have attracted a great deal of interest due to their high interconnectivity and routing advantages; hypercube machines include Caltech Cosmic Cube and its descendants (Seitz, 1985), Intel iPSC, NCUBE/ten, FPS/T and the Connection Machine CM-2. Routing in a k-dimensional hypercube is along the dimension in which the communicating nodes differ by one bit position; the maximum number of steps is therefore k or $\ln(N)$.

Cube-connected cycles
Even greater connectivity is achieved by taking a hypercube as an underlying structure for *cube-connected cycles* (CCCs). A CCC is a k-dimensional hypercube the vertices of which are rings of k nodes. The rings are identified by $i = \{0,1, . . .,(2^k - 1)\}$ and two rings are connected if they differ by 2^i; the nodes whose dimension is i on the differing rings are connected. The nodes in the ring have degree k, while the total number of nodes (N) in the CCC is $k2^k$. Routing from any node to any other takes $2.5\ln(N)$ steps.

Table 13.1 gives a comparison of some popular static topologies. N is the number of nodes in each network. Flexibility gives a comparative indication of the ability to re-route messages through alternative nodes when routes are blocked. Fault tolerance gives an indication of reliability of the topology when one or more nodes are not working. Flexibility and fault tolerance are difficult to estimate and are given here on a comparative scale. Bandwidth shows how

Table 13.1 Comparison of popular static topologies

	Two-dimensional mesh	Binary tree	Star	Fully connected	Hypersurface	Hypercube	CCC
Flexibility	Medium	Low	Low	High	Medium	Medium	Medium
Fault tolerance	Medium	Low	Low	High	Medium	Medium	Medium
Bandwidth	N	N	N	N	N	N	N
Cost	N	N	N	N^2	N	$N\ln N$	N
Complexity	4	3	N	N	4	$\ln N$	3

much traffic each topology can handle per unit time. The item 'Cost' is the cost of the interconnecting wires for each topology. Complexity gives the degree of a node; this is the number of neighbours each node is connected to.

13.3.5 Pipelines

Pipelines are here given a section to themselves in recognition of their potential importance to problems such as tomographic reconstruction. By developing overlapping pipelines, conventional sequential solutions may be implemented directly with immediate results.

The pipeline provides a relatively simple mechanism for implementing 'temporal' parallelism. The pipeline is similar to the assembly line in a modern factory. Each stage in the assembly line takes on the output of the last stage, transforms it and then passes the result down to the next point on the assembly line. Breaking a task up in this way means that multiple operators can work on the jobs underway (provided there are enough jobs) and gives the potential for a massive improvement in the performance of the assembly unit.

In the same way that an assembly line can be speeded up, the operation of a processor unit can also be improved to provide greater throughput than was previously available *with the added advantage of compatibility between pipelined and standard computing units.*

A linear pipeline is a static structure in which all of the processing units involved retain their structure (function and computation time) throughout the operation of the pipeline. Consider the pipeline shown in Figure 13.5. The unit consists of a simple line of computation units and buffers (which are used to 'even out' the differences in computation time between units). The clock period of the pipeline t_m is given by:

$$t_m = \max(t_i) \qquad 1 \leqslant i \leqslant n \tag{13.1}$$

where t_i is the computation time plus the buffer latch time for stage i in the pipeline.

If all n stages in the pipeline are to be used, then data will appear time T after it was fed in to the front end, where

$$T = n \times t_m \tag{13.2}$$

If we assume that we have k tasks to complete and n stages to the pipeline, then we will be able to process all k tasks in

$$[(k-1) + n] \times t_m \tag{13.3}$$

Figure 13.5 *A simple pipeline*

This time is accounted for by the fact that we have to fill our pipeline with data (during which time some parts of the pipeline will not be active) and then empty it as the last piece of data leaves the line (once again leaving some units inactive).

If we assume that all k jobs had to be done anyway (and would have been done by one processor) then the speed-up $S(n)$ can be defined as:

$$S(n) = \frac{n \times k}{k + n - 1} \tag{13.4}$$

We can then go on to define an efficiency $E(n)$ (that is the actual throughput compared with the theoretical throughput if every processor could be kept active) as:

$$E(n) = \frac{k}{k + n - 1} \tag{13.5}$$

13.4 Performance

13.4.1 Measurement

Performance of an individual processor element may be measured by instruction bandwidth B_i (MIPS) or data bandwidth B_d (MFLOPS). As measurements, these are widely quoted by manufacturers – in practice they are potentially very misleading and difficult to translate directly into an understanding of how much faster a machine will run on one architecture than on another.

13.4.2 Performance measurement for parallel systems

Two other measurements are widely used to assess the performance of parallel architectures, speed-up and efficiency:

Speed-up $= S(n) = T(1)/T(n)$ (13.6)

where $T(n)$ is the time taken to compute a solution on n processors, and

Efficiency $= E(n) = S(n)/n$ (13.7)

Basic measures of performance which are used for uniprocessor systems are often of limited value. Consider a pipelined processor array for example; individual/average instruction execution times do not measure the impact of the parallelism (of degree n, the number of processors/pipeline segments available). One measure of potential value is the time $T(n,N)$, i.e. the time for a complex operation, for example inverting an $N \times N$ matrix with n. This may be expressed in approximate form using O notation:

$$T(n,N) = O[f(n,N)] \tag{13.8}$$

This means that there are constants k and $N_0 > 0$ such that $T(n,N) \leqslant kf(n,N)$

for all $N > N0$. As N grows beyond N_0, $T(n,N)$ grows at a rate which is less within a constant factor k than that of the function $f(n,N)$.

Another description of the machine is the degree of parallelism n_i. This is the minimum value of n for which efficiency and speed-up reach maximum values at time i during execution Q. The quantity n_i represents the maximum level of parallelism that can be exploited by Q at time i.

If we consider a very simple model of processor operation in which two different types of floating point operation exist

- Fixed length vector operations of length N.
- Scalar operations of length $N = 1$.

If we make f equal to the fraction of all floating point operations (scalar) then this gives $1 - f$ as a measure of the degree of parallelism in the program (varying from 0 through 1). If we assume two different throughputs, b_v (vector) and b_s (scalar) then b is the average system throughput where b is given by

$$\frac{1}{b} = \frac{f}{b_s} + \frac{1-f}{b_v} \tag{13.9}$$

(since the use of instructions with throughput b is obviously 1). The execution time for a single scalar operation is $T_s = 1/b_s$ and that for a single vector operation is $T_v = 1/b_v$. An N component vector operation will take

$$T_v = T_0 + \frac{N T_s}{n} \tag{13.10}$$

where T_0 is the start-up time (initialization etc. of the vector) and $N T_s/n$ is the processor parallelism degree.

For large N,

$$T_v = \frac{N T_s}{n} \tag{13.11}$$

substituting in b_s,

$$b = \frac{m b_s}{1 + (m - 1)f} \qquad \text{where } m = \frac{n}{N} \tag{13.12}$$

If we set $b_s = 10$ MFlops, $m = 100$ and thus $b = 1000/(1 + 99f)$. We can estimate the change in performance with the changing fraction of scalar and vector operations, which indicates how sensitive a system of this type is to scalar operations (see Table 13.2).

In order to understand the limits to parallel performance it is necessary to be aware of the problem of complexity – a problem that puts bounds to the effectiveness of any computer solution to an algorithm.

13.4.3 Solution complexity

At the heart of parallel computing is the question of just how much parallelism can be extracted from a given problem. Some problems may exhibit a high

Table 13.2 *The relationship between throughput and scalar operations*

Fraction of scalar operations, f	Throughput, b (MFlops)
0.00	1000
0.01	502.5
0.05	168.0
0.10	91.7
0.20	48.0
0.40	24.6
0.80	12.4
1.00	10.0

degree of parallelism while others may be extremely difficult to re-cast from their serial nature to a parallel form. *Amdahl's law* addresses this 'serialness' and provides a figure for the maximum possible parallel benefit for any problem.

Assume that a fraction f of a program must execute sequentially with $0 \leqslant f \leqslant 1$. Assume also that the remaining fraction $(1 - f)$ executes in parallel with 100% efficiency. Let p be the degree of parallelism in the hardware. (This is the number of processors in MIMD; the number of processing elements in SIMD, and the vector/scalar speed ratio in pipelined SIMD.) Let $T(p)$ be the time the program takes on a hardware parallelism p. With simple separation into strictly sequential and perfectly parallel parts, the execution time is

$$T(p) = fT(1) + (1 - f)\frac{T(1)}{p} \tag{13.13}$$

and *speed-up* is given by

$$S(p) = \frac{T(1)}{T(p)} = \frac{1}{f + (1 - f)/p} \tag{13.14}$$

This is Amdahl's law. The corollary is that a small number of sequential operations can significantly limit the speed-up achievable by a parallel computer. *Efficiency* is given by

$$E(p) = \frac{S(p)}{p} = \frac{1}{1 + (p - 1)f} \tag{13.15}$$

To achieve an efficiency $E(p) > 50\%$ means that f can be no larger than $1/(p - 1)$, and as p grows, this becomes harder to satisfy. This illustrates the problem in designing efficient parallel programs.

13.4.4 Parallel computational complexity

There are two types of complexity: *time* and *space* complexity. The former is a measure of the time required to execute an algorithm, while the latter is a measure of the space required in the computation.

Parallel computational complexity is necessary for measuring the efficiency of parallel algorithms. Let p be the number of computing nodes. The *time complexity* of a parallel algorithm with a problem of size n when executed on a parallel computer of size p is denoted by $T_p(n)$. In a *dependent-size problem, n* is a function of p (that is the size of the problem is determined by the size of the machine). *Independent-size problems* occur when n is independent of p.

Consider a simple example of summing, using a message-passing algorithm. The serial algorithm which starts off by initializing a variable to zero and incrementing by each of the n numbers at a time has complexity $\theta(n)$.

Suppose $n = p$ so that each of the values to be summed is in a processor. On a private memory message-passing system, the parallel algorithm is best considered as a process of adding pairs of numbers and the pairs of pairs, and so on, on a binary tree interconnection topology where the nodes of the tree represent each of the p processors. The number of steps required to complete the summation is equal to the depth of the tree which is $\ln p$ and so the algorithm has complexity

$$T_p(n) = \theta(\ln p) = \theta(\ln n) \tag{13.16}$$

With the serial complexity being $\theta(n)$, the speed-up of this algorithm is

$$S_p(n) = T_1(n)/T_p(n) = \theta(n)/\theta(\ln n) = \theta(p/\ln p) \tag{13.17}$$

and the efficiency is

$$E_p(n) = S_p(n)/p = \theta(1/\ln p) \tag{13.18}$$

This scales poorly, since increasing the problem size (as well as machine) means that the efficiency tends to zero; this is not surprising since only two levels of the binary tree are active at any time, with higher levels waiting for partial sums to propagate upwards.

Consider the case of the *independent-size problem*. Let each processor have m items. This introduces a local phase to the computation. All the processors take $(m - 1)$ steps individually to sum their local items taking $\theta(m)$. They then enter a global phase and repeat the steps described above taking an extra time $\theta(\ln p)$ so that the problem size $n = mp$ now has complexity,

$$T_p(n) = \theta(m) + \theta(\ln p) = \theta(m + \ln p) \tag{13.19}$$

In the limiting case when m is large, the complexity becomes $T_p(n) = \theta(m)$ with corresponding speed-up:

$$S_p(n) = \theta(mp)/\theta(m + \ln p) = \theta(p) \tag{13.20}$$

and efficiency $E_p(n) = S_p(n)/p = \theta(1)$. This means that the problem has become fully parallelizable with all the processors virtually kept busy in their

local phases. How large does m has to be to achieve this maximum efficiency? The global phase does not grow with loading. By keeping $\theta(m)$ and $\theta(\ln p)$ in eqn (13.19) to be of comparable complexity (the asymptotic complexity of a sum is the same as that of the largest term), the speed-up and efficiency remain unaltered. This means that by using a *loading factor*, $m = \theta(\ln p)$, the summing algorithm becomes completely parallelizable for a message-passing machine of size p.

13.5 Computers versus algorithms versus problem size

Compared with serial machines, parallel machines allow more freedom in problem analysis and algorithm development. For a detailed description, see the books by Modi (1988) and Fox *et al.* (1988). The following general guidelines are often useful:

- The obvious approach is to examine a serial algorithm and convert it into a parallel one that runs concurrently on a parallel machine. Note that the latest and most efficient serial algorithm is often not best suited to such adaptation; an earlier, less efficient one may possess a higher degree parallelism and is much more adaptable to parallel computation.
- An iterative algorithm equivalent of a direct method may have some independent computations and be implemented efficiently on a parallel machine. However, the stability of the method should be examined to ensure fast rate of convergence. The cost-effectiveness of the procedure should be compared with the direct method.
- The computation may be broken down into smaller parts and distributed among the processors.

For instance, for small finite element problems, in one or two dimensions, the best algorithms often involve explicit matrix inversion. This approach is impractical, however, for large three-dimensional finite-element problems where the preferred approach is to use iterative techniques. On serial machines, this change is dictated by the excessive memory requirements of the direct method. It is interesting that, although direct matrix inversion can be implemented quite well on a concurrent processor, the iterative techniques fit even more beautifully on such machines and offer the most 'natural' concurrent algorithms (Law, 1986; King and Sonnad, 1987; Sadayappan and Ercal, 1987; Willis and Wait, 1989).

Algorithm performance on serial, parallel and vector processors is quite different. It also depends on the size of the problem (such as the mesh size for a finite-element analysis) and the number of processing elements (M_p) available in a given parallel system. For vector processors the maximum length of vectors (M_v) is often a factor affecting the algorithm performance.

The total time needed to perform the same operation on N data items is compared in Table 13.3 in terms of time t_i ($i = s$, p or v) for a single operation (for a subtask in the case of a vector processor) and other characteristics of the

Table 13.3 *Comparison of total time needed to perform the same operation on* N *data items on serial, parallel and vector processors*

	Serial processor	Parallel processor	Vector processor
Total time	Nt_s	$[N/M_p]t_p$	$Nt_v + [N/M_v]s_v$

$[x]$ denotes the smallest integer $\geqslant x$. s_v, Start-up time for vector operation.

machine. It can be seen that the timing, as a function of N, depends on one parameter (t_s) or two $(t_p$ and $M_p)$ for serial and parallel processors and three parameters $(t_v, s_v$ and $M_v)$ for vector processors. The vector processor thus exhibits hybrid characteristics.

13.6 Discussion

Process tomography is a computationally demanding task that is likely to become more so in the future. Improvements in data-collection techniques and the range of applications is likely to create the need for reconstruction systems capable of executing at many times the speed of current systems. The designer has two options:

- If an initial delay is acceptable, pipelined groups of processors, either DSP or RISC units are probably the cheapest, easiest to program and the most expandable option.
- If delays are unacceptable (in control applications, for example) then arrays of processors must be developed. These are likely to be expensive and application-specific architectures although, as shown above, they offer the best option for high-speed, on-line processing.

References

Bertin, P., Roncin, D. and Vuillemin, J. (1989) Introduction to programmable active memories. In *Systolic Array Processors* (ed. J. McCanny, J. McWhirter and E. Swartzlander, Jr.), Prentice-Hall, Englewood Cliffs, NJ, 301–309

Bertin, P., Roncin, D. and Vuillemin, J. (1992) Programmable active memories: a performance assessment. In *Proceedings of the 1st International ACM SIGDA Workshop on Field-Programmable Gate Arrays, Berkeley, CA, February 1992, Supplement*

Cockshott, P., Shaw, P., Barrie, P. and Milne, G. J. (1992) *A Scalable Cellular Array Architecture.* HardLab, University of Strathclyde

Flynn, M. J. (1972) Some computer organizations and their effectiveness. *IEEE Trans. Comput.*, **21**, 948–960

Fox, G. C., Johnson, M. A., Lyzenga, G. A., Otto, S. W., Salmon, J. K. and Walker, D. W. (1988) *Solving Problems on Concurrent Processors, Vol. 1, General Techniques and Regular Problems* Prentice-Hall, London

Gray, J. P. and Kean, T. A. (1989) Configurable hardware: a new paradigm for computation. In *Proceedings of the Decennial Caltech Conference on VLSI, Pasadena, CA, March 1989*

Gokhale, M., Holmes, W., Kosper, A., Lucas, S., Minnich, R., Sweely, D. and Lopresti, D. (1991) Building and using a highly parallel programmable logic array. *IEEE Comput.*, **24**, 81–89

Hey, A. J. G. (1989) Reconfigurable transputer networks: a practical concurrent computation. In *Scientific Applications of Multiprocessors*, (eds. R. J. Elliot and C. A. R. Hoare) Prentice-Hall, Englewood Cliffs, NJ, 39–54

Howard, N., Taylor, R. and Allinson, N. (1992) The design and implementation of a massively-parallel fuzzy architecture. In *Proceedings of the IEEE International Conference on Fuzzy Systems, San Diego, March 1992*, 545–552

INMOS Ltd (1991) *The T9000 Transputer Products Overview Manual*. S. G. S. Thomson

King, R. B. and Sonnad, V. (1987) Implementation of an element by element solution algorithm for the finite element method on a course grained parallel computer. *Comput. Method. Appl. Mech. Eng.*, **65**, 47–59

Law, H. K. (1986) A parallel finite element solution method. *Comput. Struct.*, **23**. 845–858

Modi, J. J. (1988) *Parallel Algorithms and Matrix Computation* Clarendon Press, Oxford

Page, I. and Luk, W. (1991) Compiling Occam into FPGAs. In *FPGAs – Oxford* 1991 *International Workshop on Field Programmable Logic and Applications* (eds. W. R. Moore and W. Luk) Abingdon EE&CS, Abingdon, 271–283

Quinn, M. J. (1987) *Designing Efficient Algorithms for Parallel Computers* McGraw-Hill, New York

Sadayappan, P. and Ercal, F. (1987) Nearest neighbour mapping of finite element graphs onto processor meshes. *IEEE Trans. Comput.*, **36**, 1408–1424

Seitz, C. L. (1985) The Cosmic Cube. *Comm. ACM*, **28**, 22–33

Willis, C. J. and Wait, R. (1989) Distributed finite element calculations on a transputer array. In *Proceedings of the 1st International Conference on Applied Transputers, 23–25 August 1989*, Liverpool, 319–324. University of Liverpool

Other useful references

Almasi, G. S. and Gottlieb, A. (1989) *Highly Parallel Computing* Benjamin/Cummings, Redwood City

Andrews, G. R. and Schneider, R. B. (1983) Concepts and notations for concurrent processing. *ACM Comput. Surv.*, **15**, 3–43

Browne, J. C. (1984) Parallel architectures for computer systems. *IEEE Comput.*, **17**. 83–87

Chow, Y. C. and Kohler, W. (1979) Models for dynamic load balancing in a heterogeneous multiple processor system. *IEEE Trans. Comput.*, **28**, 354–361

Chu, W. W., Holloway, L. H., Lan, M. and Efe, K. (1980) Task allocation in distributed data processing. *IEEE Comput.*, **13**, 57–69

Dongarra, J. J. (1987) *Experimental Parallel Computing Architectures* North-Holland, Amsterdam

Feng, T. Y. (1981) A survey of interconnection networks. *IEEE Comput.*, **14**, 12–27

Gheringer, E. F., Siewiorek, D. P. and Segal, Z. (1987) *Parallel Processing: The Cm* Experience* Digital Equipment Corporation, Bedford, MA

Ghezzi, C. (1985) Concurrency in programming languages: a survey. *Parallel Comput.*, **2**, 229–241

Gottlieb, A., Lubachevsky, B. D. and Rudolf, L. (1983) Basic techniques for the efficient coordination of very large numbers of cooperating sequential processors. *ACM Trans. Program. Lang. Syst.*, **5**, 164–189

Hockney, R. W. and Jesshope, C. R. (1981) *Parallel Computers: Architectures, Programming and Algorithms* Adam Hilger, Bristol

Hwang, K. and Briggs, F. A. (1986) *Computer Architecture and Parallel Processing* McGraw-Hill, New York

Krishnamurthy, E. V. (1989) *Parallel Processing – Principles and Practice* Addison Wesley, New York

Riele, H. J. J., Dekker, T. J. and van der Vorst, H. A. (1987) *Algorithms and Applications on Vector and Parallel Computers* North-Holland, Amsterdam

Parallel-processing approach using transputers – case studies

C. G. Xie, B. S. Hoyle and D. G. Hayes

14.1 Introduction

In Chapter 13, the computer needs for process tomography systems were described in general. The parallel-processing approach using multiple processors has been identified as the main stream for future development. A lot of experience has been gained in using INMOS transputers as the basic processing element for tomography systems exploiting the power of parallel processing (Wiegand and Hoyle, 1991; Xie *et al.*, 1992; Hayes, 1994). In the following sections, transputer-based electrical capacitance and ultrasonic tomography systems for flow imaging applications are described.

It would be useful, first of all, to briefly describe the basic architecture of the transputer family. The transputer family is a range of very-large-scale integration (VLSI) building blocks for concurrent processing systems. They all have a similar architecture incorporating a processor, memory and four bi-directional communication links for direct connection to other transputers (Figure 14.1). OCCAM language is often used as the associated design formalism; it is an easy and natural language for the programming and specification of concurrent systems (INMOS Ltd, 1988). The transputer is essentially a computer of multiple instruction, multiple datastream (MIMD) architecture.

The parallel programming model of transputers consists of a number of independent processes executing simultaneously and communicating through channels. Channels are one-way communication paths that allow processes to exchange data. A process can be built from any number of other parallel processes, so that an entire software system can be described as a hierarchy of intercommunicating parallel processes. Communication between processes is synchronized. When data are passed between two processes the output process does not proceed until the input process is ready. Buffered communication and multiplexing process can be achieved by introducing a specific buffer or multiplexing process between the two processes.

Current INMOS transputer products include the 16-bit T2xx, the 32-bit T4xx and the T80x, a 32-bit transputer with an integral high-speed floating point processor. A 30-MHz T800 transputer can achieve a realistic performance of 2.25 Mflops (6 million Whetstone s^{-1}). The transputer serial communication link is a high-speed system interconnect (10 or 20 Mbit s^{-1}) which provides powerful full duplex communication between transputers. The transputer is fully supported by transputer development systems (TDS) which often

Figure 14.1 *The transputer architecture*

comprises an integrated editor, compiler and debugging system, enabling transputers to be programmed in OCCAM and in industry standard languages (C, FORTRAN and Pascal). The family also includes peripheral controllers and communication products. For example, the INMOS C011 and C012 link adaptors are communications devices enabling the serial communication link to be connected to parallel data ports and microprocessor buses. The use of the C011 link adaptor in the transputer-based electrical capacitance tomography system is described in Chapter 4.

INMOS has further exploited the power of the transputer architecture and technology by providing a range of modular hardware products for integration into end-user systems (INMOS Ltd., 1991). This TRAM (Transputer modules) concept offers many advantages over conventional system configurations, including:

• Industrial standard multi-processor interface.
• Upgradability at incremental cost.

- Maximum flexibility with respect to cost/performance.

The transputers for use with the electrical capacitance tomography system discussed below are based on the concept of TRAMs.

A second-generation transputer family, the T9000, is under the development. It can offer processing and communication speeds that are about 10 times as fast as those of the T80x family. Other parallel processors similar to the transputer concept are also emerging, such as the Texas Instrument's C40 parallel digital signal processor (DSP). The future of process tomography systems, which will involve faster parallel data-acquisition schemes and more computation-intensive image reconstruction algorithms, looks very promising.

14.2 Parallel implementation of back-projection algorithm for use with electrical capacitance tomography (ECT) for flow imaging

A 12-electrode electrical capacitance tomography (ECT) system has been developed at UMIST for oil-field flow pipeline imaging (Xie *et al.*, 1992). The design of the capacitance sensing electronics incorporating a C011 interface with the transputer system is described in Chapter 4; the sensing electronics is capable of capturing capacitance data at 100 frames (6600 samples) per second. The associated image reconstruction algorithm based on linear back-projection is covered in Chapter 15. In this section the implementation of the back-projection algorithm using transputers is discussed.

It has been found that it takes about 100 ms for one T801 transputer (25 MHz) to complete one image (32 × 32 pixels) reconstruction; this is equivalent to an imaging rate of about 10 frames/s. To increase the imaging speed of the ECT system, multiple transputers can be used in parallel to implement the back-projection algorithm. One of the simplest, and often the most efficient, ways of exploiting parallel processing is to distribute independent tasks to each of the processors. Such a configuration of the system is often called a 'task farm'. The transputer-based ECT system has been organized in this way as a load-balancing pipeline (Figure 14.2).

The task farm consists of a host processor on a PC card (INMOS B004 compatible card, T800–20 MHz with 4 Mbyte DRAM, used also as TDS), a master processor (T801–25 MHz TRAM with 32 Kbyte SRAM and 4 Mbyte DRAM), a graphics processor (T800–25 MHz TRAM with 1 Mbyte VRAM; its RGB-cable is connected to a graphics monitor), and a number of slave processors (T801–25 MHz TRAMs each with 32 Kbyte SRAM and 4 Mbyte DRAM). All these TRAMs are mounted on a double-Eurocard TRAM motherboard which has 16 size-1 TRAM slots.

The host processor handles the external input/output of the whole transputer network. It distributes the codes (developed under TDS) into the appropriate processors in the network, presents data on the PC's VDU, selects program options via keyboard input, loads data (e.g. the sensitivity maps and

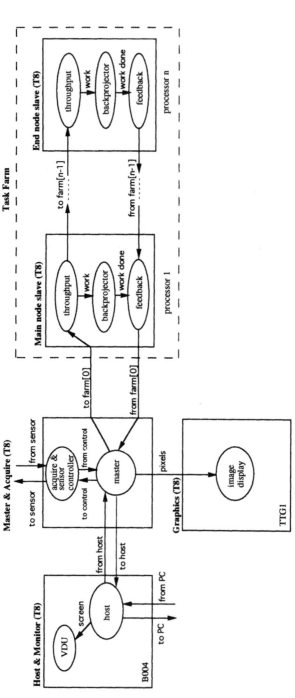

Figure 14.2 *Transputer-based multi-processor system with a task-farm configuration for parallel implementation of the back-projection image-reconstruction algorithm*

the calibration data of the sensor system, see Chapter 15) from the PC hard-disk into the slave processors, and saves data (e.g. the captured streams of 66 capacitance measurements sent by the master) to the PC hard-disk for future use.

The master processor in the network controls, via a pair of transputer serial link of 10 Mbit s$^{-1}$ speed, the remote sensor electronic circuit (e.g. setting gain, offset and measurement frequency), performs acquisition of capacitance measurements (see Chapter 4), distributes the tasks (a stream of captured 66 capacitance measurements) to the slave processors, collects and pass on the results (the corresponding flow concentrations and/or the reconstructed images) to the graphics and the host processors.

Each slave processor in the task farm executes the same serial program (the back-projection algorithm) on its own data set. In a load-balancing pipeline, several buffer processes (the 'throughput' and the 'feedback') carrying tasks to workers, and results to the display are also run on each slave processor, ensuring that whenever a slave processor completes one task another task is immediately available.

The graphics processor displays grey-level images of flows on the graphics monitor. It also displays the 66 normalized capacitance measurements (as a diagnostic aid for the sensor and the transputer systems) and the trend diagram of oil concentration change with time.

Note that, all the processors described above execute their own processes concurrently, and the interprocessor communications are performed via the INMOS bi-directional links (with speeds of 10 or 20 Mbit s$^{-1}$). To illustrate the elegance of OCCAM for use with transputers, the transputer network-configuration program (written in OCCAM-2) which corresponds to the topology of Figure 14.2 is given in Figure 14.3. In this example, the number of slaves (variable num.slaves) in use is 2 and this is the only parameter that needs modifying for the whole system software, showing the simplicity of OCCAM programming.

When the graphics transputer is used to display flow images for every set of capacitance data, the imaging frame-rate when different numbers of slave processors are used is as shown in Figure 14.4. Figure 14.4(a) indicates that, when the image is reconstructed and displayed using 32×32 pixels, nearly 30 frames/s speed has been achieved when three slaves are in use. The speed-up is almost linear (speed-up $= N_n/N_1$, where N_n and N_1 are the frame-rate achieved by n slaves and 1 slave, respectively). This is because the time taken for one slave to reconstruct an image is about three times that for the graphics transputer to display an image (see Figure 14.5(a)). It can be anticipated that, when the fourth slave is added to the task farm, the imaging rate would not be increased. This effect can be appreciated when the image is reconstructed and displayed using 20×20 pixels (see Figure 14.4(b) and Figure 14.5(b)). The image frame rate achieved by one slave is 21 frames/s. However, the increase of imaging frame rate when the number of slaves in use are from two to three is only marginal (from 41.6 to 42.5 frames/s). The speed-up is thus rather non-linear and the use of the third slave is non-economical. The above observations also indicate that the bottleneck of the whole transputer network

```
#USE   strmhdr                      -- TDS    library
#USE   linkaddr                     -- TDS    library
#USE   "linkhdr.tsr"                -- user library

-- Folders containing programs running on each processor in the network:
... SC PROC < Host.and.Monitor >
... SC PROC < Graphics >
... SC PROC < Master.and.Acquire >
... SC PROC < Main.node.slave >
... SC PROC < End.node.slave >

-- number of slave processors in the task farm:
-- (this is the only parameter needs changing in this program)
VAL num.slaves IS 2:

-- Define Protocols for the transputer links:
-- (Protocols are defined in user library above)
CHAN OF ANY from.PC, to.PC:
CHAN OF RECONS from.host, to.host, pixels:
CHAN OF BYTE from.sensor, to.sensor:
[num.slaves] CHAN OF RECONS to.farm, from.farm:

PLACED PAR    -- Parallel (PAR) placement of codes for each processor below

    -- processor 0 is the < Host & Monitor > transputer (on B004 PC-card)
    PROCESSOR 0 T8    -- define transputer number and the type
        -- assign physical links:
        --(defined in the TDS library: linkaddr)
      PLACE from.PC    AT link0.in:
      PLACE     to.PC  AT link0.out:
      PLACE to.host    AT link2.in:
      PLACE from.host AT link2.out:
        Host.and.Monitor (from.PC, to.PC, from.host, to.host)

    -- processor 1 is the < Master & Acquire > transputer
    PROCESSOR 1 T8
      PLACE from.host     AT link1.in:
      PLACE         to.host AT link1.out:
      PLACE from.farm[0] AT link2.in:
      PLACE     to.farm[0] AT link2.out:
      PLACE from.sensor AT link0.in:
      PLACE     to.sensor AT link0.out:
      PLACE          pixels AT link3.out:
        Master.and.Acquire (from.host, to.host, to.farm[0], from.farm[0],
                                  pixels, from.sensor, to.sensor)

    -- Main node slave processor(s) in the task farm
    PLACED PAR i = 2 FOR (num.slaves-1)
      PROCESSOR i T8
          PLACE from.farm[i-2] AT link1.out:
          PLACE     to.farm[i-2] AT link1.in:
          PLACE from.farm[i-1] AT link2.in:
          PLACE     to.farm[i-1] AT link2.out:
            Main.node.slave (to.farm[i-2], to.farm[i-1],
                                  from.farm[i-2], from.farm[i-1])

    -- End node slave processor in the task farm
    PROCESSOR (num.slaves+1) T8
      PLACE from.farm[num.slaves-1] AT link1.out:
      PLACE     to.farm[num.slaves-1] AT link1.in:
        End.node.slave (to.farm[num.slaves-1], to.farm[num.slaves-1])

    -- Graphics processor (TTG1)
    PROCESSOR (num.slaves+2) T8
      PLACE pixels AT link2.in:
        Graphics (pixels)
```

Figure 14.3 *OCCAM-2 network configuration program for the transputers shown in
Figure 14.2*

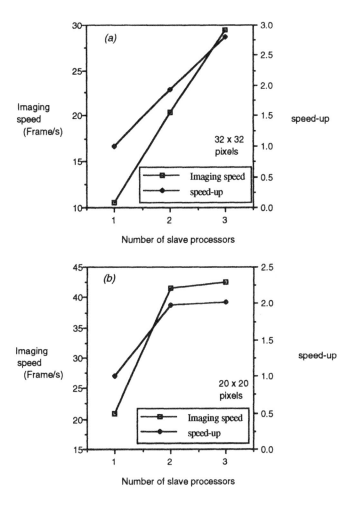

Figure 14.4 *The image frame rate and the speed-up versus the number of slave processors for reconstruction of images of (a) 32 × 32 pixels and (b) 20 × 20 pixels*

shown in Figure 14.2 lies in the graphics transputer. Because of this limitation, the data capturing rate of the capacitance sensing system (100 frames/s) cannot be fully utilized. To realize *true* 100 frames/s real-time performance for images with 20 × 20 pixels, a faster graphics TRAM (one with at least 2.5 times the speed of the one used in Figure 14.2) and five slave transputers are needed; this is obviously an expensive solution. A cheap alternative to achieve *pseudo* real-time performance is to capture data at 100 frames/s, but reconstruct only alternate images and display them at 40 frames/s, using the same graphics transputer and two slave transputers. The images having 100 frames/s temporal resolution can be displayed in slow motion (2.5 times slower) at 40 frames/s during the post-processing stage.

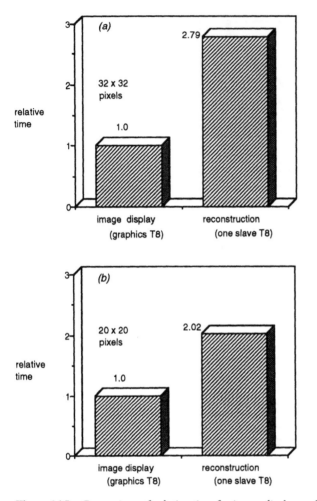

Figure 14.5 *Comparison of relative time for image display and reconstruction of images of (a) 32 × 32 pixels and (b) 20 × 20 pixels*

14.3 Minimization of processing requirements of DSP/transputer based ECT system for flow-velocity profile imaging

The ECT system described in Section 14.2 is able to measure the concentration profile of two-phase flows (e.g. oil/gas flow). However, to obtain the volume flow rate of the flow, the velocity profile also needs to be measured. This section examines how the ECT system can be used to obtain velocity profile measurements in real-time using efficient correlation techniques. This is seen to be a key step in the development of a two-phase oil/gas (and ultimately,

three-phase oil/gas/water) measurement system. The capacitance transducer electronics system can collect a complete set of data at 100 frames/s (Chapter 4). For two axially spaced sensors the reconstruction rate must also be 100 frames/s. A transputer/DSP based system has been designed to satisfy this requirement.

14.3.1 Principle of velocity profile measurement

The principle of velocity profile measurement can be explained with reference to Figure 14.6. Two ECT systems are placed a short distance apart along the pipe to be monitored. A computer system then reconstructs the images at the two planes. The concentration function at each plane $\beta_c(x,y)$ can thus be determined, where $\beta_c(x,y)$ is the concentration of component c at position (x,y) in the vessel. For a pipe of circular cross-section, the total concentration of component c can be obtained by integrating this function over the area of the pipe:

$$\beta_c^{\text{tot}} = \frac{1}{A} \int_{-r}^{r} \int_{-r}^{r} \beta_c(x,y) \mathrm{d}x \mathrm{d}y \tag{14.1}$$

By measuring the time taken for features at one plane to reach the second plane, the velocity v of the features can be obtained since:

$$v = \frac{L}{\tau} \tag{14.2}$$

where L is the distance between the image planes and τ is the measured transit

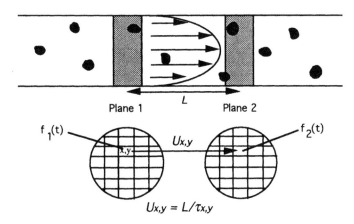

Figure 14.6 *Velocity profile measurement made on image cross-correlation. Features passing through pixel* (x,y) *in plane 1 produce a signal* $f_1(t)$; $f_2(t)$ *will be similar to* $f_1(t)$, *but delayed by the transit time* τ_{xy} *and with added noise*

time. If the velocity profile $U_c(x,y)$ is known then the total volumetric flow rate of component c (Q_c) can be found:

$$Q_c = \frac{1}{A} \int_{-r}^{r} \int_{-r}^{r} \beta_c(x,y) U_c(x,y) \mathrm{d}x \mathrm{d}y \tag{14.3}$$

The velocity profile is found by cross-correlating pixels in plane 1 with their corresponding pixels in plane 2. This can be done in a variety of ways, the most common technique being to use the cross-correlation function (Beck and Plaskowski, 1987; Jordan *et al.*, 1989):

$$R_{12}(\tau) = \frac{1}{T-\tau} \int_0^{T-\tau} f_1(t) f_2(t-\tau) \mathrm{d}t \tag{14.4}$$

where $f_1(t)$ and $f_2(t)$ are the time signals (pixel values) produced by pixels in planes 1 and 2, respectively, and T is the observation time. The transit time is given by the value of τ that maximizes the cross-correlation function.

In discrete form, eqn (14.4) is often written as

$$y(n) = \sum_{m=0}^{N-1-n} x_1(n+m) x_2(m) \qquad n = 0,1,2, \ldots, N-1 \tag{14.5}$$

where the factor outside the integral has been removed for simplicity.

In principle, for images consisting of P pixels, P correlation functions need to be calculated. In practice, the turbulent nature of many flows means that this is not necessarily the case. Firstly, in some cases, e.g. inclined flows, it may be necessary to correlate pixel (x,y) in plane 1 with pixels other than pixel (x,y) in plane 2. This would substantially increase the number of correlation functions to be calculated. However, as the number of pixels in the images are increased, there comes a point when correlating more pixels produces negligible additional velocity information. This is because signals from adjacent pixels will in themselves be highly correlated. Hence this would reduce the number to be correlated. Whichever pixels are to be correlated in a given system, it is clear that there is a substantial processing requirement involved.

A dedicated, application-specific hardware system would achieve the fastest implementation. However, a general-purpose microprocessor implementation provides greater flexibility, an important feature of a new system in which different algorithms may need to be tested. In the following text, some techniques for allowing a general-purpose DSP implementation are examined.

14.3.2 Comparison of real-time algorithms

This section examines real-time algorithms for pixel correlation. It should be noted that there are two basic types of operation:

(i) *Pseudo real-time*: here, a number of measurements are first stored and then analysed later. This would involve both image reconstruction and pixel correlation. This procedure is repeated at the maximum rate sustainable

by the processor system in use to give periodic updates, hence the term 'pseudo real-time'.

(ii) *True real-time*: this is exactly as the name suggests; the flow measurements are updated in true real-time fashion after each new set of measurements.

It is the latter that will be considered here, the reason being as follows. It may initially be thought that pseudo real-time operation would require less processing power than true real-time operation. This is not necessarily the case. Consider case (i) and assume that a display of the velocity profile is to be updated a given number times per second. For each update, a set of data is stored and then analysed. This requires a complete set of correlation functions to be calculated. With reference to eqn (14.5), it can be seen that each calculation requires a computation time approximately proportional to NM, where N and M are the number of delays and the number of samples used, respectively. A true real-time system can make use of the redundancy in consecutive calculations of eqn (14.5). Hence it is possible to apply the following recurrence relationship:

$$[\text{New value}] = [\text{Old value}] + [\text{New product}] - [\text{Old product}] \quad (14.6)$$

Or, in algebraic terms,

$$y_i(n) = y_{i-1}(n) + x_1(n + N - 1 + i)x_2(N - 1 + i) - x_1(n + i)x_2(i) \quad (14.7a)$$

$$y_0(n) = \sum_{m=0}^{N-1} x_1(n + m)x_2(m) \qquad n = 0,1,2,\ldots, N - 1 \quad (14.7b)$$

where $y_i(n)$ is the value of the ith correlation function at delay n.

This shows that once the first correlation function has been calculated $(y_0(n))$ using eqn (14.7b), successive functions can be computed using the recurrence equation (eqn (14.7a)). In the following, these two methods will be referred to as 'complete' and 'recurrent' correlations, respectively. Now, in terms of processing requirements, addition is similar in complexity to subtraction. Hence, for computational comparisons, addition will be assumed to encompass subtraction. For N delays each recurrent correlation calculation then requires $2N$ multiplications and $2N$ additions. This is a considerable saving compared with a full computation. The actual processing time is now only proportional to N rather than NM (N is the number of delays, M is the number of samples).

One drawback with this technique is that more memory is required to store the values of the correlation functions at each value of delay n. For N delays and P correlation functions (pixels), an additional NP memory locations are required. It is possible to reduce the number of multiplications from $2N$ to N by storing all the products that have been calculated. However, there will be an even larger number of these: MNP for M delays, N samples and P pixels, and this will significantly increase the memory requirements, particularly for an image correlation using many pixels.

Using this technique, although the update rate for a set of correlation functions may be 100 times per second (the current sensor acquisition rate),

instead of say, 10 times per second for pseudo real-time, the calculations can be done much faster. Thus, a true real-time system is preferred from this point of view.

14.3.3 Limits to the number of correlation functions used

In order to make real-time operation possible, there is a limit to the number of correlation functions (pixels P) that can be calculated. This is determined primarily by the image reconstruction rate (T_F), and the time taken to calculate a single correlation function when the recurrence formula is being used (T_R):

$$P_{max} = T_F/T_R \qquad\qquad (14.8)$$

Figure 14.7 shows P_{max}, the maximum number of pixels that can be correlated, as a function of T_R for three different values of the frame rate T_F. The graph is plotted over the most useful range of values with respect to the performance obtainable by modern processors. For example, with the current frame rate of 10 ms, a value of $T_R = 100$ μs allows a maximum of 100 correlation functions to be calculated. This value of T_R is not unrealistic with high-performance DSP chips. A device running at 10 million instructions per second (MIPS) can execute 1000 instructions in 100 μs. If there are 128 delays per correlation function then this allows a maximum of seven instruction cycles to be used to calculate each *point* of the correlation function. If the recursive algorithm is used this figure is obtainable with the use of DSPs due to their optimized architecture and complex instruction set. Note that no account here has been taken of other overheads such as communication of data and results, or any other code that must be executed.

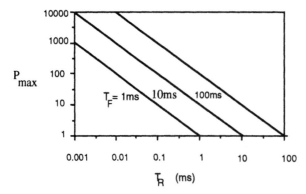

Figure 14.7 *The maximum number of pixels (P_{max}) that can be correlated with the time (T_R) taken to calculate one correlation function based on the recurrence relationship (eqn (14.7)) for different image-reconstruction rates (T_F)*

14.3.4 Comparison of image-buffering techniques

This section will investigate the time required to achieve real-time operation using the recursive algorithm. At the initial stage, the real-time performance will not normally be obtainable. The reason for this is that the first set of correlation functions have to be calculated without the use of the recurrence relation. This process is relatively slow and unless the processor is exceptionally fast, or very few pixels are correlated, the complete set of correlations cannot be completed in the time taken for the next set of data to arrive. Thus, any new sets of data are stored, or buffered, until the first set of correlations is complete. Recursive calculations can then begin and gradually use up the stored data. If these faster correlations proceed at a rate greater than that with which new images arrive (currently 100 frames/s from each sensor) then eventually all stored data will be used up. This is the point when real-time operation starts. The time taken to reach this point is very important for two main reasons: (i) it determines how long the system, and therefore the operator, has to wait before real-time operation is obtained; and (ii) it determines how many images need to be stored in a buffer, and therefore the memory requirements. Of these, the second is of far greater importance than the first due to the high rate at which images are acquired. Two possible image buffering algorithms will now be examined.

Algorithm A – buffering whole images

This algorithm is conceptually the simplest and entails collecting a sequence of complete images from two imaging planes. The cross-correlation functions of the pixels in plane 1 with the corresponding pixels in plane 2 are then calculated. This is computationally intensive and is difficult to complete in the time taken to capture another image (typically 10 ms). To overcome this, the incoming images are stored to be used later. Once the first set of complete correlation functions have been calculated the stored images are then used to calculate subsequent sets of correlation functions. These, however, can be calculated using the recurrence relation described in Section 14.3.2; this is very much faster. At the same time, any new images that arrive are stored. Now, if the rate of correlating a set of pixels in an image using the recurrence relation is greater than the rate at which new images are captured, then the number of stored images will decrease and eventually reach zero. At this point continuous real-time operation is reached.

Using some simple algebra, it can be shown (Hayes 1994) that the time (T_A) taken for algorithm A to reach real-time operation is:

$$T_A = T_c P_c \left(1 + \frac{P_c}{P_{max} - P_c} \right) \tag{14.9}$$

where T_c is the time taken to calculate a single complete correlation function, and P_c is the number of pixels to be correlated. Equation (14.9) indicates that T_A is proportional to the time taken to calculate a complete correlation function without using the recurrence relation and rises very rapidly when P_c is

close to P_{max}. This will normally be the case if the maximum possible number of pixels are to be correlated. When $P_c = P_{max}$, T_A becomes infinite and real-time operation can never be obtained.

Equation (14.9) is plotted in Figure 14.8 for four different values of T_R. This gives a visual indication of how many pixels can be correlated before the computation time rises rapidly. Values of $T_c = 1$ ms and $T_F = 10$ ms have been assumed, but the readings can be scaled appropriately.

The memory requirements of this simple algorithm can also be easily calculated. The number of images to be buffered is given approximately by the ratio $2T_A/T_F$ (the factor of 2 arises because there are two image planes). From eqn (14.9), and assuming 1 byte/pixel, the buffer size (in byte) for algorithm A (B_A) is given by:

$$B_A = \frac{2T_c P_c^2}{T_F} \left(1 + \frac{P_c}{P_{max} - P_c} \right) \tag{14.10}$$

The buffer size B_A is related to P_c^2 which is a large memory requirement and is very sensitive to small changes in P_{max} and P_c. For correlating the maximum possible number of pixels ($P_c \approx P_{max}$), the memory requirement will be substantial. With this in mind a more efficient algorithm should be used.

Algorithm B – buffering partial images

This is a variation of algorithm A, but is intended to reduce both the time taken to achieve real-time operation and the memory requirements. For this version, whole images are not buffered during the initial phase of obtaining the first set of correlation functions. Instead, only values of a few pixels are stored; the number increases as more complete correlations are completed. Eventually

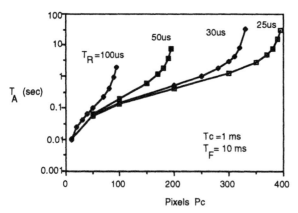

Figure 14.8 *Time (T_A) taken for algorithm A to reach real-time operation versus the number of image pixels (P_c) for four different values of T_R (the time taken to calculate one correlation function based on the recurrence relationship (eqn (14.7)))*

there will be a point when all pixels have been included in the complete correlation calculation and all the pixels are stored when a new image is provided by the reconstruction software.

Figure 14.9 illustrates this technique for the simplified case of just four pixels per image. It is assumed here that two new images arrive in the time taken to perform a complete correlation using four pixels, or data points. First, four images (0–3) are collected but, only pixel 0 is stored from the first two and pixels 0 and 1 from the second two. This is because no other pixels from these images will be needed. The first correlation is done using pixel 0 in images 0–3. During this time, two more images (4 and 5) arrive and pixels 0–2 are stored. The next complete correlation is done using pixel 1 in images 2–5. Note that image 5 is the latest image to be collected and so the most up-to-date four-point correlation function does not need pixel 1 from the first two images. In parallel with this, pixel 0 has its new correlation function calculated twice using the recurrence relationship. The first time this is done with pixels 1–4, and then with 2–5. These calculations are much faster. Again, two more images (6 and 7) arrive, but this time all the pixels are stored since they will all be needed in later calculations. As image 7 is now the latest, the third complete correlation function is calculated using pixel 2 from images 4–7. Again, pixel 2 data prior to image 4 are not needed and are not therefore stored. This process is repeated until four complete correlations have been calculated, each using the most recent four images. At this point, real-time operation is obtained. Subsequent correlations are then done using the recurrence formula.

It is evident that this method is both faster and uses less memory than algorithm A. It is faster because fewer recursive correlation calculations are required; only the latest images are used in calculating the first correlation function for a given pixel. The reason for needing less memory is obvious – fewer pixels are stored. For this algorithm, it can be shown that the time (T_B) taken to reach real-time operation for P_c pixels is:

$$T_B = \sum_{p=1}^{P_c} T_c \left(1 + \frac{p}{P_{max} - p}\right) \tag{14.11}$$

The corresponding buffer size for this algorithm (B_B) is significantly smaller than that for algorithm A; for this case, it is only necessary to buffer a sequence of pixels from a single pixel. It is readily shown that the maximum length of this sequence (and hence buffer size in byte) is:

$$B_B = 2 \left(\frac{T_c}{T_F} + \frac{P_c}{P_{max}}\right) \tag{14.12}$$

This is a substantial reduction when compared with the approach of buffering every image. It still allows identical performance once 'up to speed'. Figure 14.10 shows how T_B varies with P_c for four different values of T_R and for $T_c = 1$ ms and $T_F = 10$ ms. Results for other values of T_c can be obtained simply by scaling these graphs appropriately.

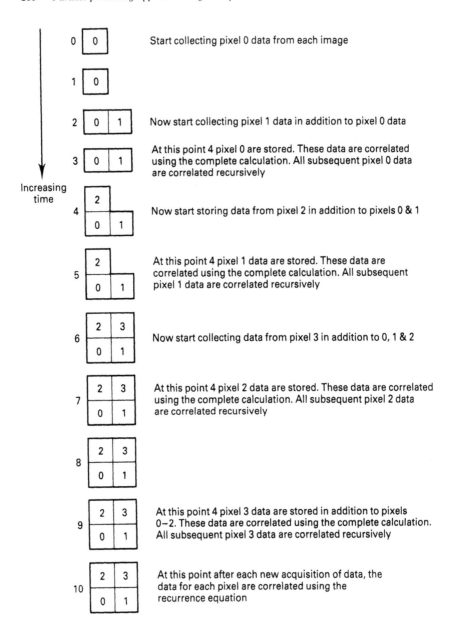

0 Start collecting pixel 0 data from each image

2 Now start collecting pixel 1 data in addition to pixel 0 data

3 At this point 4 pixel 0 are stored. These data are correlated using the complete calculation. All subsequent pixel 0 data are correlated recursively

Increasing time

4 Now start storing data from pixel 2 in addition to pixels 0 & 1

5 At this point 4 pixel 1 data are stored. These data are correlated using the complete calculation. All subsequent pixel 1 data are correlated recursively

6 Now start collecting data from pixel 3 in addition to 0, 1 & 2

7 At this point 4 pixel 2 data are stored. These data are correlated using the complete calculation. All subsequent pixel 2 data are correlated recursively

9 At this point 4 pixel 3 data are stored in addition to pixels 0–2. These data are correlated using the complete calculation. All subsequent pixel 3 data are correlated recursively

10 At this point after each new acquisition of data, the data for each pixel are correlated using the recurrence equation

Figure 14.9 *Illustration of algorithm B – buffering partial images*

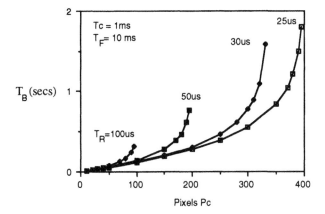

Figure 14.10 *Time* (T_B) *taken for algorithm B to reach real-time operation versus the number of image pixels* (P_c) *for four different values of* T_R *(time taken to calculate one correlation function based on the recurrence relationship (eqn (14.7)))*

14.3.5 Hardware implementation

The techniques presented above provide a means of implementing a general-purpose system without using application-specific devices. The use of a recurrence relationship can be fully exploited with general-purpose processors; redundancy is difficult to exploit with dedicated FFT devices and convolvers, etc. As a result it is possible to use a combination of transputers and digital signal processors for the entire image reconstruction/correlation system.

The system is similar in architecture to that developed for the single-plane capacitance imaging system (Figure 14.2). This is basically a process farm arranged as a pipeline. A master transputer sends capacitance measurements to each of the slave processors and receives reconstructed images back. In order to boost the performance of the slave processors, up to six Motorola DSP devices can be memory mapped into the transputers address space as shown in Figure 14.11 (only four DSPs are shown). However, due to the different requirements of image reconstruction and correlation, different DSP devices from the same family can be used. For image reconstruction, 24-bit 56001 devices can be used to reduce quantization and rounding errors; for correlation, faster 16-bit 56116 devices are more suitable. By taking this approach, a large degree of compatibility with an existing system has been achieved and yet the performance has been considerably enhanced (Hayes, 1994).

14.3.6 Conclusion

In this section we have presented techniques for minimizing the processing requirements involved in cross-correlation velocity profile measurements. A

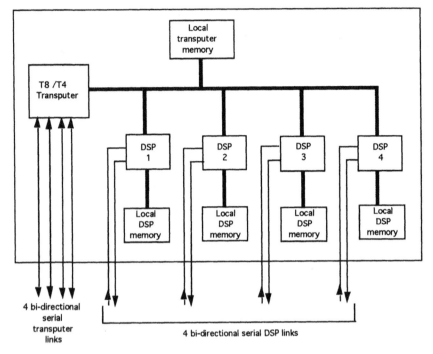

Figure 14.11 *The architecture of a DSP/transputer board*

cross-correlation system based on a recurrence relationship provides a very fast method of calculating successive correlation functions in real-time. However, this must be used in conjunction with an efficient image-buffering technique if the memory requirements are not going to be excessive. In addition, by increasing the time-delay increments at the longer time-delay positions, and interpolating the correlation functions, a general-purpose transputer/DSP implementation becomes feasible.

14.4 Parallel implementation of ultrasonic image-reconstruction algorithm using a transputer network

14.4.1 Introduction

Figure 14.12 shows the components of an ultrasound flow imaging system. Typically a transducer will have a wide sector-angle aperture and be able to transmit a pulse of ultrasound and then receive echo signals arising from reflections. Such reflections arise in this application from flow interfaces in pipe, for example due to gas bubbles in a liquid. The received ultrasonic signals

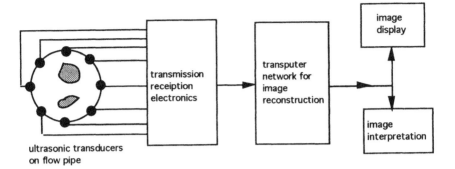

Figure 14.12 *The components of an ultrasonic flow-imaging system*

are converted by the transducer electronics into a form suitable for the reconstruction network.

Reconstruction of the flow image has to be done in real time, possibly at the data-acquisition rate, so that the reconstruction matches the changing flow patterns passing through the image plane. The processing demand is influenced by the pipe diameter, the flow velocity, and the information that can be extracted from a particular ultrasonic transducer arrangement.

In order to achieve real-time image reconstruction for a variety of imaging environments, the processing unit must be flexible. One approach is to design dedicated hardware that implicitly exploits parallelism, but it this often lacks flexibility. Design centred around software is much easier to implement than multiple hardware designs. Therefore the use of multiple processors and the exploitation of parallelism in the imaging process is chosen. Real-time performance could be realistic, provided enough parallelism in the problem can be found and the processors used have an adequate performance. In the following we discuss the processing aspects of the real-time reconstruction of an image from the sensor data.

14.4.2 The image-reconstruction process

Here the reconstruction of a flow image is performed by using data from reflection-mode and transmission-mode ultrasound. The former is processed with the well-known ultrasound back-projection method, and the latter is used to reduce noise and enhance the back-projected image.

Back-projection with reflection-mode ultrasound

In reflection-mode an ultrasound transducer is first used to transmit a short pulse of acoustical energy into the medium, and then to receive the resulting reflected signal as a function of time. The output signal (or *echo*) in reflection mode is called an *A-scan*; this provides information relating echo strength and

time. Knowledge of the sound velocity in the medium allows the time axis to be calibrated as range. An A-scan generated from a two-phase gas/liquid flow contains mainly discrete echoes. A two-phase flow cross-section can be regarded as a binary field, where there is near-zero reflectivity within the liquid phase and high reflectivity at the interfaces to the gaseous phase. An echo peak marks the arrival time and yields range information, provided there is constant ultrasound velocity in the medium. The amplitude information of an echo is not used directly in the system described here; it is assumed that any echo above noise level originates from a liquid/gas interface such as a bubble. A complex echo signal is therefore interpreted as a square pulse with a width corresponding to the physical size of a pixel and unity amplitude.

It is assumed that the reflector is located on an arc determined by the range information, the angular dispersion angle and the position of the transducer. The arc is called the *projection arc* and in order to reconstruct the image the value unity is back-projected over this arc. Repeating this process for all transducer positions around the pipe produces multiple projection arcs and their intersections define the reconstructed object(s).

The number of transducer positions around the pipe has a significant effect on the quality of a reconstructed image. It has been shown that the filtered back-projection method results in artefacts and noise from the limited number of measurements taken around the pipe. As would be expected these effects progressively degrade the image quality as the number of transducers decreases. A relatively high number of transducer positions is acceptable for non-destructive testing or medical applications, where the data-capture time is not crucial; it is not feasible, however, for flow-imaging applications where real-time image reconstruction is of prime importance. Imaging systems with multiple receivers active per transmitted pulse have therefore been investigated; a scan with multiple receivers has the same data-acquisition time as that for a single active receiver, but the data are increased *n*-fold. Echoes received by transducers on either side of the transmitter are the result of contributions from reflectors which lie on an ellipse rather than an arc, where the observed time of flight is constant along the elliptical path.

The ability of the system to predict the source direction of an echo along the projection arc (for a single active receiver) or ellipse (for multiple active receivers) is enhanced when the receiver(s) have *multiple segments*. Such transducers can be constructed when the active sensing surface is split into a small number, say three, separate segments, each having one-third of the angular field of view of a single segment transducer. The increased data from the multiple segments may be employed by modifying the back-projection algorithm to include directional information. A full description of the segment sensor and its detailed incorporation into the system may be found elsewhere (Wiegand and Hoyle, 1989).

Transmission-mode ultrasound for flow imaging
The combination of both reflection- and transmission-mode ultrasound data can further increase the amount of information available to the reconstruction process, without increasing the number of sensor positions. Due to the

assumed binary nature of the medium to be imaged, transmission-mode ultrasound can be integrated into the flow-imaging process as follows.

The number of sensors acting as receivers of reflected ultrasound is given by N_r and the remaining sensors N_t receive transmitted ultrasound. If a signal is detected by one of these sensors it can be concluded that there is no object between the transmitter and the receiver. For a given sensor arrangement the direct paths between transmitters and receivers can be predetermined. The recorded pixel count of a signal is then checked to see if it corresponds to the direct path between the respective transmitter and receiver pair, and only in this case are data registered. The data-acquisition time is increased because the receivers for both the reflection mode and the transmission mode are active simultaneously. For a reconstruction with additional transmission-mode ultrasound, a simple and effective approach is to decrement pixels along the direct paths by one. Reconstruction artefacts and noise are reduced and the transmission-mode data can be processed immediately on reception which simplifies the data acquisition. Only the pixel count needs to be calculated from the time-of-flight measurements, which is consistent with the recording of reflection-mode data.

14.4.3 Parallel implementation of reconstruction algorithm

The reconstruction algorithm was implemented using OCCAM for a network of T4xx transputers.

The reconstruction with tuned parallelism
The topology 1 considered for tuned parallelism is shown in Figure 14.13(a). The processes involved are described below:

- *Feed* A process reads a data set from data files which originate from either a computer simulation or an experimental test rig. It can be used to simulate a data acquisition system. The test data set used for reconstruction was produced by simulation in the case of 30 transducers around the pipe with five receivers active for each transmitted pulse.
- *Line* A process implementing an incremental line tracing algorithm used to select the pixels along lines between the transmitter and the receiver positions (referred to as the *projection lines*) for transmission-mode data processing. All floating point operations are precalculated and stored as look-up tables. The local pixel array is called *LineArray*.
- *Arc* A process implementing an incremental arc tracing algorithm used to trace the pixels located on projection arcs, or projection-arc sectors in cases where multiple segment receivers are employed. All floating point operations are precalculated and stored as look-up tables. The local pixel array is called *ArcArray*.
- *InitArc* A process responsible for the initialization of the look-up tables for the projection arcs. It forms a two-stage pipeline with the *Arc* process to generate projection arcs.

(a)

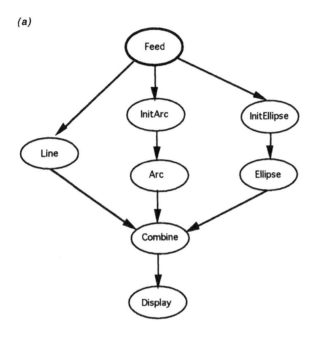

(b)

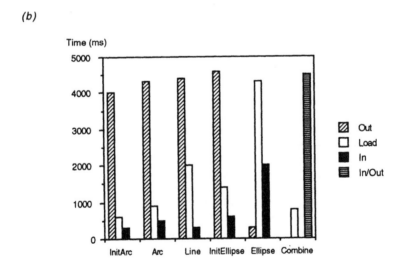

Figure 14.13 *Topology 1 for tuned parallelism: (a) topology; (b) timing diagram*

- *Ellipse* A process implementing an incremental ellipse tracing algorithm used to trace the pixels located on projection ellipses when multiple receivers are used. All floating point operations are precalculated and stored as look-up tables. The local pixel array is called *EllipseArray*.
- *InitEllipse* A process responsible for the initialization of the look-up tables for the projection ellipses. It forms a two-stage pipeline with the *Ellipse* process to generate projection ellipses.
- *Combine* In this process, the *ArcArray* and *EllipseArray* are added and the *LineArray* is subtracted from the result. The final pixel array is called *ReconArray*.
- *Display* A process connected to the *Combine* process via a transputer link. It is continuously ready to receive and display the pixel arrays (*ReconArray*). The graphics transputer executing this process is able to display images of 64×64 pixels at 10 frames/s.

Once the network has been initialized it is continuously ready to receive data items. To mark the end of a data set *Feed* sends an 'end of frame' (EOF) flag to the network. On reception of EOF, *Line*, *Arc* and *Ellipse* communicate their pixels arrays to *Combine*, which in turn completes the reconstruction of the flow pattern. The overall performance of a reconstruction network corresponds to the time taken to produce 30 image frames. For the assessment of speed-up, *Line*, *Arc* and *Ellipse* were combined to form a sequential version of the reconstruction algorithm. The corresponding reconstruction time for 30 image frames serves as the benchmark for the sequential performance.

The timing diagram of topology 1 for 30 reconstructions of the data set is given in Figure 14.13(b). The communication times and the processing times (load) of each process are shown. It can be seen that the calculations of the *Ellipse* process take twice as long as *Line* and more than three times as long as *Arc*. This is caused by differences in the number of data items to be processed by the individual processes; there are 452 projection ellipses to be traced for one image frame compared to only 238 projection lines and 151 projection arcs (geometric unbalance). Moreover, the pipeline consisting of *InitEllipse* and *Ellipse* is unbalanced, in that *Ellipse* takes more than twice as long as *InitEllipse*. Excessive output communications times of the processes *InitArc*, *Arc*, *InitEllipse* and *Line* occur, since they have to wait for *Ellipse* to finish the processing of a frame before they can continue. The resultant speed-up for this particular data set was found to be 3.4, although six processors share the calculations.

In order to improve the balance of the projection-ellipse pipeline, the *Ellipse* process has been split into two processes: *Ellipse1* (tracing the first half of an ellipse) and *Ellipse2* (tracing the second half of an ellipse). The *InitEllipse* process communicates the parameters required for the tracing of a projection-ellipse to *Ellipse1*. Some overheads are introduced because *Ellipse1* and *Ellipse2* operate on individual pixel arrays, at the end of a frame, *Ellipse1* has to pass its array through *Ellipse2* to *Combine*.

Since there are 452 data items for projection ellipses per frame and only 151 data items for projection arcs, the projection-ellipse data are divided between

two identical pipelines introducing additional geometric parallelism. The resulting topology (2) is shown in Figure 14.14(a). The transfer of data to the network has to be done by two *Feed* processes to enable four parallel inputs to the *Line* process, the arc pipeline and the two ellipse pipelines. Also, the *Combine* process has to be implemented on three processors, where *CombineL* handles the arrays of the *Line* process and the arc pipeline, while *CombineR* receives the arrays of the two ellipse pipelines. It can be seen from the timing diagram shown in Figure 14.14(b) that the balance between *Line*, the arc pipeline and the ellipse pipelines has improved considerably. Communication overheads caused by the synchronization at the end of each frame have been reduced resulting in a speed-up of 8.4 using 12 processors, a speed-up improvement of more than 100% and an efficiency improvement of 2.5% compared to topology 1. The relatively low efficiency improvement is due to the three *Combine* processes required for topology 2, which do not contribute to the speed-up.

The performance of the tuned parallelism as discussed above depends heavily on the nature of the data. The geometric parallelism is unbalanced because the member processes have different amounts of data to process and are required to synchronize at the end of a reconstruction. Multiple ellipse pipelines improve the balance when multiple receivers are active per transmitted pulse. However, the amount of data to be processed by the *Line* process depends on the nature of the flow as well as the number of transducers receiving transmission-mode ultrasound. A flow with high void fraction results in most of the ultrasonic energy being reflected and little being transmitted, so that the processing demands for *Line* are comparatively small. If there is a low void fraction the load for the *Line* is comparatively high. It is therefore difficult to match the processing network to the data generated by a particular imaging system and achieve maximum efficiency. Also, the balance of the algorithmic parallelism (pipelines) is difficult to maintain, since the processing loads of *Arc* and *Ellipse* (*Ellipse1*, *Ellipse2*) vary with the data, whereas the processing loads of *InitArc* and *InitEllipse* are constant. Projection arcs and projection ellipses with large radii and major axes require comparatively more pixels to trace than those with smaller radii and major-axes. Consequently, long echo delay times demand more processing time than do short delay times. The same dependence is observed for the characteristics of the receiving segments; the wider a segment the more pixels have to be traced. Equally, the higher the pixel resolution the more demanding is the processing load for equivalent projection arcs, ellipses and lines. A network topology that enables automatic load balancing without introducing too much overhead is therefore essential for the efficient application of parallelism to flow-imaging reconstruction.

The overall processing load of a reconstruction network also depends on the imaging system used: the more transducers around the pipe and the more receivers are active per transmitted pulse, the higher the processing requirement. It is hence desirable to have a network that can be expanded easily. This is difficult to realize with tuned parallelism, since any added processor requires modifications of the neighbouring processes.

(a)

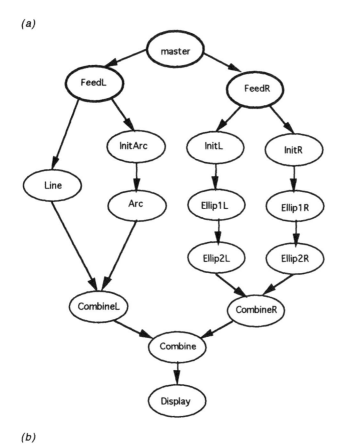

(b)

Figure 14.14 *Topology 2 for tuned parallelism:* (a) *topology:* (b) *timing diagram*

The reconstruction with dynamic parallelism

A processor farm is not bound to a specific topology and a diversity of network configurations, such as rings, linear arrays and tree structures, can be used. A tree of degree 3 has been found to be the best solution for this application, since communication paths are short and maximal use of the four independent transputer links is made. The first transputer in the network can be regarded as the trunk of the tree from which three transputers branch off; each branch transputer may have three further sub-branches. Figure 14.15 gives an overview of the processing network used for flow-image reconstruction exploiting dynamic parallelism. Five different classes of processes are involved and the functions and communications structures of the individual processes are discussed below.

The *Trace* process is responsible for the tracing of projection lines, arcs or ellipses into a local pixel array. The individual trace algorithms are identical to the *Arc*, *Ellipse* and *Line* discussed before. The *Initialize* processes receive data items (echo pixel count, positions of the transmitter and receiver) from the *Distribute* process and convert them for the trace algorithms. The look-up tables are set up before the actual reconstruction starts. *Feed* process transmits the (EOF) flag to the network via *Distribute* and causes the *Trace* processes to transfer their local pixel array to the *Initialize* processes. Since multiple link communications can be activated in parallel, the *Initialize* process is able to receive three pixel arrays simultaneously. To send the three arrays to the *Distribute* process will take three times as long because only one link is

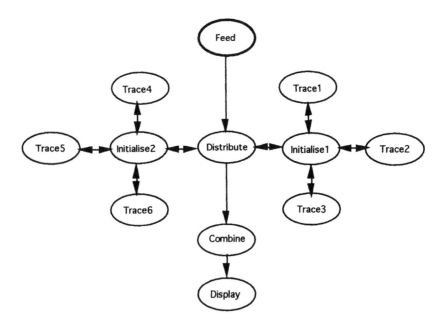

Figure 14.15 *Topology for dynamic parallelism*

available. Therefore the three pixels arrays are added together by the *Initialize* process and the resulting array is sent to *Distribute*. *Distribute* adds the two arrays received from the two *Initialize* processes and sends the result to the *Combine* process. It is thus ensured that each link in the network transfers only one array at the end of a reconstruction. The *Combine* process filters spurious negative pixel values, which may arise from the transmission-mode processing, to form the final pixel array. *Combine* always holds the latest update of the reconstructed image, which is sent to the *Display* process which shows it on the graphics monitor.

It should be noted that Figure 14.15 only shows one possible network configuration. Due to the use of flexible routing software any number of *Trace* processes can be used. Similarly, one or two *Initialize* processes can be used. The detail of the router has been described by Wiegand and Hoyle (1991).

The timing results of the dynamic parallelism are given in Figure 14.16. Figure 14.16(a) shows how the speed-up is affected by the number of *Trace* processes used, ranging from 2 to 6 (more than three *Trace* processes requires a second *Initialize* process). The time taken by a network with only one *Trace* process serves as the benchmark for speed-up measurements. It can be seen from Figure 14.16(a) that two *Trace* processes result in a near maximum speed-up. Six *Trace* processes show a decline in the speed-up, because the throughput of the two *Initialize* processes is not high enough to support three *Trace* processes each. The speed-up dependent on the total number of processors is depicted in Figure 14.16(b). The *Distribute* processor is not counted because it does not execute any part of the reconstruction algorithm. Maximum speed-ups are observed when the *Initialize* processes support two *Trace* processes each. When only one *Trace* processor per *Initialize* is used, an unbalance between *Trace* and *Initialize* decreases the speed-up. The performance of three *Trace* processes per *Initialize* is degraded due to the effect discussed above. However, the overall efficiency of the dynamic parallelism is much higher than that of the tuned parallelism.

The best performance is achieved with two *Trace* processes per *Initialize* process, where seven processors shared the reconstruction task. The reconstruction time for 30 image frames is 2.6 s. The reconstruction of the same data on a tuned parallel network with 12 processors (topology 2 in Figure 14.14(a)) takes 1.9 s. The speed-up of the dynamic parallel network was found to be 6.2, using six processors (employing the same sequential benchmark as the tuned parallel network for speed-up measurement); whereas use of a tuned parallel network resulted in a speed-up of 8.4 with 12 processors. The tuned parallel network required five processors more than the dynamic parallel network in order to achieve comparable speed-ups and the efficiency of the latter is, on average, 23% higher.

14.4.4 Conclusions

The first form of parallelism to be exploited is tuned to the back-projection algorithm and the particular sensor arrangements used for imaging experiments.

(a)

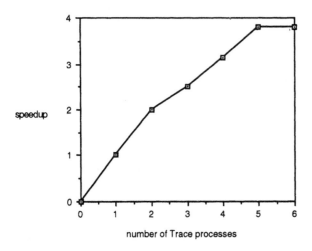

(b)

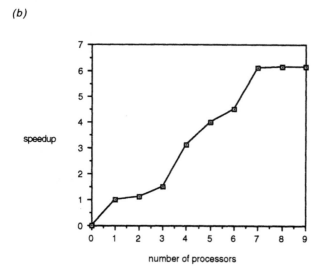

Figure 14.16 *Speed-up of transputer topology exploiting dynamic parallelism. (a) Speed-up versus number of* Trace *processes. (b) Speed-up versus the number of processors*

Parallelism inherent in the data-acquisition process is employed to speed up processing times. One transducer transmits a pulse and all the other transducers around the pipe receive either reflection-mode ultrasound or transmission-mode ultrasound. Hence, the data of multiple simultaneously activated receivers are processed in parallel, which is referred to as 'geometric

parallelism'. The actual algorithmic steps to be performed on each data item are executed in processor pipelines with a maximum of three stages each, thereby introducing algorithmic parallelism. The main problem of tuned parallelism for flow imaging, comprising geometric and algorithmic parallelism, is the lack of load balance between processors in the network. The pipeline processes are not balanced because the individual processing times vary and are dependent on the data. The geometric parallelism is unbalanced because it is unpredictable how many data items are received by individual transducers. Another problem with tuned parallelism is the matching of the processing power to particular imaging requirements. The latter strongly fluctuates with the velocity of the flow, the size of the pipe, the number of transducers around the pipe and the complexity of the flow patterns to be imaged. Any addition of processors to the tuned network requires reconsideration of the overall communication structure between processes and needs extra development which is undesirable.

An efficient data router enables the application of a processor farm topology to real-time flow imaging. The router dynamically allocates the data to processors on demand, so that there is an automatic load balance and all processors are fully utilized. The processing power can be increased by adding processors to the network without process modifications. This is very suitable to flow imaging, since the number of processors in the reconstruction network can be chosen to match the demands of a particular flow-imaging situation.

References

Beck, M. S. and Plaskowski, A. (1987) *Cross Correlation Flowmeters – Their Design and Application*, Adam Hilger, Bristol

Hayes, D. G. (1994) 'Tomographic flow measurement by combining distribution and velocity profile measurements in 2-phase oil/gas flows' (PhD thesis), UMIST, Manchester

INMOS Ltd (1988) *Communicating Process Architecture*, Prentice Hall, New York

INMOS Ltd (1991) *Transputer Development and iq Systems Databook*, Redwood, Melksham

Jordan, J., Bishop, P. and Kiani, B. (1989) *Correlation-Based Measurement Systems*, Ellis Horwood, Chichester

Wiegand, F. and Hoyle, B. S. (1989) Simulation for parallel processing of ultrasound reflection-mode tomography with applications to two-phase flow measurement. *IEEE Trans. Ultrason. Ferroelec. Freq. Cont.*, **36**, 652–660

Wiegand, F. and Hoyle, B. S. (1991) Development and implementation of real-time ultrasound process tomography using a transputer network. *Parallel Comput.*, **17**, 791–807

Xie, C. G., Hayes, D. G., Huang, S. M., Gregory, I. A. and Beck, M. S. (1992) Transputer/DSP-based capacitance tomography for real-time imaging and velocity profile measurement of oilfield flow pipelines. In *Proceedings of Parallel Computing & Transputer Applications 92, 21–25 September 1992, Barcelona, Spain, Part II* (eds. M. Valero *et al.*), IOS Press, Amsterdam, 1453–1462.

Chapter 15

Image reconstruction

C. G. Xie

15.1 Introduction

Various tomographic sensing systems for data acquisition from the boundary of an object to be imaged have been discussed in previous chapters. The subsequent stage of any tomographic imaging system is to process the acquired data using an appropriate *image reconstruction algorithm* implemented on suitable computer hardware. Depending on the physical principle of a sensing system, the reconstructed image, in essence, may contain information on the cross-sectional distribution of the constituent parameter of the object; for example, the permittivity distribution for an electrical capacitance system, the conductivity distribution for an electrical resistance system, or the distribution of attenuation coefficient for a γ-ray system.

Various tomographic techniques for process applications have been reviewed and the associated image-reconstruction algorithms identified. The main results are tabulated in Table 15.1. The table covers nucleonic, optical, microwave, NMR, acoustic and electrical techniques. For each technique, different operating modes and their typical scientific and/or industrial applications are listed. For example, for nucleonic technique, there are tomographic methods based on transmission, emission or scattering principles. The schematic principle diagrams of each technique in various operating modes are also included for clarity.

For each entry in Table 15.1, mathematical formulation for the boundary measurement versus the distribution of the constituent parameter to be imaged, i.e. the description of the forward problem, is also given. The similarities and the complexities of different tomographic techniques can then be compared and appreciated, and the linear and non-linear problems identified.

Algorithms for three major tomography techniques (transmission tomography, diffraction tomography, and electrical tomography) are discussed in this chapter. Transmission tomography is a technique associated with a radiating source (e.g. X-rays) that interact with a medium with straight rays. Section 15.2 briefly describes the well-developed Fourier inversion, the convolutional back-projection and algebraic reconstruction technique (ART) algorithms for transmission tomography. When a radiation source exhibits wave properties which diffract or scatter when interacting with a medium, diffraction tomography then comes into play. Algorithms for diffraction tomography are presented in Section 15.3, using a microwave system as an illustrative example (some acoustic systems have been identified to have the same system equation

Table 15.1 Tomographic techniques

Tomographic techniques	Schematic principle diagram	Measurement vs profile parameters	Image-reconstruction method†	Typical industrial applications†
(a) Nucleonic methods Transmission: • Photon transmission (X-ray and γ-ray) • Neutron transmission		Projection along L at angle ϕ: $p(\xi;\phi) = \ln\left(\dfrac{I}{I_0}\right) = \displaystyle\int_L \mu(\mathbf{r})\mathrm{d}\eta$ *Unknown*: attenuation profile $\mu(\mathbf{r})$ (\propto density profile $\rho(\mathbf{r})$)	*Direct method* [1–3]: Fourier inversion Filtered back-projection *Iterative method* [1–3]: Algebraic reconstruction technique (ART)	Multiphase flow imaging [6–11] Mixing study [12] Fluidized bed imaging [13, 14] NDT & E [15–18]
Emission:* • SPECT • PET		Detected nucleonic emission I: for SPECT (one detector array) $I = \displaystyle\int_L e(\mathbf{r})\exp\left\{-\int_{L(r)} \mu(\mathbf{r}')\mathrm{d}l'\right\}\mathrm{d}l$ for PET (two detector arrays) $I = \exp\left\{-\displaystyle\int_L \mu(\mathbf{r}')\mathrm{d}l'\right\}\displaystyle\int_L e(\mathbf{r})\mathrm{d}l$ *Unknown*: emission profile $e(\mathbf{r})$	For SPECT: No direct solution – iterative method used [4] For PET: Direct method – Fourier inversion [3, 4]	NDT & E in nuclear industry [19] Particulate flow imaging [20]

Scattering:
- Neutron scattering
- γ-Ray scattering (Compton)

Single scattering model:

$$[I_i]_M = [a_{ij}]_{M \times N}[\beta_j]_N \quad (M \geq N)$$

$$a_{ij} = w_j \exp\left\{ -A_0 \sum_n x_n \beta_n \right\} P(\theta)$$

$$\exp\left\{ -A_i \sum_m y_m \beta_m \right\}\left[\frac{1}{2\pi R_{ij}^2} \right]$$

$P(\theta) =$ PDF‡ of scattering at θ.

Unknown: void profile $[\beta_j]$

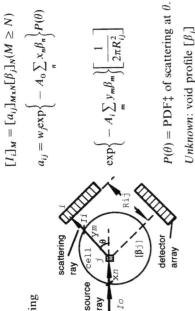

ART based:
Solve matrix equation based on regularized least-squares inversion (direct-problem solved at every iteration) [5]

Imaging volume fraction profile of gas-liquid flow [5, 21]

(b) Optical methods

Transmission — Similar to that of nucleonic transmission method — Similar to that for nucleonic transmission method [22] — Flow study and combustion diagnostics [22–25]

Emission (infra-red) —

The detected IR emission $p(\xi;\theta)$ (wavelength from λ_1 to λ_2) is:

$$p(\xi;\theta) = c \iint_L \int_{\lambda_1}^{\lambda_2} W[\lambda, T(\mathbf{r})]\,d\lambda\,d\eta$$

Filtered backprojection [26, 27] — Temperature imaging [26, 28] Plasma diagnostics [27]

Table 15.1 (continued)

Tomographic techniques	Schematic principle diagram	Measurement vs profile parameters	Image-reconstruction method†	Typical industrial applications†
		$$= c \int_L W_{\lambda_1 - \lambda_2}[T(\mathbf{r})]d\eta$$ $W[\lambda, T(\mathbf{r})]$ = Planck's function *Unknown:* temperature $T(\mathbf{r})$		
Interferometric	**Interferometer**	Fringe shift p is related to the refractive index $n(\mathbf{r})$ via (r, reference; m, measuring): $$p\lambda = \int [n_r(\mathbf{r}) - n_m(\mathbf{r})]dl$$ *Unknown:* profile $n(\mathbf{r})$	ART [29] Series expansion [31]	Temperature imaging [29] Mixing study [30,76] Flow imaging [31]

(c) Microwave and NMR methods

Microwave
diffraction

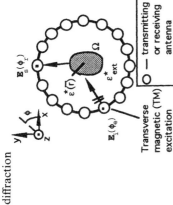

— transmitting
or receiving
antenna

Transverse
magnetic (TM)
excitation

Scattered field $E_s(\mathbf{r})$ is related to the complex permittivity $\varepsilon^*(\mathbf{r})$ via:

$$E_s(\mathbf{r}) = \int_\Omega J(\mathbf{r}')G(\mathbf{r};\mathbf{r}')\mathrm{d}\mathbf{r}'$$

$J(\mathbf{r}) = [k_{ext}^2 - k^2(\mathbf{r})][E_i(\mathbf{r}) + E_s(\mathbf{r})]$
$k^2(\mathbf{r}) = \omega^2\mu_0\varepsilon^*(\mathbf{r}),\ k_{ext}^2 = \omega^2\mu_0\varepsilon_{ext}^*$
$\varepsilon^*(\mathbf{r}) = \varepsilon_0\varepsilon_r(\mathbf{r}) - j\sigma(\mathbf{r})/\omega$
$G(\mathbf{r};\mathbf{r}') = -\frac{i}{4}H_0^{(1)}(k_{ext}|\mathbf{r}-\mathbf{r}'|)$

Unknown: permittivity $\varepsilon^*(\mathbf{r})$

With Born approximation;
Fourier inversion [32, 33]

No Born approximation:
Moment method and
pseudo-inversion [34–36].
Simulated annealing [37].

A developing subject.
Use for, e.g. remote
thermal sensing, robotic
vision and NDT
have been proposed
[38]

NMR

The measured signal $S(t)$, a sum of the spin magnetization profile in the xy plane over the sample volume Ω, is given by:

$$S(t) = \int_\Omega M(\mathbf{r},t)\exp[-j\Phi(\mathbf{r},t)]\mathrm{d}\mathbf{r}$$

where $M(\mathbf{r},t)$ and $\Phi(\mathbf{r},t)$ are the magnitude and phase profiles of the spin magnetization, and

$$\Phi(\mathbf{r},t) = \gamma\int_\Omega\int_0^t G(t')\mathbf{r}(t')\mathrm{d}t'$$

Fourier inversion [39, 40]

Flow velocity imaging
[39, 40]

Table 15.1 (continued)

Tomographic techniques	Schematic principle diagram	Measurement vs profile parameters	Image-reconstruction method†	Typical industrial applications†
		where $G(t)$ is the field gradient. With spatial encoding gradient being G_z and flow velocity encoding gradient G_v: $$\Phi(\mathbf{r},t) = \gamma G_z zt + \phi[v(\mathbf{r})]$$ $$\phi[v(\mathbf{r})] = \gamma \int \int G_v(t') \int_0^{t'} v(\mathbf{r},t'')\mathrm{d}t''\mathrm{d}t'$$ *Unknown*: velocity profile $v(\mathbf{r})$		
(d) Acoustic methods				
Transmission	Similar to that of nucleonic transmission method	Similar to that of nucleonic transmission method	Similar to that for nucleonic transmission methods [41]	Bubbly flow imaging [41]
Reflection	T – transmitter & receiver	For transducer at angle θ, the reflecting interface $f(\mathbf{r})$ that produces echo is located at: $$L(\theta) = 0.5ct(\theta)$$ where c = speed of sound, $t(\theta)$ = measured echo time. *Unknown*: interface profile $f(\mathbf{r})$	Back-projection [42]	Two-phase flow study [42]

Time-of-flight (TOF)	T – transmitter or receiver	The sum of TOF (t_+) and the differential of TOF (t_-) are related to sound and flow velocity profiles $c(\mathbf{r})$ and $v(\mathbf{r})$ via: $$t_+ = 2\int_L \frac{1}{c(\mathbf{r})}\,\mathrm{d}l$$ $$t_- = 2\int_L \frac{v(\mathbf{r})}{c^2(\mathbf{r})}\,\mathrm{d}l$$	Back-projection [43]. Series expansion and pseudo-inversion [44]. ART [45, 46]. Transform methods (Fourier inversion or filtered back-projection [48, 49]	Flow void imaging [43]. Furnace temperature imaging [44, 45]. Flow velocity imaging – scalar [45–47]; vectoral [48, 49]		
Diffraction (forward and/or back scattering)	T – transmitter or receiver	*Unknown*: profiles $c(\mathbf{r})$ and $v(\mathbf{r})$ Scattered acoustic pressure $p_\omega^s(\mathbf{r})$ is: $$p_\omega^s(\mathbf{r}) = -k^2 \int_\Omega \gamma_\kappa(\mathbf{r}')p_\omega(\mathbf{r}')G(\mathbf{r};\mathbf{r}')\mathrm{d}\mathbf{r}'$$ $$+ \int_\Omega \nabla\cdot[\gamma_\rho(\mathbf{r}')p_\omega(\mathbf{r}')]G(\mathbf{r};\mathbf{r}')\mathrm{d}\mathbf{r}'$$ $$p_\omega(\mathbf{r}) = p_\omega^i(\mathbf{r}) + p_\omega^s(\mathbf{r}),$$ $$k = \frac{\omega}{c_0} = \omega\sqrt{\kappa_0\rho_0}$$	*With Born approximations*: Direct solution using Fourier inversion [50–52] NB: The $G(\mathbf{r};\mathbf{r}')$ is Green's function and is given below (see also microwave diffraction: $$G(\mathbf{r};\mathbf{r}') = -\tfrac{i}{4}H_0^{(1)}(k	\mathbf{r} - \mathbf{r}')$$	Fluid study, NDT [50, 51]

Table 15.1 *(continued)*

Tomographic techniques	Schematic principle diagram	Measurement vs profile parameters	Image-reconstruction method†	Typical industrial applications†
		$$\gamma_\kappa(\mathbf{r}) = \frac{\kappa(\mathbf{r}) - \kappa_0}{\kappa_0},$$ $$\gamma_\rho(\mathbf{r}) = \frac{\rho(\mathbf{r}) - \rho_0}{\rho(\mathbf{r})}$$ *Unknown*: compressibility and density profiles $\kappa(\mathbf{r})$ and $\rho(\mathbf{r})$		
(e) Electrical methods Capacitance		The charge $Q_\theta(\phi)$ detected by a sensing electrode at position ϕ, with source electrode $(V(\theta) = V)$ at position θ, is: $$Q_\theta(\phi) = -\varepsilon_0 \oint_{\Gamma(\phi)} \varepsilon(\mathbf{r}) \nabla V_\theta(\mathbf{r}) \, \mathrm{d}l$$ $$\nabla \cdot [\varepsilon(\mathbf{r}) \nabla V_\theta(\mathbf{r})] = 0$$ *Unknown*: permittivity $\varepsilon(\mathbf{r})$	Back-projection [53–60]. Iterative method based on optimization technique [61].	Gas/oil, gas/solids two-phase flow imaging [53–59]. Fluidizing bed imaging [60].

Resistance

The differential voltage $\Delta V_\theta(\phi)$ between electrode pairs at ϕ and $(\phi + \alpha)$, with current-driving electrode pairs at θ and $(\theta + \alpha)$, is given by:

$$\Delta V_\theta(\phi) = V_\theta(\phi + \alpha) - V_\theta(\phi)$$

$$= \int_{P(\phi+\alpha)}^{P(\phi)} \nabla V_\theta(\mathbf{r}) \cdot dl$$

$$\nabla \cdot [\sigma(\mathbf{r})\nabla V_\theta(\mathbf{r})] = 0$$

Unknown: conductivity $\sigma(\mathbf{r})$

See [62]. Filtered back-projection between equipotential lines [63]. Back-projection using sensitivity coefficient [64]. Perturbation method [65, 66]. Double-constraint method [67]. Newton–Raphson method [68, 69].

Hydrocyclone imaging [69]. Mixing study [70]. Geophysical prospecting [71–73]

| Impedance using induced current | Similar to above but without current-injecting electrodes. Current is induced by coils surrounding the vessel. | Similar to that of resistance imaging (above) | Back-projection [74] | A new technique [74, 75] |

*SPECT, single photon emission CT; PET, positron emission CT.

†References: [1] Herman (1979); [2] Herman (1980); [3] Natterer (1986); [4] Bates and McDonnel (1989); [5] Hussein and Meneley (1986); [6] Iizuka et al. (1984); [7] Vinegar and Wellington (1987); [8] Munshi (1990); [9] Munshi et al. (1991); [10] Tsomaki and Kanamori (1984); [11] Zakaib et al. (1978); [12] Wang et al. (1985); [13] Simons et al. (1992); [14] Hosseini-Ashrafi et al. (1992); [15] Richards et al. (1982); [16] Gilboy and Foster (1982); [17] Sawicka and Palmer (1988); [18] Ioka and Yoda (1988); [19] Phillips et al. (1981); [20] Parker et al. (1992); [21] Kondic et al. (1983); [22] Beiting (1992); [23] Santoro et al. (1981); [24] Goulard and Emmerman (1980); [25] Snyder and Hesselink (1984); [26] Uchiyama et al. (1985); [27] Hino et al. (1987); [28] Hall and Bonczyk (1990); [29] Hertz (1985); [30] Snyder and Hesselink (1988); [31] Cha (1988); [32] Pichot et al. (1985); [33] Broquetas et al. (1991); [34] Ney et al. (1984); [35] Caorsi et al. (1991); [36] Chiu et al. (1991); [37] Garnero et al. (1991); [38] Bolomey (1989); [39] Kose et al. (1985); [40] Caprihan and Fukushima (1990); [41] Wolf (1988); [42] Weigand and Hoyle (1989); [43] Gai et al. (1989); [44] Norton et al. (1984); [45] Schwarz (1992); [46] Sato and Shiraki (1984); [47] Ko et al. (1989); [48] Norton (1989); [49] Braun and Hauck (1991); [50] Duchêne et al. (1989); [51] Blackledge et al. (1987); [52] Pourjavid and Tretiak (1991); [53] Huang et al. (1989a); [54] Huang et al. (1989b); [55] Xie et al. (1989a); [56] Xie et al. (1989b); [57] Huang et al. (1992); [58] Xie et al. (1992a); [59] Xie et al. (1992b); [60] Fasching and Smith (1991); [61] Isaksen and Nordtvedt (1992); [62] Webster (1990); [63] Barber (1990); [64] Kotre (1989); [65] Kim and Woo (1987); [66] Yorkey et al. (1987); [67] Wexler et al. (1985); [68] Yorkey et al. (1986); [69] Abdullah et al. (1992); [70] Ilyas et al. (1992); [71] Lopes and Lopes (1992); [72] Daily et al. (1992); [73] Daily and Ramirez (1994); [74] Purvis et al. (1993); [75] Tozer et al. (1992); [76] Mewes et al. (1992).

‡PDF, probability density function

as that of the microwave systems). Algorithms based on the moment method and pseudo-inversion technique have been discussed in some detail. Electrical tomography systems, such as capacitance and resistance imaging systems, are based on electrostatic fields. Their image-reconstruction algorithms are thus different from those of both the transmission and the diffraction tomography techniques. Section 15.4 is therefore devoted to describing imaging algorithms developed at UMIST for both electrical capacitance tomography and resistance tomography. Some simulation and experimental results are also presented.

For brevity, algorithms for emission tomography and nuclear magnetic resonance (NMR) imaging techniques are not described in this chapter. Interested readers can find them described in Chapter 12 and from the references included in Table 15.1. Typical non-medical applications of all tomographic techniques are also listed in the table. Potential users of tomographic techniques may find this information rather useful.

15.2 Transmission tomography

15.2.1 Introduction

Some radiation sources, such as X-rays and γ-rays, are highly penetrative because of their extremely short wavelengths compared with the size of a practical object. Rays emitted from these sources are able to pass through an object without being bent but with their radiation intensity attenuated. The degree of attenuation is dependent on the material composition and the size of an object being penetrated. Tomographic systems can be constructed by using these sources and the appropriate detectors mounted outside the object of interest. They are generally called *transmission tomography* systems for the reasons mentioned above. Most high-resolution, nucleonic imaging systems are based on the principle of transmission tomography, e.g. the commercially available X-ray compared tomography (CT) scanners. The uses of transmission tomography in optical systems (mainly laser based) and ultrasonic systems have also been found. Care should be taken, however, when non-nucleonic sources are used. Ultrasonic transmission-tomography systems (Chapter 8), for example, may produce erroneous results if not used properly, since reflection and/or diffraction effects may dominate, depending on the properties of the object being interrogated and on the operating frequencies of the ultrasonic waves. It should be borne in mind that the diffraction phenomena of waves can be fully utilized and the related tomography techniques are categorized as *diffraction tomography* (Section 15.3).

In this section, typical image-reconstruction algorithms for transmission tomography are briefly described. Note that many transmission-tomography algorithms have been well developed for medical CT scanners; the detailed descriptions of these algorithms can be found in the books by Herman (1979, 1980) and Natterer (1986).

The object function to be reconstructed, $f(r,\phi)$ (or $f(x,y)$), may be a spatial

description of the attenuation coefficient (for a nucleonic system) or the absorption coefficient (often so called for an optical system). The source is assumed to be monochromatic and the spectral dependence of f is also ignored. (In practice, suitable measures are needed to correct the beam-hardening effects for X-ray sources which have a distributed energy spectrum (Herman, 1980).)

The phenomenon of transmission attenuation in a two-dimensional plane (r,ϕ) can be represented as:

$$I = I_o\exp\left[-\int_L f(r,\phi)\mathrm{d}l \right] \tag{15.1}$$

where I_o and I are, respectively, the intensity of the source and the intensity measured by the detector. Equation (15.1) can be rewritten as

$$p = \int_L f(r,\phi)\mathrm{d}l \tag{15.2}$$

where

$$p = \ln(I_o/I)$$

It can be observed that recovering f from the given data p (a line integral of f along the projection line L) is not a straightforward problem. Radon showed that it is possible to recover f from a set of integral values p along various projection lines L (Herman, 1979, 1980).

In CT methodology, multiple attenuation data p (given by eqn (15.2)) can be collected by different data-collection modes. Two popular ones are identified as parallel-beam and fan-beam geometries. CT scanners based on the parallel-beam geometry often have a rotation–translation mechanism involving an opposing source–detector pair (an array of opposing sources and detectors may also be used). At one particular scanning angle, the source–detector pair moves translationally so that data are collected along parallel beams; the data can be thus collected at various scanning angles. CT scanners incorporating the fan-beam geometry involve a rotating module including a single source and an array of detectors located on an arc. At one particular scanning angle, a single source views all the detectors simultaneously and the data are collected by the detectors corresponding to various angles (i.e. along fan beams). This process is repeated for the source at various angles. Scanners based on the fan-beam geometry are more efficient in data collection and, therefore, are more popular in the practical scanners. However, the associated image-reconstruction algorithms are more complex than their parallel-beam counterparts. In the following, for illustrative purposes, only the image-reconstruction algorithms for parallel-beam geometry are dealt with. For details of algorithms for use with fan-beam geometry, see Herman (1980) and Natterer (1986).

Figure 15.1 depicts the schematic diagram for a parallel-beam scanner. The distance of the ray (line S–D) of the source–detector pair from the origin of the co-ordinate system (ξ,η) is denoted by ξ, and the source–detector pair can be

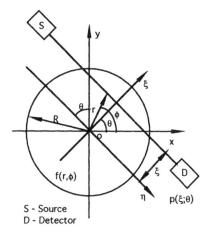

S - Source
D - Detector

Figure 15.1 *Transmission tomography: parallel-beam geometry*

rotated to different angles $\theta(0 \leqslant \theta \leqslant \pi)$ to give different views or *projections*. A set of data (p) can be collected at different $\xi(-R \leqslant \xi \leqslant R)$ for a given view angle θ (or a projection), and is denoted here by $p(\xi;\theta)$. Note that a semi-colon is used here to indicate the procedures involved in data collection.

15.2.2 Fourier reconstruction algorithm

The inversion formula for the parallel-beam geometry is based on the *projection theorem* for Fourier transforms of a two-dimensional function. The theorem states that the one-dimensional Fourier transform of the projection data, $p(\xi;\theta)$, with respect to the first variable ξ, is equal to the two-dimensional Fourier transform of the object function $f(r,\phi)$ being imaged (Herman, 1980; Bates and McDonnell, 1989). Mathematically,

$$\hat{f}(v;\theta) = \hat{p}(v;\theta) \tag{15.3}$$

Taking the inverse Fourier transform of eqn (15.3) gives

$$f(r,\phi) = \int_0^\pi \int_{-\infty}^\infty \hat{p}(v;\theta)\exp[-j2\pi vr\cos(\theta - \phi)]|v|\,\mathrm{d}v\mathrm{d}\theta \tag{15.4}$$

Here, for a given θ,

$$\hat{p}(v;\theta) = \int_{-R}^R p(\xi;\theta)\exp(-j2\pi v\xi)\mathrm{d}\xi \tag{15.5}$$

Equation (15.4) requires projection data on a continuous basis for all values of ξ and θ. However, in practice, projections $p(\xi;\theta)$ are taken at discrete sampling points. That is, for each of the projection directions θ_i uniformly distributed over the half-circle ($\theta_i = [\pi(i-1)]/M, i = 1, \ldots, M$), $p(\xi;\theta)$ is sampled at $2N + 1$ equally spaced points $\xi_j(\xi_j = j\Delta\xi; j = -N, \ldots, N; \Delta\xi = R/N)$,

resulting in a set of discrete data $p(\xi_j;\theta_i)$. As a consequence, discrete Fourier transforms (DFTs) should be used to represent equations (15.4) and (15.5). For simplicity, these discrete equations are not included here. Comprehensive treatments of the effects of data sampling on the quality of image reconstruction, e.g. the ill-posedness problems and the incomplete data problems, can be found elsewhere (Natterer, 1986).

For computational purposes a finite cut-off (spatial) frequency has to be introduced in the Fourier domain. This cut-off frequency (v_c) is usually implemented by using a filter function, $W(v)$, which vanishes for $|v|$ greater than v_c. Thus the filtered version of eqn (15.4) becomes

$$\tilde{f}(r,\phi) = \int_0^\pi \int_{-\infty}^\infty \hat{p}(v;\theta)\exp[-j2\pi vr\cos(\theta - \phi)]W(v)|v|\,dv\,d\theta \qquad (15.6)$$

Here, \tilde{f} is an approximate reconstruction due to the finite cut-off introduced in the computation. Also, the aforementioned discrete nature of the CT data forces the practical implementation of v_c to be governed by the sampling theorem, i.e.

$$v_c > 1/(2\Delta\xi)$$

One band-limiting filter, the rectangular window function, is given by

$$W(v) = \begin{cases} 1, & |v| < v_c \\ 0, & |v| > v_c \end{cases}$$

and another popular 'sinc' filter is written as

$$W(v) = \begin{cases} \sin\left(\dfrac{\pi v}{2v_c}\right)\bigg/\left(\dfrac{\pi v}{2v_c}\right), & |v| < v_c \\[2ex] 0, & |v| > v_c \end{cases}$$

15.2.3 Convolutional back-projection algorithm

The reconstruction algorithm based on the inversion formula, such as shown by eqn (15.6), is known as the *transform method*. It has been observed that this method is time consuming and requires very accurate interpolation schemes (from polar-grid to square-grid) in computing the two-dimensional inverse Fourier transforms (often done by using a fast Fourier transform (FFT)) (Herman, 1980). The introduction of convolutions can eliminate the step of computing the Fourier transform of the projection data and the subsequent two-dimensional Fourier inversion which is often time consuming.

Exploiting the convolution property of Fourier transforms, eqn (15.6) can be written as

$$\tilde{f}(r,\phi) = \int_0^\pi \int_{-R}^R p(\xi;\theta)q(\xi' - \xi)\,d\xi\,d\theta \qquad (15.7)$$

where

$$q(\xi) = \int_{-v_c}^{v_c} W(v) |v| \exp(j2\pi v\xi) dv \qquad (15.8)$$

and

$$\xi' = r\cos(\theta - \phi)$$

Here, q is known as the 'convolving function' and is the inverse Fourier transform of the filter function, $W(v)$. Equations (15.7)–(15.8) are the fundamental equations of the convolutional (or filtered) back-projection algorithm in CT. The inner integral of (15.7) is a convolution and the outer integral is often termed the 'back-projection'. The convolutional back-projection algorithm is the most widely used method of reconstruction used by commercial CT scanners.

15.2.4 Algebraic reconstruction techniques

Another group of reconstruction methods based on iterative schemes has also been developed. Such methods are known as 'algebraic reconstruction techniques' (ARTs). Depending on how the discretization is carried out, there are different versions of ART (Natterer, 1986). The fully discrete case is described briefly below.

Here the integral equation (eqn (15.2)) is transformed into a linear system of equations by the collocation method with piecewise constant trial functions, which is widely used in numerical analysis. Suppose the following equations are to be solved:

$$\int_{L_j} f(\mathbf{x}) d\mathbf{x} = g_j, \qquad j = 1, \ldots, Q \qquad (15.9)$$

with straight projection lines L_j for the object function f. First the function f is discretized by decomposing it into pixels S_i, $(i = 1, \ldots, P)$ and f is assumed to be constant in each pixel. This leads to replacing the function f by a vector $\tilde{\mathbf{f}}$ whose ith component is the value of f in S_i. Now, let

$$a_{ji} = \text{length of } (L_j \cap S_i) \qquad (15.10)$$

Since L_j intercepts with only a small fraction (\sqrt{P}, roughly) of the pixels, most of the a_{ji} are zero. Putting

$$\mathbf{a}_j = (a_{j1}a_{j2} \ldots a_{jP})^T$$

eqn (15.9) can be written as

$$\mathbf{a}_j^T \tilde{\mathbf{f}} = g_j \quad (j = 1, \ldots, Q) \qquad (15.11)$$

By applying Kaczmarz's method (a variant of the successive over-relaxation (SOR) method) (Natterer, 1986), the iterative solution to eqn (15.11) reads

$$\tilde{\mathbf{f}}_j = \tilde{\mathbf{f}}_{j-1} + \frac{\omega}{|\mathbf{a}_j|^2}(g_j - \mathbf{a}_j^T\tilde{\mathbf{f}}_{j-1})\mathbf{a}_j \ (j = 1, \ldots, Q) \tag{15.12}$$

where $\omega\,(0 < \omega < 2)$ is the relaxation parameter that affects the speed of convergence.

A definite advantage of ART lies in its versatility. It can be used for any scanning geometry and even for incomplete data problems. (This does not necessarily mean that the results of ART are satisfactory for such problems). Statistical approaches can also be readily incorporated in the ART. One typical example is the maximum entropy method. In this method some *prior* knowledge is included in the image-reconstruction process; it has been proven to be useful for incomplete data problems (see, for example, Smith *et al.* (1991)). It is worth mentioning that ART is usually more time consuming than, for example, the convolutional back-projection algorithms.

15.2.5 Examples

Practical, non-medical, applications of transmission tomography are listed in Table 15.1 for nucleonic, optical and acoustic based systems. In the references cited therein, many interesting imaging results have been presented. Some results of image reconstruction based on transmission tomography can be found in Part IV.

15.3 Diffraction tomography

15.3.1 Introduction

Rays and waves interact with materials in very difrrerent ways due to the fact that they have very different frequency spectra. Unlike X-rays, for example, microwaves have a wavelength comparable to the size of the objects, and thus refraction and diffraction that lead to 'ray' bending cannot be neglected (Chapter 9). The approximations related to straight-ray propagation cannot be applied, because scattering phenomena and multiple paths must be taken into account. Image-reconstruction algorithms described for transmission tomography systems (Section 15.2), where the probing rays are straight lines, are not applicable (Vest, 1985; Andrienko *et al.*, 1992). Different image reconstruction algorithms based on wave-diffraction principles should be used.

The aim of diffraction tomography is to reconstruct the properties (dielectric or acoustic) of a scatterer irradiated with waves (electromagnetic or acoustic) from the measurements of the scattered fields taken at multiple angles around the scatter.

For brevity, in this section, microwave systems with transverse magnetic

(TM) excitation will be used as an illustrative example for describing the algorithms for diffraction tomography. It is worth noting that, when the density variation ($\rho(\mathbf{r})$) of the medium is neglected, the propagation of the acoustic waves can be described by the same type of equation (the scalar Helmholtz equation) that describes the microwave propagation. In this case, the speed of sound ($c(\mathbf{r})$) is taken as the reconstruction variable (see Table 15.2). This simplification has often been used in modelling acoustic systems, although it is a poor representation of an acoustic medium. The integral solution to the more comprehensive differential equation describing the acoustic wave propagation is given in Table 15.1(d), where both the density $\rho(\mathbf{r})$ and the compressibility $\kappa(\mathbf{r})$ of the medium are the reconstruction variables. For a weakly scattering object (where the Born approximation is invoked, see below), the related reconstruction algorithms are based on the Fourier inversion (Blackledge *et al.*, 1987).

Reconstruction algorithms based on the well-known *diffraction slice theorem* (the diffracted field produces data that are related to a slice in the spatial Fourier domain of the scatterer) were developed for microwave (Pichot *et al.*, 1984; Broquetas *et al.*, 1991) and ultrasonic (Duchêne *et al.*, 1988; Blackledge *et al.*, 1987; Pourjavid and Tretiak, 1991) tomography systems. Such algorithms are generally based on Born or Rytov approximations when solving the related wave equations so that the scattered field within the scatterer being imaged can be neglected. These algorithms are suitable for weakly scattering objects; they usually fail when applied to strong scatterers.

For strongly scattering objects, reconstruction algorithms based on moment method and matrix pseudo-inversion were developed (Ney *et al.*, 1984; Caorsi *et al.*, 1991; Chiu and Kiang, 1991). Techniques based on iterative methods, such as simulated annealing, were also developed to solve the inverse problem in diffraction tomography (Garnero *et al.*, 1991). They produced images of improved quality, but are often computationally time consuming.

In the following, an algorithm based on the moment method and matrix pseudo-inversion will be described for microwave imaging systems. The description of the algorithm is partly based on the works of Ney *et al.* (1984)

Table 15.2 *Comparison of differential equations for (simplified) acoustic and transverse magnetic (TM) microwave fields – the scalar Helmholtz equation*

	Acoustic system	Microwave system
Differential equations	$\nabla^2 p(\mathbf{r}) + k^2(\mathbf{r}) p(\mathbf{r}) = 0$	$\nabla_T^2 E_z(\mathbf{r}) + k^2(\mathbf{r}) E_z(\mathbf{r}) = 0$
	$p(\mathbf{r}) =$ acoustic pressure field.	$E_z(\mathbf{r}) =$ TM electric field.
	Wavenumber $= k(\mathbf{r}) = \omega/c(\mathbf{r})$	Wavenumber $k(\mathbf{r}) = \omega[\mu_0 \varepsilon^*(\mathbf{r})]^{\frac{1}{2}}$
Constituent parameters	Speed of acoustic waves: $c(\mathbf{r})$	Complex permittivity: $\varepsilon^*(\mathbf{r}) = \varepsilon_0 \varepsilon_r(\mathbf{r}) - j\sigma(\mathbf{r})/\omega$

and Caorsi *et al.* (1991). Since this algorithm does not invoke the Born approximation, it is applicable to objects exhibiting both weak and strong scattering. For the reasons mentioned above, this algorithm should, in principle, be usable for some of the acoustic systems based on diffraction tomography (Table 15.2).

15.3.2 Algorithm based on moment method and pseudo-inversion

The case of a cylindrical object of arbitrary cross-section under TM excitation is studied. Figure 15.2 illustrates the imaging geometry and notation. The cross-section Ω of the object may be strongly inhomogeneous and is characterized by its complex permittivity $\varepsilon^*(\mathbf{r})$. The expression of $\varepsilon^*(\mathbf{r})$ is given in Table 15.2, where $\varepsilon_r(\mathbf{r})$ is the relative permittivity and $\sigma(\mathbf{r})$ is the conductivity at a point $\mathbf{r} = (x,y)$. The object is surrounded by a medium of complex permittivity $\varepsilon_o^*(\varepsilon_o^* = \varepsilon_o\varepsilon_o^r - j\sigma_o/\omega)$. Note that it is assumed that the dielectric property of the object does not vary along the 0–z axis. An incident plane wave of angular frequency ω with electric field E_i polarized parallel to 0–z illuminates the object (the subscript z for E in Table 15.2 is omitted herein for convenience). The scattered field is measured by an array of detectors situated, for example, on an arc L whose normal direction at the midpoint is parallel to the propagation direction of the incident wave. This process is repeated for different angles ϕ by rotating jointly the detector-array and the source generating the incident field. The inverse problem then is posed as estimating the complex permittivity $\varepsilon^*(\mathbf{r})$ of the cross-section Ω from the scattered field measurements under the multiple incidence.

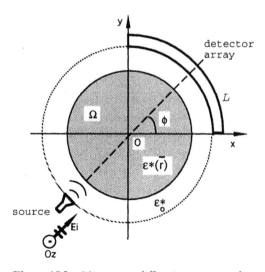

Figure 15.2 *Microwave diffraction tomography*

Let the total electric field at a point \mathbf{r} be $E(\mathbf{r})$, the incident field be $E_i(\mathbf{r})$ and the scattered field be $E_s(\mathbf{r})$, then:

$$E(\mathbf{r}) = E_i(\mathbf{r}) + E_s(\mathbf{r}) \tag{15.13}$$

All these fields are polarized parallel to the 0–z axis since the characteristics of the object is assumed unchanging along the 0–z axis. This assumption leads to a reduction of the wave equation to the scalar Helmholtz equation, as shown in Table 15.2; its exact solution is represented by the integral equation:

$$E(\mathbf{r}) = E_i(\mathbf{r}) + \int_\Omega [k_o^2 - k^2(\mathbf{r})]E(\mathbf{r}')G(\mathbf{r};\mathbf{r}')d\mathbf{r}' \tag{15.14}$$

where $k_o = \omega[\mu_o\varepsilon_o^*]^{\frac{1}{2}}$ and G is the free-space Green's function for a homogeneous medium:

$$G(\mathbf{r};\mathbf{r}') = -\frac{j}{4}H_0^{(1)}(k_o|\mathbf{r} - \mathbf{r}'|) \tag{15.15}$$

with $H_0^{(1)}$ the Hankel function of the first kind for an $\exp(-j\omega t)$ time dependence.

Here, it is worth mentioning that, for a weakly scattering object, the Born approximation assumes that $|E_s(\mathbf{r})| \ll |E_i(\mathbf{r})|$, so the total field $E(\mathbf{r})$ within the integral of eqn (15.14) can be replaced by the incident field $E_i(\mathbf{r})$. Only based on this assumption can the inverse of eqn (15.14) be obtained by using, for example, the Fourier inversion approach. Otherwise, eqn (15.14) can be rewritten as

$$E(\mathbf{r}) = E_i(\mathbf{r}) + k_o^2 \int_\Omega \chi^*(\mathbf{r})E(\mathbf{r}')G(\mathbf{r};\mathbf{r}')d\mathbf{r}' \tag{15.16}$$

where $\chi^*(\mathbf{r})$ is the complex permittivity *contrast*, which is given by:

$$\chi^*(\mathbf{r}) = 1 - \frac{\varepsilon^*(\mathbf{r})}{\varepsilon_o^*} \tag{15.17}$$

By rotating jointly the source (the incident wave) and the detector array for N different angles ϕ_1, \ldots, ϕ_N, N integral equations can be obtained (using eqn (15.13)):

$$E_s(\mathbf{r};\phi_n) = k_o^2 \int_\Omega \chi^*(\mathbf{r})E(\mathbf{r}';\phi_n)G(\mathbf{r};\mathbf{r}';\phi_n)d\mathbf{r}' \qquad (n = 1, \ldots, N) \tag{15.18}$$

These equations provide the basis for reconstructing the scatterer $\chi^*(\mathbf{r})$ by using scattered field data $E_s(\mathbf{r};\phi_n)$ gathered at different views ϕ_n. It should be pointed out that each equation in (15.18) is non-linear since it includes the product of two unknowns – the complex permittivity contrast and the total electric field. It is therefore necessary to solve the problem in two linear steps by introducing an intermediate variable, i.e. the equivalent current density $J(\mathbf{r})$:

$$J(\mathbf{r}) = [k_o^2 - k^2(\mathbf{r})]E(\mathbf{r}) = k_o^2\chi^*(\mathbf{r})E(\mathbf{r}) \tag{15.19}$$

Substituting eqn (15.19) in eqn (15.18) gives

$$E_s(\mathbf{r};\phi_n) = \int_\Omega J(\mathbf{r}';\phi_n)G(\mathbf{r};\mathbf{r}';\phi_n)d\mathbf{r}' \qquad (n = 1, \ldots, N) \tag{15.20}$$

This results in a set of linear integral equations with unknowns $J(\mathbf{r};\phi_n)$ ($n = 1$, ..., N). The dielectric properties of the scatterer can then be derived after solving these equations (via eqn (15.19)).

Moment methods can be used to solve eqn (15.20) numerically (Harrington, 1968). To achieve this, the domain Ω is discretized into M cells. For each angle ϕ_n, the value of the equivalent current density inside each cell is assumed constant. In other words, $J(\mathbf{r};\phi_n)$ is expanded as a sum of M basis functions:

$$J(\mathbf{r};\phi_n) = \sum_{m=1}^{M} J_m^{\phi_n}f_m(\mathbf{r}) \qquad (n = 1, \ldots, N) \tag{15.21}$$

where $J_m^{\phi_n}$ ($m = 1, \ldots, M$) are the M coefficents to be determined, and the M basis functions f_m are the same for each angle ϕ_n.

To test the scattered field outside Ω (the measurement domain) the Dirac delta (impulse) function is normally used (Caorsi *et al.*, 1991). The use of P such functions will lead to a measurement of the total field at P points outside Ω and to a derivation of the scattered field (via eqn (15.13)). The following matrix equation can be obtained by applying the moment method:

$$\mathbf{E}_s = \mathbf{GJ} \tag{15.22}$$

where $\mathbf{E}_S = [\mathbf{E}_s^{(1)}\mathbf{E}_s^{(2)} \ldots \mathbf{E}_s^{(N)}]$ is a $P \times N$ matrix (N vectors with each having P terms representing measurements of the scattered field); \mathbf{G} is a $P \times M$ matrix derived from the discretization of the Green's function; and $\mathbf{J} = [\mathbf{J}^{(1)}\mathbf{J}^{(2)} \ldots \mathbf{J}^{(N)}]$ is a $M \times N$ matrix (N vectors with each having M terms representing the coefficents of equivalent current densities, i.e. the coefficents $J_m^{\phi_n}$ ($m = 1$, ..., M; $n = 1, \ldots, N$) in eqn (15.21)).

The above discretized problem is often ill conditioned. To overcome this, the solution to eqn (15.22) can be achieved via regularization. Matrix pseudo-inverse transformation has been shown to be effective in achieving this (Natterer, 1986; Golub and Van Loan, 1989). By so doing, matrix \mathbf{J} is then obtained as follows:

$$\mathbf{J} = \mathbf{G}^+\mathbf{E}_S \tag{15.23}$$

where \mathbf{G}^+ is the pseudo-inverse matrix of \mathbf{G}. (Note that matrix \mathbf{G}^+ needs calculating only once for a particular system arrangement; it can be stored and used when needed.)

After \mathbf{J} has been computed, the dielectric reconstruction is then achieved in the following way. The total electric field inside the scatterer (i.e. inside Ω) is

$$E(\mathbf{r};\phi_n) = E_i(\mathbf{r};\phi_n) + \sum_{m=1}^{M} J_m^{\phi_n} \int_\Omega f_m(\mathbf{r}')G(\mathbf{r};\mathbf{r}';\phi_n)d\mathbf{r}' \quad (n = 1, \ldots, N) \tag{15.24}$$

Using eqn (15.19), the approximate complex permittivity contrast, $\tilde{\chi}^*(\mathbf{r})$, can be obtained as the mean value of the complex permittivity contrasts of all views:

$$\tilde{\chi}^*(\mathbf{r}) = \frac{1}{k_{\mathrm{o}}^2} \frac{1}{N} \sum_{n=1}^{N} \frac{\displaystyle\sum_{m=1}^{M} J_m^{\phi_n} f_m(\mathbf{r})}{E_{\mathrm{i}}(\mathbf{r};\phi_n) + \displaystyle\sum_{m=1}^{M} J_m^{\phi_n} \int_{\Omega} f_m(\mathbf{r}')G(\mathbf{r};\mathbf{r}';\phi_n)d\mathbf{r}'} \tag{15.25}$$

Finally, the estimated distribution of complex permittivity $\varepsilon^*(\mathbf{r})$ is derived from eqn (15.17).

The above algorithm can be summarized as follows. For a particular microwave imaging system, the system pseudo-inverse matrix \mathbf{G}^+ is precalculated by using a number of test functions, and is stored. The image reconstruction is then simply done in two linear steps. First, the equivalent current densities \mathbf{J} (an intermediate parameter) inside the scatterer are computed by a view-by-view fast matrix-by-matrix multiplication (eqn (15.23), where \mathbf{E}_S contains the detected scattered field of all views due to an unknown distribution of $\varepsilon^*(\mathbf{r})$). Second, the reconstructed image of $\varepsilon^*(\mathbf{r})$ of each view is decoupled from the computed \mathbf{J}. The final image is then taken as the average of the images of all views.

15.3.3 Examples

Practical, non-medical, applications of diffraction tomography are emerging. Relevant references are cited in Table 15.1 for microwave (see also Chapter 9) and acoustic imaging (see also Chapter 8) systems. Some imaging results have been reported in the references given in the table.

15.4 Electrical tomography

15.4.1 Introduction

Excitation sources (voltage or current) for use with electrical capacitance or electrical resistance tomography systems are generally of low frequency (say below 5 MHz). Therefore, unlike microwave systems which usually operate in the gigaherz range and thus are described by the wave equations (Table 15.2), electrical capacitance and resistance imaging systems are described by equations governing the *electrostatic field* –the Poisson equations (see Table 15.3). It is perhaps not surprising that differential equations for TM excited microwave fields and electrostatic fields are all special cases of the following generalized inhomogeneous Helmholzt equation (Silvester and Ferrari, 1990):

$$\nabla\cdot[m(\mathbf{r})\nabla u(\mathbf{r})] + k^2 u(\mathbf{r}) = f(\mathbf{r}) \tag{15.26}$$

where $u(\mathbf{r})$ is a scalar variable which is the system unknown, $m(\mathbf{r})$ represents the

Table 15.3 *Comparison of differential equations of electrical capacitance and electrical resistance systems – the Poisson equations*

	Capacitance system	Resistance system
Differential equations	$\nabla \cdot [\varepsilon(\mathbf{r}) \nabla V(\mathbf{r})] = 0$	$\nabla \cdot [\sigma(\mathbf{r}) \nabla V(\mathbf{r})] = 0$
Constituent parameters	Permittivity: $\varepsilon(\mathbf{r})$	Conductivity: $\sigma(\mathbf{r})$

property of the medium, $f(\mathbf{r})$ is a given driving function, and k is a position-invariant constant.

For simplicity, tomography systems based on electrostatic fields for imaging dielectric and/or conducting properties of a medium are hereafter called *electrical tomography* systems. For imaging of a dielectric object, multiple a.c. voltage-driven and (charge) current sensing electrodes are used on the periphery of the object (Chapter 4); whereas for imaging a conducting object, multiple a.c. current-driven and voltage sensing electrodes are used (Chapter 5). The aim of electrical tomography is to reconstruct the dielectric and/or conducting properties of an object from the measurement of electrical signals (charge currents or differential voltages) taken from all possible combinations (views) of the electrodes.

It is well known that, for electrostatic fields, when electric flux (or current) lines are encountered by an interface of different permittivities (or conductivities), the flux (or current) lines will deflect, i.e. bend. Therefore image-reconstruction algorithms described for straight-ray transmission tomography (see Section 15.2) are not applicable. Since propagation of electromagnetic waves and the distribution of electrostatic field lines are governed by different differential equations (as mentioned above), reconstruction algorithms for diffraction tomography (Section 15.3) may not be suitable. Therefore, different image-reconstruction algorithms should be developed for electrical tomography.

Owing to the promising potential of electrical tomography for routine industrial as well as biomedical applications, over the last decade tremendous efforts have been made to develop related image-reconstruction algorithms. A diversity of algorithms, both non-iterative and iterative, have emerged. A concise summary of these algorithms and the relevant references are listed in Table 15.1(e).

In the following sections, two image-reconstruction algorithms for electrical tomography systems developed at UMIST are described. First, a qualitative, non-iterative back-projection algorithm for an electrical capacitance system is described. A description is then given of a quantitative, iterative algorithm based on a modified Newton–Raphson method for use with an electrical resistance system. Some imaging results are also presented for both algorithms.

15.4.2 Back-projection image-reconstruction algorithm for electrical capacitance tomography

The inverse problem for electrical capacitance tomography system can be described in matrix form:

$$\mathbf{g} = \mathbf{Sc} \tag{15.27a}$$

where \mathbf{g}, the system unknown, is a $P \times 1$ vector representing the grey level of a P-pixel image approximating the distribution of $\varepsilon(\mathbf{r})$; and \mathbf{c}, the system known, is an $M \times 1$ vector representing the M measurements taken from the multi-electrode system ($M = [N_e(N_e - 1)]/2$, where N_e is the total number of boundary electrodes); and \mathbf{S} is a $P \times M$ matrix the meaning of which can be better understood by partitioning it in the following way:

$$\mathbf{S} = [\mathbf{s}_{(1)}\mathbf{s}_{(2)} \cdots \mathbf{s}_{(M)}] \tag{15.27b}$$

where $\mathbf{s}_{(m)}$ $(m = 1, \ldots, M)$ is a $P \times 1$ vector related to the mth measurement c_m (c_m is the mth component of vector \mathbf{c}). Using eqn (15.27b), eqn (15.27a) can be rewritten as :

$$\mathbf{g} = \sum_{m=1}^{M} c_m \mathbf{s}_{(m)} \tag{15.27c}$$

Equation (15.27c) reveals that $\mathbf{s}_{(m)}$ is the contributing factor to the grey-level of image \mathbf{g} due to the mth measurement, i.e. it is the system's *spatial sensitivity distribution* for the electrode-pair making the mth measurement. The final image \mathbf{g} is formed (by summation) by back-projecting measurement data c_m ($m = 1, \ldots, M$) from all M views over the image domain, with the data from each view c_m being weighted (by multiplication) by the corresponding sensitivity distribution $\mathbf{s}_{(m)}$. Algorithms based on this principle have also been called the 'back-projection algorithms'. Note that they should not be confused with the convolutional back-projection algorithms developed for transmission tomography (Section 15.2.3).

It can be observed that, if the system's spatial sensitivity distribution \mathbf{S} is known, the image-reconstruction process is just a simple vector-matrix multiplication (eqn (15.27a)). This aspect is very similar to the algorithm used for microwave diffraction tomography (Section 15.3.2). However, it should be pointed out that \mathbf{S} is actually dependent on the unknown distribution $\varepsilon(\mathbf{r})$ due to the non-linear relationship between the measured capacitance and the permittivity distribution. Therefore, the use of a precomputed \mathbf{S} under one situation implies the linearization of the non-linear problem. It has been found that this linearization process produced satisfactory results for, for example, a gas/oil two-component flow where the ratio of the permittivities of the two components is rather small ($\varepsilon_{oil}/\varepsilon_{gas} \approx 2.5$). For other types of flow, for example, the oil/water flow where the ratio of the permittivities of the two components is rather large ($\varepsilon_{water}/\varepsilon_{oil} \approx 30$), this linearization has produced erroneous results. In this case, an iterative algorithm would be more appropriate (see, for example, Section 15.4.3).

In the next subsection, the calculation of matrix S by using the finite-element method (FEM) is described for gas/oil flows.

Forward problem: computation of sensitivity matrix S based on FEM

A 12-electrode capacitance tomography system for imaging gas/oil flows will now be considered. A schematic diagram of the sensor is shown in Figure 15.3. The capacitance between the source electrode i (applied with a voltage V_c) and the detecting electrode j (at earth potential; the other 10 electrodes are also at earth potential) is calculated using the following integral equation (with the aforementioned Dirichlet boundary conditions being imposed):

$$C_{i,j} = -\frac{\varepsilon_o}{V_c} \oint_{r \subseteq \Gamma_j} \varepsilon(\mathbf{r}) \nabla V_i(\mathbf{r}) \cdot d\mathbf{r} \quad (i = 1, 2, \ldots, 11; j = i + 1, \ldots, 12) (15.28)$$

where Γ_j represents a curve enclosing the detecting electrode j; $V_i(\mathbf{r})$ is the potential distribution when electrode i is the source electrode.

Equation (15.28) implies that there are in total 66 capacitances for a 12-electrode system. To determine them for a known $\varepsilon(\mathbf{r})$, Poisson's equation (see Table 15.3) must first be solved to obtain the potential distribution $V_i(\mathbf{r})$. Since distribution $\varepsilon(\mathbf{r})$ is often irregular, there is no analytical solution to Poisson's equation. Therefore, a numerical method based on the FEM is often used. To obtain a finite-element solution, the region shown in Figure 15.3 is divided into E mesh elements corresponding to Q nodes. $\varepsilon(\mathbf{r})$ can then be expressed by a subset of the vector $\boldsymbol{\varepsilon} = (\varepsilon_1, \varepsilon_2, \ldots, \varepsilon_E)$ representing the permittivities of the E elements. $V_i(\mathbf{r})$ is expressed by the nodal potential vector $\mathbf{v}_{(i)}$ (a $Q \times 1$ vector). It can be shown that (Silvester and Ferrari, 1990):

$$\mathbf{A}\mathbf{v}_{(i)} = \mathbf{b}_{(i)} \tag{15.29}$$

where $\mathbf{b}_{(i)}$ is a $Q \times 1$ vector incorporating the aforementioned Dirichlet boundary conditions, and \mathbf{A} is a sparse $Q \times Q$ matrix the components of

Figure 15.3 *Schematic diagram of a 12-electrode capacitive primary sensor*

which depend on the element permittivities ε as well as on the element topology. Since matrix \mathbf{A} is symmetric and positive-definite, there exists a non-singular upper triangular matrix \mathbf{U}, with unit diagonal matrix \mathbf{D}, such that

$$\mathbf{A} = \mathbf{U}^{\mathrm{T}}\mathbf{D}\mathbf{U} \tag{15.30a}$$

After performing the matrix factorization indicated by eqn (15.30a) (this is only done once for each of the 11 source electrodes), the solution to $\mathbf{v}_{(i)}$ in eqn (15.29) is carried out by

(1) Forward reduction: $\mathbf{U}^{\mathrm{T}}\mathbf{z} = \mathbf{b}_{(i)}$. $\qquad\qquad$ (15.30b)

(2) Diagonal scaling: $\mathbf{D}\mathbf{y} = \mathbf{z}$. $\qquad\qquad$ (15.30c)

(3) Back-substitution: $\mathbf{U}\mathbf{v}_{(i)} = \mathbf{y}$. $\qquad\qquad$ (15.30d)

This finite-element model can be used to predict the performance of a capacitance imaging system and to design an optimal multi-electrode sensor (Xie *et al.*, 1992a) (Chapter 16). For instance, capacitance measurement data of a system due to various flow patterns, e.g. stratified flows and oil droplet flows, can be calculated (see Figures 15.4 and 15.5). The spatial sensitivity distribution of a system can also be calculated by using a small 'point' test object to disturb the field everywhere inside the pipe. The sensitivity distribution of electrode pair i–j, $S_{i,j}^{(k)}$, is calculated as

$$S_{i,j}^{(k)} = \left(\frac{1}{\beta^{(k)}}\right)\frac{C_{i,j}^{(k)} - C_{i,j(\mathrm{gas})}}{C_{i,j(\mathrm{oil})} - C_{i,j(\mathrm{gas})}} \qquad (k = 1, \ldots, K) \tag{15.31}$$

where $C_{i,j}^{(k)}$ is the capacitance when the kth in-pipe element (the element inside $|\mathbf{r}| < R_1$) has permittivity $\varepsilon_{\mathrm{oil}}$ and the rest of the in-pipe elements all have the permittivity $\varepsilon_{\mathrm{gas}}$. $C_{i,j(\mathrm{gas})}$ and $C_{i,j(\mathrm{oil})}$ are, respectively, the capacitances when the pipe is fully filled with gas and with oil. $\beta^{(k)}$ is the fractional area of the kth in-pipe element (with respect to the pipe cross-sectional area πR_1^2).

Owing to the property of symmetry, only six out of 66 distributions of the field sensitivity need to be calculated: $\{S_{1,2}\}, \{S_{1,3}\}, \{S_{1,4}\}, \{S_{1,5}\}, \{S_{1,6}\}$ and $\{S_{1,7}\}$. This can significantly reduce the computation time since the rest of the 60 sensitivity distributions can be obtained by simple rotation transformation. To render these 66 sensitivity distributions accessible by the image-reconstruction process, an interpolation procedure was used to map them from the finite-element domain to the image domain (Xie *et al.*, 1992a).

The matrix \mathbf{S} in eqn (15.27b) can thus be obtained. Note that the following correspondence is used to arrange the 66 electrode pairs (i,j) in relation to the 66 components (m) of \mathbf{S}:

$$\{(m); m = 1, \ldots, 66\} \Leftrightarrow \{(i,j); i = 1, \ldots, 11; j = i + 1, \ldots, 12\} \tag{15.32}$$

To put eqn (15.32) into context, we have

$$\{S_{1,2}\} \Leftrightarrow \mathbf{s}_{(1)}, \{S_{1,3}\} \Leftrightarrow \mathbf{s}_{(2)}, \ldots, \{S_{1,12}\} \Leftrightarrow \mathbf{s}_{(11)}, \ldots, \{S_{11,12}\} \Leftrightarrow \mathbf{s}_{(66)}$$

Figure 15.6 shows the typical six sensitivity distributions $\mathbf{s}_{(1)}$ to $\mathbf{s}_{(6)}$ (or $\{S_{1,2}\}$ to

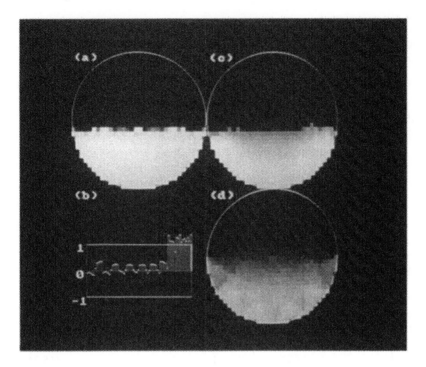

Figure 15.4 *Comparison of images reconstructed using different algorithms. (a) A stratified gas/oil flow model, where the high grey level represents the oil phase and the low grey-level represents the gas. (b) The corresponding 66 normalized capacitances* **c** *of the flow model (a) calculated for the model sensor (see text). (c) Image reconstructed using* **c** *and the back-projection algorithm using full sensitivity data (as shown in Figure 15.6). (d) Image reconstructed using the '0/1 algorithm'*

$\{S_{1,7}\}$), for a sensor with $R_1 = 76.2$ mm, $R_2 - R_1 = 15$ mm, $R_3 - R_2 = 7$ mm, $d = 9$ mm, $\theta = 26\,°$, $\varepsilon_{se} = 4$ and $\varepsilon_{pl} = 5.8$ (for the sensor parameters see Figure 15.3; this sensor is here called the *model sensor*). The figure shows that the field sensitivity is higher near the pipe wall than in the middle of the pipe, and in some areas the sensitivity exhibits a positive response, otherwise it is negative (the sunken areas) or zero. The area of positive response interrogates different parts of the pipe cross-section for different electrode pairs.

Inverse problem: detailed description of back-projection algorithm

For a capacitance tomography system, the inverse problem is to find the permittivity distribution from the capacitance measurements. It should be pointed out that there is no analytical solution to such an inverse problem. An image-reconstruction algorithm based on a simple back-projection method has been developed in the past for capacitance tomography (Huang *et al.*, 1989a; Xie *et al.*, 1989b). When the back-projection process was carried out, only the binary format of the capacitance sensitivity distributions (as shown in

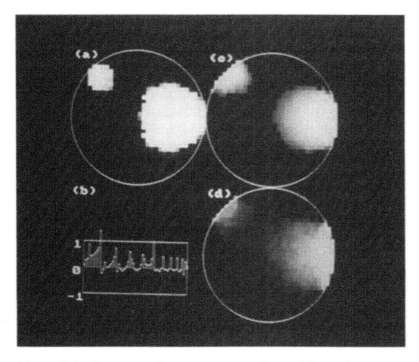

Figure 15.5 *Comparison of images reconstructed using different algorithms. (a) A gas/oil flow model showing two oil blocks. (b) The corresponding 66 normalized capacitances* **c** *of the flow model (a) calculated for the model sensor (see text). (c) Images reconstructed using* **c** *and the back-projection algorithm using full sensitivity data (as shown in Figure 15.6). (d) Image reconstructed using the '0/1 algorithm'*

Figure 15.6) was used, i.e. for the pth pixel, $s_{(m)}^{(p)} = 1$ if $s_{(m)}^{(p)} > 0$, otherwise $s_{(m)}^{(p)} = 0$ (this is called the '0/1 algorithm' below for brevity). A direct consequence of this method is that the reconstructed image has severe artefacts (e.g. streaks) (see, for example, Figures 15.4(d) and 15.5(d). To alleviate this problem, the back-projection algorithm is modified by using the precalculated full sensitivity **S** (Xie *et al.*, 1992a). The algorithm is written as follows (which is a variant of eqn (15.27a)):

$$\mathbf{g} = \mathbf{D}(\mathbf{Sc}) \tag{15.33a}$$

where **D** is a $P \times P$ diagonal matrix with its ith diagonal component d_{ii} given by:

$$d_{ii} = \left(\sum_{m=1}^{M} s_{(m)}^{(i)} \right)^{-1} \tag{15.33b}$$

and **c** is the vector containing the normalized capacitance measurements whose components $c_{(m)}$ are given by:

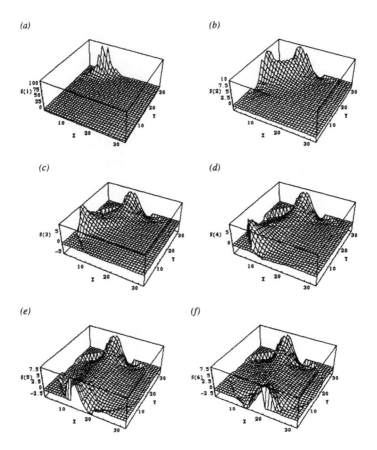

Figure 15.6 *Capacitance sensitivity distributions of six typical electrode pairs calculated for the model sensor (see text). (a) Adjacent electrode pair, $s_{(1)}$. (b) Electrode pair separated by one electrode, $s_{(2)}$. (c) Electrode pair separated by two electrodes, $s_{(3)}$. (d) Electrode pair separated by three electrodes, $s_{(4)}$. (e) Electrode pair separated by four electrodes, $s_{(5)}$. (f) Diagonally separated electrode pair, $s_{(6)}$*

$$c_{(m)} \Leftrightarrow c_{i,j} = \frac{C_{i,j(\text{flow})} - C_{i,j(\text{gas})}}{C_{i,j(\text{oil})} - C_{i,j(\text{gas})}} \tag{15.33c}$$

where $C_{i,j(\text{flow})}$ is the capacitance between the electrode pair i–j due to an unknown flow distribution $\varepsilon(\mathbf{r})$. Note that, in eqn (15.33c) the correspondence expressed by eqn (15.32) is invoked.

For a linear system, the normalized capacitance data **c** should fall within the interval [0,1], as should the resulting *normalized*-image grey level **g** (eqn (15.33a)). Since a capacitance tomography system exhibits non-linearity, **c** may have overshooting (> 1) or undershooting (< 0) components (see **c** in Figures 15.4(b) and 15.5(b)), as may **g**. Therefore, some processing of **g** is

needed before the grey-level image is displayed. Overshooting in **g** can be eliminated by using a truncation operation, i.e. in eqn (15.33c), $c_{(m)} = 1$ if $c_{(m)} > 1$. Undershooting is dealt with by using a threshold operation, as described below.

The use of a threshold operation can reduce the low grey-level artefacts present in an image. It has been observed that the level of thresholding is dependent on the flow distribution and the flow component fraction, so an adaptive threshold operation is usually required. Numerical experiments have suggested that the following threshold operation is suitable (in our imaging system, 256 integer grey-levels, (0–255), are used):

$$\mathbf{g}^{(p)} = \begin{cases} 0 & \text{if } g^{(p)} < \eta \\ 255 g^{(p)} & \text{otherwise} \end{cases} p = 1, \ldots, P \tag{15.34a}$$

where $g^{(p)}$ is the pth term of the vector **g**, and the threshold level $\eta (0 \le \eta \le 1)$ is given by:

$$\eta = (1 - 0.5\alpha)\zeta \tag{15.34b}$$

where

$$\alpha = \frac{1}{M} \sum_{m=1}^{M} c_{(m)} \text{ (here } c_{(m)} = 1 \text{ if } c_{(m)} > 1) \tag{15.34c}$$

$$\zeta = \frac{1}{P^+} \sum_{p=1}^{P^+} g^{(p)} \text{ (here } P^+ \text{ is the number of positive } g^{(p)} \text{ values)} \tag{15.34d}$$

To illustrate the effectiveness of this algorithm, Figure 15.4(c) shows the reconstructed image using the capacitance data **c** shown in Figure 15.4(b) (calculated using the FEM for flow model shown in Figure 15.4(a)), which closely resembles the flow model. The image reconstructed using the '0/1 algorithm' and a similar threshold operation is shown in Figure 15.4(d); it has poorer fidelity in comparison with Figure 15.4(c). A second example is given in Figure 15.5, from which the same observations can be made.

Parallel implementation of back-projection algorithm using transputers

The image-reconstruction algorithm described in the last section was implemented using a transputer-based system which is described in more detail in Chapter 14. It takes about 100 ms for a single T801 transputer (25 MHz) to complete one image reconstruction; this is equivalent to an imaging rate of about 10 frames/s. For real-time flow-imaging purposes, a faster imaging speed is often needed. To achieve this, multiple transputer-based processors were used in parallel to implement the back-projection algorithm (Figure 14.2).

The transputer network consists of a host processor on a PC card (INMOS B004 compatible, T800–20 MHz; used also as the transputer development system (TDS)), a master processor (T801–25 MHz), a graphics processor (T800–25 MHz), and three slave processors (T801–25 MHz). The host

handles the external input/output (I/O) for the transputer network. It distributes the codes (development under TDS) to the appropriate processors in the network, presents data on PC's VDU, selects program options via keyboard input, loads data (e.g. sensitivity distributions **S**) from the PC hard disk into the slave processors, and saves data (e.g. the captured streams of 66 capacitance data sent by the master) to the PC hard-disk for future use. The master processor in the network controls the remote sensor electronic circuit (e.g. gain and offset adjustments) and performs acquisition of capacitance measurements (see Chapter 14); it also distributes the tasks (a stream of captured 66 capacitance measurements) to the slave processors, and collects and passes on the results (the calculated flow component fractions and/or the reconstructed images) to the graphics and the host processors. Each slave processor in the task farm executes the same serial program (the back-projection algorithm) on its own data set. In this load-balancing pipeline, several buffer processes (the 'throughput' and the 'feedback') carrying tasks to workers and results to the display are also run on each slave, ensuring that whenever a slave completes one task another task is immediately available. The graphics processor displays grey-level images **g** of flows on a graphics monitor via RGB outputs. It also displays the 66 normalized capacitance measurements **c** (a useful disgnostic aid of the imaging system) and the trend diagram of oil fraction change with time (see Figure 15.7(b)).

The imaging frame rate when different numbers of slave processors are used is shown in Figure 14.4. From one slave to two, the speed-up is quite linear (speed-up = F_n/F_1, where F_n and F_1 are the frame-rate achieved by one slave and n slaves, respectively). This is because the time taken for one slave to reconstruct an image is about two times that taken for the graphics transputer to display it (Figure 14.4(b)), so when a third slave is added to the task farm the imaging rate is only increased slightly (Figure 14.4(a)). This indicates that the bottleneck of the whole transputer network comes from the graphics transputer.

Typical results of on-line experiments

The performance of the imaging system has been tested extensively, including tests made under static conditions using physical models, and under dynamic conditions (various gas/oil flow rates and pipe inclinations) on a 6 in. internal diameter flow loop, at the Schlumberger Cambridge Research (SCR) Ltd, UK. The details of the static test are described in Chapter 17. Figure 15.7 shows some typical dynamic test results obtained at the SCR. Images in Figure 15.7(a) show the evolution of gas slugs on the top part of the pipe. The variation in the oil fraction with time is given in the right-hand half of Figure 15.7(b), where 2500 instantaneous readings are displayed. The test conditions were: the 6 in. internal diameter flow pipe was $6°$ from horizontal; the flow rate of oil (kerosene) was 2.7 m^3/h^{-1} and that of gas (compressed nitrogen) was 28 (a meter reading, the exact flow rates unknown). From this the pseudo-periodic nature of gas slugs is clearly visualized, and the frequency of occurrence of gas slugs and the mean oil fraction can be readily derived. In

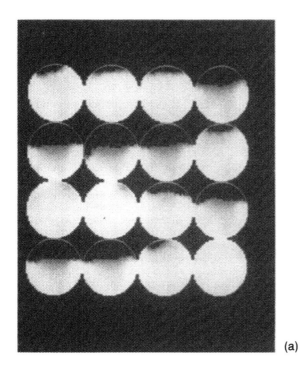

(a)

(b)

(c)

Figure 15.7 *Typical dynamic test results of gas/oil flow. (a, b) Flow loop 6° from horizontal. (a) The evolution of the gas slugs (displayed in dark grey levels). Time interval between successive images: 80 ms. Order of images: left to right, top to bottom. (b) Right: the variation of oil fraction with time (2500 instantaneous readings; time interval between successive readings, 10 ms). Bottom left: the instantaneous 66 capacitance measurements* **c** *(the 2500th set of data in this particular case). Top left: the corresponding reconstructed flow image. (c) Flow loop vertical: the development of churn/annular flows. Time interval between successive images: 30 ms. Order of images: left to right, top to bottom*

Figure 15.7(b), the instantaneous 66-capacitance measurements (components of vector **c**) are also displayed at the bottom left, and the corresponding reconstructed flow image is displayed at the top left-hand side of the figure. This integrated display has provided a powerful means of visualizing the dynamics of gas/oil flows. Figure 15.7(c) shows the flow regime when the flow loop was vertical and the gas flow rate was rather high (flow rate of gas was 425 meter-reading and that of oil $4.2\,\mathrm{m}^3\,\mathrm{h}^{-1}$), indicating the random occurrence of annular and churn flows.

15.4.3 Iterative modified Newton–Raphson image-reconstruction algorithm for electrical resistance tomography

This section describes the iterative, modified Newton–Raphson (MNR) image-reconstruction algorithm based on the work of Abdullah *et al.*, (1992).

A 16-electrode resistance tomography system is used as an example. By injecting current using a pair of neighbouring electrodes and measuring the voltage differences using all the other pairs of neighbouring electrodes, and repeating this process by injecting current using different pairs of neighbouring electrodes, a total number of $M = 104$ independent differential voltage measurements can be made ($M = N_e(N_e - 3)/2$, where $N_e = 16$). This is the so-called 'four-electrode measurement protocol'.

For a set of *measured* differential voltages \mathbf{v}^m (an $M \times 1$ vector) due to an unknown resistivity distribution $\boldsymbol{\wp}$ (a $K \times 1$ vector where K is the total number of finite elements in the pipe, often $K = M$), the basic steps of MNR image reconstruction algorithm are as follows:

(1) The nth boundary voltages \mathbf{v}_n due to the nth resistivity distribution $\boldsymbol{\rho}_n$ is calculated using the FEM ($\boldsymbol{\rho}_0$ is an initial guess).
(2) If $\| \mathbf{v}_n - \mathbf{v}^m \| > \varepsilon$, where ε is a prescribed the error limit, then go to (3), otherwise stop.
(3) The MNR method is used to update the resistivity distribution to $\boldsymbol{\rho}_{n+1} = \boldsymbol{\rho}_n + \Delta\boldsymbol{\rho}_n$, where $\Delta\boldsymbol{\rho}_n$ is dependent on the difference between the calculated and the measured voltages $\mathbf{v}_n - \mathbf{v}^m$ (see below). Go to (1) with subscript $n = n + 1$.

It can be seen that the forward-problem solving process (step (1)) is involved in this iterative algorithm. It determines, to a great extent, the performance of the image-reconstruction algorithm, since a fairly accurate and efficient finite-element model is required to achieve a faithful and fast image reconstruction.

Forward problem: boundary voltage calculation

The model of a source free conducting inhomogeneous body Ω, with a conductivity distribution $\sigma(\mathbf{r})(\sigma(\mathbf{r}) = 1/\rho(\mathbf{r}))$, into which a steady-state current is injected and the corresponding voltage $V(\mathbf{r})$ is measured, is governed by Poisson's equation (Table 15.3). For a unique solution to exist, sufficient boundary conditions must be imposed. For electrical resistance tomography, these conditions (Neumann boundary conditions) are often:

$$V = 0 \qquad \text{at the reference point} \qquad (15.35a)$$

$$\int \sigma \frac{\partial V}{\partial \mathbf{n}} = + I \qquad \text{on the current source electrode} \qquad (15.35b)$$

$$\int \sigma \frac{\partial V}{\partial \mathbf{n}} = - I \qquad \text{on the current sink electrode} \qquad (15.35c)$$

where I denotes the applied current over the electrodes surface, and \mathbf{n} is the outward unit normal to a vessel.

Like electrical capacitance tomography, FEM can be used to solve Poisson's equation for electrical resistance tomography. Figure 15.8 shows a

finite-element mesh used for a 16-electrode system, consisting of 69 nodes and 104 triangular elements (which equals the number of boundary voltage measurements). Note that for a 16-electrode system, there are 14 current injections when the four-electrode measurement protocol is used. For the ith current injection, the use of FEM converts the solution to Poisson's equation to the solution of the following set of linear equations:

$$\mathbf{A}\mathbf{v}_{(i)} = \mathbf{b}_{(i)} \qquad (i = 1, \ldots, 14) \tag{15.36}$$

where \mathbf{A} is the system's stiffness matrix of 69×69 entries; $\mathbf{v}_{(i)}$ is a vector representing the 69 unknown nodal potentials; and $\mathbf{b}_{(i)}$ is a 69×1 vector incorporating the Neumann boundary conditions indicated by eqns (15.35b) and (15.35c) for the ith current injection.

Note that eqn (15.36) is essentially identical to eqn (15.29) and, therefore, the same methods described for eqn (15.30) can be used to solve the unknown $\mathbf{v}_{(i)}$; they are not repeated here.

The 104 boundary (differential) voltages \mathbf{v} can be then extracted from the calculated 14 vectors $\mathbf{v}_{(i)}$ ($i = 1, \ldots, 14$) using the relation:

$$\mathbf{v} = \mathbf{T}[\mathbf{v}_{(1)}^{T}\mathbf{v}_{(2)}^{T} \ldots \mathbf{v}_{(14)}^{T}]^{T} \tag{15.37}$$

where \mathbf{T} is a matrix whose columns contain only two non-zero entries (± 1) corresponding to the boundary nodes of interest.

Inverse problem: resistivity distribution update

The inverse problem is to determine the resistivity distribution ρ from a finite number of boundary voltage measurements. Yorkey (1986) first described the use of a modified form of the well-known Newton–Raphson technique for reconstructing resistivity images. In essence, the modified Newton–Raphson algorithm iterates to a final solution of ρ based on an initial guess, by updating

Figure 15.8 *Finite element mesh (104 elements, 69 nodes) used to reconstruct quantitative resistivity images for a 16-electrode imaging system*

the resistivity distribution in response to an error formed by the difference between the computed voltage values (via forward-problem solving) and the measured values. If this error is smaller than a prescribed error limit, the resultant resistivity distribution is considered acceptable. The algorithm employed to update the resistivity distribution is given by (Yorkey, 1986):

$$\Delta\boldsymbol{\rho}_n = - [\mathbf{v}'(\boldsymbol{\rho}_n)^T \mathbf{v}'(\boldsymbol{\rho}_n)]^{-1} \mathbf{v}'(\boldsymbol{\rho}_n)^T [\mathbf{v}(\boldsymbol{\rho}_n) - \mathbf{v}^m] \tag{15.38}$$

where $\Delta\boldsymbol{\rho}_n$ is the change of resistivity values at the nth iteration; $\mathbf{v}'(\boldsymbol{\rho}_n)$, referred to as a Jacobian matrix, represents the sensitivity directional of the forward solution for a given resistivity distribution; \mathbf{v}^m are the measured boundary voltages.

The Jacobian matrix $\mathbf{v}'(\boldsymbol{\rho}_n)$ was calculated and assembled using a standard differentiation technique (Yorkey, 1986). The product of the transposed Jacobian by itself, the first expression on the right-hand side of eqn (15.38), forms a Hessian matrix. This matrix is often ill-conditioned, making its inverse both difficult to calculate and sensitive to measurement errors. Ill-conditioning arises from the non-linear behaviour of the resistivity distribution with respect to the measured boundary voltages (for example, resistivity changes in elements situated at the centre of the model produce virtually no significant changes in boundary voltages). Furthermore, the positive definiteness of the Hessian matrix deteriorates due to numerical rounding errors and the poor initial guess of $\boldsymbol{\rho}$. In such instances, the algorithm often diverges and results in negative values of resistivity. One approach of improving the conditioning of the Hessian matrix is to employ the Marquardt method (Marquardt, 1963), in which a normalized Hessian matrix (denoted by *) is treated with a smoothing operation to guarantee its positive definiteness and, therefore, the existence of its inverse. The normalization procedure is performed by multiplying all the row elements of the Hessian matrix and then all its column elements by $1/\sqrt{h_{ii}}$ which makes all of the diagonal elements equal to 1. The smoothing operation is performed on the normalized matrix by adding all the diagonal elements (h_{ii}) to a smoothing factor ω_n. Thus $\Delta\boldsymbol{\rho}_n$ in eqn (15.38) becomes:

$$\Delta\boldsymbol{\rho}_n = - \{[\mathbf{v}'(\boldsymbol{\rho}_n)^T \mathbf{v}'(\boldsymbol{\rho}_n)]^* + \omega_n \mathbf{I}\}^{-1} [\mathbf{v}'(\boldsymbol{\rho}_n)^T (\mathbf{v}(\boldsymbol{\rho}_n) - \mathbf{v}^m)]^* \tag{15.39}$$

where \mathbf{I} is the identity matrix.

For noise-free simulation studies, normalization has been shown to be effective in improving the accuracy of the reconstructed resistivity distribution. The value of ω_n has been found to be related to the convergence rate of the algorithm and was obtained empirically. ω_n is decreased by a single order of magnitude per iteration once the algorithm begins to converge. This order of magnitude decrease is necessary since the quadratic convergence property of the MNR becomes more pronounced as the distance between the estimated and actual resistivity distribution decreases. The initial value of ω_n is often chosen as 0.1.

Case studies

The MNR algorithm is coded in 'C' and run on an i860-based co-processor board with 8 Mbyte of linearly addressable RAM. The board, available

commercially, was supplied with a Greenhills C compiler which operates in a Unix-like environment. The 25-MHz i860 has a theoretical peak performance of 25 MFlops (million floating-point operations per second) on double precision arithmetic. Unfortunately, due to limitations imposed by the design of the board and its associated software development environment, a sustainable performance of just over 4 MFlops was achieved. This performance equates to one iteration taking 3.86 s on the i860 compared with over 52 min on a 'standard' 16-MHz i386sx-based PC. From data acquired using a practical data-acquisition system, four or five iterations are normally required to produce a final image. The initial value of resistivity fed into the MNR algorithm is that of the bulk resistivity of the inhomogeneous material inside the vessel which, in almost all cases, is within $\pm 40\%$ of the final solution imperative for convergence. Hence, the convergence of the solution is governed only by the choice of ω_n. The relationship between the normalized reconstruction error and the number of iterations taken for different values of ω_n is given in Figure 15.9. For decreasing values of ω_n Figure 15.9 indicates that the descent towards the actual resistivity distribution requires fewer iterations. However, if ω_n is decreased beyond a threshold limit (i.e. $\omega_n \leqslant 10^{-6}$ in this situation), the algorithm fails to converge.

To assess the accuracy of the reconstructed image a simulation study was performed using the FEM to model an object with a known resistivity. The model (Figure 15.10(a)) depicts a circular object of 4.5 cm diameter and 400 Ω-cm resistivity placed at the centre of a 9 cm diameter vessel. Objects placed at this location are known to be less easily detectable for the data-collection method employing the four-electrode measurement protocol, since variations

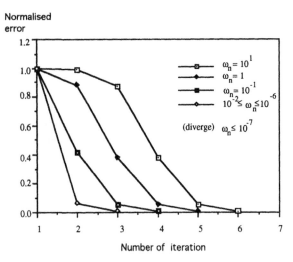

Figure 15.9 *Variation in the normalized reconstruction error versus the number of iterations for different values of* ω_n

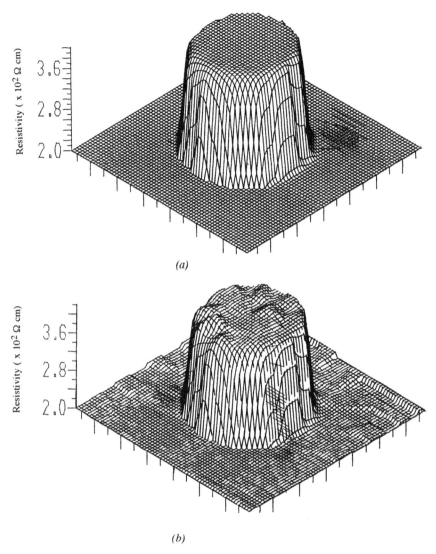

(a)

(b)

Figure 15.10 *Simulated object from the element mesh representing the vessel.* (a) *True image* (b) *Reconstructed image*

of resistivity in this region produce very small changes in the measured potential differences on the periphery. Figure 15.10(b) shows the reconstructed image with an initial resistivity of 200 Ω-cm corresponding to the background resistivity. To enable quantitative characterization of the reconstructed image, the average and maximum percentage errors were calculated using mathematical formulae similar to the ones proposed by Dines and Lytle (1981). For the reconstructed image shown in Figure 15.10(b), the average percentage error

between the reconstructed and actual resistivity of the object is less than 1% and the maximum error is around 5%. Also, it is apparent that, due to numerical computation errors, that the resistivity of some pixels is caused to oscillate. The oscillation error varies from 2% to 6% for the object, while for pixels not associated with the object the error is less than 1%.

In order to validate these results experimentally, an object of 4.8 cm diameter was made from solidified non-nutrient agar and saline to a resistivity of 200 Ω-cm and placed into the 9 cm vessel. The vessel was fitted with 16 equispaced point-sized silver palladium electrodes filled with saline of 400 Ω-cm resistivity. It can be seen from Figure 15.11 that, if the contrast between the object resistivity and the background resistivity is maintained at a ratio of 2:1 or lower, the objects resistivity can be determined. However, for larger contrast ratios such as 100:1, the instabilities caused by the propagation of numerical errors throughout the iterative procedure will saturate into the pixels representing the object and affect their resistivity. For very large contrast ratios, produced when both highly conducting (e.g. aluminium) and highly insulating (e.g. Perspex) materials are inserted into the vessel, the iterative reconstruction algorithm is terminated after four or five iterations in order to avoid overcontaminating the image pixels with cumulative numerical artefacts.

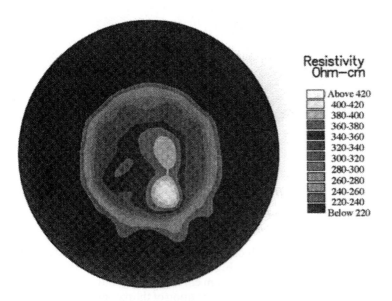

Figure 15.11 *Two-dimensional reconstruction from the MNR algorithm for a 4.8 cm diameter 200 Ω cm agar disc placed at the centre of a 9 cm diameter 400 Ω cm saline-filled vessel*

15.5 Summary

The main points of this chapter are:

- Three major image-reconstruction algorithms are identified for transmission, diffraction and electrical tomography. They are based on straight-ray propagation (e.g. X-rays), wave propagation (e.g. microwaves), and the conservation field (e.g. capacitance imaging based on electrostatic field), respectively.
- Image-reconstruction algorithms can be broadly classified into two categories: transform methods (e.g. Fourier inversion) and iterative methods (e.g. ART).
- Problems associated with transmission tomography are mostly linear. Related algorithms are well developed for medical CT scanners, with the convolutional back-projection algorithm being the most popular. For industrial applications, limited data problems are often common; therefore, ART-based algorithms incorporating some prior knowledge are often used.
- Problems associated with diffraction tomography are inherently non-linear. Algorithms have been developed with or without inclusion of Born approximation. The Born approximation is invoked for objects exhibiting weak scattering and the related algorithms are mostly based on Fourier inversion. For strong scatterers, algorithms based on moment method and matrix pseudo-inversion are usually used.
- Problems associated with electrical tomography are also inherently non-linear. Many algorithms have been emerging, with back-projection methods (mostly non-iterative) and Newton–Raphson methods (iterative) being the ones most commonly used.
- Algorithms based on iterative approaches are often computationally more time consuming. For practical applications, parallel computer architecture, for example transputers, can be used to realize real-time performance.

References

Abdullah, M. Z., Quick, S. V. and Dickin, F. J. (1992) Quantitative algorithm and computer architecture for real-time image reconstruction in process tomography. *Proceedings of the 1st Meeting on European Concerted Action on Process Tomography, 26–29 March, Manchester* (ed. M. S. Beck), 179–192

Andrienko, Y. A., Dubovikov, M. S., Gladun, A. D. and Pak, Un. (1992) Refraction in interferometric tomography. *Appl. Opt.*, **31**, 2615–2620

Barber, D. C. (1990) Quantification in impedance imaging. *Clin. Phys. Physiol. Meas.*, **11**(Suppl. A), 45–56

Bates, R. H. T. and McDonnell, M. J. (1989) *Image Restoration and Reconstruction* Clarendon Press, Oxford

Beiting, E. J. (1992) Fiber-optic fan-beam absorption tomography. *Appl. Opt.*, **31**, 1328–1343

Bolomey, J. C. (1989) Recent European developments in active microwave imaging for industrial, scientific and medical applications. *IEEE Trans. Microwave Theory Tech.*, **MTT-37**, 2109–2117

Braun, H. and Hauck, A. (1991) Tomographic reconstruction of vector fields. *IEEE Trans. Signal Proc.*, **39**, 464–471

Broquetas, A., Romeu, J., Rius, J. M., Elias-Fuste, A. R., Cardama, A. and Jofre, L. (1991) Cylindrical geometry: a further step in active microwave tomography. *IEEE Trans. Microwave Theory Tech.*, **39**, 836–844

Blackledge, J. M., Burge, R. E., Hopcraft, K. I. and Wombell, R. J. (1987) Quantitative diffraction tomography: I. Pulsed acoustic fields. II. Pulsed elastic waves. *J. Phys. D: Appl. Phys.*, **20**, 1–17

Caorsi, S., Gragnani, G. L. amd Pastorino, M. (1991) A multiview microwave imaging system for two-dimensional penetrable objects. *IEEE Trans. Microwave Theory Tech.*, **39**, 845–851

Caprihan, A. and Fukushima, E. (1990) Flow measurements by NMR. *Phys. Rep.*, **198**, 195–235

Cha, S. (1988) Interferometric tomography for three-dimensional flow fields via envelope function and orthogonal series decomposition. *Opt. Eng.*, **27**, 557–563

Chiu, C.-C. and Kiang, Y.-W. (1991) Electromagnetic imaging for an imperfectly conducting cylinder. *IEEE Trans. Microwave Theory Tech.*, **39**, 1632–1639

Daily, W. and Ramirz, A. (1994) Environmental process tomography in the United States. In *Process Tomography – A strategy for industrial exploitation*, (ed. M. S. Beck, *et al.*) Proc. of the 3rd Meeting on European Concerted Action on Process Tomography, 24–26 March, 1994, Oporto, Portugal, pp. 501–512. UMIST, Manchester

Daily, W., Ramirez, A. and LaBrecque, D. (1992) Electrical resistivity tomography of vadose water movement. *J. Water Resources Res*, **28**, 1429–1442.

Dines, K. A. and Lytle, R. J. (1981) Analysis of electrical conductivity imaging. *Geophysics*, **46**, 1025–1036

Duchêne, B., Lesselier, D. and Tabbara, W. (1988) Experimental investigation of a diffraction tomography technique in fluid ultrasonics. *IEEE Trans. Ultrason. Ferroelec. Frequency Control*, **35**, 437–444

Fasching, G. E. and Smith, N. S. (1991) A capacitive system for three-dimensional imaging of fluidised beds. *Rev. Sci. Instrum.*, **62**, 2243–2251

Gai, H., Li, Y. C., Plaskowski, A. and Beck, M. S. (1989) Flow imaging using ultrasonic time-resolved transmission mode tomography. In *Proceedings of the 3rd International Conference Image Processing Applications Warwick, 18–20 July*, 237–241, IEE, London

Garnero, L., Franchois, A., Hugonin, J.-P., Pichot, C. and Joachimowicz, N. (1991) Microwave imaging – complex permittivity reconstruction by simulated annealing. *IEEE Trans. Microwave Theory Tech.*, **39**, 1801–1807

Gilboy, W. B. and Foster, J. (1982) Industrial applications of computerised tomography with X- and gamma-radiation. In *Research Techniques in Non-destructive Testing* (ed. R. S. Sharpe) Academic Press, London

Golub, G. H. and Van Loan, C. F. (1989) *Matrix Computations*, 2nd edn, Johns Hopkins University Press, London, 243

Goulard, R. and Emmerman, P. J. (1980) Combustion diagnostics by multiangular absorption. *Topics Current Phys.*, **20**, 215–227

Hall, R. J. and Bonczyk, P. A. (1990) Sooting flame thermometry using emission/absorption tomography. *Appl. Opt.*, **29**, 4590–4598

Harrington, R. F. (1968) *Field Computation by Moment Method*. Macmillan, New York

Herman, G. T. (ed.) (1979) Image reconstruction from projections: implementation and applications. In *Topics in Applied Physics*, Vol. 32, Springer-Verlag, Berlin

Hermann, G. T. (1980) *Image Reconstruction from Projections – The Fundamentals of Computerised Tomography*, Academic Press, New York

Hertz, H. M. (1985) Experimental determination of 2-D flame temperature fields by interferometric tomography. *Opt. Commun.*, **54**, 131–136

Hino, M., Aono, T., Nakajima, M. and Yuta, S. (1987) Light emission computed tomography system for plasma diagnostics. *Appl. Opt.*, **26**, 4742–4746

Hosseini-Ashrafi, M. E., Tüzün, U. and MacCuaig, N. (1992). Study of bed voidage in packed bed flows using photon transmission tomography. *Proceedings of the 1st Meeting on European Concerted Action on Process Tomography, 26–29 March, Manchester* (ed. M. S. Beck), 307–320

Huang, S. M., Plaskowski, A., Xie, C. G. and Beck, M. S. (1989a) Capacitance-based tomographic flow imaging system. *Electron. Lett.*, **24**, 418–419

Huang, S. M., Plaskowski, A., Xie, C. G. and Beck, M. S. (1989b) Tomographic imaging of two-component flow using capacitance sensors. *J. Phys. E: Sci. Instrum.*, **22**, 173–177

Huang, S. M., Xie, C. G., Thorn, R., Snowden, D. and Beck, M. S. (1992) Design of sensor electronics for electrical capacitance tomography. *IEE Proc. G*, **139**, 83–88

Hussein, E. M. A. and Meneley, D. A. (1986) Single-exposure neutron tomography of two-phase flow. *Int. J. Multiphase Flow*, **12**, 1–34

Iizuka, M., Morooka, S., Kimura, H. and Kagawa, T. (1984) Measurement of distribution of local void fraction in two-phase flow by X-ray computed tomography. *J. At. Energy Soc. Jpn.*, **26**, 421–429

Ilyas, O. M., Williams, R. A., Mann, R., Ying, P., El-Hamouz, A. M., Dickin, F. J., Edwards, R. B. and Rushton, A. (1992) Advances in and prospects for the use of electrical impedance tomography for modelling and scale-up of liquid/liquid and solid/liquid processes. In *Proceedings of the 1st Meeting on European Concerted Action on Process Tomography, 26–29 March, Manchester* (ed. M. S. Beck), 251–264

Ioka, I. and Yoda, S. (1988) Measurements of the density profile in oxidised graphite by X-ray computed tomography. *J. Nucl. Mater. (Netherlands)*, **151**, 202–208

Isaksen, Ø. and Nordtvedt, J. E. (1992) Capacitance tomography: reconstruction based on optimization theory. In *Proceedings of the 1st Meeting on European Concerted Action on Process Tomography, 26–29 March, Manchester* (ed. M. S. Beck), 213–224

Kim, Y. and Woo, H. W. (1987) A prototype system and reconstruction algorithms for electrical impedance technique in medical body imaging. *Clin. Phys. Physiol. Meas.*, **8** (Suppl. A), 63–70

Ko, D. S., DeFerrari, H. A. and Malanotte-Rizzoli, P. (1989) Acoustic tomography in the Florida Strait: temperature, current, and vorticity measurements. *J. Geophys. Res.*, **94**, 6197–6211

Kondic, N., Jacobs, A. and Ebert, D. (1983) Three-dimensional density field determination by external stationary detectors and gamma sources using selective scattering. In *Proceedings of the 2nd International Meeting on Nuclear Reactor Thermal-Hydraulics* (ed. M. Merilo), 1443–1462

Kose, K., Satoh, K., Inouye, T. and Yasuoka, H. (1985) NMR flow imaging. *J. Phys. Soc. Jpn.*, **54**, 81–92

Kotre, C. J. (1989) A sensitivity coefficient method for the reconstruction of electrical impedance tomograms. *Clin. Phys. Physiol. Meas.*, **11** (Suppl. A), 275–281

Lopes, E. P. and Lopes, E. P. (1992) Electromagnetic geophysical tomography. *IEE Proc. F*, **139**, 27–35

Marquardt, D. W. (1963) An algorithm for least-square estimation of non-linear parameters. *SIAM J. Appl. Math.*, **11**, 431–441

Mewes, D., Fellhölter, A. and Renz, R. (1992) Measurement of mixing phenomena in gas and liquid flow. *Proceedings of the 1st Meeting on European Concerted Action on Process Tomography, 26–29 March, Manchester* (ed. M. S. Beck), 295–306

Munshi, P. (1990) A review of computerised tomography with applications to two-phase flows. *Sādhanā (India)*, **15**, 43–55

Munshi, P., Arora, P. and Rathore, R. K. S. (1991) Application of improved Fourier filters in tomographic measurements of air–water flows. *Nucl. Instrum. Method. Phys. Res.*, **A300**, 586–594

Natterer, F. (1986) *The Mathematics of Computerised Tomography*. Wiley, Chichester

Ney, M. M., Smith, A. M. and Stuchly, S. S. (1984) A solution of electromagnetic imaging using pseudoinverse transformation. *IEEE Trans. Med. Imaging*, **MI-3**, 155–162

Norton, S. J. (1989) Tomographic reconstruction of 2-D vector fields: application to flow imaging. *Geophys. J.*, **97**, 161–168

Norton, S. J., Testardi, L. R. and Wadley, H. N. G. (1984) Reconstructing internal temperature distributions from ultrasonic time-of-flight tomography and dimensional resonance measurements. *J. Res. Nat. Bureau Stand.*, **89**, 65–74

Parker, D. J., Hawkesworth, M. R., Beynon, T. D. and Bridgewater, J. (1992) Process engineering studies using positron-based imaging techniques. *Proceedings of the 1st Meeting on European Concerted Action on Process Tomography, 26–29 March, Manchester,* (ed. M. S. Beck), 239–250

Phillips, J. R., Barnes, B. K., Barnes, M. L., Hamlin, D. K. and Medina-Ortega, E. G. (1981) An assessment of precision gamma-scanning for inspecting LWR fuel rods. *Electric Power Research Institute Report EPRI-NP 1952,* Palo Alto, USA

Pichot, C., Jofre, L., Peronnet, G. and Bolomey, J.-C. (1985) Active microwave imaging of inhomogeneous bodies. *IEEE Trans. Antennas Propagation,* **AP-33,** 416–425

Pourjavid, S. and Tretiak, O. (1991) Ultrasound imaging through time-domain diffraction tomography. *IEEE Trans. Ultrason. Ferroelec. Frequency Control,* **38,** 74–85

Purvis, W. R., Tozer, R. C., Anderson, D. K. and Freeston, I. L. (1993) An induced current impedance imaging system. *IEE Proc. A.,* **140,** 135–141

Richards, C. O. J., McClellan, G. C. and Tow, D. M. (1982) Neutron tomography of nuclear fuel bundles. *Mater. Eval.,* **40,** 1263

Santoro, R. J., Semerjian, H. G., Emmerman, P. J. and Goulard, R. (1981) Optical tomography for flow field diagnostics. *Int. J. Heat Mass Transfer,* **24,** 1139–1150

Sato, T. and Shiraki, M. (1984) Tomographic observation of flow in a water tank. *J. Acoust. Soc. Am.,* **76,** 1427–1432

Sawicka, B. D. and Palmer, B. J. F. (1988) Density gradients in ceramic pellets measured by computed tomography. *Nucl. Instrum. Methods Phys. Res. A, Accel. Spectrom. Detect. Assoc. Equip.,* **A263,** 525–528

Schwarz, A. (1992) Acoustic measurement of temperature and velocity fields in furnaces. In *Proceedings of the 1st Meeting on European Concerted Action on Process Tomography, 26–29 March, Manchester* (ed. M. S. Beck), 381–389

Silvester, P. P. and Ferrari, R. L. (1990) *Finite Elements for Electrical Engineers,* 2nd edn, Cambridge University Press, Cambridge

Simons, S. J. R., Seville, J. P. K., Clift, R., Gilboy, W. B. and Hosseini-Ashrafi, M. E. (1992) Application of gamma-ray tomography to fluidised and spouted beds. *Proceedings of the 1st Meeting on European Concerted Action on Process Tomography, 26–29 March, Manchester* (ed. M. S. Beck), 227–238

Smith, R. T., Zoltani, C. K., Klem, G. J. and Coleman, M. W. (1991) Reconstruction of tomographic images from sparse data sets by a new finite element maximum entropy approach. *Appl. Opt.,* **30,** 573–582

Snyder, R. and Hesselink, L. (1984) Optical tomography for flow visualisation of the density field around a revolving helicopter rotor blade. *Appl. Opt.,* **23,** 3650–3656

Snyder, R. and Hesselink, L. (1988) Measurement of mixing fluid flows with optical tomography. *Opt. Lett.,* **13,** 351–353

Tozer, R. C., Simpson, J. C., Freeston, I. L. and Mathias, J. M. (1992) Noncontact induced current impedance tomography. *Electron. Lett.,* **28,** 733–774

Tsumaki, K. and Kanamori, T. (1984) Measurement of void fraction distribution by gamma-ray computed tomography. *J. Nucl. Sci. Technol.,* **21,** 315–317

Uchiyama, H., Nakajima, M. and Yuta, S. (1985) Measurement of flame temperature distribution by IR emission computed tomography. *Appl. Opt.,* **24,** 4111–4116

Vest, C. M. (1985) Tomography for properties of materials that bend rays: a tutorial. *Appl. Opt.,* **24,** 4089–4094

Vinegar, H. J. and Wellington, S. L. (1987) Tomographic imaging of three-phase flow experiments. *Rev. Sci. Instrum.,* **58,** 96–107

Wang, S. Y., Huang, Y. B., Pereira, V. and Gryte, C. C. (1985) Application of computed tomography to oil recovery from porous media. *Appl. Opt.,* **24,** 4021–4027

Webster, J. G. (ed.) (1990) *Electrical Impedance Tomography,* Adam Hilger, Bristol, Chap. 10

Weigand, F. and Hoyle, B. S. (1989) Simulations for parallel processing of ultrasound

reflection-mode tomography with applications to two-phase flow measurement. *IEEE Trans. Ultrason. Ferroelec. Frequency Control*, **36**, 652–660

Wexler, A., Fry, B. and Neuman, M. R. (1985) Impedance computed tomography algorithm and system. *Appl. Opt.*, **24**, 3985–3992

Wolf, J. (1988) Investigation of bubbly flow by ultrasonic tomography. *Part. Part. Syst. Charact.*, **5**, 170–173

Xie, C. G., Plaskowski, A. and Beck, M. S. (1989a) 8-electrode capacitance system for two-component flow identification. Part 1: Tomographic imaging. *IEE Proc. A*, **136**, 173–183

Xie, C. G., Plaskowski, A. and Beck, M. S. (1989b) 8-electrode capacitance system for two-component flow identification. Part 2: Flow regime identification. *IEE Proc. A*, **136**, 184–190

Xie, C. G., Huang, S. M., Hoyle, B. S., Thorn, R., Lenn, C., Snowden, D. and Beck, M. S. (1992a) Electrical capacitance tomography for flow imaging: system model for development of image reconstruction algorithms and design of primary sensors. *IEE Proc. G*, **139**, 89–98

Xie, C. G., Huang, S. M., Hoyle, B. S., Lenn, C. P. and Beck, M. S. (1992b) Transputer-based electrical capacitance tomography for real-time imaging of oilfield flow pipelines. In *Proceedings of the 1st Meeting on European Concerted Action on Process Tomography, 26–29 March, Manchester* (ed. M. S. Beck), 333–346

Yorkey, T. J., Webster, J. G. and Tompkins, W. J. (1986) An optimal impedance tomographic reconstruction algorithm. *Proc. Ann. Int. Conf. IEEE Eng. Med. Biol. Soc.*, **8**, 339–342

Yorkey, T. J., Webster, J. G. and Tompkins, W. J. (1987) An improved perturbation technique for electrical impedance imaging with some criticisms. *IEEE Trans. Biomed. Eng.*, **BME-34**, 898–901

Zakaib, G. D., Harms, A. A. and Vlachopoulos, J. (1978) Two-dimensional void reconstruction by neutron transmission. *Nucl. Sci. Eng.*, **53**, 145–154

Chapter 16

Computer modelling of process tomography sensors and systems

S. H. Khan, C. G. Xie and F. Abdullah

16.1 Introduction

During the last decade, with the continuously increasing power of modern computers, numerical techniques, such as the finite-element method, have been widely used in sensor modelling. Efficient numerical solutions are now available for a wide range of mathematical problems that are intractable when using analytical methods. It is now common practice for designers to solve many of the complex problems during the design phase of sophisticated modern electrical and electronic devices, for example electrical machines and nuclear magnetic resonance (NMR) magnets, by using largely automatic and general-purpose software packages. There is no exception for the design of sensor systems. Such design capabilities are due not only to the enormous advances in computer technology, but also to the new developments in numerical methods that enable increasingly difficult problems to be solved. With the present rate of development, genuine computer-aided design (CAD) procedures may soon be practical for three-dimensional systems, i.e. the integration of design layout software with core analysis programs (e.g. electromagnetic field analysis programs) is likely to become a reality.

There are three main types of numerical method: the finite-difference method, the finite-element method, and the integral method. The finite-difference method has been widely used in fluid dynamics and semi-conductor modelling; it has been replaced by the finite-element method (Silvester and Ferrari, 1990) in many other branches of engineering modelling. The main drawbacks of the finite-difference method are two fold: (1) there are considerable difficulties in modelling problems of complex boundaries since the discretization scheme has a fixed topology; and (2) considerable complications are involved when extending the method to higher order approximations. Both of these problems are readily overcome by the finite-element method. The finite-difference and finite-element methods are mainly used with the differential formulations of the problem (e.g. Poisson's equation), whereas the integral method is used with the corresponding integral formulations (e.g. equations based on Green's theorem). The moment method is an example of an integral formulation (Harrington, 1968). Another type of integral procedure is the boundary element method based on applications of Green's integral theorems (Brebbia, 1980). The integral method is a relatively new development in numerical methods and it has been used extensively in certain static and high-frequency problems. This method can produce accurate and economical solutions, although it is often difficult to apply.

In general, the following three essential stages are involved in sensor modelling:

(1) The mathematical model of the sensor must be identified, and the governing equations and related boundary conditions determined.
(2) The geometric model of the sensor must be established; attention should be paid to the significant aspects and the special features of the problem domain so that the amount of data can be minimized.
(3) An efficient numerical method (discretization scheme) must be chosen in order to realize a computer solution of the problem.

This chapter describes the design and modelling of sensors for process tomography applications using the finite-element method. The sensors discussed in detail include those based on an electromagnetic field (electrical capacitance sensors) and the piezoelectric phenomenon (ultrasonic sensors). The basic elements of a computer modelling environment based on the finite-element method will be discussed, followed by a discussion of the two design examples.

16.2 Software environment for sensor design and modelling

A heuristic sensor design procedure is represented in Figure 16.1. A designer repeats the following three conceptual processes until a satisfactory design is achieved:

- A process for defining geometric and material data of a sensor – the pre-processor.
- A process for solving the defining equation of the sensor numerically – the solution processor.
- A process for examining and extracting the results, e.g. contours, gradients or integrals – the post-processor.

The three processors are illustrated in more detail in Figure 16.2. All three processors should access a common file database. The designer often controls interactively the pre- and post-processing processes via a graphics terminal. To solve the problem numerically the sensor model has to be discretized by generating finite-element meshes that conform to the sensor model. The accuracy of the modelling result will depend on the level of discretization and this requires an algorithmic method for mesh generation – either semi-automatic or manual (Binns *et al.*, 1992).

The finite-element discretization scheme reduces the governing equations to the general form:

$$\mathbf{K}(u)u = Q \tag{16.1}$$

where \mathbf{K} is a matrix of coefficients depending on the governing equation of the sensor and discretization. \mathbf{K} is often symmetric and positive definite, sparse and banded. Q defines the sources (e.g. space charges) and is generally a

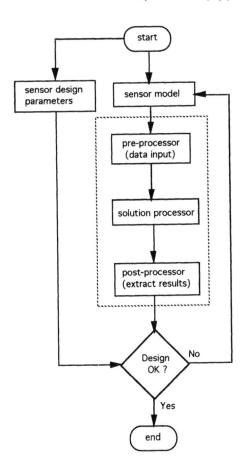

Figure 16.1 *Flow diagram of heuristic sensor design*

function of position, and u is the dependent solution variable. For non-linear problems the matrix \mathbf{K} is also a function of u.

The solution processor shown in Figure 16.2 should have all the necessary procedures to discretize the governing equations of the sensor model, to generate the matrix coefficients and to solve the linear or non-linear algebraic equations. Methods for solving eqn (16.1) can be classified into direct methods and iterative methods. Direct methods include Gauss elimination (GE) and iterative methods include Gauss–Seidel (GS), successive over-relaxation (SOR) and the conjugate gradient method preconditioned by the incomplete Cholesky factorization (ICCG). The relative merits of the direct and the iterative methods implemented on serial computers for a test problem are shown in Figure 16.3 (Binns *et al.*, 1992). The tests were performed on serial computers for solving the Poisson equation over a unit square discretized using a uniform mesh of first-order triangles. It is expected that for some

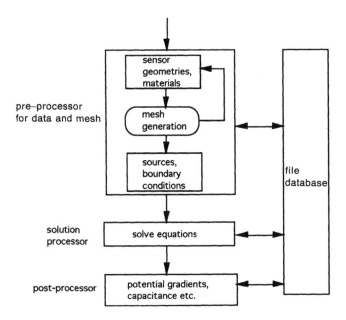

Figure 16.2 *The elements of a sensor design system based on the finite-element method*

algorithms having intrinsic parallelism, the use of concurrent computers will give rise to very different performance (Modi, 1988). The superiority of the ICCG method can be clearly seen from Figure 16.3; no special ordering of finite elements is required to minimize the bandwidth *m* of the system matrix **K**. Other methods can also be competitive if a node-ordering strategy is used. For solving fully populated systems encountered in, for example, integral-equation formulations, a direct Gauss elimination method has been found to be optimal. However, when the matrix is full and diagonally dominant, simple iterative methods can be very effective.

The post-processor shown in Figure 16.2 should facilitate the conversion of the problem solution (e.g. nodal potentials) to useful engineering quantities, e.g. the gradients at the lowest level and the capacitances up to the level of design parameters. The post-processor may involve smoothing techniques to improve the quality of the output data, e.g. the gradient values, so that the required capacitances can be calculated more accurately. The post-processor is, to a large extent, model dependent. This is different from the pre-processor and solution processor which are often common to different physical areas, e.g. electrostatic, thermal, fluid and stress analysis. In addition to the computational tasks of post-processing, the designer needs to view interactively the results on a graphics terminal for displaying curves and maps of the solution and derived quantities. The post-processors of virtually all commercial finite-element packages allow the display of, for example, contour plots, vector plots and the integration of variables along chosen line segments.

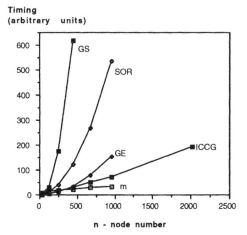

Figure 16.3 *Comparison of the methods used for sparse systems. The times on vertical axis are in arbitrary units, and the system matrix bandwidth* (m) *is in absolute units. A symmetric band solver was used for Gaussian elimination* (GE). *The operation count is proportional to* m^2n *and the results show a good fit to this dependence. The basic Gauss–Seidel* (GS) *method needs far too many iterations to be competitive. Successive over-relaxation* (SOR) *decreases the number of iterations, but finding an optimum value of the relaxation factor is difficult. This method is widely used for finite-difference discretizations with tri-diagonal systems, where the matrix coefficients are trivial and can be cheaply calculated in situ; this approach is also suited to non-linear problems since the latest solution vector can be used as a starting value for the next non-linear iteration. The operation count goes as* $m \times n \times l$, *where* l *is the number of iterations. The results in the figure were obtained after converging to* 1×10^{-5}. *The conjugate gradient method, preconditioned by the incomplete Cholesky factorization* (the ICCG method) *is very popular and the results here suggest why – the operation count goes approximately* $n\log n$ *and is largely independent of bandwidth* (m)

Another aspect of post-processing is the ability to compare, numerically and graphically, the solutions for a number of sensors, each having slightly different geometries and material properties. This goes back to the input pre-processor where design changes are made in the sensor model, and the heuristic procedure starts again (Figure 16.1). The question of optimization is therefore raised; an algorithm should be considered to provide a systematic approach of design rather than the time-consuming approach based on trial and error. As an example, consider the problem of determining the geometry of a two-electrode capacitance sensor for flow void fraction measurement. To minimize dependence of capacitance on the flow regime, it is desirable for the sensor to produce a uniform field in the flow region $r < R_1$ (see Figure 16.4). The electric field E will be primarily dependent on the sensor geometry $\delta_1 = (R_2 - R_1)/R_1, \delta_2 = (R_3 - R_2)/R_1$ and θ. The insulating materials of the sensor (with relative permittivities ε_1 and ε_2) are normally chosen with

Figure 16.4 *A two-electrode capacitance sensor*

required mechanical and electrical properties. Thus at a point P in the flow region $\mathbf{r} < R_1$:

$$E_p = E(\delta_1, \delta_2, \theta, \mathbf{r}) \tag{16.2}$$

where $\mathbf{r} = (x, y)$ are the co-ordinates of point P.

The optimization problem is to determine the values of δ_1, δ_2 and θ that produce a constant value of E_p inside the pipe. One way of achieving this is to solve the Poisson equation by using the finite-element method for a range of values of δ_1, δ_2 and θ. If only two values of each parameter are explored then there will be $2^6 = 64$ cases to run. Therefore, to achieve an optimum design, a lot of computation is required. In practice, many fewer trials are expected because trends will often be observed by designers during the computation (Xie *et al.*, 1990). Nevertheless, automatic optimization techniques (Papalambros and Wilde, 1988) should be considered in cases like this. To illustrate the ideas, the widely used least-squares method is described conceptually below.

Equation (16.2) can be rewritten as

$$E_p = E(\mathbf{g}, \mathbf{r}) \tag{16.3}$$

where \mathbf{g} is a vector:

$$\mathbf{g} = (\delta_1, \delta_2, \theta) \tag{16.4}$$

Suppose the flow region $\mathbf{r} < R_1$ in Figure 16.4 is represented by a finite-element mesh containing n nodes, then the following objective function $F(\mathbf{g})$

$$F(\mathbf{g}) = \sum_{i=1}^{n} |E(\mathbf{g}, \mathbf{r}_i) - E(\mathbf{g}, \mathbf{o}_i)|^2 \tag{16.5}$$

is a measure of the departure of the field E from its value at the origin \mathbf{o}_i. The objective function $F(\mathbf{g})$ will be identically zero if a perfectly uniform field is found. Therefore the optimization problem is to determine the vector \mathbf{g} (with

four degrees of freedom) that minimizes $F(\mathbf{g})$. Many standard procedures for minimizing functions of several variables are available (see Papalambros and Wilde (1988)).

It should be borne in mind that numerical methods are techniques for solving mathematical problems by numerical approximations. Its use will introduce 'modelling errors' called 'discretization' or 'truncation' errors which arise when the mathematical description of a sensor (a continuous partial differential equation) is replaced by an approximate numerical description by discrete points. The use of computers will invariably introduce errors due to the limited precision of the numbers stored. The capacity of the computer memory will often limit a perfect representation of a sensor of complex geometry; thus the actual physical sensor is usually replaced by a 'computer model' built to represent the critical features of the sensor. The traditional method of estimating error is to re-solve the problem with an increased level of discretization or, alternatively, by using higher order finite elements. Unfortunately, the computation costs of performing such error checking quickly become prohibitive, especially with three-dimensional sensor modelling. Local refinement of particular portions of the sensor model is usually carried out. Ideally, the most efficient procedure is to include the mesh-generation stage within the solution processor (Figure 16.2). This will depend on the development of an automatic and adaptive mesh generator; a reliable error estimator is needed which allows for where extra nodes should to added to the sensor model in order to improve the overall accuracy of the sensor modelling.

16.3 Basic procedures in finite-element analysis

In finite-element analysis the domain of the problem is discretized into elements; for example, triangular elements in two-dimension and tetrahedral elements in three-dimensions. Consider a single element and assume that the solution variable ϕ (e.g. potential) obeys the polynomial relationship:

$$\phi = a_1 + a_2 x + a_3 y + a_4 xy + a_5 x^2 + \cdots \tag{16.6}$$

where a_i are constants. Since the solution must be continuous across an element boundary, eqn (16.6) should be expressed in terms of the potential values at the element vertices or nodes. Thus for three-node triangular elements eqn (16.6) can be truncated to:

$$\phi = a_1 + a_2 x + a_3 y \tag{16.7}$$

and expressed, in terms of nodal potentials ϕ_i, as

$$\phi = N_1 \phi_1 + N_2 \phi_2 + N_3 \phi_3 \tag{16.8}$$

where N_i are called the 'shape functions'. The spatial co-ordinates of these functions can be easily evaluated, providing the number of nodes in eqn (16.8) is equal to the number of terms in eqn (16.7). Therefore a linear variation of the local solution can be represented by using a three-node triangle and a second-order variation by using a six-node one (three at the vertices and three

at the mid-sides). The attraction of the finite-element technique is the ability to extend the order of the local solution variable in a simple way.

The local element description, characterized by eqn (16.8), can be integrated over the entire problem domain in order to establish the global behaviour of the problem, taking account of the boundary and interface conditions. The general approach is to use the method of weighted residuals (Zienkiewicz and Morgan, 1983). The alternative is to apply the variational principle to a functional describing the system energy. For instance, for electrostatic fields, a necessary condition for the potential energy to be a minimum is that the electrostatic potential must satisfy the Laplace equation. For electrostatics this energy can be expressed as:

$$W = \int_{\Omega} \frac{1}{2} \mathbf{E} \cdot \mathbf{D} d\Omega = \frac{1}{2} \int_{\Omega} \varepsilon E^2 d\Omega = \frac{1}{2} \int_{\Omega} \varepsilon \left(\left[\frac{\partial \phi}{\partial x} \right]^2 + \left[\frac{\partial \phi}{\partial y} \right]^2 \right) d\Omega \qquad (16.9)$$

Substitution of eqn (16.8) into eqn (16.9) and summing over all M elements yields:

$$W = \sum^{M} W_{\text{elem}} = \sum^{M} \frac{1}{2} \varepsilon \int_{\text{elem}} \left[\left(\sum_{i}^{3} \frac{\partial N_i}{\partial x} \phi_i \right)^2 + \left(\sum_{i}^{3} \frac{\partial N_i}{\partial y} \phi_i \right)^2 \right] d\Omega \qquad (16.10)$$

To minimize the total energy W, eqn (16.10) must be differentiated with respect to a typical ϕ_j and be set to zero, thus

$$\frac{\partial W}{\partial \phi_j} = \sum^{M} \varepsilon \int_{\text{elem}} \left[\left(\sum_{i}^{3} \frac{\partial N_i}{\partial x} \phi_i \right) \frac{\partial N_j}{\partial x} + \left(\sum_{i}^{3} \frac{\partial N_i}{\partial y} \phi_i \right) \frac{\partial N_j}{\partial y} \right] d\Omega = 0 \qquad (16.11)$$

after assembling the element contributions into a system matrix \mathbf{K}, and taking account of merging contributions for elements with shared nodes, eqn (16.11) finally takes the form

$$\mathbf{K}\Phi = 0 \qquad (16.12)$$

with the entry for the system matrix \mathbf{K} as

$$K_{ij} = K_{ji} = \int_{\text{elem}} \varepsilon \left[\frac{\partial N_i}{\partial x} \frac{\partial N_j}{\partial x} + \frac{\partial N_i}{\partial y} \frac{\partial N_j}{\partial y} \right] d\Omega \qquad (16.13)$$

Note that Dirichlet and/or Neumann boundary conditions (see Section 16.4) are normally applied where potentials or their derivatives are specified at the boundaries. To obtain nodal potentials Φ the system equation (eqn (16.12)) can be solved by using direct or iterative methods (Section 16.2).

Note that the energy functional (eqn (16.9)) can be easily extended to include spatial sources in the case of the Poisson equation. The basic steps for computing numerical solutions for the Poisson equation using, for example, three-node triangle elements, are illustrated in Figure 16.5.

Level	Model	Illustration
1	**Physical** Dielectric materials enclosed by electrical capacitance electrodes applied with different voltages Assume that permittivity profile ε and charge-density profile ρ are all symmetrical about the vertical axis	
	Mathematical Poisson equation: $\nabla \cdot \varepsilon \nabla V = -\rho.$ Exploit properties of symmetry to save computational time and assign mixed boundary conditions	
	Finite-Element Discretise problem domain with e.g. linear triangle elements: $\phi = \sum_{i=1}^{3} N_i \phi_i$ Entries of element matrices: $K_{ij} = \int\limits_{\text{elem}} \varepsilon \left[\dfrac{\partial N_i}{\partial x} \dfrac{\partial N_j}{\partial x} + \dfrac{\partial N_i}{\partial y} \dfrac{\partial N_j}{\partial y} \right] d\Omega$ $f_i = \int\limits_{\text{elem}} \rho N_i \, d\Omega$	
	Algebraic Assemble & merge element matrices to obtain banded symmetric system **KΦ = F** with boundary conditions included. Store **K** in compact form $(b \times n)$ by utilising sparsity and banded nature.	
	Computation Nodal potentials Φ solved by using direct method (e.g. Gauss elimination) or iterative method (e.g. ICCG).	

Figure 16.5 *The basic modelling levels in the finite-element method*

16.4 Quasi-static electromagnetic field equations for electrical tomography

Tomography techniques based on the principles of electromagnetic field theory include: electrical impedance tomography (EIT) (see Chapter 5); electrical capacitance tomography (ECT) (see Chapter 4); and electromagnetic tomography (EMT) (see Chapter 6). If the wavelengths of the time-varying fields are large compared with the physical dimensions of the problem, which is often the case, the displacement current term in Maxwell's equations is negligible compared with the free current density \mathbf{J}, and there is no radiation. In this situation the field equations can be approximated by:

$$\nabla \cdot \mathbf{D} = \rho \text{ (Gauss' law)} \tag{16.14}$$

$$\nabla \cdot \mathbf{B} = 0 \tag{16.15}$$

$$\nabla \times \mathbf{E} = \frac{\partial \mathbf{B}}{\partial t} \text{ (Faraday's law)} \tag{16.16}$$

$$\nabla \times \mathbf{H} = \mathbf{J} \quad \text{(Ampère's law)} \tag{16.17}$$

\mathbf{D} is the electric flux density and \mathbf{E} is the electric field strength. \mathbf{B} is the magnetic flux density and \mathbf{H} is the magnetic field strength. ρ is the free charge density, and \mathbf{J} the free current density in the problem domain. The field vectors \mathbf{D} and \mathbf{E} and also \mathbf{B} and \mathbf{H} are related by the constitutive properties of the material:

$$\mathbf{D} = \varepsilon_r \varepsilon_0 \mathbf{E} = \varepsilon \mathbf{E} \tag{16.18}$$

$$\mathbf{B} = \mu_r \mu_o \mathbf{H} = \mu \mathbf{H} \tag{16.19}$$

where ε and μ are the permittivity and permeability, respectively. In practice, μ may be field dependent as some materials will exhibit both anisotropy and hysteresis effects. The current density is given by:

$$\mathbf{J} = \sigma \mathbf{E} \text{ (Ohm's law)} \tag{16.20}$$

where σ is the material conductivity. The current continuity condition follows from eqn (16.17),

$$\nabla \cdot \mathbf{J} = 0 \tag{16.21}$$

The basic field vectors (\mathbf{B}, \mathbf{D}, \mathbf{H} and \mathbf{E}) must satisfy the following interface conditions (materials of two different properties are identified by subscripts 1 and 2):

$$(\mathbf{B}_2 - \mathbf{B}_1) \cdot \mathbf{n} = 0 \tag{16.22}$$

$$(\mathbf{D}_2 - \mathbf{D}_1) \cdot \mathbf{n} = \rho_s \tag{16.23}$$

$$(\mathbf{H}_2 - \mathbf{H}_1) \times \mathbf{n} = \mathbf{j}_s \tag{16.24}$$

$$(\mathbf{E}_2 - \mathbf{E}_1) \times \mathbf{n} = 0 \tag{16.25}$$

where \mathbf{j}_s and ρ_s are the surface current and charge density, respectively. Equation (16.22) indicates the continuity of magnetic flux across a boundary and eqn (16.23) is the equivalent form in terms of electric flux. Equation (16.24) results from Ampère's law and eqn (16.25) expresses the continuity of the tangential component of electric field strength.

From the above basic field equations, the differential equations for the ECT (electrostatic problem), EIT (electric-current flow problem) and EMT (the magnetostatic problem) can be readily derived (see Table 16.1). Table 16.1 shows that all three imaging modalities (in two dimensions) can be similarly formulated by a Poisson-type differential equation:

Table 16.1 *Mathematical equations for electrostatic, electric current flow and the magnetostatic problems, and the related imaging modalities*

Problem type	Potential	Defining equation	Imaging modality
Electrostatics	Scalar	$\nabla \cdot \varepsilon \nabla V = -\rho$	ECT
Current flow	Scalar	$\nabla \cdot \sigma \nabla V = 0$	EIT
Low-frequency	Vector*		EMT
magnetostatics	(1) For exciting current-carrying regions	$\nabla \times \left(\dfrac{1}{\mu} \nabla \times \mathbf{A} \right) = \mathbf{J}$	
	(2) For eddy-current regions (with high σ and low μ)	$\nabla \times \left(\dfrac{1}{\mu} \nabla \times \mathbf{A} \right) = -\sigma \dfrac{\partial \mathbf{A}}{\partial t}$	
	(3) For air (low σ and μ) and magnetic regions (low σ and high μ)	$\nabla \times \left(\dfrac{1}{\mu} \nabla \times \mathbf{A} \right) = 0$	
	(4) For regions with both high σ and μ	$\nabla \times \left(\dfrac{1}{\mu} \nabla \times \mathbf{A} \right) = \mathbf{J} - \sigma \dfrac{\partial \mathbf{A}}{\partial t}$	
	Two-dimensional case: $\mathbf{J} = (0, 0, J_z)$	$\nabla \cdot \left(\dfrac{1}{\mu} \nabla A \right) = J_z$	

*$\mathbf{B} = \nabla \times \mathbf{A}$.

$$\nabla \cdot \kappa \nabla \phi + Q = 0 \qquad (16.26)$$

where the constitutive parameter κ, defined in the interior of a domain Ω enclosed by a surface Γ, is generally a function of position and/or field. ϕ is the potential; over the surface Γ it is either:

$$\phi = \phi_0 \ \text{(Dirichlet boundary condition)} \qquad (16.27)$$

or,

$$\frac{\partial \phi}{\partial n} = q \ \text{(Neumann boundary condition)} \qquad (16.28)$$

Sometimes a mixed boundary condition over Γ is used:

$$a_0 \phi + b_0 \frac{\partial \phi}{\partial n} = c_0 \qquad (16.29)$$

The numerical solution of the Poisson equation using the finite-element method has been illustrated in Section 16.3 (see also Figure 16.5). Commercial finite-element packages are available for solving the electromagnetic field equations described above, e.g. the package PE2D for two-dimensional electromagnetic field problems and the TOSCA for three-dimensional problems (Vector Fields Ltd, 1990).

Since ECT, EIT and EMT systems are basically represented by the same mathematical model, the fundamental approach towards the solution of any one of these systems is directly applicable to the other two. Of course one has to take into consideration certain factors which are specific to a given tomography system. These could be the various modes of excitation of the field, material properties of the media, their dependence on the field, or boundary conditions. For example, in the ECT system the permittivities of dielectric media usually do not depend on the electric field, whereas in the EMT system the permeabilities of the ferromagnetic media can have a strong dependence on the magnetic field in case of saturation. The modelling of fields of electrical tomography systems is necessary not only to generate data for the image-reconstruction algorithm but also for a basic understanding of the physical processes of the primary sensors, their performance prediction and evaluation, and design optimization. There are still many challenges to be met in the design of primary sensors for electrical tomography systems. For example, in the EIT system, three-dimensional finite-element modelling is basically required to model the three-dimensional behaviour of small electrodes, which are often used. The EMT technique is still in its infancy and extensive field modelling is needed in order to quantify the effects of basic sensor parameters such as the field excitation frequency, and the physical and geometric parameters of the magnetic coils. In the ECT system at least six geometric parameters need to be considered for design optimization and performance evaluation of the primary sensor system (see Section 16.5).

The inverse problems of electrical tomography systems are inherently non-linear; to overcome these iterative reconstruction algorithms are often used in which the Poisson equation (the forward problem) is solved

repeatedly, using the finite-element method, in order to achieve a correct solution (Chapter 15). This once again shows the vital importance of sensor field modelling in tomography systems. In the next section this is demonstrated with respect to the modelling and design of the ECT primary sensors. The various aspects of the design philosophy are readily applicable to other electrical tomography systems.

16.5 Modelling of ECT sensors for flow imaging

The modelling of the ECT systems for flow imaging was carried out in two dimensions using the PE2D package. The following assumptions were made:

- Fringing field effects due to finite lengths of electrodes are negligible. This assumes that for a flow pipe, the electric field distribution along its axial direction remains the same for any plane perpendicular to that direction. It allows one to use two-dimensional models of the electrode system instead of three-dimensional ones, which would be far more complicated and computationally intensive. For low pipe-diameter/electrode-length ratios this is well justified, especially when screens along the pipe axial direction are used to reduce the fringing fields. However, for large pipe-diameter/electrode-length ratios fringing field effects should be expected to become more evident and a suitable three-dimensional model has to be used to take them into account.
- Within the electrode length the flow component distributions do not change spatially along the axial direction of the pipe.
- Permittivities of flow components remain constant and do not depend on the field. This assumes linearity of permittivities for any given field.
- The dielectric medium in the two-dimensional region of the ECT primary sensor system is piecewise homogeneous and isotropic.

16.5.1 Design and performance parameters of a multi-electrode ECT system

The cross-section of a 12-electrode ECT system is shown in Figure 16.6. It consists of 12 capacitive electrodes, mounted symmetrically on the outer surface of an insulating section of the pipe. There are 12 earthed radial screens situated between the electrodes which reduce large capacitances between adjacent electrodes and force electric fields more towards the central region of the flow pipe (see Section 16.5.4). The earthed outer screen with radius R_3 is used to make the whole electrode system stray-capacitance immune (Chapter 4). The insulating material (with relative permittivity ε_2) between the outer screen and the outer surface of the pipe wall (width $\delta_2 = R_3 - R_2$) provides the electrode system with rigidity. The insulating pipe wall (with relative permittivity ε_1) has a fixed inner radius R_1 for a particular pipeline (3 in. or 76.2 mm in this case); its outer radius R_2 and hence the thickness $\delta_1 = R_2 - R_1$ can be varied. The radial

Figure 16.6 *Cross-section of a 12-electrode capacitance system for flow imaging (not drawn to scale)*

screen thickness δ_4 and its penetration depth δ_3 inside the pipe wall can also be varied. The insulating materials for the sensor are normally chosen according to the required mechanical and electrical properties. In this case study, $\varepsilon_1 = 5.8$ (ceramics) and $\varepsilon_2 = 4.0$ (potting resin).

The electric field distribution inside the flow pipe is therefore dependent on the following sensor design parameters: $\delta_1, \delta_2, \delta_3, \delta_4, N$ and θ, where N and θ are the number and the angular size of the electrodes, respectively. The main task in the modelling and design of ECT primary sensor systems is the evaluation of the effects on the system performance parameters by the variation of these design parameters, thus leading to the optimization of the sensor system. The following performance parameters of the sensor system can be identified:

- Standing capacitance, C_{oij}: the capacitance between electrode pair i–j when the flow pipe is empty (relative permittivity inside the pipe $\varepsilon = \varepsilon_0$). The standing capacitance between diametrically opposed electrode pairs (e.g. pair 1–7) is the smallest. Standing capacitances C_{oij} are closely related to the sensitivity of the data-acquisition electronics. It is therefore important to be able to predict these values by means of simulation.
- Relative sensitivity of the system, S_{ij}:

$$S_{ij} = \Delta C_{ij}/C_{oij} = (C_{ij} - C_{oij})/C_{oij} \qquad (16.30)$$

where C_{ij} is the capacitance between the electrode pair i–j when the pipe is not empty. The relative sensitivity S_{ij} is the measure of the capacitance

changes between various electrode pairs due to the presence of permittivity materials (with relative permittivity ε) inside the pipe. This presence cannot be detected if the corresponding change ΔC_{ij} is smaller than the noise level of the capacitance measuring electronics. For an object with fixed ε, the smallest cross-sectional area that can be detected by the measuring circuit is related to the input signal resolution of the imaging system (Chapter 17). Note that the input signal resolution is position dependent over the pipe cross-section.

- Normalized capacitance, C^n_{ij}:

$$C^n_{ij} = (C^\beta_{ij} - C_{oij})/(C^f_{ij} - C_{oij}) \tag{16.31}$$

where C^β_{ij} is the capacitance between electrodes i and j for a given flow concentration β (with respect to the pipe cross-sectional area), and C^f_{ij} is the capacitance when the pipe is full ($\beta = 1.0$). In ECT systems, the data-acquisition electronics are calibrated for empty and full pipes. The normalized capacitance C^n_{ij} indicates the change in capacitance for a given flow distribution by comparing it with the capacitances for empty and full pipes. Normalized capacitances are used for qualitative image reconstruction (Chapter 15). To avoid saturation of sensor electronics due to excessively high and/or low capacitance changes and to ensure good quality image reconstruction, it is desirable to limit the normalized capacitances so that $0 \le C^n_{ij} \le 1$. It can be demonstrated that the sensor design parameters, in particular δ_1, have a profound effect on the range of normalized capacitances.

- Maximum-to-minimum standing capacitance ratio, K_c:

$$K_c = C_{max}/C_{min} \tag{16.32}$$

As is obvious from the geometry of the electrode system, the capacitances between adjacent electrodes (e.g. C_{012} between electrodes 1 and 2 in Figure 16.6) are usually much larger than those between diametrically opposite ones (e.g. C_{017}). These are referred to as C_{max} and C_{min}. Increased measurement accuracy can be obtained by minimizing the ratio K_c, as a lower dynamic range is then demanded of the capacitance sensor electronics.

16.5.2 Finite-element realization of 12-electrode ECT sensor models

Under the assumptions discussed above, the finite-element modelling of a capacitive electrode system involves the solution of the corresponding Poisson equation in terms of the electrostatic potential $V(x,y)$ for a given permittivity distribution of the flow components $\varepsilon(x,y)$. A typical finite-element model of the electrode system with boundary conditions is shown in Figure 16.7. The mesh was generated by the PE2D's pre-processor, where linear triangular elements were used. Using PE2D's post-processor, the field vectors (e.g. the electric flux \mathbf{D}) and capacitances between various pairs of electrodes can be calculated from nodal potential values. The capacitance is found from the total charge Q distributed over the detecting electrode: $C = Q/V$. This total charge Q can be obtained from Gauss' law (eqn (16.14)). The capacitance is then calculated by performing the integration:

Figure 16.7 *The full finite-element model of the 12-electrode capacitance system*

$$C = \frac{Q}{V} = \frac{\displaystyle\oint_s \rho_s \mathrm{d}s}{V} = \frac{\displaystyle\oint_s D_n \mathrm{d}s}{V} = \frac{\displaystyle\oint_s \mathbf{D}\cdot\mathrm{d}s}{V} \qquad (16.33)$$

where s is the surface enclosing the detecting electrode, and ρ_s is the surface charge density.

For effective and consistent model definition, the complicated geometric features of the 12-electrode ECT shown in Figure 16.6 constitute a major challenge at the preprocessing stage. Because it is necessary to realize finite-element models for various flow regimes (see below), the task of setting up these models could become unacceptably complex and time consuming. To avoid this a systematic approach is adopted for model definition at the preprocessing stage which exploits the symmetrical geometry of the electrode system (Khan and Abdullah, 1993a). In this method all the finite-element models of the electrode system (like the full model shown in Figure 16.7) are built from the basic 'building block' shown in Figure 16.8(a). This building block constitutes only 1/24 of the full model and consists mainly of curvilinear

finite-element regions defined by the PE2D's model definition commands (Vector Fields Ltd, 1990). Figure 16.8(b–d) show the results of successive rotations and mirror reflections of this elementary block by which a half or a full model can be created using PE2D's *copy* command. All these model-definition commands need to be typed in once and stored in a *command input file*. This file can be easily updated, modified and executed to set up models with various geometric parameters.

Finite-element models of the electrode system could be used to evaluate the system response to typical two-phase flow regimes, e.g. core, annular and stratified flows (Figure 16.9). The flow concentration β is given by the ratio of the cross-sectional area of the higher permittivity component to that of the flow pipe. By adding appropriate finite-element regions in the basic model defined above, models for the simulation of these flow regimes are created. Figure 16.10(a) shows the model for core flow of any given flow concentration. This model could also be used for annular flow regimes, simply by interchanging the permittivity values of the appropriate finite-element regions (Figure 16.10(b)). As core and annular flows are radially symmetrical, only half of the electrode system needs to be considered. Finite-element models for stratified flows could also be obtained by adding finite-element regions inside the pipe in the basic model; a full model has to be used (Khan and Abdullah, 1993b). It should be noted that for all these models appropriate readjustments of parameters, such as the number of subdivisions of the finite-element region, have to be made for different flow concentrations β to ensure a consistent discretization pattern for various models.

In order to validate the finite-element model of capacitive electrode systems, simulations have been carried out for two different electrode systems and the results compared with experimental data obtained from the corresponding physical systems (Khan and Abdullah, 1993c). During the experiment capacitances were measured between various electrode pairs and the sensitivities of electrode systems were explored by inserting axially a Perspex rod of circular cross-section at various positions inside the pipe. Figure 16.11 shows the finite-element model of one of the experimental electrode systems (with radial screens) which is built from the basic 'building block' shown in Figure 16.12 (note the differences in this building block from the one discussed earlier due to the presence of circular regions for rod positions marked by encircled numbers). Permittivities of these circular regions could be easily changed which allows modelling of the electrode system with empty pipe as well as with the simulated test rod inserted at one of the positions.

16.5.3 Error estimation in finite-element modelling of ECT sensors

Errors in the finite-element modelling of ECT systems are directly related to the accuracy of the solution of the Poisson equation. As a result, the accuracy of the capacitances calculated from field vectors is affected. After model discretization, the Poisson equation is solved for an unknown potential distribution which constitutes the basis for error estimation for a given sensor model. Although comparison of modelling results with experimental data is

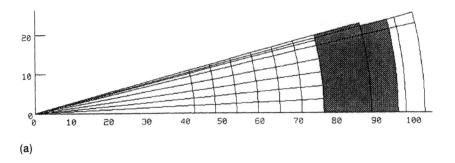

(a)

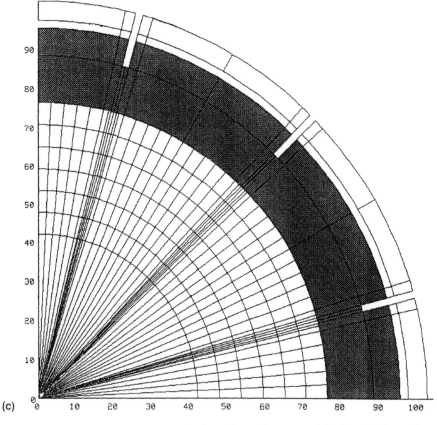

Figure 16.8 *The stages in creating the basic finite-element model of the 12-electrode capacitance system. (a) The basic 'building block'. (b) Copying of the basic block. (c) Quarter-model obtained by successive copying of the basic block. (d) Half-model obtained by mirror reflection of the quarter-model*

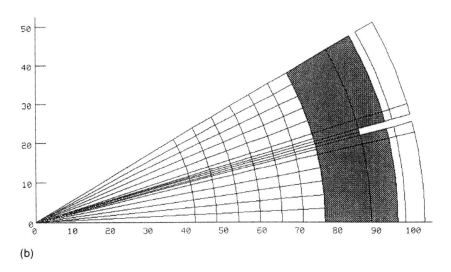

(b)

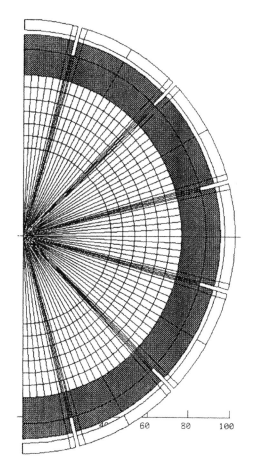

(d)

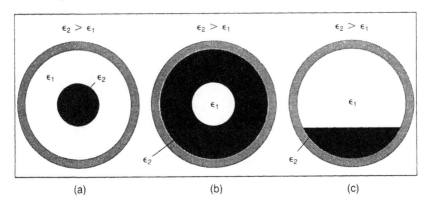

Figure 16.9 *Typical two-phase flow patterns: (a) core flow; (b) annular flow; (c) stratified flow*

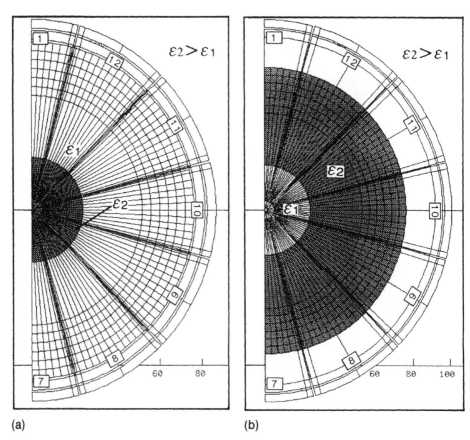

(a) (b)

Figure 16.10 *Finite-element models for the simulation of typical flow patterns: (a) core flow ($\beta = 0.1$); (b) annular flow ($\beta = 0.9$)*

Figure 16.11 *Finite-element model of the thick pipe wall experimental sensor with radial screens*

the ultimate way of evaluating modelling accuracy, there are several alternative ways, both qualitative and quantitative. Qualitatively, one can identify the need for further mesh refinement by visually checking the smoothness of the equipotential lines. In homogeneous finite-element regions, with adequately refined the mesh equipotential contours should be smooth. Apart from this, comparison of field computation results for different mesh configurations of the same sensor model would normally give an indication of the need for further mesh refinement, globally over the whole problem area. In the case of ECT systems, the most efficient way of assessing the modelling accuracy is to calculate the known potential difference (given in the form of boundary conditions) between the active and the detecting electrodes from field computation results.

Figure 16.12 *The basic building block for the finite-element-model definition of the experimental sensor system*

The potential difference, $\phi_i - \phi_j$, at two points i and j in the field can be written as:

$$\phi - \phi_j = -\int_l \mathbf{E} \cdot d\mathbf{l} = -\int_l E \cos\alpha \, dl \qquad (16.34)$$

where l is the integration path. In the case of ECT systems it is convenient to choose the line connecting the central points of diametrically opposite electrodes (active and detecting) as the integration path ($l = 2R_2$, $\cos\alpha = 1$, where α is the angle between \mathbf{E} and path l). Using PE2D's line-integration facilities the above integration could be carried out automatically after every field solution.

However, the above two methods do not give much information about the local errors which arise from finite-element discretization. This can be readily obtained from the package PE2D which displays local and global errors in the

field derived from potential solutions (Vector Fields Ltd, 1990). The global error gives an indication of the quality of overall discretization, whereas the local errors show where the finite-element mesh needs local refinement. Using these two error-estimation facilities it is possible to minimize discretization errors with relative ease.

16.5.4 Typical modelling results

As discussed earlier, the performance parameters of the ECT sensor system depend on the system design parameters δ_1, δ_2, δ_3, δ_4, N and θ. This is illustrated below by typical modelling results.

The number of independent capacitance measurements M in the ECT system increases as the number of electrodes N increases: $M = N(N-1)/2$. To a large extent, the image resolution increases with increasing number of independent capacitance measurements; therefore, the larger is N the better is the image resolution. However, for ECT systems, θ generally decreases with increasing N. This reduces the standing capacitances C_{oij} and demands more sensitive capacitance-measuring electronics. The minimum detectable void fraction β (fractional area of an elongated bubble at the centre of the pipe) is also increased as shown in Figure 16.13.

The ratio $K_c = C_{\max}/C_{\min}$ also depends on θ (Figure 16.13(b)) and the outer screen distance from the pipe wall δ_2 (Figure 16.14). These figures also show

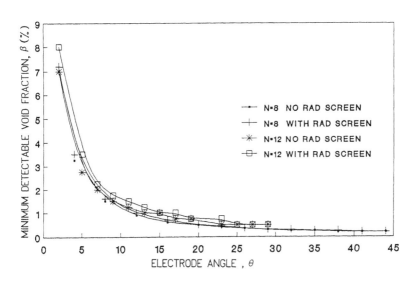

Figure 16.13 *The effect of the electrode angle (θ) on K_c and the minimum detectable void fraction (β). (a) Variation in β with θ for 8- and 12-electrode sensors with and without radial screens. (b) Variation in K_c with θ for 12-electrode sensors with and without radial screens*

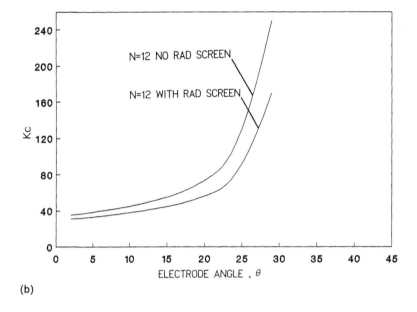

(b)

Figure 16.13 (*continued*)

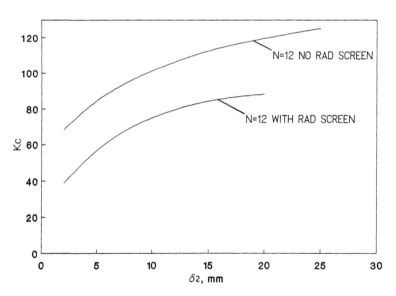

Figure 16.14 *Variation in* K_c *with the distance of the outer screen from the pipe wall* (δ_2)

the positive effects of interelectrode radial screens in reducing capacitances between adjacent electrodes by shielding electric fields from the active electrode and guiding them in towards the central regions of the pipe. Qualitatively, this is evident from the equipotential plots in the vicinity of the active (electrode 1) and the adjacent (electrode 12) electrodes for three different electrode designs, without (Figure 16.15(a)) and with (Figure 16.15(b, c)) radial screens. Although an appropriate combination of radial screen depth δ_3, thickness δ_4 and pipe wall thickness δ_1 effectively reduces the standing capacitances (and hence K_c) between adjacent electrodes (Figure 16.16). Unfortunately, however, these parameters also reduce the capacitances

(a)

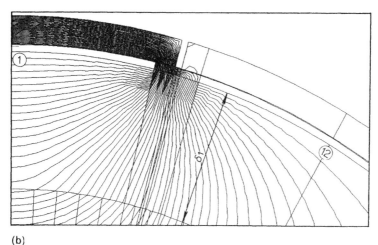

(b)

Figure 16.15 *Equipotential contours for 12-electrode capacitance sensors showing the effects of interelectrode radial screens. (a) Sensor without radial screens. (b) Sensor with radial screens, $\delta_3 = 0$ mm. (c) Sensor with radial screens, $\delta_3 = 5$ mm*

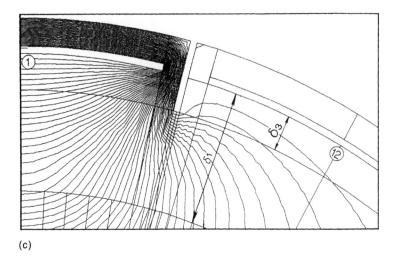

(c)

Figure 16.15 (*continued*)

between diametrically opposite electrodes (Figure 16.17). This suggests that these parameters have to be optimized in terms of capacitances between both adjacent and diametrically opposite electrodes. Moreover, as discussed later, the radial screen penetration depth δ_3 and pipe wall thickness δ_1 play a key role in determining the range of normalized capacitances C^n_{ij} and the uniformity of sensitivity distribution inside the pipe. This, to a great extent, also determines the quality of the reconstructed images.

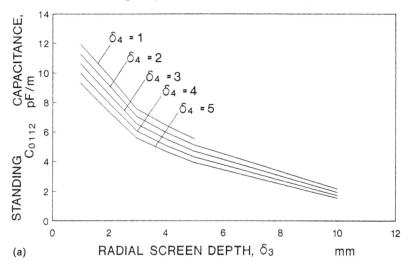

(a)

Figure 16.16 *Variation in the standing capacitance* C_{0112} *with: (a) radial screen depth,* δ_3 (δ_1 = constant); (b) pipe wall thickness, δ_1 (δ_4 = constant)

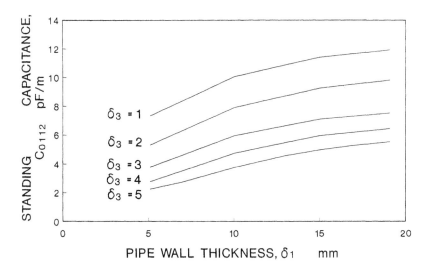

Figure 16.16 (*continued*)

Simulation of typical flow regimes is essential to the evaluation of system responses in terms of normalized capacitances C^n_{ij}. Finite-element modelling allows one to visualize the effects of sensor design parameters such as δ_1 and δ_3 on normalized capacitances for various flow regimes. In this way it is possible to determine a set of design parameters, mainly δ_1 and δ_3, for which these

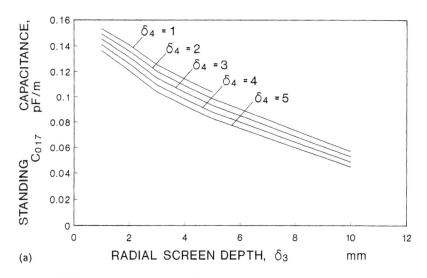

(a)

Figure 16.17 *Variation in the standing capacitance C_{017} with: (a) radial screen depth, δ_3 ($\delta_1 = constant$); (b) pipe wall thickness, δ_1 ($\delta_4 = constant$)*

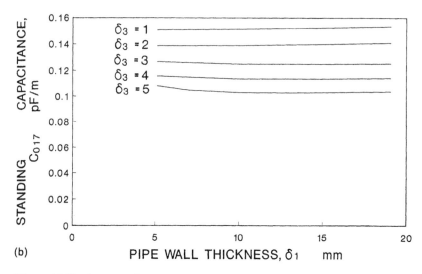

Figure 16.17 (*continued*)

capacitances would mostly remain within the range 0–1. Figures 16.18–16.21 show some of the modelling results for core and annular flow regimes of various concentrations β. Two extreme cases of pipe wall thickness δ_1 have been considered: $\delta_1 = 5$ mm (Figures 16.18 and 16.19) and $\delta_1 = 20$ mm (Figures 16.20 and 16.21). As can be seen from Figures 16.18 and 16.19, for thin pipe wall electrode systems the normalized capacitances C^n_{ij} mostly

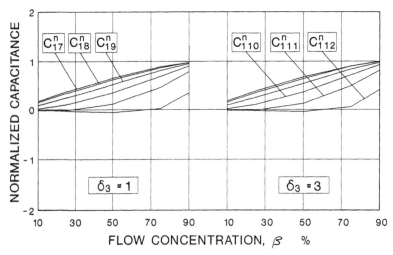

Figure 16.18 *The effects of flow concentration (β) and the radial screen depth (δ_3) on normalized capacitances (core flow $\delta_1 = 5$ mm)*

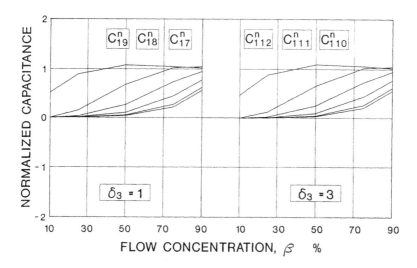

Figure 16.19 *The effects of flow concentration (β) and the radial screen depth (δ₃) on normalized capacitances (annular flow δ₁ = 5 mm)*

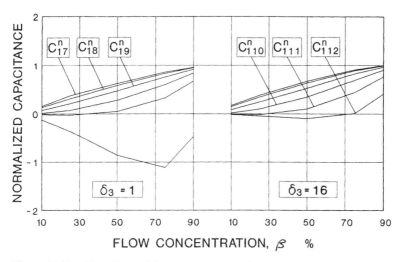

Figure 16.20 *The effects of flow concentration (β) and the radial screen depth (δ₃) on normalized capacitances (core flow δ₁ = 20 mm)*

remain within the range 0–1, and this is virtually independent of the radial screen penetration depth δ_3. In the case of a thick pipe wall, sharp changes in normalized capacitances between adjacent electrodes C^n_{112} (electrode 1 is the active electrode) are observed for smaller δ_3 (Figures 16.20 and 16.21). This undesirable effect is especially evident for annular flow regimes for which

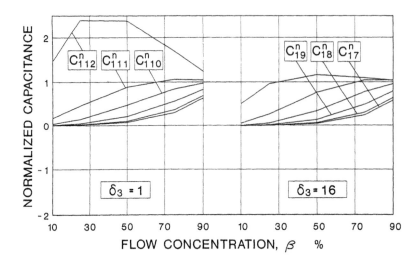

Figure 16.21 *The effects of flow concentration (β) and the radial screen depth (δ_3) on normalized capacitances (annular flow $\delta_1 = 20$ mm)*

C^n_{112} goes well beyond 1. However, these high and low (Figure 16.20) normalized capacitances can be corrected by increasing the radial screen penetration depth δ_3. In short, all these modelling results suggest that almost identical responses to both core and annular flow regimes could be obtained from thin and thick pipe wall electrode systems, provided that the radial screen depth is correctly chosen.

The effects of the pipe wall thickness δ_1 on the quality of the reconstructed image are illustrated in Figure 16.22 ($\delta_1 = 15$ mm) and Figure 16.23 ($\delta_1 = 20$ mm). Figures 16.22(a) and 16.23(a) show the true stratified flow model. Figures 16.22(b) and 16.23(b) depict the modelling results based on the finite-element method, and the corresponding 66 normalized capacitances C^n_{ij} of the two sensors. Figures 16.22(c) and 16.23(c) give the corresponding reconstructed images from the two sensors using the simulated data; the back-projection image reconstruction algorithm was used (Chapter 15). Note that the sensor with the thick pipe wall ($\delta_1 = 20$ mm) exhibits a very large normalized capacitance (Figure 16.23(b)); as a result, the image quality is poorer than that produced by the sensor with a thin pipe wall ($\delta_1 = 15$ mm) (compare Figures 16.22(c) and 16.23(c)).

Typical modelling results of the two experimental electrode systems mentioned above are shown in Figures 16.24 and 16.25, illustrating the variations in sensitivity for sensor models with and without radial screens for test rods at various positions (see Figure 16.11). Both the modelled and the experimental results presented in these figures clearly reflect the effects of pipe wall thickness (Figure 16.25) and radial screen penetration depth (Figure 16.24) on the sensitivity distribution inside the pipe. A comparison of the experimental and modelled sensitivity curves shows that the deviations of the

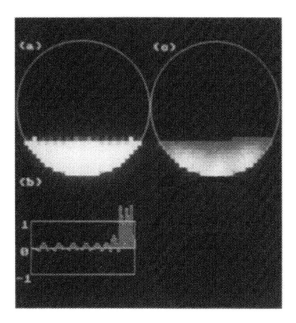

Figure 16.22 *The effect of pipe wall thickness on the quality of the reconstructed image: (a) stratified flow model; (b) 66 normalized capacitances of the flow model shown in (a) calculated using the finite-element method; (c) reconstructed image obtained using the simulation data shown in (b)*

modelling results from the experimental ones are different for different sensitivities and electrode designs. Although the modelled results for the sensitivities S_{17} show reasonable agreement with experiment, a fairly large discrepancy is observed for negative sensitivities S_{112} (Figure 16.25). This is particularly true for test rod at positions 9, 10 and 'C', for which very small values of capacitance change ΔC_{112} were obtained. All these differences between modelling and experimental results are due to various experimental and modelling errors which could be minimized or, in some cases, totally eliminated (Khan and Abdullah, 1993c).

16.5.5 Discussion

The modelling and design of ECT primary sensor electrodes discussed in this section have demonstrated the effectiveness of the finite-element technique. The general approach of field analysis is directly applicable to the modelling of other electrical tomography systems (EIT and EMT). The finite-element field analysis could form part of the iterative image-reconstruction process to overcome the non-linearity of electromagnetic sensing fields. An integrated, knowledge-based, computer-aided design (CAD) software environment will

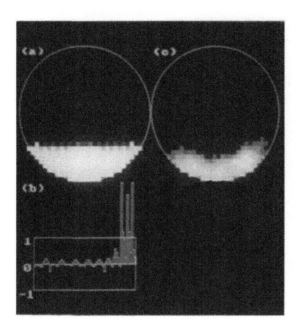

Figure 16.23 *The effect of pipe wall thickness on the quality of the reconstructed image*
($\delta_1 = 20$ mm): (a) stratified flow model; (b) 66 normalized capacitances for the flow
model shown in (a), calculated using the finite-element method; (c) reconstructed image
obtained using the simulation data shown in (b)

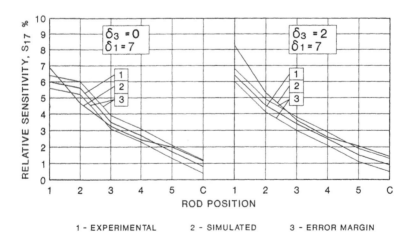

Figure 16.24 *Variation in the relative sensitivity (S_{17}) with rod position, showing the*
effects of radial screen depth (δ_3) ($\delta_1 = $ constant). (1) Experimental; (2) simulated; (3)
experimental error margin

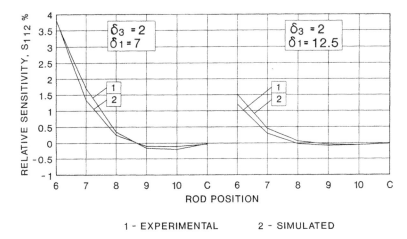

Figure 16.25 *Variation in the relative sensitivity (S$_{112}$) with rod position, showing the effects of pipe wall thickness (δ_1) (δ_3 = constant). (1) Experimental; (2) simulated*

be the future development which will have the capability of handling all aspects of design and performance evaluation of electrical tomography sensor and image reconstruction systems.

16.6 Modelling of ultrasonic imaging sensors

16.6.1 Introduction

The performance of an ultrasonic transducer is often characterized by the following parameters: centre frequency, bandwidth, and insertion loss (Kino, 1987). These performance parameters are influenced by the variation in transducer design parameters, including the acoustic impedance, the resonance frequency, the electrical input impedance, the electromechanical coupling coefficient of the piezo-electric element, the acoustic impedance of the backing, the thickness and acoustic impedance of the matching layer, and the thickness of the bonding layer. In the past, the development of ultrasonic transducers was primarily based on empirical trial and error, which is time consuming and expensive. Computer simulations have been used to optimize the performance of ultrasonic transducers with regard to transducer materials, geometry, etc. Most of the models used are one-dimensional, such as Masons model or the KLM model (Kwun *et al.*, 1988). However, the actual transducer design and optimization often demand a model that takes into account the two- or three-dimensional nature of the transducer. For this purpose, the finite-element method has been implemented in two dimensions (Lord *et al.*, 1990; Kunkel *et al.*, 1990; Lanceleur *et al.*, 1992) and three dimensions (Lerch, 1988, 1990; Challande, 1990). The main advantages of the finite-element method are the

ability to compute transient responses and to handle structure with non-uniform damping. Simulations can be obtained of piezoelectric media with anisotropy and virtually any geometry. When ultrasonic transducers are used for e.g. flow-imaging purposes, the interaction between transducers and fluids (gas or liquid) has to be considered, since in this case the transducers transmit and/or receive acoustic fields in the external media. The influence of the surrounding media on the vibrational behaviour of the ultrasonic transducer can also be determined by using the finite-element method (You *et al.*, 1991).

16.6.2 Finite-element formulation of ultrasonic transducers

The theory and implementation of piezoelectric finite elements have been reported recently (Lerch, 1990; Lord *et al.*, 1990). It allows the static and dynamic analysis of linear piezoelectric media with anisotropy and arbitrary geometries. A finite-element mesh discretizing a piezoelectric domain is mathematically described by the following set of linear equations (Lerch, 1988):

$$\begin{pmatrix} \mathbf{M_s} & \mathbf{0} \\ \mathbf{0} & \mathbf{0} \end{pmatrix} \begin{pmatrix} \ddot{\mathbf{u}} \\ \ddot{\mathbf{V}} \end{pmatrix} + \begin{pmatrix} \mathbf{D_s} & \mathbf{0} \\ \mathbf{0} & \mathbf{0} \end{pmatrix} \begin{pmatrix} \dot{\mathbf{u}} \\ \dot{\mathbf{V}} \end{pmatrix} + \begin{pmatrix} \mathbf{K_s} & \mathbf{K_{uV}} \\ \mathbf{K_{uV}^T} & \mathbf{K_V} \end{pmatrix} \begin{pmatrix} \mathbf{u} \\ \mathbf{V} \end{pmatrix} = \begin{pmatrix} \mathbf{F_s} \\ \mathbf{Q} \end{pmatrix} \tag{16.35}$$

where \mathbf{u} is the vector of nodal displacements in the piezoelectric solid; $\mathbf{F_s}$ is the vector of nodal forces in the piezoelectric solid; $\mathbf{M_s}$, $\mathbf{D_s}$ and $\mathbf{K_s}$ are the mechanical mass, damping and stiffness matrices, respectively, of the piezoelectric solid; \mathbf{V} is the vector of the nodal electrical potentials in the piezoelectric solid; \mathbf{Q} is the vector of the nodal electrical charges; $\mathbf{K_V}$ is the dielectric stiffness matrix; and $\mathbf{K_{uV}}$ is the piezoelectric coupling matrix.

This model describes the mechanical and electrical behaviour of piezoelectric transducers in a vaccum, i.e. the effects of interaction of acoustic fields with the surrounding media are not considered. The influence of the surrounding medium involves mass loading effects and damping due to sound emission. To include these effects in the simulation model, the wave equation governing the propagation of acoustic waves should be added to the equations governing the mechanical and electrical dynamics of the piezoelectric solid. The interaction between the fluid medium and the piezoelectric solid can be modelled by using piezoelectric finite elements for the piezoelectric transducer and acoustic finite elements for the fluid (Lerch, 1988).

It is well known that the propagation of acoustic waves in non-viscous media can be described by a scalar acoustic velocity potential $\psi(\mathbf{r},t)$ (Kino, 1987):

$$\mathbf{v} = -\nabla\psi \tag{16.36}$$

where \mathbf{v} is the vector of particle velocity. The velocity potential ψ obeys the wave equation (the scalar Helmholtz equation):

$$\nabla^2\psi = \frac{1}{c^2}\frac{\partial^2\psi}{\partial t^2} \tag{16.37}$$

where c is the velocity of sound.

To implement eqn (16.37) based on finite-element analysis, an appropriate variational principle for dynamic problems can be used, for example, Hamilton's variational principle:

$$\delta \int L dt = 0 \tag{16.38}$$

where L is the acoustic Lagrange energy which is given by

$$L = E_{kin} - E_{pot} + W_{ext} \tag{16.39}$$

where E_{kin}, E_{pot} and W_{ext} are the kinetic energy, the potential energy and the external work, respectively, which are given by:

$$E_{kin} = \frac{\rho_0}{2} \int_{\Omega} |\nabla \psi|^2 d\Omega \tag{16.40}$$

$$E_{pot} = \frac{\rho_0}{(2c)^2} \int_{\Omega} \left(\frac{\partial \psi}{\partial t}\right)^2 d\Omega \tag{16.41}$$

$$W_{ext} = \int_{A} \rho_0 \left[\frac{\partial \psi}{\partial t}\right] u_n dA \tag{16.42}$$

where: ρ_0 is the static density of the fluid; Ω is the volume of the fluid: A is the area normal to the boundary of the fluid; and u_n is the displacement normal to the fluid boundary due to external forces.

In order to compute the sound field, the piezoelectric solid domain and the fluid domain have to be discretized into finite elements. The mesh of the fluid domain can be coupled by special interface elements to a mesh describing the piezoelectric solid domain (Olson and Bathe, 1985). If there is an outer infinite fluid region, infinite finite elements can be used in the model. Using standard finite-element techniques (Zienkiewicz and Morgan, 1983), the above equations can be reduced to a set of linear equations which describe the dynamic behaviour of a piezoelectric transducer embedded in a surrounding fluid (Lerch, 1988):

$$\begin{pmatrix} \mathbf{M}_s & \mathbf{0} & \mathbf{0} \\ \mathbf{0} & \mathbf{0} & \mathbf{0} \\ \mathbf{0} & \mathbf{0} & -\mathbf{M}_f \end{pmatrix} \begin{pmatrix} \ddot{\mathbf{u}} \\ \ddot{\mathbf{V}} \\ \ddot{\psi} \end{pmatrix} + \begin{pmatrix} \mathbf{D}_s & \mathbf{0} & \mathbf{C}_{fs}^T \\ \mathbf{0} & \mathbf{0} & \mathbf{0} \\ \mathbf{C}_{fs} & \mathbf{0} & -\mathbf{C}_l \end{pmatrix} \begin{pmatrix} \dot{\mathbf{u}} \\ \dot{\mathbf{V}} \\ \dot{\psi} \end{pmatrix} +$$

$$\begin{pmatrix} \mathbf{K}_s & \mathbf{K}_{uV} & \mathbf{0} \\ \mathbf{K}_{uV}^T & \mathbf{K}_V & \mathbf{0} \\ \mathbf{0} & \mathbf{0} & -\mathbf{K}_f & -\mathbf{K}_l \end{pmatrix} \begin{pmatrix} \mathbf{u} \\ \mathbf{V} \\ \psi \end{pmatrix} = \begin{pmatrix} \mathbf{F}_s \\ \mathbf{Q} \\ \mathbf{0} \end{pmatrix} \tag{16.43}$$

where: \mathbf{M}_f and \mathbf{K}_f are the acoustic 'mass' and 'stiffness' matrices; \mathbf{C}_{fs} is the coupling matrix describing the interaction between the piezoelectric solid and

the fluid medium; \mathbf{C}_I is the 'damping' matrix of infinite fluid elements taking into account the Sommerfeld radiation at the boundaries of fluid; and \mathbf{K}_I is the 'stiffness' matrix of the infinite fluid elements.

To implement the theory described above, a standard finite-element-equation solver used for structural mechanics problems can be used, e.g. the package ANSYS (Varadan *et al.*, 1990). The standard Newmark step-by-step integration method can be used to compute the transient responses to mechanical (displacement or force) and electrical (charge or voltage) excitations (see e.g. Ludwig and Lord, 1988).

16.6.3 Examples of ultrasonic transducer design

The solution of eqn (16.43) yields the mechanical displacement \mathbf{u} and the electrical potential \mathbf{V} in the piezoelectrical medium, and the acoustic velocity potential ψ in the fluid. In addition to these nodal or local results, integral quantities characterizing a piezoelectric transducer can also be evaluated, such as the electromechanical coupling coefficient and the electrical input impedance. These integral quantities, as mentioned in Section 16.1, will be ultimately used to facilitate the design of ultrasonic transducers. Some examples are given below.

Electromechanical coupling coefficient
The electromechanical coupling coefficient λ is defined by

$$\lambda^2 = \frac{E_{em}^2}{E_m E_e} \tag{16.44}$$

where E_{em} is the electromechanical energy, E_m the pure mechanical energy, and E_e the pure electrical energy. In terms of piezoelectric finite-element matrices, these three energies are written:

$$E_{em} = \frac{1}{4} (\mathbf{u}^T \mathbf{K}_{uV} \mathbf{V} + \mathbf{V}^T \mathbf{K}_{uV}^T \mathbf{u}) \tag{16.45a}$$

$$E_m = \frac{1}{2} \mathbf{u}^T \mathbf{K}_s \mathbf{u} \tag{16.45b}$$

$$E_e = \frac{1}{2} \mathbf{V}^T \mathbf{K}_V \mathbf{V} \tag{16.45c}$$

The magnitude of λ of a vibrational mode indicates the significance of that particular mode compared with the other modes. If for a certain mode $\lambda \geqslant 0.5$, that mode will be strongly excited. The insertion loss and the bandwidth of an ultrasonic transducer are also related to the magnitude of the electromechanical coupling coefficient. The larger the electromechanical coupling coefficient of the mode of interest, the lower will be the insertion loss and the broader the bandwidth of the transducer.

The dependence of the transducer performance on electromechanical coupling, which in turn depends on the transducer geometry, is often used to optimize the transducer design. To illustrate this, the design of an ultrasonic transducer array for medical imaging, where a piezoceramic bar is the basic sensing element (material similar to PZT5A), is used as an example (Lerch, 1990). The electromechanical coupling coefficient λ for piezoelectric bars of two different thickness/width ratios ($W/T = 0.6$ and 2.0) is given in Figure 16.26. For $W/T = 2.0$, the total energy is split almost equally among several modes, whereas for $W/T = 0.6$ (the optimum W/T ratio) the energy is mainly concentrated on the thickness mode and, therefore, most of the electrical energy is converted into a normal displacement of the sound-emitting face of the transducer. With this optimum W/T ratio the array elements are able to transmit and receive ultrasonic signals with optimum efficiency. Note that the thickness mode is the one mainly used for imaging applications.

The Frequency × Thickness product (given in megaherz-millimetres; horizontal axis in Figure 16.26) is equal to half the sound velocity (given in 10^3 m s$^{-1}$). In a typical design of an ultrasonic array transducer, the W/T ratio of the transducer elements is first determined to achieve maximum electromechanical coupling. The thickness of the elements is then determined according to the velocity of the fundamental thickness mode and the specified operating frequency of the transducer array.

Electrical input impedance

The electrical input impedance $Z(\omega)$ is another characterizing parameter of ultrasonic transducers which can be easily verified experimentally using a network analyser. The input impedance of a piezoelectric transducer reveals

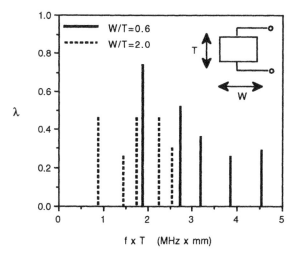

Figure 16.26 *The electromechanical coupling coefficient (λ) of the vibrational modes of piezoceramic bars (material: Siemens-Vibrit 420, PZT5A-like) for two width/thickness ratios ($W/T = 0.6$ and 2.0). (Adapted from Lerch (1990))*

all the resonances (the natural frequencies for short-circuit electrodes) and anti-resonances (the natural frequencies for open-circuit electrodes) of the transducer. The minima and the maxima of the $Z(\omega)$ curve correspond to the resonances and anti-resonances of different vibrational modes. To compute $Z(\omega)$ using the finite-element method, one electrode of the transducer is excited by electrical charge of a delta function ($Q(t) = Q_0\delta(t)$), while the other electrode is grounded. Since the charge current $I = dQ(t)/dt$, the input impedance $Z(\omega)$ is given by:

$$Z(\omega) = \frac{F\{V_{\text{electrode}}(t)\}}{j\omega Q_0} \qquad (16.46)$$

where $F\{V_{\text{electrode}}(t)\}$ is the Fourier transform of the electrical potential at the excited electrode.

A typical simulation result of the electrical input impedance $Z(\omega)$ of a piezoceramic bar ($W/T = 1.0$), with and without fluid loading, is given in Figure 16.27 (Lerch, 1988). The minima (corresponding to resonances) and the maxima (corresponding to anti-resonances) are clearly visible for different vibrational modes. A comparison of two $Z(\omega)$ curves shows the damping effects due to sound emission (the difference between the impedance values at resonance and anti-resonance) and mass loading effects (downshift of eigenfrequencies). Figure 16.27 also shows that, for W/T ratio larger than 0.8, the thickness mode and the second to fifth vibrational modes are strongly coupled. Reducing the W/T ratios, say to $W/T = 0.6$, a single strong thickness

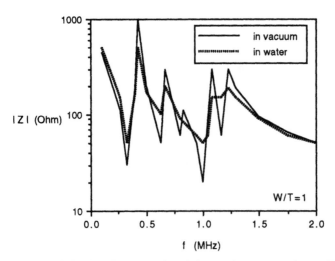

Figure 16.27 *Simulation results of electrical input impedance (IZI) of piezoceramic array transducers (Siemens-Vibrit 420) versus frequency (f) without fluid loading (in a vacuum) and with fluid loading (in water). (Adapted from Lerch (1988))*

mode can be made dominant within this frequency range (see Figure 16.26) (Lerch, 1990).

Transducer backing and cross-coupling

The piezoelectric transducer elements are often constructed with a backing, the effects of which can also be analysed by using finite-element modelling. Backing is used to provide mechanical support and sound absorption. A backing damps resonances due to the transfer of acoustic energy to the sound-absorbing backing material (e.g. epoxy). The energy transfer is determined by the ratio of the acoustic impedance of the piezoceramic material to that of the backing (Kino, 1987). The effects of backing on the mechanical output (displacement), the electrical input impedance and the resonance frequency have been investigated; for example, the resonance frequency has been found to be approximately 5% lower due to mass loading of the backing (Lerch, 1990).

Cross-coupling between transducer elements of an ultrasonic array has been found to degrade the image quality. Finite-element modelling has been used to analyse the mechanism behind this, including electrical and mechanical effects. Methods of reducing transducer cross-coupling have been investigated in detail by, for example, Lerch (1990), where finite-element techniques have been found extremely useful in design.

16.6.4 Discussion

The finite-element method is an effective and useful tool in the optimal design of ultrasonic transducers in two and three dimensions, with respect to efficiency, bandwidth, cross-coupling, etc. It allows the solution of many design problems, one of which is the simultaneous occurrence of various vibrational modes with quite different physical characteristics. The simulation is also able to provide a deeper understanding of the physical mechanisms of acoustic wave propagation in the surrounding medium.

Computer simulations of transducers are becoming increasingly important in technology. This development is being accelerated by the continuous improvements in modern computers and numerical techniques. The aim for the future is to combine such simulations with appropriate CAD techniques.

16.7 Summary

* Numerical methods are generally used for sensor design and modelling. The complex geometries of the sensor, the inhomogeneous distributions of the sensor material and the media, and the non-linearity of the media render analytical methods impossible.
* There are basically three types of numerical method used for engineering design and modelling: the finite-difference, the finite-element and the integral method (moment method and boundary element method). The

finite-element method is widely used because of the ease of fitting any complex geometries of a problem domain and of extension to higher-order elements.

- Three basic stages are involved in sensor modelling. (1) Identification of the mathematical model of the sensor and the determination of the governing equations and the related boundary conditions. (2) Establishing the geometric model of the sensor, paying attention to the significant aspects and the special features of the problem domain in order to minimize the amount of data. (3) Selection of an efficient numerical method with which to realize computer solution of the problem.
- ECT, EIT and the special case of EMT techniques can all be characterized by the Poisson equation. Attention should be paid to the boundary conditions, which are excitation-mode as well as the chosen model dependent, and specific to each imaging modality. General-purpose finite-element software packages for electromagnetic field modelling (e.g. OPERA and TOSCA) often contain the solution to the problems related to all three imaging techniques. Finite-element modelling of ultrasonic imaging sensors is also becoming established; the related mathematical models are generally more complex.
- The variation in design parameters of the imaging sensors will affect the sensors' performance parameters. There are usually many design parameters that are strongly associated with the sensor performance; the optimization of these design parameters often demands a lot of computation. Use of automatic optimization techniques, such as one based on the least-squares method, is recommended.
- An integrated, knowledge-based CAD environment is likely to be the future development in sensor design. This includes the incorporation of design rules into the knowledge base and the use of artificial-intelligence languages to establish solutions to design problems not tractable by classical analysis.
- The successful sensor design will ultimately depend on the judgement and inventiveness of the designer. The results of computer modelling will only be meaningful and robust if the physical modelling is well understood and tested.

References

Binns, K. J., Lawrenson, P. J. and Trowbridge, C. W. (1992) *The Analytical and Numerical Solution of Electric and Magnetic Fields*, Wiley, Chichester

Brebbia, C. A. (1980) *The Boundary Element Method for Engineers*, 2nd edn, Printec Press

Challande, P. (1990) Optimizing ultrasonic transducers based on piezoelectric composites using a finite-element method. *IEEE Trans. Ultrason. Ferroelec. Freq. Control*, **37**, 135–140

Harrington, R. F. (1968) *Field Computation by Moment Methods*, Macmillan, New York

Khan, S. H. and Abdullah, F. (1993a) Finite element modelling of multielectrode capacitive systems for flow imaging. *IEE Proc.-G*, **140**, (3) 216–222

Khan, S. H. and Abdullah, F. (1993b) Finite element modelling of electrostatic fields in process tomography capacitive electrode systems for flow response evaluation. *IEEE Trans. Magnetics*, **29**, (6) part I, 2437–2439

Khan, S. H. and Abdullah, F. (1993c) Validation of finite element modelling of multi-electrode capacitive system for process tomography flow imaging. In *Tomographic Techniques for Process*

Design and Operation, (eds M. S. Beck, E. Campogrande, M. Morris, R. A. Williams and R. C. Waterfall) Computational Mechanics Publications, Southampton, 63–73

Kino, G. S. (1987) *Acoustic waves – Devices, Imaging and Analog Signal Processing*, Prentice-Hall, Englewood Cliffs, NJ

Kunkel, H. A., Locke, S. and Pikeroen, B. (1990) Finite-element analysis of vibrational modes in piezoelectric ceramic disks. *IEEE Trans. Ultrason. Ferroelec. Freq. Control*, **37**, 316–328

Kwun, H., Jolly, W. D., Light, G. M. and Wheeler, E. (1988) Effects of variations in design parameters of ultrasonic transducers on performance characteristics. *Ultrasonics*, **26**, 65–72

Lanceleur, P., de Belleval, J. F. and Mercier, N. (1992) Modeling of transient deformation of piezoelectric ceramics. *IEEE Trans. Ultrason. Ferroelec. Freq. Control*, **39**, 293–300

Lerch, R. (1988) Piezoelectric and acoustic finite elements as tools for the development of electroacoustic transducers. *Siemens Forsch. Entwickl.-Ber. Bd.*, **17**, 284–290

Lerch, R. (1990) Simulation of piezoelectric devices by two- and three-dimensional finite elements. *IEEE Trans. Ultrason.*, **37**, 233–247

Lord, W., Ludwig, R. and You, Z. (1990) Developments in ultrasonic modeling with finite element analysis. *J. Nondestruct. Eval.*, **9**, 129–143

Ludwig, R. and Lord, W. (1988) A finite-element formulation for the study of ultrasonic NDT systems. *IEEE Trans. Ultrason. Ferroelec. Freq. Control*, **35**, 809–820

Modi, J. J. (1988) *Parallel Algorithms and Matrix Computation*, Clarendon Press, Oxford

Olson, L. G. and Bathe, K. J. (1985) Analysis of fluid-structure interactions – a direct symmetric coupled formulations based on the fluid velocity potential. *Comput. Struct.*, **21**, 21–32

Papalambros, P. Y. and Wilde, D. G. (1988) *Principles of Optimal Design: Modelling and Computation*, Cambridge University Press, Cambridge

Silvester, P. P. and Ferrari, R. L. (1990) *Finite Elements for Electrical Engineers*, 2nd edn, Cambridge University Press, Cambridge

Varadan, V. V., Chin, L.-C. and Vradan, V. K. (1990) Hybrid finite element methods for the numerical simulations of the sensor and actuator performance of composite transducers including the effect of the fluid loading. In *1990 Ultrasonics Symposium, Honolulu, HA, 4–7 December 1990*, Vol. 3, 1177–1181

Vector Fields Ltd (1990) *TOSCA, GFUN, CARMEN, ELEKTRA, BIM2D, OPERA, and PE2D User Manuals*, 24 Bankside, Kidlington, Oxford OX15 1JE

Xie, C. G., Stott, A. L., Plaskowski, A. and Beck, M. S. (1990) Design of capacitance electrodes for concentration measurement of two-phase flow. *Meas. Sci. Technol.*, **1**, 65–78

You, Z., Lusk, M., Ludwig, R. and Lord, W. (1991) Numerical simulation of ultrasonic wave propagation in anisotropic and attenuative solid materials. *IEEE Trans. Ultrason. Ferroelec. Freq. Control*, **38**, 436–445

Zienkiewicz, O. C. and Morgan, K. (1983) *Finite Elements and Approximation*, Wiley, New York

Error analysis of tomography systems – a case study

S. M. Huang and C. G. Xie

17.1 Introduction

In Chapter 15, various image-reconstruction algorithms are described for imaging systems based on different sensing principles. However, no systematic approach has been taken to quantify the quality or fidelity of the reconstructed images. The 12-electrode capacitance flow-imaging system, for example, has produced images (at 40 frames/s) which appeared to be similar to the actual flow pattern. However, we are unable to state quantitatively how well the reconstructed images represent the real flow distributions. It is therefore imperative to devise an analysis or test procedure for the quantitative assessment of system errors under different flow conditions and to compare the effects of, for example, sensor structures, numbers of electrodes and reconstruction algorithms.

This chapter describes an experimental method for evaluating the performance of tomographic systems. It is, however, difficult to understand system performance without giving any concrete examples. Thus electrical capacitance flow-imaging systems are used here in a case study. The methodology described in this case study should be applicable to other tomography systems.

Seagar *et al.* (1987) investigated the theoretical limits to the sensitivity and resolution of electrical resistance tomography systems, and their results provide useful guidelines for the evaluation of capacitance-based systems. However, their work mainly considered the theoretical limitations in the forward-problem-solving process; the effects of the reconstruction algorithm and sensor structure on the reconstructed image were not considered. Moreover, the distributions studied were only simple circular, cylindrical objects, whereas a flow-imaging system often deals with more complex distributions, such as stratified flow and deviated bubbly flow, which are difficult to analyse. Unlike the imaging errors in some optical systems, which can be obtained theoretically via well-defined point-spread functions (Bates and McDonnell, 1989), the imaging errors of capacitance tomographic systems are difficult to estimate, being generated mainly during an inverse-problem-solving process performed on a very limited number of measurements. In addition, the capacitance sensing fields are influenced by the component distribution within the sensing volume. The objective of this chapter is to develop an experimental test method for the quantitative assessment of capacitance tomographic flow-imaging systems. Since standards for dynamic calibration are not available, static physical models which simulate typical

flow distribution patterns are used for the evaluation. Criteria characterizing system performance, namely spatial and permittivity resolution, accuracy (system errors) and signal-to-noise ratio, are quantified by comparing the reconstructed images with the physical models. With this approach, the effects of different primary sensors, sensor electronics, and reconstruction algorithms as well as complete systems can be compared.

In the following sections, the definitions of the criteria are given, then the experimental system and physical models for the tests are described and test results for different distribution patterns presented, and, finally, conclusions are drawn on the performance limitations of capacitance tomographic flow-imaging systems.

17.2 Definitions

The quality of a tomographic flow-imaging system can be judged by comparing the reconstructed cross-sectional image (two dimensional) of a physical model with the actual model. To perform the comparison on the image-reconstruction computer, a standard image of the model is generated on the computer, which closely matches the cross-section of the model (depending on the fineness of the image-display pixels). The image plane, representing the cross-section of the flow conveying pipe, is divided into P square image pixels (Figure 17.1(a)), and the image of a two-component distribution is defined by assigning an appropriate grey level (or colour code) to each pixel. For example, with reference to Figure 17.1(b), the standard image $G_S(p)$ is an array of P pixels ($p = 1, 2, \ldots, P$) describing the (standard) model in terms of the grey level of each pixel:

$$G_S(p) = \begin{cases} G_M \text{ at pixels occupied by component of permittivity } \varepsilon_2 \\ 0 \ \text{ at pixels occupied by component of permittivity } \varepsilon_1 \end{cases} (p = 1, 2, \ldots, P)$$

$$(17.1)$$

where G_M is a grey level linearly dependent on permittivity. For a two-component flow-imaging system, G_M is often chosen to be the maximum grey level of the image-display hardware (e.g. $G_M = 255$).

For the reconstructed image, $G_R(p)$ values, the grey level values of the total P pixels, are determined from the set of independent capacitance measurements via the image-reconstruction algorithm. An algorithm based on the filtered back-projection method has been developed for electrical capacitance tomography (see Section 15.4.2). In this the normalized capacitance measurement values (normalized between empty-pipe and full-pipe capacitances), weighted by their corresponding sensitivity distribution functions, are back-projected onto the pipe cross-section and the resultant image is filtered by a threshold operation.

For an ideal tomographic imaging system, the (filtered) reconstructed image, $G_R(p)$, should be identical to the standard image, i.e.

$$G_R(p) - G_S(p) = 0 \qquad (p = 1, 2, \ldots, P)$$

(a)

Fluid
conveying pipe

Pipe cross-section
with P pixels

(b)

$\varepsilon 1$

$\varepsilon 2$

$(P-Ns)$ pixels

Ns pixels

Figure 17.1 (a) *Illustration of the image plane of the tomographic flow-imaging system.* (b) *Simple model of a two-component flow* $(\varepsilon_2 > \varepsilon_1)$

In practice, this rarely happens and the reconstructed image always differs from the standard. The departure from the ideal situation can be characterized by the difference image

$$D(p) = G_{\text{R}}(p) - G_{\text{S}}(p) \qquad (p = 1, 2, \ldots, P)$$

The difference image is a two-dimensional graphical presentation and, in practice, it is more convenient to use some simple values to describe the quality of an imaging system. These criteria are defined in the following subsections.

17.2.1 Spatial and permittivity errors

When imaging a physical model in the pipe, the reconstructed cross-section may differ from the standard model in area, average grey level, shape and

position (e.g. centre of gravity). The differences in area, shape and position can be classified as spatial errors, whereas the difference in grey level is regarded as a permittivity error. Here we define the *spatial image error (SIE)* of the system using the expression:

$$SIE = \frac{\sum\limits_{p=1}^{P} |G_B(p) - G_S(p)|}{\sum\limits_{p=1}^{P} G_S(p)} = \frac{\sum\limits_{p=1}^{P} |G_B(p) - G_S(p)|}{N_S G_M} \qquad (17.2)$$

where N_S is the number of pixels with component permittivity ε_2 (Figure 17.1(b)). $G_B(p)$ is the 'binary' reconstructed image, and is defined as

$$G_B(p) = \begin{cases} 0 & \text{if } g^{(p)} < \eta \\ G_M & \text{if } g^{(p)} \geqslant \eta \end{cases} (p = 1, 2, \ldots, P) \qquad (17.3)$$

where $g^{(p)}$ and η are the same as in eqn (15.34a), indicating the threshold operation of grey-level images.

SIE represents the spatial error information as given on the difference image. It contains all the spatial errors such as those in shape, cross-sectional area and position of the reconstructed object. In practice, the error in the cross-sectional area of the reconstructed object is often a good representation of the spatial image error, and is easier to estimate than the *SIE* (see Section 17.4.2). The area error (*AE*) is defined by the formula:

$$AE = \frac{\sum\limits_{p=1}^{P} G_B(p) - \sum\limits_{p=1}^{P} G_S(p)}{\sum\limits_{p=1}^{P} G_S(p)} = \frac{N_R - N_S}{N_S} = \frac{N_R}{N_S} - 1 \qquad (17.4)$$

where N_R is the number of pixels with non-zero grey levels in both the reconstructed and the binary image.

The *permittivity error* (PE) of the system is defined as the difference between the average grey level (G_R) of the reconstructed object and the grey level of the standard model (G_M) (see eqn 17.1), divided by G_M:

$$PE = \frac{G_R - G_M}{G_M} = \frac{G_R}{G_M} - 1 \qquad (17.5)$$

where G_R can be calculated using the formula:

$$G_R = \frac{1}{N_R} \sum\limits_{p=1}^{P} G_R(p) \qquad (17.6)$$

Note that only N_R non-zero values of $G_R(p)$ are actually summed here.

17.2.2 Component fraction measurement error

The component fraction (e.g. oil volume fraction in an oil/gas flow) is an important parameter of two-component flow. One objective of flow imaging is to provide a method of measuring this from the cross-sectional image of the two-component flow. In our system, the component fraction, β_R, is calculated by averaging the normalized grey-level values of all filtered image pixels over the pipe cross-section:

$$\beta_R = \frac{1}{P} \sum_{p=1}^{P} \left[\frac{G_R(p)}{G_M} \right]$$

$$= \frac{N_R G_R}{P G_M} = \left(\frac{N_S}{P} \right) \left(\frac{N_R}{N_S} \right) \left(\frac{G_R}{G_M} \right) \tag{17.7}$$

$$= \beta_S(1 + AE)(1 + PE)$$

where β_S is the component fraction of the standard model defined by

$$\beta_S = \frac{N_S}{P} \tag{17.8}$$

The *component fraction measurement error* (CFME) of the system is calculated from

$$\text{CFME} = \beta_R - \beta_S \tag{17.9}$$

$$= \beta_S(AE + PE + AE\ PE)$$

CFME depends on the combined effect of the area error (AE) and the permittivity error (PE). However, a small CFME does not necessarily mean that the AE and PE are small because their contributions may tend to cancel each other out.

17.2.3 Signal-to-noise ratio

Due to noise generated by the sensor electronics of capacitance tomography systems (see Chapter 4), the area and grey level of the reconstructed image, and therefore the calculated value of β_R, always fluctuate randomly with time, even when the component distribution in the pipe is stationary. In capacitance tomography, the signal that causes the sensor to respond is the component fraction change. Here we choose the time-averaged value of the component fraction, $\beta_R(t)$ (eqn (17.7)), as the signal and define the signal-to-noise ratio (SNR) of the system as:

$$\text{SNR} = \frac{\text{AVG}(\beta_R(t))}{\text{r.m.s.}(\beta_R(t))} \tag{17.10}$$

where r.m.s. $(\beta_R(t))$ is the root-mean-square value of the time variable $\beta_R(t)$, representing the amplitude of the random fluctuation.

To reduce the effect of random noise, when calculating the SIE or AE and PE, the reconstructed image ($G_R(p)$) is obtained from a time average of 100 consecutive frames of real-time images. For example, G_R in eqn (17.5) is time averaged (see eqn (17.6)) to reduce its random fluctuation, and the time-averaged value of β_R (see eqn (17.7)) is used in eqn (17.9).

17.2.4 Input signal resolution

'Resolution' is a term frequently used to describe the performance of an imaging system. For an image display, it means the spatial resolution determined by the size of image pixels. For a measurement system, on the other hand, it means the smallest input signal that will cause an identifiable output change (Doebelin, 1983). In the presence of noise, an output change is identifiable only if it is clearly above the noise level. Therefore the resolution of a measurement system is related to the noise level of that system. For a capacitance tomographic flow-imaging system, which can be regarded as a measurement system with the component fraction β_S as its input and the reconstructed image as its output, we define the *input signal resolution* (ISR) as *the smallest component fraction change that can be identified on the reconstructed image*. This criterion represents the capability of the system to detect the presence of small changes in component fraction, and it should not be confused with the spatial accuracy of the system which was defined in Section 17.2.1 by eqn (17.2).

In this study, the reconstructed image of a dielectric object (in an empty pipe) is regarded as definite (identifiable) if its signal to noise ratio (see eqn (17.10)) is greater than 3. In determining the ISR, only the simple situation where an object with higher permittivity appears in a homogeneous lower permittivity background (e.g. a plastic test rod in an empty pipe), is considered. In this case, if the reconstructed image has a SNR of 3, then the ISR of the system at that point on the cross-section equals the area–permittivity product of the test rod (the area of the rod is normalized against that of the full pipe).

Two more definitions can be derived from the above definition:

- *Spatial signal resolution* (SSR): given the differential permittivity (the permittivity difference of the two components) of the test object, the smallest increment in its cross-sectional area (usually from zero) that can be identified (SNR = 3) on the reconstructed image. For two-component flows, the permittivity values of both components are usually known; in the tests described in the following sections the permittivity values of the test models are known. Therefore, in practice the term 'input signal resolution' usually means the 'spatial signal resolution' and is often expressed as a fraction of the pipe cross-sectional area or as a fraction of the pipe diameter.
- *Permittivity resolution*: given the cross-sectional area of the test object, the smallest increment in its differential permittivity (usually from zero) that can be identified on the reconstructed image. This definition is useful when investigating the sensitivity of an imaging system to component permittivity changes.

It should be noted that all the criteria defined above are position dependent. For instance, the ISR at the pipe centre is different from that near the pipe wall. Therefore, it is meaningless to quote a criterion value without mentioning where on the pipe cross-section it applies. The position dependence of the criteria is investigated experimentally in Section 17.4.

17.3 Experimental system and physical test models

The industrial pre-prototype capacitance flow-imaging system, recently developed at UMIST, was used for the tests. Basically, the system consists of three parts: the primary sensor, the sensor electronics, and the image-reconstruction computer (Chapter 4). Two different primary sensors were used for the tests. One had eight electrodes on a 3 in. insulation pipe of 280 mm length (Figure 17.2(a)), and the other had 12 electrodes on a 6 in. insulation pipe of 380 mm length (Figure 17.2(b)). The length of the electrodes along the pipe axis was 100 mm. This length is considered necessary to provide the measuring electrode pairs with adequate sensitivities which are proportional to the electrode area. Projected earthed guards are used in both sensors to

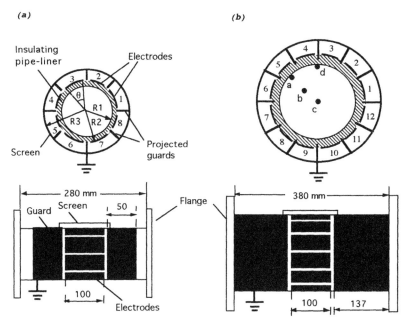

Figure 17.2 *Primary sensors for the tests (not to scale). (a) Eight-electrode sensor:*
$R_1 = 42.5$ *mm,* $R_2 - R_1 = 5$ *mm,* $R_3 - R_2 = 5$ *mm,* $\theta = 39°$; *pipe liner –Perspex;*
length of projected guard = 5 mm. (b) Twelve-electrode sensor; $R_1 = 77$ *mm,*
$R_2 - R_1 = 15$ *mm,* $R_3 - R_2 = 7$ *mm,* $\theta = 25.6°$; *pipe liner – potting resin and Perspex;*
length of projected guard = 9 mm

reduce the standing capacitance between the adjacent electrodes. For the 12-electrode sensor, these guards extend 2 mm into the insulating pipe liner, whereas in the eight-electrode sensor, the guards are flush with the liner surface. The guards at both ends of the electrode section are used to protect the electrodes from the interference of external electrical fields. Their length is no less than the outer diameter of the insulation pipe (R_2) (Figure 17.2). The effects of the finite electrode length and the end guards on a two-dimensional imaging system have been investigated and are described in Section 17.4.4.

The sensor electronics has a typical r.m.s. noise level of 0.08 fF, which equals to the smallest sensor capacitance change caused by an approximately 0.5% component (permittivity = 2.5) fraction change (area change) at the pipe centre. The sensor electronics provides a data-capture rate of 100 frames (6600 measurements) per second for the 12-electrode system and about 160 frames/s for the eight-electrode system. The reconstructed image is displayed on an image plane (Figure 17.1(a)) consisting of 3228 pixels $(P = 3228)$. (The image is actually displayed using 64×64 pixels, with 868 pixels outside the pipe.)

The physical models simulating different flow patterns are of three types. The first of these are cylindrical rods of plastic (permittivity = 2.5). When placed at the pipe centre, they simulate core flow patterns of different component fractions. The second are plastic tubes with different wall thicknesses, simulating annular flow of different volume fractions. The stratified flow pattern with different volume fractions is simulated with the level of oil (kerosene, permittivity = 2.5) in a horizontal sensor pipe section. These models and their dimensions are shown in Figure 17.3 and Table 17.1.

17.4 Results and discussion

17.4.1 Signal-to-noise ratio and input signal resolution

Signal-to-noise ratio
The signal-to-noise ratio (SNR) of the imaging system was tested for both the eight- and the 12-electrode configurations. The tests were performed by

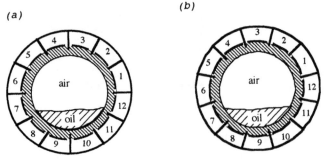

Figure 17.3 *Stratified flow pattern with: (a) the electrode gap as the central position; (b) the pipe rotated 15° from the position shown in (a)*

Table 17.1 *Physical models for the tests: (a) plastic rods (Perspex); (b) plastic tubes (Perspex) (when simulating annular flow, the gap between the outer surface of the tube and the pipe is filled with oil)*

(a)

	Rod No.									
	1	*2*	*3*	*4*	*5*	*6*	*7*	*8*	*9*	*10*
D (mm)	9	15	20	27	40	57	70.5	80	111	127
A in the 6 in. pipe (%)	0.34	0.95	1.69	3.07	6.75	13.7	21	27	51.95	68
A in the 3 in. pipe (%)	1.12	3.1	5.5	10.1	22.1	45	68.8	—	—	—

(b)

	Tube No.					
	1	*2*	*3*	*4*	*5*	*6*
Inner *D* (mm)	24.5	51	64.5	74	100	121
A of annular flow in the 6 in. pipe ('oil' fraction) (%)	97.5	89	82.5	76.9	57.8	38.3

A, area; *D*, diameter.

placing plastic rods of different diameters at four different positions in the pipe (a–d in Figure 17.2(b)) and calculating the SNR for each set-up using eqn (17.10). The results are plotted versus the cross-sectional area fraction of the test rod in Figure 17.4. The following observations can be made from Figure 17.4:

- The SNR increases as the component fraction (rod size) β_s increases.
- The SNR improves as the rod moves from the pipe centre towards the pipe wall. This improvement is greater for small rods and indicates a significant difference in measurement sensitivity between the centre and wall of the pipe.
- The SNR of the 12-electrode configuration is about half that of the eight-electrode configuration. This is because, for the sensor structure shown in Figure 17.2, the area of each electrode reduces as the total number of electrodes increases, resulting in a reduction in the capacitance signal level.

The input signal resolution

The ISR is closely related to the SNR. These tests were performed with small rods to find out the smallest size which satisfies the condition SNR > 3 (see Section 17.2.4). Input signal resolution values (in terms of the percentage areas occupied by the rod) were obtained at the same four positions as above for both the eight- and 12-electrode configurations, and these are shown in Table 17.2. Note that, some of the figures, say less than 0.2%, in the table are obtained by extrapolating from Figure 17.4, since rods of very small size were not available for the experimental tests (Table 17.1(a)).

It can be seen from Table 17.2 that, the ISR of the eight-electrode sensor is

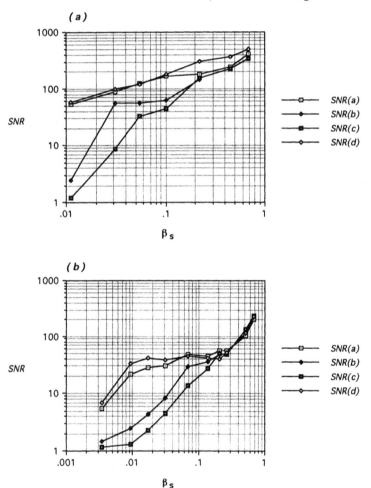

Figure 17.4 *The SNR of the imaging systems tested with plastic rods at four different positions (a–d in Figure 17.2(b)) in the pipe versus the rod area fraction β_s. (a) Eight-electrode configuration. (b) Twelve-electrode configuration*

Table 17.2 *Resolution (%) of the imaging systems (plastic rods in empty pipe, area fraction)*

Sensor system	Rod position			
	a	*b*	*c*	*d*
8 electrode	Better than 0.1%	1.2	2.0	Better than 0.1
12 electrode	0.2%	1.5	2.0	0.15

better than that of the 12-electrode sensor. This is attributed to the higher SNR of the eight-electrode sensor (see above). The ISR of a capacitance imaging system is notably position dependent. Near the pipe wall (positions a and d), it is at least an order of magnitude higher than it is at the pipe centre (position c), due to the higher capacitance sensitivity near the pipe-wall area (see above). The ISR near the electrode gap (position d) is slightly higher than that near the electrode centre (position a).

17.4.2 Imaging system errors

The imaging system errors include the spatial image error (SIE) or the cross-sectional area error (AE) and the permittivity error (PE) and these were calculated from the test results according to eqns (17.2), (17.4) and (17.5).

Tests with plastic rods
Rods were placed at positions a, c or d as shown by Figure 17.2(b), and the errors SIE, AE and PE calculated. The results for the different rod sizes shown in Table 17.1, using sensors with eight and 12 electrodes are plotted in Figures 17.5–17.8 versus the area fraction of the rod β_S (normalized to the pipe cross-sectional area).

Figure 17.5 shows the AE values for both the eight- and the 12-electrode configurations. Note that AE is dependent on both the size and the position of the test rod. In general, AE reduces as the rod size increases, and the error is significantly larger at the pipe centre than it is near the pipe wall, except for rods smaller than a few per cent of the pipe cross-section where the situation is reversed. It is unclear why the error at the pipe centre reduces as the rod size reduces towards its resolution limit.

The AE values for positions a and d are not very different for rod sizes larger than about 10%. For small rod sizes, there are some differences. For the eight-electrode configuration, AE(a) < AE(d), whereas for the 12-electrode

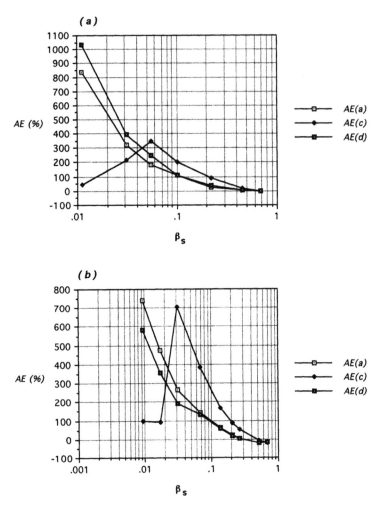

Figure 17.5 *The cross-sectional area error (AE) of the test rods (Table 17.1(a)) at three positions in the pipe (a, c and d, see Figure 17.2(b)) versus the rod area fraction β_s: (a) eight-electrode configuration; (b) twelve-electrode configuration*

configuration the situation is the opposite, possibly due to different sensor structures (Section 17.3).

Figure 17.6 shows a comparison between the cross-sectional area error (AE) and the overall spatial image error (SIE) for the 12-electrode configuration. Obviously the two criteria show similar trends, although the values of SIE are larger than those of AE because SIE contains errors in shape and position as well as cross-sectional area (see Section 17.2.1). In calculating the SIE, the precise position of the test rod in the pipe must be known in order to guarantee the accuracy of the calculation. However, with our simple experimental model

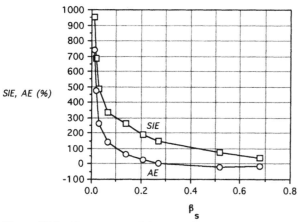

Figure 17.6 *Comparison of the spatial image error (SIE) and the cross-sectional area error (AE) with the area fraction (β_S) of the test rods, for the 12-electrode configuration (test rods at position a)*

it was difficult to control precisely the position of the physical models. Therefore in the following sections, AE, instead of SIE, is used to indicate the spatial error of the reconstructed image.

Figure 17.7 compares the image area error of the 12-electrode configuration with that of the eight-electrode system. It is noted that, near the pipe wall (Figure 17.7(a)), the 12-electrode system produces a smaller area error than the eight-electrode system. This is more obvious when the size of the test rod is small. For instance at $\beta_S = 0.03$ the average of AE(a) and AE(d) for the 12-electrode system is about 65% that of AE(a) and AE(d) for the eight-electrode system. At the pipe centre (Figure 17.7(b)) and for $\beta_S > 0.1$, the results for the two configurations are not very different. However, the error for the 12-electrode system becomes larger as the rod size reduces because of an increased random noise contribution to the image area error.

Figure 17.8 shows the permittivity error (PE) for the eight- and 12-electrode configurations. The values of PE are all negative, indicating that the average grey level of the reconstructed object is always lower than that of the standard. The error is largest at the pipe centre, and increases as the rod size reduces. Comparison of Figures 17.8(a) and Figure 17.8(b) shows that the 12-electrode system has a smaller PE (about 10% on average).

Tests with tubes

These tests were performed with the 12-electrode system only. A plastic tube (permittivity = 2.5) was placed at a given position (a or c) in the pipe, with the gap between its outer surface and the inner surface of the pipe wall filled with oil (permittivity = 2.5), simulating a cylindrical gas bubble in oil. The volume fraction of oil (and the bubble size) was changed by selecting tubes with different inner diameters. The maximum bubble size used was 62% as larger tubes were not available.

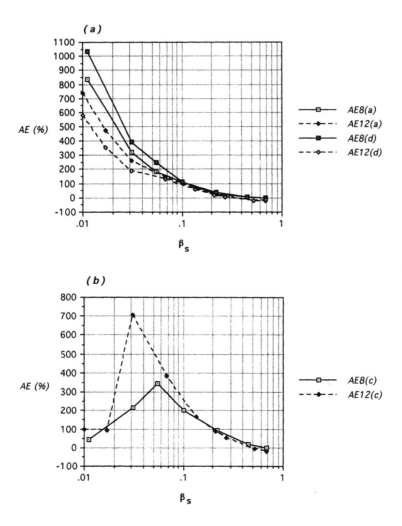

Figure 17.7 *Comparison of the eight- and twelve-electrode configurations. Image error (AE) curves (a) near the pipe wall, and (b) at the pipe centre. β_s, area fraction of the test rods*

The cross-sectional area error of the bubble (AE), was calculated from the difference between the standard and the reconstructed bubble cross-section (divided by the standard cross-section). The results are plotted versus oil area fraction in Figure 17.9(a). In the figure the points with AE = – 100% represent the situation when the reconstructed bubble size is zero (i.e. when it cannot be seen on the reconstructed image). This happens when the bubble size is less than about 3% near the pipe wall, and less than 12% at the pipe centre. (Actually, at the centre, bubbles smaller than 25% become blurred on

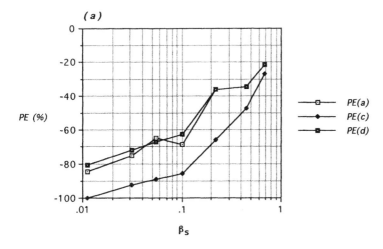

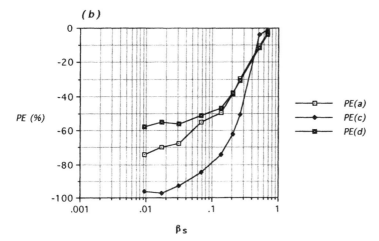

Figure 17.8 *Permittivity error (PE) of the test rods at positions a, c and d (Figure 17.2(b)) versus the rod area fraction (β_S): (a) eight-electrode configuration; (b) twelve-electrode configuration*

the reconstructed image.) For large bubbles (> 25%), the AE is no more than 15% of the reading.

The resolution of the system for gas bubbles in oil is much poorer than for test rods (see above), where the minimum detectable rod size was about 2% (at pipe centre). In this work, the phenomenon that a low permittivity object is obscured by its surrounding high-permittivity material is called the 'dielectric screen effect'. It was noticed that even when the bubble was unrecognizable on the image, the changes in the 66 capacitance measurements were clearly

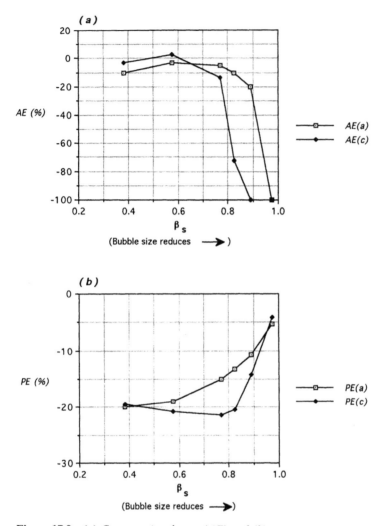

Figure 17.9 (a) *Cross-sectional area (AE) and* (b) *permittivity error (PE) of the twelve-electrode system, tested with tubes (Table 17.1) at positions a and c (Figure 17.2(b)) versus oil area fraction (β_s)*

observable. This means that the bubble was detected by the measurements, but the image-reconstruction algorithm failed to reconstruct it.

Figure 17.9(b) shows the permittivity error (PE) of the reconstructed bubble. Compared with Figure 17.8, the values of PE in Figure 17.9(b) are much smaller, and the error is smaller at the pipe centre than it is near the pipe wall. Note that the bubble-in-oil tests were performed with relatively large values of β_s, and that when the bubble is at the centre there is more oil (high permittivity) in the more sensitive region of the sensor (near the wall).

Therefore it is clear that the permittivity error depends on the input (capacitance) signal amplitude.

Tests with stationary oil

The tests were performed using the 12-electrode sensor. Oil was put into the horizontally laid sensor pipe to simulate the stratified flow patterns (see Figure 17.3) and the amount of oil in the pipe was increased step by step to produce different oil fractions. Image errors AE and PE were obtained for the two different electrode orientations shown in Figures 17.3(a) and 17.3(b) and these were plotted versus the oil fraction in Figure 17.10.

Figure 17.10(a) shows that, for stratified oil flow, AE is large at very low oil levels, and it reduces as the oil fraction increases. At oil fractions higher than 30%, AE becomes slightly negative. The trend is similar to that shown by Figure 17.7(a). The trend in PE seen in Figure 17.10(b) is similar to that seen in Figure 17.8(b). The AE and PE values for the two different orientations are not very different, except at low oil levels where the orientation shown in Figure 17.3(a) produces less error because of its higher sensitivity near the bottom of the pipe (near the electrode gap).

17.4.3 Component fraction measurement errors

For the 12-electrode sensor, the CFMEs for core, annular and stratified flow patterns were obtained from the reconstructed images using eqn (17.9). Core flows and annular flows over a range of component fractions (0–70% and 35–100%, respectively) were simulated by plastic rods and tubes placed at the pipe centre. The stratified distributions were obtained in the same way as described in Section 17.4.2 with the electrode orientation shown in Figure 17.3(a). The CFMEs are plotted versus oil area fraction in Figure 17.11(a), and the maximum CFME being about 17% (absolute) for all three flow patterns. This shows that the accuracy of calculating the component fraction from the reconstructed image is limited by the linear back-projection algorithm.

Other methods of obtaining the component fraction have been tried. One of these is to use the the average value of the 66 normalized capacitance measurements, i.e.

$$\frac{1}{66} \sum_{m=1}^{66} c_m,$$

to replace β_R in eqn (17.9). Figure 17.11(b) illustrates the CFME calculated using this method. Compared with the imaging method, this produces a smaller error (maximum 9%) for the stratified pattern, but larger errors for core pattern (maximum 35%) and annular pattern (maximum 20%). The distribution of the error values in Figure 17.11(b) shows the effect of the non-uniform sensitivity distribution of the imaging sensor. For instance the negative values for core pattern and the positive values for annular pattern

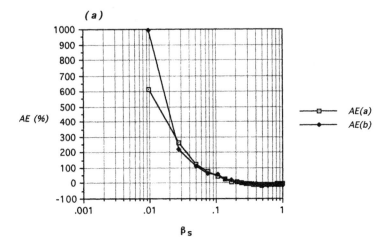

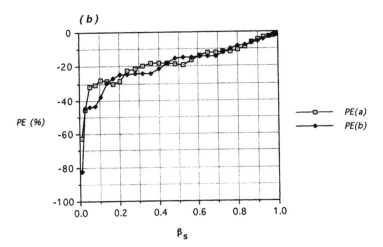

Figure 17.10 *(a) Cross-sectional area (AE) and (b) permittivity error (PE) of the twelve-electrode system at positions a and b (Figure 17.2(b)) versus oil area fraction (β_S)*

show the sensitivity difference between the near wall and central areas on the pipe cross-section.

In order to improve the accuracy for component fraction measurement, better methods of image reconstruction and/or data processing should be investigated. For example, Figure 17.11(c) shows the CFME calculated by using the average value of the 54 normalized capacitance measurements to replace the β_R in eqn (17.9), i.e. measurements from the 12 adjacent electrode pairs are omitted, as these are found prone to generate large overshoots or undershoots (Section 15.4.2), leading to overestimated or underestimated

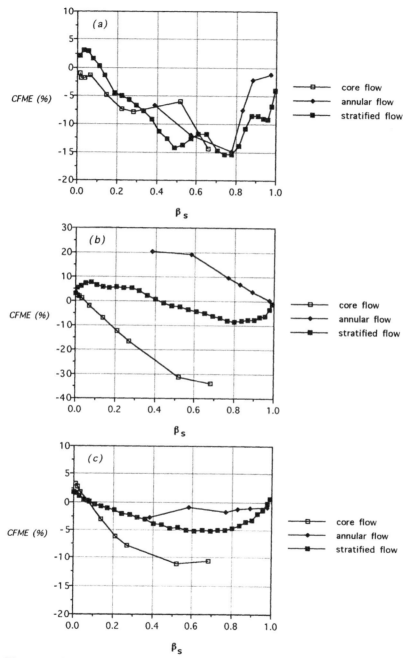

Figure 17.11 *Component fraction measurement error (CFME) of the twelve-electrode sensor versus the real component fraction (β_s). (a) CFME calculated from the reconstructed images (eqn (17.9)). (b) CFME calculated from the average of the 66 normalized measurements. (c) CFME calculated from the average of the 54 normalized measurements (omitting the 12 adjacent electrode pairs)*

measurements. Figure 17.11(c) indicates that, using this method, the CFME has significantly reduced to 5% (maximum) for annular and stratified flows, and to 12% (maximum) for core flow.

17.4.4 Third-dimension effect

Due to the finite length of the electrode in the axial direction (100 mm), the image produced by such a system actually represents the cross-sectional component distribution averaged over the length of the electrode. A simple experiment was carried out with the 12-electrode sensor to investigate the effect of electrode length on the reconstructed image. As shown in Figure 17.12, a test rod representing about 14% component fraction, was gradually plunged into the centre of the pipe. The imaging system errors (AE and PE), the SNR and the component fraction described by β_R corresponding to different positions of the model front in the pipe, were obtained (Figure 17.13).

Figures 17.13(a) and 17.13(b) show the improvement in SNR, PE and CFME as the rod moves into the sensing volume. This was because the input signal level (the product of permittivity and the volume fraction of the rod in the sensing zone) increases as the rod moves in. Suppose that the electrode length is halved when imaging the same rod placed across the whole sensing zone, although the PE of the system is likely to be the same through

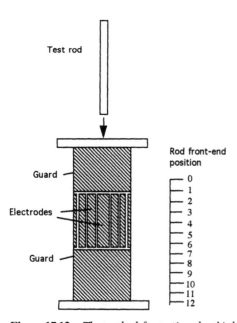

Figure 17.12 *The method for testing the third-dimension effect. (Space between the rod positions, 20 mm; position 0 is 20 mm above the electrodes)*

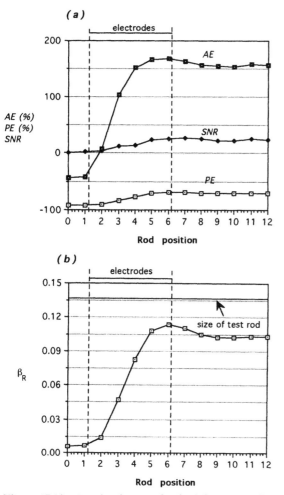

Figure 17.13 *Results showing the third-dimension effect of the twelve-electrode sensor. (a) AE, PE and SNR corresponding to different positions of the rod front in the pipe (see Figure 17.12). (b) The measured component fraction (β_R) based on the image grey-level versus the rod front position*

re-calibration of the system and normalization of the measurements with new values of the full scale capacitances, the signal level, and hence the SNR, will drop to 50% of their original values. This also implies that the SNR will be improved if the permittivity difference of the two components is large.

Figure 17.13(a) also show that the reconstructed rod cross-sectional area increases as the rod moves deeper into the sensing zone. This indicates that for the present system, the averaging effect of the electrode length influences not only the permittivity values but also the spatial area of the reconstructed image.

The effect of the end guards can be seen from Figure 17.13(b). When the rod front is at the end of the sensing zone (near position 6), β_R exhibits overshoot values because, at this position, the rod disturbs most severely the electric flux lines in the sensing zone, compared with the situation when there is no rod in the zone at all. This overshoot diminishes when the rod front is well out of the sensing zone and the rod is under the entire sensing zone (position 9 onwards); β_R is stabilized, showing about 4% measurement error in volume fraction compared with the actual size of the test rod.

17.4.5 Tests with multiple objects

The following tests were carried out with more than one object in the pipe simultaneously in order to investigate the mutual influence between the objects. Results were obtained for three situations using the 12-electrode sensor:

(1) *All the objects in the high-resolution area near the pipe wall.* Test rods 3 and 4 (see Table 17.1) were both placed in the pipe with rod 3 at position a and rod 4 at position e (see Figure 17.2(b)). Then rod 4 was moved towards rod 3 along the inner pipe wall. The minimum distance (between the rod surfaces) necessary to keep the reconstructed images of the two rods separate was about 1 electrode width (about 40 mm). The mutual influence of the objects was observed; usually the size of the reconstructed object tended to decrease when the second object was put in.
(2) *Objects in the low resolution area near the pipe centre.* Rods 3 and 4 were placed respectively at positions a and f, and then moved towards the centre of the pipe simultaneously from both sides. The minimum distance necessary to separate the two reconstructed objects was about the inner radius of the pipe (75 mm). This was larger than that found in (1), showing a poor resolution near the centre.
(3) *Objects in both the high- and the low-resolution areas.* Rod 4 was placed in the centre of the pipe. When rod 3 was put into the area close to the pipe wall, the image of rod 4 almost disappeared and only rod 3 could be seen on the display. This indicates that if the component with higher permittivity appears in large concentrations in the near-wall area, it tends to obscure the component distribution in the central area of the pipe. This is similar to the situation described in Section 17.4.2, where the 'dielectric screen effect' obscured the simulated air bubbles in the pipe centre. When rod 4 was removed from the pipe, the average value of the 66 measurements produced about 17% change (of reading). This showed that the presence of rod 4 was detected by the measurement system, but the linear back-projection algorithm failed to reconstruct this.

17.5 Summary

It is very difficult to fully describe the performance of a capacitance imaging system. In this chapter, a system was evaluated for only a number of simple

distribution patterns. Although it is difficult to predict precisely the system errors for more complex distribution patterns, the criteria defined for the simple patterns do provide a quantitative way of describing some aspects of the system performance, as well as standards for comparing different systems and reconstruction algorithms. Referring to the definitions given in Section 17.2 and the results given in Section 17.4, the following conclusions can be drawn for the present UMIST 12-electrode system.

- For an object with a permittivity of about 2.5 in an empty pipe, the minimum size that the imaging system can resolve is 0.2% (of pipe cross-section) near the pipe wall and 2.0% at the pipe centre. These are the best input signal resolution values that can be achieved with the current signal to noise ratio. For more complex distributions, the resolution might not be as good.
- The system errors such as the spatial image error and the permittivity error are strongly dependent on both position and flow pattern. Tests with a 3% area rod near the pipe wall showed that the signal to noise ratio, area error and permittivity error were improved by factors of 6, 3 and 1.33 respectively over the corresponding values at the pipe centre.
- Discrete objects formed by the low-permittivity component tend to be obscured by the high-permittivity component surrounding them. Similarly, objects near the pipe centre tend to be masked by any high-permittivity component present near the pipe wall. This is here called the 'dielectric screen effect'. Due to this effect, objects of lower permittivity in the higher permittivity component are more difficult to detect than vice versa. System errors are particularly large when gas bubbles at the pipe centre are imaged. (Minimum reconstructable bubble size is around 20%.) The fact that the bubbles can be detected by the measurement circuit suggests that this effect may be reduced by using other image reconstruction algorithms which are more accurate than the linear back-projection method.
- When the component fraction is estimated from the reconstructed image, the errors can be large for all the simulated flow regimes (all at about 17% maximum). When the component fraction is estimated from the average of the 54 normalized capacitance measurements (excluding those from the adjacent electrode pairs), the errors are significantly reduced (for stratified and annular flows to 5% maximum, for core flow to 12% maximum). In order to improve the accuracy further, either more accurate image reconstruction algorithms or an appropriate (adaptive and weighted) average of the capacitance measurements have to be used.
- The increase in the number of electrodes reduces the system errors such as the spatial imaging error, particularly in the areas near the pipe wall. However, the SNR and ISR deteriorate as the number of electrodes increases. Thus when the number of electrodes is increased from 8 to 12, the AE (for a 3% rod) in the near wall area is reduced by about 30%, and the PE by about 15%. However, at the pipe centre, the situation is little improved or may be even be made worse due to the reduced signal-to-noise ratio (about half of the original value). This agrees with the theoretical predictions by Seagar *et al.* (1987). The use of 12 electrodes instead of 8 may

be justified by the reduction of the errors in the near wall area and by the possibility of further reducing the noise level of the sensor electronics.

• The images obtained with this system represent the component distribution averaged over the finite length of the electrodes. Reducing the electrode length results mainly in a reduction in the signal-to-noise ratio of the system.

References

Bates, R. H. T. and McDonnell, M. J. (1989) *Image restoration and reconstruction*, 2nd edn, Oxford University Press, Oxford

Doebelin, E. O. (1983) *Measurement Systems: Application and Design*, 3rd edn, McGraw-Hill, London

Seagar, A. D., Barber, D. C. and Brown, B. H. (1987) Theoretical limits to sensitivity and resolution in impedance imaging. *Clin. Phys. Physiol. Meas.*, **8** (Suppl. A), 13–31

Process applications

Section Editor: *R. A. Williams*

Measurement of bed porosity distribution in particulate flows using photon transmission tomography

U. Tüzün, M. E. Hosseini-Ashrafi and N. MacCuaig

18.1 Theoretical introduction

The porosity of a packed bed is a key parameter in determining the stress and flow behaviour of granular solids in bulk storage, handling and transport equipment. During packed bed flow, both the velocity fields of particles as well as of the interstitial fluid are known to scale by the distribution of interstitial void space within the particle bed.

Perhaps the most commonly quoted equation for the calculation of interstitial fluid pressure distributions in packed beds is that proposed by Ergun (1952) which takes the form:

$$\text{grad } p = [K\mu_f(1 - \varepsilon)^2/d_p^2\varepsilon^2]\Delta U + [K'\rho_f(1 - \varepsilon)/d_p\varepsilon]\Delta U^2 \tag{18.1}$$

where $\Delta U = U_f - U_s$.

In slow shearing flow of a particulate bed, the relative velocity between the particles and the surrounding fluid is small and the first term in eqn (18.1) dominates where the viscous drag on the particles due to the interstitial fluid is significant. Here, the group inside the brackets in the first term in eqn (18.1) is often referred to as the 'permeability coefficient' or the 'permeability resistance' of the particulate bed.

Those materials with a high degree of permeability usually comprise coarse, rigid particles of uniform size and shape. In this case, the bed porosity is believed to be more or less uniform and the interstitial fluid will tend to percolate uniformly through the packed bed and the interstitial pore pressure gradients will be small. However, materials with a wide particle size and shape distribution or with easily deformable particles will show significant variations in the local values of the interstitial voidage within the packed bed. Hence, the magnitude of the packed bed permeability coefficient can be taken to be constant only for incompressible beds of uniform particle shape and size. When the particle bed is compressible, then the first term in the Ergun equation (eqn (18.1)) becomes:

$$\text{grad } p/\Delta U = K\mu_f[1 - \varepsilon(\sigma)]^2/d_p^2\varepsilon(\sigma)^2 \tag{18.2}$$

where the nature of the bed compressibility function $\varepsilon(\sigma)$ can be determined by

uniaxial compression tests on the packed beds. Some typical results obtained with a variety of granular materials are shown in Figure 18.1.

In general, two limiting functional forms are considered, (see e.g. Rathbone *et al.* (1987) and Crewdson *et al.* (1977)):

For large $\Delta\sigma$: $\varepsilon(\sigma) = \varepsilon_0 - A\ln\sigma$ (18.3a)

For small $\Delta\sigma$: $\varepsilon(\sigma) = \varepsilon_0 - B\sigma$ (18.3b)

where ε_0 is taken as the value of the packed bed voidage at zero consolidating load. Hence with compressible packed beds, the permeability resistance will increase with increased consolidation of the packed bed, resulting in large interstitial fluid pressure gradients within the flow field.

Equation (18.1) also predicts the permeability resistance to vary inversely with the square of the particle size d_p. Hence fine particle beds show much greater resistance to interstitial fluid percolation through the bed resulting in long fluid retention time or fluid entrapment within the bed. This is, for example, believed to be the cause of the condition known as 'flooding' during discharge of powder beds from storage hoppers (see Rathbone *et al.* (1987)).

During material discharge from hoppers, the large adverse pore pressure gradients which result from increased permeability resistance act to impede the motion of solids within the flow field. The result is a significant reduction in the observed discharge rates under gravity controlled conditions. Nedderman *et al.* (1982, 1983) propose:

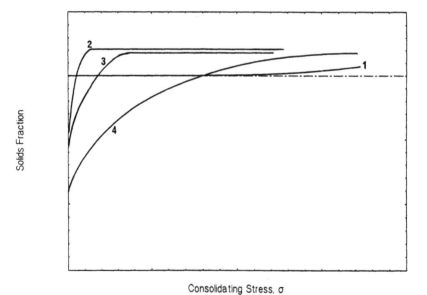

Consolidating Stress, σ

Figure 18.1 *Compressibility curves for packed granular beds under uniaxial compressions. (1) Table salt, granulated sugar, fine sand (100 μm < d < 500 μm). (2) Sauce mix (d < 50 μm). (3) Flour, corn flour, silica (d < 20μm). (4) Icing sugar (d < 50μm)*

$$W \propto \rho_s(1 - \varepsilon_f)[g - C \text{ grad } p_0/\rho_s(1 - \varepsilon_f)]^{1/2} \tag{18.4}$$

where grad p_0 is the orifice pressure gradient and ε_f is the local value of the flowing voidage at the vicinity of the orifice. Quite clearly, the magnitude of the discharge rate is affected very severely by any variation in the local value of the flowing bed voidage close to the hopper outlet.

The porosity of the packed bed does also affect the magnitude of the shear stresses experienced by the particles during flow. In general, low values of bed porosity necessitate high shear stresses to initiate flow for given values of the normal stress. Furthermore, when strong interparticle forces exist such as those due to van der Waals, capillary or electrostatic effects, any reduction in bed voidage helps to enhance the 'cohesivity' of the particulate bed again resulting in greater resistance to shear during flow (see for example Clift (1985)). The dependency of the frictional properties such as internal and wall friction coefficients and bulk cohesion on the value of the interstitial voidage is discussed in detail by Tüzün (1988), who also includes many references to the relevant literature.

More recently, Tüzün *et al.* (1988) have shown the dependency of the magnitude of wall friction in static and flowing packed beds on the variations in the local bed porosity near the wall surface. The porosity of a packed bed of particles is determined largely by the single-particle properties such as particle size and shape distributions (Cumberland and Crawford, 1987) as well as particle surface properties such as surface roughness and hardness. The effect of geometric constraints such as a wall boundary is known to be confined very locally to within a distance of a few particle diameters. (Laohakul, 1978).

Particulate mixtures comprising a distribution of particle sizes and shape scan give rise to significant variations in local bed porosity in both static and flowing beds. In general, with discrete particle mixtures, the bed porosity will scale by the order of the mixture according to:

$$\varepsilon_{\text{mix}} \geqslant (\varepsilon_l)^n \tag{18.5}$$

where n denotes the number of size classes in the mixture. Here, the values ε_i represent the porosity associated with a mono bed of particles in each particle size class i. Equation (18.5) will yield equality if there is no geometric interaction between particles of different sizes in the mixture; a condition which is approached at very high particle-size ratios. Otherwise, the value of ε_{mix} will be a function of both the particle-size ratios and the relative concentration of different size particles in the mixture (see Sherrington and Oliver (1984)). Hence, polydisperse particle beds are intrinsically much more susceptible to the spatial as well as the time transients of local bed voidage during packed bed flows.

The interstitial pore structure of static assemblies of mono size, binary and ternary mixtures of spheres has been the subject of many theoretical studies (see e.g. Dodds, 1980; Yu and Standish, 1988; Arteaga and Tüzün, 1990). There is yet to emerge a completely analytical method for predicting the so-called 'packing efficiency' of different size spheres as a function of particle-size ratio and relative volume fraction (McGeary, 1961). There are

also theoretical studies such as those by Stovall *et al.* (1986) and Ouchiyama and Tanaka (1989), of the mean field values of the bulk density of materials corresponding to different continuous functional forms of the particle size distribution. In contrast, non-spherical particle shape or, indeed, particle shape distributions have received very little attention.

Finally, the variations in local bed porosity resulting from polydisperse single-particle properties such as size and shape will also be reflected both in the magnitude of pore pressures (eqn (18.1)) (see Molerus, 1980) as well as in the solids discharge rates (eqn (18.4)) (see Tüzün and Arteaga, 1991).

This contribution presents an attempt to quantify the distribution of bed porosity in both mono and binary particulate beds during gravity discharge from a holding vessel. The spatial and time profiles of voidage obtained with tomographic measurements can be coupled readily with measurements of pore pressure profiles and solids discharge rates which in turn does provide a strong quantitative basis for the mathematical modelling of packed bed flow and stress fields.

18.2 Industrial background

The need for the measurement and control of bed porosity is well established in industrial applications such as extrusion, tabletting, agglomeration, mixing and blending, dosing and metering of granular materials. Problems range from the lack of control on solids flow rates, build up of adverse pore pressures during solids discharge, to the prevention of particle segregation and attrition during bed compaction and shearing, and to achieving desired bulk density specification of the products. The extent and the frequency of these problems are believed to be closely linked to the transients of the bulk voidage experienced by the particle assemblies during handling in the respective process units. It is hoped that the techniques which provide sufficiently accurate quantification of the bed porosity distribution will eventually be incorporated in the on-line monitoring and control of the process applications cited above.

18.3 Comparison of techniques for voidage measurement

Measurements of flowing bed voidage have not met with much success in the past, largely due to the lack of technology which currently exists in remote imaging. Photography could only be used to visualize voidage patterns next to a transparent wall surface such as in a two-dimensional or a semi-cylindrical vessel (see e.g. Tüzün *et al.*, 1982). The X-ray radiography technique used in the 1970s by such investigators as Bransby and Blair-Fish (1975), relied on the use of lead markers for the identification of deformation patterns during flow. The hazards associated with high-energy radiation and the practical difficulty of developing numerous radiographic plates to cover a few seconds of flow have seriously hindered progress.

The use of probe techniques such as laser, acoustic or fibre optics (see Tüzün *et al.*, 1982) can provide local information around the vicinity of the probe, but often with rather poor spatial accuracy. The electrical capacitance measurements of the granular beds has also been used with some success by workers such as Hancock (1970) to monitor voidage changes during flow. Usually, the measurements of voidage are averaged across the bed cross-section since the accuracy of the capacitance reading deteriorates as one moves from the vessel walls into the centre of the bed. Moreover, to detect changes in voidage on a number of cross-section planes, it is necessary to set up integrated wire circuits on the holding vessel. Thus, in general, the spatial accuracy afforded by the capacitance technique limits its use to the detection of large bubbles or cavities (of the order of centimetres) while monitoring the relative volume fractions of the solid and fluid phases passing through the circuits.

The main consideration in choosing the appropriate imaging technique for the purpose of quantifying the interstitial voidage profiles is the need to achieve the necessary spatial resolution. Various non-intrusive techniques are presently available which are capable of measuring specific properties of optically opaque flowing beds. Kouris *et al.* (1982) have detailed the principles and application of different imaging techniques with ionizing radiation, while similar work has been compiled for non-ionizing radiation based methods by Jackson (1983).

Of the techniques that employ ionizing radiation, the most established are computer-aided photon-transmission tomography (CAT), photon-emission tomography (EM), and positron-emission tomography (PET). CAT is used for measuring the difference in the material electron density, i.e. morphology of the object, whilst EM and PET are employed to measure the distribution of radiation activity within the object, e.g. the position of a positron emitter placed inside the powder bed.

The most popular non-ionizing radiation-based methods include nuclear magnetic resonance (NMR) imaging, ultrasonics and, electrical impedance and capacitance. Of these, only the NMR technique can provide the desired spatial accuracy, but its successful application to solid/gas beds is still to be demonstrated. Although the other non-ionizing radiation based techniques mentioned above suffer from poor spatial resolution, they have the advantage of fast data acquisition at the small capital costs involved (see Williams *et al.*, 1991). Several of these techniques are discussed elsewhere in this volume.

18.4 Photon transmission tomography

The transmission tomography technique employed here has allowed us to quantify interstitial voidage profiles to within 1–2 mm of spatial accuracy, while allowing consecutive scans of many cross-sectional planes at various stages of discharge from an axially symmetric holding vessel. Engaging a system of multiple parallel radiation sources for scanning has ensured that the scan times are reduced to within a few minutes. The high spatial accuracy of the voidage readings provided by the current technique is essential for

detecting the effects of the single-particle properties discussed above on the void structure of the packed beds. Our measurements to date have already revealed reproducible trends in both the horizontal and vertical variations of voidage in different flow regimes corresponding to different stages of batch discharge from a holding vessel.

18.4.1 Mobile multiple source scanner

The scanner employs six $^{153}$Gd emitted, parallel geometry photon beams in conjunction with six collimated CsI scintillation detectors arranged on a circular ring which is placed around the object to be scanned (Figure 18.2). $^{153}$Gd emits photons of predominantly 44 and 100 keV and has a radioactive half-life of about 240 days. The availability of two energies per emission provides the additional opportunity of dual energy transmission tomography and the high specific activity of the sources allows the utilization of high photon fluxes.

Tungsten is used as the collimator material due to its high photon attenuation power as well as its favourable mechanical properties. Collimators with two different aperture widths (1 and 2 mm) were used in the present study to scan 3 mm thick cross-sectional slices of the powder beds. Work is currently underway to update the software to allow use of a 0.5 mm width collimator.

With the six source–detector system used here, each linear scan is performed in one-sixth of the steps required for a single source and detector system such as described by Seville *et al.* (1986). Furthermore, instead of rotating the object to be scanned through the beam (MacCuaig *et al.* 1985), here the object is scanned by the laterally moving source/detector arrangement in steps of 1.0° each followed by a rotation of 1.5° around the object until a full 180° rotation is made (Figure 18.2). Presently, the maximum diameter of the object that can be scanned is 100 mm, but it is planned to increase this to 150 mm in the near future. The shortest total scan time achieved is with the 2 mm wide collimator aperture and is currently of the order of 90 s.

Once the scanning is completed, the aim is then to recover the linear attenuation coefficient values (μ) for each pixel from the set of projections measured at different angles; the reconstructed image for the 1 mm collimator consists of a 155 mm × 155 mm square grid of 1.0 mm × 1.0 mm pixels. The simplest method of 'reconstruction' may be implemented by back-projecting each profile across the plane; applying the magnitude of each measurement to all the points along the ray. However, since each value is applied not only to points of high electron density but to all points along the ray, this method of reconstruction does not produce accurate results. The problem is overcome by mathematically 'filtering' the profiles before back-projecting to reconstruct the image. Such an approach, called 'filtered back-projection', is adopted here for image reconstruction. A description of this and of other reconstruction techniques are reviewed by Brooks and Di Chiro (1976).

The reconstructed image is displayed using a grey scale in which regions with high values are light and regions with low μ values are dark. A linear

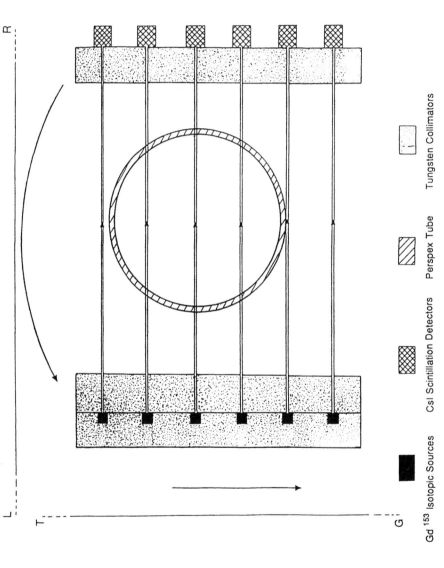

Figure 18.2 *Schematic of the rotating scanner ring comprising six parallel geometry photon beams; also showing the L–R and T–G axes*

Gd 153 Isotopic Sources CsI Scintillation Detectors Perspex Tube Tungsten Collimators

scaling is carried out by considering the lowest and highest μ values for each image.

18.4.2 Procedure for image evaluation

The best resolution currently achievable is given by 1 mm × 1 mm square pixel of 3 mm thickness. With granular materials of different particle sizes in the field of view, two possibilities exist: (1) individual particle sizes are larger than the pixel size in which case the boundaries of individual particles may be observed directly; and (2) the particle sizes are smaller than the resolving element when no particle boundaries will be observed and a volume averaging over each pixel between the particle and the surrounding medium occurs.

Figures 18.3(a) and 18.3(b) compare the reconstructed images of the same horizontal plane across a static granular bed with mono-sized (850–1000 μm) acrylic beads set against a binary mixture of 8.3 ÷ one size ratio of 30% by weight of fines (90–125 μm). Since the individual particle sizes are less than the spatial resolution of the scans, it is not possible to distinguish between these two images by visual inspection. Figure 18.4(a) compares the line profiles of the scaled attenuation coefficients (GS) across the centres of the two images shown in Figure 18.3. In this case, the difference between the two beds is more apparent, with somewhat higher values of the attenuation coefficient for the binary mixture bed.

Given that no useful information could be obtained by visual inspection of the two images, an analytical procedure was developed to extract from the photon attenuation maps the numerical values for the fractional solids content of each pixel within the field. The linear attenuation coefficient at a given discrete photon energy is a strong function of the atomic number of the material's constituting elements as well as its solid density. If particles of the same material are used, the attenuation coefficients will be linearly related to the density and the following equation may be used to calculate the fractional solids content, at position $\eta(x,y)$ of a single pixel:

$$\eta(x,y) = \frac{\mu_{(x,y)} - \mu_{air}}{\mu_{solid} - \mu_{air}} = 1 - \varepsilon(x,y) \tag{18.6}$$

where $\mu_{(x,y)}$ represents the reconstructed linear attenuation coefficient value of the pixel with the unknown solids content and μ_{air} and μ_{solid} are the reconstructed linear attenuation coefficient values of air and solid filled pixels, respectively. In practice, μ_{air} and μ_{solid} are determined by averaging the reconstructed attenuation coefficient values of a representative sample of pixels which are filled totally by air or solid, respectively. Both values therefore have associated standard deviations, which in turn may affect the calculated $\eta(x,y)$ values.

Figure 18.4(b) compares the profiles of solids fraction along the T–G axes of the reconstructed images shown in Figure 18.3. These profiles were calculated by averaging the $\eta(x,y)$ values obtained from eqn (18.1) for each successive line

Figure 18.3 *Reconstructed images of the same horizontal plane across two different static beds. (a) Monosize bed of spherical particles (diameter 850–1000 μm); no flow history; static imaging. (b) Binary mixture bed of 850–1000 μm and 90–125 μm diameter spherical particles; 30% by weight of fines; no flow history; static imaging*

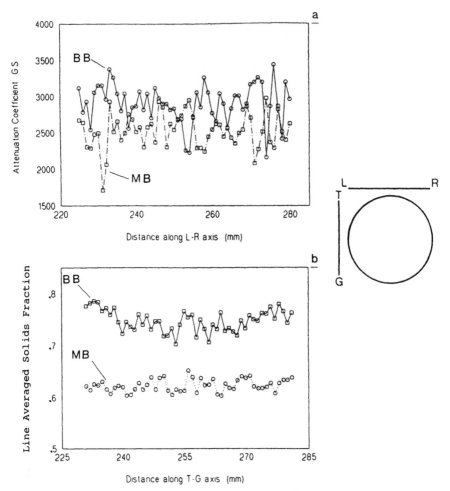

Figure 18.4 *Line scans along the L–R and T–G axes at the same horizontal plane with two different static beds. BB, binary bed; MB, mono-bed*

across the L–R axis. The difference in the solids contents of the mono and binary beds is now quite apparent, as can be seen in Figure 18.4(b).

Computer software has been developed to extract the line profiles of the interstitial voidage both on the Cartesian and polar co-ordinates from the back-projected linear attenuation coefficient maps. The Cartesian co-ordinate system maintains consistency with the pixel geometry (Figure 18.5(a)), whilst the polar co-ordinate system ensures consistency with the hopper geometry (Figure 18.5(b)). In the Cartesian co-ordinate system the average void fraction is calculated on the L–R axis and is plotted in the T–G axis. In the polar co-ordinate system, however, the average values are calculated for a pre-selected radius and plotted for various angles (β) in steps of 1° and from zero to 360°.

Furthermore, the necessary software has been developed to calculate averaged void fraction values for equal-area strips spanning radially away from the centre of the hopper cross-section (Figure 18.5(c)). It is thought that the results together from the three complementary analysis routines provide a complete dataset allowing features such as axial asymmetry and radial variations to be recognized and quantified.

The plane mean void fraction (E) over n pixels per horizontal plane is given by:

$$E = \left[\sum_{i=1}^{n} \varepsilon(x_i, y_i)\right]\bigg/ n = 1 - \left[\sum_{i=1}^{n} \eta(x_i, y_i)\right]\bigg/ n \tag{18.7}$$

where n is the number of pixels in a given planar section and η is the solids fraction of each pixel as defined in eqn (18.1). It must be emphasized, however, that each reconstructed image represents a cross-sectional slice of the object with a finite thickness. The thickness of the slice is determined by the aperture height of the collimator which was kept at 3 mm in the present study. Therefore, the values of ε and η used in eqn (18.2) are averaged over each volume element.

The plane mean void fractions presented here were calculated by considering a central circular region of interest (Figure 18.5(b)), where the minimum distance between the region of interest and the bin perimeter (Δr) is not allowed to be smaller than 8–10 particle diameters, thereby excluding the 'wall effect' on the values of the voidage obtained; see, for example, the report by Laohakul (1978). Further work will address the voidage variations near the walls as a function of wall roughness and hopper half-angle.

18.4.3 Performance of the system

The accuracy of the quantification technique described above was tested using a 'phantom' object constructed from nine Perspex cylindrical pellets of 9 mm diameter (Figure 18.6). Several images of the solids were obtained with different scan times using the 1 mm wide aperture collimator. The fractional solids content in a given region encompassing all the pellets was calculated. The calculated values were all found to lie within $\pm 1.5\%$ of the actual geometric solids fraction.

It is vital to keep the image noise level to a minimum if small differences in local fractional solids contents are to be detected with a high confidence level. The predominant source of noise is inherent in the scanning procedure and is associated with the statistical uncertainty in the recorded ray-sum values.

Provided that an accurate reconstruction is made from M projections, the standard deviation (s.d.) of the density values is related to the number of recorded photons per ray-sum by (Foster, 1981):

$$\text{s.d.} = \frac{k\pi}{\sqrt{(M\bar{I}Bs^2)}} \tag{18.8}$$

where s is the projection step length, \bar{I} is the number of detected photons per

Figure 18.5 *The co-ordinate systems for the calculation of the mean voidage values at the hopper plane, excluding the wall region: (a) Cartesian co-ordinates; (b) polar co-ordinates; (c) annular segment co-ordinates*

Figure 18.6 *Schematic of the Perspex phantom used to test the accuracy of the interstitial voidage quantification technique*

ray-sum, and k is a constant which varies with filter type ($k = 0.289$ for a Bracewell–Ramachandram filter).

A water-filled hopper which is believed to represent a totally homogeneous object was imaged and analysed several times to investigate the effect of the number of recorded events per ray-sum on the image noise. A maximum spread of less than 4% around the mean of the grey levels of the pixels (one standard deviation) was calculated corresponding to scanning times of the order of a few minutes. It is, however, possible to reduce the image noise significantly by increasing scan times several fold. Although, long scan times can be used when scanning static beds, flowing beds require minimum scan times if the local voidage transients are to be detected at all.

Comparison of the results from repeated scans of the water-filled hopper revealed that the plane mean values of voidage were highly reproducible; the spread defined at two standard deviations about the statistical mean of the 'plane mean void fraction' was found to be less than $\pm 1.5\%$. These results were obtained for scans of total duration of the order of about 30 min.

18.4.4 Axially symmetric flow experiments

In a series of experiments involving batch discharge of granular materials from a model hopper unit (Figure 18.7), the interstitial voidage transients occurring in cylindrical and conical hopper sections have been monitored as a function of the duration of discharge. Cross-sectional line profiles in the polar

Figure 18.7 *Schematic diagram of the experimental apparatus*

co-ordinate system of voidage were generated to within 1 ° spatial accuracy at various heights along the model silo using both mono-dispersed and binary mixture beds. In a series of start–stop flow experiments, the same horizontal planes were scanned consecutively, in time steps of 5–10 s over a period of 1–2 min of discharge.

Materials
The particles used throughout the study were polymethyl methacrylate spheres. They had an original size range of 90–1000 μm and were sieved into

the required size classes. Quantimetric analyses were performed on representative samples from each particle batch, the results of which are shown in Table 18.1.

The hopper was filled by pouring the particles down a copper tube of inner diameter 10 mm with its outlet positioned at no more than 100 mm from the free surface of the bed. The binary bed was prepared by mixing small amounts of the particles in the two size classes (combined mass of 15–25 g) and using the copper tube to build up the desired height of the mixture bed.

Model hopper rig

Figure 18.7 shows a schematic diagram of the model hopper rig used in the present study. A 2 m tall Perspex cylinder of 96 mm inner diameter is mounted on a conical hopper section of 10 ° half-angle and a 10 mm diameter orifice so chosen to achieve 'mass flow' condition. The flow experiments reported here were carried out under the open-top condition, although flows in closed-top bins could usefully be investigated in a similar fashion.

The scanner is fixed on a vibration-free stone table and is therefore restricted to imaging on a fixed horizontal plane. To allow for scans at different heights, the model hopper is mounted on an aluminium frame which is driven by a computer controlled stepping motor. The stone table has a hole drilled to match the central opening of the scanner rig, thus allowing the hopper to travel up and down a vertical distance of about 850 mm. Hopper travel over this distance was found to be reproducible to within ± 0.01 mm. The maximum speed of hopper travel was 8 mm s$^{-1}$, and in the range 0.1–3 mm s$^{-1}$ the accuracy of the speed of travel was measured to be better than ± 0.001 mm s$^{-1}$. The versatility of the hopper rig ensures that scanning experiments can be run in one of three modes:

(1) Sequential scanning at different heights in start–stop flow mode to maximize reconstructed image quality.
(2) Sequential scanning at a fixed height during continuous discharge to produce different time-averaged voidage profiles.
(3) Continuous discharge and simultaneous upwards hopper travel at a specified speed to match the flow velocity of the particles. This brings the

Table 18.1 *Material properties*

Particle size class (μm)	*Mean particle diameter* * $\pm \sigma$ (μm)	*Mean sphericity*† $\pm \sigma$ (%)
90–125	110 \pm 13	85.2 \pm 12.6
125–212	179 \pm 25.8	84.3 \pm 7.3
850–1000‡	915 \pm 80.6	88.8 \pm 6.0

*(4 × Surface area/π)$^{0.5}$.
†Sphericity (%) = $4\pi K \times 100$; K = Surface area/ (Perimeter)2.
‡After the hydrometric separation process.

particles moving at the same speed as the hopper travel to relative
stagnation and, therefore, into 'focus' during imaging.

Only results of experiments of type (1) will be illustrated here.

18.4.5 Analysis of experimental data

The experimental scans may be analysed for the following purposes:

- To provide a comparison between the static and flowing voidage profiles
 across different horizontal planes in both the conical and cylindrical hopper
 sections.
- To generate height profiles of the planar void fraction at different stages of
 discharge.

Comparison of static voidage profiles

Figure 18.8 shows some typical data obtained on the variation of the plane

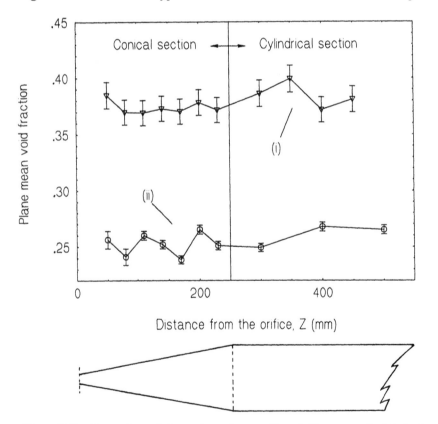

Figure 18.8 *Comparison of the static voidage profiles of: (i) a mono-sized bed of
125–212 μm diameter spheres; and (ii) a binary bed of 75% by weight of 850–1000 μm
and 25% by weight of 125–212 μm diameter spheres*

mean voidage with height in a static bed of mono-sized particles in comparison with a binary mixture of 25% by weight of fines of 5.1 \pm one size ratio. Both sets of results were obtained in the model silo rig shown in Figure 18.7. Each data point in Figure 18.8 was calculated using the procedure described in Section 18.4.2 and given by eqn (18.7). The data obtained over several runs were found to be reproducible to within $\pm 2\%$, as indicated in Figure 18.8. It is not possible to comment on quite how much of this is due to the accuracy of the scanner data analysis and how much is due to the intrinsic assembly fluctuations within the packed beds characteristic of the batch-filling technique used (see Section 18.4.4).

The static bed values of the solids fraction are found not to alter significantly with height in either the cylindrical or the conical sections of the model hopper. Figure 18.8 demonstrates this point, and the mean value of the plane mean solids fractions obtained at 13 different heights under the static condition is reported in Table 8.2. However, there is a somewhat visible increase in voidage in going from the conical to the cylindrical section of the silo rig, in line with the previously measured trends in bulk stress fields set up during filling (see e.g. Tüzün and Nedderman, 1985). Similarly, voidage also appears to increase with approach to the orifice in Figure 18.8; however, the present apparatus arrangement makes it impossible to record data closer than about 50 mm ($\sim 5D_0$). Future work will enable data to be gathered at the vicinity of the orifice plane which is known to affect significantly the mass discharge rates from hoppers (see e.g. Nedderman *et al.*, 1982).

Comparison of flowing voidage profiles

Flow experiments were conducted in the experimental rig shown in Figure 18.7 both with mono-sized and binary mixture samples. A series of cross-sectional scans of the silo contents were obtained at various heights during batch discharge. The static bed height was set at about 700 mm above the orifice prior to each run and the material top surface was found to descend to a height of about 400 mm during a 60 s discharge time. As expected, no significant coning of the top surface was observed during its descent in the cylindrical section of the silo.

Figure 18.9 shows some typical sample data on the flowing voids fraction

Table 18.2 *Solids fractions of binary mixtures of finite particle size ratios (i.e.* $\Phi_R < 10$)

Φ_R	X_f	$(\eta_{mix})_{exp}$	$X_{fl}{}^*$	$(\eta_{mix})_{max}{}^*$
5.1:1	0.25	0.75 \pm 0.02	0.44	0.79
8.3:1	0.30	0.78 \pm 0.02	0.33	0.83

*Comparison of plane mean solid fractions obtained with γ-ray transmission tomography with predictions by Arteaga and Tüzün (1990) of maximum solid fractions of randomly packed binary mixtures. x_{fl}, Predicted weight fraction of fines at maximum solids fraction.

profiles obtained in different co-ordinate systems using the three analysis routines discussed in Section 18.4.2. As indicated in Figure 18.9, the data showing line variation (Figure 18.9(a)) and angular variation (Figure 18.9(b)) of void fraction across a given horizontal plane exhibit large ($\leqslant \pm 10\%$) pixel-to-pixel fluctuation. More importantly, the present technique is able to detect asymmetry about the centre of the flow in both line and polar scan data.

The noise in the voidage scan data is reduced considerably in the example given in Figure 18.9(c), where the voidage values are calculated over annular

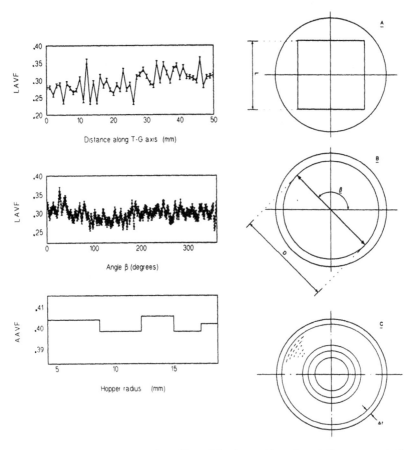

Figure 18.9 *Cross-sectional profiles of flowing voidage in axially symmetric flow.* (a) *Line scan data for a binary bed of 75% by weight of 850–1000 μm and 25% by weight of 125–212 μm diameter spheres after 5 s of discharge at* Z = 230 mm. (b) *Polar scan data for the same binary mixture bed as in* (a) *but after 60 s of discharge and at* Z = 400 mm. (c) *Annular segment scan data for a mono-sized bed of 125–212 μm diameter spheres after 7 s of discharge and at* Z = 140 mm. *LAVF, line averaged void fraction; AAVF, annular averaged void fractions*

segments of equal cross-sectional area across the hopper. The damping effect of averaging voidage fluctuations in flow over distances of some tens of particle diameters rather than a few at a time is self-evident and is demonstrated clearly in Figure 18.9(c).

Figures 18.10(a)–18.10(c) compare the height profiles of plane mean values of voidage obtained at various stages of batch discharge of a mono-bed of fine particles. Similar data are shown in Figures 18.11(a)–18.11(c) for a binary mixture comprising the same fine particles in the presence of a 75% by weight of large granules of 5.1 ÷ 1 size ratio.

Considering first the mono-bed of fines data (Figure 18.10), two main features emerge: (1) there appears to be a well-defined voidage maximum within the conical section, the position of which is shown to propagate up the silo with continued discharge; and (2) the interstitial voidage attains a

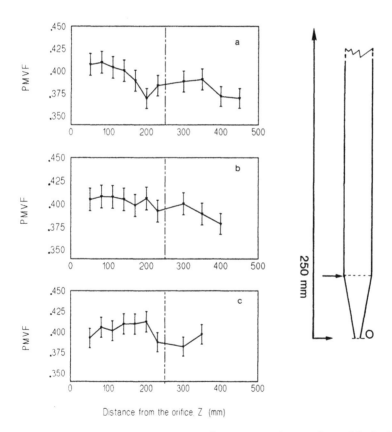

Distance from the orifice, Z (mm)

Figure 18.10 *Vertical profiles of the plane mean voidage in the model silo during batch discharge of a mono-sized bed of 125–212 μm diameter spheres. (a) After 7 s of discharge. (b) After 18 s of discharge. (c) After 51 s of discharge. PMVF, the plane mean void fraction*

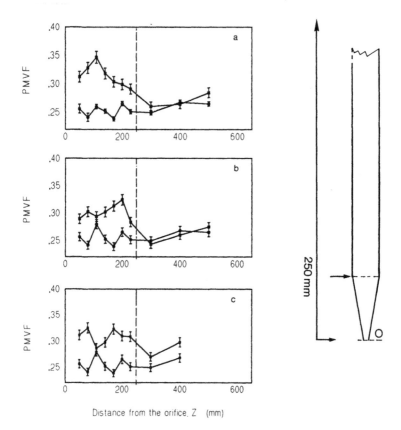

Distance from the orifice, Z (mm)

Figure 18.11 *Vertical profiles of the plane mean voidage in the model silo during batch discharge of a binary mixture bed of 75% by weight of 850–1000 μm and 25% by weight of 125–212 μm diameter spheres in comparison with the initial static fill voidage profile. (a) After 5 s of discharge. (b) After 20 s of discharge. (c) After 60 s of discharge. PMVF, the plane mean void fraction*

minimum value within the cylindrical section close to the cylinder/cone transition plane.

Similar observations are also applicable to the profiles shown in Figures 18.11(a)–18.11(c) for the binary mixture. However, this time, the positions of voidage maxima and minima are much more sharply defined. An important feature of Figure 18.11 is the dynamics of the voidage maximum in the conical section. It has been assumed by many workers previously that the position of the voidage maximum is a static feature of the fully developed flow fields in conical hoppers where the position is altered only by altering the hopper half-angle and the level of surcharge on the conical section (see e.g. Spink and Nedderman, 1978; Gu *et al.*, 1991). In Figure 18.11, the position of the voids maximum is seen to propagate up the cone with a decaying magnitude, while a second maximum is seen to emerge behind it with an increasing amplitude.

This clearly indicates a dynamic wave behaviour, strongly linked to the material properties of the flowing beds as well as the percolation behaviour of the interstitial air through the bed.

18.4.6 Discussion of experimental results

Comparison of experimental and theoretical values of mean voidage

Table 18.2 compares the statistical average of the plane mean values of the static solids fraction obtained from the tomographic scans at 13 different heights with the theoretical maxima predicted by Arteaga and Tüzün (1990) for the corresponding particle-size ratios. Details of their calculations are given elsewhere (Arteaga and Tüzün, 1990; Tüzün and Arteaga, 1991) and will not be repeated here. The agreement between theory and experiment is encouraging, especially in the case of $\Phi_R = 8.3$ (as is also revealed by Figure 18.4(b)).

Calculation of propagation velocity of voidage maximum during flow

Using the type of data presented in Figure 18.11, an empirical procedure was adapted to calculate the voidage maximum propagation velocity within the conical hopper. Figure 18.12(a) shows a second-order polynomial fit to data used to calculate the position of the voidage maximum as a function of the discharge time. The results are shown in Figure 18.12(b), where the position of the voidage maximum is plotted against the 60 s discharge time. Here the data point corresponding to the 60 s discharge time was generated by fitting a third-order polynomial to the voidage profile in Figure 18.11(c) due to the pronounced second peak following the first one. Furthermore, the data presented in Figure 18.12(b) are fitted with another second-order polynomial so as to allow the calculation of the velocity of void propagation as a function of discharge time.

It is worth noting here that a second-order fit to the voidage wave velocity profile, results in a constant rate of deceleration of the wave velocity with height above the outlet (i.e. $dV_\varepsilon/dr = $ constant). This is at odds with a radial velocity field which would predict:

$$V_\varepsilon \propto \frac{1}{r^2}$$

and therefore:

$$\frac{dV_\varepsilon}{dr} \propto \frac{1}{r}$$

where r is the radial distance from the hopper outlet.

However, further inspection of the available data has revealed no significant reduction in errors by fitting a third-order polynomial to the wave velocity

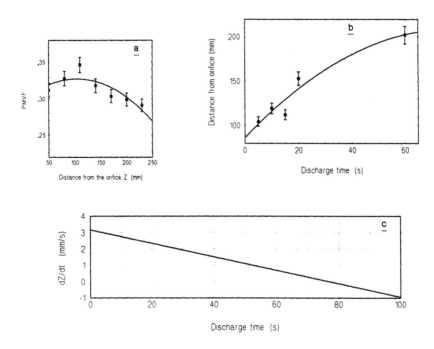

Figure 18.12 *Calculation of propagation velocity of the voidage maximum during batch discharge of a binary mixture bed of 75% by weight of 850–1000 μm and 25% by weight of 125–212 μm diameter spheres. (a) Variation in the plane mean void fraction (PMVF) in the cone section after 5 s of discharge. (b) Point of maximum voidage versus discharge time. (c) Velocity of maximum voidage versus discharge time*

profile shown in Figure 18.12. It is suspected that the significant variation (if any) in the rate of deceleration of the wave velocity will be confined to a small region very close to the outlet plane, which will be the subject of further study in that region.

Figure 18.12(c) shows a plot of void maximum propagation velocity versus the discharge time obtained by differentiating the curve in Figure 18.12(b). Extrapolation to zero time results in a maximum value of the propagation velocity of about 3.2 mm s$^{-1}$. Similarly, propagation velocity is reduced to zero after about 75 s of discharge. Clearly, flow times in excess of 75 s are required in this case to verify the time constants for these voidage transients.

Calculation of rate of descent of top surface during batch discharge

The mass discharge rate from the orifice was determined during the period of descent of the material top surface in the cylinder. Table 18.3 gives the discharge rate data for the binary mixture voidage profiles shown in Figure 18.11. It is possible to relate the mass discharge rate (W) to the descent velocity (V_d) of the material top surface in the cylinder by:

$$V_{\mathrm{d}} = \frac{W}{\pi \cdot R \cdot \rho_{\mathrm{s}}^2 (1 - \varepsilon_{\mathrm{f}})} \tag{18.9}$$

where R is the cylinder radius, and ρ_{s} and ε_{f} are the solids density and flowing bed voidages, respectively. Using the plane mean values of flowing voidage obtained from tomographic scans (Table 18.3), the descent velocity (V_{d}) of the material top surface in the cylinder were calculated as a function of discharge time. These results are also tabulated in Table 18.3.

These results indicate that the material top surface starts to descend within less than 5 s of discharge. The apparent time constant for the decay of the voidage wavefront is about 75 s, as shown in Figure 18.12. Hence it is fair to say that the observed propagation of voidage wave is not an initial transient feature of the flow field, but a permanent cyclic phenomenon with a time constant much larger than the duration of the initial transient.

18.5 Conclusions

A novel computerized scanner featuring a multiple source and detector ring for γ-ray transmission tomography is developed specially to measure static and flowing voidage profiles of granular beds in axially symmetric containers. The present equipment provides spatial resolutions of 1–2 mm in imaging combined with scan times of the order of a few minutes. These features make it ideal for its use in continuous imaging of flowing particle beds in a number of modes, as described above.

The values of solids fractions obtained in static and flowing beds compare well with the theoretical values corresponding to the random packings of mono-sized and binary mixtures of spheres. The error analyses carried out on the accuracy and the reproducibility of the tomographic scan data have revealed less than $\pm 1.5\%$ error in the values of the plane mean voidage and

Table 18.3 *Discharge and material top surface descent rates**

t^* (s)	W (g s$^{-1}$)	$1 - \varepsilon_f$	V_{d} (mm s$^{-1}$)
0	—	—	—
5	11.3	0.720	1.92
10	14.43	0.724	2.43
15	15.74	0.709	2.71
20	16.17	0.733	2.69
60	17.25	0.702	3.00

*75% by weight of 850–1000 μm and 25% by weight of 125–212 μm diameter spheres. For explanation of the notation, see Section 18.5.3.

less than $\pm 4\%$ in the values of the solids fraction calculated per pixel volume along the cross-sectional line profile taken over scan times of the order of a few minutes.

The voidage profile data generated in the model silo are used to identify the planes of maximum and minimum voidage as well as that of the propagation velocity of the voidage maximum as a function of the time of discharge. These results agree well with the expected initial flow transients and the subsequent flow regime transitions in the cylindrical and conical sections of the model silo. Further study of the voidage wave propagation described here should prove valuable in modelling the interstitial fluid and particle percolation patterns in packed bed flows.

Acknowledgements

The authors would like to thank Surrey Medical Imaging Systems Ltd, Surrey University Research Park, for the design and construction of the CAT Scanner Facility and the associated software. The SERC (EPSRC) major equipment grant and the research funding provided under the Specially Promoted Programme in Particle Technology are also gratefully acknowledged.

References

Arteaga, P. and Tüzün, U. (1990) Flow of binary mixtures of equal-density granules in hoppers – size segregation, flowing density and discharge rates. *Chem. Eng. Sci.*, **45**, 205

Bransby, P. L. and Blair-Fish, P. M. (1975) Initial deformation during mass flow from a bunker: observation and idealization. *Powder Technol.*, **11**, 273

Brooks, R. A. and Di Chiro, G. (1976) Principles of computer assisted tomography (CAT) in radiographic and radioisotopic imaging. *Phys. Med. Biol.*, **21**, 689

Clift, R. (1985) Particle–particle interaction in gas particle systems. *Inst. Chem. Eng. (G.B.) Symp. Ser. No. 91.*

Crewdson, B. J., Ormond, A. L. and Nedderman, R. M. (1977) Air impeded discharge of fine particles from a hopper. *Powder Technol.*, **16**, 197

Cumberland, D., and Crawford, R. J. (1987) The packing of particles. In *Handbook of Powder Technology*, Vol. 6 Elsevier, Amsterdam, 59

Dodds, J. A. (1980) The porosity and contact points in multi-component random sphere packings calculated by a statistical geometric model. *J. Coll. Interface Sci.*, **77**, 317

Ergun S. (1952) Fluid flow through packed columns. *Chem. Eng. Prog.*, **48**, 89

Foster, J. (1981) Computerised tomographic gamma-ray scanning system for non-destructive testing. Ph.D. Thesis, University of Surrey, Guildford, Surrey

Gu, Z. H., Arnold, P. C. and McLean, A. G. (1991) Prediction of air pressure distribution in mass flow bins. *Powder Technol.*, **72**, 157–166

Hancock, A. W. (1970) Stress on bunker walls. Ph.D. Thesis, University of Cambridge, UK

Jackson, D. F. (1983) *Imaging with Non-Ionizing Radiations* Surrey University Press, Guildford, Surrey

Kouris, K., Spyrou, N. M. and Jackson, D. F. (1982) *Imaging with Ionizing Radiations* Surrey University Press, Guildford, Surrey

Laohakul, C. (1978) Velocity distribution of flowing granular materials. Ph.D. Thesis, University of Cambridge, UK

MacCuaig, N., Seville, J. P. K., Gilboy, W. B. and Clift, R. (1985) Application of gamma-ray tomography to gas fluidized beds. *Appl. Opt.*, **24**, 4083

McGeary, R. K. (1961) Mechanical packing of spherical particles. *J. Am. Ceram. Soc.*, **44**, 513

Molerus, O. (1980) A coherent representation of pressure drop in fixed beds and of bed expansion for particulate fluidized beds. *Chem. Eng. Sci.*, **55**, 1331

Nedderman, R. M., Tüzün, U., Savage, S. B. and Houlsby, G. T. (1982) The flow of granular materials. I: Discharge rates from hoppers. *Chem. Eng. Sci.*, **37**, 1597

Nedderman, R. M., Tüzün, U. and Thorpe, R. B. (1983) The effect of interstitial air pressure gradients on the discharge from bins. *Powder Technol.*, **35**, 69

Ouchiyama, N. and Tanaka, T. (1989) Predicting the densest packings of ternary and quaternary mixtures of solid particles. *Ind. Eng. Chem. Res.*, **28**, 1530

Rathbone, T., Nedderman, R. M. and Davidson, J. F. (1987) Aeration, deaeration, and flooding of fine particles. *Chem. Eng. Sci.*, **42**, 725

Seville, J. P. K., Morgan, J. E. P. and Clift, R. (1986) Tomographic determination of voidage structure of gas fluidised beds in the jet region. In *Proceedings of the V World Conference on Fluidisation; Elsimore, Denmark* Engineering Foundation, New York, 87

Sherrington, P. J. and Oliver, R. (1984) Granulation. *Monographs in Powder Science and Technology* Heydon, London

Spink, C. D. and Nedderman, R. M. (1978) Gravity discharge rate of fine particles from hoppers. *Powder Technol.*, **21**, 245

Stovall, T., De Larrard, F. and Buil, M. (1986) Linear packing density model of grain mixtures. *Powder Technol.*, **48**, 1

Tüzün, U. (1988) Effects of consolidation and yield history on the measured angles of friction of particulate solids. In *Tribology in Particulate Technology* (eds M. J. Adams and B. J. Briscoe) Adam Hilger, New York, 38

Tüzün, U. and Arteaga, P. (1991) Microstructural effects on stress and flow fields of equal density granules in hoppers. *Proc. Inst. Mech. Eng.* (*G.B.*), **12**, 265

Tüzün, U. and Nedderman, R. M. (1982) An investigation of the flow boundary during steady-state discharge from a funnel-flow bunker. *Powder Technol.*, **31**, 27

Tüzün, U., Houlsby, G. T., Nedderman, R. M. and Savage, S. B. (1982) The flow of granular materials. II: Velocity distribution in slow flow. *Chem. Eng. Sci.*, **37**, 1691

Tüzün, U., Adams, M. J. and Briscoe, B. J. (1988) An interface dilation model for the prediction of wall friction in a particulate bed. *Chem. Eng. Sci.*, **43**, 1083

William, R. A., Xie, C. G., Dickin, F. J., Simons, S. J. R. and Beck, M. S. (1991) Multi-phase flow measurements in powder processing. *Powder Technol.*, **66**, 203

Yu, A. B. and Standish, N. (1988) An analytical-parametric theory of the random packing of particles. *Powder Technol.*, **55**, 171

Notation

A	empirical stress coefficient in eqn 3a
B	empirical stress coefficient in eqn 3b
D_0	orifice diameter
d_p	particle diameter
E	plane mean void fraction
grad p	pore pressure gradient
grad p_0	pore pressure gradient at the orifice
$^{153}$Gd	Gadilinium isotope of atomic mass number 153

g	gravitational acceleration
I	the average number of detected photons per ray-sum
K	empirical coefficient in the Ergun equation
K'	empirical coefficient in the Ergun equation
k	reconstruction filter dependent constant
M	number of projections in a complete scan
R	cylinder radius
r	radial distance from the hopper outlet
Δr	minimum distance between region of analysis and silo wall
s	projection step length
s.d.	standard deviation of the density values
U_f	interstitial fluid velocity
U_s	velocity of solid particles
ΔU	slip velocity
V_d	descent velocity of the material top surface
V_E	voidage wave velocity
W	mass discharge rate

Greek Letters

β	Angle used in the definition of the polar co-ordinate system
ε	interstitial void fraction
ε_o	interstitial void fraction at the orifice
ε_f	flowing bed interstitial void fraction
Φr	particle size ratio
μ	linear photon attenuation coefficient
μ_f	fluid viscosity
η	interstitial solid fraction
ρ_f	fluid density
ρ_s	solids density
σ	consolidation stress

Subscripts

AIR	totally in air
f	flowing bed
MAX	maximum
MIX	mixture
SOLID	totally in solid

Chapter 19

Powder mixing

J. Bridgwater

19.1 Introduction

The mixing together of powders and granular materials remains a Cinderella subject within chemical engineering. Although it has always been of importance to civilization, only in the last 50 years has there been much progress in developing understanding, and since then knowledge has crept ahead slowly. While it is considered that the crucial mechanisms at work have been inferred, it is now time to see if the inferences are sound and the subject can be advanced significantly using techniques such as position-emission tomography. The utility of this technique for tracking single particles and line sources is illustrated in this chapter.

19.2 Principles and significance of powder mixing

We have available two recent thorough surveys of the literature on powder mixing, one by Fan *et al.* (1990) and another by Poux *et al.* (1991). These works provide a great deal of information for the present discussion. Bridgwater (1976) thoroughly surveyed the fundamental mixing mechanisms and, recently, he (Bridgwater, 1990) took another look at the subject. The latter survey in part looked at the content of articles published in *Powder Technology* in 1990 and showed that the topics were generally the same ones that had been under scrutiny some 20 years before. The present discussion seeks to put a perspective on these contributions.

It is clear from the efforts of many workers that the need to understand the unit process of powder mixing remains a most important area of endeavour for engineering scientists, one driven by the need to understand an area of considerable industrial significance. The range of interest is potentially considerable – animals feeds, foods, ceramics, pigments, cosmetics, pharmaceuticals, chemicals, to name just a selection. Powder mixing is often the key stage that can control the quality of the final product, and so interest in the subject is far from academic.

Poux *et al.* (1991) provide an account which, like that of Fan *et al.* (1990), is comprehensive, readable and useful. Poux *et al.* set as their goal 'to review and update the available data on powder mixing in vessels' and their agenda was in particular

- Review of fundamental principles and definitions.
- Existing powder mixers and their characteristics.
- Assessment of homogeneity by mixing index and technical methods.
- Numerical model (*sic*) to simulate the mixing process.

It is convenient here to structure this discussion under some of the issues raised.

19.2.1 Mixture quality and mixing indices

It is important to distinguish between mixing duties, for which it is necessary that microscopic structure is correct (as might be necessary prior to carrying out a chemical reaction), from those for which it is required that a batch of the product, say a packet to be marketed, shall have within it the desired relative proportion of the constituents. The microstructure could be described by using autocorrelation and cross-correlation techniques, but this has not yet been carried out experimentally. It remains to be seen how useful such methods will prove in view of the tendency in many powder mixing systems for there to be significant variations in the concentrations of components with long-range position. With regard to viewing a mixture structure on the scale of a packet, or scale of scrutiny as it is known, this can be satisfactorily deployed to look at a sequence of samples being withdrawn from a mixer. Indeed, as this is an examination of the stream coming from the mixer, this measurement is physically sensible. However, there is still the significant problem of how to analyse the samples in a time such that the findings will be of any use, nor does it say anything to us about the processes occurring in the mixer and also in the process of discharge from the mixer. With regard to the microscopic structure, the very process of sampling disturbs the structure and there are constant worries that it biases the concentration measurement. If the technique were one of examining, say by a light reflectance method, what is seen at an external surface or at the end of an inserted probe, there are always worries that what is seen is merely that which is seen at a surface.

With regard to the definition of mixing indices, Poux *et al.* (1991) point out that each author gives his or her own definition and that, in part because of the sheer diversity of applications, general selection criteria for mixers do not exist. A difficulty in assessing the quality of a mixture stems from relating the information obtained from samples of different sizes. For example, if one particle is examined the system appears unmixed, whereas if the whole system were sampled it would necessarily appear well mixed. This issue has bedevilled the literature with some authors apparently not appreciating that in reporting variances of sample concentrations the results are affected by sample size. Added to this is the practical difficulty of withdrawing a sufficient number of samples for the statistical assessment of the variance of sample concentrations to be of much use. Forty samples is an oft-quoted number. It is generally impracticable to consider taking such a quantity of data, even in fundamental studies this is very rare. The time necessary to analyse samples means that 'on-line' control is not possible.

Poux *et al.* (1991) concluded that: 'the nomenclature created by many authors to reflect the nature of mixing becomes more and more complex. In consequence, the authors propose a plethora of different definitions which results in a confused nomenclature . . .'; '. . . the same problem occurs with mixing indices, each author giving his own definition . . .'; and '. . . the many types of powder mixers developed are due to the diversity of products and their uses . . .'. This shows that general criteria do not exist for selecting a device as a function of the nature of the ingredients. In their concluding remarks, Poux *et al.* say '. . . the observations presented in this survey clearly show that new approaches are necessary . . .'. In their work, Fan *et al.* (1990) included the concluding remark that '. . . representation of the complex characteristics of a solids mixture through any available mixing index appears to be far from satisfactory . . .'.

This discussion immediately points out the need for modern imaging and data-acquisition technologies. We need to have methods for following the motion of individual particles or groups of particles. We need to be able to analyse the structure either on-line during operation or, failing that, on stopping the mixer, but without touching the mixer contents. Only in this way will it be possible to obtain information, and process it so that we can readily obtain quantification of the structure developed, and thereby devise sound engineering techniques for the description of structure.

19.2.2 Mixing mechnisms

Poux *et al.* (1991) review the classical mechanisms that have been advanced, namely mixing by convection, mixing by diffusion, and shear mixing. Mixing by convection causes a body of powder or groups of particles to be moved from one place to another. Convection is supposed to cause progressive subdivision of clumps and to promote an increase in contact and between components. Mixing by diffusion is a process that leads to fine scale mixing, being responsible for the particle–particle neighbours. Shear mixing is associated with the development of slip planes in a deforming powder and may be linked to the other two mechanisms.

It is not at all clear that identification of these mechanisms has served to advance the subject greatly and it is useful to reflect briefly on how a powder behaves when under shear. When subject to a known normal stress, a powder of known voidage will initially be subject to a small displacement that changes the particle orientations but does not change the particle neighbours. When greater shear is imparted, a slip zone or shear zone is created, this being about 10 particle diameters in width, and the particle neighbours changing rapidly. Only if a powder is extremely loosely packed initially will deformation throughout the bulk occur. If the initial voidage is changed, this will affect the conditions under which shear will occur. If the initial composition of the material is changed, this will again influence the conditions of shear.

It is a truism that particle–particle interactions are most significant in mixing. Consider first of all cohesive mixing, i.e. mixing in which the forces

between particles are less than the force of gravity separating one particle from another. Cohesion may arise from a number of sources, for example due to electrostatic double layers, van der Waals' forces, or surface tension due to free liquid. Agglomerates of such particles will generally exist and the process of mixing will promote both the destruction of agglomerates and the formation of new ones; we are then concerned with describing the dynamic behaviour of the agglomerate size distribution and the progressive change in composition of the various parts of an agglomerate size distribution. There has been considerable interest, notably for pharmaceutical applications, in so-called ordered mixing, a cohesive mixing process in which one set of particles is coated by another set.

Cohesionless systems have a number of processes at work that can either enhance mixing or inhibit it. For instance, if material is thrown into the gas phase, effects arise due to different particles flowing different tracks, and 'free-flight' segregation is said to exist. However, there are also processes occurring in the bulk of powders or in the surface regions which, though still in the bulk, are very close to the free surface. Within the bulk, segregation due to difference in size can occur in the failure zones, whereas near the free surface, a phenomenon called 'free surface segregation' arises, in which segregation is found to be dependent upon both size and density. The mode of any impacting into a free surface is also of importance. A summary of some such fundamental studies was given by Bridgwater *et al.* (1983) and by Drahun and Bridgwater (1983).

Thus the issue of powder mixing mechanisms proves somewhat problematical. There are sweeping descriptions such as 'shear mixing', but it is not clear precisely what this is and it is not possible, at least yet, to study the phenomenon separately, so that we can use it in any predictive sense. On the other hand, there are a number of proposals regarding potential mechanisms such as interparticle percolation, but it is not all certain when one of these is really important and how it integrates into the behaviour of the system as a whole.

Fan *et al.* (1990) chose to treat mixing mechanisms as diffusion, convection and diffusion–convection. They consider that stochastic processes are likely to find favour over deterministic ones. This could well be so, but the rules determining the stochastic processes need to be understood. When it is possible to have such broad conjectures on how the mixing process takes place, the need for direct measurements of the processes are critical. These are presently denied to us.

It is clear that we need direct observation of the internal flows to provide a means of cutting through to determine the critical or rate-determining steps.

19.2.3 Mathematical models

Poux *et al.* (1991) look at the mathematical models which have been employed to examine the mixing process and they point out that Markov chain processes, Monte Carlo techniques and use of the diffusion equation have each been employed. However, all such approaches contain adjustable

parameters, and the present author rather reserves the position in this area until we are in a position to use physically based models. Perhaps the one exception to this is modelling of the rotating horizontal drawn by the diffusion equation in which the mechanism of axial dispersion is the displacement of particles tumbling down the free surface. However, this is only useful for self-diffusion, since particles of different types are classified by the rolling action.

Fan *et al.* (1990) consider that much progress has been made in powder mixing, but on the other hand stress that '. . . an effective design procedure employing both heuristics and algorithms needs to be developed . . .'. They argue for the development of expert systems to promote a systematic approach and to incorporate all the information generated to date. This is not a view shared by the present author. It must be remembered that we do not know what is going on inside mixers, it is almost like not knowing about laminar and turbulent flow of fluids and suddenly having Osborn Reynolds come and inject a dye so that we could see what is happening. The subject is rather at a stage that will benefit from visualization; this is to be followed by an understanding of mechanisms and, yet later, a quantitative and scientifically based means of developing performance analysis and equipment design.

19.3 Application of positron-emission tomography

The poor state of knowledge in powder mixing is a consequence of an inability to see what is happening and hence there is now considerable interest in using, *inter alia*, positron-emission tomography to unravel some of the problems. Parker *et al.* (1993) have given details of the positron-emission camera available at the University of Birmingham and have described the general approaches that are available. A fuller discusion of this is given in Chapter 12. The scale of view is currently 350 mm × 300 mm × 300 mm. A positron emission is inferred from the two γ-rays created by its annihilation by an electron within a millimetre of its point of emission in a dense phase system such as a powder. These γ-rays are detected on two multi-wire detectors, coincident pulses enabling one to know the line along which the positron annihilation occurred. There are a number of ways of using the technique, one relying on single positron-emitting particles. From determination of the equations of successive lines, the position of the emitter is determined. Methods have been developed to allow for γ-ray scatter. It is possible to record about 3000 estimates per second of the position of a positron-emitting carrier particle. Grouping these together it is possible to form a reliable estimate of particle position about 30 times per second. With a particle moving at about 2 m s$^{-1}$, its position is known to within about 10%, and with it moving slowly its position is known to within 2–3 mm. Active particles of a size of 1 mm or greater can be used. The potential for this technique to be used to develop this subject is assessed below with reference to three pieces of work.

19.3.1 Solids mixing in a fluidized bed

Studies of a fluidized bed have been used for coal combustion in which it was proposed to collect and extract large lumps of minerals within the coal by use of a sloping fluidized bed distributor. It was anticipated that the lumps of mineral would sink to the bottom of the bed and then slide down the sloping distribution to a removal point. Studies were carried out in a fluidized bed having a sloping base of 360 mm which was 150 mm wide. The bed was fluidized with sand a large particle of 12 mm glass loaded with a $^{22}$Na source of 2 mm diameter inserted into it through a drilled hole that was then sealed.

The results from one set of experiments is shown in Figure 19.1. The elevation shows the positron emitter falling to the base and then being moved up the fluidized bed distributor to the top of the plate. The downwards movement is corroborated in the end elevation. The plan view shows the lateral movement, which occurs mainly in the lower portion of the bed. Once on the distributor, the particle moves gradually up the slope, passing first towards a wall and then away from and ultimately coming to a stable position at the top of the perforated plate distributor. Of course, this had quite a profound effect on the bed design. The behaviour is explained by the existence of a bulk flow pattern in the fluidized solids. Owing to the lower hydraulic

Figure 19.1 *The motion of a 12 mm glass sphere in a fluidized bed of sand with a sloping perforated distributor plate*

resistance at the top of the plate due to the lower level of solids, the fluidizing velocity was greater at the plate top than the plate bottom. This in turn induces solids to flow up the plate and, as a consequence, there is an opposite net horizontal flow of solids near the surface of the fluidized bed.

19.3.2 Paste flow: line and volume sources

This technique can be useful for cohesive powders and pastes. The potential has been shown in work to obtain direct information on the extrusion of a paste from a barrel through a convergent nozzle into a die land. Work on a barrel of diameter 75 mm is shown in Figure 19.2. Here a line of radioactive material has been injected into the paste, $^{68}$Ga being used as the label. In this instance the paste flow has been stopped and the resultant array analysed by a more complicated algorithm, the line deformation being given by the locus of the most probable positions, it being physically known that the initial line source can be thought of as an extending thread. It shows that paste slip occurs at the walls and that the flow down the convergent section is not axisymmetric. Furthermore, the main flow occurs from the central core of the core into the die level. As a consequence, there must be a radial component of velocity to draw the paste into the more rapidly moving stream around the axis.

Imaging methods for examining the dispersion of a marked volume of material are currently being developed.

Figure 19.2 *Flow of paste from a barrel into a die land. The deformation of a line source as a function of barrel displacement is shown. The results of five analyses are superimposed*

19.3.3 Powder mixing in rotary device

Two types of mixer have been given some scrutiny, together with studies in rotary horizontal cylinders, and work is about to start on a further mixer type. However, the most detailed studies have been carried out on a small Lödige powder mixer (Figure 19.3). The powder in the mixer is a form of sodium phosphate of about 500 μm in size and the tracer diameter is 7 mm. The mixer is 140 mm in diameter, 180 mm long and has two ploughshare-type blades mounted on the central shaft together with a scraper blade at each end. The blade speed is 4 Hz, giving a blade tip speed of 1.8 m s$^{-1}$.

When the mixer is 16% full of powder, the relationship between axial position of the tracer and time is as depicted in Figure 19.4. The particle stays in one location, and after an uncertain period moves to another. There are three preferred regions of location corresponding physically to the three regions of space between the two blades and the two end wall scrapers. When the average occupancy in the radial plane is examined we have the distribution shown in Figure 19.5, with the associated distribution of mean velocity vectors also being included. However, when the mixer is sliced into five equal axial portions, we get differences (Figure 19.6) for the local radial distribution of material and its local velocity distribution. It can be seen that the technique detects significant variations in behaviour which must be related to the fine detail of the equipment design (as yet unknown). All such issues are currently under intense scrutiny and it is hoped that an authoritative analysis will be available in the open literature within the next 12 months. However, when one considers the wealth of studies carried out on the flow and mixing of gases and

18cm

Figure 19.3 *Lödige mixer for powder mixing studies*

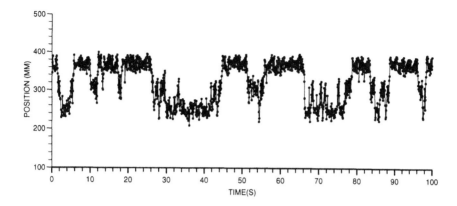

Figure 19.4 *Axial variation of the position of the positron-emitting particle in the Lödige mixer (16% full)*

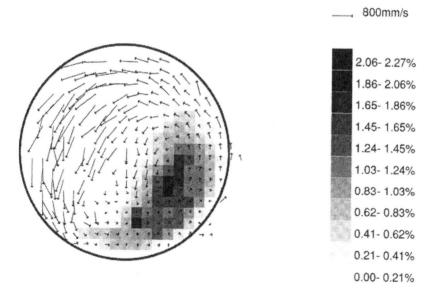

Figure 19.5 *Axially averaged position in a radial plane and the associated mean velocity vectors*

liquids, it has to be appreciated that we are only now at the very earliest stages of gaining scientific understanding of powder mixing.

The process of experimental interpretation still requires much care and needs to be based on a grasp of fundamentals. Thus single-particle tracking necessarily needs to take account of mechanisms such as interparticle percolation and free surface segregation. For example, while a large particle

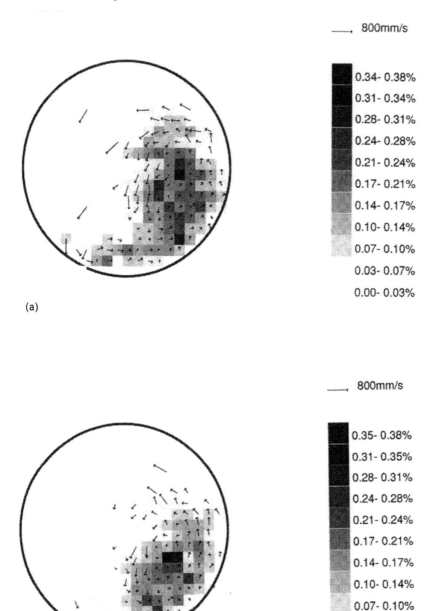

(a)

(b)

800mm/s

	0.34- 0.38%
	0.31- 0.34%
	0.28- 0.31%
	0.24- 0.28%
	0.21- 0.24%
	0.17- 0.21%
	0.14- 0.17%
	0.10- 0.14%
	0.07- 0.10%
	0.03- 0.07%
	0.00- 0.03%

800mm/s

	0.35- 0.38%
	0.31- 0.35%
	0.28- 0.31%
	0.24- 0.28%
	0.21- 0.24%
	0.17- 0.21%
	0.14- 0.17%
	0.10- 0.14%
	0.07- 0.10%
	0.03- 0.07%
	0.00- 0.03%

Figure 19.6 *Position in a radial plane averaged over each of the slices A, B, C, D, E and the associated mean velocity vectors averaged in each slice. A, E are end slices*

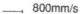

800mm/s

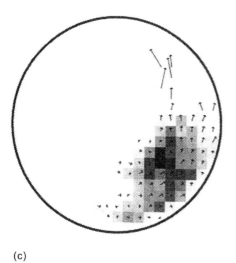

0.37- 0.41%

0.33- 0.37%

0.30- 0.33%

0.26- 0.30%

0.22- 0.26%

0.19- 0.22%

0.15- 0.19%

0.11- 0.15%

0.07- 0.11%

0.04- 0.07%

0.00- 0.04%

(c)

800mm/s

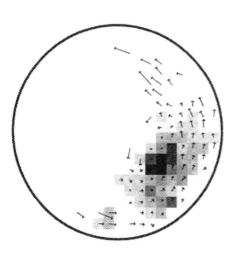

0.36- 0.39%

0.32- 0.36%

0.28- 0.32%

0.25- 0.28%

0.21- 0.25%

0.18- 0.21%

0.14- 0.18%

0.11- 0.14%

0.07- 0.11%

0.04- 0.07%

0.00- 0.04%

(d)

Figure 19.6 (*continued*)

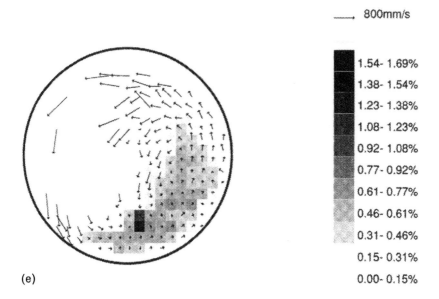

(e)

Figure 19.6 *(continued)*

will follow fine particles in the bulk, in any free space above the bulk or on the free surface, it will be different. Even with a bulk of fine particles, there will be small effects that have a significant effect after many revolutions as in the phenomenon of particle migration, i.e. the movement of large particles to the position of maximum rate of strain (Foo and Bridgwater, 1983).

19.4 Conclusion

Powder mixing is a rather poorly developed subject area which requires a good method to enable us to visualize flows so that mechanisms can be understood and the influence of particle properties and equipment design determined. Positron-emission tomography is a method which does allow progress to be made. Single-particle tracking using a tracer down to about 1 mm diameter has been demonstrated and this can operate with continuous data acquisition. Techniques for determining a marked volume of particles of any size are being developed, these relying on stopping the mixing process in order to determine structure.

Acknowledgement

Thanks are due to the Engineering and Physical Sciences Research Council and to Unilever for support. The project is one jointly organized by the School

of Chemical Engineering and the School of Physics and Space Research at the University of Birmingham, and particular thanks are due to Dr T. D. Beynon and Mr C. J. Broadbent.

References

Bridgwater, J. (1976) Fundamental powder mixing mechanisms. *Powder Technol.*, **15**, 215–236

Bridgwater, J. (1990) Mixing and kneading – an overview. In *Proceedings of the 2nd World Congress on Particle Technology, Kyoto, 19–22 September*. Society of Powder Technology, Japan, Part III, 228–238

Bridgwater, J., Cook, H. H. and Drahun, J. A. (1983) Strain induced percolation. *Inst. Chem. Eng. Symp. Ser.*, **69**, 171–191

Drahun, J. A. and Bridgwater, J. (1983) The mechanisms of free surface segregation. *Powder Technol.*, **36**, 39–53

Fan, L. T., Chem, Y.-M. and Lai, F. S. (1990) Recent developments in solids mixing. *Powder Technol.*, **61**, 255–287

Foo, W. S. and Bridgwater, J. (1983) Particle migration. *Powder Technol.*, **36**, 271–273

Parker, D. J., Hawkesworth, M. R., Beynon, T. D. and Bridgwater, J. (1993) Process engineering studies using positron-based imaging techniques. In *Tomgraphic Techniques For Process Design and Operation* (eds. M. S. Beck *et al.*), Computational Mechanics Publications, Southampton, 239–250

Poux, M., Fayolle, P., Bertrand, J., Bridoux, D. and Bousquet, J. (1991) Powder mixing; some practical rules applied to agitated systems. *Powder Technol.*, **61**, 213–234

Pneumatic conveying and control

T. Dyakowski and R. A. Williams

20.1 Capacitance imaging of flowing powders

Monitoring of two-phase gas–solid flow structures can be helpful for the design and operation of pneumatic transport systems. Examples include the design of transportation systems for fragile foodstuffs, optimizing solids distribution in pipelines up-stream to flow splitters, and in the operation of solids transport at minimum velocity to minimize energy consumption.

Solids behaviour in pneumatic conveyors has been investigated using various visualization techniques and there is a substantial body of knowledge on critical conveying velocities and on the flow transition boundaries in solids transport (Marcus et al., 1990). In practice, it is difficult to operate systems in a satisfactory way using predetermined design data, because the fluid dynamic behaviour of the solid particles may change (due to slight variations in particle shape, size, distribution, etc.). Therefore it is useful to consider on-line techniques which could directly measure the flow pattern in a pneumatic conveyor, on which the effective operation of conveying is highly dependent.

Here, the results of using capacitance tomography mainly as an aid to the process control and design of pneumatic conveyors are presented. These results were obtained in industrial and pilot-scale rigs (McKee, 1992; Brodowicz et al., 1993; McKee et al., 1995), both for horizontal and inclined pipelines. Pneumatic conveying of large and dense solids has been investigated. The results are presented for the four different types of solid in Table 20.1. The relative permittivity of all solids was approximately 3.

Capacitance tomography is useful for examining processes and structures where density or temperature gradients (e.g. for flame visualization) exist. It can be used as an non-intrusive tool for process control of various gas–solid flow structures as well as an auxiliary device for locating appropriate positions where samples can be removed from a flowing material stream.

Capacitance tomography provides information about processes in virtually real time. In the case of gas–solid flows, rapid on-line measurements provide important measurements, thus allowing a proper flow structure within the process pipe to be maintained.

The principle of capacitance tomography has been described in detail in Chapter 4. The instrumentation employed in the applications described below consists of a simple eight-electrode capacitance sensor, a data-collection system and an image-reconstruction capability based on a back-projection algorithm using a PC. Figure 20.1 shows a photograph of the installation on a

Table 20.1 *Characteristics of solid particulates*

	Solid type			
	Acetal resin pellets	*Polypropylene pellets*	*Rape seed*	*Sea salt*
Particle shape	Ellipsoidal	Ellipsoidal	Spherical	Irregular
Mean diameter (mm)	2.8	3.8	1.8	5.9 (coarse) 1.7 (fine)
Solid density (kg m$^{-3}$)	1350	906	2204	1180
Bulk density (kg m$^{-3}$)	879	680	1229	670

Figure 20.1 *The eight-electrode capacitance flow-imaging system mounted on a conveyor plant*

horizontal section of a pneumatic conveying test facility. Typically, the sensor electronics had a root-mean-square (RMS) noise level of 0.08 fF, which is equivalent to the sensor capacitance charge caused by an approximately 0.05 change in solids volume fraction (based on solids exhibiting a relative permittivity of 3) at the pipe centre (which is the least sensitive part of the cross-section). The sensor shown in Figure 20.2 was constructed quite simply by using eight brass plates each of length 190 mm mounted on the external surface of a glass pipe section having an outer diameter of 96 mm and an inner diameter of 82 mm. The time required to collect data for a single image was approximately 10 ms.

20.2 Process monitoring and control

20.2.1 Settling and slugging behaviour

The distribution of solids in a channel cross-section can normally be detected using capacitance tomography, depending on the precise value of the local volume concentration of solids and the difference in dielectric permittivity between the continuous and dispersed phases (see Chapters 3 and 4). The permittivity of a very dilute and fully dispersed air–solid flow is nearly equal to the permittivity of air. Therefore, for such a flow, the sensitivity of the capacitance method is often insufficient to allow visualization of the distribution of solids in the pipe cross-section. For this reason the method is best employed to image *dense* flow structures and to interrogate the extent of solid dispersion along the length of the channel. It is well known that the dense flow system exists

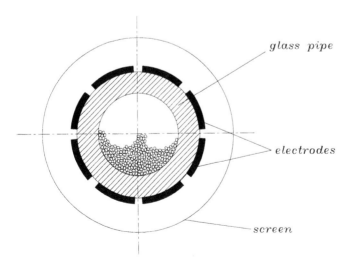

Figure 20.2 *Section through the capacitance sensor assembly*

at a low air velocity (Mills, 1991; Wirth and Molerus, 1985) which allows the transport of solids whilst minimizing attrition and breakage. Dynamic images of the solids distribution within a pipe enable capture of transitions from one flow regime to another to be followed. For example, from a stratified to a slug flow, which is often encountered in dense phase pneumatic transport.

The image grey level is related to the mean relative permittivity of solids in the sensing zone which is a function of solids concentration. This relationship is shown in Figure 20.3 where the grey level is normalized on a scale of 0–1. The two points shown on the x axis show a typical calibration over a narrow solids concentration range using a fluidized-bed arrangement; the hatched zones corresponding to the experimental measurement accuracy. In the graph ϕ_{mf} and ϕ_{1p} are the mean solids concentration (expressed as volume fractions) for the conditions of minimum fluidization and a loosely packed bed, respectively. In dense flow system, the solids concentrations do not vary greatly and fall into the range shown in Figure 20.3.

A tomographic image of a stratified flow in the form of a sliding layer, as frequently encountered in dense flow conveying, is shown in Figure 20.4. The tomographic image and the photograph, taken through a glass-walled pipe, show a similar solids distributions. For these flow conditions the superficial air velocity was below the particle saltation velocity.

The reduction in the air velocity causes settlement of solids which form a settled layer. This situation takes places until a balance is achieved when the air velocity is capable of transporting the solids in the form of dunes above this layer. This is evident in Figure 20.5 where a discontinuity in the solids

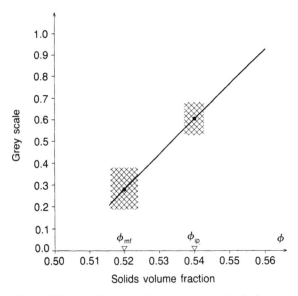

Figure 20.3 *Calibration of the image grey level over a narrow solids concentration for rape seed in a fluidized-bed apparatus*

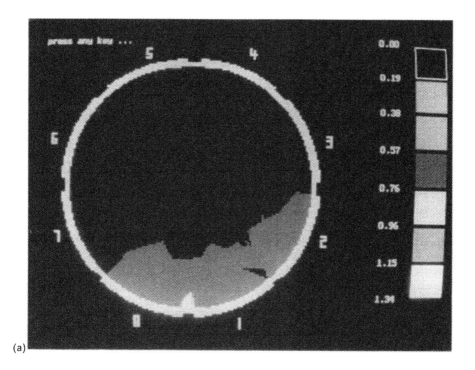

(a)

(b)

Figure 20.4 (a) *Tomographic image of a stratified flow with a sliding layer of rape seeds in air.* (b) *Corresponding photographic elevation view through pipe wall*

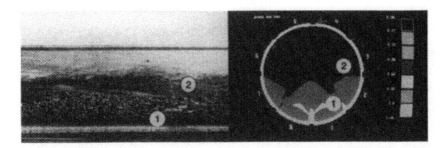

Figure 20.5 *Discontinuity in the mean solids concentration of a stratified air–rape seed flow with moving dunes, showing (1) the settled or stationary bed ($\phi = 0.64$), (2) the moving dune ($\phi = 0.52$)*

concentration between the dune ($\phi = 0.52$) and the settled layer ($\phi = 0.64$) is seen. The movement of solids becomes impeded as the concentration of solids increases. A further decrease in the air velocity, below the saltation velocity of a single solid particle, may cause pluggage of the pipe line directly downstream of the position at which solids are introduced to the conveying line. Upon blocking this part of the pipe, the air pressure increases, which results in the appearance of slugs (Tomita *et al.*, 1981). Conveying solids at a low velocity is a relatively new and emerging technique which is advantageous since it may decrease energy consumption, reduce pipe-wall erosion, and mitigate attrition and breakage of particles (Mills, 1991; Wirth and Molerus, 1985). This method will be especially attractive in food processing.

The slugs are periodically conveyed to the end of the pipeline, plugging the pipe cross-section. The mechanism of flow involves a slug of solids moving ahead of a settled layer of solids on the pipe base, the overall effect being that of wave-like motion. The slug entrains solids in its path and accelerates them to the solids velocity in the mixing zone. The settled layer is transported downstream as a whole by the same distance every time the slug passes. The slug *celerity* (or wave velocity) is larger than particle velocity. The relationship between slug celerity and particle velocity obtained by capacitance tomography (McKee *et al.*, 1995) is shown in Figure 20.6.

Knowledge of different gas–solid flow patterns as a function of both air and solid mass flow rates, is crucial in process control of pneumatic conveyors. Traditionally, various flow patterns are presented in a two-dimensional space. An example of such a diagram, or 'flow map', is shown in Figure 20.7. This map has been obtained by analysing flow images (Brodowicz *et al.*, 1993) and provides a parametric location of various flow structures.

20.2.2 Selection of sampling position

The other control problem which can be solved by employing capacitance tomography, is to find the most reliable and appropriate location along the

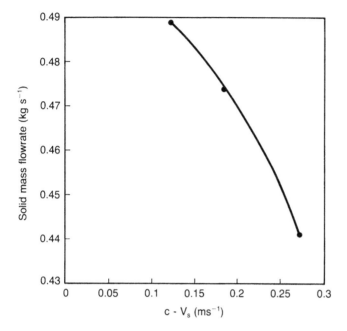

Figure 20.6 *Mass flow rate of polypropylene pellets versus the relative velocity between slug celerity* (c) *and solid velocity* (V$_s$) *measured on-line using capacitance imaging*

pipeline for sampling the moving material stream during *dilute* conveying. The gas–solid flow should be sampled in the region where all solids are homogeneously suspended in the air stream or, in other words, where a settled layer disappears. When particles are conveyed around a pipe bend the effect is often to destabilize the suspension. A common assumption made in the process industry is that such a settled layer will disappear at a distance of approximately 10 pipe diameters downstream of a pipe bend. However, it is not clear how this distance depends on such flow parameters as solids size, loading factors and the air superficial velocity. McKee *et al.* (1995) has used capacitance tomography to provide an insight into this problem. A schematic diagram of the test plant is given in Figure 20.8 which shows the locations (I–VI) at which images were obtained.

Experiments were carried out at locations V and VI downstream from a vertical-to-horizontal pipe bend (Figure 20.8). Data were collected for coarse and fine sea salt and an acetal resin. The physical properties of the particulates are summarized in Table 20.1. Loading factors (solid/gas mass flow rates) were in the range 1–14.9 and the air superficial velocity was varied from 14 to 24 m s$^{-1}$.

The only location at which *no image* of a settled layer was recorded occurred at distances in excess of 20 pipe diameters away from the bend when the coarse sea salt was conveyed with loading factors 1 or 4.5 at a superficial air velocity of 22 ms$^{-1}$.

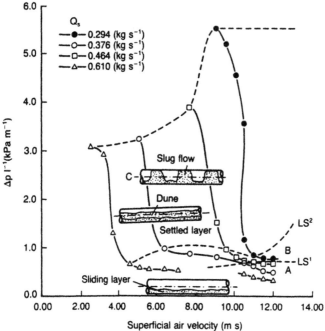

Figure 20.7 *Flow map for air–rape seed conveying showing the pressure gradient versus air superficial velocity for various solids mass flow rates (Q_s): (A) stratified flow with a sliding layer; (B) stratified flow with settling layer and dune moving on the top; (C) slug flow; (LS^1) line separating structures A and B; (LS^2) line separating structures B and C*

At 20 pipe diameters a settled layer was present for higher loading factors and for lower velocitites. In this instance the tomographic sensor detected the absence of a settled layer only beyond 30 pipe diameters downstream of the bend. This suggests that, for these flow conditions the gas–solid stream should be sampled, at least of 30 pipe diameters away from the vertical-to-horizontal pipe bend (Bell *et al.*, 1993).

20.3 Plant design parameters

20.3.1 Rotary feed valve and start-up characteristics

Knowledge of dynamic effects concerning the changes of a thickness of a settled layer is an important parameter in the design of a pneumatic conveyor. These changes depend both on the position of the settled layer along the pipeline and on time. Rotary feeders are commonly used to feed solids to the conveyor. On start-up a settled layer builds up at the bottom of the pipe wall. For a given type of solids and for a given superficial gas velocity the

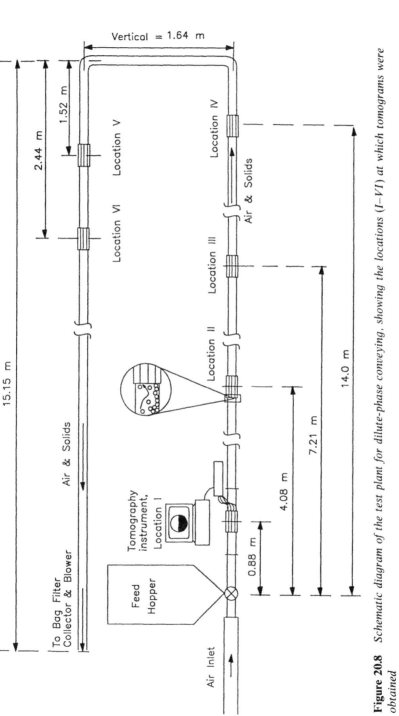

Figure 20.8 *Schematic diagram of the test plant for dilute-phase conveying, showing the locations (I–VI) at which tomograms were obtained*

fluctuations in the settled layer thickness depend mainly on the characteristic parameters of the rotary feeder.

Two factors are of crucial importance – the number of feed pockets in the valve and the rotation speed. Fluctuations in the pipe cross-section (at location I, Figure 20.8) occupied by the settled layer of acetal resin with time after starting the rotary feeder reflect these design and speed of the rotary valve. For instance, Figure 20.9 shows a sequence of measurements of the percentage of the pipe cross-section occupied by solids at different times for a rotary valve rotation rate of 2 rev/min. After a period of 1 min from start-up, an average fill of about 30% of the pipe cross-section was established. When the loading factor increases the average fill of the pipe cross-section is also increased.

For higher loading factors a swirling flow was observed, which is evidenced by the presence of solids near the top of the pipe wall (Figure 20.10).

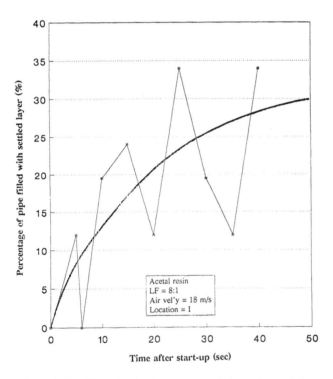

Figure 20.9 *Variation in the area occupied by the settled layer with time for acetal resin (rotary feed valve with six pockets rotating at 2 rev/min). Results obtained at a distance 0.88 m from the feed hopper with a loading factor of 8 and an air velocity of 18 m s$^{-1}$*

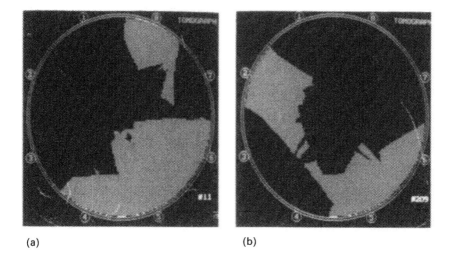

(a) (b)

Figure 20.10 *Images of swirling flows of sea salt obtained at locations I and II (Figure 20.8) ((a) 0.88 m and (b) 4.1 m downstream of the rotary feeder) at an air superficial velocity of 18 m s$^{-1}$ and a loading factor of 10*

20.3.2 Entry conditions and acceleration length

Only a proportion of the solids entering the conveying pipe become immediately airborne and never settle inside the pipe. The rest of the solids, however, travel a short distance, and then fall to the bottom of the pipe. This layer of solids is gradually eroded by the gas stream, but new solids are re-deposited in the same location. The length of this unstable solids layer is of great importance in the design of conveyor loop. The reason is that changes in flow may result in the pipeline plugging. This length depends both on a value of a loading factor and on air superficial velocity. An approximate length of this unstable layer can be obtained (McKee *et al.*, 1995) by analysing images taken at different locations along the pipe line. Figure 20.11 shows tomograms obtained at the two different locations (I and II) along the pipeline. No images could be obtained for loading factors of 1 and 4 with an air conveying velocity of 28 m s$^{-1}$ at a distance of 4 m from the rotary feed hopper. This means that *fully suspended*, but necessarily stable, flow exists there. Thus, it may be concluded, that for the above flow conditions, the length of this unstable layer is no longer than 4 m. Such tomographic data can be used to verify design equations and used to develop robust correlations to predict the effects of particle shape, size and density, etc.

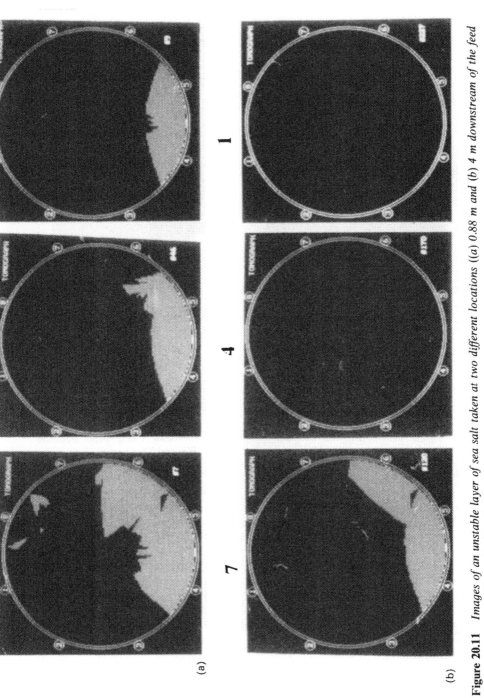

Figure 20.11 *Images of an unstable layer of sea salt taken at two different locations ((a) 0.88 m and (b) 4 m downstream of the feed position) for three different loading factors*

20.4 Future developments

It is evident from the results presented in this chapter that two-dimensional dielectric images contain a wealth of information on the distribution of solids which can be used to identify gas–solid flow patterns. These images also reflect the *dynamic behaviour* of conveying processes within a pipeline which is of value in the control and design of plant. The current technique is unable to detect individual solid particles suspended in air or to monitor very dilute dispersions, but the thickness of solid deposits can be measured.

Future applications for capacitance tomography in analysing powder behaviour are likely to include visualizing flow structures in bends, inclines, powder mixing kinetics, discharge of aerated powders from hoppers and silos. Quantitative measurement of powder mass flow may also be possible by continuous monitoring of powder flows using multiple planes of sensors. Detailed modelling of flow phenomena, in particular process dynamics, is likely to result as the method is applied more widely since, whilst the spatial sensitivity is relatively poor, the temporal resolution is excellent.

Acknowledgement

The authors wish to acknowledge the access to industrial test facilities provided by the PARSAT group at DuPont Engineering (Newark) and Neu Engineering (Stockport).

References

Bell, T. A., Allen, T., Boxman, A., McKee, S. L. and Dyakowski, T. (1993) New methods of monitoring materials being pneumatically conveyed. In *Proceedings of the Bulk Solids Handling Conference, May 1993, Chicago*. American Institute of Mechanical Engineers, New York

Brodowicz, K., Maryniak, L. and Dyakowski, T. (1993) Application of capacitance tomography for pneumatic conveying process. In *Tomographic Techniques for Process Design and Operation* (eds. M. S. Beck *et al.*) Computational Mechanics, Southampton, 361–368

Marcus, R. D., Leung, L. S., Klinzing, G. E. and Rizk, F. (1990) *Pneumatic Conveying of Solids* Chapman & Hall, New York

McKee, S. L. (1992) On-line measurements of particle-fluid transport processes using tomographic techniques. M.Sc. Thesis, University of Manchester Institute of Science and Technology

McKee, S. L., Dyakowski, T., Williams, R. A., Bell, T. A. and Allen, T. (1995) Solids flow imaging and attrition studies in a pneumatic conveyor. *Powder Technol.*, **82**, 105–113

Mills, D. (1991) *Pneumatic Conveying Design Guide* Butterworths, London

Tomita, Y., Jotaki, T. and Hayashi, H. (1981) Wave-like motion of particulate slugs in a horizontal pneumatic pipeline. *Int. J. Multiphase Flow*, 7, 151–166

Wirth, K. E. and Molerus, O. (1985) Critical solids transport velocity with horizontal pneumatic conveying. *Powder Bulk Solids Technol.*, **9**, 17–24

Chapter 21

Capacitance imaging of fluidized beds

J. S. Halow

21.1 Introduction

21.1.1 Background to the development of a capacitance instrument

The Morgantown Energy Technology Center (METC) has an active development programme in a number of fossil energy technologies, including fluidized bed combustion, coal gasification, hot gas clean-up, and oil shale retorting. Many of the systems for these technologies include fluidized beds as processing reactors, heat exchangers or other gas–solid contacting devices. The fluidization behaviour of the coarse particle systems of interest in fossil energy has not been studied extensively and methods of designing them are limited. To address this need, a technique utilizing capacitance measurements has been developed to study the detailed hydrodynamics of these systems.

Capacitance techniques for determining point values and cross-sectional averages of voidage in fluidized beds have been used by fluidization researchers for many years. Probes inserted into beds of fluidized solids or split ring electrodes mounted on the walls of the bed were used to develop time traces of the variations in void fraction within the bed. By using pairs of vertically spaced probes, measurements of bubble velocities and sizes have been made in a variety of systems.

In the 1970s, work on capacitance-based instruments was initiated at METC to measure bed levels, solids flow rates and other gas–solid mixture parameters. These efforts have evolved into a non-intrusive system capable of imaging in three dimensions the voidage distributions within a fluidized bed. Imaging rates of 30–100 frames/s have been used in studies to date. Preliminary observations with an early 49-pixel version of the system are reported by Halow et al. (1990). Details on this system, its operation, and methods of image construction from the measured quantities are given in Fasching and Smith (1988, 1991). Observations of a fluidized bed with a higher (193 pixel) resolution, second-generation system are reported in Halow and Nicoletti (1992) and Halow et al. (1991). Details of the 193 pixel system is given by Fasching and Smith (1990).

21.1.2 Operation of fluidized beds

Fluidized beds are widely used to contact granular solids and gases or liquids in the petroleum, chemical, minerals processing, and other industries. In terms

of the volume of gases processed, catalytic cracking of heavy feed stocks in the petroleum industry is the largest use of fluidized beds. In fact, over half of the gasoline produced in the world is produced in these devices. Combustion in fluidized beds has been used for many years as a means of incinerating waste materials and generating steam for process or electric power generation. Fluidized beds also have smaller scale applications, including drying and pelletizing materials in the food and drug industries.

When gas is made to flow with sufficient velocity through a vessel containing a granular material, the granular material assumes a condition resembling a liquid and the bed is said to be 'fluidized'. Objects with a density lower than the bed will float while objects with a density higher than the bed will sink. Like a liquid, the bed can be stirred and the solids will discharge in a stream from an opening in the side or bottom of the bed.

As gas is introduced into the bottom of a bed of slumped or non-fluidized solids, it is forced to flow around and between the individual grains in a tortuous path up through the bed. This restriction of flow gives rise to a pressure drop proportional to the depth of the solids in the vessel. As the gas velocity is increased, the pressure drop increases. Finally, a point is reached at which the pressure drop applied over the cross-section of the vessel produces a force sufficient to balance the force of gravity on the granular material. Under this condition the bed will undergo a slight expansion and become fluidized. The expansion separates the grains slightly and they become supported, not by their contact with grains below them but by a drag force caused by the gas flowing by them. This condition is referred to as 'incipient fluidization'. The velocity at which it occurs is called the 'minimum fluidization velocity', and the void fraction at that time is called the 'void fraction at minimum fluidization'.

If the gas velocity is increased further, the granular solids may expand slightly to accommodate gas, but most of the gas will collect in relatively solid-free voids that rise vertically through the bed. Figure 21.1 illustrates this behaviour. Because these voids resemble gas bubbles in a liquid they are commonly referred to as 'bubbles'. While they resemble gas bubbles in liquids, the voids have no true interface or boundary. Gas flows into the bottom of the void and out the top. This flow-through of gas serves to support the void roof and causes it to move up through the bed. The velocity at which the voids rise through the bed is proportional to the square root of their size, so larger voids rise faster.

The analogy with gas bubbles in liquids has been frequently used to describe fluidized beds in what is called the 'two-phase theory'. In this theory the granular material is referred to as the 'emulsion phase' and is analogous to the liquid. The voids are referred to as the 'bubble phase', just as the gas in the liquid. Sizes of voids formed at the gas distributor and the rise velocity of voids through the bed is described by equations analogous to those for the gas-in-liquid case.

Unlike many liquids, however, granular materials are not transparent and there has been considerable difficulty in experimentally confirming the two-phase theory. Methods used to measure bubble sizes and velocity include various types of capacitance or pressure probe, and occasionally X-ray

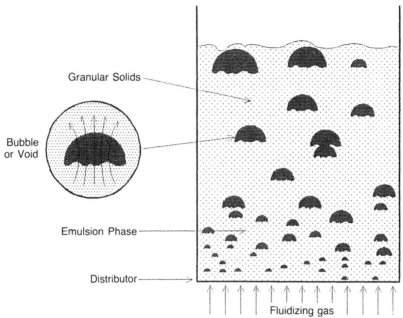

Figure 21.1 *Elements of a fluidized bed*

movies. These techniques have appreciable uncertainties and difficulties. Probes inserted into the bed always present the possibility of disturbing the flow and thereby contaminating the measurement. The X-ray technique is non-intrusive but is difficult to carry out and provides only a two-dimensional projection of the three-dimensional void. Other techniques have equally serious limitations.

The role of voids in fluidized beds is important, particularly when it is necessary to achieve substantial or prolonged contact between the gas and the solids for chemical reaction or physical processing of the gas. When voids are large, substantial quantities of gas can pass through the bed without appreciable contact with the solids. Because of their importance to process performance, determining the size, velocity and other characteristics of bubbles has been a central topic of research in the fluidized beds since the 1950s.

Bubble characteristics vary greatly with the granular material being fluidized, the gas density and viscosity, the position in the bed and the vessel diameter. Bubbles formed at a distributor undergo a rapid process of coalescence as they rise. Bubble volume increases with coalescence, but the number density decreases and the bubbles become more widely spaced. The process will continue but at a decreasing rate as the number density decreases. If bubbles grow to where their diameter is about 20% of the vessel diameter, they become influenced by the vessel walls. As they continue to grow, this wall effect becomes more and more important. At a diameter of about 80% of the vessel diameter, coalescence leads to a lengthening of the void, but with little

increase in diameter. The void is then referred to as a 'slug'. Its rise velocity and other characteristics are strongly influenced by the size of the vessel. This transition from bubble to slug gives rise to substantial difficulties in scaling up fluidized-bed reactors. Pilot-scale work is often performed in small beds which may be characterized by slug flow, while the commercial reactor is much larger and may operate as a bubbling bed. The difference in flow regimes has inhibited many applications of fluidized beds because of the difficulty in using pilot-scale results to design commercial beds.

Despite a 50-year history of commercial application and literally thousands of publications of research results, many basic aspects of the hydrodynamics of fluidized beds remain unclear.

Capacitance imaging offers a tool to actually see inside the bed and clarify many of these aspects. Its limited application to a single bed already provided quantitative measurements of what had been only suspected phenomena, revealed unknown details of other phenomena, revealed completely unknown behaviours and, coupled with new techniques to describe non-linear dynamics, is leading to completely new models for describing bed dynamics. Davidson and Harrison (1963, 1971) and Geldart (1986) provide further background information on fluidized bed technology.

21.2 Capacitance imaging system

21.2.1 Instrumentation

The imaging system used in the METC studies consists of a number of electronic circuits which serve to energize and then sense and record electrical currents in electrodes embedded in the walls of a 15.24 cm diameter fluidized bed. Figure 21.2 illustrates the METC system. Four rings of sensing electrodes are mounted flush with the bed wall at adjacent vertical positions. Each ring contains 32 individual sensing electrodes spaced symmetrically around the wall. A 500 V, 400 kHz electric potential is applied to sets of electrodes within each level. This potential induces a current flow which is dependent on the electrical permittivity of the material contained in flux tubes between pairs of electrodes. By rapidly switching through various sets of electrodes, a sequence of measurements is made in which various flux tubes cross the bed and intersect each other. From the measured currents, the permittivity of individual regions or pixels within the sensing level can be deduced (Fasching and Smith, 1988).

Prior to each day's experiments, calibration of the instrument is performed using all air and then all solids at a compacted voidage to establish the extremes of permittivity. With this calibration, void fraction is assumed to be proportional to the measured permittivity. While other relationships could be used to improve the accuracy of the measurements in some regions, the linear relationship has been sufficient for the measurements to date.

During an imaging experiment, current measurements are stored in memory built into the imaging electronics. Signals are also processed on line

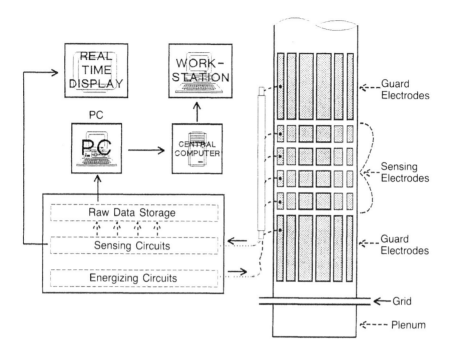

Figure 21.2 *The METC imaging system*

to give a real-time display of the void fraction patterns on a video monitor. These pictures can be recorded and an instant 'replay' carried out if desired. At the end of the experiment, these data are transferred to a central computer and then to a graphics workstation. The workstation is used to process the data and to construct a variety of visual representations. The central computer is used in some studies to evaluate alternate techniques for processing the current measurements.

The current METC system produces maps at each imaging level containing 193 individual pixels. Figure 21.3 provides the definition of the pixels in the current METC system. The average cross-sectional area covered by a pixel as about 0.95 cm$^2$. Axially, each pixel includes a distance of 2.54 cm. Imaging is carried out at around 60 frames/s for a duration of 21 s. The basic limitations on the imaging speed and resolution of the system is related to the speed of the switching electronics of 24 000 s$^{-1}$. Currently, multiple measurements are made of each of the flux tube currents and averaged to ensure a good measurement. Higher resolution requires more measurements. The choice of resolution, speed and multiple measurements to ensure accuracy is a trade-off which can be adjusted to match the needs of the application. The 21 s duration of the experiments is limited by the data-storage capability of the instrument. This can be readily expanded by the addition of memory. Additional levels could be readily added.

Figure 21.3 *Pixel definition*

21.2.2 Experimental measurements

The bed was fluidized with air at ambient temperature and pressure through a distributor consisting of a 1.26 cm thick porous ceramic disk with a nominal 50 μm pore size. A perforated plate grid and a single nozzle have also been used in some experiments. The pressure drop across the grid and the bed was measured along with the air flow rate. The pressure drop across the porous plate varied from 30% to 300% of the bed pressure drop, thus ensuring adequate distribution.

Before each experiment the bed was first vibrated to a compacted state and a baseline established on the imaging sensing circuits. From the known weight of the bed material and the depth of the bed after compaction, a compacted voidage was calculated. The bed was then fluidized at the desired superficial velocity until the bed surface showed that a well-fluidized state had been achieved. The imaging electronics also displayed the bed condition on the

real-time monitor. The imaging electronics were then set to begin acquiring the raw imaging data. Flow rates and pressure drop were recorded, in addition to acquiring the imaging data. In some experiments, high-speed transducers were used to acquire transient pressure drop data along with imaging data. After acquiring and transferring the raw data to a PC, current versus time traces were constructed to give a visual indication of the adequacy of the acquired data.

The bed regions imaged include a region 1.25 to 2 bed-diameters above the grid (Halow *et al.*, 1990; Halow and Nicoletti, 1992) and a region 3 to 3.75 bed-diameters above the grid (Halow *et al.*, 1991). Six granular materials used in the experiments to date including a 30×270 mesh acrylic powder, a 700 μm narrow-size-distribution plastic, a 6×7 mesh angular acrylic, $\frac{1}{8}$ in. nylon spheres, a $3\frac{1}{2} \times 6$ mesh angular acrylic, and a fluid cracking catalyst. Table 21.1 gives the physical parameters of the materials. All materials except the cracking catalyst have been imaged in the current 193-pixel system. Fluidization velocities in the studies were varied from slightly above minimum fluidization velocity to up to four times minimum fluidization velocity.

Extremely large quantities of data were acquired during the experiments. For example, during the 37 experiments reported by Halow *et al.* (1991) a total of nearly 10 million voidage determinations were made. Two types of information have been extracted from these measurements. Visual representations of the bed are the unique information provided by tomography. They allow an understanding of physical mechanisms and bed dynamics not achievable by any other method. Quantitative information such as void diameters, lengths, volumes, spacing, frequencies and rise velocities are also extracted from the data. This is the information that can be compared to previous studies and used in design.

Table 21.1 *Properties of the fluidized particles*

Material	Weight average diameter (μm)	Particle density (g cm$^{-3}$)	Bulk density (g cm$^{-3}$)	Packed voidage	Minimum fluidization velocity (cm s$^{-1}$)
Cracking catalyst	70	1.44	0.63	0.38	0.70
30×70 Mesh acrylic	300	1.14	0.52	0.45	8.0
700 μm plastic	704	1.46	0.73	0.53	19.0
6×7 mesh acrylic	3075	1.14	0.57	0.43	80.1
$\frac{1}{8}$ in. Nylon spheres	3175	1.12	0.64	0.43	84.1
$3\frac{1}{2} \times 6$ mesh acrylic	4475	1.14	0.62	0.32	82.2

21.2.3 Data visualization techniques

There are a variety of techniques that can be used to visualize the imaging data. Each has advantages and disadvantages. It is usually necessary to use several of the techniques on each dataset in order to gain complete insight into the behaviour of the fluidized bed.

Cross-section slices

The most straightforward representation of the imaging data is to construct a polar plot for each imaging level and frame showing the pixels for each level and indicating void fraction by a colour or grey-tone scale. Figure 21.4 shows such a plot for a cross-section of a large void. The darker areas represent higher void fractions or gas and the lighter areas indicate lower void fraction or solids. The section has been computer enhanced by interpolation to produce smoothed contours of constant void fraction. The figure reveals a common characteristic of many voids of similar size observed in various materials. While there is a region of high void fraction on one side of the tube and a corresponding region of low void fraction or emulsion phase on the opposite side, there are substantial regions with intermediate voidages.

Cross-sectional slices have the advantage of being easy to understand while providing a clear picture of voidage distribution in the imaging plane. It is

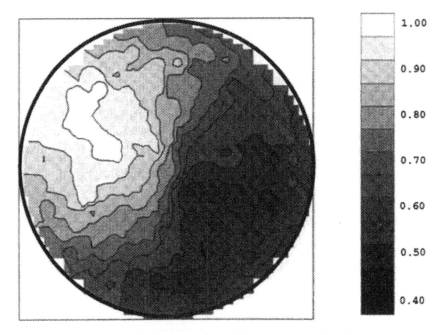

Figure 21.4 *Voidage cross-section of a bubble attached to the wall*

difficult, however, to use them to understand the vertical voidage distribution and, in particular, to understand the time-dependent aspects of the distribution.

Three-dimensional Euclidian representation

At first thought, a three-dimensional visualization of the imaging data may appear to be obvious, as perhaps a movie-like video. The data, however, consist of an independent variable (the void fraction of solids) measured over three physical dimensions and time. If void fraction is represented by grey tones or colours, such a visualization gives a view of the outside of a cylindrical section of the bed defined by the imaging zone at each instant in time. Animating this as a video still only reveals the outer surface of the imaged zone. What is happening within the bed is hidden by this visualization.

By adopting a two-phase perspective, a better representation can be constructed. A 'cut-off' value of void fraction below which the bed is defined as an emulsion phase and above which it is defined as a bubble phase can be selected. Then a visualization can be constructed in which either all regions above or all regions below that void fraction are cut off or erased from the picture. When regions with void fractions below the cut-off are erased, the image represents the bubble phase. These regions are seen to rise into the imaging zone and disappear out the top. If the regions with void fractions above the cut-off are erased, then the image represents the particulate or emulsion phase. A void fraction of between 0.70 and 0.75 usually provides a reasonable cut-off point for this type of representation.

Figure 21.5 shows a three-dimensional representation of the top and bottom of a gas slug constructed in this matter. This image is from an experiment with the 700 μm plastic fluidized at 44.5 cm s$^{-1}$. The figure shows the rounded nose and the tapered tail of a large slug typical of this material. The lighter regions represent slightly higher voidages than the darker regions. This variation is created by the workstation's vertical interpolation of the data.

The three-dimensional Euclidian cut-off representation is easy to understand when animated because it appears as a video of the bubble or emulsion phase. Time-dependent behaviour unfolds as the images progress. The disadvantage of this representation is that it is strongly biased toward a two-phase impression of the bed when there are in fact appreciable gradients and distributions of voidage within the bed. In the METC system, because there are only four imaging levels, the impression is like a window of limited vertical extent looking into the bed. Often the gas bubbles or slugs may be larger than the window, resulting in only part of the slug being seen at any one instance. The problem of seeing 'inside' the bubble or emulsion phase is also still present. While varying the cut-off allows the bubble or emulsion phase to be stripped away or added back in layers, the internal structure is still not clearly represented.

Eulerian voidage contours

An alternative approach to representing the images as time-varying Euclidean images is to adopt a Eulerian perspective. In this approach voidage patterns at a single level are viewed as they vary with time rather than with vertical

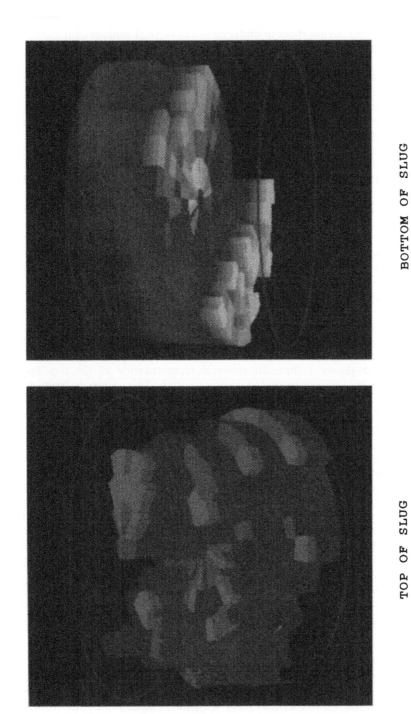

TOP OF SLUG

BOTTOM OF SLUG

Figure 21.5 *Three-dimensional representation of a slug*

position. As a void passes, we see the voidage at a lateral position in its path rise and then fall. If the velocity of the void is known and assumed not to change during the time the void passes, successive imaging frames represent cross-sections of the void taken along the vertical dimension of the void and spaced at a distance equal to the rise velocity of the void divided by the imaging rate. This is like taking a picture of a train moving past a slot in a fence. If the speed of the train is known and the pictures taken rapidly enough, a complete photograph of the train can be constructed. A Eulerian representation can be constructed in three dimensions by placing successive cross-sectional voidage contour plots along a vertical axis. Physical models constructed in this way are a very useful aid to understanding voidage distributions which vary in the imaging plane and with time. They are, however, time consuming to construct. Computer-generated images of this type which can be rotated and viewed from various angles are a more easily generated substitute.

A simpler method of visualizing the imaging data is to construct two-dimensional Eulerian slices. In this technique, the horizontal co-ordinate is taken along one of the tube diameters and successive frames are shown below the preceding frame. Figure 21.6 shows the voidage contours around a bubble, constructed using this technique. This bubble was in the 700 μm plastic fluidized at 49.5 cm s$^{-1}$. The void appears to have two zones of high voidage around which voidage contours of successively lower void fraction extend out into the bed. The Eulerian slice is a helpful technique because it resembles the familiar images of two-dimensional beds which have been used to visualize fluidized beds.

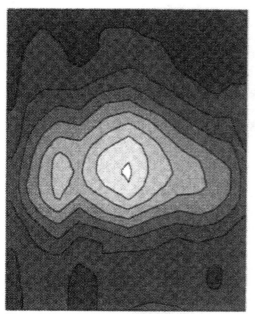

Figure 21.6 *Voidage contours around a void*

21.3 Insights from visualization

21.3.1 Coalescence

Coalescence of voids is a critical process that determines many of the properties inherent to fluidized beds. Void formation at the gas distributor is strongly influenced by the configuration of the distributor and in the design of fluidized beds it is generally given special attention. The goal is usually to cause the formation of numerous small bubbles which will provide a high degree of contact of the gas with the solids. However, once formed, the voids begin to rise and coalescence of voids causes rapid growth in size and decrease in number density. Much of the gas–solid contacting in beds can occur during this period of rapid coalescence.

The traditional view of coalescence is that bubbles rising through the bed carry with them a 'wake' of emulsion-phase solids extending behind the bubble for perhaps two bubble-diameters. When a following bubble enters this wake, it accelerates relative to the preceding bubble (but not relative to the emulsion phase solids), and catches up and coalesces with the preceding bubble.

The imaging experiments, however, present a somewhat different picture of coalescence. Figure 21.7 shows three-dimensional Euclidian images at successive times illustrating the coalescence of two voids. In the first frame, the bottom of a large slug is visible in the upper imaging levels. A following void, still below the imaging section, has extended a central spike connecting to the lead slug. In the successive frames, the following slug has elongated and rises along this spike to coalesce with the leading slug.

Constructing Eulerian slices for all four levels provides a means of understanding bed processes as they change with vertical position in the bed. Bubble coalescence can be clearly visualized in this way. In all, four general types of coalescence were observed in the experiments. Figures 21.8 and 21.9 illustrate the two most common types. In Figure 21.8 three voids are undergoing what can be termed 'explosive' coalescence. In the level 1 image, three distinct high voidage regions are visible. A connecting shroud envelopes all three voids. In level 2 the lower two voids have combined, and by level 3 all three voids have coalesced. Figure 21.9 represents a 'draining' type of coalescence. In this form, the lower void does not actually rise rapidly into the upper void but seems to lose its gas through one or more elevated voidage tubes connecting the voids. Gas drains off from the lower to the upper void. The images in both figures were obtained in experiments with the 700 μm plastic, but at different fluidizing velocities.

Two other less common forms of coalescence were observed during the experiments. In one of these a large void catches up with and captures or absorbs a smaller void ahead of it. In a fourth type, a small void was observed to flow across the bed in the process of coalescing.

It is clear from the imaging that in all forms of coalescence the leading void leaves one or more trails of slightly elevated voidage behind it. Trailing voids seem to follow along these trails during the processes of coalescence. The

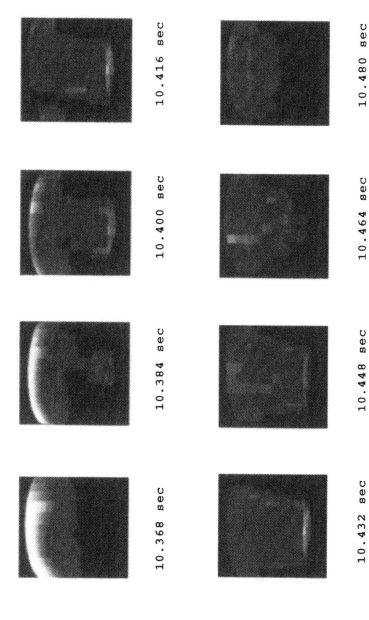

Figure 21.7 *Three-dimensional images illustrating coalescence*

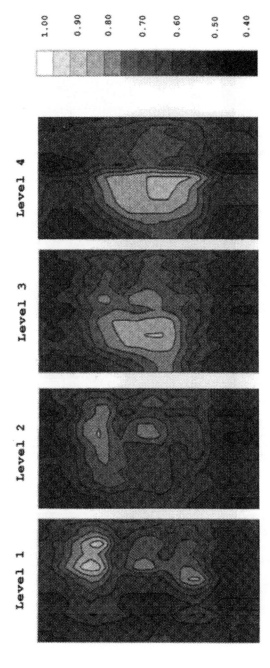

Figure 21.8 *Explosive coalescence of three voids*

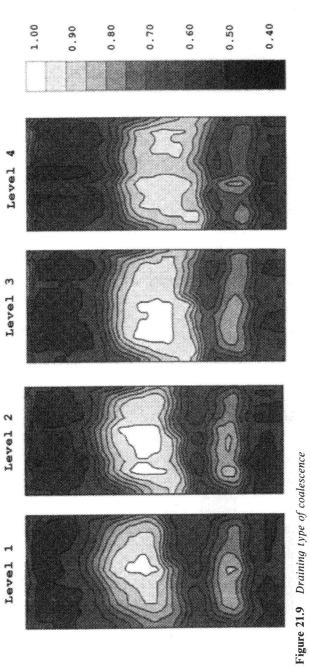

Figure 21.9 *Draining type of coalescence*

connecting channel provides a path of reduced resistance to gas flow for the gas passing through the trailing void and more gas passes from the trailing void along this preferential path. The increased gas flow expands the channel and increases its void fraction. This, in turn, increases the tendency for gas to flow along this channel and the process cascades. There are still many uncertainties about the process, such as what conditions give rise to the different types of coalescence and the mechanisms which control the decay of the voidage trails with time.

21.3.2 Void shapes

The voids observed in these experiments exhibited a variety of shapes, depending on the material and the fluidization velocity. In the low-velocity experiments with the finer materials, more or less rounded voids were generally observed. With the coarser materials, voids were typically large and blunt nosed.

Figure 21.10 shows a Eulerian slice of the bed with the 30×270 mesh acrylic at a velocity of 10.3 cm s$^{-1}$. The slice shows bubbles typical of this material. The bubbles are 5.5–7 cm in frontal diameter and are rising at

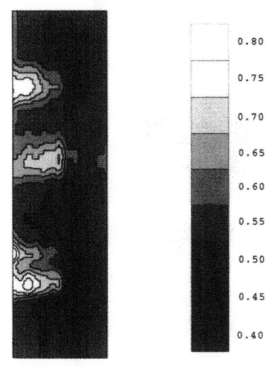

Figure 21.10 *Eulerian slice of voids in the 30×270 mesh acrylic*

velocities of 40–60 cm s$^{-1}$. The frontal diameters, lengths and rise velocities of the voids were determined from average cross-sectional voidage plots. The methods for doing this are described later in this chapter. The lower two bubbles seem to be in the process of coalescing. There are gradients of voidage around a higher voidage centre. Figure 21.11 shows a cross-sectional slice of the second bubble near its maximum voidage plane. It shows a higher voidage region not attached to the tube wall, but also not in an axially symmetric location. Bubbles are more often attached to the wall, and are almost never in the centre of the tube.

Figure 21.12 shows a Eulerian slice typical of the voids in the 700 μm plastic at the lower velocities. The void is a slug filling over half of the tube. It is rising at 68 cm s$^{-1}$. The slice is taken to intersect both the high voidage centre and a lower voidage region. There are voidage gradients ahead of and following the slug, with the highest voidage region located along the wall. The shape of these slugs suggests that solids flow around them and down along the wall or through some preferred low-voidage region. This cross-sectional voidage distribution near the position of maximum voidage is illustrated in Figure 21.13. This shows regions of high and low voidage on opposite sides of the tube. The slug appears to rise along one wall of the tube while solids flow down along the opposite side. Note that there are gradients and a substantial region where the voidage is 0.7–0.9.

The 700 μm plastic at higher fluidizing velocities is characterized by many

Figure 21.11 *Cross-section of a void in the 30 × 270 mesh acrylic*

Figure 21.12 *Eulerian slice of a slug in the 700 μm plastic*

full slugs. Figure 21.14 shows the Eulerian slices for all four imaging levels of two voids in the 700 μm plastic fluidized at 77.6 cm s$^{-1}$. A large upper slug is followed by a much smaller trailing slug. Note the apparent decrease in the dark low-voidage region between the slugs in going from level 1 to 4. This suggests that the lower bubble is catching up with the slug. The images illustrate an unsteady mode of solids flow around the larger void. Starting in level 4, a region of solids extends along the left side of the images. In level 3 this region has enlarged and extends further down along the side until in level 2 it has merged with the emulsion phase behind the slug. A small higher voidage 'bulge' develops near the top of the slug. In level 1 this gas bulge has grown and has nearly pinched off the solids flow in this region. Note the shortening of the slug and the expansion of the emulsion phase directly behind the slug, which also suggests some redistribution of gas. The upper slug has an average length of 31 cm and a rise velocity of 68 cm s$^{-1}$. The lower slug has a length of 9 cm and a rise velocity of 79 cm s$^{-1}$. Figure 21.15 shows a cross-sectional slice of

Figure 21.13 *Cross-section of a slug in the 700 μm plastic*

the level-1 data, showing the high voidage and lower voidage regions. The slice is taken to intersect a high-voidage region on the right and a lower voidage region on the left. Note that the low-voidage region in which the solids flow around the slug is confined to less than a 90° segment of the tube.

'Blunt-nosed' slugs are generally observed with the $\frac{1}{8}$ in. nylon spheres, even at the lowest superficial velocities. These slugs have unusually flat leading and trailing edges. They often extend across the entire tube, even when their lengths were considerably less than a tube diameter. They might best be described as flat voidage waves passing through the bed. Figure 21.16 gives a Eulerian slice of a short blunt-nosed slug observed with the $\frac{1}{8}$ in. nylon spheres fluidized at a superficial velocity of $112\,\mathrm{cm\,s^{-1}}$. This slug has a frontal diameter of 13 cm and a length of 6 cm. Its rise velocity is $25\,\mathrm{cm\,s^{-1}}$. Figure 21.17 shows a cross-section of this slug through the region of highest voidage near the axial centre of the slug. The section shows some variation in voidage. A high-voidage region likely represents gas up-flow and a lower voidage region is probably the region for solids down-flow. Note, however, that almost all of the section has a voidage of from about 0.8 to 0.9, even though this material has a minimum fluidization voidage of near 0.45.

Figure 21.18 gives Eulerian slices of the four levels of a long blunt-nosed slug obtained with the $\frac{1}{8}$ in. nylon spheres fluidized at $146.6\,\mathrm{cm\,s^{-1}}$. This slug has a frontal diameter of 14.7 cm, a length of 22 cm, and is rising at $34\,\mathrm{cm\,s^{-1}}$. The

level 1 level 2 level 3 level 4

Figure 21.14 *Eulerian slice of a long slug in the 700 μm plastic*

slug extends fully to the walls and shows wall 'spikes' or higher voidage regions along the walls preceding the slug. The tail of the slug has a steep voidage gradient with the material behind the slug at nearly slumped voidage. Solids appear not to flow around or 'rain' evenly through this slug. Rather, clumps or packets of solids appear to fall through the slug in at least several locations. Downward motion of the clumps can be seen by comparing levels 4 and 3, levels 3 and 2, and so on. Figure 21.19 shows a cross-sectional slice through this slug in level 1. The cross-section was taken to intersect the large clump near the top of the Eulerian slice.

As with the $\frac{1}{8}$ in. nylon spheres, with the coarse angular materials slugs are common, but they tend to be round nosed and have an expanded region ahead of them. Figure 21.20 shows a Eulerian slice of a slug in the $3\frac{1}{2} \times 6$ mesh acrylic fluidized at 112 cm s$^{-1}$. This slug has a frontal diameter of 12.7 cm and a rise velocity of 53 cm s$^{-1}$. The slice shows a lower voidage region on the right-hand side through which the solids are flowing down. At higher velocities longer slugs are formed with this material and the solids flow appears to be still through a preferred region, but is somewhat 'clumpy', as for the $\frac{1}{8}$ in. spheres.

While the Eulerian slices and cross-sections are useful visualizations, it should be pointed out that the bubbles and slugs observed are often not axially symmetric and a three-dimensional representation is necessary to visualize them truly. We sometimes construct physical three-dimensional models based on the Eulerian approach in order to understand particular voidage distributions.

Figure 21.15 *Cross-section of a long slug in the 700 μm plastic*

21.4 Quantitative measurements on a fluidized bed

21.4.1 Bubble behaviour

Average voidage plots
Constructing plots of the average void fraction in the imaging level versus time for each level provides a means of extracting various bubble parameters from the imaging data. The plots are readily constructed for each level and frame by integrating the void fraction of each pixel times the pixel area over the cross-section. The average void fraction is this integral divided by the cross-sectional area. Figure 21.21 shows a plot of the average void fraction versus time for all four levels. As a void begins to enter the lowest imaging level, the average void fraction rises. If the void is a bubble and not a slug, the curve will rise to a peak value and then rapidly fall off as the trail of the bubble passes through the imaging region. If the void is a slug, the curve will rise and remain somewhat flat as the elongated body of the slug passes through the region, and then fall off rapidly as the slug passes out of the imaging zone. Because the imaging region has a finite thickness, the curve will not drop off

	0.90
	0.85
	0.80
	0.75
	0.70
	0.65
	0.60
	0.55
	0.50
	0.45
	0.40

Figure 21.16 *Eulerian slice of a thin blunt-nosed slug in the nylon spheres*

instantly, even if the void were defined by sharp boundaries. Each imaging level will exhibit this type of curve; the difference in the positions of the curve is due to a time shift with successive layers since the void arrives later at the higher levels. Figure 21.22 shows an expanded portion of the curves shown in Figure 21.21; the time shift at the four levels can be seen clearly.

Several bubble parameters can be determined from the average voidage plots. From the time shift and the known spacing of the imaging levels, a rise velocity can be calculated. The passage of the void trail or the point where the voidage begins to fall is the most consistent place to mark the voids for determining the time shift. From the peak average voidage, a bubble 'frontal' diameter can be calculated if it is assumed that all the excess voidage above the emulsion phase voidage is contained in a void of circular cross-section. This representation requires the adoption of the two-phase representation of the bed. By integrating the average void fraction over time for each bubble and knowing the bubble velocity, a bubble volume can be determined. If a shape

Figure 21.17 *Cross-section of a thin blunt-nosed slug in the nylon spheres*

Figure 21.18 *Eulerian slice of a long blunt-nosed slug in the nylon spheres*

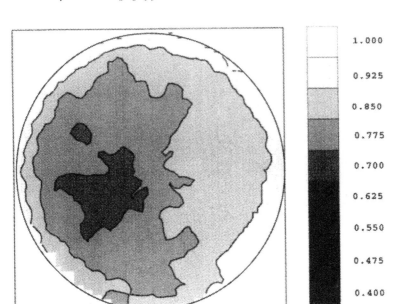

Figure 21.19 *Cross-section of a long blunt-nosed slug in the nylon spheres*

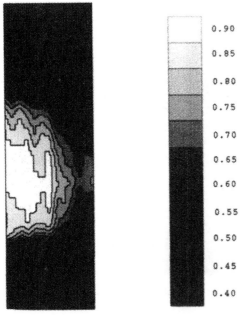

Figure 21.20 *Eulerian slice of a slug in the $3\frac{1}{2} \times 6$ mesh acrylic*

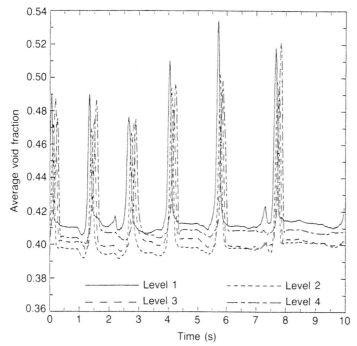

Figure 21.21 *Average cross-sectional voidage (full scale)*

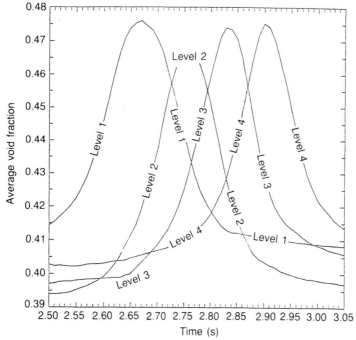

Figure 21.22 *Average cross-sectional voidage (expanded scale)*

such as a cylinder is assumed for the void, a void length can be determined from the volume and frontal diameter.

Bubble frequency is easily determined from a count of the bubbles present over a given time period. An average emulsion phase void fraction can also be determined by averaging the low voidage points between bubbles which are not close enough to have overlapping peaks. The spacing between voids can be estimated from the time difference between voids passing one level if the velocity of one of the voids is known and is assumed to remain constant. Spacing will generally vary since bubbles rarely have identical velocities. Using the velocity of the leading bubble gives the spacing between the bubbles at the time the trailing bubble arrives at the imaging level.

The average void fraction method is a consistent way of calculating bubble parameters and has been used in all of the METC studies to date. It is straightforward as long as there is not such large spacing between the voids that their peaks do not overlap. Significant overlap does occur during the final stages of bubble coalescence. In these situations, a visual estimate of a cut-off point to separate the voids is needed when integrating the voidage curve.

Alternative approaches to measuring bubble parameters

An alternative approach to measuring bubble diameter is to measure it directly in the cross-sectional plots. This has the advantage of avoiding the overlap problem. The principle difficulty, however, is in defining the bubble boundary. Since the cross-sections typically show voidage gradients, there is no clear way of saying what is bubble and what is emulsion phase. There is in fact no real 'bubble' in the sense of the two-phase representation. One approach is to simply pick a voidage value, as was done in the three-dimensional Euclidian representation, and define it as the boundary. An alternative approach is to use image-enhancement techniques (Young and Fu, 1986). Several standard techniques for edge enhancement have been successfully applied to the imaging data. Determining the contour where the Laplacian or second derivative of the void fraction equals zero seems to provide a clear way of defining several voids in a single level.

It should be pointed out that characterizing the fluidization in terms of a two-phase representation has serious limitations. Voids observed in these experiments rarely exhibit the circular cross-section of spherical cap bubbles. Voidage gradients rather than sharp boundaries enclose real bubbles. The emulsion phase between bubbles exhibits some expansion and voidage gradients as well. Notwithstanding these limitations, a two-phase representation is a convenient way to describe some bubble characteristics such as bubble diameter, bubble length and rise velocity. The average voidage method of determining size generally gives bubble diameters corresponding to the void fraction contours of 0.7–0.75.

Bubble length

As described above, bubble frontal diameters and lengths were determined using the average void fraction method. Under most fluidization conditions, a

substantial range of diameters and lengths were measured in each experiment. This indicates a dynamic condition in the bed. The degree to which individual bubbles have undergone coalescence prior to reaching the imaging level varies, giving rise to the varied sizes. In general, bubble length increases linearly with bubble diameter up to a size equal to about two-thirds of the bed diameter. Above this, the bubble length begins to increase more rapidly with increasing diameter. As the bubble diameter approaches the bed diameter, increased bubble volume can only be accommodated by increased length.

Figure 21.23 shows the bubble aspect ratio or length/frontal diameter versus frontal diameter/tube diameter ratio for the experiments with the 700 μm plastic. There appear to be three regions. For small bubbles the aspect ratio increases with increasing diameter up to about a bubble/tube diameter ratio of 0.5. From 0.5 to about 0.8, the aspect ratio is nearly constant and beyond this it increases at an increasingly faster rate. An empirical curve shown on the plot is given by the equation:

$$\frac{L_b}{D_b} = 1.25\left(\frac{D_b}{D}\right)\exp\left(\frac{1}{8[1 - (D_b/D)]}\right) \tag{21.1}$$

where D_b is the frontal diameter of the void, L_b is the void length (assuming the void is a cylinder), and D is the tube diameter.

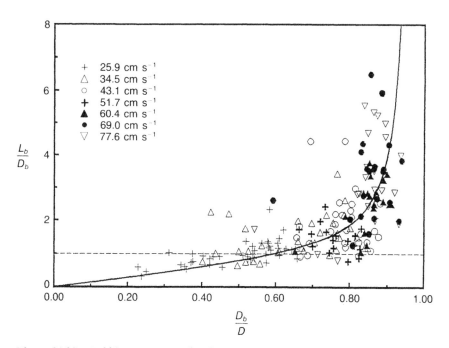

Figure 21.23 *Bubble aspect ratio for the 700 μm plastic*

Most of the data lie along this curve. There are some points, however, that lie substantially above the curve. Examination of the three-dimensional images revealed that, in general, these bubbles are in the process of coalescing with the preceding bubble. The three-dimensional Euclidian images also reveal that accelerating bubbles elongate as they approach a preceding bubble prior to coalescence.

The other materials exhibited similar behaviour. The finer materials usually did not form slugs, while the coarser materials frequently did have elongated slugs. The data collected in this study suggest that there is a range of length/diameter relationships depending on the material being fluidized. This would correspond to results of previous studies by other authors in which the wake fraction of bubbles varied with the type of material fluidized. There is, however, significant scatter even within a single material, suggesting that under a specific fluidization condition more than one bubble form can exist; there is, in fact, no average or typical bubble in these cases.

Bubble rise velocity

The rise velocities, bubble diameters, bubble lengths and spacings determined by the average void fraction method from the imaging data provide a comprehensive set of parameters from which a correlation can be developed. A theoretical basis has been developed for a correlation based on solids flow around a void (Halow and Nicoletti, 1992). The rise velocity is given by the equation (Halow *et al.*, 1991):

$$U_{a} = \sqrt{\frac{gL_{b}}{[A^*/(1 - A^*)]^2 + 2}} \times \left[1 + 3\left(\frac{D_{i-1}}{\mathrm{Sp}}\right)^3\right] \qquad (21.2)$$

where A^* is the ratio of the void cross-sectional area to the bed area, D_{i-1} is the diameter of the preceding bubble, g is the acceleration due to gravity, L_b is the bubble length, U_a is the rise velocity of the bubble, and Sp is the tail-to-tail spacing of the bubble and the preceding bubble.

Figure 21.24 gives the correlation for the 30 × 270 mesh acrylic. The plot follows the general trend showing an increase in velocity as spacing decreases. The correlation shows that velocity increases with bubble length. The effects of the tube walls are contained in the A^* term which decreases bubble velocity as the bubble diameter approaches the tube diameter. The bubble-spacing effect is a cubic term in the equation. As the spacing between bubbles decreases, the rise velocity increases in a non-linear way. This gives rises to further acceleration until the bubbles finally coalesce. As bubbles approach each other, the lower bubble elongates, contributing further to an increasing acceleration. There are a substantial number of closely spaced bubbles which do not show a high velocity. These correspond to bubbles that are closely spaced but not aligned angularly. The acceleration effects apparently only occur when there is a reasonable degree of alignment of a bubble with the preceding bubble.

Eulerian slices of voids indicate that voids leave behind them trails of

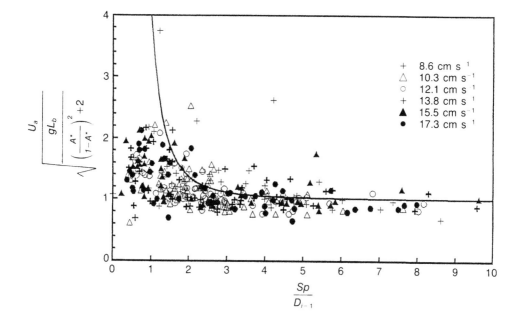

Figure 21.24 *Velocity correlation for the 30 × 270 mesh acrylic*

elevated voidage which persist for some period of time. These trails provide a
preferred path for gas percolating through the roof of a following bubble. This
tends to cause alignment of the bubbles by providing a track along which the
following bubble will rise.

The other materials fluidized in the METC studies also generally follow eqn
(21.2). Some exceptions are observed due to peculiarities in the bubble
behaviour. The 700 μm plastic fluidized at a bed velocity of 43.1 cm s$^{-1}$ gives a
substantial number of low points. These low data points generally correspond
to bubble doublets in which two bubbles closely spaced vertically but at
different angular positions rise together. If the bubbles formed in a bed have
slightly different velocities, have diameters about equal to the radius of the
bed, and are at alternating angular positions, the faster bubbles catch up with
bubbles ahead of them but do not coalesce. This pairing interferes with solids
flow around the bubbles and leads to reduced rise velocities. Some high data
points with this material correspond to the third and fourth bubbles in
angularly aligned bubble chains. If the leading bubble is itself rising rapidly
because of its closeness to a bubble ahead of it, the bubble following it is
accelerated more that is accounted for by the spacing term in eqn (21.2).

With the three coarser materials, the data often fall below the curve defined
by eqn (21.2), especially with the blunt-nosed slugs. The mechanism of solids
flow observed for the blunt-nosed slugs, i.e. the clumps or clusters of solids

falling sporadically through the bubble, is different from the smooth flow of solids around the bubble assumed in developing the correlation equation. This is probably the source of the discrepancy.

Bubble frequency

The peaks on the average void fraction versus time plots show that bubbles arrive at the imaging zone in an irregular time sequence. In some instances, such as in slugging beds, the peak sequence can become nearly periodic. In others, the sequence is highly variable and sometimes shows a shifting between several modes suggesting a chaotic behaviour. From the counts of bubbles in each of the experiments and the length of the experiments, average bubble frequencies were calculated. Figure 21.25 gives the average frequency of bubbles (Halow and Nicoletti, 1992) versus the ratio of superficial velocity to minimum fluidization velocity. These data are for an imaging position of 1.5–2.0 bed-diameters above the grid. With the finer materials, frequency first rises slightly with velocity as more and more bubbles are formed at the distributor, then decreases as the incidence of coalescence increases. With the coarser materials, the frequency is lower since larger slugs are present. The data generally follow smooth curves. There are, however, five points which show marked deviations from the curves. The bubbles in these cases are generally of a uniform size and nearly equally spaced, resembling slugs, although the voids did not always fill the cross-section of the bed.

The four Eulerian slices of a void in one of these low-frequency conditions is shown in Figure 21.26. The slices show two side-by-side voids, or a doublet.

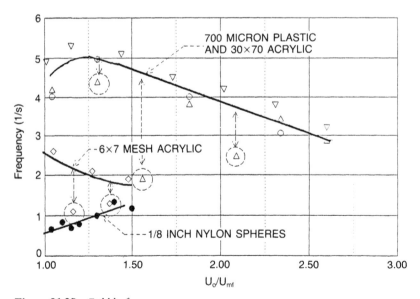

Figure 21.25 *Bubble frequency*

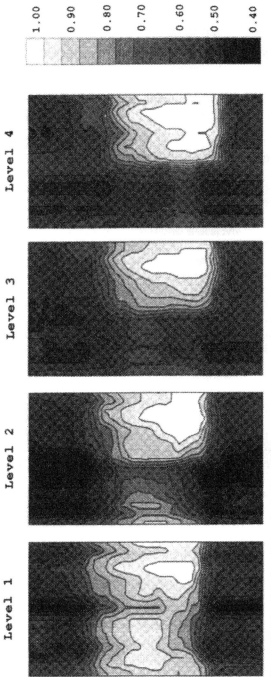

Figure 21.26 *Eulerian slices of a bubble doublet*

The condition appears to not be stable; a form of coalescence occurs in which one void loses gas to the other. The low-frequency phenomena resemble a form of resonance in which specific superficial velocities provide just enough gas to form stable, evenly spaced voids.

While average frequencies are useful overall characterizations of bed dynamics, it should be noted that the actual dynamics of the bed are much more complex than inferred by the average frequency. The chaotic behaviour of the bed gives rise to substantial variation in void sizes, velocities, and frequencies with time, even under the same fluidizing conditions.

21.4.2 Formation of voids near minimum fluidization

In one experiment with a 6×7 mesh angular acrylic material, the formation of voids in a bed slightly above minimum fluidization is imaged. In the imaging section showing this behaviour, the bubbles are very small in level one but grow substantially at the higher levels in a way that can be best described by analogy to condensation. Air in elevated voidage channels appears to collect or condense into the nascent voids at higher levels in the bed. Figure 21.27 shows the Eulerian slices for the four imaging levels. Level 1 shows several higher voidage channels with several nascent voids forming along the channel. In progressing through level 4 the voids grow substantially without coalescence, while the voidage in the channels decreases substantially. This may correspond to a condition of a bed at the incipient bubbling point. Figure 21.28 shows a cross-sectional slice of level 1, showing a number of elevated voidage channels through the bed.

21.4.3 Emulsion-phase expansion

The traditional two-phase theory of fluidization assumes that the emulsion phase, like the liquid phase in the air–water system, is incompressible and remains at the voidage at minimum fluidization. Although it has been suspected for some time that the emulsion phase in the vicinity of bubbles is not homogeneous, no accurate measurements have been possible. The imaging data were used to make approximate measurements of the expansion of the emulsion phase, The minimum average void fraction across the bed was determined for the times when no voids were present. The three-dimensional imaging visualization allowed these conditions to be selected with some certainty. Figure 21.29 shows a plot of the average emulsion phase voidage versus the superficial bed velocity/minimum fluidization velocity ratio. The data in this plot were taken at a bed height of around 1.5 tube-diameters above the grid. All materials except a 30×270 mesh acrylic showed expansion of the emulsion phase with increasing superficial velocity. It should be noted that, while much of the emulsion phase has a relatively constant voidage, higher voidage channels left in the wakes of voids contribute substantially to the elevated average voidage. Imaging at a higher point in the bed does not show

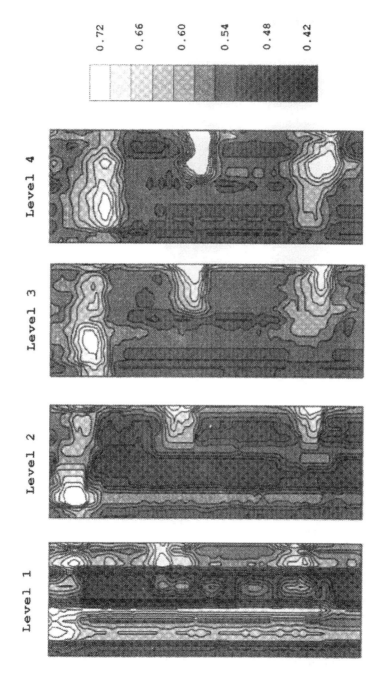

Figure 21.27 *Eulerian slice of void formation by 'condensation'*

0.625
0.600
0.575
0.550
0.525
0.500
0.475
0.450
0.425
0.400

Figure 21.28 *Cross-section at level 1 of bed during 'condensation'*

the dependence on superficial velocity, but does show a general elevation of the emulsion-phase voidage.

21.4.4 Imaging of a bed surface

Two sets of experiments were conducted to image the surface of a fluidized bed. In one series material was removed from the bed until the bed surface was between the third and fourth imaging levels while the bed was fluidized. With this arrangement, voids were observed as they approached and came through the surface. In the second set of experiments, the bed level was adjusted until the fluidized bed surface was between the first and second imaging levels. In this series of experiments, the sloshing liquid-like behaviour of the bed could be observed. The general behaviour was that as a void approached the surface, solids above the void would swell up prior to the arrival of the void. Figure 21.30 illustrates such a swell in the surface. The lighter shades indicate higher void fractions. Void fractions above 0.85 have been cut off, leaving the image of the solids. Gas flowing from the void would penetrate and open up the surface leaving a cavity in the bed surface. The cavity would fill in the cavity from the bottom. The process generally created a back-and-forth sloshing of the bed surface. Other effects were sometimes observed. Apparently the

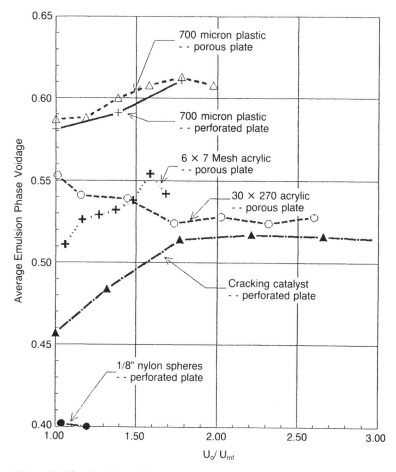

Figure 21.29 *Emulsion phase expansion*

behaviour is dependent on the size, location and velocity of the void. One such observation included a circumferential wave which started as a swell followed by a ridge of solids flowing circumferentially around the tube wall, both clockwise and counterclockwise, to a point 180° from the initial eruption. Figure 21.31 illustrates a time sequence showing the circumferential wave created after the eruption of a void.

21.4.5 Jetting into a fluidized bed

Capacitance imaging can also be used to examine the behaviour of a gas jet entering a fluidized bed. In several experiments in the METC system, a bed of the 700 μm plastic was fluidized at minimum fluidization velocity and a

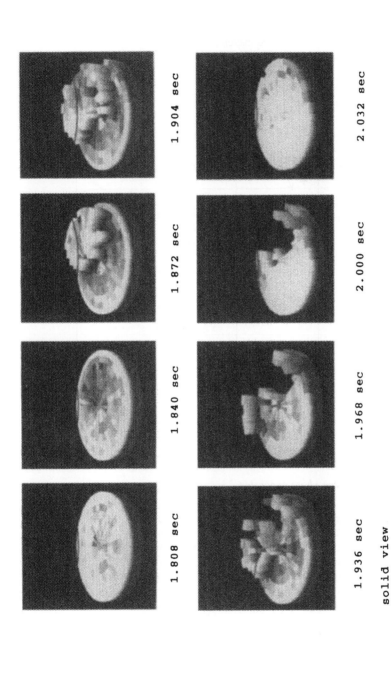

1.904 sec

2.032 sec

1.872 sec

2.000 sec

1.840 sec

1.968 sec

1.808 sec

1.936 sec

solid view
cutoff = 0.85

Figure 21.30 *Solids' swell in the bed surface preceding void*

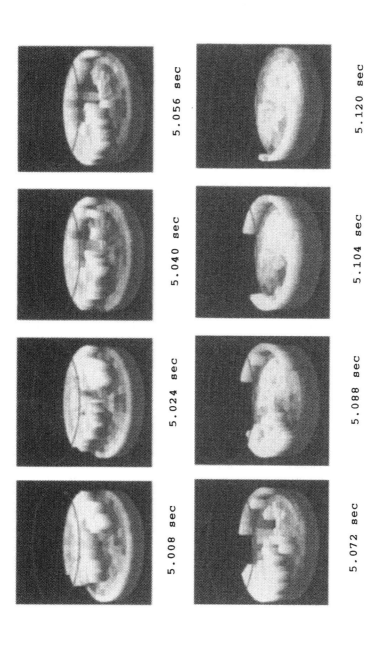

5.056 sec

5.040 sec

5.024 sec

5.008 sec

5.120 sec

5.104 sec

5.088 sec

5.072 sec

solid view
cutoff = 0.85

Figure 21.31 *Formation of a circumferential wave on the bed surface*

0.64 cm diameter tube located along the axis of the bed used to continuously inject gas into the bed. Gas flows from the nozzle forms voids in the bed which are periodically released. At low jetting velocities, the voids form at the end of the nozzle. At moderate and high jetting velocities, the voids are formed away from the end of the nozzle. Under these conditions, a higher voidage channel forms in the bed. This channel extends from the nozzle tip to a point where the voids are formed. The process resembles the blowing up of a balloon. Finally, the channel will temporarily collapse, allowing the void to be released. Figure 21.32 illustrates a time sequence showing the process. In the first frame, a voidage channel is formed. Subsequent frames show the increasing size of the void and the collapse of the voidage channel. The lighter shades represent higher void fractions. Void fractions less than 0.64 have been cut away to reveal the gas portions. Note that, because the void is being formed in the third and fourth imaging levels, the upper portion of the void is not imaged. Note also that, because of the limited resolution of the system, the jet could have a smaller diameter than indicated in Figure 21.32.

21.4.6 Enhancement of fluidization models

The results of capacitance imaging serve to point out the deficiencies in the two-phase models traditionally used to describe fluidized beds. These models fail to account for the voidage distributions in and around voids. The idealized spherical-cap shape assumed in most of models was rarely observed. Voids also exhibit a dynamic changing form not accounted for by these models. These considerations must be especially important when the purpose of the model is to describe the contact between gas and solids and when chemical reactions are occurring and are important to the description of the system. Improvements in these models which consider the voidage gradients within the bubbles and, especially, the emulsion phase are needed if the models are to become useful design tools.

The insight into the void frequency and dynamics gained in the imaging experiments suggest a description of fluidized beds based on the theory of deterministic chaos (Daw and Halow, 1991a,b). Average voidage versus time data from imaging experiments and pressure-drop data taken in other beds exhibit the behaviour of a chaotic system. Phase plane plots characteristic of bubbling beds and slugging beds have been identified. A simple model incorporating the essential non-linear dependence of bubble rise velocity on bubble spacing using eqn (21.2) exhibits the characteristics of deterministic chaos. Chaotic dimensionality of the system appears to be relatively low. While this approach to describing fluidized beds is in its infancy, it has the potential to provide a simple way of describing the complex dynamics observed in real beds.

21.5 Conclusions

Capacitance imaging is a valuable tool for examining the detailed voidage distributions within fluidized beds. The high speed of the technique allows the

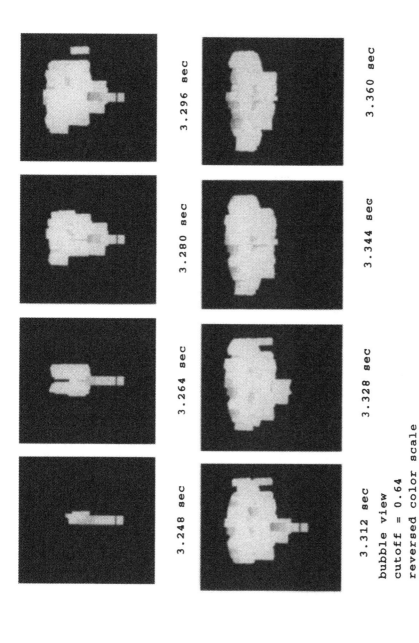

3.248 sec 3.264 sec 3.280 sec 3.296 sec

3.312 sec 3.328 sec 3.344 sec 3.360 sec

bubble view
cutoff = 0.64
reversed color scale

Figure 21.32 *Jetting into a fluidized bed*

dynamic behaviour of fluidized beds to be studied in detail. The technique confirms many early observations in a much more direct way and reveals previously unobserved behaviours.

Extensions of the current method used at METC are expected to include increasing resolution to over 500 pixels per level, decreasing the thickness of imaging levels from 2.54 to 1.27 cm, increasing imaging rates to at least several hundred frames per second, and imaging in larger beds for longer periods of time. A 1 ft diameter imaging section has been constructed and is now operating. Application of the METC capacitance imaging system to other gas-solid flows are being developed.

Acknowledgements

The author wishes to acknowledge: the inventors of the imaging system, Mr George Fasching and Dr Nelson Smith; the contributions of Mr Philip Nicoletti in developing the software to visualize and analyse the data; Mr Carol Utt, Mr Keith Dodrill and Mr John Trader, who built and operated the system; Mr James Spenik who assisted in planning and conducting many of the experiments; and Dr Jean Loudin who evaluated many techniques for analysing the current data.

References

Davidson, J. F. and Harrison, D. (1963) *Fluidized Particles* Cambridge University Press, Cambridge

Davidson, J. F. and Harrison, D. (eds) (1971) *Fluidization* Academic Press, London

Daw, C. S. and Halow, J. S. (1991a) Characterization of voidage and pressure signals from fluidized beds using deterministic chaos theory. In *Proceedings of the 1991 Conference on Fluidized Bed Combustion, Montreal*, 777–786. American Institution of Chemical Engineers, New York

Daw, C. S. and Halow, J. S. (1991b) Modeling deterministic chaos in fluidized beds. In *AIChE Annual Meeting, Los Angeles* paper 103a. American Institution of Chemical Engineers, New York

Fasching, G. E. and Smith, N. S. (1988) High resolution capacitance imaging system. *NTIS Report No. DE88010277*

Fasching, G. E. and Smith, N. S. (1990) Three-Dimensional capacitance imaging system. *NTIS Report No. DE90000470*

Fasching G. E. and Smith, N. S. (1991) A capacitive system for three-dimensional imaging of fluidized beds. *Rev. Sci. Instr.*, **62**, 2243–2251

Geldart, D. (ed.) (1986) *Gas Fluidization Technology* Wiley, New York

Halow, J. S. and Nicoletti, P. (1992) Observations of fluidized bed coalescence using capacitance imaging. *Powder Technol.*, **69**, 255–277

Halow, J. S., Fasching, G. E. and Nicoletti, P. (1990) Advances in fluidization engineering. *A.I.Ch.E. Symp. Ser.*, **86**, 41–50

Halow, J. S., Fasching, G. E., Nicoletti, P. and Spenik, J. L. (1991) In *1991 Annual AICHE Meeting, Los Angeles* Paper No. 105c. American Institution of Chemical Engineers, New York

Young, T. Y. and Fu, K. S. (1986) *Handbook of Pattern Recognition and Image Enhancement* Academic Press, London, 215–222

Chapter 22

Mixing processes in fluids

D. Mewes and A. Fellhölter

22.1 Introduction

In all process engineering studies that are concerned with three-dimensional fields with variable velocities, temperatures or concentrations, it is desirable to be able to measure these parameters simultaneously at all points in the space. For this purpose tomographic measurement methods have been developed.

The four-beam optical tomography by holographic interferometry as well as light absorption was developed for single-phase transparent liquid and gas flows. Mayinger and Lübbe (1984) measured three-dimensional temperature fields by holographic interferometry and examined the time- and location-dependent mixing of a liquid component in a stirred vessel. Ostendorf and Mewes (Mewes and Ostendorf, 1983; Ostendorf and Mewes, 1988; Mewes, 1991) extended these kinds of measurement using viscous liquids in order to visualize temperature fields created by turbulent mixing and dissipative heating. Haarde and Mewes (1988, 1990) developed an experimental set-up for the observation of non-steady-state mass exchange processes occurring during jet mixing. They observed the concentration profiles of a dye by the intensity change of light beams. The experimental results were recorded with diverging light in the form of transillumination projections from four angles of view.

In the continuation of these experiments holographic interferometry was used to record concentration fields by parallel coherent monochromatic light beams from four directions in a single-phase gas flow (Mewes et al., 1992; Herman et al., 1992; Fellhölter and Mewes, 1992). The concentration fields were reconstructed by tomography during the mixing process in ducts of large cross-section. The results were used for the development of mixing devices with very low pressure losses.

The mixing of liquids by jet flow of one component was observed in order to develop an emergency system for large reactor vessels and tanks (Mewes et al., 1992; Renz and Mewes, 1992). In case of an exothermic chemical reaction a small quantity of liquid reaction stopping agent has to be distributed homogeneously throughout a large volume of reacting liquid. A system of discontinious operating jets was developed by consideration of the experimental results from tomographic reconstruction of the instationary concentration fields. Coloured jets were used, spreading in optical transparent liquids of different viscosity.

22.2 Techniques for determining experimental parameters

Tomographic measurement methods require a signal and a sensor for measurement purposes. Since the signal is a beam of visible light, transport processes are to be observed only inside optical transparent fluids. For this purpose absorption and interferometric techniques may be used. While absorption techniques make use of the decrease in the intensity of a light wave during the irradiation of fluids, the change in the phase of a coherent light wave with respect to a reference wave is measured with interferometric techniques. The wavelength and the amplitude of the radiationship are influenced by the physical properties of the fluid. These properties are called 'field parameters'.

The variation in these field parameters is caused by the temperature, concentration, density or velocity fields under investigation. Probes are positioned outside the volume to detect these variations; their signals are related to the line integral of the selected field parameter.

This relationship is shown schematically in Figure 22.1 for one plane of the volume to be measured. The field parameter (f) which is variable in the plane, is projected onto an image plane. Field parameters are parameters such as the absorption coefficient or the index of refraction of transparent fluids or solid-state bodies. If several projections can be related to different directions, the field parameter can be determined from the measured projections by using suitable algorithms (Mewes *et al.*, 1989).

The following mathematical correlation exists for the relationship between the field parameter f and its projections in different directions θ:

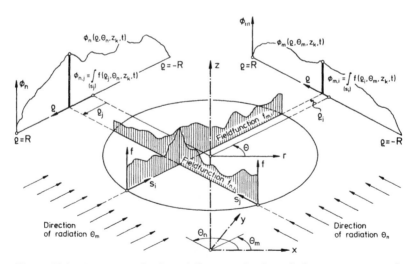

Figure 22.1 *Line integrals along different paths through the measurement volume*

$$\int_{s_i} f(x, y, z, t)\mathrm{d}s = \phi_i(\sigma_i, \theta, z, t) \tag{22.1}$$

where ϕ_i is the measured physical parameter and s_i is equivalent to the length of the path through the measurement volume. Depending on the field parameter that is to be determined experimentally, these are different possibilities of measuring individual projected parameters.

22.2.1 Absorption techniques

Absorption measurement techniques make use of the decrease in the intensity of the light during the irradiation of fluids or solid matter. They belong to the category of absorption techniques. The field parameter indicated in eqn (22.1) is equivalent to the location-dependent absorption coefficient (μ).

The experimental parameter in eqn (22.1) is equal to the natural logarithm of the ratio between the intensity of the light (I_0) entering the measurement volume and the intensity (I) of the light leaving the measurement volume. Consequently, eqn (22.1) must be transformed into

$$-\ln\frac{I}{I_0} = \int_{s_i} \mu(x, y, z, t)\mathrm{d}s \tag{22.2}$$

for absorption techniques.

For tomographic techniques, the measurement volume is irradiated from different directions. The reduced light intensity becomes visible as the projections with the use of sensors that are selected according to the type of radiation. Since the absorption coefficient depends on the wavelength of the applied wavetype as well as on the material properties of the fluids or the solid matter contained in the measurement volume, monochromatic waves must be applied to obtain a holographic recording of the experimental parameter. This is the only way to relate the reconstructed absorption coefficient to one particular material property.

For the observation of nonsteady-state mass exchange processes occurring during jet mixing in small sized vessels, Haarde and Mewes (1988, 1990) developed the experimental set-up shown in Figure 22.2.

In this set-up, the concentration profiles of a dye can be observed with the use of optical tomography. The dyes are either injected or they develop during a colour change reaction. They cause a decrease of the light in the cylindrical mixing vessel. The experimental results are recorded with diverging light in the form of transillumination projections from four angles of view with divergent light. The axes of the light bundles are directed towards the centre of the vessel at an angle of 45° to one another. Thus, the light bundles cover a range of 180°. The light is guided through the measurement chamber from four directions via mirrors and two beam splitters. With cylindrical lenses, the vessel can be illuminated in sections of 50 mm (overall) height each. For this purpose, the measurement chamber, which is about 200 mm high and has a diameter of 200 mm, is divided into four sections that are located above each

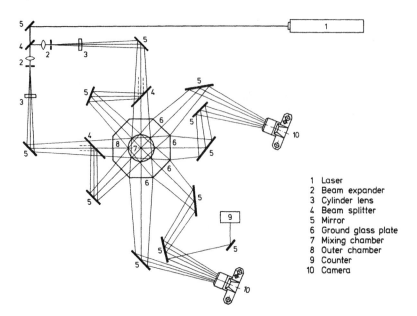

1	Laser
2	Beam expander
3	Cylinder lens
4	Beam splitter
5	Mirror
6	Ground glass plate
7	Mixing chamber
8	Outer chamber
9	Counter
10	Camera

Figure 22.2 *Experimental facility used for the measurement of non-stationary jet mixing processes inside large vessels by means of variation in light intensity*

other. In order to implement this investigation, the measurement chamber has to be located on a table with variable height that is positioned opposite the optical set-up. The cylindrical measurement chamber is located in the octagonal measurement chamber. The space between the octagonal exterior chamber and the cylindrical interior chamber is filled with water. This configuration is necessary to supress total reflection as much as possible. After penetrating the chamber, the beams hit matte photographic screens. Photographs of four matte screens are taken with synchronized, motor-driven microphotographic cameras. The negatives are fed into a picture processing unit and the film density is digitized.

22.2.2 Interferometric techniques

In addition to the change in the intensity of a wave, the change in the phase of a wave, with respect to a reference wave, during the irradiation of a measurement volume can be used to record projections of three-dimensional field parameters in a measurement chamber. The shifting of the phase of a wave, called the 'phase shift', is equivalent to the integral change of the field parameter along the irradiation path. In accordance with the relationship between the field parameter f and the experimental parameter ϕ indicated in eqn (22.1), the following equation is obtained for interferometric techniques:

$$\phi_i(\sigma_i,\theta,z,t) = \int_{s_i} \Delta f(x,y,z,t)\mathrm{d}s \qquad (22.3)$$

The function Δf is the change in the field parameter with respect to a reference condition. The advantage of interferometric techniques compared with absorption techniques is the fact that the recorded experimental parameters are equivalent to the integral change in the field parameter. For absorption techniques, the recorded experimental parameter is proportional to the integral change in the field parameter. Therefore, the experimental results of interferometric techniques do not have to be calibrated.

In order to determine temperature fields in mixing vessels or concentration fields in wind tunnels, holographic real-time interferometry can be used as measuring technique. With holographic interferometry the phase shift of two light waves due to the change in refractive index can be measured. The refractive index depends on the concentration for constant temperature or on the temperature for constant concentration. A detailed description of holographic interferometry is given in Mewes (1991) and Mewes and Ostendorf (1983).

The optical set-up for measuring projection data in four different directions with holographic interferometry is shown in Figure 22.3. The light beam emitted from an argon-ion laser reaches a beam splitter (**BS**) where it is divided into an object beam and a reference beam. The ratio between the intensity of the object beam and the intensity of the reference beam can be varied with this beam splitter. The next beam splitter divides the object beam into two portions, each of which is again divided into two object waves of identical

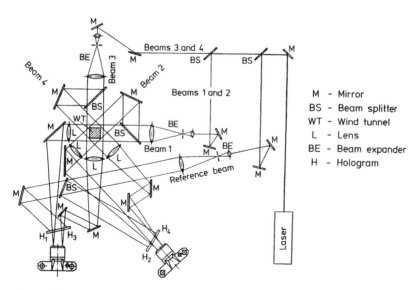

Figure 22.3 *Experimental facility with four-beam holographic interferometry*

intensity value via two large beam splitters, after passing through the enlargement optics (BE). Thus they irradiate the wind tunnel at displacement angles of 45°. The object waves are then bundled with lenses (L) which results in an increase of intensity of the light in the holographic plane (H). By this the exposure time for the holograms are reduced which is of special importance for the recording of non-steady-state processes. Two object waves can be projected onto a holographic plate with the mirror (M). The reference beam is also enlarged. It bypasses the wind tunnel and is divided into two reference beams for one holographic plate each. The holographic plates are installed in clamped frames and fixed mountings with three point bearings. This allows an exact repositioning of the holograms after their formation.

22.3 Tomographic reconstruction of temperature and concentration profiles

The experimental procedure is shown in Figure 22.4 for the reconstruction of concentration fields in a wind tunnel. The interferogram is recorded from one direction of irradiation during the injection of two co-flowing jets of carbon dioxide. Four interferograms which are taken simultaneously from four different directions of view are recorded for picture processing using a video camera. The interferograms are digitized, filtered and the skeleton lines are extracted. The interferograms of the reference beams and the phase-shifted

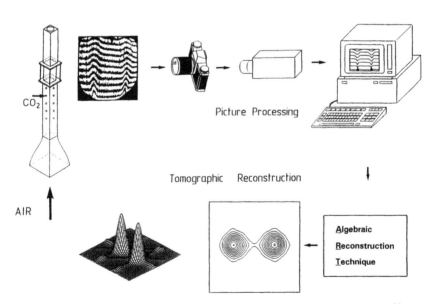

Figure 22.4 *Procedure for tomographic reconstruction of concentration profiles*

beams are superpositioned and the phase shifts due to changes in refractive index are measured. The interferograms of the four different directions are evaluated.

The concentration profiles are reconstructed tomographically in discrete cross-sectional areas of the wind tunnel from the measured data. The tomographic reconstruction is done by using the algebraic reconstruction technique (ART) developed by Gordon *et al.* (1970). Because of the small number of directions of the different transversing beams, only the combination obtained with the so-called 'sample method' described by Sweeney (1972) gives considerable reconstruction quality. The computer-time limitation restricts the iteration process to areas of 200 mm × 200 mm which are broken down to a grid of 50 × 50 area elements. Nearly 5 min of computer time is necessary on a Cyber 990 computer to run through six iterations in order to keep the reconstruction quality below an average systematic deviation of 5%. One possibility of prescribing the number of iteration steps is to observe the quality of reconstruction obtained with different numbers of iteration processes with the use of a test function. Two-dimensional analytic functions are used for test purposes. The values of these functions and the number of extreme values in the investigated range correspond with the course of the assumed field parameter. The applied functions should have no symmetrical axes in the direction of the beam and are integrated along the defined paths. The obtained integral values represent simulated experimental results, which reconstruct the required analytic functions with the use of the mentioned method.

The quality of the reconstructions obtained depends on the number of completed iteration processes. When the desired quality of reconstruction is achieved, the determined number of iteration steps can be used as a measure for the number of iterations required for the calculation of the field function from experimental results.

The average deviation obtained for different numbers of iteration processes for two different test functions is shown in Figure 22.5. The number of iterations has to be determined individually for each application and each required quality of reconstruction.

22.4 Mixing of fluids

22.4.1 Measurements by light absorption in liquids

Concentration profiles were measured for different cross-sections inside a continuously operated jet mixed vessel by (Haarde and Mewes, 1988, 1990). The aim of these investigations was a proper sizing of jet mixing systems responsible for cooling or mixing inside large storage vessels and tank farms.

In the case of an emergency it is quite normal that the ordinary mixing and cooling systems are out of operation, and in such a case a possible exothermic chemical reaction might have to be stopped. In this case small amounts of liquid have to be injected by jets in order to stop the chemical reaction. The

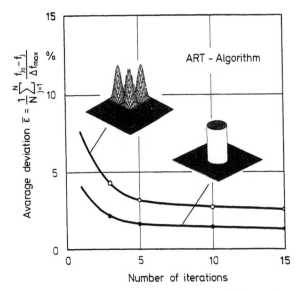

Figure 22.5 *Two different test functions and their influence on the necessary number of iterations*

small liquid volume injected has to be distributed among the large vessel volume homogeneously, without any additional power input.

In the experiments, the concentration profiles which correspond to the non-steady-state mass exchange processes during jet mixing were measured. The mass concentrations were visualized by dyes which were injected together with the liquid jet flows. The dye causes a decrease of light in the cylindrical vessel which is proportional to the concentration. A typical image composed of four pictures taken at different heights is presented in Figure 22.6.

Pictures from four different directions are photographed simultaneously using the optical set-up shown in Figure 22.2. The three-dimensional concentration fields are obtained by tomographic reconstruction from several planes of the mixing vessel. Results are given in Figure 22.7(a) for a sequence of tomograms in five different cross-sections of the vessel after the injection of the dye. Areas of a higher concentration are hatched. The three-dimensional distribution is shown in Figure 22.7(b).

Renz and Mewes (1992) used non-stationary operated jets which are injected during short intervals of time. They investigated the influence of the viscosity ratio as well as the angle of inclination of the nozzle axis and the time period for which the jets are in operation. Several concentration profiles representing the three-dimensional concentration field obtained with the use of tomographic reconstruction are shown in Figure 22.8 for different cross-sections of the vessel taken simultaneously.

Figure 22.9 shows four photographs of one single jet injected during a short period of time into liquids of increasing viscosity. The photographs are taken at the same time after starting the process. The figure gives an

Figure 22.6 *A visualized concentration field inside a jet-mixed vessel*

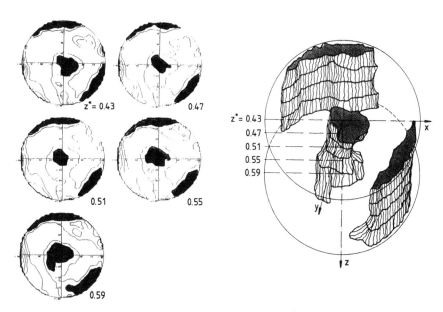

Figure 22.7 (*a*) *Concentration fields in a storage tank due to non-stationary jet mixing taken from four directions by light absorption.* (*b*) *Tomographic reconstruction*

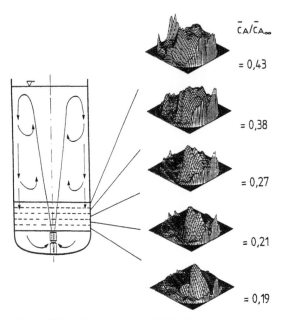

$\bar{c}_A / \bar{c}_{A_\infty}$

= 0,43

= 0,38

= 0,27

= 0,21

= 0,19

Figure 22.8 *Concentration fields of a dye-coloured non-stationary operated liquid jet in different horizontal planes at one moment of time*

impression of the mixing process by an intermediate operated single water-jet injected into liquids of different viscosity.

22.4.2 Measurements by holographic interferometry in liquids

Mewes and Ostendorf (Mewes and Ostendorf, 1983; Ostendorf and Mewes, 1988) used holographic real-time interferometry in order to measure temperature fields in mixing vessels. They used a cylindrical vessel and a six-blade disk stirrer in order to investigate mixing in the laminar region of flow. The stirrer is located in the centre between the top and the bottom of the vessel. A small volume of the same liquid but of different temperature was injected into the liquid volume contained in the stirred vessel. The mixing process in the stirred vessel and the equalization of the temperature were observed. Figure 22.10 shows the interference images for an irradiation angle at certain points in time after the warmer liquid was added.

Before the warmer liquid was added, the interference pattern showed evenly spaced stripes. This pattern was obtained by changing the angle between reference and object wave slightly after the formation and the back-positioning of the hologram. During the mixing process a temperature change occurs. It can be calculated from deflection of the interference stripes for each plane of the vessel and from the distance between the stripes in the zero-field

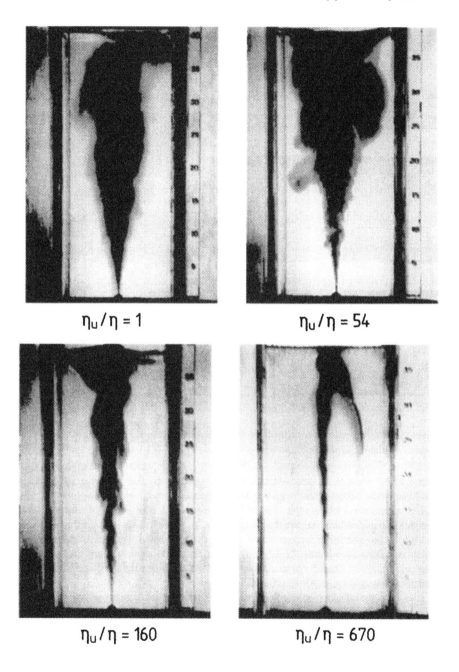

Figure 22.9 *Non-stationary operation of a jet over a short period of time at different viscosity ratios of two mixing liquids*

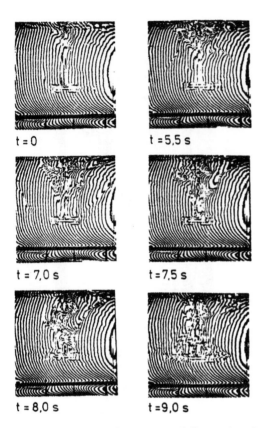

t = 0 t = 5,5 s

t = 7,0 s t = 7,5 s

t = 8,0 s t = 9,0 s

Figure 22.10 *Interferograms at different times in a mixing vessel. A small heated volume of fluid is supplied at the top of the vessel*

interference image. A reconstructed temperature profile is given in Figure 22.11 for one cross-section of the mixing vessel.

In order to obtain the spatial expansion of the liquid volume, the temperature profiles at several levels are reconstructed in the immediate vicinity of the stirrer. The plane cuts this liquid volume at the six superimposed levels marked in Figure 22.12 in order to present a picture of the vertical expansion of the liquid volume. The temperature difference between adjacent isotherms amounts to $T = 0.02\,^{\circ}\mathrm{C}$.

In the cross section of the stirrer (H31) the volume flow of the liquid is divided into two smaller streams of liquid of different vertical expansion. The vertical position of the other mentioned temperature profiles in the agitated vessel are presented in Figure 22.13.

In Figure 22.14(a) a three-dimensional, perspective representation of the spatial shape of this fluid element is given. At the time t = 7.5 s, the two lower ends of the fluid element by-pass the impeller blases. 0.5 s later, they separate from the remaining part of the element and two new volume portions develop.

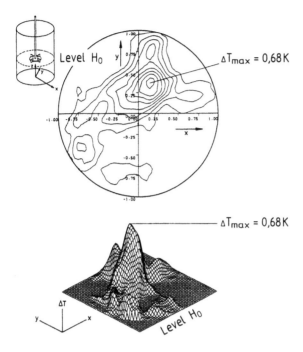

Figure 22.11 *Temperature profile of one cross-section of the mixing vessel computed by tomographic method*

In Figure 22.14(b) a three-dimensional, perspective representation of these volumes is given. The separation of the volume portions coincides with the development of new fluid elements.

Experimental investigations of temperature profiles caused by dissipationof kinetic energy were implemented by Ostendorf and Mewes in the laminar flow regime of a Newtonian fluid and by Friederich and Mewes (1990) in the laminar flow régime of a non-Newtonian fluid in a mixing vessel. Figure 22.15 shows the interference images in the near vicinity of a six-blade stirrer in a Newtonian fluid. The interference fringes are deformed into wedge shapes at the height of the stirrer. In the rest of the volume of the stirrer vessel, their positions remain constant throughout the entire stirring process.

Temperature profiles were reconstructed from these interferograms. In Figure 22.16 a comparision between temperature profiles caused by a disk impeller in a Newtonian and a non-Newtonian fluid is given. The different stirring times result from the impeller speeds adjusted for the individual test parameters and the parameters of the indicated times. For almost identical energy inputs, a strong radial expansion of the temperaturefield is obvious for the Newtonian fluid. Particularly in the impeller level, the temperature field expands almost to the vessel wall.

In the polymer solution, no pronounced deformation of the temperature field is present in the cross-section of the impeller. In spite of the Reynolds

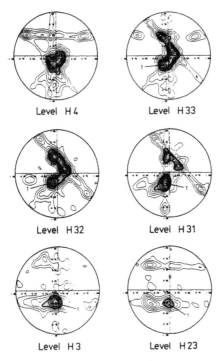

Level H4 Level H33

Level H32 Level H31

Level H3 Level H23

Figure 22.12 *Reconstructed temperature fields at* t = 7.5s *after adding the heated
liquid volume*

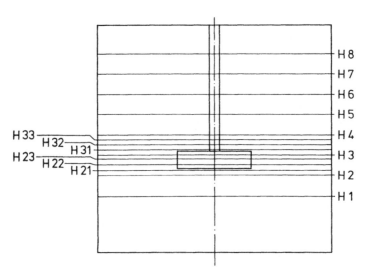

Figure 22.13 *Positions of different cross-sections under investigation in the
agitated vessel*

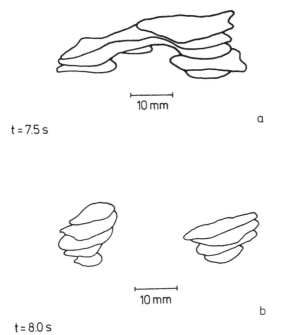

10 mm

a

$t = 7.5\,s$

10 mm

b

$t = 8.0\,s$

Figure 22.14 *Visualization of reconstructed fluid elements at (a) $t = 7.5\,s$ and (b) $t = 8.0\,Ms$ after adding the heated liquid volume*

number of Re = 8, which is twice as high in the polymer solution compared to the Reynolds' number in the Newtonian fluid, the flow in radial direction and, consequently, a convective transfer towards the edge of the mixed region in the polymer solution are too small to be measured. The diameter of the mixed region is about half the size of the diameter of the vessel. Within the mixed region of the polymer solution, the molecular mass transfer dominates over the convective mass transfer. If the Reynolds' numbers are increased further, the convective transfer dominates over the molecular transfer. In Newtonian fluids, the convective transfer dominates.

For the experiment described, a polymer solution with $Re^2Pr = 413\,000$ was used. In glycerin this value is approximately one-third (i.e. $Re^2Pr = 140\,000$) that of the polymer. In Newtonian fluids the convective transfer for values should no longer be negligible over the molecular transfer for values $Re^2Pr > 1000$. In the examined polymer solution this is the case for much higher values of the parameter product Re^2Pr. For values of $Re^2Pr > 800\,000$, a convective transfer can be observed in the liquids.

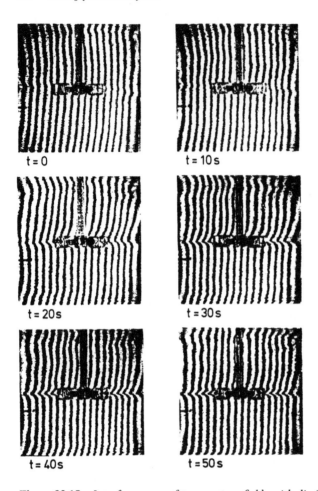

Figure 22.15 *Interferograms of temperature fields with dissipation effect at different times of viscous mixing*

22.4.3 Measurements by holographic interferometry in gases

The optical method has been applied to mixing in single-phase gas flows (Fellhölter and Mewes, 1992; Mewes and Fellhölter, 1992). Mixing of gases with different temperatures and concentrations is of great significance in the chemical and power plant industries. The intention of research in this area is to realize homogeneous concentrations and temperatures in ducts and channels of very large as well as smaller sized cross-sections after short mixing lengths of gas flow. Technical applications are the mixing of ammonia into large quantities of flue gas in order to minimize nitrogen oxide emissions or the

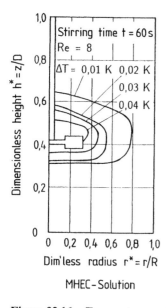
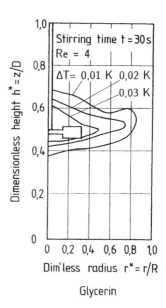

Figure 22.16 *Temperature profiles of a turbine impeller with inclined blades rotating at different speeds*

reheating of gas flows entering into a catalytic conversion process by mixing with small quantities of gas with higher temperatures.

The investigations were carried out in a transparent, open circuit wind tunnel with a square cross-sectional area (Figure 22.17). The lateral length of the channel is 85 mm. The channel is positioned vertically and has a total length of 1190 mm. The carrier gas flow is sucked through the channel by a roots compressor. Ambient air is accelerated into the channel through a specially designed nozzle. Carbon dioxide taken from a compressed gas cylinder can be injected in six different areas of the channel. Thus it is possible to measure the concentration fields at different distances from the point of injection.

The mixing of gases by co-flowing jets requires long channel lengths to ensure complete homogenization. The injection of carbon dioxide perpendicular to the carrier gas will improve the degree of mixing shown in Figure 22.18. At the outlet of the nozzle the flow pattern is similar to the flow around a cylinder. An eddy flow develops in the trail of the jet, which is axisymmetric in this initial section. Due to shearing forces at the edge of the jet a circularity flow is induced in the jet itself. As a result of pressure and shearing forces, peripheral fluid elements of the jet are more forcefully bent by the deflecting flow, which leads to the development of a cross-sectional area that is kidney shaped. With increasing distance from the point of injection the jet flows parallel to the carrier gas flow. The different cross-sectional areas of a jet injected perpendicularly into a carrier gas flow are depicted in the interferograms. The presented interferogram results from two jets injected perpendicularly into the

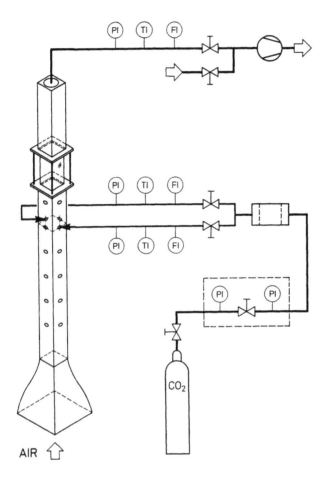

Figure 22.17 *Experimental facility used for gas-mixing experiments*

carrier gas flow. In the kidney-shaped cross-section of the jets the deflection of the fringes shows two maxima and one minimum. The minimum disappears with increasing distance from the point of injection.

The concentration fields of a single jet injected perpendicularly were reconstructed in several areas of the mixing channel. A comparison of the maximum concentration between a cross-flowing and a co-flowing jet is given in Figure 22.19. The diameter of the nozzles is 4 mm; the velocity ratio is the same in both experiments. While the maximum concentration of the co-flowing jet decreases slowly, the cross-sectional area of the jet injected perpendicularly is greatly deformed due to the greater momentum exchange between jet and carrier gas flow. As a result, the maximum concentration of the cross-flowing jet is smaller than that of a co-flowing jet at the same mixing length.

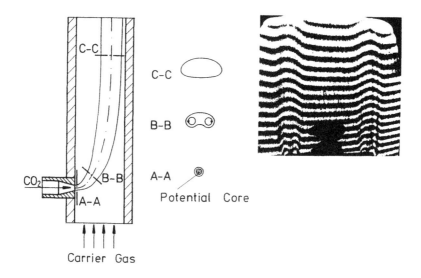

Figure 22.18 *Expansion of a gaseous jet in a cross-flow of gas*

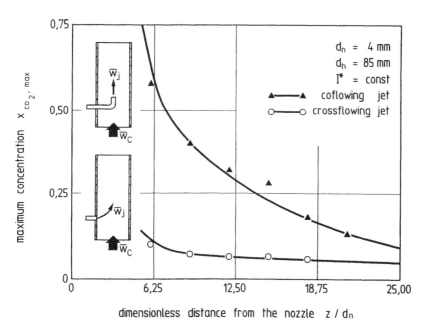

Figure 22.19 *The maximum concentration in cross-sections at different distances from the nozzle outlet for co-flowing and cross-flowing jets*

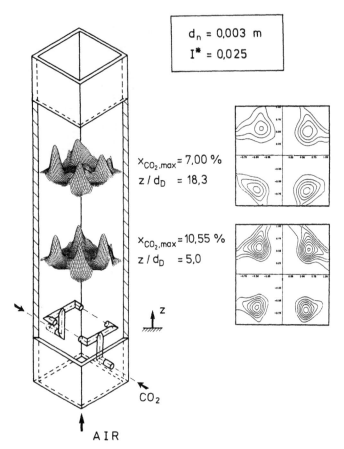

$d_n = 0,003$ m

$I^* = 0,025$

$x_{CO_2,max} = 7,00$ %

$z / d_D = 18,3$

$x_{CO_2,max} = 10,55$ %

$z / d_D = 5,0$

z

CO_2

A I R

Figure 22.20 *Concentration fields of four cross-flowing jets in different sections of the channel*

In order to investigate the interaction between multiple jets, concentration fields which result from four jets discharging into the carrier gas flow are measured. The nozzles are located peripherally. The distance between two nozzles is 42.5 mm. The tomographically reconstructed concentration fields in two discrete cross-sectional areas of the channel are presented in Figure 22.20. The three-dimensional concentration fields in the left-hand part of Figure 22.20 are scaled to the maximum concentration of carbon dioxide in the respective cross-sectional area. The maximum concentration is 11% of the initial value at the distance of 15 mm downward of the injection point, while at a distance of 50 mm the maximum concentration is still 7%.

In the area of jet deformation the maximum concentration of carbon dioxide decreases rapidly. The concentration exchange slows down if jet and carrier gas are flowing parallel and velocity differences are small.

The quality of mixing can be improved by increasing the ratio of momentum

flow between jet and carrier gas flow. This is illustrated in Figure 22.21 which shows the intensity of segregation as a function of the dimensionless distance from the nozzle for different ratios of momentum flow. The intensity of segregation accounts for the deviation of the concentration from the mean concentration at every point of the cross-sectional area of the channel. The intensity of segregation is unity for complete separation and zero for homogeneous mixing of the two components.

A higher quality of mixing can be achieved for an increased ratio of momentum flow. Figure 22.21 also shows the intensity of segregation for jets in counterflow. Due to the higher momentum exchange between jet and carrier gas flow, the quality of mixing can be improved even further.

22.5 Conclusions

In process engineering studies done using tomographic measurement techniques are applicable to the observation of the concentration and temperature profiles in optical transparent single-phase gases and liquids. The concentration and temperature fields are three-dimensional and non-stationary. Absorption and interferometric techniques can be used to record the measured values. Tomographic reconstruction of considerable accuracy is possible by projection of different bundles of parallel light beams transversing the whole measurement volume from four different directions.

Experimental results are presented for the mixing process and dissipation of

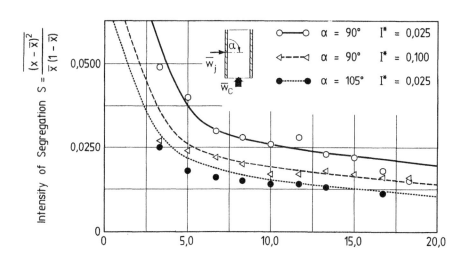

Figure 22.21 *Intensity of segregation as a function of the distance from the point of injection for different ratios of momentum flow and different angles of injection*

energy in the vicinity of a stirrer as well as for the jet-mixing process of liquids in large vessels and tanks and the continuous flow of gas mixtures inside channels of large cross-section.

References

Fellhölter, A. and Mewes, D. (1993) Flow visualization and measurement of concentration fields in gases by optical tomography. In *Imaging in Transport Processes* (eds S. Sideman and K. Hijikata). Begell House, New York

Friederich, M. and Mewes, D. (1990) Dissipative heating of Newtonian and non-Newtonian viscous fluids in mixing vessels. *Institution of Chemical Engineers Symposium. Series No. 121, Yorkshire*

Gordon, R., Bender, R. and Herman, G. T. (1970) Algebraic reconstruction technique (ART) for three-dimensional electron microscopy and X-ray photography. *Theor. Biol.*, **29**, 471–481

Haarde, W. and Mewes, D. (1988) Tomograpfie auch in der Verfahrenstechnik. *Chem. Ind.*, **11**, 76–83

Haarde, W. and Mewes, D. (1990) Das Vermischen geringer Stoffmengen in großvolumigen Lagertanks und chemischen Reaktoren. *Chem. Ing. Techn.*, **62**, 52–53

Herman, C., Mewes, D. and Mayinger, F. (1992) Optical techniques in transport phenomena. In *Advances in Transport Processes*, Vol. 8 (eds A. S. Mujundar and R. A. Mashelkar) Elsevier, Amsterdam, 1–58

Mayinger, F. and Lübbe, D. (1984) Ein tomografisches Meßverfahren und seine Anwendung auf Mischvorgänge und Stoffaustausch. *Wärme- Stoffübertragung*, **18**, 49–59

Mewes, D. (1991) Measurement of temperature fields by holographic tomography. *Exp. Therm. Fluid Sci.*, **4**, 171–181

Mewes, D. and Ostendorf, W. (1983) Einsatz tomografischer Meßverfahren für verfahrenstechnische Undersuchungen. *Chem. Ing. Tech.*, **55**, 856–864

Mewes, D., Ostendorf, W., Friederich, M. and Haarde, W. (1989) Tomographic measurement techniques for process engineering studies. In *Handbook of Heat and Mass Transfer* (ed. N. P. Cheremisinoff), Gulf Publishing Company, Houston, TX

Mewes, D., Fellhölter, A. and Renz, R. (1992) Measurement of mixing phenomena in gas and liquid flow. In *Tomographic Techniques for Process Design and Operation* (eds M. S. Beck *et al.*). Comp. Mech. Publ., Southampton

Ostendorf, W. and Mewes, D. (1988) Measurement of three-dimensional unsteady temperature profiles in mixing vessels by optical tomography. *Chem. Eng. Technol.*, **11**, 148–155

Renz, R. and Mewes, D. (1992) Experimentelle Untersuchung zur Ausbreitung von Reaktions-stoppern in Lagertanks. *Chem. Ing. Tech.*, **64**, 565–567

Sweeney, D. W. (1972) Interferometric measurement of three-dimensional temperature fields. Ph.D. Thesis, University of Michigan

Chapter 23

Resistivity imaging of mixing, transport and separation processes

R. A. Williams and F. J. Dickin

23.1 Introduction

The design of process equipment for dispersing and mixing components of similar or dissimilar phase represents a major and important step in many chemical and biological processes. In some instances the mixing process itself may induce or involve a change of phase (e.g. crystallization, precipitation, dissolution). Separation processes are the inverse analogue of mixing, in which components have to be segregated and separated according to differences between one or more chemical, electromagnetic, physical or physico-chemical property.

The problems faced by process engineers in attempting to design mixing and separation systems for various types of mixtures involve optimizing:

- Equipment geometry.
- Processing sequence (batch or continuous mode; feed and product removal sequencing, etc.).
- Ease of monitoring and control (e.g. to allow for changes in feed type, to detect and correct malfunctions, to provide maximum flexibility).

Traditionally, the design task is approached with recourse to previous experience coupled with experimental investigations at a laboratory and then pilot-plant scale. Predictions from *first principles* are difficult due to the complex fluid dynamics encountered in most processes. Theoretical predictions become increasingly problematic if phase changes occur or if interaction between dispersed particulates has to be considered.

For instance, the increasing availability of powerful computational tools has allowed, to a limited degree, some direct prediction of the mixing kinetics by solving the Navier–Stokes equation. Subject to certain limiting conditions (associated with the nature of local turbulence, the degree of swirl present in the stirred tank, assuming axial symmetry, etc.) it is possible to estimate the evolution of component axial concentration profiles with time in two dimensions for mixing processes coupled with a chemical reaction kinetic model. More sophisticated computational fluid dynamics (CFD) simulators also claim to produce three-dimensional data. These are clearly valuable in guiding process design, but in practice are often difficult, or impossible, to verify without using invasive instrumentation. If invasive sensors are used then some ambiguity in interpreting the comparison between predicted and measured results arises. Furthermore, appropriate sensors are not always

available. It is in this context that tomography offers the opportunity to radically transform the confidence of the design engineer by enabling robust, validated models to be devised, leading to an improved simulation capability. The application of tomographic instrumentation to a process on-line also opens up the possibility of yielding measurements that can be used to monitor and control the process.

Since many chemical, mineral, ceramic, food and water-treatment processes involve the rapid flow of aqueous-based mixtures, a tomographic technique that is capable of responding quickly is vital. Instrument methods based on optics are not tenable since most process liquors and dispersions are semi-transparent or opaque. Therefore, this chapter will consider the application of *electrical resistance tomography* (ERT) to measure differences in electrical conductivity within complex electrically conducting mixtures. The principles of the measurement method and instrumentation have been discussed in Chapter 5. Three types of application will be described.

The first set of application case study examples consider: the batch mixing of miscible liquids; batch mixing of a solid–liquid suspension; and monitoring the state of suspension of solids in a hydraulic conveyor.

The second group of applications demonstrate how ERT can be used: to monitor the flow of fluid within a stationary solid matrix; to elucidate the packing characteristic of particulate marine sediments; and in geophysical applications for environmental monitoring and land remediation studies. In such cases there is normally no need for image data to be acquired at high speed.

The third set of results illustrate how ERT can be used to provide information on the operation of hydrocyclone and dense-medium separators and the potential implications for on-line control.

23.2 Scale-up of mixing and transport of process fluids

23.2.1 Miscible liquids

One of the first important applications for ERT was in following the kinetics of batch mixing of two miscible liquids in a flat-based tank of 0.29 m diameter and 22 dm$^3$ capacity agitated by a six-bladed Rushton turbine impeller (Ilyas *et al.*, 1993). By mixing a more conducting saline solution (18.2 mS cm$^{-1}$ at 18 °C) into a less conducting saline electrolyte (1.9 mS cm$^{-1}$ at 18 °C) radial profiles of the relative changes in conductivity at various horizontal cross-sections on the stirred tank could be obtained. Four planes of 16 stainless-steel electrode bolts were mounted into the mixer (see Figure 5.2(c)). ERT measurements were made using the adjacent electrode technique (Dickin *et al.*, 1993) employing a small amplitude current (5 mA) at a fixed frequency (50 kHz). A fast back-projection algorithm was used to reconstruct the measured data (Barber and Seagar, 1987). The images produced were semi-quantitative in the sense that the zones indicated as having different conductivities represent regions of relative change (scaled and normalized by the user and presented on an arbitrary colour scale or grey level) rather than providing

absolute conductivity values. The 80×80 cubic pixels produced on the screen repesent a slightly higher spatial resolution than is justified by the reconstruction method. This computationally enhanced resolution was achieved by interpolating between the actual reconstructed data sets (32×32 pixels) resulting in smoothing of the conductivity profiles.

In the measurements reported here, the data to reconstruct a single frame were acquired over a 79 ms period, typically at a frequency of one such frame every second. Measurements were made at four imaging planes, although it was not possible to perform data collection simultaneously without *a priori* knowledge of the three-dimensional electrical field interaction between the four planes. Data could be obtained by sequentially scanning down each plane; however, to ensure that important time-dependent observations could be made it was more appropriate to follow the mixing behaviour in a given plane with time and then to repeat the identical experiment for each of the other three remaining cross-sections. Experimental measurements were stored for reconstruction off-line.

The geometry of the tank conformed to the accepted scaling characteristics (Harnby *et al.*, 1992). The impeller was fabricated from steel and attached to an aluminium shaft. Two of the electrode planes were in the vicinity of the impeller and two above the impeller (Figure 23.1). The higher conductivity (secondary) liquid was added to the lower conductivity (primary) liquid either via a burette or from a farm of syringes mounted just above the level of the primary liquid. Aliquots of 8–33 cm$^3$ of the secondary liquid were added to the tank in either an axisymmetric (symmetric) or asymmetric manner, using the the syringe farm or burette, respectively. The secondary liquid could also be mixed into the tank close to the impeller itself via a long narrow-bore tube adjacent to the shaft.

Figure 23.1 provides a qualitative comparison of cross-sectional ERT images with visual images obtained by performing the experiment using a Nigrosine dye tracer. The dispersion of the tracer was captured on video and stills taken from the video are presented in the figure. The results show how mixing progresses with time when the secondary liquid is added in an axisymmetric manner. The time $t = -1$ s corresponds to the frame used as the reference for reconstruction of the electrical measurements. Shortly after addition of the secondary tracer liquid, time $t = 0$s some asymmetry can be seen at the base of the plume and to the left-hand side of the impeller. The impeller was rotating at 100 rev/min in a clockwise direction. This feature is also detected by the second ERT imaging plane from the base. Similar asymmetries are perceivable from the tomograms at $t = 1$ s for all three lower planes. The usefulness of ERT is evident from this experiment since the external observation using a video and dye tracer is unable to provide the two-dimensional (x,y) co-ordinates of concentration variations.

Obtaining a good quality pixel dataset is the first stage in the process of rendering an image of the cross-section. Although qualitative observations based on human assessment of images is often instructive, this cannot be incorporated into a quantitative assessment strategy. Therefore the ultimate goal is quantitative (numerical) interpretation of perhaps thousands of images

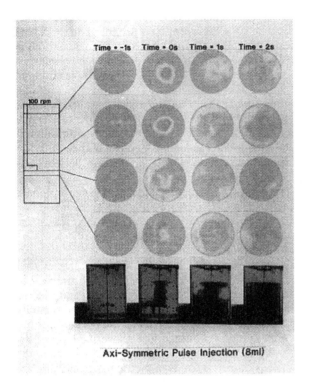

Figure 23.1 *Time sequence of resistivity images at four cross-sections through the mixer after a pulse axisymmetric addition of 1 wt% brine solution to 0.1 wt% brine solution whilst stirring at 100 rev/min. Photographs beneath each vertical column of tomograms correspond to video stills taken from an identical parallel experiment using a dye tracer*

from which features of interest (concentration profiles, objects boundaries) have to be recognized and analysed. The type of reconstruction algorithm used here prohibits precise quantitative analysis, although by assuming a linear relationship between the conductivity and electrolyte concentration over the measured range it is possible to obtain plots of relative concentration. For instance, Figure 23.2 shows the relative radial concentration profiles at four times for the upper image plane in Figure 23.1 (note that the image for $t = 3$ s is not shown in Figure 23.1). Such procedures can be repeated for any line across a diameter through any cross-section.

In the sequence shown in Figure 23.3 the secondary liquid was added asymmetrically at a single location just above the turbine. On addition it is dispersed to the left-hand side and then upwards, also being broken up by the action of the baffles. By adding the liquid close to the impeller the mixing kinetics are very much faster than adding the liquid just below the surface of the primary liquid (as in Figure 23.1). The tomograms allow detailed analysis of the mixing characteristics to be visualized. Measurements of *mixing times*

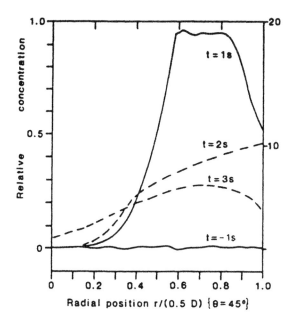

Figure 23.2 *Relative radial concentration profiles (for a radius at $\theta = 45°$ clockwise from the vertical centre line of the printed image) with time for the upper image plane and conditions given in Figure 23.1*

required to ensure dispersion of liquids have been performed using ERT (Ilyas *et al.*, 1993), for which reconstruction methods that yield relative conductivity information are perfectly adequate.

More recently, ERT instrumentation and reconstruction methods have been developed to allow the absolute determination of conductivity in a cross-section. Using the UMIST ERT system (Dickin *et al.*, 1993) it is possible to set the injection current amplitude and frequency and to reconstruct the measured data using a quantitative algorithm based on a finite-element reconstruction (see Section 15.4). The electrodes are slightly larger than used above, typically 5 mm × 10 mm and constructed from silver-plated brass. Plate 1a, b shows a test case when a conducting aluminium rod and non-conducting Perspex rod are inserted into the vessel. The contour plot (a) shows the outline of the rods, although these are not perfectly reconstructed since both should yield a circular cross-section. The isometric view (b) demonstrates the usefulness of visualizing the data in this form since the more resistive (i.e. less conducting) Perspex material (on the left-hand side) is clearly distinguishable from the conducting metal rod (on the right-hand side). The reconstruction is not precise because this test case presents a challenging problem in which it is necessary to delineate the phase boundaries of the two limiting cases of an 'infinitely' non-conducting and a highly conducting

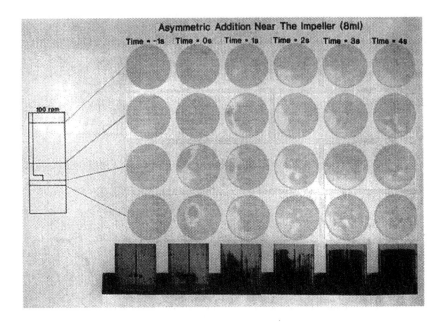

Figure 23.3 *Three-dimensional tomographic visualization of a pulse asymmetric addition of 1 wt% brine solution at the impeller whilst stirring at 100 rev/min. Photographs beneath each vertical column of tomograms correspond to video stills taken from an identical parallel experiment using a dye tracer material within the same region.* In practice both are unlikely to be encountered in many process mixing applications since the dispersed-phase component concentration gradients are generally diffuse. For comparison Plate 1(c) shows a quantitative reconstruction for a saline solution presented as an isometric plot (note the sensitivity of the resistivity scale).

Figure 23.4 shows an experimental ERT system integrated into a 22 dm$^3$ mixing tank which has a torispherical base, baffles and is instrumented with four sensor planes of 16 electrodes each. Hence with the ability to obtain quantitative information, a wealth of data becomes accessible to enable detailed modelling of mixing. The information content is compatible with that produced using CFD modelling. For instance, Figure 23.5 shows a comparison between ERT and a CFD approach based on a cellular model. The cellular model, known as the network-of-zones (NWZ), divides the three-dimensional space into voxels or cells arranged in nested flow loops and can simulate the single-point asymmetric addition of a liquid. Each cell undergoes an equal and opposite exchange flow with adjacent flows in the lateral inner and outer flow loops which mimics the effect of turbulent exchange between parallel flowing streams of fluid which circulate by the action of the impeller. The swirling tangential convective flow which distributes and mixes the liquid added at the

Figure 23.4 *Experimental ERT system for investigating liquid–liquid and solid–liquid mixing in a 22 dm³ baffled mixing tank with a torispherical base. Four planes of 16 electrodes have been installed*

single point in axial, radial and tangential directions can be specifically included (Ying, 1993). The figure shows the resultant solid-body graphics representation of the simulation compared with an ERT image (McKee *et al.*, 1994). Only one image cross-section is included here at each instant of time, but evidently statistical comparison of the measured and simulated data can be undertaken. For this purpose it is helpful if the geometry of the image pixels can be matched with the simulation cells. Figure 23.5(a) shows that in the case of asymmetric addition the mixing was complete after 10 s, after which no significant changes in concentration between pixels were measured. This result was congruent with the NWZ prediction. The swirl off the centre injection between the 1.2 s and 6 s images is clearly visible. For axisymmetric addition (Figure 23.5(b)) the mixture became essentially homogeneous after 6 s.

Sometimes a *mixing index* is used to access the degree of homogeneity in a reactor:

$$\text{Mixing index} = \frac{1}{\bar{C}} \left\{ \frac{1}{(n-1)} \sum_{i=1}^{n} (C_{xy} - \bar{C})^2 \right\}^{1/2} \tag{23.1}$$

where here we shall define C_{xy} to be the local salt concentration in the x,yth

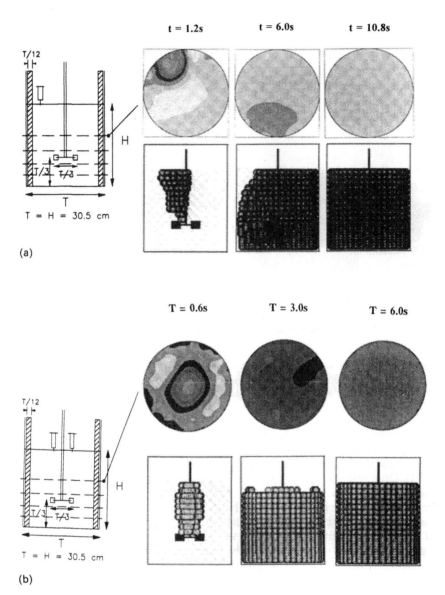

Figure 23.5 *Comparison of ERT measurement and theoretical three-dimensional simulation using a network-of-zones (NWZ) model in a 22 dm³ (Figure 23.4) tank with Rushton turbine rotating at 100 rev/min adding 8 cm³ of a high conductivity liquid at a single point: (a) asymmetric addition, (b) axisymmetric addition. (The NWZ predictions show the front elevation of a solid-body image based on visibility if the predicted concentration is less than one-half of the final mean concentration)*

pixel for a total of n pixels, and \bar{C} is the mean concentration. Given the plethora of data from multiple-plane ERT, this index can be evaluated for different cross-sections in the mixer at different times. Performing the evaluation for the asymmetric data sets for a horizontal slice corresponding to the top imaging plane (17.5 cm above the vessel base) yields the plots shown in Figure 23.6. As the mixing process continues the index tends to zero as the concentration variations diminish. The ERT and NWZ curves show the same trends with time.

These graphs show how advanced tomographic measurements can be useful in verifying and developing theoretical simulations. Quantitative interpretation of the three-dimensional image data allows the extent of mixing to be measured *throughout the entire reactor volume.* Hence mixing indices can be computed for the entire volume or along specified vertical, horizontal or radial sections through the mixer. The implication is that such a methodology could be adopted for routine on-line monitoring or control of a mixer, provided that electrodes could be installed safely inside the reactor itself (Jia *et al.*, 1995).

23.2.2 Solid–liquid suspensions

The mixing of particulate solids into liquids is notoriously difficult to model but is of substantial technological importance. The mechanisms of suspension

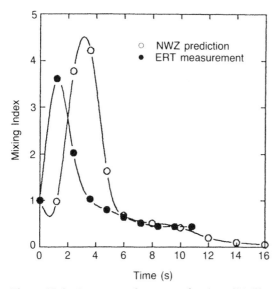

Figure 23.6 *Variation of mixing index (eqn (23.1)) with time for asymmetric liquid–liquid mixing calcuated from ERT (●) measurements (Figure 23.5) and NWZ (○) model predictions. (Calculated for a horizontal plane 17.5 cm above the vessel base, conditions as for Figure 23.5(a))*

arises from the complex effects of particle–liquid interaction and turbulent eddies. The design of mixing vessels and specification of agitators and stirrer motors to ensure homogeneous mixing is generally based on empirical models. The models are directed at predicting the *solids distribution* and the *minimum speed required to ensure particle suspension*. It is important to know how these characteristics vary with particle size, particle density, stirring speed, impeller type, solids concentration, fluid viscosity and fluid density for different mixer tank geometries.

Existing experimental measurements have relied heavily on the use of invasive conductivity probes which are inserted into the mixer on rods or suspended on fine guidewires throughout the reactor (Mak, 1992; McKee *et al.*, 1994). A major limitation of such methods is the experimental dexterity and time required to collect sufficient data to allow the mixing process to be characterized. The other problem in using probes is the uncertainty associated with not knowing how the invasive nature of the sampling probe biases the measurements. ERT has found to offer some advantages since it allows the mixer to be analysed in a wholly non-intrusive manner and data can be obtained rapidly. For instance a sequence of multi-plane measurements can be completed in 2 or 3 h, compared with perhaps 10 days continuous work using a single-probe method. The viability of using conductivity-based methods to predict the concentration of solids presumes that an accurate functional relationship is available to relate the conductivity to the local solid volume fraction. Normally these are based on Maxwell's equation. For example, Bruggeman (1935) presents the slurry conductivity (σ_S) as a function of solids volume fraction (ϕ):

$$\sigma_S = \sigma_C (1 - \phi)^n \tag{23.2}$$

where σ_C is the conductivity of the continuous (liquid) phase, and n is a constant related to the solid properties (electrical properties, particle shape, etc.). Hence well-defined particle–liquid systems can be calibrated, yielding values for n close to 1.5. However, in industrial systems particular care has to be taken to recognize that corrections for fluctuations in temperature may have to be incorporated into the calibration procedure. In addition, if the solids exhibit any solubility in the liquid phase or if the conductivity of the bulk liquid phase changes with time for any reason, this too must be taken into account. Examples of the use of this eqn (23.2) and alternative formulations have been given Holdich and Sinclair (1992), Banisi *et al.* (1993), McKee *et al.* (1993), and Mualem and Friedman (1991). Examples of quantitative calibration of ERT systems for slurry measurements can be found in McKee (1994).

Investigations similar to those reported in Section 23.2.1 can be performed for slurry mixing, for instance to quantify the homogeneity of the suspension for different agitation speeds and slurry properties (McKee *et al.*, 1994; McKee, 1994; Jia *et al.*, 1995). Figure 23.7 show results of a series of tests to examine the influence of impeller design on the *axial solids concentration profile*. Measurements were obtained by moving a single conductivity probe down the vessel obtaining data at five different heights. ERT was used to monitor the same process but only four axial data points could be obtained,

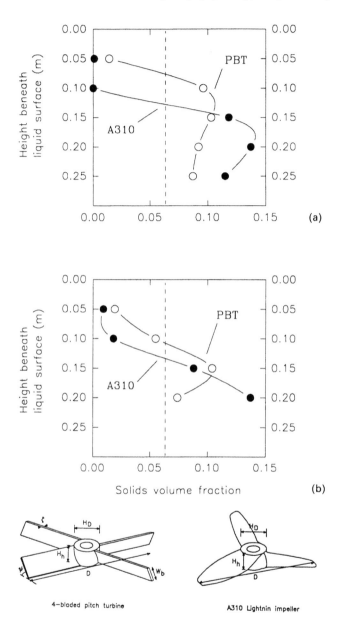

Figure 23.7 *Effect of impeller design (a pitched blade turbine (PTB) and a Lightnin™ A310 turbine (A310), as shown beneath) on the axial concentration profile of solids measured using (a) an invasive conductivity probe, and (b) from ERT. (Mean particle diameter = 463 μm; particle density = 2650 kg m⁻³; average solid volume fraction φ = 0.063; impeller speed = the 'just-suspension' speed)*

corresponding to the *average conductivity* in each of the four imaging planes (Figure 23.5). Hence in one case (Figure 23.7(a)) the measurements are essentially single-point data, whereas with ERT (Figure 23.7(b)) the measurements are averages derived from pixels in the cross-sectional image. Results for a pitched blade turbine (PBT) and Lightnin™ (A310) turbine are compared for a constant slurry concentration ($\phi = 0.063$) and keeping the clearance below the turbine and the base of the mixer constant at $T/3$, where T is the tank diameter (see Figure 23.5). In all cases the mixing speed was kept constant at the so-called *just-suspension speed* (N_{js}). This was the speed at which all solids are just kept in suspension, in this case $N_{js} = 343$ rev/min for the PTB and $N_{js} = 545$ rev/min for the A310 turbine. The figures show that the conductivity probe and ERT yield similar trends in the axial profiles, showing a marked increase in concentration in the vicinity of the impeller. If the suspension was uniformly distributed, which it was not, zero axial variation would have been measured (i.e. a vertical line at $\phi = 0.063$). In this case the measurements reveal that the PBT appears to be more efficient in mixing the slurry. ERT can therefore be used to optimize the selection of mixer geometry and operating conditions under practical conditions.

23.2.3 Visualization of hydraulic transport of slurries

The same procedures used to map axial and radial solid concentration profiles in the preceding section can be applied to hydraulic conveyors. Essentially the problem is similar to that described in pneumatic conveying (see Chapter 20). Some of the first feasibility tests (McKee *et al.*, 1993) demonstrated that the back-projection method could be used to identify the formation of particulate sediments. The results could be visualized to show the relative solid concentrations (Plate 2).

In the presence of high-velocity flows of concentrated suspensions the electrode noise generated by impingement of particles on the electrode surface and the passage of gas bubbles tends to complicate quantitative reconstruction procedures (Abdullah, 1993). This problem can be reduced by increasing the data-acquisition time and averaging. Such procedures are acceptable since the processes under investigation are close to steady-state and rapid transitions do not have to be captured. Increasing the size of the sensing electrodes also reduces the signal-to-noise ratio. Alternatively, noise can be considered as a part of the reconstruction method either explicitly (which is computationally complex) or implicitly by adopting different reconstruction philosophies. The use of *a priori* knowledge holds some promise in allowing improved recognition of patterns of solid concentration profiles (Scott, 1994). The use of empirical simulators based on neural networks are also likely to be fruitful. Neural networks are trained using simulated data of boundary voltages determined by finite-element methods, from which the solution of the inverse problem (see Section 15.4.2) can be estimated. Wiedenroth (1993) and Wetzlar (1994) have demonstrated the use of such a system for imaging solid concentrations in a 125 mm diameter pipe conveying a concentrated sand slurry (Figure 23.8). The

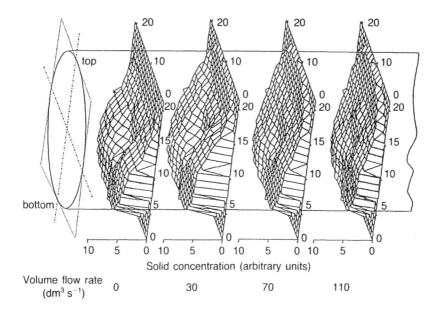

Figure 23.8 *Semi-quantitative solid concentration profiles in a 125 mm hydraulic conveyor at difference mass flow rates calculated using a neural-network-based reconstruction. (1 mm sand particles in water, mean conveyed solids concentration 40 vol%) (Wetzlar, 1994)*

effect of increased settling of sand grains on the bottom of the pipe as the flow rate is reduced is clearly evident. Interestingly, even at high flow rates a distinct concentration profile can be seen.

23.3 Measurements in porous media

Mapping the distribution and movement of fluids travelling through porous media or determining porosity variations in granular sediments can also be undertaken using resistance imaging. Unlike the preceding examples on mixing and flow, the kinetics of these processes are often slow. Consequently, the technical performance demands on the instrumentation are reduced, since more time is available to acquire and analyse data. Broadly, two categories of measurement exist:

- Mapping permeate flow in porous media (rock core samples, soil, natural strata, in sedimentation and filtration processes).
- Mapping solid density fluctuations in granular beds (seabeds, alluvial sediments, process sediments).

The second category can be regarded as the reverse-image of the first, since in

case it is the fluid itself which is being sensed directly, whereas in the second case the structure of the porous media is of prime importance. The majority of these applications lie in the domain of environmental technology and geophysics and can be implemented over varying length scales. For instance, in the laboratory from, say, 50 mm upwards, and in field measurements over distances of up to 1 km. Various forms of electrical logging of porous media have been used in geophysics using d.c. and a.c. injection methods, predominantly via linear arrays or rings of electrode rods which are driven into the ground. In the strictest sense such invasive measurements do not conform with the definition of tomography given in Chapter 1. Three examples will be mentioned below for successively larger measurement length scales.

23.3.1 Monitoring liquid flow in rigid media

The imaging of rock core samples is widely practised using high-resolution instrumental methods (X-ray, magnetic resonance imaging (MRI)). Useful information can also be derived using ERT, provided that a means exists to ensure adequate electrical contact between the sensing electrodes and the rock sample. Lin and Daily (1988) presented one of the first comparisons of using penetrating radiation, ultrasound and electrical resistance methods to deduce structural information about the integrity of core specimens.

With the more recent development of quantitative reconstruction methods (Section 23.2.1) it is possible to probe the permeability characteristics of rock cores using dynamic ERT techniques. Figure 23.9 shows a sequence of images of a Berea sandstone core (36 mm diameter, 75 mm long) obtained at one plane of a multiple-plane measurement experiment (Dickin, 1992). The core sample had been saturated in brine (500 Ω-cm) which was displaced by forcing water (10 000 Ω-cm) through the sample at high pressure under controlled volumetric flow rates (about 8 cm$^3$ min$^{-1}$). The resistivity increases with time as the brine is diluted and displaced. (Note that the grey scales in each image are different.) In this manner the rate of perfusion of the core can be quantified and this can be used to determine the variations in permeability within the core sample.

23.3.2 Porosity mapping in sediments

A natural extension the previous application is to use ERT to detect *variations* in the porosity of non-rigid media. Examples might include the solid cake retained on a filter cloth during process separations and the compaction of sediment either in process engineering or in natural lake, river or marine environments. In the sub-sea environment ERT could, in principle, be achieved by making measurements between sensors mounted on rods and immersed in the sediment bed by means of quadrapod vehicles. Some development of single-rod sensors have been reported (Qiu *et al.*, 1994) in

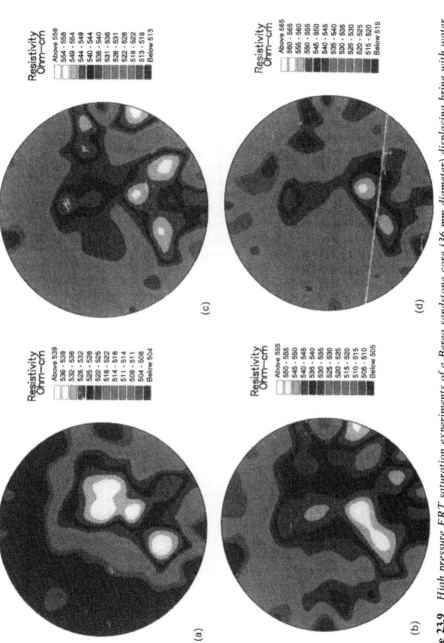

Figure 23.9 *High pressure ERT saturation experiments of a Berea sandstone core (36 mm diameter) displacing brine with water (8 cm³ min⁻¹) for one image plane after: (a) 2, (b) 4, (c) 8, and (d) 10 min*

which each rod carries a number of electrode rings separated by insulating spacers. Linear measurements between rings are made (Webster, 1990; Ramirez and Daily, 1993) and the measured data are reconstructed using a finite-difference method. Figure 23.10 shows a typical result of imaging vertical porosity variations in the vicinity of a 25 mm diameter 16-electrode-ring sensor pole in a natural saline environment. Coarse (3 mm diameter) glass beads are positioned within the sediment to create a layer of 30 mm thickness. This layer and the reconstructed image is shown in Figure 23.10(a). If a large insulating object (15 mm diameter) is then positioned beneath the layer close to the electrode pole, the effect on the reconstructed image can be seen (Figure 23.10(b)). In the latter case the delineation of the object and the coarse bead layer is possible, but the two morphologies are not readily discernable, due primarily to the reconstruction method which is susceptible to the magnitude of the potential gradient. In the present example these gradients are large in the region close to the electrodes and decay rapidly further away. Hence the sensitivity is improved closer to the sensor array.

Information on the detailed microstructure of sediments could probably be improved by decreasing the size of the electrodes and increasing the number of electrodes, but this has not yet been investigated in any detail.

23.3.3 Groundwater mapping and soil remediation

The distribution and motion of liquids in soil and rock strata has been a major preoccupation of geophysicists, mathematicians and environmental scientists.

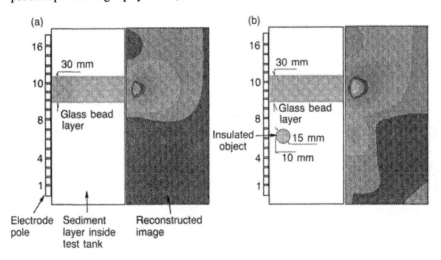

Figure 23.10 *Porosity mapping of sediments using a single sensor pole with 16-electrode sensor rings to detect vertically-spaced discontinuities due to (a) a layer of coarse glass beads, and (b) a layer of coarse glass beads and a single object within a marine sediment*

Some models exist for predicting flow, for example, beneath long-term nuclear-waste storage sites, effluent plume monitoring in domestic and industrial disposal sites. However, in general, it is often difficult to verify process models. ERT can be used in certain circumstances to address this most important need (Daily *et al.*, 1992) normally using a low-frequency or switched d.c. excitation signal.

The use of tracer migration studies in a labaratory provide an example of how groundwater movements can be sensed. The experimental arrangement consists of an undisturbed soil sample (approximately 250 mm diameter, 240 mm long) supported on a porous plate. Sixteen stainless-steel electrodes are inserted into the soil mass, positioned equidistantly around the perimeter. The core is saturated from the base, first passing mains water until a steady state is achieved after which a NaCl solution (having a conductivity of 10 mS cm$^{-1}$) was added at a fixed rate (500 cm$^3$ h$^{-1}$) for a period of 16 h, followed by a further period of water flushing for 16 h. The total volume of liquid added in each period was approximately equal to the pore volume. Electrical resistance tomograms were obtained at two imaging planes every 5 min, based on data-collection periods of 3 min. The conductivity of the effluent stream was measured every 5 min to enable the construction of breakthrough curves.

Figure 23.11 shows the breakthrough outflow from which it is evident the tracer emerged after about 20 min, which is much less than the average expected residence time. This indicates that the soil structure must contain preferential pathways through which the tracer was passing. The sequence of resistance tomograms at a plane 155 mm above the tracer source (Plate 3) confirms that inhomogeneities in the packing must exist, since early signs of breakthrough are seen in the process (after 107 and 204 min) prior to the gross

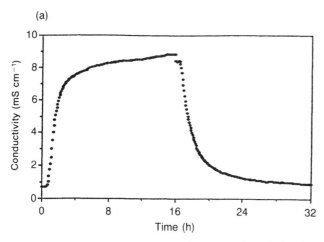

Figure 23.11 *Tracer migration study in an undisturbed soil core experiment showing breakthrough curve based on the conductivity measured in the liquid leaving the soil mass*

changes in the conductivity over most of the core cross-section. It has been demonstrated that the early localized breakthrough is reduced if the tracer addition rate is reduced (Binley *et al.*, 1993).

The clean-up of contaminated land associated with previous activities such as oil-fuel dispensing, organics manufacture and nuclear processing, etc., is of world-wide concern. Substrata mapping based on geophysical techniques such as seismic and electromagnetic methods can be used to define the structure of the land mass. However, electrical methods also offer some specific opportunities for identifying aquitards such as clay layers, and are obviously particularly sensitive to the movement of fluids. One of the most significant demonstrations has been undertaken by the Lawrence Livermore Laboratory in California, where ERT was used as part of a study to investigate dynamic underground stripping methods for cleaning up volatile organic compounds (VOCs) from saturated and unsaturated soils. This work was funded by the US Department of Energy and based at the field site. The clean-up process involved subsurface steam injection coupled with ohmic heating to remove VOCs, in this case gasoline fuel, from soil. Three-dimensional resistance tomograms showing the moisture distribution and movement of the steam front were obtained from electrodes inserted into bore-holes traversing the site. Typically each bore-hole contained 10 electrodes spaced every 3.6 m at depths of 15.9–50 m. The image planes varied between 12.5 and 48.3 m in width (Aines, 1991; Daily and Ramirez, 1994). The value of *in situ* imaging was demonstrated and is now being applied to a variety of land remediation and monitoring problems.

23.4 Visualization of hydrocyclone and dense medium separation

Centrifugal separation of solid and liquid particulates from gas or liquid media is widely employed in chemical and mineral processing. For *solid–solid* and *solid–liquid* separation in a liquid continuum the two main types of separator are *hydrocyclones* and *dense medium cyclones.* In a hydrocyclone the continuous fluid is water, whereas in dense medium separation (DMS) the continuous phase is a dense fluid such as suspension of fine magnetite or ferrosilicon. Separation of solid particulates depends on their size and specific gravity with respect to the continuous phase. The separation cut-point is controlled by balancing the competing radial forces due to fluid drag on the particles against the centrifugal action generated by the swirling fluid. Pressurized slurry enters the cyclone at a tangent to the upper cylindrical section (Figure 23.12(a)) and leaves via one of the two exits: the apex (or underflow) or vortex finder (overflow). The volumetric liquid split to the exit orifices is determined by the diameters of the respective outlets and, most importantly, by the diameter of the *air core* which is normally present during proper operation of the hydrocyclone. This arises due to the vortex nature of the flow inside the hydrocyclone body which generates an air core along the entire length of the body. Dense medium cyclones and separators (Figure 23.12(b)) operate in a similar fashion and find application in separation of iron

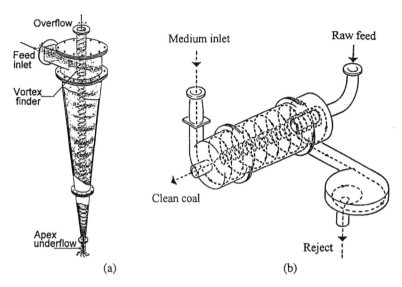

Figure 23.12 *Schematic diagram of (a) hydrocyclone showing the principle of separation, and (b) LARCODEMS dense medium separator*

ores from siliceous gangue, coal from shale, diamonds from kimberlitic gangue and in a variety of metal and plastics recycling operations. Industrial units of 1.2 m diameter typically handle 250 tonne h^{-1} of coal (see Figure 23.16).

Both types of separator are therefore of strategic importance for dewatering and solid sorting duties in a wide range of manufacturing and material recycling operations.

23.4.1 Industrial significance of tomographic data

Despite the ubiquity of centrifugal devices, very little is known about the fundamental fluid flow which controls the separator performance. Primarily this is because most equipment has opaque metal walls and the process slurry is also opaque and moving at high speed, thus prohibiting visual inspection, except under controlled laboratory conditions using transparent model fluids. Tomographic interrogation of the separator would appear to offer some definite benefits for both equipment design and in gaining a better understanding of the underlying fluid mechanics. Two examples relevant to the hydrocyclone operation are explored below (Figure 23.12(a)).

Separator design and on-line monitoring
One developing application is the use of ERT to obtain information on the radial solid concentration profile within separators, and to see how the distribution of solids changes as the hydrocyclone geometry and feed flow rate is adjusted. Figure 23.13(b) shows one such image obtained in the upper

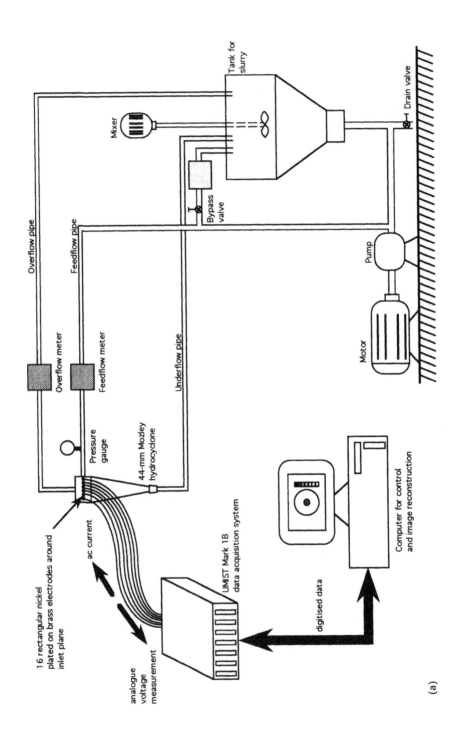

(a)

HIGH RESISTIVITY· DUE TO ——
SOLIDS AT PERIPHERY
OF AIR CORE

HIGH RESISTIVITY DUE TO
CONCENTRATION OF
SOLIDS AT WALLS

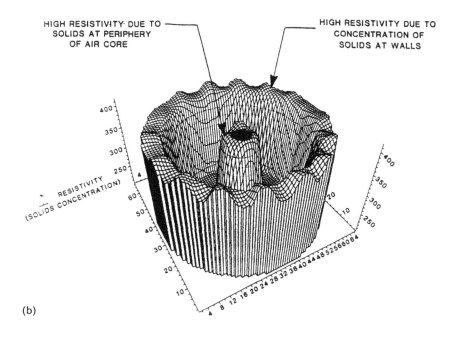

(b)

Figure 23.13 (a) *Use of ERT to image solids concentration and air core position in a 44 mm diameter hydrocyclone operating in closed circuit. (b) A typical resistivity image taken in the cylindrical section of the unit for a 2% v/v fine silica slurry in water*

cylindrical portion of a 44 mm diameter hydrocyclone unit operating in closed circuit (Figure 23.13(a)) treating a dilute slurry (2% v/v silica). The tomogram reveals the higher resistivity regions near the hydrocyclone wall (where a high concentration of coarse particles exists) and near the central air core (where the concentration of finer particles is high). Hence high regions of resistivity are indicative of high concentrations of the non-conducting solids. The small oscillations around the perimeter are a consequence of the electrode placements rather and not due to a real physical effect. Abdullah (1993) has given additional data for other flow conditions, including the effects of changing the internal geometry of the cyclone by introducing a central rod (which has the effect of displacing the air core) and operating at high solids concentrations (Figure 23.14).

An application that is likely to be of immediate significance to the detection of malfunctions is the use of ERT to monitor the solids concentration in the region of the underflow apex. Blockages can often occur, for example, in hydrocyclones that are used to produce *backfill* in mining operations. Tomographic measurements can be employed to detect sudden changes in the underflow concentration, which may suddenly increase due to plugging (Williams *et al.*, 1995). These events may also be accompanied by a sudden

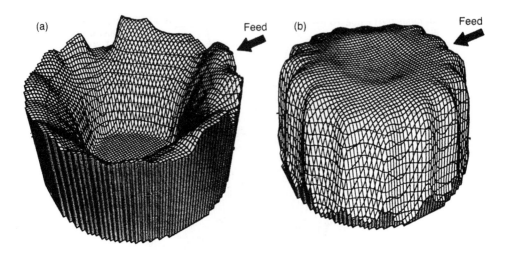

Figure 23.14 *ERT images representing solids distribution in a cross-section in the cylindrical section of a 44 mm diameter hydrocyclone. (a) For a 2.8% v/v feed with a rod positioned inside the separator replacing the air core (note the slight asymmetry of the distribution, with higher resistivity below the tangential feed point). (b) For a 55% v/v feed under normal operation with an air core*

change in the size and dynamic behaviour of the air core inside the hydrocyclone (Dyakowski and Williams, 1995). This too provides a useful *on-line* indicator of cyclone performance, since if the concentration of solids discharged through the underflow increases the nature of the flow discharging from the apex orifice may change from being a fan-spray to a rope-jet of slurry. In the latter case the air core itself may disappear. These monitoring methods are under active investigation since ERT is in principle a convenient, simple and relatively low cost sensing method.

Studies of air-core dynamics have been facilitated by ERT. Figure 23.15 shows how the air-core diameter varies as a function of the effect of flow rate (expressed in terms of body Reynolds' number shown on the x axis and actual volumetric flow rates on the right-hand y axis). These data were obtained for a water feed for a fixed orifice ratio λ:

$$\lambda = D_U/D_0 = 6.5/11.0 = 0.59 \tag{23.3}$$

where D_U and D_0 are the diameters (in millimetres) of the underflow and overflow orifices, respectively. The air-core diameter (D_A) is expressed in dimensionless form (σ_0) with respect to the overflow diameter:

$$\sigma_0 = D_A/D_0 \tag{23.4}$$

The air-core diameter was calculated from the apparent area by pixel counting, assuming that the core was circular. By observing the location of the

(a)

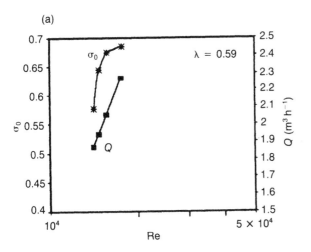

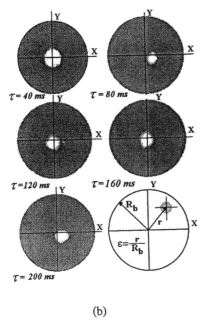

(b)

Figure 23.15 (a) σ_o *versus Re measured using ERT for 44 mm diameter hydrocyclone.*
(b) *Time sequence of air-core images.* (c) *Measured apparent σ_0 and ε values*

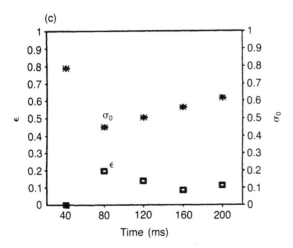

(c)

Figure 23.15 (*continued*)

air core every 40 ms its position can be tracked (Figure 23.15(b)). In addition, the eccentricity (ε) of the core can be computed; where ε is defined as the ratio of the distance from the centre of gravity of the core to the geometric centre of the of the cyclone divided by the hydrocyclone body radius at that cross-section. Hence eccentricity–time plots can be derived (Figure 23.15(c)). Examining the temporal variations in ε provides an indication of the *stability* of the air core, which is believed to be significant in determining the separation efficiency of the separator.

Validation of computational fluid dynamic models
The ability to sense changes in solid concentration inside the hydrocyclone offers new opportunities to compare predications of concentration profiles based on a computational fluid dynamics model with reality. A key issue here is the verification of codes that are being developed to simulate the behaviour of concentrated suspensions in which particle–particle interaction effects may be important (Hsieh and Rajamani, 1991; Rajamani and Milin, 1992). In addition, it is necessary to allow for the effects of fluid swirl within the hydrocyclone (Dyakowski and Williams, 1993; Dyakowski *et al.*, 1994).

23.4.2 Air-core monitoring in dense medium separators

The role of the air core is of significance in large-diameter dense-medium cyclones. Figure 23.16 shows an industrial scale LARCODEMS unit. Measurements on a scaled-down laboratory LARCODEMS separator (150 mm diameter, 450 mm long, $D_0 = 50$ mm, $D_U = 24 \times 35$ mm) instrumented with two imaging planes of 16 electrodes (Figure 23.17(a)). Figure 23.17(b) shows the effect of flow rate (expressed in terms of Reynolds' number, based on

Figure 23.16 *A LARCODEMS installation (3 m long, 1.2 m diameter) for coal–shale separation, treating over 250 tonnes of coal per hour*

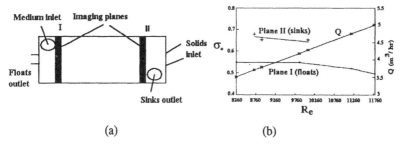

(a)　　　　　　　　　　　　　(b)

Figure 23.17 *(a) Schematic diagram of LARCODEMS. (b) Measured σ_0 versus (body) Re (and flow rate Q) at upper 'sinks' (II) and lower 'floats' (I) imaging planes*

LARCODEMS body diameter) of the measured apparent dimensionless air core diameter (σ_0) at the two locations (I and II) shown in Figure 23.17(a). The air core in the zone near the *sinks* exit (II) is larger than near the vortex finder in the vicinity of the *floats* exit. The air core becomes unstable below (body) Reynolds numbers of 8750, at which point $\varepsilon \gg 0$.

Figure 23.18 shows a sequence of measurements performed over a 2 s period when the flow was reduced to induce collapse of the air core. The air core at plane II disappeared after 1.6 s (at which point the electrodes were in contact with air due to the very low liquid level) and after 1.2 s for plane I (when the air core was replaced by liquid). Note that the eccentricity of the air core (Figure 23.18(c), plane II) suggests an increasing instability as the flow (Figure 23.18(a)) is reduced below a critical value. It may be postulated that the

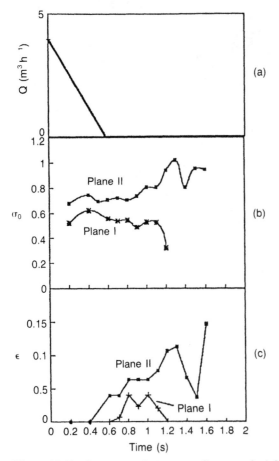

Figure 23.18 *Dynamics of air-core collapse as feed flow (a) is reduced over a 2 s period, showing corresponding air core diameter (b) and eccentricity (c)*

eccentricity could be used as a means of *monitoring air-core stability* and that values above $\varepsilon = 0.1$ should be avoided.

Figure 23.19 illustrates the dynamics of air core collapse and reformation on cycling the inlet flow rate. Tests have confirmed that it is evident that once the air core is formed it persists even if the feed flow rate is reduced below the critical flow necessary to form the stable air core. This demonstrates the usefulness of ERT to capture separator dynamics. During normal operation the air core is not necessarily circular and also exhibits a conical shape along the body length. The collapse dynamics are rapid. Further interpretation of images is being performed with the objectives of describing the asymmetry of the core and its dependence on fluid viscosity and density before proceeding with similar measurements on slurry feeds.

The above work has demonstrated that ERT is capable of delivering *on-line* information on the size, shape and dynamics of air core movement in centrifugal separators. It is now recognized that this information is relevant to design and operation of dense medium cyclones. Such data will allow improved modelling of separator performance using both empirical and more fundamental fluid mechanics methods. Opportunities exist for utilizing ERT measurements of air core dynamics for routine control of some types of centrifugal separator, for instance, using a variable diameter apex orifice or by back-pressuring an outlet stream. It seems likely that future work may allow the use of ERT to image both air core dynamics *and* solid concentration profiles within the separator.

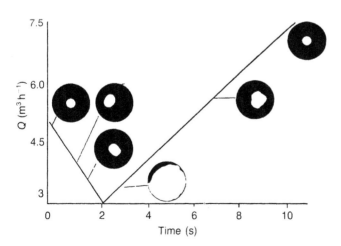

Figure 23.19 *Images illustrating the dynamics of air-core collapse and reformation on cycling the feed flow*

23.5 Conclusions

A growing number of applications for resistance tomography are under development relevant to the characterization of structured solids and liquid systems. The resolution of electrical methods is inferior compared with hard field sensing methods; however, their principal advantage is the ability to capture images rapidly using relatively simple sensor hardware. The method can be used to interrogate process length scales ranging from a few millimetres up to several metres. Major advances have been made in using ERT to provide detailed three-dimensional information on the flow of complex multi-phase mixtures in mixing and conveying processes. This provides a wealth of data which allows development and validation of flow simulation models. By analysing the image data, characteristics of the process can be obtained, for instance, the homogeneity of the electrical conductivity in a given cross-section can be quantified and represented by a single number which can then be embodied into a process control strategy or other decision-making function.

Future developments in full impedance and spectroscopic measurements are likely to evolve which may allow improved discrimination between phases or components in the process mixture or structured material under examination. A fully three-dimensional imaging capability may result using multiple stacked planes of electrodes, thus allowing abstraction of velocity vectors and other information.

Acknowledgements

The authors acknowledge the financial support provided by the Engineering and Physical Sciences Research Council, the European Steel and Coal Commmunity and the British Council. Thanks are also due to Unilever Port Sunlight Research, DuPont Engineering, British Nuclear Fuels plc, BP Group Research and Engineering Centre, British Coal Technical Services and Research Executive and the Royal Academy of Engineering for supporting the work in providing resources and experimental test facilities.

References

Abdullah, M. Z. (1993) Electrical impedance tomography for imaging conducting mixtures in hydrocyclone separators. Ph.D. Thesis, University of Manchester Institute of Science and Technology

Aines, R. (1991) Dynamic underground stripping demonstration project. In *Environmental Technology Program, FY91 Annual Report (CURLIER 105199-91)*, Lawrence Livermore National Laboratory, Livermore, CA

Banisi, S., Finch, J. A. and Laplante, A. R. (1993) Electrical conductivity of dispersions: a review. *Mineral Eng.*, **6**, 369–387.

Barber, D. C. and Seagar, A. D. (1987) Fast reconstruction of resistance images. *Clin. Phys. Physiol. Meas.*, **8A**, 47–54.

Binley, A. M., Dickin, F. J., Henry-Pouter, S. A., Abdullah, M. Z., and Gregory, P. J., Observation of tracer migration in soils using resistive impedance tomography, In *Process*

Tomography – A strategy for Industrial Exploitation 1993, Brite Euram Concerted Action/UMIST Manchester. 275–279

Bruggeman, D. A. G., (1935) Calculation of various physical constants of heterogeneous substances. Part 1. Constant and conductivity of mixtures of isotropic substances, *Ann. Phys.* Leipzig, **24**, 636

Daily, W. and Ramirez, A. (1994) Environmental process tomography in the United States. In *Process Tomography – A Strategy for Industrial Exploitation 1994*, Brite-Euram Concerted Action/UMIST, Manchester, 501–512

Daily, W., Ramirez, A., LaBreque, D. and Nitao, J. (1992) Electrical resistance tomography of vadose water movement. *Water Resources Res.*, **28**, 1429–1442

Dickin, F. J. (1992) Private communication

Dickin, F. J., Williams, R. A. and Beck, M. S. (1993) Determination of the composition and motion of multicomponent mixtures in process vessels using electrical impedance tomography. *Chem. Eng. Sci.*, **48**, 1883–1897

Dyakowski, T. and Williams, R. A. (1993) Modelling turbulent flow within a small diameter hydrocyclone. *Chem. Eng. Sci.*, **48**, 1143–1152

Dyakowski, T. and Williams, R. A. (1995) Prediction of air core size and shape in a hydrocyclone. *Int. J. Mineral Process*, in press

Dyakowski, T., Hornung, G. and Williams, R. A. (1994) Simulation of non-Newtonian flow in a hydrocyclone. *Trans. Inst. Chem. Eng.*, **72**, (A), 513–520

Harnby, N., Edwards, M. F. and Nienow, A. W. (1992) *Mixing in the Process Industries*, 2nd edn, Butterworth-Heinemann, Oxford

Holdich, R. G. and Sinclair, I. (1992) Measurement of slurry solids content by electrical conductivity. *Powder Technol.*, **72**, 77–88

Hsieh, K. T. and Rajamani, R. K. (1991) Mathematical model of the hydrocyclone based on the physics of flow. *AIChE.J*, **37**, 735–746

Ilyas, O. M., Williams, R. A., Mann, R., Ying, P., El-Hamouz, A. M., Dickin, F. J., Edwards, R. B. and Rushton, A. (1993) Advances in and prospects for the use of electrical impedance tomography for modelling and scale-up of liquid/liquid and solid/liquid processes. In *Tomographic Techniques for Process Design and Operations* (eds M. S. Beck *et al.*), Computational Mechanics Publications, Southampton, 251–264

Jia, X., Williams, R. A. Dickin, F. J. and McKee, S. L. (1995) in *Process Tomography '95* (eds M. S. Beck et al.). Brite Euram Concerted Action/Umist Manchester

Lin, W. and Daily, W. (1988) Laboratory determined transport properties of core from the Salton Sea scientific drilling projects. *J. Geophys. Res.*, **93**, 13047–13056

Mak, A. T.-C., (1992) Solid–liquid mixing in mechanically agitated vessels. Ph.D. Thesis, University College London

McKee, S. L. (1994) Ph.D. Thesis, University of Manchester Institute of Science and Technology

McKee, S. L., Abdullah, M. Z., Dickin, F. J. and Williams, R. A. (1993) Dynamic imaging of solid concentration profiles in slurry processes using resistance tomography. In *Hydrotransport 12*, BHR Group Mechanical Engineering Publications, Cranfield, London, 319–330

McKee, S. L., Williams, R. A., Dickin, F. J., Mann, R., Brinkel, J., Ying, P., Boxman, A. and McGrath, G. (1994) Measurement of concentration profiles and mixing kinetics in stirred tanks using a resistance tomography technique. In *Proceedings of the 8th European Conference on Mixing, Cambridge*, 1. Chem. E., Rugby, 9–16

Mualem, Y. and Friedman, S. P. (1991) Theoretical prediction of electrical conductivity in saturated and unsaturated soil. *Water Resources Res.*, **27**, 2771–2777

Qiu, C. H., Dickin, F. J., James, E. A. and Wang, W. (1994) Electrical resistance tomography for imaging sub-seabed sediment porosity: initial findings from laboratory experiments using spherical glass beads. In *Process Tomography – A Strategy for Industrial Exploitation 1994*, Brite-Euram Concerted Action/UMIST, Manchester, 33–41

Rajamani, R. K. and Milin, L. (1992) Fluid-flow model of the hydrocyclone for concentrated slurry classification. In *Hydrocyclones – Analysis and Applications* (eds L. Svarovsky and M. T. Thew), Kluwer, Dordrecht, 95–108

Ramirez, A. and Daily, W. (1993) Monitoring an underground stream injection process using electrical resistance tomography. *Water Resources Res.*, **29**, 78–83

Scott, D. M. (1994) Workshop report on reconstruction and image analysis techniques. In *Process Tomography – A Strategy for Industrial Exploitation 1994*, Brite-Euram Concerted Action/UMIST, Manchester, 41–44

Webster, J. G. (ed.) (1990) *Electrical Impedance Tomography*, Adam Hilger, Bristol

Wetzler, D. (1994) Neural network solving the inverse problem of electrical impedance tomography. In *Process Tomography – A Strategy for Industrial Exploitation 1994*, Brite-Euram Concerted Action/UMIST, Manchester, 276–284

Wiedenorth, W. (1993) On-line critical velocity and concentration distribution measurements of solid matter in horizontal pipelines. *Hydrotransport 12*, BHR Group Mechanical Engineering Publications, Cranfield, London, 331–341

Williams, R. A., Ilyas, O. M. and Dyakowski, T. (1995) Air core imaging in cyclonic coal separators using electrical resistance tomography. *Coal Preparation*, **15** (3–4)

Ying, P. (1993) Development and validation of a 3-D mixing model for a stirred vessel. Ph.D. Thesis, University of Manchester Institute of Science and Technology

Chapter 24

Applications of nuclear magnetic resonance tomography

S. L. McKee

24.1 Introduction

Nuclear magnetic resonance imaging (NMRI) is a non-invasive tomographic technique, resulting in the production of high-resolution images. These images can be either planar or three-dimensional (Rothwell, 1985). Traditionally, the most extensive use of MRI has been in medicine for diagnostic purposes, but more recently applications have extended to the sphere of process and biochemical engineering. As an example of a clinical application, Yang and Burger (1990) reported on the potential of using this technique to determine the flow of blood in the arteries of patients suffering from atherosclerotic vascular disease, thereby establishing the condition of the patient and allowing the effective administering of medicine. The non-invasive nature of the technique lends itself to an array of uses in medicine, as substantiated by Gainsborough (1989) who presented images of brain tumours and highlighted the fact that, in contrast to X-ray computer assisted tomography (CAT), the presence of bone does not affect the quality of the final image. Since a magnetic resonance signal is not emitted by bone, a whole range of areas of the human anatomy can be explored by NMRI: the nervous system, muscles and spinal cord. It is also possible to obtain NMR images in real time, enabling for example the blood flow and velocity to be quantified.

The initial stimulus for the use of NMRI in medicine was provided by the experimental work of Lauterbur (1973). Lauterbur christened the imaging technique 'zeugmatography' and studied the response of active nuclei, in fluids containing the isotopes hydrogen and deuterium, to the application of a constant magnetic field gradient. Clearly, the potential use of the technique in other fields was recognized and has facilitated many novel applications.

The chapter identifies the basic principles involved in NMRI and illustrates the variety of applications, by citing recent experimental studies.

24.2 Basic principles

NMRI involves subjecting atomic nuclei to an external magnetic field and by their magnetic nature the nuclei will oscillate. The frequency at which such nuclei oscillate is given by the relationship:

$$\omega = \gamma \cdot B \tag{24.1}$$

where $\omega = 2\pi f$ (where f is the Larmor frequency (Hz)), γ is the magnetogyric ratio (a physical constant characteristic of the nuclei), and B is the strength of external magnetic field (T).

A useful description of the principles of NMRI is given by Ellingson *et al.* (1989). In NMRI further magnetic fields are involved, i.e. pulsed linear magnetic field gradients (McCarthy, 1990). Upon achieving equilibrium, after excitation due to an external magnetic field, a magnetization vector occurs in the direction of the applied field and in order to locate an NMR signal it is necessary to divert the magnetization away from its original direction, by the use of a suitable radio frequency (r.f.) pulse from a transmitter (Hollewand and Gladden, 1992). In turn, a r.f. receiver coil is employed to detect the NMR signal.

Associated with the time taken to return a system to equilibrium are two time constants which are of a fundamental importance: the spin–lattice relaxation and the spin–spin relaxation time constants. The former, (T_1) is related to the movement of energy between nuclei having a nuclear spin and the neighbouring environment or 'lattice', while the latter time constant (T_2) refers to the transfer of energy between individual nuclear spins (McCarthy, 1990).

Coupled with the application of pulsed linear magnetic field gradients, is the variation in space of the resultant NMR frequencies of the oscillating nuclei. Projections are obtained in different directions and combined to yield a two-dimensional image (Rothwell, 1985) while three-dimensional images are gained by obtaining two-dimensional images at various depths along a sample. Such information is used in a data-acquisition procedure, such as a back-projection technique, ultimately resulting in an image via a suitable reconstruction algorithm.

24.3 Applications of NMR tomography

The examples which follow reflect the technological applications which have implications for manufacturing and process engineering. Notably, many studies have focused on the imaging of fluids within porous solids and such images have provided a better understanding of the mechanics of transport processes within porous media. NMR images have also been used to support theoretical models and can accurately elucidate velocity profiles. The imaging of solids is complicated by characteristic short spin–spin relaxation times and large magnetic resonance linewidths but, as will be demonstrated, NMRI techniques have been developed to overcome these impediments.

Many extensions of the basic NMRI technique have been proposed and have subsequently improved features such as imaging time and spatial resolution. Edelstein *et al.* (1980) proposed an NMRI technique which they referred to as 'spin warp imaging' and considered its application to the imaging of the human body. The procedure employed a static magnetic field gradient of varying strength which caused nuclear spins, at various heights, to be subjected to varying degrees of phase shift. Subsequently, all the projections obtained differed. In contrast to conventional NMRI, which relies on the use of projections taken at different angles, spin warp imaging uses projections in

the same direction and the influence of an inhomogeneous static field upon the original imaging data is negligible. The hollow magnet employed could house an entire human body and images were obtained on a 128 × 128 pixel array, in terms of both the spin–lattice relaxation time constant (T_1) and the proton density.

Spatially localized high-resolution NMR spectroscopy, which employed stimulated echoes to provide NMR images, was reported by Frahm *et al.* (1987). The method centred on a particular 'volume of interest' and utilized a selective combination of r.f. pulses and right-angled linear magnetic field gradients. Both NMR images and spectra were obtained for phantoms with an total imaging time of about 4.5 min.

More recently, Haase (1990) described the use of 'snapshot FLASH MRI', a real-time method acquiring data within 200 ms by the improved design of the hardware used to generate the magnetic field gradients. FLASH MRI relies on the principle of employing r.f. pulses having 'low flip angles' and modifications to the imaging technique were investigated by the use of various phantoms, to quantitatively obtain values of the spin–spin relaxation and spin–lattice relaxation time constants.

Ceramics manufacture was studied by Ellingson *et al.* (1989). One of the manufacturing methods identified was the slip casting of ceramics, in which a slip of water, containing both Al_2O_3 and $CuSO_4$, was placed within a mould. An 8 mm thick section of the entire arrangement was interrogated with NMRI on an image array comprising 128 × 128 pixels and the resultant images illustrated the migration of water. An alternative to slip casting is injection moulding in which the ceramic material is entrained within an organic medium. The distribution of this medium is fundamental to the manufacture of a good quality ceramic. However, the response of the organics to the application of linear magnetic field gradients, due to a short spin–spin relaxation time constant, required the use of a custom made NMRI device. Again an image array of 128 × 128 pixels was employed. NMRI was also used to investigate the porosity of a ceramic material and results were obtained with success. Improvements in the technique referred to the frequently cited spatial resolution and data-acquisition time, involving the use of higher magnetic field strengths.

Images of the density distribution within a foam can be obtained non-invasively by the use of NMRI (McCarthy, 1990). This was illustrated by the use of either fresh or reconstituted egg white; Figure 24.1 depicts the vertical variation in the NMRI signal intensity, clearly demonstrating the form of the drainage. The significance of the two equilibrium time constants (the spin–lattice relaxation and the spin–spin relaxation time constants) was also outlined. The latter was found to increase with both time and density. Such an increase was attributed to an expansion, with time, in the size of the bubbles. It was suggested that to obtain a true portrait of the drainage process, the measured signal intensity should be corrected for the consequence of spin–spin relaxation, as shown in Figure 24.2. The promising results provided by this investigation were deemed sufficient to provide a basis for future experimental work to test the validity of theoretical models used to describe foams.

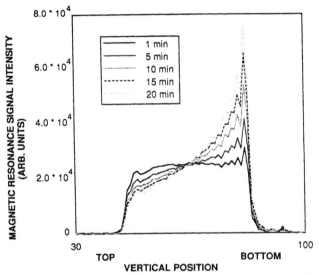

Figure 24.1 *Vertical variation in magnetic resonance signal intensity for a draining egg-white foam. (From M. J. McCarthy, Interpretation of the magnetic resonance imaging signal from a foam, AIChEJ., 36 (1990) 287–290. Reproduced by permission of the American Institute of Chemical Engineers © 1990 AIChE)*

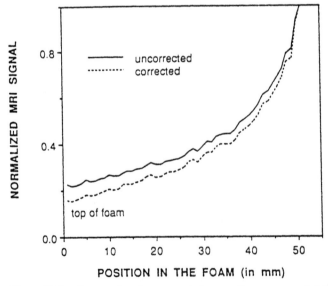

Figure 24.2 *Corrected and uncorrected magnetic resonance signal intensity. (From M. J. McCarthy, Interpretation of the magnetic resonance imaging signal from a foam, AIChEJ., 36 (1990) 287–290. Reproduced by permission of the American Institute of Chemical Engineers © 1990 AIChE)*

The process of convective transport in membrane bioreactors was investigated with the aid of NMRI by Heath *et al.* (1990). Such reactors are being used in the production of protein-based products, but the process of mass transfer associated with such systems presents a problem. To this end NMRI was used in the validation of a proposed model to subsequently understand the mechanics of mass transfer and ultimately enable such reactors to be designed cost-effectively.

Part of the objectives were to use NMRI in the validation of a simplified mathematical model from which fluid velocity profiles could be simulated, for a single hollow-fibre membrane bioreactor excluding the presence of cells. Two-dimensional images were obtained illustrating velocity profiles by the use of a suitable Fourier transformation. The experimental arrangement is illustrated in Figure 24.3 which made use of a phantom, in the form of a glass tube, to calibrate the resultant images obtained via NMRI.

The phantom was supplied with a flow of 2.5×10^{-7} m^3 s^{-1} having velocities in the range 0–10 mm s^{-1}. The images obtained by NMRI were found to compare well with those from the simplified model, using peak axial velocities in the range 0.32–0.82 cm s^{-1}, as illustrated by Figure 24.4. A multiple-fibre bioreactor comprising 40 fibres was also investigated with the assistance of NMRI to assess the potential of the technique to assist in both the design and operation of such devices.

It is possible to image the distribution of fluids within porous materials by the use of NMRI, as shown by many researchers, often using sandstone as the solid material. NMRI images the presence of hydrogen nuclei and it was on this basis that Rothwell *et al.* (1984) studied the absorption of water in a solid polymer material. Two composites of glass fibre reinforced with epoxy resin, having diameters of 2.54 cm, were used as a basis for comparison. One of the

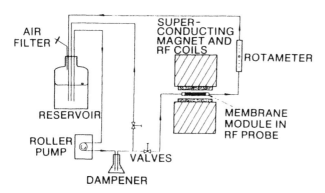

Figure 24.3 *Experimental arrangement used to study flow within membrane bioreactors. (From C. A. Heath, G. Belfort, B. E. Hammer, S. D. Mirer and J. M. Pimbley, Magnetic resonance imaging and modeling of flow in hollow-fiber bioreactors, AIChEJ., **36** (1990) 547–558. Reproduced by permission of the American Institute of Chemical Engineers © 1990 AIChE)*

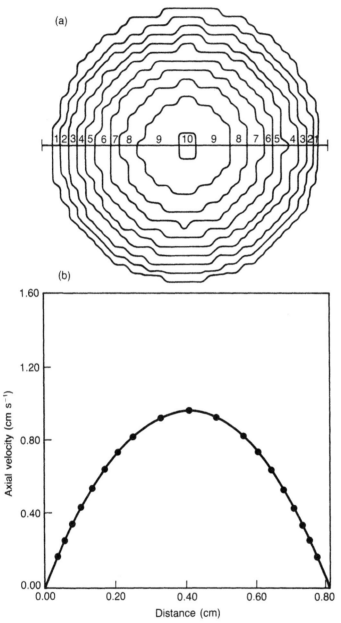

Figure 24.4 *Velocity plots obtained by (a) Magnetic resonance flow imaging and (b) equation of profile for flow phantom. (From C. A. Heath, G. Belfort, B. E. Hammer, S. D. Mirer and J. M. Pimbley, Magnetic resonance imaging and modeling of flow in hollow-fiber bioreactors, AIChEJ., 36 (1990) 547–558. Reproduced by permission of the American Institute of Chemical Engineers © 1990 AIChE)*

composites was hardened with an anhydride, while the other was hardened with an aromatic amine and found to contain small fractures. After immersion of both composites in a water bath for a period of about 2–3 months at 93°C, NMR images were obtained to determine the profile of water through the composites. The images were obtained in about 15 min by the use of 120 different projections.

The composite sample containing the fractures was found to have the greatest concentration of water at its centre, whereas the absorbed water on the composite hardened with the anhydride was localized near the confines of the material. The results of the experiments clearly advocated the use of NMRI for this particular application and illustrated the dependence of the absorption process on both the physical and chemical nature of the polymer material.

The imaging of oil field core samples, namely berea sandstone and Lion Mountain sandstone, was studied by Rothwell and Vinegar (1985). As in the previous application example, the number of projections obtained in a given direction was 120, with images obtained at various depths along the core sample by movement through the r.f. coil. For the berea sandstone, containing a solution of brine, images were presented in terms of both proton density and the spin–spin relaxation time constant (T_2) which was found to have an average value of 32 ms. The images obtained reflected the porosity profile and acted as a guide to the size of the pores. The Lion Mountain sandstone comprised clean sand, a layer of sand and shale and finally a shale layer. The resultant longitudinal NMR images elucidated the porosity profile in the layers of both clean sand and sand/shale, with the porosity found to be higher in the former. However, the physical nature of the shale layer and short spin–spin relaxation times (T_2) negated the use of NMR to image this region. Characteristically, such problems render the imaging of solids difficult, which well be discussed later.

The distribution of water in sandstone was also addressed by Hall and Rajanyagam (1987). Using a multiplicity of slice images (930 μm thickness) spaced at 2.8 mm along a sample of sandstone, it was possible to visualize the distribution of water. The results showed a non-uniform distribution of water and illustrated the absence of water from the central core of the sample.

Three-dimensional and two-dimensional slice images have also been obtained by Osment *et al.* (1990) for sandstone. The three-dimensional images of sandstone, doped with brine, clearly revealed a region of shale, while the slice selected image of limestone illustrated the porosity profile of the sample. Such images will prove most useful in interrogating the nature of transport processes and in surveying the porosity distribution.

Mass transfer of water, by tracing hydrogen nuclei, in two different environs, via two-dimensional images, was the focus of Hollewand and Gladden (1992). The images were obtained via the spin warp imaging technique, described earlier, of Edelstein *et al.* (1980). One of the transfer processes involved the diffusion of water into a catalyst, while the other considered the drying process of a wet catalyst pellet. Cylindrical pellet diameters ranged from 1 to 3 mm, with image resolution between 0.06 and 0.2 mm. Study of the pellets into which water had diffused revealed a non-uniform

distribution of water, while analysis of the drying process revealed drying of the catalyst pellets to be more apparent at the centre of the sample.

The use of NMRI to image solid materials is a long-standing problem. This is attributed to the broad magnetic resonance linewidths and the spin–spin relaxation times being much shorter than those associated with liquids (Strange, 1990). Consequently, the prime objective of many studies having the objective of imaging such materials, has been to narrow the linewidths characteristic of a solid. Two-dimensional images of solids were produced by Chingas *et al.* (1986) by using multiple pulses and varying magnetic field gradients to image the distribution of protons. Miller *et al.* (1990) reported on the use of an imaging sequence based on the MREV-8 pulse sequence, detailed by Rhim *et al.* (1973), which employed a sequence of eight pulses. Miller *et al.* (1990) highlighted the problem of moving 'off-resonance', which impedes the performance of the MREV-8 sequence. However, a combination of 'refocused gradient imaging' and pulsed linear magnetic field gradients was found to impart an improvement in the resultant spatial resolution of images obtained for solids.

As opposed to narrowing the broad linewidths of solids, it is feasible to rely on the use of large magnetic field gradients despite the subsequent power demands (as discussed by Strange (1990)). A spin–echo method was illustrated with the aid of one-dimensional profiles and gradient spin echoes were used in conjunction with r.f. pulses to successfully image samples of rubber having different spin–spin relaxation time constants (T_2). Images of less clarity were obtained via a planar imaging method which utilized changing magnetic gradients between echoes. However, with advancements in the technique, it was suggested that processes could be monitored having a time domain equivalent to the spin–lattice relaxation time.

Imaging of solids in three dimensions was also featured in the study, using 'pulse-sustained gradient echo modulation', along with three right-angled magnetic fields, as described by Cottrell (1990). Various techniques have been outlined by Cottrell *et al.* (1991) involving 'slice selection' NMR imaging of solids. The principal method yielding the best resolution of images entailed a combination of r.f. pulses, of varying strengths, and both slice selection and imaging magnetic field gradients. As the former was increased, image quality of rubber samples was found to improve. An alternative method used an oscillating imaging gradient but, despite using slice selection magnetic gradients of greater strength than the previous method, image resolution was not as high. Three-dimensional imaging was also highlighted, in which three orthogonal imaging magnetic field gradients are initialized before the application of r.f. pulses and sustained until the NMR signal is received. This imaging technique was found to have a resolution of 0.7 mm in each of the three orthogonal directions.

Gladden (1994a,b) has given a useful review of emerging industrial applications of NMRI applied to ceramics processing, polymer technology, characterization of transport in porous media and reactors, food processing and flow imaging.

24.4 Limitations of NMR imaging

Clearly, sensor volume and the inability to function if significant amounts of iron are present are significant constraints upon any direct application of NMRI to the process industry. Most of the studies cited here have employed small bore magnet and the bore of the magnet obviates, for example, any study of large-diameter industrial process vessels. In contrast, vessel size does not impede the potential application of tomography based on other sensing techniques, to imaging the contents of such process equipment. The sensors employed in electrically based tomographic techniques, as in resistive and capacitance methods, are inherently simpler and, in addition, such sensors have a faster dynamic response than those associated with the radiation-based NMRI technique. However, the decisive advantage of NMR tomography is its specificity to chemical composition.

The execution of NMR Imaging is decidedly expensive. However, the high resolution of images obtained advocates its role in the validation of theoretical models, thereby establishing the technique as a significant and important research and design tool.

References

Chingas, G. C., Miller, J. B. and Garroway, A. N. (1986) NMR images of solids. *J. Magn. Reson.*, **66**, 530–535

Cottrell, S. P. (1990) NMR imaging of solids using echoes. Ph. D. thesis, University of Kent

Cottrell, S. P., Halse, M. R., Ibbett, D. A., Boda-Novy, B. L. and Strange, J. H. (1991) Slice selection methods for the NMR imaging of solid materials. *Meas. Sci. Technol.*, **2**, 860–865

Edelstein, W. A., Hutchison, J. M. S., Johnson, G. and Redpath, T. (1980) Spin warp imaging and applications to human whole-body imaging. *Phys. Med. Biol.*, **25**, 751–756

Ellingson, W. A., Wong, P. S., Dieckman, S. L., Ackerman, J. L. and Garrido, L. (1989) Magnetic resonance imaging: a new characterization technique for advanced ceramics. *Ceram. Bull.*, **68**, 1180–1186

Frahm, J., Merboldt, K. L. and Hanicke, W. (1987) Localized proton spectroscopy using stimulated echoes. *J. Magn. Reson.*, **72**, 502–508

Gainsborough, N. (1989) Magnetic resonance imaging. *Image Technol.*, **71**, 16–18

Gladden, L. F. (1994a) Industrial applications of NMR imaging. In *Process Tomography – A Strategy For Industrial Exploitation 1994* (eds M. S. Beck *et al.*) UMIST, Manchester, 466–477

Gladden, L. F. (1994b) Nuclear magnetic resonance in chemical engineering: principles and applications, *Chem. Eng. Sci.*, **49**, (2), 3339–3408

Haase, A. (1990) Snapshot FLASH MRI. Applications to T_1, T_2 and chemical-shift imaging. *Magn. Reson. Med.*, **13**, 77–89

Hall, L. D. and Rajanyagam, V. (1987) Thin-slice, chemical-shift imaging of oil and water in sandstone rock at 80 MHz. *J. Magn. Reson.*, **74**, 139–146

Heath, C. A., Belfort, G., Hammer, B. E., Mirer, S. D. and Pimbley, J. M. (1990) Magnetic resonance imaging and modeling of flow in hollow-fiber bioreactors. *AIChE J.*, **36**, 547–558

Hollewand, M. P. and Gladden, L. F. (1992) Visualization of phases in catalyst pellets and pellet mass transfer processes using magnetic resonance imaging. *IChemE Res. Event Proc.*, *9–10 January, Manchester*, 77–79, 1. Chem. E., Rugby

Lauterbur, P. C. (1973) Image formation by induced local interactions: examples employing nuclear magnetic resonance. *Nature*, **242**, 190–191

McCarthy, M. J. (1990) Interpretation of the magnetic resonance imaging signal from a foam. *AIChE J.*, **36**, 287–290

Miller, J. B., Cory, D. G. and Garroway, A. N. (1990) Line-narrowing approaches to solid state NMR imaging: pulsed gradients and second averaging. *Phil. Trans. R. Soc. A*, **333**, 413–426

Osment, P. A., Packer, K.J., Taylor, M. J., Attard, J. J., Carpenter, T. A., Hall, L. D., Herrod, N. J. and Dorran, S. J. (1990) NMR imaging of fluids in porous solids. *Phil. Trans. R. Soc. A*, **333**, 441–452

Rhim, W. -K., Elleman, D. D. and Vaughan, R. W. (1973) Enhanced resolution for solid state NMR. *J. Chem. Phys.*, **58**, 1772–1773

Rothwell, W. P. (1985) Nuclear magnetic resonance imaging. *Appl. Opt.*, **24**, 3958–3968

Rothwell, W. P. and Vinegar, H. J. (1985) Petrophysical applications of NMR imaging. *Appl. Opt.*, **24**, 3969–3972

Rothwell, W. P., Holecek, D. R., and Kershaw, J. A. (1984) NMR imaging: study of fluid absorption by polymer composites. *J. Poylm. Sci.: Poylm. Lett. Edn.*, **22**, 241–247

Strange, J. H. (1990) Echoes and imaging in solids. *Phil. Trans. R. Soc. A*, **333**, 427–439

Yang, G. Z. and Burger, P. (1990) Enhancement and segmentation of NMR images of blood flow in arteries. Conf. on Visual Comm. & Image Processing '90 (Lausanne, Switzerland). In *Proc. of SPIG – The Int. Soc. for Opt. Eng.* v1360 Pt. 2 Published by Int. Soc. for Opt. Eng., Bellingham, WA, USA, 702

Chapter 25

Application of optical tomography to visualize temperature distributions in flames

H. Burkhardt and E. Stoll

25.1 Introduction

Combustion processes are very complex reactive fluid dynamical processes. A thorough analysis is a pre-requisite to reduce pollutant emissions, for fuel economy, for the optimization of burner performance and for on-line control purposes. Local point measurements (e.g. with thermocouples or local radiation pyrometry and spectroscopic methods) give only little information to characterize these spatially distributed and time-dependent processes. Large array sensors like CCD arrays in video cameras provide us with an enormous amount of information, and automatic image processing as well as pattern-recognition methods give a much higher potential for the analysis of such processes and have the attraction of a non-contact and non-intrusive optical measurement technique. The literature shows that there is already a wide acceptance of these methods, and gives examples for the potential of the methods (see e.g. Jähne, 1992; Warnecke, 1983; Haussmann and Lauterborn, 1980; Mesch et al., 1987; Mesch, 1990).

The task of analysing the complex digital images is made more difficult by the fact that there are deficiencies caused by the projection of a three-dimensional process into the two-dimensional camera plane. The simplest case is a transparent (optically thin) process with a linear superposition model for transmitted or emitted radiation. However, in general there may be non-linear effects by extinction and occlusion. The loss of information by projections may at least partially be recovered by stereo or multiple views with more than one camera. Tomographic analysis may be used for back-projection to get cross-sections of three-dimensional distributions based on digital calculations. Another possibility of cross-section analysis may be realized by illuminating a fluid process with planar light sources, e.g. by beam splitting a laser.

Parametric physical and chemical models may be used to incorporate *a priori* knowledge of the process. This *model-based* image analysis allows a quantitative analysis of process parameters like temperature or component concentrations.

It is attractive to exploit the potential of image-analysis and pattern-recognition methods for still images and image sequences for a rather complete analysis of complex processes in chemical engineering (Burkhardt, 1993). Methods of *still-image* analysis may be used for *stationary processes*. Pattern-recognition algorithms can discriminate between different modes of operation and model-based tomographic methods give quantitative answers for measuring

process parameters. A multi-spectral image analysis may be necessary to discover components in reactive zones.

Non-stationary processes may be recorded in *image sequences* as a database for an image analysis with respect to space and time (spatiotemporal analysis). Microscopic as well as macroscopic motion phenomena within the image sequence may be traced to characterize the kinetics of a fluid process. Velocity vector fields describe particle trajectories and flow rates. Of further interest are measurements on particle residence time, particle survival in regions or a collision analysis. Macroscopic phenomena like the propagation of reaction zones, the fluctuation of density wavefronts or aggregations in form of particle clusters describe diffusion and transportation in the process. If changes in the process are fast it can be necessary to use high-speed cameras because standard video frame cycles do not give a good time resolution.

In the following sections we describe the application of image-processing algorithms for the tomographic analysis of digitized video image sequences taken from luminous flames. We describe a fast reconstruction of three-dimensional temperature distributions on a transputer-based parallel computer with video bus. The measurements are taken from filtered video images of axisymmetric sooting flames. The luminous flames are modelled as grey radiators including absorption. Quotient pyrometry is applied to multispectral images to eliminate the unknown constants of the optoelectronic imaging system. With a sufficient number of transputers we reach a near-real-time analysis response.

25.2 Image acquisition and image processing

Figure 25.1 shows schematically the components of an image-processing system used in our investigation on emission tomographic analysis of self-radiating flames. The object under investigation is mapped by an optical system with filters onto a CCD sensor of a video camera with a resolution of 512×512 pixels. The European video norm CCIR assumes 25 frames per second. The analogue-to-digital converter is assumed to have 8–12 bit resolution. Because of the high video data rate it is necessary in many situations to use a parallel computer for the image analysis to reach real-time or almost-real-time response which is often needed in technical applications.

Figure 25.1 *Building blocks of an image-processing system*

The left-hand side of Figure 25.2 shows the image of a Bunsen burner flame. The background was separated and set to a constant value. The right-hand side shows a window zoomed by a factor of 8, clearly indicating the pixel structure of the digitized image.

25.3 Radiation model and tomographic reconstruction

25.3.1 Model-based tomographic analysis

This section describes three-dimensional model-based temperature measurements with tomographic imaging methods for luminous flames (Burkhardt *et al.*, 1989; Fischer, 1989, 1990, 1992; Fischer and Burkhardt, 1990). It is a non-intrusive optical measurement technique based on multi-spectral image frames taken by a video camera. Emission tomography is based on a process with radiation. Projections may be described by the Radon transform. To solve the inverse problem it is, in general, necessary to have available a large number of projections from different viewpoints. Many steady flames, however, show a *rotational symmetry* and, therefore, it is sufficient to use only one projection. The three dimensions are reduced to two, namely height z and radius $r = \sqrt{x^2 - y^2}$. In this case the Radon transform turns into the Abel transform \mathscr{A}

$$g(x,z) = [\mathscr{A}f](x,z) = 2 \int_x^\infty \frac{rf(r,z)}{\sqrt{r^2 - x^2}} \, dr \tag{25.1}$$

The variables x and z are the spatial co-ordinates perpendicular and along the main axis in flow direction of the flame.

The measured radiation may now be used for a tomographic reconstruction of the three-dimensional radiation distribution and hence it is possible to calculate a cross-section through the centre of the flame. There are different ways to solve the inverse problem, e.g. inverse Abel transform, filtered back-projection, algebraic reconstruction techniques, singular value decomposition (SVD) of the Abel transform, or a reconstruction based on the

Figure 25.2 (*Left*) *Flame image.* (*Right*) *Zoomed detail* (*factor 8*)

Abel–Fourier–Hankel cycle. Fischer (1922) reports on the properties of these different techniques.

For a temperature interpretation we need a radiation model. Luminous flames containing unburnt carbon particles (soot particles) causing the visible radiation can be assumed to be grey radiators. The radiation of a black body may be described by Planck's law:

$$J_{\lambda b}(\lambda, T) = \frac{2hc_0^2}{\lambda^5} \frac{1}{\exp(c_0 h/k\lambda T) - 1} \tag{25.2}$$

where $J_{\lambda b}(\lambda, T)$ is the spectral intensity which is emitted from a surface with the temperature T at a wavelength λ (c_0 is the speed of light, h is Planck's constant, and k is Boltzmann constant). Grey radiation may be described by $J_{\lambda g}(\lambda, T) = \varepsilon \cdot J_{\lambda b}(\lambda, T)$, with an emission coefficient of $0 \leqslant \varepsilon \leqslant 1$.

Because of the difficulties to determine the local emission coefficients as well as the optical properties of the filters and camera, quotient pyrometry is applied to eliminate the unknown constants (Fischer and Burkhardt, 1990; Fischer, 1992) based on two measurements with different optical filters. A special tungsten filament lamp with known temperature was used to calibrate the optoelectronic sensitivity of the video camera.

25.3.2 Symmetry along a curved axis of the flame

Even in the case of a laminar flickering flame we can find an axisymmetric symmetry along a curved axis (see Figure 25.3). We observe an approximate rotational symmetry in each horizontal cross-section (row in digitized image matrix).

The symmetry axis is determined by calculating the centre of gravity x_s of the grey value function in each row of the image orthogonal to the flow direction. It is therefore given by

Axis of symmetry

Flame

Figure 25.3 *A laminar, flickering flame*

$$x_{\mathrm{s}} = \frac{\displaystyle\sum_{i=0}^{n} f_i \cdot x_i}{\displaystyle\sum_{i=0}^{n} f_i}$$

where f_i is the grey value of pixel i, x_i is the x location of pixel i, and n is the number of pixels.

If the calculated centre of gravity is not an integer value, the corresponding image line is translated by that fraction with linearly interpolated grey values. The tomographic reconstruction is applied separately to the left- and to the right-half sections of each row. In a last step the row is moved to its original position.

The symmetry assumption is confirmed in the experiment, as only slight discontinuities were observed at the boundary of the left and the right reconstructed sections of the image (see Plate 6).

25.3.3 Temperature calculation

For a given integral radiation density $J_{\lambda b}(j)$ in each cross-section (where j denotes the corresponding horizontal layer in Figure 25.4) the local temperature can be determined by using tomographic calculation and Planck's law of black body radiation given by eqn (25.2). Due to the uncalibrated measuring system, we get the radiation up to an unknown proportionality factor $\tilde{J}_{\lambda b}(j) = c'(\lambda) c'' J_{\lambda b}$. This factor can be divided into a first portion which is dependent on the wavelength $c'(\lambda)$ (transmission of the used optical filters and spectral sensitivity of the camera target) and a second wavelength independent portion

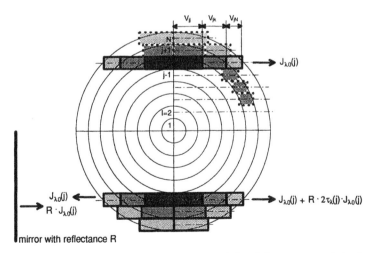

Figure 25.4 *Discretized flame radiation model including a mirror behind one-half of the flame*

c'' which is characterized by the mapping properties of the given optical geometry.

Reference measurements with a special tungsten band bulb with known temperature may be used to calibrate $c'(\lambda)$. The unknown value of c'' can be eliminated by dividing two spectrally different measurements of the same flame at the same time (quotient pyrometry). With $c_1 = hc_0^2$ and $c_2 = hc_0/k$ the ratio of the relative radiation densities is given by:

$$\frac{\tilde{J}_{\lambda_1 b}}{\tilde{J}_{\lambda_2 b}} = \frac{c'(\lambda_1)J_{\lambda b}}{c'(\lambda_2)J_{\lambda b}} = \frac{c'(\lambda_1)\lambda_2^5(e^{\frac{c_2}{\lambda_2 T}} - 1)}{c'(\lambda_2)\lambda_1^5(e^{\frac{c_2}{\lambda_1 T}} - 1)} \tag{25.3}$$

This equation cannot be solved explicitly for the temperature T. For temperatures between 300 and 3000 K and wavelengths between 0.5 and 1 μm a fairly good approximation of Planck's law is obtained by using Wien's formula:

$$J_{\lambda b} \approx \frac{2c_1}{\lambda^5 \cdot \exp(c_2/\lambda \cdot T)}$$

Its error is below 1% (Gröber *et al.*, 1981) for the given range. Equation (25.3) can therefore be simplified according to

$$\frac{\tilde{J}_{\lambda_1 b}}{\tilde{J}_{\lambda_2 b}} = \frac{c'(\lambda_1)\lambda_2^5[\exp(c_2/\lambda_2 T)]}{c'(\lambda_2)\lambda_1^5[\exp(c_2/\lambda_1 T)]}$$

This equation can now be solved explicitly with respect to the unknown temperature:

$$T = \frac{1}{\ln\left[\dfrac{c'(\lambda_2)\lambda_1^5 \tilde{J}_{\lambda_1 b}}{c'(\lambda_1)\lambda_2^5 \tilde{J}_{\lambda_2 b}}\right]} \cdot \left(\frac{c_2}{\lambda_2} - \frac{c_2}{\lambda_1}\right) \tag{25.4}$$

25.3.4 Determination of the absorption coefficient

To a first-order approximation flames can be modelled as optically thin media. Thus a linear superposition is obtained of the local radiation densities in a projection. The model may be refined by taking into account the extinction in the model consisting of absorption and scattering. The locally generated radiation is partly reabsorbed while travelling through the flame. Each spatial location x has associated with it an emission coefficient $e_\lambda(x)$ and an absorption coefficient $k_\lambda(x)$. The scattering coefficient may be neglected with respect to the absorption coefficient (Hall and Bonczyk, 1990). The local emission coefficient is defined as the amount of increased radiation density at point x. The absorption is proportional to the existing radiation density and is characterized by the absorption coefficient. The following differential equation is obtained:

$$\frac{dJ_\lambda(x)}{dx} = \varepsilon_\lambda(x) - k_\lambda(x)J_\lambda(x) \tag{25.5}$$

According to Kirchhoff's law,

$$\varepsilon_\lambda(x) = k_\lambda(x) \cdot J_{\lambda b}(x, T)$$

under the assumption that the coefficient k_λ is independent of the radiation field, the following solution of the differential equation is obtained for an arbitrary inhomogeneous system of width b:

$$J_\lambda(b) = J_\lambda(0) \cdot e^{\int_0^b k_\lambda(x)dx} + \int_0^b k_\lambda(x) \cdot J_{\lambda b}(x) \cdot \left[\exp\left(-\int_x^b k_\lambda(\xi)d\xi \right) \right] dx \tag{25.6}$$

The overall radiation which leaves the system is composed of the radiation entering the system $J_\lambda(0)$ multiplied by the spectral transmittance:

$$\tau_\lambda(b) = \exp\left(-\int_0^b k_\lambda(x)dx \right) \tag{25.7}$$

and the radiation which is emitted by the system itself is

$$J_{\lambda system}(b) = \int_0^b k_\lambda(x) \cdot J_{\lambda b}(x) \cdot \left(\exp\left[-\int_x^b k_\lambda(\xi)d\xi \right] \right) dx \tag{25.8}$$

With the help of a mirror according to the measuring arrangement given in Figure 25.4, it is possible to determine the transmittance, and thus by tomographic reconstruction the local absorption coefficient can be determined (Porter, 1964). For an axisymmetric model we may position a mirror behind one half of the flame. Based on a discretization of an ART algorithm the measured radiation densities in the camera target may be described by the system of equations:

$$J_{\lambda M}(j) = J_{\lambda 0}(j) \left[1 + R \cdot \exp\left(-2 \sum_{k=j}^N \hat{k}_\lambda(k) \cdot V_{jk} \right) \right] \tag{25.9}$$

where the indices M and 0 denote 'with mirror' and 'without mirror', respectively. R is the dimensionless reflectance of the mirror, $\hat{k}_\lambda(k)$ denotes the absorption coefficient on the kth circular layer of the discretized model (see Figure 25.4), and V_{jk} corresponds to the length of the volume element under consideration. The variables are normalized to a thickness of 1 in all circular layers.

For $j = 1, \ldots, N$ eqn (25.9) forms an upper triangular matrix if we take the logarithm for which we get the following general solution:

$$\hat{k}_\lambda(j) = \frac{1}{-2V_{jj}} \left[\ln\left(\frac{J_{\lambda M}(j) - J_{\lambda 0}(j)}{J_{\lambda 0}(j)R} \right) + 2 \cdot \sum_{k=j+1}^N \hat{k}_\lambda(k) \cdot V_{jk} \right] \tag{25.10}$$

From eqn (25.10) it is possible to calculate all $\hat{k}_\lambda(j)$.

The integral sum of radiation on the camera target may be calculated as:

$$J_{\lambda 0}(j) = \sum_{k=j}^{N} J_{\lambda b}(k)\hat{k}_\lambda(k)V_{jk}\left[\exp\left(-\sum_{l=k+1}^{N}\hat{k}_\lambda(l)V_{jl}\right)\right.$$
$$\left. + \exp\left(-\sum_{l=j}^{k-1}\hat{k}_\lambda(l)V_{jl} - \sum_{l=j}^{N}\hat{k}_\lambda(l)V_{jl}\right)\right] \qquad (25.11)$$

Finally, the general solution of the system of equation (25.11) is given by:

$$J_{\lambda b}(j) =$$

$$\frac{J_{\lambda 0} - \sum_{k=j+1}^{N} J_{\lambda b}(k)\hat{k}_\lambda(k)V_{jk}\left[\exp\left(-\sum_{l=k+1}^{N}\hat{k}_\lambda(l)V_{jl}\right) + \exp\left[-\sum_{l=j}^{k-1}\hat{k}_\lambda(l)V_{jl} - \sum_{l=j}^{N}\hat{k}_\lambda(l)V_{jl}\right]\right]}{\hat{k}_\lambda(j)V_{jj}\left[\exp\left(-\sum_{l=j+1}^{N}\hat{k}_\lambda(l)V_{jl}\right) + \exp\left(-\sum_{l=j}^{N}\hat{k}_\lambda(l)V_{jl}\right)\right]}$$

$$(25.12)$$

Based on the known absorption $\hat{k}_\lambda(i)\cdot V_{ik}$ it is now possible to calculate the radiation density for each circular layer.

The results of applying this method are presented in Section 25.5.3. Stoll (1994) gives an analysis of the reconstruction error caused by the discretization error of the analogue-to-digital converter.

It is possible to extend the mirror technique with small errors also to flickering flames with a curved symmetry axis. By positioning a mirror behind the whole flame we can measure $J_{\lambda M}$. At the same instant we need $J_{\lambda 0}$. This requires a second mirror (Stoll, 1994) beside the first one which is able to map the flame directly to the camera target. This arrangement suffers only from the deficiency that we get a measurement which is additionally weakened by the reflection factor of the mirror, the image being captured from a slightly different angle than the first image.

25.4 Fast implementation on a parallel computer

25.4.1 Image sequence capturing with the Harburger System

Image sequences were captured using the Harburger System (see Figure 25.5). This parallel computer system was developed at the Technical University in Hamburg-Harburg for image-processing tasks (Lang and Burkhardt, 1990; Lang, 1991) and is based on transputers. In addition to standard features of transputer-based systems it includes a real-time video pipeline bus which allows on-line scattering of video data among the parallel processors with random data arbitration. Besides other tasks it can also be used to capture image sequences. The length of the sequence is only limited by the memory size of the parallel-processor kernel. The actual prototype system contains eight

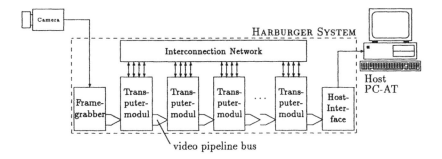

Figure 25.5 *Overview of a parallel image-processing system*

transputers in the kernel, each equipped with 1 Mbyte of memory. A small amount of memory is used by the operating software, but more than 90% can be used to store images in the sequence application. When 512×512 frames are selected, up to 30 successive images can be stored at video rate of 25 frames/s, covering a period of more than 1 s of measuring time.

25.4.2 On-line analysis on a Supercluster

The algorithm may also very easily be implemented on a massively parallel computer, as long as the number of processors is smaller than the number of cross-sections in the digitized image. Each line corresponding to a cross-section may be calculated independently on one processor. Therefore it is possible to distribute an equal number of lines to all processors.

The ART algorithm was implemented on a Supercluster from Parsytec with 128 transputers which was funded to the University of Technology at Hamburg-Harburg by the German National Science Foundation. The machine is equipped with a frame grabber for video data acquisition and a graphic card for display. From our laboratory we have direct video links to the machine. For our implementation we used a modular and scaleable image-processing library, called PIPS (Nölle *et al.*, 1994), which was developed in our institute during the past couple of years. The underlying message passer MEPS uses a de Bruijn or perfect shuffle network for data communication.

The flame is segmented from the background by simple thresholding. In each row we realize a separate determination of the point of symmetry of the flame axis according to Section 25.3.2.

The frame grabber takes an image of dimension 512×512 from the CCD camera from which a 256×256 section is transmitted to the slave processors. The algorithm is scalable and the data may be transmitted to a number $N = 1$ up to $N = 64$ processors (depending on availability). Each transputer works on $256/N$ image lines, reconstructing the corresponding $256/N$ cross-sections. The result is gathered again across the de Bruijn network and then transmitted to the graphic card for display.

The whole reconstruction algorithm takes 120 ms on 64 transputers which corresponds almost to video real-time. The data transmission from the frame grabber and to the graphic card, however, is only realized over one transputer link, thus slowing down a complete cycle to approximately 3 s.

25.5 Experimental results

25.5.1 Temperature distribution

The above-described method for the tomographic reconstruction of three-dimensional temperature distributions was applied to candle and Bunsen burner flames. A Bunsen burner flame requires a premix of air and gas (propane and butane). We used an adjustment with a laminar flow and a luminous sooting flame in the visible range. The images were taken with a colour camera (IKEGAMI HC-230). Figure 25.6 shows the spectral projections of the Bunsen burner flame in the red, green and blue range (from left to right). In order to make small intensity changes in the radiation more visible a look-up table with a sawtooth profile was applied to the density values in the range 0–255 (8-bit resolution). Figure 25.7 shows a profile along the marked line.

The results given here are based on a regularized SVD-algorithm (Fischer,

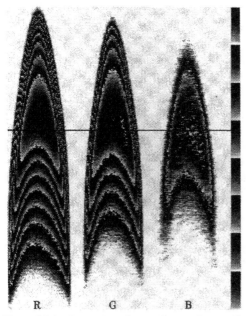

Figure 25.6 *Projections from a Bunsen burner flame in three spectral ranges: (R) red; (G) green; (B) blue*

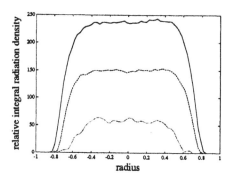

Figure 25.7 *One-dimensional intensity profiles of the spectral projections in Figure 25.6 along the marked line: (top) red; (middle) green; (bottom) blue*

1992) applied to the Abel transform. Figure 25.8 shows the reconstruction result for a Bunsen burner (Figure 25.6) representing a cross-section through the flame. Figure 25.9 shows a horizontal profile of the reconstructed radiation densities. The results correspond to the projections given in Figure 25.6.

The model-based interpretation of the temperatures is based on quotient

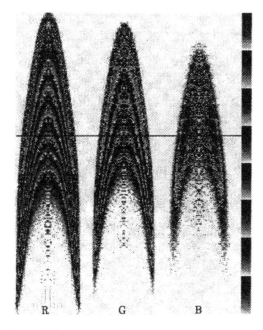

Figure 25.8 *Tomographic cross-section reconstruction of the spectral radiation density of an axisymmetric Bunsen burner flame in the red (R), green (G) and (B) blue ranges*

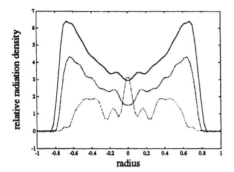

Figure 25.9 *One-dimensional radial intensity profile of the cross-sections in Figure 25.8 along the marked line: (top) red; (middle) green; (bottom) blue*

pyrometry (Fischer, 1992). We can observe that the radiation in the blue channel is much smaller than the green and red channels and has a lower signal-to-noise ratio. The reconstruction is therefore based on the green and red channels.

Figure 25.10 shows the result, including a smoothed temperature field obtained with a low-pass filter applied to the reconstructed image. The profile

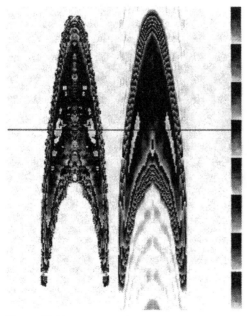

Figure 25.10 *Tomographic cross-section reconstruction of the radial temperature of an axisymmetric Bunsen burner flame calculated with quotient pyrometry based on measurements in the green and red ranges. (Right) Smoothed image*

in Figure 25.11 was taken across the range of highest temperatures in the Bunsen burner flame. The histogram of the temperature distribution (Figure 25.12) shows an accumulation of temperatures around 2100 K. An analysis of the accuracy of the proposed method results in a relative error of approximately 15% (Fischer, 1992).

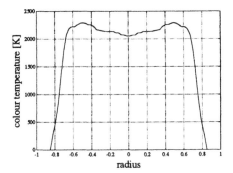

Figure 25.11 *Horizontal radial profile along the marked line of the smoothed temperature in Figure 25.10*

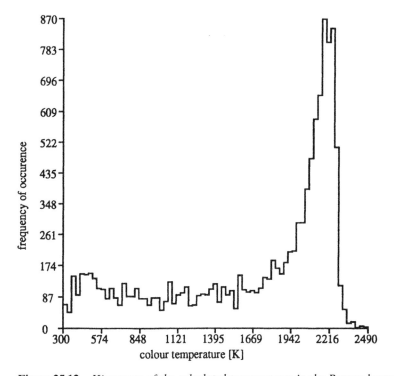

Figure 25.12 *Histogram of the calculated temperatures in the Bunsen burner flame*

25.5.2 Quasi-rotational symmetry

In the case of small deviations from axisymmetry, the tomographic reconstruction can be improved by capturing two orthogonal projections from two video cameras at an angle of 90°. The following experiments were done with a Bunsen burner using two cameras. The parameters were chosen such that the flame was under a laminar flow condition. The left-hand side of Figure 25.13 shows the two projections of the flame. The right-hand side shows the cross-sections $f(x,0,z)$ and $f(0,y,z)$ of the radiation density of the flame.

The window which was relevant for the calculation contained 280×67 pixels. Figure 25.14 shows the horizontal profiles of the two projected radiation densities at height z_2, and Figure 25.15 shows the corresponding profiles of the tomographic reconstruction. Details of the reconstruction algorithm are given in Fischer (1992). Figure 25.16 shows horizontal cross-sections of a reconstructed Bunsen burner flame from top to bottom (only every fourth cross-section is shown from top left to bottom right).

If the air and gas flow of the burner are increased we observe a transition from laminar to turbulent flow. In the turbulent operating mode we no longer have an axisymmetric flame and hence the methods presented here can no longer be applied. In the transition phase we observe a laminar flickering flame which may still be reconstructed using the results presented in Section 25.3.2.

The results can even be improved by using four projections (Stoll, 1994). By using an appropriate arrangement of mirrors it is possible to capture all four projections simultaneously using one video camera. Plate 4 shows tomographic reconstructions from image sequences based on four projections.

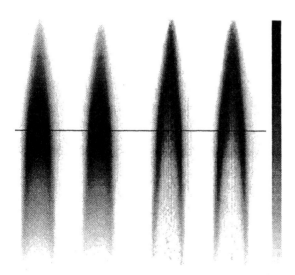

Figure 25.13 (*Left*) *Orthogonal projections \check{f}_0 and $\check{f}_{\pi12}$ from a Bunsen burner flame.* (*Right*) *Reconstructed, local radiation density (cross-sections) f(x,0,z) and f(0,y,z)*

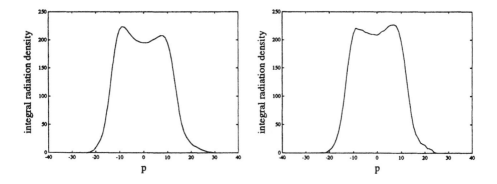

Figure 25.14 *Horizontal profiles of projections from a Bunsen burner flame at height* z_2: *(a)* $\check{I}_0(p,z_2)$; *(b)* $\check{I}_{\pi/2}(p,z_2)$

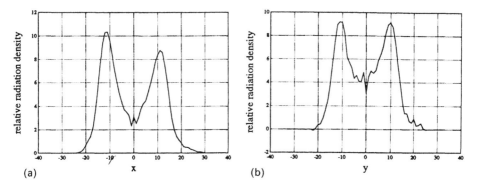

Figure 25.15 *Horizontal radial profiles of the radiation density (cross-section) at height* z_2: *(a)* $f(x,0,z_2)$; *(b)* $f(0,y,z_2)$

25.5.3 Determination of the absorption coefficient

Plate 5 shows the results of the determination of the absorption coefficient. Based on the image of a candle flame (a) we see the local radiation densities (b) reconstructed by tomography. The spectral absorptance (c) can be determined from measurements obtained with the mirror technique. The calculations are based on $1 - \tau_\lambda$ (τ_λ is the spectral transmittance according to eqn (25.7)). Based on this we can finally reconstruct the spectral absorption coefficient. Plate 5(d) shows a radial cross-section of the absorption coefficient. We observe a good agreement with the results of Hall and Bonczyk (1990), who determined the absorption coefficients of diffusion flames with transmittance measurements. The cylindrical distributions are very typical for diffusion flames. The oxygen slowly diffuses from the outer zones into the flame. There we find the first reactions (this is the main reaction zone according to Gaydon

Figure 25.16 *Three-dimensional reconstruction of a Bunsen burner flame from two orthogonal projections; horizontal cross-sections from the top to the bottom of the flame*

and Wolfhard (1970)). In the centre of the flame we observe an increase in the absorption coefficient in the direction of the top of the flame, whereas the temperature in the upper part decreases. Due to the lack of oxygen we observe a sublimation of carbon on very small floating particles in the gas phase (Boehm, 1958).

25.5.4 Application to image sequences

We used the Harburger System to capture image sequences from flickering flames of a Bunsen burner under different adjustments of gas and oxygen.

Plate 6 shows an image sequence of a flickering Bunsen burner at video frame rate (time between images 20 ms). On the left-hand side we see the projection of the radiation density and on the right-hand side the tomographic reconstruction under the assumption of axisymmetry along a winding axes (see Section 25.3.2). The flickering can be determined to be approximately 10 Hz.

According to eqn (25.4) we need two narrow-band captured images to be able to apply quotient pyrometry for the determination of the temperature. As the Harburger System has only one video channel, we mapped the flame with prisms and two near-infra-red narrow-band interference filters onto a monochromatic CCD sensor. By using a camera with high sensitivity in the

near-infra-red region we were able to reduce the bandwidth of the optical filters to 12 nm.

Plate 7 shows (from left to right): two radiation density projections at 961.3 nm and 812.9 nm; the two corresponding tomographic reconstructions of the radiation densities; and the line of sight temperature calculated with quotient pyrometry from the two projections. This corresponds approximately to something like an averaged temperature along the projection. On the far right the tomographic reconstruction of the temperature in a cross-section through the flame is shown.

Acknowledgements

These investigations are supported by the German Science Foundation (Deutsche Forschungesgemainschaft, DFG) within the research program SFB238 at the University of Technology in Hamburg-Harburg.

References

Boehm, H.-P. (1958) Zur Struktur der Rußteilchem. *Z. Anorg. Allg. Chem.* **297**, 315–321

Burkhardt, H. (1993) Image analysis and control of combustion processes (invited keynote lecture). In S. Sideman and K. Hijikata, *Proceedings of the International Seminar on Imaging in Transport Processes, Athens, May 1992* (eds S. Sideman and K. Hijikata), Begell House, New York

Burkhardt, H., Höhne, K. H. and Neumann, B. (1989) *Mustererkennung 1989, Hamburg, 1989. 11. DAGM – Symposium 'Mustererkennung', Informatik-Fachberichte*, Springer-Verlag, Berlin

Fischer, W. (1989) Temperaturbestimmung in Flammen mittels multispektraler Aufnahmen und tomographischer Bildverarbeitung. In *Mustererkennung 1989* (eds H. Burkhardt *et. al.*), Springer-Verlag, Berlin, 145–152

Fischer, W. (1990) Anwendung der digitalen Bildverarbeitung zur räumlichen Temperaturbestimmung in Flammen. *Bild Ton, Leipzig*, **43**, 230–232

Fischer, W. (1992) Flammenanalyse mittels tomographischer und multispektraler Bildverarbeitung. Ph.D. thesis, Technische Universität Hamburg-Harburg

Fischer, W. and Burkhardt, H. (1990) Three-dimensional temperature measurement in flames by multispectral tomographic image analysis. In *SPIE International Symposium on Optical and Optoelectronics – Applications of Digital Image Processing XIII*, Vol. 1349, *San Diego, July 1990. Bellingham, Washington*

Gaydon, A. G. and Wolfhard, H. G. (1970) *Flames, Their Structure, Radiation and Temperature*, Chapman & Hall, London

Gröber, H. Erk S. and Grigull U. (1981) *Die Grundgesetze der Wärmeübertragung*, Springer-Verlag, Berlin

Hall, R. J. and Bonczyk, P. A. (1990) Sooting flame thermometry using emission/absorption tomography. *Appl. Opt.*, **29**, 4590–4598

Haussmann, G. and Lauterborn, W. (1980) Determination of size and position of fast moving gas bubbles in liquids by digital 3-D image processing of hologram reconstructions. *Appl. Opt.*, **19**, 3529–3535

Jähne, B. (1992) Spatio-temporal image processing with scientific applications. Habilitation thesis, Computer Science Department, University of Technology in Hamburg-Harburg

Lang, B. (1991) Digitale Bildverarbeitung mit kombinierter Pipeline- und Parallel-Architektur. Ph.D. thesis, Technische Universität Hamburg-Harburg

Lang, B. and Burkhardt, H. (1990) A parallel transputer system with fast pipeline interconnection. In *SPIE International Symposium on Optical & Optoelectronic Applications of Digital Image Processing XIII, Vol. 1349, San Diego*. Bellingham, Washington

Mesch, F. (1990) Indirekte Erfassung verteilter Meßgrößen mit berürungslosen Sondenarrays. In *Automatisierungstechnik 90, VDI Berichte 855*, VDI-Verlag, Düsseldorf

Mesch, F., Braun, H. and Deuble, P. (1987) Optische Messung von Geschwindigkeit- und Dichtefeldern in Brennräumen mit tomographischer Auswertung. *Forschungsbericht des Sonderforschungsbereiches 167 'Hochbelastete Brennräume – Stationäre Gleichdruckverbrennung*, Universität Karlsruhe

Nölle, M., Schreiber, G. and Schulz-Mirbach, H. (1994) PIPS – a general purpose parallel image processing system, In G. Kropatsch, Hrsg., *16. DAGM – Symposium 'Mustererkennung'*, Wien, September Reihe Informatik XPress, TU-Wien

Porter, R. W. (1964) Numerical solution for local emission coefficients in axisymmetric self-absorbed sources. *SIAM Rev.*, **6** (3), 228–242

Stoll, E. (1994) Anwendung von Bildverarbeitungs- und automatischen Bildauswertemethoden für multispektrale und multisensorielle bildgebende Meßtechnik. *DFG-Forschungsbericht (Abschlußbericht) im SFB 238, 'Prozeßnahe Meßtechnik und systemdynamische Modellbildung für mehrphasige Systeme', Projekt Bu-C5 und Interner Bericht 2/94*, Techniscke Informatik I, TU-HH

Warnecke, G. (1983) Aspects of dynamic scene analysis in meteorology. In *Image sequence processing and dynamic scene analysis* (ed. T. S. Huang) Springer, Berlin/Heidelberg

Index

Printed and bound by CPI Group (UK) Ltd, Croydon, CR0 4YY

03/10/2024

01040430-0016